TS1445 .C585 2009
Collier, Billie J.
Understanding textiles
c2009.

2009 01 22

DATE DUE	RETURNED
	OCT 0 3 2011
NOV 162011	
	NOV 2 9 2011
NOV 3 0 2011 OCT 1 0 2013	OCT 0 820W
	001 0 02010
OCT 1 1 2016	OCT 0 4 2016 K

LAKESHORE CAMPUS
LEARNING RESOURCE CENTRE
3199 LAKESHORE BLYD. WEST
TORONTO ONTARIO MEY 1KS

*	

Understanding Textiles

DWINGWATERIONU

Understanding Textiles

SEVENTH EDITION

BILLIE J. COLLIER *Florida State University*

MARTIN J. BIDE University of Rhode Island

Phyllis G. Tortora *Queens College*

165101

Upper Saddle River, New Jersey Columbus, Ohio

Library of Congress Cataloging-in-Publication Data

Collier, Billie J.

Understanding textiles / Billie J. Collier, Martin J. Bide, Phyllis G.

Tortora.—7th ed.

p. cm.

Includes bibliographical references and index.

ISBN-13: 978-0-13-118770-2

ISBN-10: 0-13-118770-8

1. Textile industry. 2. Textile fibers. 3. Textile fabrics. I.

Bide, Martin J. II. Tortora, Phyllis G. III. Title.

TS1445.C585 2009

677—dc22

2008008630

Editor in Chief: Vernon Anthony Acquisitions Editor: Jill Jones-Renger Editorial Assistant: Doug Greive Project Manager: Alicia Ritchey

AV Project Manager: Janet Portisch Operations Specialist: Deidra Schwartz

Art Director: Michael Fruhbeis

Project Coordination: Raman Arora, Aptara, Inc.

Cover Designer: Ilze Lemesis

Cover art: Getty One

Director of Marketing: David Gesell Marketing Manager: Leigh Ann Sims Marketing Assistant: Les Roberts Copyeditor: Andrea Howe

This book was set in Times by Aptara, Inc. and was printed and bound by Edwards Brothers. The cover was printed by Phoenix Color Corp.

Copyright © 2009, 2001 by Pearson Education, Inc., Upper Saddle River, New Jersey 07458. Pearson Prentice Hall. All rights reserved. Printed in the United States of America. This publication is protected by Copyright and permission should be obtained from the publisher prior to any prohibited reproduction, storage in a retrieval system, or transmission in any form or by any means, electronic, mechanical, photocopying, recording, or likewise. For information regarding permission(s), write to: Rights and Permissions Department.

Pearson Prentice HallTM is a trademark of Pearson Education, Inc. **Pearson**[®] is a registered trademark of Pearson plc **Prentice Hall**[®] is a registered trademark of Pearson Education, Inc.

Pearson Education Ltd., London Pearson Education Singapore Pte. Ltd. Pearson Education Canada, Inc. Pearson Education—Japan Pearson Education Australia Pty. Limited Pearson Education North Asia Ltd., Hong Kong Pearson Educación de Mexico, S.A. de C.V. Pearson Education Malaysia Pte. Ltd.

Dedicated to John and Nedra for their continuing help and support

To the memory of Vincent

AND SHEET OF THE SHEET OF THE

and the state of the second of

PREFACE

his book provides a framework for students who are studying textiles. Some students may be planning to enter one of the many career areas that require some knowledge of textiles. Others may be interested in becoming better-informed consumers. Whatever motivates students to enter an introductory course in textiles, certain basic concepts are essential to their understanding of the subject. It is our hope that these concepts are presented in a clear, logically developed format. We explain how the behavior of textile products depends on the properties and processing of the components of the textile.

We discuss the considerations in developing, or putting together, a textile product. Understanding how the components go together and what is possible is one aspect. Another is understanding the textile manufacturing and finishing processes because these significantly affect not only the cost, but also the timelines for acquiring textile materials.

The text begins with an overview of the global textile industry. The emphasis is on the global textile supply chain, describing components of the chain and, where appropriate, the organization and global span of the various steps in processing. In keeping with the theme of understanding textiles, we discuss throughout the book why the elements of the supply chain are organized as they are.

The majority of students are likely to begin their study of textiles without any prior knowledge of the origin, manufacture, and distribution of the wide variety of textile products they use daily. The first chapter presents an overview of the journey of textile products beginning with fiber production and manufacture of yarns or other components, to fabric production, design, and manufacture of the final product.

We set a context for the chapters that follow in which basic processes, rooted in science and technology, are explored in depth, beginning with the basic building blocks of fabrics: fibers. Throughout the text emphasis is placed on the interrelationships of fibers, yarns, fabric constructions, dyes, and finishes. What is known about each of these components is applied to the understanding of textile behavior and performance. The chapters build on each other, much as the textile structure

itself is built, and summaries in the text review the properties that affect performance. We reinforce this view of analyzing the components of a textile through case studies of particular end-use products.

Diagrams and photographs have been selected to illustrate the concepts and processes described in the text. As textile production has moved to countries other than the United States, students have limited access to manufacturing sites and the opportunity to personally view the various textile processes. Photographs and diagrams of these processes are included to support understanding.

Each chapter begins with learning objectives to identify student outcomes, and each chapter ends with bulleted summary points, providing a checklist of major concepts presented in the text. Review questions invite students to summarize and apply the concepts to demonstrate understanding. The recommended readings at the end of each chapter complement the subject matter. We have made a conscious effort to include both relatively elementary and highly technical material so as to introduce students to the variety of resources in the field.

Chapter 1 introduces the reader to the various elements from which textiles are made and the present-day organization of the textile industry. Chapter 2 describes how fibers are classified and the requirements for fiber content labeling. This leads into a discussion of polymers, the basic building blocks of all fibers, and the ways in which polymers are processed into manufactured fibers. Material on manufacturing fibers was moved from Chapter 5 in the previous editions because this content follows well the discussion of polymers. Chapter 3 now establishes the relationship of fiber properties to fiber behavior. Chapters 4 through 12 discuss the different textile fibers, beginning with the natural fibers. Cellulosic fibers are discussed because they are simpler in structure than the protein fibers and because cotton is so widely used. Protein fibers, with emphasis on wool and silk, are presented next. Chapters on manufactured fibers follow, with cellulosic fibers in Chapter 6, and Chapters 7 through 12 covering related groups of manufactured fibers.

Fiber chapters are updated and are all organized in the same way, with many of the topic headings being repeated in the same order in which they were introduced in Chapter 3 in order to facilitate comparisons among fibers. Brand names and trademarks of manufactured fibers are mentioned, but as companies merge and change products, readers are encouraged to remain current by obtaining information from websites. A table summarizing some of the more important characteristics of the major fiber groups is included in each of those chapters.

From fibers the text moves to yarns, presenting structures and classifications first (Chapter 13) then detailed descriptions of yarn processing (Chapter 14). Fabrics is the next topic, and a new Chapter 15 has been added to introduce fabrics in general and related structures such as leather. Weaving and woven fabrics continue as two separate chapters (16 and 17) because of the large volume of material to be covered. Chapter 18 describes knitted fabric structures and processes. Nonwovens is now a separate Chapter (19) as they have become so prevalent in many end uses. A number of other fabric construction methods are described in Chapter 20.

For the yarn and fabric chapters, the contributions of the structural components of fiber, yarn, and fabric construction to textile product performance are summarized under the headings of performance factors affecting durability, appearance, and comfort. This enables readers to begin to put together the parts of a textile product

The material on dyeing and finishing has been rearranged from the previous edition. General principles of textile wet processing are introduced in Chapter 21, which also covers routine preparation of fabrics for dyeing and finishing. The various methods of adding color and design as well as finishing fabrics are discussed in Chapters 22 through 25. Finishes are now divided into physical and mechanical finishes (Chapter 24) and chemical finishes (Chapter 25). Chapter 26 is devoted to the care of textiles, even though some material on this subject appears in preceding chapters. A significantly updated Chapter 27 discusses the important topic of "Textiles and the Environment, Health, and Safety."

The final chapter presents some factors related to product development. Specifications and testing and their roles in communicating through the textile supply chain are discussed. Performance of products is related to specific end uses by additional case studies on swimwear, men's dress shirts, and automotive textiles.

Consumer briefs, now retitled "Take a Closer Look," appear throughout the text and explore specific topics in depth. This feature includes updates on wool and polyester, lyocell fibers, carpeting, wrinkle-resistant fabrics, and preserving historic textiles.

Special reference tools provided are a glossary of terms (many from the *Annual Book of ASTM Standards*) and a summary of textile legislation.

Online Instructor's Resources

To access supplementary materials online, instructors need to request an instructor access code. Go to www. pearsonhighered.com/irc, where you can register for an instructor access code. Within 48 hours after registering, you will receive a confirming e-mail, including an instructor access code. Once you have received your code, go to the site and log on for full instructions on

downloading the materials you wish to use.

ACKNOWLEDGMENTS

We have received assistance from many individuals and organizations and would like to acknowledge those who provided assistance with previous editions as well as those more directly involved in the current edition. We are grateful for the encouragement and support provided by our families, who gave their time and advice so generously. Dr. John R. Collier was especially helpful as a consultant and for providing an "engineering" perspective. Nedra Reynolds was a continuing source of support.

We extend our thanks to the libraries and other support services at Florida State University, the University of Rhode Island, and the University of Tennessee.

It is impossible to acknowledge all the help we received in obtaining illustrative material. We have specified the sources in the figure captions and thank the many individuals who helped with these illustrations and granted permission for their

use. Among those to whom we wish to offer special thanks are Gordon Covell of the Islay Woollen Mill in Scotland for opening his weaving shop; Erica Puckett of Wooly Bully in Tallahassee, Florida, for an opportunity to photograph her yarns; Robert L. Brewer, Jr., for a series of photographs; Cotton, Incorporated, for the opportunity to photograph cotton processing equipment; Nancy Bock of the Soap and Detergent Association for illustrations and advice; Dr. Michael Ellison from Clemson University for the spider illustrations; Will Donelon of Harve Bernard for an industry perspective on product development; and Seth Walters and Tom Kingsbury of Bridgestone/Firestone for a glimpse inside tires.

We want to thank the many individuals and trade and professional associations that provided both information and illustrations. Among the trade associations that provided useful information are the American Association of Textile Chemists and Colorists (AATCC); the American Fiber Manufacturers Association (AFMA); the American Society for Testing and Materials (ASTM); and the Association of the Nonwoven Fabrics Industry (INDA).

We thank the following reviewers for their valuable feedback: Diane Ellis, Meredith College; Jessie Chen-Yu, Virginia Tech; Debra McDowell, Missouri State University; Kathryn Callahan, Central Missouri State University; Linda Sivils, Louisiana Tech University; Elizabeth Easter, University of Kentucky; Thomas M. Ariail, Tricounty Technical College; Maxine M. Johns, Western Michigan University; Gwendolyn Lewis Huddresten, The Art Institutes; and Mary Lynn Realff, Georgia Institute of Technology.

BRIEF CONTENTS

PREFACE		vii
CHAPTER 1	Introduction	1
CHAPTER 2	Textile Fibers	15
CHAPTER 3	Fiber Properties	39
CHAPTER 4	Natural Cellulosic Fibers	59
CHAPTER 5	Protein Fibers	89
CHAPTER 6	Manufactured Cellulosic Fibers	125
CHAPTER 7	Nylon and Aramid Fibers	147
CHAPTER 8	Polyester Fibers	161
CHAPTER 9	Acrylic Fibers	175
CHAPTER 10	Olefin Fibers	187
CHAPTER 11	Elastomeric Fibers	197
CHAPTER 12	High-performance and Specialty Fibers	207
CHAPTER 13	Yarn Structures	223
CHAPTER 14	Manufacturing Yarns	239
CHAPTER 15	Fabrics and Related Structures	265
CHAPTER 16	Woven Fabrics	273

CHAPTER 17	The Weaves	291
CHAPTER 18	Knitted Fabrics	321
CHAPTER 19	Nonwoven Fabrics	347
CHAPTER 20	Other Fabric Construction Methods	363
CHAPTER 21	Introduction to Textile Wet Processing: Preparation of Fabrics for Dyeing and Finishing	391
CHAPTER 22	Adding Color to Textiles	403
CHAPTER 23	Textile Printing and Design	423
CHAPTER 24	Physical/Mechanical Finishes	439
CHAPTER 25	Chemical Finishes	451
CHAPTER 26	The Care of Textile Products	475
CHAPTER 27	Textiles and the Environment, Health, and Safety	501
CHAPTER 28	Textile Product Development and Performance	521
APPENDIX A:	Summary of Regulatory Legislation Applied to Textiles	539
GLOSSARY		541
INDEX		547

CONTENTS

PREFACE	vii
CHAPTER 1	
Introduction	1
Learning Objectives 1 Fibers 4 Yarns 4 Fabric Structures 5 Coloring and Finishing 6 The Textile Supply Chain 7 Retailers 7 Wholesalers and Distribution Centers 8 Product Manufacturers 8 Yarn and Fabric Mills 8 Fiber Producers 9 The Global Textile Industry 9	
Summary Points 13 Professionals Speak: How Understanding Textiles Helps Me Do My Job	12
Questions 13	
References 13 Recommended Readings 13	
CHAPTER 2	
Textile Fibers	15
Learning Objectives 15 Classifying and Labeling Fibers 16 Generic Fiber Classification 16 Textile Fiber Products Identification Act 17	

Understanding Polymers 20	
Polymer Basics 21	
Polymer Processing: Intermolecular Forces and Fiber Manufacture	23
Fiber Manufacture 24	
Additions to the Melt/Solution 25	
Fiber Spinning 26	
Fiber-spinning Modifications 29	
Microfibers 29	
Bicomponent Fibers 31	
Drawing or Stretching: Morphology of Fibers 33	
Fiber Variations: Deliberate and Accidental 35	
Summary Points 36	
Take a Closer Look: Cotton, Linen, and Rayon:	
The Same, but Not the Same 22	
Questions 36	
References 37	
Recommended Readings 37	
CHAPTER 3	
	20
Fiber Properties	39
Learning Objectives 39	
Physical Properties 40	
Color 40	
Shape and Contour 40	
Crimp 42	
Length 43	
Density and Specific Gravity 43	
Diameter or Fineness 44	
Mechanical Properties 46	
Strength 46	
Modulus 47	
Flexibility 47	
Elongation 47	
Elastic Recovery 48	
Resiliency 48	
Chemical Properties 48	
Absorbency 48	
Electrical Conductivity 50	
Effect of Heat 50	
Chemical Reactivity and Resistance 51	
Response to Environmental Exposure 53	
Other Properties 54	
Dimensional Stability 54	
Abrasion Resistance 54	
Cost 57	

Summary Points 58	
Questions 58	
References 58	
Recommended Readings 58	
CHAPTER 4	
Natural Cellulosic Fibers 59)
Learning Objectives 59 The Cellulose Family 60 General Characteristics of Cellulosic Fibers 60 Seed Hair Fibers 61 Cotton 61 Cotton in the Global Market 61 The Cotton Plant 62 Types of Cotton 63 Cultivation 64 Production of the Fiber 65 Molecular Structure 66 Properties of Cotton 67	
Uses 71	
Care Procedures 71	
Minor Seed Hair Fibers 72	
Kapok 72	
Milkweed 72	
Bast Fibers 72	
Flax 73	
The Flax Plant 73	
Cultivation 74	
Preparation of the Fiber 74	
Properties of Flax 75	
Uses 78	
Care Procedures 80	
Other Bast Fibers 80	
Ramie 80	
Jute 81	
Kenaf 83	
Hemp 84	
Leaf Fibers 84	
Miscellaneous Fibers 85	
Summary Points 86	
Questions 86	
References 87	
Recommended Readings 87	

CHAPTER 5	
Protein Fibers	89
Learning Objectives 89 The Protein Family 90 Animal Hair Fibers 91 Sheep's Wool 91 Types of Wool 91	
Wool in the Global Market 92 Wool Harvesting and Processing 93 Wool Products Labeling Act 94 Molecular Structure 96 Properties of Wool 96	
Uses 101 Care Procedures 102 Specialty Hair Fibers 103 Cashmere 103 Camel Hair 104 Other Members of the Camel Family 106 Mohair 108	
Qiviut 109 Fur Fiber 110 Cow Hair and Horsehair 111 Silk 111	
History of Silk Culture 111 Silk Production 112 Molecular Structure 115 Properties of Silk 115 Special Finishes Applied to Silk 118 Uses 118 Care Procedures 119 Spider Silk 120	
Regenerated Protein Fibers 121 Summary Points 121 Take a Closer Look: What's New with Wool? 102 Questions 122 References 122 Recommended Readings 122	
CHAPTER 6 Manufactured Cellulosic Fibers Learning Objectives 125 Rayon 126 Viscose Rayon 126	25

References

159

160

Recommended Readings

CHAPTER 8	
Polyester Fibers	161
Learning Objectives 161 Manufacture 162	
Drawing 162 Other Polyester Fibers 163 PTT Fibers 163	
PBT Fibers 164 PEN Fibers 164 PLA Fibers 164	
Molecular Structure 164 Properties of Polyester 165	
Physical Properties 165 Mechanical Properties 165 Chemical Properties 167 Environmental Properties 167	
Other Properties 168 Polyester Trademarks 168 Uses 168	
Care Procedures 170 Summary Points 172 Take a Closer Look: Polyester Today: Clotheshorse,	
Workhorse 171 Questions 172 References 173 Recommended Readings 173	
CHAPTER 9	
Acrylic Fibers	175
Learning Objectives 175 Acrylic 176 Manufacture 176	
Molecular Structure 177 Properties of Acrylics 177 Bicomponent Acrylic Fibers and Yarns 179 Uses 180	
Care Procedures 182 Modacrylic 183	
Manufacture 183 Properties of Modacrylics 183 Uses 184	
Care Procedures 185 Summary Points 185 Ouestions 186	

References 186 Recommended Readings 186	
CHAPTER 10 Olefin Fibers	107
Learning Objectives 187 Polypropylene Fibers 188 Manufacture 188 Molecular Structure 189 Properties of Polypropylene Fibers 189 Uses 191 Care Procedures 193 Polyethylene Fibers 194 Summary Points 195 Questions 195 References 195	187
Recommended Readings 195 CHAPTER 11 Elastomeric Fibers	197
Learning Objectives 197 Spandex 197 Manufacture 198 Properties of Spandex 198 Uses 200 Care Procedures 202 Other Manufactured Elastomeric Fibers 203 Rubber Fibers 204 Summary Points 205 Questions 205	
References 205 Recommended Readings 205	
CHAPTER 12	
High-performance and Specialty Fibers	207
Learning Objectives 207 High-strength, High-modulus Fibers 208 Carbon Fibers 208 Glass Fiber 210 Manufactured Fibers 213 Heat-resistant Fibers 214 Asbestos 214 Manufactured Fibers 214	

Other Specialty Fibers 216 Metallic Fibers 216 Chlorofibers 217	
Fluoropolymer 218	
Vinal 219	
The Future of High-performance and Specialty	
Fibers 219	
Summary Points 220	
Questions 220 References 221	
Recommended Readings 221	
Recommended Reddings 221	
CHAPTER 13	
Yarn Structures	223
Learning Objectives 223 Types of Yarns 223	
Filament Yarns 224	
Staple Yarns 224	
Yarns Classified by Number of Parts 224	
Yarns Classified by Similarity of Parts 225	
Core-spun Yarns 226	
Thread 227	
Yarn Twist 227 Effects of Twist 227	
Direction of Twist 229	
Yarn Size 229	
Direct Numbering Systems 229	
Indirect Numbering Systems 230	
Effects of Yarn Structure	
on Fabric Performance 230	
Durability Factors 230 Appearance 232	
Appearance 232 Comfort Factors 233	
Summary Points 236	
Putting it all together for Tire Cords 233	
Questions 236	
References 236	
Recommended Readings 237	
CHAPTER 14	
Manufacturing Yarns	239
	237
Learning Objectives 239 Making Filament Verns 239	
Making Filament Yarns 239 Texturing Filament Yarns 240	
Leavening I would leave I lo	

Making Staple Yarns 244		
Preparation of Staple Fibers for Spinning	246	
Systems for Processing Different Types		
of Staple Fibers 246		
Insertion of Twist into Yarn 252		
Ply Yarns 256		
Other Methods of Manufacturing Yarns 257		
False-twist, or Self-twist, Spinning 257		
Yarn Wrapping 257		
Making Yarns from Films 258		
Blends 260		
Properties of Blended Yarns 261		
Summary Points 262		
Questions 262		
References 263		
Recommended Readings 263		
Tee on michael Iteasings		
CHAPTER 15		
		265
Fabrics and Related Structures		265
Learning Objectives 265		
Fabric Construction Methods 265		
Yarn Preparation 267		
Describing Fabrics 268		
Fabric Weight 268		
Fabric Thickness 269		
Fabric Width 269		
Fabric Symmetry 270		
Related Structures 270		
Leather 270		
Films 270		
Summary Points 272		
Questions 272		
References 272		
Recommended Readings 272		
Recommended Readings 272		
CHAPTER 16		
Woven Fabrics		273
Learning Objectives 273		
Zeuming dejetimes =	73	
Fabric Grain 273		
Fabric Count 274		
Selvages 275		
The Loom 276		

Wodeli weaving Flocesses 277	
Preliminary Steps 277	
Basic Motions of Weaving 279	
Yarn Transport Methods 280	
Shuttle Looms 280	
Shuttleless Weaving Machines 281	
Control of Loom Motions 286	
Cam Loom 286	
Dobby Loom 286	
Jacquard Loom 287	
Summary Points 288	
Questions 288 References 289	
Recommended Readings 289	
Recommended Readings 209	
CHAPTER 17	
	201
The Weaves	291
Learning Objectives 291	
Basic Weaves 291	
Plain Weave 291	
Twill Weave 296	
Satin Weave 299	
Novelty Fabrics from Basic Weaves 301	
Variations of the Basic Weaves 302	
Dobby Fabrics 302	
Jacquard Fabrics 302	
Hand-woven Tapestries 304	
Leno-weave Fabrics 305	
Woven Pile Fabrics 306	
Chenille 310	
Decorative Surface Effects 310	
Woven Effects 310	
Interwoven, or Double-cloth, Fabrics 311	
Triaxial Woven Fabrics 313	
Effects of Woven Structure	
on Fabric Performance 313	
Durability Factors 313	
Appearance 315	
Comfort Factors 316	
Summary Points 319	
Putting it all together for	
Upholstery Fabrics 317 Ouestions 320	
Questions 320 References 320	
Recommended Readings 320	

CHAPTER 18	
Knitted Fabrics	321
Learning Objectives 321 Basic Concepts 321 Loop Formation 322 Gauge and Quality 324 Weft Knits 326 Jersey, or Single, Knits 326 Two-bed Knits 330 Weft-knit Stitch Variations 334 Three-dimensional Knitting 337	
Warp Knits 337 Tricot 338 Simplex Knits 340 Raschel Knits 340	
Creating Pattern and Design	
in Knitted Goods 341 Warp and Weft Insertion 342	
Care of Knitted Fabrics 342	
Dimensional Stability 342	
Mechanical Damage 343 Effects of Knit Structure on Fabric Performance 344 Durability Factors 344 Appearance 344	
Comfort Factors 345	
Summary Points 345	
Take a Closer Look: T-shirts 328 Questions 345	
References 346	
Recommended Readings 346	
CHAPTER 19	
Nonwoven Fabrics	347
Learning Objectives 347 Nonwovens Defined 347 The Global Industry 348 Manufacture 348 Fiber Web Formation 348 Fiber Bonding/Entangling 352	
Uses 356 Other Fabric Made from Fibers 358 Felt 358	

Bark Cloth

359

Effects of Nonwoven Structure	
on Fabric Performance 359	
Durability Factors 359	
Appearance 360	
Comfort Factors 360	
Summary Points 361	
Questions 361	
References 362	
Recommended Readings 362	
CHAPTER 20	
Other Fabric Construction Methods	363
Learning Objectives 363	
Multicomponent Fabrics 363	
Carpets 364	
Tufting 364	
Other Machine Carpet Constructions 366	
Handmade Carpets 368	
Textile-reinforced Composites 370	
Other Multicomponent Fabrics 371	
Embroidery 371	
Quilted Fabrics 374	
Laminated or Bonded Fabrics 375	
Flocked Fabrics 377	
Fiber and Textile Wall Coverings 378 Hybrid Fabrics Using Polymer Films 379	
Hybrid Fabrics Using Polymer Films 379 Fibrillated Films 380	
Stitch-bonded Fabrics 381	
Knotted Fabrics 382	
Nets 382	
Macramé 383	
Lace 384	
Crochet 385	
Braided Fabrics 385	
Effects of Structure	
on Fabric Performance 386	
Durability Factors 387	
Appearance 387	
Comfort Factors 387	
Summary Points 388	
Take a Closer Look: Residential Wall-to-Wall	
Carpeting 369	
Questions 388	
References 388	
Recommended Readings 389	

403

CHAPTER 21 Introduction to Textile Wet Processing: Preparation of Fabrics for Dyeing and Finishing 391 Learning Objectives 391 Batch versus Continuous Processing 392 Drying 393 Preparation of Fabrics 394 Cotton Fabrics 394 Singeing 394 Desizing 395 Scouring 395 Bleaching 395 **Knitted Fabrics** 396 Practical Processes 396 Mercerization 397 Silk 397 Wool 398 Scouring 398 Carbonizing 398 Crabbing 398 Bleaching 398 Flax and Other Bast Fibers 398 Manufactured Fibers 399 Inspection and Repair 399 **Summary Points** 400 Questions 401 401 References Recommended Readings 401

CHAPTER 22

Yarn Dyeing

Fabric Dyeing

410

412

Adding Color to Textiles
Learning Objectives 403
Dyes and Pigments 403
Natural Dyes 404
Synthetic Dyes 405
Dyes, Dyeing, and the Supply Chain 405
Design and Color Selection 405
The Dyer 406
The Dyeing Process 407
Dyeing at Different Processing Stages 409
Solution Dyeing 409
Dyeing Fibers 410

Garment Dyeing 415	
Dyeing Blends 417	
Dye Classes 417	
Dyes for Cellulosic Fibers 418	
Dyes Used for Wool, Silk,	
and Nylon 419	
Dyes Used Primarily	
for Manufactured Fibers 420	
Fugitive Tints 420	
Summary Points 421	
Questions 421	
References 421	
Recommended Readings 421	
CHAPTER 23	
Textile Printing and Design	42
Learning Objectives 423	
Colorants Used in Printing:	
Basic Principles 424	
Printing with Dyes:	
Wet Printing 424	
Printing with Pigments 424	
Means of Achieving a Design 425	
Direct (Blotch) Printing 425	
Overprinting 426	
Discharge Printing 426	
Resist Printing 426	
Printing Machinery 428	
Block Printing 428	
Roller Printing 428	
Screen Printing 429	
Ink-jet Printing 432	
Other Printing Techniques 433	
Heat-transfer Printing 433	
Photographic Printing 434	
Burnout (Devore) Printing 434	
Plissé Designs 435	
Flock Printing 435	
Warp Yarn Printing 435	
Mordant Printing 436	
Summary Points 437	
Questions 438	

References

438

438

Recommended Readings

CHAPTER 24
Physical/Mechanical Finishes 439
Learning Objectives 439 Surface Finishes 440 Calendering 440 Beetling 442 Breaking 442 Napping and Sueding 443 Enzyme Treatment 444
Milling/Fulling 445 Shripkora Control 445
Shrinkage Control 445 Dimensional Stability 445 Mechanical Shrinkage Control 446 Shrinkage Control for Knits 448 Shrinkage Control for Wool 448 Shrinkage Control for Thermoplastic Fibers 449
Summary Points 449
Questions 449 References 450 Recommended Readings 450
CHAPTER 25
Chemical Finishes 451
Learning Objectives 451 Application of Chemical Finishes 452 Wrinkle Resistance and Recovery for Cellulosic Fabrics 452 Wrinkle-resistant Finishes 452 The Finishes: Formaldehyde or Not? 453 Manufacturing Wrinkle-free Products 454 Wrinkle-free Fabrics in Use 454 Chemical Shrinkage Control 456 Washable Wools 456
Chemical Finishes That Affect Fabric Hand 457 Hand Builders and Softeners 457 Enzyme Treatment 458 Parchmentizing 458 Water and (S)oil Repellency 458
Water and (S)oil Repellency 458 Water Repellency 458
Soils: Repellency and Release 460
Flame Resistance 462 Terminology 462 Flammable Fabrics Act 463

Antimicrobial Finishes 467	
Antistatic Finishes 468	
Special-purpose Finishes 469	
Mothproofing Finishes 469 Temperature-regulating Finishes 469	
Temperature-regulating Finishes 469 Light-reflectant Finishes 470	
Ultraviolet-absorbing Finishes 470	
Other Specialty Finishes 472	
Summary Points 472	
Take a Closer Look: Wrinkle-resistant Fabrics	
of 100 Percent Cotton 471	
Questions 473	
References 473	
Recommended Readings 474	
CHAPTER 26	
	475
The Care of Textile Products	4/3
Learning Objectives 475	
Refurbishing of Textiles 476	
Laundering 476	
Stain Removal 485	
Drying 486	
Pressing 489	
Commercial Laundering 489	
Dry Cleaning 490 Storage of Textile Products 491	
Storage of Textile Products 491 Permanent-care Labeling 492	
Labeling Requirements 492	
International Care Symbols 495	
Summary Points 497	
Take a Closer Look: Preserving Historic Textiles 496	
Questions 498	
References 499	
Recommended Readings 499	
Further Sources of Information 499	
CHAPTER 27	
	501
Textiles and the Environment, Health, and Safety	301
Learning Objectives 501	
Safety and Environmental Impact 502	
Textile Production 502	
Textile Use 505	

463

466

Flammability Standards and Tests

Flame-resistant Textiles

Disposal of Textile Products 507 Legislation and Regulation 512 Ecolabeling: Green Textile Products and Processes 514 Hazards to Consumers: Product Ecolabeling 516 Hazards in Production: Process Ecolabeling and Life Cycle Analysis 517 Summary Points 518 Questions 519 References 519
Recommended Readings 520
CHAPTER 28
Textile Product Development and Performance 521
Learning Objectives 521 Product Development 522 Specifications 522 The Development Process 523
Maintaining Quality in the Textile Supply Chain Basic Physical Properties 525 Testing Factors Related to Durability 525 Mechanical Properties 525 Abrasion Resistance and Pilling 526
Testing Properties Related to Appearance Dimensional Stability 527 Wrinkle Recovery 527 Colorfastness 527 Hand and Drape 529
Testing Properties Related to Comfort Sensorial Comfort 530 Thermal Comfort 530 Summary Points 535 Putting it all together for Swimwear 530
Putting it all together for Automotive Textiles Putting it all together for Men's Dress Shirts Questions 536 References 536 Recommended Readings 536
Appendix A: Summary of Regulatory Legislation Applied to Textiles 539
Glossary 541
Index 547

in a community of the contract of the contract

INTRODUCTION

Learning Objectives

- 1. Describe the parts of a textile fabric.
- 2. Describe the textile supply chain and the flow of goods and information.
- Explain the roles and regulations of various organizations in the global textile trade.

very day each of us makes decisions about textiles. From the simplest choice of what clothes to wear to the commitment of a major portion of the family budget to buy a new carpet, judgments about the performance, durability, attractiveness, and care of textiles are consciously or unconsciously made. The economic implications of decisions about fibers, yarns, and fabrics obviously increase if someone is involved professionally with textiles. But whether or not understanding textiles is required for personal or for professional purposes, the key to informed decision making is knowledge about fibers, yarns, fabrics, and finishes and the ways in which these are interrelated.

Textiles fulfill so many purposes in our lives that their study can be approached in a number of ways. Textiles may be seen as being purely utilitarian, in relationship to the numerous purposes they serve. On awaking in the morning, for example, we climb out from under sheets and blankets and step into slippers and a robe. We wash our faces with washcloths, dry them with towels, and put on clothing for the day. Even the bristles of our toothbrushes are made from textile fibers. If we get into a car or bus, we sit on upholstered seats; the vehicle moves on tires reinforced with strong textile cords. We stand on carpets, sit on upholstered furniture, and look out of curtained windows. The insulation of our houses may be glass textile fiber. Not only are golf clubs, tennis rackets, and ski poles reinforced with textile fibers, but so are roads, bridges, and buildings. Strong, heat-resistant textile fibers in the nose cones of spaceships travel to distant planets. Physicians implant artificial arteries made of textiles or use surgical fibers that gradually dissolve as wounds heal. Few of our manu-

FIGURE 1.1

(a) Mountain climber in activewear made from polypropylene fiber.
Courtesy of Helly Hanson;
(b) Sofa upholstered in fabric made from olefin fiber. Courtesy of Amoco Fibers and Fabrics/
Westpoint Pepperell;
(c) Nonwoven household cleaning products;
(d) Robe of high-pile fabric for warmth.
Courtesy of the Acrylic Council.

factured products could be made without textile conveyor belts. Even our processed foods have been filtered through textile filter paper. There is truly no aspect of modern life that is untouched by some area of textiles. (See Figure 1.1.)

Some individual or some group of persons will be the ultimate consumer of each textile product. The ultimate consumer selects the product for a particular end use, whether that use be a fashionable garment or a fabric used to reinforce high-technology building materials. In all cases, consumers want to select products that will perform well in the projected end uses. Most also seek to minimize cost. The ways in which textiles are produced affect their costs. Some steps in manufacturing are more expensive than others. Manufacturers may be able to choose one procedure instead of another. When alternatives are available, manufacturers are likely to select processes that will maximize their profits while making products

that will sell at competitive prices and also fulfill the customers' desire for satisfactory performance. Many products must also meet the demands of current fashion.

Even though we all personally experience textiles at home, at work, and at play, we usually encounter only the complete product; rarely do we deal with the individual components. But each finished product makes a long journey from its beginnings in the laboratory or on the farm to the place where it is acquired by the ultimate consumer. An introductory course in textile study can be a sort of road map or itinerary of that journey; therefore, this text is organized to begin with the first steps in the long progression from fiber to completed fabric and goes on to examine subsequent steps in a generally chronological sequence.

If you were to take the shirt or sweater that you are wearing at this moment and break it down into its components, you would have to work backward, taking apart the fabric structure. Most likely your garment is woven or knitted. Weaving and knitting are the two most common means of creating fabrics for apparel, although other methods do exist. Both weaving and knitting are subject to a great many possible variations, and these differences contribute to the enormous variability in appearance, drapability, texture, wrinkle recovery, durability, feel, and many other qualities of fabrics.

To take a woven or knitted structure apart requires that the fabric be unraveled into the yarns from which it was constructed. The yarns (with some few exceptions) are made either from short fibers or from long, continuous fibers that are twisted together. By untwisting the yarns, it is possible to separate the yarn into these small, fine, hairlike fibers that are the basic units that make up the majority of textile products. (See Figure 1.2.)

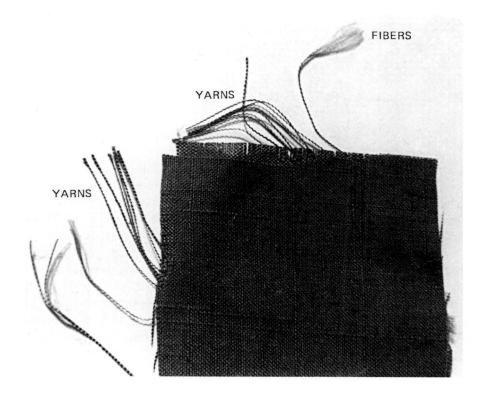

Fabric unravels into separate yarns. Yarns untwist into individual fibers.

FIBERS

Textile fibers exist in nature or are created through technology. Technical definitions of the term *textile fiber* such as that of the American Society for Testing and Materials (ASTM) tend to stress their dimensions: "a generic term for any one of the various types of matter that form the basic elements of a textile and that is characterized by having a length at least 100 times its diameter" (ASTM 2001).

Although this explains how a fiber looks, some materials that do fit this definition are not suitable for use in textiles. The fibrous structure of an overcooked pot roast, for example, is obviously not suitable for use in a textile. Fibers appropriate for use in textiles must have not only fineness and flexibility, but also sufficient strength and durability to withstand conditions encountered in processing and use.

To understand and evaluate suitability of different fibers for particular products, professionals in the textile field and consumers need to understand the physical and chemical properties of fibers. Particular fibers may be suitable for use in some textile applications but not in others. Carbon fibers, excellent for use in high-technology products and sports equipment, are not useful for wearing apparel. Even among those fibers used in many apparel and home furnishing items, some are preferred for particular applications. Nylon long ago replaced silk and rayon in women's dress hosiery.

On reflection, then, it is obvious that we tend to prefer some kinds of fibers for certain uses because those particular fibers offer some special advantages. For example, a particular fabric may seem to be more comfortable in warm or cool weather, may soil less easily, may dry more quickly, or may have an appearance that is best suited to a particular kind of occasion. The reasons for these differences among fibers reside in the specific properties of each fiber. If we are to have a clear understanding of the finished products and what qualities are to be expected of them, we need to know the fibers from which the product is made—and the characteristics of those fibers.

YARNS

Fibers alone cannot make a textile. Although it is possible to entangle groups of fibers or to bond them together in some way to create a textile (as is done with felt, for example), most of the cloth that is made into apparel and home furnishings is formed from yarns. *Yarns* are assemblies of fibers twisted or otherwise held together in a continuous strand. An almost endless variety of yarns can be created by using different fibers, by twisting fibers more or less tightly, by combining two or more individual yarns to form a more complex yarn, or by giving yarns a wide range of other special treatments.

Just as different fibers will vary in their individual properties, different kinds of yarns have varying characteristics. (See Figure 1.3.) And to complicate matters still further, two yarns of the same structure will have different properties if they are made from markedly different kinds of fibers.

Figure 1.3
Fabrics made from the same fiber and in the same (plain) weave look different because different kinds of yarns are used.

FABRIC STRUCTURES

Yarns must be united in some way if they are to form a cohesive structure. The transformation of individual yarns into textile fabrics can be accomplished by an individual with a pair of knitting needles, a crochet hook, or a hand loom or through the use of powerful machines that combine yarns by weaving, knitting, or stitch bonding to produce thousands of yards of completed fabrics. As with fibers and yarns, the potential for variations in the structure is enormous, and a walk through any department store will reveal to even the most casual observer the almost endless variety of textile structures produced and consumed by the public in the form of apparel or household textiles.

And once again, if the construction being used is varied, the resulting properties will differ. Furthermore, even when the same weave or knit construction is

6 UNDERSTANDING TEXTILES

FIGURE 1.4Fabrics made from the same fiber and from similar types of yarns look different because different types of weaves were used in their construction.

used, the end product will be distinctive if the fiber or yarn type is varied. (See Figure 1.4.)

COLORING AND FINISHING

Appearance—color, pattern, and texture—is one of the major factors that leads consumers to purchase one product over another. Most textile fabrics intended for personal, household, or architectural use have been decorated in some way, by dyeing the fabric, printing designs on it, or weaving with varicolored yarns. Large segments of the textile industry are devoted to dyeing and/or printing fabrics, yarns, or fibers.

As the reader will learn, certain properties are inherent to each fiber, yarn, or fabric structure. Consumers find some of these properties desirable, while others are not valued. For example, fabrics of synthetic fibers dry quickly after laundering. Most consumers value this quality. But the same fabrics may tend to build up static electric charges, producing small electrical shocks or "static cling." Consumers do not like this quality. When a fiber, yarn, or fabric has unacceptable properties, special treatments called *finishes* may be applied to overcome undesirable properties. Finishes may be used to give to the fibers, yarns, or fabrics some properties that they do not normally possess but that will enhance performance or alter appearance. Static cling can thus be decreased or overcome. Most people are familiar with wrinkle-free finishes, for example, or may have purchased upholstered furniture with soil-resistant finishes. Other examples are discussed in chapters 24 and 25 dealing with finishes.

FIGURE 1.5

The textile supply chain. Adapted from Nordås, 2004.

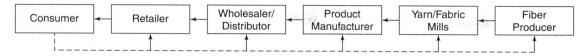

THE TEXTILE SUPPLY CHAIN

Today an immense international industrial complex encompasses the production of fiber, spinning of yarns, fabrication of cloth, dyeing, finishing, printing, and manufacture of goods for purchase. Collectively they make up the textile supply chain. (See Figure 1.5.) The fiber producer is the supplier for the yarn manufacturer, who in turn provides products to the weaver or knitter. Fabrics are colored and finished then sent to product manufacturers. Communication up and down the supply chain has become increasingly important and integrated as manufacturers minimize their inventories and supply products just in time for the next step (Azoulay 2005). The picture is made more complex when so many producers today are located around the globe.

We have just seen how a textile is composed starting with fibers and moving to fabrics then ultimately to a final product. In describing the operation of the textile supply chain, it is useful to start at the product end to illustrate how consumers are the drivers in the system.

Retailers

The textile supply chain is driven by the preferences and purchases of the consumer, resulting in what can be described as a *demand-pull* system (Nordås 2004). Inputs and activity at each production stage are based on data derived from the final point of sale of the product. The bar codes on products, scanned when a consumer makes a purchase, provide information down the supply chain through what is known as electronic data interchange, or EDI. The retailer thus becomes a key player in supplying products the consumer wants, and EDI allows retailers to function more efficiently in today's competitive global environment. They can maintain data on which products sell well and use EDI to track inventories and reorder popular items when needed. At the same time, manufacturers and raw material producers can influence the flow of goods through marketing efforts, providing a *push* through the supply chain.

For specialty and high-tech industrial textiles, end users will work directly with manufacturers to obtain items meeting agreed-on performance properties. An example is development of textile-containing materials for aerospace and national defense. The National Aeronautics and Space Administration or the Department of Defense will specify to a manufacturer the properties a product must have for purchase by the government and will work directly with that manufacturer as the product is developed and tested.

Wholesalers and Distribution Centers

Armed with information transmitted from the retailer, the wholesaler performs the traditional function of buying in bulk from the manufacturer and supplying a number of retailing establishments. As the retailing industry has become more concentrated, however, large firms with heavy buying power have changed the landscape, and distribution centers have replaced wholesalers to an increasing degree in the textile and apparel industry. These are central facilities where goods are received from manufacturers and distributed to retailers, all through EDI from bar codes.

Product Manufacturers

Participants in this sector include everything from high-fashion apparel designers and producers to makers of industrial textiles such as filters, seat belts, tents, and geotextiles for stabilizing roads. The mills that make textile yarns and fabrics sell their products to apparel or home furnishings manufacturers. This buying, or *sourcing*, of fabrics and other materials by manufacturers is increasingly international, as further discussion in the section on the global textile industry illustrates (see page 9).

Producers of apparel, and increasingly of household textiles, are also involved in the identification of current fashion trends. The usual practice in the apparel industry has been to work four to five months in advance of the time at which a garment will be sold. This requires that the textiles for these garments be prepared twelve to eighteen months before the garments are sold. With the introduction of computer-based, automated procedures for textile manufacture and management, firms can take advantage of the rapid information flow along the supply chain to respond quickly to fashion trends. These procedures can cut delivery time from months to weeks.

Yarn and Fabric Mills

To make most fabrics, fibers must be converted into yarns. The exception is fabrics classified as nonwovens in which the fibers themselves are bonded into a cohesive structure. The production of yarns from short fibers is done by spinners. Manufactured fiber producers, though, often construct yarns from their continuous filament fibers and deliver them to customers in this form. Textile mills then produce woven or knitted fabrics from the yarns and color and finish them, or send them to specialty dyers and finishers. All of these enterprises make up the textile mill product segment of the industry. Many household textile products, such as sheets, towels, tablecloths, curtains, bed coverings, and area carpets, are constructed in the appropriate dimensions and require only some simple finishing such as hemming before they are sold to wholesalers or to retailers. Fabric used for coverings of mattresses and upholstery for furniture is sold to the manufacturer, where it is cut and applied to the mattress or furniture body.

Yarn and fabric producers keep up with design and fashion trends as information on consumer purchases and preferences flows back down the supply chain.

They must anticipate the direction in which fashion will move, not only for apparel, but also for household textiles, to supply the manufacturer with fabric in a timely manner.

In sourcing fabrics, product maufacturers specify the properties the fabric must have for the desired final product. This requires testing to demonstrate these properties, as described in chapter 28.

Fiber Producers

The producer of natural fibers and the producer of manufactured fibers are engaged in two very different businesses. The farmer who raises cotton, the rancher who herds sheep, or the grower of silkworms is trying to produce a maximum quantity of fiber from animal or plant sources. If the demand for a product increases or decreases, the grower cannot, like the manufactured fiber producer, simply increase or decrease the short-term supply of fiber. Except for cotton, which is grown in large quantities in the United States, much of the supply of natural fibers such as wool, flax, and silk is produced abroad and imported to the United States.

Manufactured fibers are produced commercially through regeneration from natural materials or synthesized from chemicals. While the manufactured fibers industry must depend on available supplies of the raw materials from which fibers are made, this industry is not dependent on natural forces that regulate the supply of fiber. Many manufactured fibers are made from materials derived from petroleum, and therefore, supplies and costs of raw materials may be affected by changes in the price of oil. Oil prices not only directly affect the cost of synthetics, but also influence the energy and agrochemicals required for natural fibers.

THE GLOBAL TEXTILE INDUSTRY

Driven by relative costs and enabled by the electronic information flow around the world, the textile product supply chain depicted in Figure 1.5 has spread across national borders. All the operations mentioned thus far—namely, fiber production, spinning, weaving or knitting, coloration and finishing of textiles, and fabrication of products—can be and are carried out in many different countries. Today you are likely to find a T-shirt sewn in Honduras from fabric made in China using cotton fibers grown in the United States.

Many factors ranging from the wages paid to workers to the monetary exchange rate to international trade agreements determine where it is economical to produce textiles and textile products. The United States has seen a marked decline in textile and apparel production in the past several decades because it has become more cost effective to produce these items abroad. As trade regulations evolve and economies develop in different countries, the pattern of imports and exports among

 $^{1. \} The term {\it manufactured fiber} \ has \ superseded \ the \ older \ term {\it man-made fiber} \ in \ most \ segments \ of \ the \ textile \ industry.$

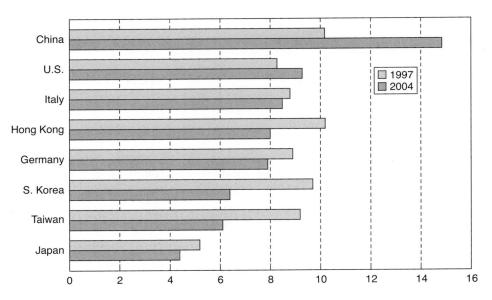

FIGURE 1.6

Percentage share of world textile exports by country.

Source: Ernst, C., A.H. Ferrer, and D. Zult. 2005. The end of the Multi-Fibre Arrangement and its implication for trade and employment. Geneva: International Labor Organization

those countries changes. Figure 1.6 shows how the main exporters of textiles changed between 1997 and 2004 (Ernst, Ferrer, and Zult 2005). China increased its share, while that of Japan, Taiwan, and South Korea declined.

Trade agreements among countries around the world have significantly influenced the global flow of textile products. (See Table 1.1.) The General Agreement on Tariffs and Trade (GATT) was originally established in 1947 to govern trade negotiations between countries. A part of the GATT specific to textiles and apparel was the Multifibre Arrangement (MFA) that allowed countries to establish quotas for imported textile goods to protect their domestic industries. The effect of the MFA was restriction of trade in textiles and apparel. When the GATT was renegotiated in 1994, a regime for trade liberalization, the Agreement on Textiles and Clothing (ATC) was approved. Its intent was to phase out MFA restrictions so that by 2005, all quotas would be terminated not only in the developed countries of the world, but also in the developing countries. A Textiles Monitoring Body (TMB) was appointed within the World Trade Organization (WTO) to oversee the phaseout. Effective January 1, 2005, quotas for textiles and apparel were largely ended, and countries around the world are still adjusting to this reality.² They are adapting their production and import practices to maximize any advantages they may have in technology, design, labor cost, or market proximity.

Another agreement that has removed trade barriers is the North American Free Trade Agreement (NAFTA), involving the United States, Canada, and Mexico. Under this agreement, tariffs on goods traded among the three countries are being eliminated in stages. A companion agreement between the United States and Central American countries, the Central American Free Trade Agreement

^{2.} Some voluntary restrictions, which end in 2008, were negotiated between the United States and China.

TABLE 1.1
What's Your Textile Trade IQ?

ATC	Agreement on Textiles and Clothing	1994-2005	Phase-out of textile quotas
CAFTA	Central American Free Trade Agreement	2005	Removed tariffs on textile goods traded between U.S. and Central America
GATT	General Agreement on Tariffs and Trade	1947	Governed trade negotiations on all goods among countries
MFA	Multifibre Arrangement	1974–2005	Provided for bilateral negotiation of textile quotas between countries
NAFTA	North American Free Trade Agreement	1994	Removed tariffs on textile goods traded among U.S., Canada, and Mexico
TMB	Textiles Monitoring Body	1994	Governed trade negotiations in textiles under the WTO
WTO	World Trade Organization	1994	Governed trade negotiations on all goods among countries

(CAFTA), was approved in 2005 with the same objective. While these agreements have contributed somewhat to the decline in the U.S. textile and apparel industry, they have not had the overwhelming impact of the elimination of quotas worldwide. This is because, under NAFTA and CAFTA, tariffs are reduced for only products originating in the participating countries. It is, therefore, to a country's benefit to source its materials from among its partner countries, rather than from those outside the region. For example, Mexican apparel producers can buy fabric and thread from the United States with no or reduced tariffs, and that is an advantage for the United States over countries such as China. And there is the added benefit to Mexico of being near the large U.S. market for selling the completed apparel products.

As imports have made increasing inroads into the U.S. textile and apparel markets, these industries have tried to increase the awareness of consumers about imports and their effect on the American industry. The U.S. Congress acted in support of American textiles by passing legislation requiring that all textile products carry labels indicating the country of origin, including a designation to show products produced in the United States.

A reported advantage the American and European textile industries have over foreign competition is their technological sophistication and, particularly, automation in production and management. Supply chain management has become a necessity as the United States and the European Union seek to remain competitive in selected industry segments. Increased automation can cut costs and make products more competitive and responsive to the need of the retail industry for a fast turnaround. Textile firms concentrated on automating their operations with new advances in computer-aided design (CAD) and computer-aided manufacturing (CAM). They are also focusing on producing textiles with both domestic and export sales potential, such as home furnishing and automotive fabrics and nonwoven fabrics for a variety of uses.

PROFESSIONALS SPEAK . . .

The fast-paced global textile and apparel industry offers a wide range of career opportunities. Knowledge of textiles—how they are made, how they perform, and what they can be used for—is essential for many of these jobs. Professionals in different positions speak here about just how essential this knowledge is.

Apparel Designers

As an assistant designer, it is vital that I have a good understanding of the materials that I am working with. I must know the physical characteristics of each fabric that is selected for a collection. I must be able to determine immediately if I am working with a terry fleece or a brushed terry; the wrong decision could be disastrous. Without a strong background in textiles, I would not be able to successfully complete my daily tasks.

As a pattern maker, it is very important to have a good working knowledge of textile components, such as fiber, yarn, and weave. Such knowledge allows me to predict how a fabric will respond in a particular design and better determine the necessity of internal, structural components of the garment.

Interior Designers

It has been very beneficial having a working knowledge of fibers and their properties. I can help advise clients about the end use of a particular fabric, as well as about durability and care. You would be amazed at the people in the trade who haven't a clue and, therefore, give bad advice. I wish I had taken more textiles courses.

Paint is often cited as an inexpensive and quick way to change the look of a room. I prefer textiles. I contend that textiles, even the most humble and economical varieties, can add color, depth, and great interest to an interior space. I recently utilized generous quantities of a wonderful, good fabric draped over a makeshift table constructed from ordinary wood doors. These fabric-draped tables provided a sensual and theatrical backdrop for antiques and fine art in a high-end residential living room.

Merchandisers/Retailers

Knowledge of textiles helps me do my job as a retail merchandiser by strengthening my credibility with clients making purchase decisions. Use of proper terminology of fabric types and constructions helps me communicate product features. I am enabled to provide advice regarding comfort, care, and performance of garments and can help justify prices of specialty fibers and fabrics. Knowledge of textiles is a powerful selling tool in the retail environment.

Working in the outerwear department of a large department store, I am frequently called on to suggest items for specific needs. My knowledge of textiles allows me to explain features of these items to make them more appealing to customers. For example, I recently was called on to provide information on the sandwich-type construction in jackets and ski wear that makes them lightweight and fashionable yet functional because of the manufacturing technique and fibers used.

Testers/Quality Control Specialists

As lab manager of the textile testing service, I deal with textiles that have varying constructions, fiber contents, and end uses. On occasion, the scientist is unaware of which test methods would provide them with the information they need, or the specifications for the textile's end use. A background knowledge of textile manufacturing and fiber processing helps us handle samples and interpret the results of testing. Recently we assisted an outside agency with determining finish on samples. That required understanding everything from differences in fibers, in fiber processing, in yarn manufacturing, fabric manufacturing, and finishing.

The quality control of apparel products involves not only the control of workmanship, but also determination of the properties of fabrics. Therefore, a good understanding of the mechanical, physical, and chemical properties of fibers and fabrics, and their manufacturing process, is essential for quality control. This knowledge allows the quality control engineer to determine if the fabric properties correspond to the values indicated by the manufacturer and to set the limits for accepting apparel products for their intended end use and consumers' expectations.

SUMMARY POINTS

- Textiles are used in a wide range of apparel, home, and industrial products
- To make a textile product:
 - Fibers are converted to yarns
 - Yarns are made into fabrics
 - Fabrics may be colored and finished
- The textile supply chain, which is now global in reach, includes the following:
 - · Retailers
 - · Wholesalers and distribution centers
 - Product manufacturers
 - Yarn and fabric mills
 - Fiber producers
- National and global trade agreements regulate the import and export of textile products and components

Questions

- 1. Explain the differences among fibers, yarns, and fabrics.
- 2. Describe how the global textile industry is consumer driven.
- 3. Select a familiar textile product and follow it through the textile supply chain.
- 4. Describe the international trade agreements established since 1947 and how they have affected international trade in textiles and apparel. What are the different effects of quotas and tariffs on textile production and sales?

References

ASTM. Compilation of ASTM Standard Definitions. West Conshohocken, PA: American Society for Testing and Materials, 2001.

Azoulay, J. F. "Tracking the Supply Chain." AATCC Review 5, no. 5 (2005): 9.

Ernst, C., A. H. Ferrer, and D. Zult. "The End of the Multi-Fibre Arrangement and Its Implication for Trade and Employment." Employment strategy paper 2005/16. Geneva: International Labour Organization, 2005.

Nordås, H. K. The Global Textile and Clothing Industry Post the Agreement on Textiles and Clothing. Geneva: World Trade Organization, 2004.

Recommended Readings

Azoulay, J. F. "Tracking the Supply Chain." AATCC Review 5, no. 5 (2005): 9.

Dickerson, K. G. *Textiles and Apparel in the Global Economy*. 2nd ed. Englewood Cliffs, NJ: Prentice Hall, 1998.

Friedman, T. L. The World Is Flat. New York: Farrar, Straus, and Giroux, 2005.

Kadolph, S. *Quality Assurance for Textiles and Apparel*. New York: Fairchild Books, 1998.

- Kim, Y., and M. Rucker. "Production Sourcing Strategies in the U.S. Apparel Industry: A Modified Transaction Cost Approach." Clothing and Textiles Research Journal 23, no. 1 (2005): 1.
- Mittlestaedt, J. D., and S. A. Jones. Exporting in a Global Economy. AATCC Review 6, no. 6 (2006): 39.
- Newman, C. "Dreamweavers." National Geographic 203, no. 1 (2003): 50.
- Rivoli, P. The Travels of a T-shirt in the Global Economy: An Economist Examines the Markets, Power, and Politics of World Trade. Hoboken, NJ: John Wiley & Sons, 2005.

2

TEXTILE FIBERS

Learning Objectives

- 1. Describe how textile fibers are classified and labeled.
- 2. Describe polymer structures and processing.
- 3. Explain how fibers are manufactured.
- Determine the effect of manufacturing processes on fiber structure and properties.

libers are the primary materials from which most textile products are made. Textile fibers are small, threadlike structures. According to this definition, many substances, natural or manufactured, can be classified as fibers, but only a few make useful yarns or fabrics. Many fibrous substances lack the essential qualities required of textile fibers. They may not be sufficiently long to be spun into a yarn. Or they may be too weak to use, too inflexible, too thick in diameter, or too easily damaged in spinning and weaving.

Useful textile fibers may be obtained from natural materials or created through technology. Natural fibers are taken from animal, vegetable, or mineral sources. The most important animal fibers are wool and silk. Cotton and flax (from which linen is made) are the most important vegetable fibers. Asbestos is a natural mineral fiber that was formerly used for many special products where nonflammable properties were important, but it has been recognized as a carcinogen and has been replaced in most applications by manufactured fibers.

Manufactured fibers are created through technology. They are generally divided into two groups: *regenerated fibers* and *synthetic fibers*. Regenerated fibers are made from natural (polymer) materials that cannot be used for textiles in their original form but that can be regenerated (re-formed) into usable fibers by chemical treatment and processing. The first commercially successful manufactured fiber was rayon, a cellulose fiber *regenerated* from wood pulp, production of which began around the beginning of the twentieth century.

FIGURE 2.1

Major classifications of textile fibers.

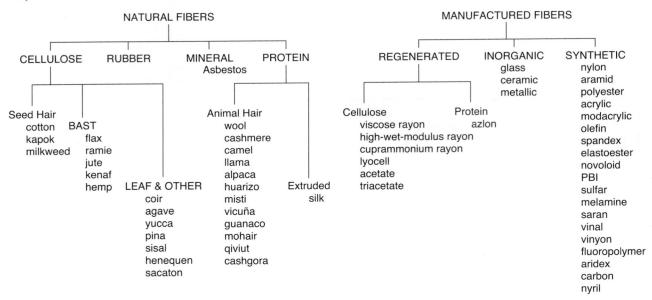

Synthetic fibers, the second type of manufactured fiber, are made from materials that are created synthetically in a chemical process. Nylon—a generic name given to the first synthetic fiber by its manufacturer, DuPont—was first marketed in 1938. The invention of nylon, and its successful marketing after World War II, stimulated the synthesis of additional fibers, and many new synthetic fibers have been developed since then, some as potential replacements for natural fibers, others to fill specialized niche markets. Today rather than being seen as replacements, synthetic fibers are basic commodities and comprise more than 50 percent of the world fiber market. Figure 2.1 shows most of the fibers and how they fall into the aforementioned classifications.

CLASSIFYING AND LABELING FIBERS

Generic Fiber Classification

Figure 2.1 uses *generic* names for fibers that are recognized and defined by the Federal Trade Commission (FTC) as a result of the Textile Fiber Products Identification Act (TFPIA) of 1960. These generic names or generic classifications are based on the chemical repeat units in the polymers that compose the fibers.

Fibers of the same generic group have similar chemical and physical properties. Groups of fibers that are related in their chemical structure may be compared with large, extended families. Each fiber family group is made up of smaller family units. These smaller family units in turn include a number of individual units. For example, some fibers have a structure made of protein (the large extended family). Subunits of the "protein" family include silk, which has no other close relatives, and animal hair fibers including wool, mohair, cashmere, camel hair, and the like. Commercial regenerated protein fibers were made from corn, soybean, peanut, and milk proteins but became obsolete, although soy fibers have recently been reintroduced.

Within the family are certain "family resemblances," or ways in which the members of each group are alike. Most protein fibers, for example, are harmed by the same chemicals, are fairly resilient, are harmed by dry heat, and are weaker wet than dry. Like human family members, however, each fiber has its own talents or eccentricities: silk has high luster, wool does not; vicuña and cashmere are exceptionally soft and luxurious to the touch; and the color of camel hair cannot be removed easily.

As commercial rather than agricultural products, manufactured fibers may also have a brand name or *trademark*. Thus, Dacron® polyester, Fortrel® polyester, and Trevira® polyester are all members of the generic group of polyesters, but each has a different trademark. These trademarked variations do not vary significantly in their chemical or physical properties from other members of the generic family. As manufactured fibers develop from specialized novelties into large-scale commodities, the use of trademark names declines. Today few basic polyesters are sold under trademark names, but specialized versions (for example Coolmax® polyester, which wicks moisture well) may be.

Textile Fiber Products Identification Act

Fiber manufacturers introduced ever-increasing varieties of new fibers to the public after World War II. No regulation was made of the use of manufactured fiber names, so each manufacturer that made its own version of a fiber gave it its own trademark. The consumer was confronted with a variety of fiber names and had no ability to distinguish one from the other. Furthermore, two or more fibers might be blended together without the consumer's knowledge. The purchaser of a man's shirt had no way of knowing whether it was made of cotton, rayon, or a cotton-and-polyester blend.

The consumer confusion resulting from this situation led to the enactment of the Textile Fiber Products Identification Act (often abbreviated TFPIA), which requires fiber content labeling of all textile products. An earlier law, the Wool Products Labeling Act of 1939, had set a precedent in textile labeling and served as a model for the TFPIA, which became effective March 3, 1960, and has since been amended several times. The legislation assigned responsibility for the enforcement and drafting of rules and regulations under the act to the FTC.

Provisions of the TFPIA. Under the provisions of the TFPIA, all fibers, either natural or manufactured; all yarns; fabrics; household textile articles; and wearing apparel are subject to this law. One of the first tasks assigned to the FTC was the establishment of generic names or classifications for manufactured fibers. (See Figure 2.1.)

A *natural fiber* is defined in the act as "any fiber that exists as such in the natural state." The common English names of natural fibers, *cotton*, *linen*, *silk*, and *wool*, appear on labels as generic names.

A manufactured fiber is defined as "any fiber derived by a process of manufacture from any substance which, at any point in the manufacturing process, is not a fiber." These categories or generic classifications established by the FTC were based on similarities in chemical composition. Along with similarities in chemical composition, fibers in these groupings had many common physical properties, care requirements, and performance characteristics. New fibers have

been developed since 1960, and thus, new generic names have been added and more may be added in future.

To earn a new generic name, the fiber "must have a chemical composition radically different' from other fibers and that chemical composition must give it significantly different physical properties; the fiber must currently be, or soon be, in active commercial use; and the granting of the generic name must be of importance to the consuming public 'at large,' rather than to a small group of knowledgeable professionals." If a new fiber meets only the last two of these three criteria, it may be given a new generic name as a subcategory of an existing generic name. Recently approved generic names are melamine and lyocell. Companies that wish to market a new fiber derive significant benefit from a new generic name because otherwise the fiber content label would not indicate a difference. Lyocell is regenerated cellulose and was given a generic name as a subcategory of rayon. Without a new generic name, it would simply appear as "rayon" on a label, and consumers would be less likely to appreciate its special qualities and distinctive character.

Labeling Requirements. The TFPIA requires that all textile items must (at the point of purchase) carry the generic name of the fibers they contain on the label.² Fiber listing on the label must be done in order of the percentage of fiber by weight that is present in the product. The largest amount must be listed first, the next largest second, and so on. Thus, for example, a fabric might be labeled as follows:

60% polyester 30% cotton 10% spandex

The manufacturer must list the generic name of the fiber but may also list the trademark. So for example, the same label could also read as follows:

60% Dacron[®] polyester 30% cotton 10% Lycra[®] spandex

Note that the trademark is capitalized but the generic term is not.

Fiber quantities of less than 5 percent must be labeled as "other fiber" unless the fibers serve a specific purpose in the product. If the fibers are listed, the function of these minor components must be stated. For example, a manufacturer could say, "96 percent nylon, 4 percent spandex for stretch," because spandex is an elastic fiber and does perform a specific function. The intent of this provision is to prevent manufacturers from implying that 5 percent or less of a fiber will produce some positive benefit. Quantities of less than 5 percent of most fibers normally have little or no effect on fabric performance. Exceptions are the use of elastic fibers such as spandex or metallic fibers that control static.

^{1.} Federal Trade Commission information sheet requesting public comment, May 28, 1985.

^{2.} With these exceptions: upholstery stuffing; outer coverings of furniture, mattresses, and box springs; linings, interlinings, stiffenings, or paddings incorporated for structural purposes and not for warmth; sewing and handicraft threads; bandages and surgical dressings.

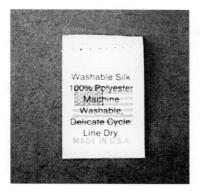

TFPIA. Not only is the fabric labeled both as "washable silk" and 100% polyester, but the print identifying the fabric as polyester is partially obscured by the

overprinting of the American flag.

Label that violates the

FIGURE 2.2

Where products are made from fibers that have not been identified, for instance, from mixed reused fiber, the label may indicate that such a product is "composed of miscellaneous scraps, rags, odd lots, textile by-products, second-hand materials, or waste materials." Such a label might read, for example,

45% rayon

35% acetate

20% miscellaneous scraps of undetermined fiber content

No trademarks or other terms may be used that imply the presence of a fiber that is not actually a part of the product. For example, it would be illegal to use either of the following labels:

SILK-SHEEN Blouses 100% nylon

Wooly Warm Blankets 100% acrylic

(Also see Figure 2.2.)

The law also requires that either the name of the manufacturer of the product, a registered trademark, or a registered identification number appear on the label. All the mandated information must appear on the same side of the label, and all fiber content information must appear in type or lettering of equal size or conspicuousness, except for the manufacturer's name or identification number. This information may be placed on the reverse side of the label or on a separate label close to the fiber content label. The main provisions of the TFPIA are summarized in Table 2.1.

Country-of-origin Labeling. Amendments to the TFPIA and Wool Products Labeling Act in 1984 sought to clarify and improve country-of-origin labeling requirements and to increase consumer awareness of origin.

The country of origin must be disclosed in a label placed in the neck of any garment having a neck; for those without necks, it must be placed on a conspicuous spot on the inside or outside of the product. Products are to be labeled separately except when several pairs of hosiery are enclosed in one retail package that will not be opened before its sale. Packages must also be labeled unless the individual product label can be seen clearly through the packaging. Mail-order catalogs and mail promotional materials such as department store advertising

TABLE 2.1

Provisions of Textile Fiber Products Identification Act

Label Must	Label Must Not	Label May	
List general fiber names in order of percent by weight	Imply presence of fibers not included	List trademark with generic name	
List manufacturer name, registered trademark, or registered identification number	List fibers less than 5% unless they serve specific purpose	Designate fibers as "unidentified"	
List country of origin			

flyers must disclose whether a product advertised was made in the United States or imported or both if the products are intended for customer purchase by mail or by phone without prior examination.

Products made entirely in the United States must carry a label that reads "Made in the U.S.A." or some other "clear and equivalent" term. (Acceptable examples include "Crafted with Pride in the U.S.A." or "Made in New York, U.S.A.") Those made in the United States using foreign materials must carry a label such as "Made in the U.S.A. of imported fabric" or equivalent terms. The FTC requires only that the manufacturer go back one manufacturing step to determine origin. For example, the manufacturer of knitting yarn sold at retail needs to identify the origin of the fiber; the manufacturer of retail piece goods needs to identify the origin of the yarn but need not identify the origin of the fiber; and the apparel manufacturer must identify the origin of the cloth. The specific country of origin need not be identified, although it may be given. Therefore, for example, a knitting yarn spun in the United States of Australian wool would need to be labeled as "Made in U.S.A. of imported wool fibers." However, if the manufacturer wished, it could say "Made in U.S.A. of Australian wool fiber."

Country-of-origin labeling was important under the trade rules of the Multifibre Arrangement and has remained an issue as trade barriers in textiles are phased out. (See Chapter 1, page 10.) The U.S. Customs Service examines articles carefully to determine if importers misrepresent the country of origin by *transshipment* of textile or apparel products. Under this practice, companies in countries that have exceeded their import limits ship their goods to the United States through a third country. If a country refuses to allow the Customs Service to verify production by on-site inspections, the United States can limit imports from that country or modify any remaining quotas on textile goods.

UNDERSTANDING POLYMERS

The detail inherent in the TFPIA legislation makes clear the importance to the consumer of understanding differences among fibers. To understand how these differences arise, to explain how fibers are manufactured, and to understand the properties that the fibers exhibit as they are processed and used, it is helpful to discuss the chemical make-up and physical structure of the fibers.

Individual fibers are small, but each contains millions of individual polymer molecules. Understanding how those molecules interact and how they are arranged helps to explain the way fibers are manufactured, the properties they have, and how they are dyed and finished. In this section we will look at how the materials and structures of fibers vary, and the "construction methods" that are used for manufactured fibers. In chapter 3 we will look at how the fibers behave.

Polymer Basics

Most fibers are formed from natural or synthetic organic (i.e., carbon-based) polymers. Understanding textiles requires understanding basic concepts related to polymers. Indeed, the fundamental distinctions among different fibers are based on their chemical composition, and textile fibers are defined by the major chemical units that make up the fiber. These definitions are provided in the chapters dealing with each fiber, and for most of these, the unit is named and its formula shown. For example, acrylic is defined as a "manufactured fiber in which the fiber-forming substance is any *long-chain synthetic polymer* composed of at least 85 percent by weight of *acrylonitrile units*." To understand these definitions and some of the properties of textile fibers, it is useful to understand terms such as *long-chain synthetic polymer* and to have some elementary understanding of the chemical structure of textile fibers. We also introduce a number of terms that appear frequently in technical writing and research about textiles and that appear occasionally in less technical communications.

Almost all fibers, whether natural or manufactured, are (chemically) *organic*; that is, they contain the element carbon with a few other elements such as hydrogen, oxygen, nitrogen, halogens (fluorine, chlorine, bromine, and iodine), and sulfur linked with covalent bonds. (This chemical use of the word *organic* is in contrast to its use when referring to food, for example, produced without synthetic chemicals. Later we will mention cotton grown in such a way as *organic cotton*.)

Most organic chemicals consist of relatively small molecules. Polymers are much larger molecules. While nature has been making organic polymers for millions of years (and polymers such as cellulose, starch, and protein are essential to life itself), one of the major achievements of the twentieth century was the development of synthetic organic polymers. Chemists developed ways to join monomers and create long chains, and it is difficult to imagine life without all the plastic items we use every day. Whether natural or synthetic, organic polymers consist of chainlike molecules made up of *repeating units* with groupings of atoms—chemical units—that repeat. These units are closely related to the small molecules (the *monomers*) that are the starting materials to create the polymer. Many polymers (and most fiber-making polymers) have only one type of repeating unit. They are *homopolymers*. Sometimes a combination of monomers (*comonomers*) can be linked to create a polymer with two or more repeating units in the chains, a *copolymer*. Natural proteins and synthetic acrylic fibers are copolymers.

The units in a polymer chain, especially those that form fibers, are typically linked end to end to form a *linear* structure. (Other polymers may be *branched*.) Polymer chains can have covalent bonds linking them to form *network* or

TAKE A CLOSER LOOK

Cotton, Linen, and Rayon: The Same, but Not the Same

Cotton, linen, and rayon are all composed of the same polymer: cellulose. One would think, therefore, that although their physical appearances differ, their chemical and other properties would be the same. The length and arrangement of the cellulose polymers in each of the three fibers, however, confer distinctive characteristics on the fibers, primarily in the areas of strength and absorbency.

Strength

Comparing three fibers with the same chemical structure can illustrate the effect of crystallinity and orientation on fiber strength. Cotton is about 70 percent crystalline and 30 percent amorphous. Rayon is only about 30 percent crystalline. As a result, cotton is stronger than rayon.

Linen is stronger than cotton not only because it is slightly more crystalline, but also because its polymers are oriented. In cotton, while some molecules are parallel to the fiber length, many are not oriented, but rather lie at an angle. In this position they are not able to bear as much load as are the more oriented molecules in linen, and so it takes less force to break them. Strength is also affected by the degree of polymerization (DP) of the cellulose molecules. The cellulose

molecules in cotton and linen can have a DP of several thousand, while those in rayon may have a DP of five hundred or less. The lower DP and lower crystallinity of rayon explain why it is significantly weaker than the chemically identical cotton or linen.

Fibers that are less crystalline, with more amorphous material, can stretch more easily as the chains in the amorphous area are pulled into a straighter configuration. This behavior is seen in rayon fibers that can be easily stretched to a longer length. Cotton and linen, with their more crystalline and oriented structures, resist stretching.

Absorbency

Cellulosic fibers are more absorbent than synthetics, but within the cellulose family, differences exist here as well. Rayon, with its more amorphous polymer arrangement is very absorbent. This is why it is often the fiber used in "cotton balls" and other absorbent products. Cotton and linen are more crystalline and, therefore, absorb less moisture. The differences also apply to the absorption of dye. Rayon absorbs dye more readily than does cotton or linen.

crosslinked structures (See Figure 2.3.). Some fibers, such as spandex, are formed with crosslinks. (See chapter 11 for a discussion of spandex.) Wool and animal hair fibers have naturally crosslinked structures that contribute to the excellent resiliency of this fiber. Crosslinks can be added to cellulose-based fibers in a finishing treatment. These crosslinks return the molecules to their original position after the fiber has been bent or folded and, thus, provide wrinkle recovery. (See chapter 25.)

The properties of a polymer depend not only on its chemical identity, but also on the (average) length of the chains. The most convenient way to indicate the length of the chains within a certain polymer is the *degree of polymerization* (DP), or the number of repeating units in the average chain. A simple example of the effect of DP on fiber properties occurs in cellulose. (See Take a Closer Look on this page.) Chemists might also measure DP in a sample of cotton to investigate any damage that bleaching may have caused. In synthetic polymers where DP can be controlled, a higher DP generally means a stronger, tougher fiber but one that is more difficult to process, so some compromises have to be made.

Another key factor in the understanding of polymers and how fiber properties are derived is the way in which the billions of polymer chains within each single

^{1.} The terms linen and flax are used interchangeably to refer to the fiber that comes from the flax plant.

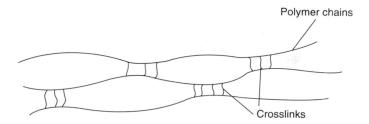

FIGURE 2.3 Crosslinks (covalent bonds) between adjacent polymer chains.

fiber are arranged, also known as the polymer morphology. Before dealing with that, however, it is helpful to understand what forces operate between polymer chains, how they are held together, and what can break them apart.

Polymer Processing: Intermolecular Forces and **Fiber Manufacture**

The atoms that make up a single polymer molecule are linked by covalent bonds. As in any chemical substance, when many billions of these molecules are together to make a lump of material, other forces hold these molecules together and give the whole lump its useful mechanical properties.

Chemists have a number of ways to describe or classify these intermolecular forces. Sometimes, covalent bonds are referred to as primary bonds, while all the other intermolecular forces are called secondary bonds. The secondary bonds may be subdivided into hydrogen bonds and polar and nonpolar van der Waals forces; the latter may also be called London forces or dispersion forces. While individually they are much weaker than a covalent bond, when many of them occur in a collection of large (polymer) molecules, they add up, cause the molecules to stick together, and provide mechanical strength to the material. If secondary forces were not present, nothing would hold the molecules together, and they would slide apart. The lump of matter would flow; it would be a liquid. So what can break these secondary bonds? How can polymer molecules be separated from each other? Or how can a lump of solid plastic be made to flow?

When the sum of all the secondary bonds is relatively weak, heat may be sufficient to break them and allow the material to flow. It melts. Polymer materials that soften and flow under the influence of heat are called thermoplastic. This is a key property of the polymers that make up many textile fibers. Thermoplastic behavior allows yarns to be textured (See chapter 14) and allows fabrics to be heat set so they do not wrinkle and will hold permanent creases. Olefin, nylon, and polyester are highly thermoplastic. Acetate and acrylic fibers are also thermoplastic enough to soften and be heat set, but as the temperature rises, the secondary forces remain large enough that by the time a melting temperature is reached, some breaking of primary bonds occurs, and the polymer is degraded.

When secondary bonds are stronger like this, a second strategy can be used to break them and create a liquid. A substance that forms stronger bonds with the polymer than the polymer does with itself will separate chains and surround them. Such a substance would be a solvent that dissolves the polymer, in the same way that water dissolves salt or sugar. (And incidentally, the Wicked Witch in The Wizard of Oz was clearly not a chemist: when she was doused with water, she should have said, "I'm dissolving! I'm dissolving!" Although it doesn't have the same ring to it, does it?). So acetone, as in the familiar nail polish remover, will dissolve acetate (careful with the prom gown!), and dimethyl formamide will dissolve acrylic fibers. The dissolving behavior of fibers is used as a way to identify them and as a way to separate them in determining the percentage of fibers in a blend.

FIBER MANUFACTURE

Using heat or a solvent to create a liquid version of a polymer substance is the fundamental basis of the manufacture of fibers. This liquid can be forced through a showerhead device called a spinneret, and the narrow streams of liquid then resolidified into long, thin fibers! The basic steps in producing manufactured fibers are shown in Figure 2.4.

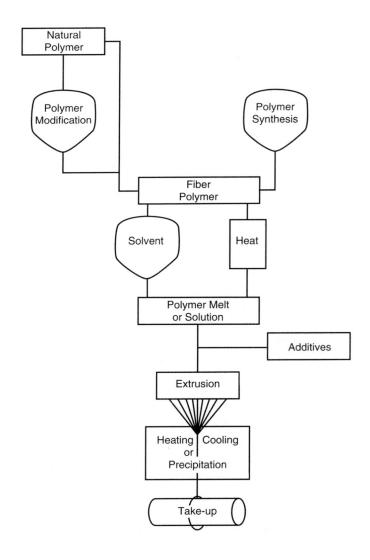

FIGURE 2.4 Flow chart for producing manufactured fibers.

Additions to the Melt/Solution

Whether it is a solution or a melt, the liquid form of the polymer is an opportunity to add substances that will provide modified characteristics to the fiber that is spun.

Delustrant

Many manufactured fibers are naturally bright, with a high luster. If brightness is not required, and to increase the opacity of the fibers, a delustering agent can be added to the liquid polymer to scatter light rays. Titanium dioxide (TiO₂) is almost invariably used as the delustrant, and most manufactured fibers contain some of it. Under the microscope, TiO₂ appears as small, dark specks within the fiber (see, for example, Figure 6.9), and seeing them is evidence that the fiber is a manufactured one. Adding a small amount of delustrant produces a *semidull* fiber, while adding more produces a *dull* fiber. Fibers without delustrant are called *bright*. Whiteness can be enhanced by the inclusion of a *fluorescent brightening agent*, also referred to as *an optical whitener*.

Color

Color, in the form of dyes and pigments, can also be added to the polymer liquid. The addition of color to the liquid has gone under many names, but the current is solution dyeing (even though it may not be a solution, and it is not truly "dyeing"). Thus "solution-dyed" polyester refers to polyester that is colored as part of the fiber manufacturing process. Because the spinning liquid for acetate fibers was originally known as "dope," dope dyeing is another name. Mass coloration and mass pigmentation have also been used. The advantages and disadvantages of coloration this way are discussed more fully in chapter 22, but the method is very useful for fibers, notably olefin, that are difficult to dye.

Flame Retardant

The burning behavior of a fiber can be reduced by the inclusion of flame-retardant additives into the melt or solution before spinning. This is generally more durable than applying the chemicals as a finish after the fiber has been spun and turned into a fabric. Polyester and rayon have probably been the fibers most often treated this way.

Stabilizers

Some fibers are prone to the action of ultraviolet light, or of atmospheric weathering. When they are used in outdoor applications (all-weather carpet or awnings, for example) they can quickly degrade. Ultraviolet absorbers and antioxidants can be added to the melt or solution to produce a fiber that is more durable in such applications.

Antimicrobials

Antimicrobial fibers have been created by the addition of substances that slowly leach out over the life of the fiber.

Fiber Spinning

After careful filtration to remove material that might clog the spinneret holes, the liquid polymer melt or solution is then *extruded* through a *spinneret* to create the fibers. Each spinneret has a number of holes, and each hole produces one filament. As they exit the spinneret, the fibers are solidified. The method of solidification forms the basis of melt spinning, dry spinning, and wet spinning, the three primary fiber-spinning processes, discussed below.

The solidified fibers that emerge from one spinneret may form a filament yarn directly. The number of holes in the spinneret will determine the number of filaments in the yarn. (See chapter 14.) When fibers being extruded are intended for conversion into staple yarns, spinnerets with larger numbers of holes are used (or the filaments from several spinnerets are collected together) to produce *filament tow* that is later cut into staple lengths.

In either case, spinneret holes are spaced to allow the filaments to be extruded without touching each other. The metal used in the plate must be capable of withstanding high temperatures, high pressures, or corrosive spinning solutions.

The spinning system also controls the size and shape of the fibers produced. Contrary to expectation, the size of the fiber produced depends less on the size of the hole and more on the pressure used to force the liquid through the spinneret, and the rate at which the fiber is drawn away from the spinning zone. The shape of the hole controls the shape of the fiber, but an exaggerated shape is required because the liquid stream that emerges will tend toward roundness (minimizing surface area). (See Figure 2.5.) Melt-spun fibers may be made through Y-shaped

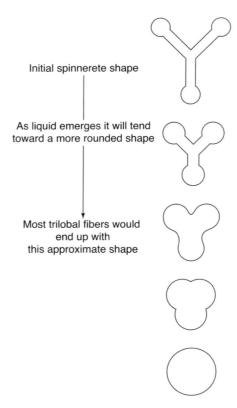

FIGURE 2.5

Diagram showing the rounding of fiber upon exiting the die.

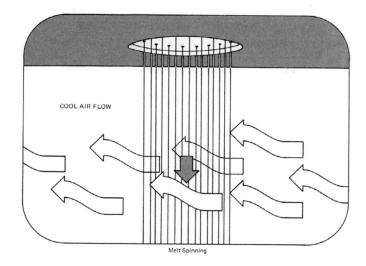

FIGURE 2.6 Melt spinning. Courtesy of the American Fiber Manufacturers Association, Inc.

holes that yield a three-lobed fiber or C-shaped holes to produce a hollow filament, for example.

Melt Spinning

Chips of solid polymer about the size of rice grains are dropped from a hopper into a melter where heat converts the solid polymer into a viscous liquid. The liquid forms a "melt pool" that is pumped to the spinneret at a carefully controlled rate of flow. Because it does not involve the expense of solvents and their recovery, melt spinning is simpler and cheaper than other spinning methods and is used when at all possible. Nylon was the first melt-spun fiber. Polyester and olefin are also melt spun.

When the molten polymer emerges from the spinneret hole, a cool air current is passed over the fiber, causing it to harden. (See Figure 2.6.)

Like many other textile processes, melt spinning has become faster and more efficient. Processing speed has increased from less than one thousand meters per minute in the 1960s to more than seven thousand meters per minute (more than 250 miles per hour!) today. Higher-speed spinning is cost effective and, up to a certain point, increases the orientation of the polymers in the fibers. Beyond a speed of about sixty-five hundred meters per minute, however, this advantage disappears as there is not enough time for the polymers to crystallize and the fibers may break (Demir and Behery 1997).

Dry Spinning

Polymers that cannot be melt spun are dissolved in a solvent to be formed into fibers. Solvents are chosen not only for their ability to dissolve the polymer, but also for their safety in use and ability to be reclaimed and reused. The solvent must be removed to solidify the fibers, and if it is relatively volatile, the most straightforward means of doing so is by evaporation. This is the basis of dry spinning.

The polymer and solvent are extruded through a spinneret into a circulating current of hot gas in a chamber called a spinning cell. The solvent evaporates from

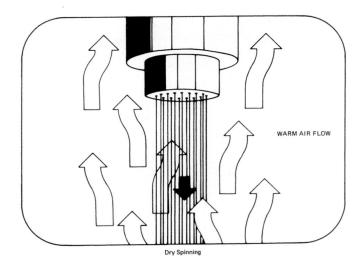

FIGURE 2.7
Dry spinning. Courtesy of the American Fiber
Manufacturers Association, Inc.

the polymer and causes the filament to harden. (See Figure 2.7.) The solvent is removed and recovered from the stream of air to be recycled.

Dry-spun filaments generally have an irregular cross section. Because the solvent evaporates first from the outside of the fiber, a hard surface skin of solid polymer forms. As the solvent evaporates from the inner part of the fiber, this skin "collapses" or folds to produce an irregular shape. If the rate of evaporation is slowed, the cross section of the filament will be more nearly round. Acetate fibers were the first to be dry spun. Meta-aramid fibers, most spandex, and some acrylic fibers are also dry spun.

Wet Spinning

Wet-spun polymers are, like dry-spun polymers, converted into liquid form by dissolving them in a suitable solvent. The polymer solution is extruded through a jet into a liquid bath. The bath washes away the solvent and causes coagulation and precipitation of the fiber. (See Figure 2.8.) Like those produced by dry spinning, these fibers tend to have an irregular cross section from the initial formation of a

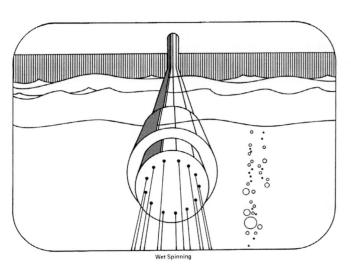

Figure 2.8

Wet spinning. Courtesy of the American Fiber Manufacturers Association, Inc.

"skin" that later collapses. Solvents are usually recovered from the liquid bath and are recycled. Viscose rayon and some acrylics are wet spun.

The chemical composition of the bath can be varied to provide changes in the detailed properties of the fiber. This is done in the manufacture of some versions of rayon, for example.

A variant of wet spinning, called dry-jet wet spinning, has been developed to produce some of the newer fibers such as lyocell, described in chapter 6, and the para-aramids discussed in chapter 7. Instead of the spinneret being immersed in the spinning bath, it is placed slightly above the bath so there is a small air gap, usually less than an inch. The fibers exiting the spinneret can be stretched to orient the molecules before they enter the bath to be solidified. This process develops high orientation and crystallinity in one step, rather than drawing in a separate step as described below (Jaffe and Jones 1985).

Other Spinning Methods

Although melt-, dry-, and wet-spinning techniques are used to form the vast majority of manufactured fibers, several other spinning techniques have been developed for specialized situations. High-molecular-weight polymers, such as those in Spectra® polyethylene, are formed by solution spinning or gel spinning. As in wet and dry spinning, the polymer is dissolved in a solvent. The polymer and solvent together form a viscous gel that can be processed on conventional melt-spinning equipment to form a gel-like fiber strand. Later in the processing, the solvent is extracted and the fibers stretched.

Fibers made from polymers that have extremely high melting points and are insoluble present obvious difficulties in spinning. Such materials may be spun by a complex process called emulsion spinning in which small, fibrous polymers are formed into an emulsion, aligned by passing the emulsion through a capillary, then fused or sintered (combined by treating with heat without melting), passed through the spinneret into a coagulating bath, and subsequently stretched.

FIBER-SPINNING MODIFICATIONS

As the technology for producing manufactured fibers has become more highly developed, manufacturers have turned to increasingly sophisticated techniques for creating new fibers. Different fiber shapes and sizes, as well as unique combinations of polymer types in the same fiber, are but several examples of these techniques.

Microfibers

Very-fine-diameter fibers have valuable properties. Several different methods have been developed for the spinning of such microfibers, generally recognized as those of less than one denier.3 Microfiber fabrics are especially soft and drapable and are also used to make high-tech wiping cloths that leave surfaces very clean. It is possible to produce microfibers through conventional melt spinning; however, to

^{3.} Denier, defined in chapter 3, is the weight in grams of nine thousand meters of fiber.

create such fine filaments requires very strict process controls and a uniformly high quality of polymer. There is a limit to the fineness of fibers extruded directly. Filaments smaller than approximately 0.5 denier are too fine to withstand the tensile forces in the melt-spinning process (Warner 1995). Several methods have been developed to make fibers even finer than this.

A common method is a bicomponent process using two different polymers that do not mix. After spinning, the filament yarns are woven into a fabric. The components may be separated into smaller units by some form of mechanical action, or the fabric can be treated with a solvent to dissolve away one component of the fibers, leaving the other. This sequence of steps minimizes the stress on the fibers until after the fabric is constructed.

Two different types of bicomponent structures are currently used to produce microfibers. In the citrus configuration, wedge-shaped polyester segments are held within a star-shaped core of nylon or a different type of polyester. The core can be dissolved or separated by a chemical treatment of the fabric. The other procedure for making microfibers begins with extrusion of bicomponent islands-in-the-sea fiber. In this structure one polymer is dispersed within the other before they are extruded. Dissolution of the "sea" leaves the tiny microfibers. (See Figure 2.9.)

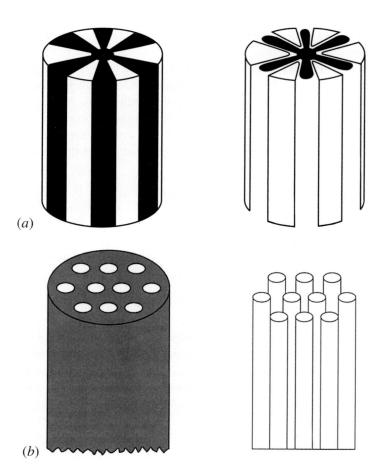

FIGURE 2.9 Formation of microfibers: (a) citrus type; (b) islandsin-the-sea type.

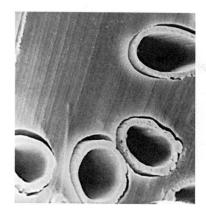

FIGURE 2.10

Micrograph of the cross-section of a hollow rayon fiber mounted in wax and photographed through a scanning electron microscope. Courtesy of Courtaulds North America, Inc.

The search for better methods to make ever finer fibers continues. One method under development, called electrospinning, uses a high voltage to draw a polymer solution from a charged nozzle onto a collector. The electrical field separates the extruded fibers into extremely fine filaments that repel each other. Some electrospun fibers are as small as one hundred nanometers in diameter (one nanometer is 1/1000 of a micron). Electrospinning is the basis of many of the experimental "nanofibers" being researched.

Hollow Fibers

Hollow fibers are made of a sheath of fiber material and one or more hollow spaces at the center. (See Figure 2.10.) These hollows may be formed in a number of different ways. The most common method today is to melt spin fibers from C-shaped spinneret holes. As the molten fibers relax after extrusion, the open end of the C closes, producing a hollow core, and this structure is set as the fiber cools. Older methods used a sheath of another and a core that could be dissolved out after the fiber was formed. Other experimental or proprietary techniques have been used to make hollow fibers. One involves spinneret holes with solid cores around which the polymer flows.

Hollow fibers provide greater bulk with less weight. They are, therefore, often used to make insulated clothing. For absorbent fibers such as rayon, hollow fibers provide increased absorbency. Some have been put to such specialized uses as filters in kidney dialysis or as carriers for carbon particles in safety clothing for persons who come into contact with toxic fumes. The carbon serves to absorb the fumes.

Bicomponent Fibers

As mentioned above under microfibers, different polymers or variants of the same polymer can be spun into a single fiber then split up. The technique can also be used to create normal-sized fibers in which the two components remain together so as to take advantage of the special characteristics of each polymer. Such fibers are known as bicomponent fibers. The American Society for Testing and Materials (ASTM) defines a bicomponent fiber as "a fiber consisting of two polymers which are chemically different, physically different, or both." Bicomponent fibers can be made from two variants of the same generic fiber (for example, two types of nylon,

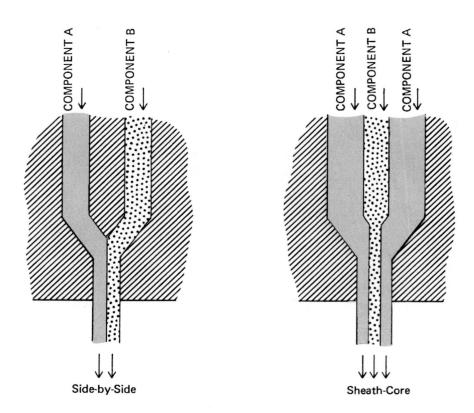

FIGURE 2.11
Formation of bicomponent fibers.

two types of acrylic) or from two generically different fibers (for example, nylon and polyester or nylon and spandex). The latter are called *bicomponent bigeneric fibers*.

Components in bicomponent fibers may be arranged either side by side or as a sheath core. In making a *side-by-side bicomponent fiber*, the process requires that the different polymers be fed to the spinneret together so they exit from the spinneret opening side by side. (See Figure 2.11.)

Sheath-core bicomponent fibers require that one component be completely surrounded by the other, so the polymer is generally fed into the spinneret as shown in Figure 2.11. Variation in the shape of the orifice that contains the inner core can produce fibers with different behavioral characteristics.

Most side-by-side bicomponent fibers are made to provide stretch or crimp to the fiber. Each of the polymers used in the bicomponent fiber has slightly different characteristics. Often one polymer is made to shrink in heat or chemical treatment more than the other, which pulls the fiber into a permanent crimp. If sufficient crimp is provided or if the fiber is elastic, the bicomponent fiber may also have increased stretchability. The recently developed elastic fiber with the generic name elasterell-P is a bicomponent polyester. Other uses for bicomponent fibers have been suggested. For example, components with different melting points could be used to bond fibers together in the construction of nonwoven fabrics. When heat is applied, one fiber softens, serving as a glue to hold the other fiber in place. A less absorbent core fiber could be sheathed in a more absorbent fiber to increase comfort or increase dyeability.

Under the TFPIA, those products made from bicomponent bigeneric fibers must have listed on their labels the generic fibers present. Constituents are to be listed in the order of "predominance by weight" and must state the "respective percentages of such components by weight." The ruling goes on to state, "If the components of such fibers are of a matrix-fibril configuration, the term 'matrix-fibril' or 'matrix fiber' may be used" (TFPIA, §303.10).

The label of a Cordelan[®] fiber product might, therefore, read as follows:

100% matrix fiber 50% vinal, 50% vinyon

Bicomponent fibers made from the same generic fiber are not covered by this regulation. They are composed of the same generic fiber type throughout, even though the different types of the same polymer may each exhibit somewhat different characteristics.

Drawing or Stretching: Morphology of Fibers

A single fiber may contain billions of individual polymer molecules. How the molecules are arranged within the fiber will affect the physical properties of the fiber. This is true of both natural and manufactured fibers, but most fiber-spinning processes include a final step of drawing in which the filaments are stretched to modify the molecular arrangements within the fiber. The arrangement of the polymer chains in a fiber affects many properties such as strength, elongation, absorbency, and dyeability.

The morphology of the polymer molecules within a fiber has two related aspects, orientation and crystallinity. Orientation refers to the extent to which the polymer chains line up in the long direction of the fiber. Processing steps that encourage the molecules to align themselves along the fiber axis increase orientation. At the same time, polymer molecules that are more oriented tend to form orderly arrangements and become more crystalline. Crystallinity refers to the degree of orderly arrangement of chains. While simple substances (salt or sugar, for example) exist as totally crystalline (ordered) materials, it is difficult for large polymer molecules to arrange themselves perfectly, so most polymers are only partly crystalline. The noncrystalline areas in which the polymer chains have a random, unorganized arrangement are referred to as amorphous regions within the fiber. (See Figure 2.12.)

Most fibers possess partly crystalline, partly amorphous structures. Fibers with the highest levels of crystallinity are the strongest fibers. The amorphous areas are weaker but contribute other important properties. Dyes and finishes, as well as moisture, are absorbed primarily in the disordered regions because there is more space there. In addition, amorphous fibers are more flexible and stretchable. The random or coiled polymers in these areas can be pulled into a linear arrangement, allowing the material to stretch. Table 2.2 summarizes some differences between crystalline and amorphous fibers. The effect that polymer arrangement can have on fiber properties is discussed more fully in Take a Closer Look on page 22.

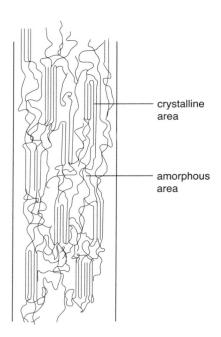

FIGURE 2.12
Schematic representation of crystalline and amorphous regions within a fiber.

Newly formed filaments are, therefore, subjected to drawing or stretching to increase orientation and crystallinity and develop the fiber's mechanical properties. Drawing is accomplished by stretching the fibers between two rollers, called *godet rolls*, with the second roller rotating faster. Drawing makes the filament both narrower and longer. A fiber fresh from the spinneret can be stretched many times its original length and does not recover from that: imagine how a garment made from such fibers would behave! Figure 2.13 shows schematically how a fiber becomes finer as it is drawn and how the molecules within it tend to align themselves along the fiber axis. Figure 2.12 is a schematic of the arrangement of polymer molecules within a fiber showing ordered and less ordered regions. Table 2.2 lists the effects of crystallinity and orientation on general fiber properties. Depending on the fiber type, drawing may be done under cold or hot temperature

Table 2.2
Effect of Crystallinity and Orientation on General
Fiber Properties

Crystalline Fibers with High Orientation	Amorphous Fibers with Low Orientation	
Stronger	Weaker	
Stiffer	More flexible	
Less stretchable	Stretchable	
Increased luster	Low luster	
Less absorbent	More absorbent	
Lower dye uptake	Higher dye uptake	

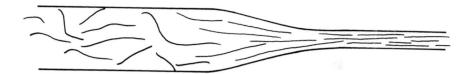

FIGURE 2.13 Effect of drawing of fibers on polymer orientation.

conditions. Fibers made from polymers that have a low glass transition temperature, such as nylon, can be drawn at room temperature. The polymers are mobile and can be pulled into positions parallel to the fiber length. Polyester, on the other hand, has a higher glass transition temperature and is drawn at higher temperatures.

Not all yarns are drawn to the maximum amount possible. Apparel fibers need to be more extensible in use, do not require great strength, and are drawn less than fibers for high-strength industrial uses. Sometimes the full drawing is delayed until a later stage of yarn processing, and partially oriented yarn (POY) is produced, as opposed to fully oriented yarn (FOY). Lower speeds in melt spinning produce fibers with lower orientation. As is true of many other textile processes, precise control of the process must be maintained so the manufacturer can achieve the qualities needed in the final product.

Other steps may be added, such as texturing (in which crimp is added to the filaments) or heat-setting treatments to ensure very low shrinkage, as is required in fibers for automobile tires. Sometimes two or more steps may be combined into consecutive operations to reduce manufacturing costs; the fibers may go from spinning directly to drawing or from spinning to drawing to texturing. Texturing of filament yarns is discussed more fully in chapter 14.

Fiber Variations: Deliberate and Accidental

As is clear from what has gone before, the fiber manufacturing process is full of opportunities for variation, both deliberate and accidental.

The same generic fiber can be produced with different diameters, different cross-sectional shapes, and different brightnesses. It can be produced as filaments or crimped and chopped into different lengths. It can be drawn more or less to change the crystallinity and, thus, the strength. A manufacturer will usually summarize all these details in a type number. Thus "Fibralon Type 245" might be a two-denier, round-cross-section, semidull, crimped fiber of two-inch staple length.

As fibers are manufactured, minor variations occur inevitably because control of the parts of the process can vary slightly. Failure to maintain constant feeding speed of molten polymer or changes in the temperature of cooling will cause irregularities in the diameter of a melt-spun fiber. The temperature of the air used to evaporate solvent in dry spinning might have a similar effect. The temperature and chemical composition of the bath in wet spinning can change slightly. The temperature and extent of drawing for any of the processes can vary. While these variations may be minor, they can have a serious effect on the later processes, especially dyeing.

Fiber manufacturers will usually test their production and assign a merge number to all fiber that they know is consistent. Weavers and knitters should use only yarn from a single merge to produce a fabric. If a fabric is produced from mixed

merges (when, for example, there is not enough yarn in stock from a single merge to complete an order), it should be labeled as such and used for white fabric only or perhaps a very "busy" print. If a mixed-merge fabric is dyed, the different morphologies of the fibers in the yarns cause minor differences in dye uptake to occur between the different merges, and bars or stripes appear in what should be an evenly colored material.

SUMMARY POINTS

- Fibers are classified several ways
 - · Natural or manufactured
 - · Manufactured fibers are classified by generic fiber names
- Textile Fiber Products Identification Act in the United States
 - · Defines generic fiber names
 - Regulates labeling of textile products by fiber content
- Fibers are composed of polymer molecules
 - Polymers are large molecules made of repeating units called monomers
 - Fiber properties depend on the polymer chemical structure, the length of the polymer molecule, and the arrangement of polymer within the fiber
- Fiber manufacturing
 - Polymers are melted or dissolved and pumped through the holes in a spinneret
 - Cooling of the melted polymer, evaporation of the solvent, or precipitation from the solvent forms the fiber
 - · Processing conditions and modifications can be used to change fiber properties

Questions

- 1. How are the different fibers classified?
- What is the difference between a generic fiber and a fiber trademark? Which must be included on labels under the TFPIA and why?
- To what kinds of products is the TFPIA applicable? Summarize its requirements. 3.
- What is a polymer? What is the degree of polymerization in a polymer? What are crosslinks?
- What are the steps that are common to all fiber manufacturing processes? What is the purpose of each step?
- What are the differences among melt spinning, dry spinning, wet spinning, gel spinning, and emulsion spinning?
- If fibers are described as delustered, partially oriented, heat-set, at which stage of manufacture is each of the three italicized characteristics given to the fibers?
- What is fiber morphology, and how is it affected by fiber processing conditions?
- Define the types of bicomponent fibers.
- 10. How are microfibers made?

References

- Demir, A., and H. M. Behery. *Synthetic Filament Yarn Texturing Technology*. Upper Saddle River, NJ: Prentice Hall, 1997.
- Jaffe, M., and R. S. Jones. "High-Performance Aramid Fibers." In *High Technology Fibers*, edited by M. Lewin and J. Prestion, 349. New York: Marcel Dekker, 1985.

Warner, S. B. Fiber Science. Englewood Cliffs, NJ: Prentice Hall, 1995.

Recommended Readings

- Hongu, T., and G. O. Phillips. *New Fibres*. Manchester, UK: Woodhead/The Textile Institute, 1998.
- Moncrieff, R. W. Man-made Fibres. New York: Wiley, 1975.
- Seymour, R. B., and R. S. Porter, eds. *Manmade Fibers: Their Origin and Development*. London: Elsevier, 1993.

FIBER PROPERTIES

Learning Objectives

- 1. Define the terms used to describe fiber properties.
- 2. Distinguish textile fibers by their differing fiber properties.
- 3. Relate fiber properties to product end use.

he many different textile fibers may not look much different to the naked eye, but they do behave differently. They have different *properties*. The term *properties* refers to the various qualities and characteristics of textile fibers. Fiber properties let designers choose among them for targeted end uses. Consumers understand what to expect from items made of different fibers: how they will wear, how comfortable they will be, and what care procedures to use. Some fibers are stronger, some are more absorbent, some will rot when buried, and some will wrinkle.

Comparison of fiber qualities and characteristics requires the use of certain basic terms and a technical vocabulary. Definition of these terms and of their meanings as they relate to textile performance and/or behavior is important for communication and understanding. Some qualities of textile fibers are closely related to their physical characteristics, while others may be more dependent on their chemical structures. Both physical and chemical properties play an important role in how textiles can be expected to behave.

Some properties are inherent in the chemistry of the fiber and cannot be changed. An example of this is the moisture uptake of the fiber. Others, such as fiber diameter, may vary (for natural fibers) or be varied (for manufactured fibers).

Many specific textile properties are defined and discussed in the following pages. These properties are determined through one or more testing methods. Test methods are standardized by organizations such as the American Society for Testing and Materials (ASTM) and the American Association of Textile Chemists and Colorists (AATCC), or by the federal government.

A precise technical vocabulary is used in describing textile properties and reporting the results of textile testing. In the past, different countries used different terminologies, and it has been difficult to compare from country to country. As textile production and trade have become global, the industry has attempted to develop worldwide, standard terminology. Part of this effort involves adopting the metric measurements of the International System of Units (SI). Its details are controlled by the International Bureau of Weights and Measures. The textile industry tends to be traditional, and not all segments may use the SI system consistently. In measuring fabric properties, units of yards, pounds, and ounces are still widespread in the United States. Researchers, however, and those writing technical literature do prefer the SI system.

Because most single fibers are so small that they cannot be examined adequately with the naked eye, the physical appearance of these fibers is best observed under a microscope. With a microscope, it is possible to observe such properties as diameter, shape, and color. The physical characteristics of each individual fiber affect the appearance and behavior of the yarns and fabrics into which the fibers are manufactured.

Color

The colors of natural fibers vary. Some, like linen, have just enough pigment to make them yellow or off-white; others, like wool, may range from white to black. If their color interferes with dyeing or printing, the color may be removed by bleaching. Manufactured fibers are usually white. Notable exceptions are paraaramid fibers, which are yellow; PBI fibers (brown); and carbon fibers (black). These colors are inherent in the fiber chemical structure and cannot be removed with bleach.

Shape and Contour

The shape of a fiber can be examined both in *cross section* and in its *longitudinal* form. Cross sections vary from fiber to fiber, ranging from circular to oval, triangular, dog-bone-shaped, U-shaped, trilobal to multilobal, and hollow. (See Figure 3.1.) Cotton fibers have a peanut-shaped cross section, while silk fibers have a somewhat irregular triangular shape. Fibers with three- and five-lobed shapes have been manufactured. Three-lobed fibers are known as *trilobal* fibers; those with five lobes are known as *pentalobal*. The term *multilobal* is used to refer to all fibers with a number of lobes in the cross section.

Some fibers have smooth, even contours when examined longitudinally; others are rough and uneven. Wool, for example, is covered with many small scales. Cotton is twisted. Horizontal lines or other markings may appear in the length of some manufactured fibers as a result of irregularities in the cross-sectional shape of the fiber. The valleys between the lobes of multilobal fibers cause shadows that (under the microscope) appear as dark lines and are known

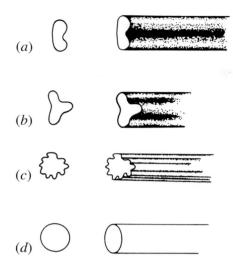

as *striations*. (See Figure 3.2.) Differences in shape and contour contribute to differences in fiber characteristics such as luster, covering power, appearance, hand (or feel), and surface texture.

Luster

Luster is the amount of light reflected by the fiber. Luster may be desirable in some products and undesirable in others. Fashion trends may increase or decrease consumer acceptance of bright or dull fabrics. Some irregularities appear in natural fibers, and although the range of differences is slight enough that fabric appearance is not much affected, these slight irregularities produce a more subtle luster than that of most manufactured fibers.

Manufactured fibers, on the other hand, tend to be bright, and as discussed in chapter 2, may have a white delustering pigment, titanium dioxide, added during manufacture to produce *semidull* or *dull* fibers. The particles of titanium dioxide show up as dark specks within the fiber as seen under the microscope. (See Figure 6.9.)

Cross-sectional shapes can also affect the luster of fibers. A shape that reflects light evenly will give a lustrous fiber. Completely flat cross sections have a high

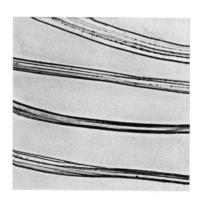

FIGURE 3.1

Typical variations in manufactured fiber cross-sectional shape together with the resulting longitudinal appearance: (a) dog bone; (b) trilobal; (c) serrated; (d) round. Notice how the shape of the cross section forms visual lines and/or shadows in the appearance of the longitudinal view.

FIGURE 3.2

Longitudinal view of rayon showing striations. Courtesy of the DuPont Company.

FIGURE 3.3
Diagrams showing differences in reflection of light in round, trilobal.

and pentalobal fibers.

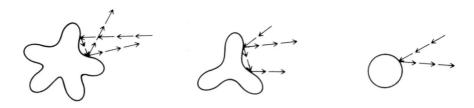

luster, and some manufacturers have produced flat fibers with a glittering luster. Those with less regular surface, such as cotton, which has a twisted and irregular cross section, do not have high luster. Trilobal fibers, whether silk or manufactured, have an increased luster. The luster results from the reflection of light not only from the surface of the fiber, but also from the light being reflected from one lobe to another. (See Figure 3.3.) Pentalobal fibers also have this tendency to reflect light from one lobe to another, but because there are more lobes among which the light can be reflected, the fibers have a soft, subdued sheen. When the lobes of the fiber are increased still further, light rays are broken up and the luster decreases. Eight-lobed, or *octolobal*, fibers have been made to decrease luster or glitter.

Covering Power

Fabrics are often used to conceal what is placed beneath them. The ability of a fabric to obscure an object is known as its *covering power*. The covering power of fibers and fabrics has two aspects: the visual and the geometric. Visual covering power is related to the ability of the fiber to hide what is placed beneath it. The more transparent the fiber, the lower its covering power. The second aspect, that of geometric covering power, might be described as the quantity of fiber required to make a fabric that will cover a specific area. The better the geometric covering power, the less expensive it will be to manufacture a yarn or fabric because a smaller quantity of fiber will be required.

The covering power of round fibers is poor because the surface area of fibers is less than that of any other shape. Also being both round and smooth, the fibers will pack closely together into a yarn. Dog-bone-shaped and flat-cross-section fibers have excellent covering power.

Smooth, round filaments with little variation in surface contour show soiling more readily than do striated or multilobal fibers. Morris (1989) has compared smooth, round fibers to smooth surfaces such as a polished mirror or silver plate on which finger marks and smears are very visible. When the smoothness of these surfaces has been altered by frosting or a matte finish, these smudges are less obvious. In the same way, altering the surface of the fiber helps to decrease obvious soiling. The ability to hide soil is especially important in some products, such as carpets, for which a variety of special multilobal fibers have been developed.

Crimp

Some fibers possess a wavy, undulating physical structure. This characteristic is called *crimp* and can affect both the warmth and resiliency of fabrics. Wool has a

FIGURE 3.4

Three-dimensional crimp in wool fiber.

natural three-dimensional crimp. (See Figure 3.4.) A number of texturing processes can be used to add crimp to manufactured fibers or yarns. Fabrics made from crimped fibers and/or yarns tend to be more resilient and have increased bulk, cohesiveness, and warmth. *Cohesiveness* is the ability of fibers to cling together and is important in making yarns.

Length

Fibers are, by definition, long and narrow. Their length may be hundreds or thousands of times their diameter. The relationship of length to width is typically referred to as the *aspect ratio*. The length of a fiber is one basis for division or classification. Fibers of relatively short length, measured in centimeters or inches, are called *staple* fibers. Within this category, historic differences between cotton (around one-inch-long staple fibers) and wool (two-or-more-inch-long staple fibers) has led to their being referred to as *short staple* and *long staple*, respectively. Indefinitely long fibers, those measured in yards or meters, are known as *filaments*.

All natural fibers except silk are staple fibers. Manufactured fibers are usually extruded in filament form, but the filaments can be cut into shorter, staple lengths. Therefore, silk and manufactured fibers may be found in either staple or filament form.

The length of the fiber will have an effect on the appearance of the yarn into which it is made. Filaments can be made into yarns with little or no twisting. These will look smooth and lustrous. Staple fibers, being short, must be twisted together to make them into a long, continuous yarn. Shorter fibers will produce more fiber ends on the surface of a yarn, thus creating a duller appearance. Staple fibers that are crimped, twisted, or rough have better cohesiveness for forming into yarns.

The *hand*, or feel, of the fabric is affected by the use of either filament or staple fibers. If a smooth filament form is selected, there are fewer fiber ends on the surface of a fabric, creating a smooth, even surface. If staple fibers are used, the short fiber ends on the surface of a fabric can create a fabric that feels soft and fluffy to the touch. Filament fibers can be crimped or coiled in a *texturing* process to make them less smooth. (See chapter 14.) Judicious selection of short staple, longer staple, or textured or untextured filament yarns enables the manufacturer to vary the appearance, the texture, and other properties of fabrics.

Density and Specific Gravity

Density and specific gravity are terms that are used in relation to the weight of fibers. The terms are similar, but each has a somewhat different technical definition.

Density is the ratio of a mass of a substance to a unit of volume. In the case of a fiber, density is expressed as grams per cubic centimeter. Specific gravity is defined as the density of the fiber in relation to the density of an equal volume of water at a temperature of 4°C. The specific gravity of water is (by definition) 1, and because it has a density of 1 g/cc, specific gravity and density are *numerically* the same. Because specific gravity is a relative value, it is simply a number and has no units.

If a fiber has a specific gravity of more than 1, it is heavier than water; if it has a specific gravity that is less than 1, it is lighter than water. Among the common textile fibers, only olefin has a specific gravity that is less than that of water (sometimes a useful identifying property), and the specific gravity of most fibers ranges from 1.0 to 1.6, with inorganic fibers such as glass or steel being higher.

Density has significance for the consumer in a number of ways. Olefins, with a specific gravity less than water, will float on top of water during laundering. The low density of olefin fibers makes possible the manufacture of fibers from smaller weights of raw materials. This results in lower costs for the fiber. Cotton has a moderate specific gravity, and glass fiber has a high specific gravity. Therefore, if a cotton fabric and a glass fabric are made of yarns of comparable size and of similar weave, the glass fabric will be much heavier than the cotton.

Diameter or Fineness

The diameter of a fiber is the distance across its cross section. In natural fibers the diameter usually varies from one part of the fiber to another because of irregularities in fiber size. Unless specifically made to have an uneven diameter, manufactured fibers usually have a uniform diameter throughout. Manufactured fibers can have any diameter that the manufacturer chooses, and the selection of diameter is generally related to the projected end use of the fiber. Clothing fibers are made in relatively small diameters, whereas heavy-duty fibers for household items or industrial uses are made with larger diameters. Among the recent technological advances in the production of manufactured fibers has been the development of extremely fine fibers called *microfibers*, discussed earlier. This term is generally applied to fibers that are less than one denier. The term *ultrafine fibers* is used for fibers that are 0.1 denier or less. (For purposes of comparison, consider that regular apparel fibers are generally two to four denier.) (See Figure 3.5.)

Fineness of fibers is related to softness, pliability, and hand, characteristics that consumers often take into account when choosing products. Thinner fibers bend more easily, and fabrics made from fine fibers are softer and drape more easily. Before manufactured fibers were developed, the most valuable natural fibers were those that were finer, and we still regard silk and cashmere as luxury fibers, largely because of their fineness. Microfibers are being promoted for use in lightweight, soft fabrics. They can be fabricated into cloth with extremely fine pores and a dense surface. In addition to their use in apparel fabrics with attractive hand and draping qualities, microfibers are used in specialized applications such as surgical masks, filtration materials, ski jacket insulation, and high-tech wiping materials.

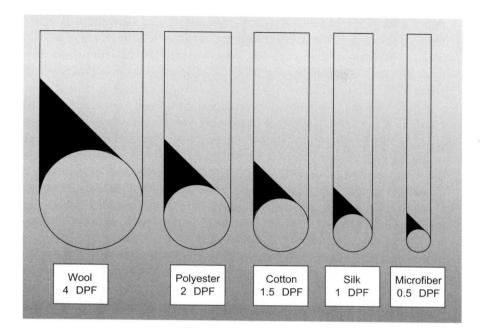

FIGURE 3.5
Relative fiber diameters.
Reprinted with permission of the American Association of Textile
Chemists and Colorists

Fineness is, thus, of major importance, and four different ways of describing or comparing it have been used. These are summarized in Table 3.1.

- 1. Fiber diameter can be measured directly in millimeters or in *microns*. One micron (called a micrometer in the SI system, with the symbol of μ m) is 1/1000 of a millimeter or 0.000039 of an inch. As an example, cotton fibers are usually from twelve to twenty microns in diameter. Wool today is often described in terms of its diameter, and "20-micron wool" might be referred to or used on a hang-tag.
- 2. Fiber fineness can also be expressed as *linear density*, or weight per unit length. Instead of measuring the distance across the fiber, a calculation is made of the weight of a specified length of fiber. The less it weighs, the finer is the fiber. Measurements used in the textile industry can be reported

Table 3.1
Systems for Describing Fiber Fineness

Principle	Name	Units/example	Use
Direct measure of fiber diameter	Microns	Millionths of a meter (10° meter, µ)	For any fiber, but most often quoted for wool
Weight in grams of a length of fiber	Denier Tex Decitex	(g/9km) (g/km) (g/10km)	For silk and manufactured fibers. Denier in U.S.; Tex and decitex in Europe
Finest spinnable yarn	Count	Numbers (e.g., "56s")	Older but still widely used for wool
Resistance to airflow in standard instrument	Micronaire reading	Numbers (e.g., 6.5)	Most widely used for cotton

either in *denier*, which is the weight in grams of nine kilometers of fiber or yarn, or in *tex*. Tex, the SI measurement, is the weight in grams of one kilometer of fiber or yarn. (To convert from denier to tex measurements, divide denier by nine or multiply it by 0.11.) To deal with numbers that are more convenient, decitex (dtex) is also used: the weight of ten kilometers. Fibers with lower denier or tex numbers are finer; those with higher denier or tex numbers are coarser. A word of caution, however: the weight of the given length will vary not only with the diameter of the fiber, but also the density of the material from which it is made. A fine, high-density fiber may have the same denier as a coarser, low-density fiber. Denier should, therefore, be directly compared only between fibers of the same generic type.

- 3. Finer fibers can make finer yarns, and in the wool world, this relationship has been used to describe the fineness of a sample of fiber. An assessment is made of the finest yarn spinnable from a sample of fiber, and the *count* of that yarn is quoted as a measure of the fiber fineness. Hence, a sample of wool may be described as "64s" or "56s." (See chapter 13 for a discussion of yarn counts.) A higher count number means finer fibers.
- 4. When cotton is harvested, among the measurements of quality that determine its price is a *micronaire* reading. A weighed sample of fiber is placed in a tube, and the resistance of the fiber to a flow of air is measured. If the sample has finer fibers, the resistance will be greater. A high micronaire reading thus indicates finer fibers.

MECHANICAL PROPERTIES

The *mechanical properties* of textiles are those that describe the textile material's behavior under the application of some type of force. The applied force may cause the textile to stretch, compress, bend, or twist.

Strength

The most important of these behaviors for fibers is their resistance to stretching, that is, to pulling forces applied parallel to the fiber axis. The stretching, or tensile, force required to break a material is called *tensile strength* and for most materials is usually measured in force per unit area (e.g., pounds per square inch). Fiber strength is more often compared in terms of *tenacity*. Tenacity of fibers is strength relative to linear density and is measured in *centiNewtons per tex* (cN/tex) or *grams per denier* (g/d).

To understand the importance of relative strength, consider spiderwebs, nature's microfibers. It is said that spider silk is among the strongest of fibers (Warner 1996). Yet we all know how easily these fine filaments can be broken, much more easily than breaking a human hair, which is bigger. If breaking strength is related to size, however, the spider silk is much stronger than human hair, and thus, the different fibers can be more appropriately compared.

The strength of some fibers is affected by moisture, and occasionally "wet tenacity" may be measured. Cotton, for example, is stronger when wet than when dry, whereas rayon and wool are weaker wet than dry. For the consumer this means that handling some fabrics during laundering may require greater care. For the manufacturer, it means that processing of fibers during dyeing or finishing must be modified.

Because linear density is used in the calculation of tenacity, fiber density affects these tenacity values. When a nylon and a polyester fiber of the same diameter break under identical tensile forces, the nylon fiber will actually have a higher tenacity. This is because it has a lower density and, therefore, a smaller denier, which is the denominator in the calculated tenacity.

Modulus

An important property related to tensile strength is fiber modulus. This refers to the fiber's initial resistance to the tensile force, before it breaks, and is a measure of fiber stiffness. If this initial resistance is low, the material will stretch or bend considerably with very little force applied. Examples of materials with low modulus are rubber bands and spandex fibers. High-modulus materials exhibit much lower stretch under tensile force. A steel wire has a high modulus, as do para-aramid and flax fibers.

Flexibility

Flexibility of fibers is their ability to be easily bent or folded and is a combination of fiber fineness and fiber modulus. The most flexible fibers will be fine fibers of low modulus, and vice versa. The effect of fineness in making a flexible fiber is clearly seen in glass fibers. A sheet of glass cannot be bent far without breaking, but a glass fiber can be looped and twisted considerably. However, it is still much stiffer than a polyester fiber of the same size, and a glass fiber fabric will tend to split if it is folded repeatedly.

Flexibility/stiffness also affects comfort. A fiber that bends easily (because it is fine and/or has a low modulus) will deform to the touch of human skin and feel soft. The high value of silk and cashmere derives from their fineness and, thus, softness. A stiffer fiber will remain straight and produce a prickly sensation. The presence of a few coarse fibers in a wool fabric is enough to give wool its prickly reputation and leads to allergy allegations, even though much of today's wool is free of these and feels soft to the touch. Despite rumors to the contrary, it is *not* the scales on wool fibers that make it scratchy!

Elongation

Elongation is the amount of stretching or lengthening of a fiber under a tensile force. It is expressed as a percentage of the original length. Measurement of elongation is commonly made as "elongation to break," the amount of stretch the fiber can withstand before it will break, and varies from 2 percent (for glass or para-aramid fibers) to 40 percent or more. Spandex has an elongation of 600 to 700 percent. A fiber that will stretch or elongate more before breaking will show greater "toughness" than a stiffer fiber that breaks at the same load but at lower elongation.

A low tenacity in a fiber might be thought a serious weakness. However, if it has a high elongation at the same time, in practice, it will not likely be stretched far enough to break it. Wool and rayon are among the weaker fibers, and both have a relatively high elongation.

As with tenacity, moisture can affect elongation. Most fibers that absorb moisture have greater elongations when wet.

Among manufactured fibers, which are drawn as part of the manufacturing process, different versions can be produced. If they are drawn more, a high-tenacity, low-elongation fiber suitable for industrial applications will be produced. If they are drawn less, a regular-tenacity fiber with higher elongation will result.

Elastic Recovery

If a fiber is elongated less than is needed to break it and is then released, it will tend to recover some of the applied stretch. Recovery that occurs instantaneously after a stress is removed, as with a rubber band, is *elastic recovery*. A slow return to original length is called *creep recovery*. Elastic recovery can be quantified. A measured fiber is elongated or stretched to a specific percentage. The stress is then removed, and the fiber is allowed to recover for a short period of time. After recovery, the fiber is remeasured, and the percentage of recovery is calculated. A fiber with 100 percent recovery has returned to its original length. A fiber with 80 percent recovery is 20 percent longer after stretching. The answer is quoted, for example as "95 percent recovery from 5 percent stretch." It is not easy to compare fibers unless the amount of original stretch is the same.

Two fibers may have similar elongation properties: they will stretch to the same extent when the same force is applied. However, one may recover much better, and that will be a better fiber for making a product that has some "give" but will not stretch out of shape. Among the common fibers, nylon has the best recovery properties, reflected in its dominance of the hosiery market. Nylon makes the best "nylons" (pantyhose) while early stockings made of rayon readily bagged at the knee.

Resiliency

While elastic recovery deals with how a fiber responds to pulling, *resiliency* refers to the ability of a fiber to spring back to its natural position after a distorting force such as bending, twisting, or compressing. Although resiliency and elasticity are not the same, high elastic recovery is usually associated with good resilience. Wool is an exception because much of its resiliency is due to the natural crimp in the fibers. Resilient fibers are likely to recover from creasing or wrinkling more quickly. Once again, nylon is an excellent fiber, and the use of wool and nylon in the best carpets is related to the resilience of those two fibers.

The term *loft* is related to resiliency. Sometimes known as *compressional resiliency*, loft is the ability of fiber assemblies to return to their original thickness after being flattened or compressed. A fabric with loft is one that is springy and resists flattening, an especially important property for carpet fibers.

CHEMICAL PROPERTIES

Absorbency

The ability of a fiber to absorb water affects many aspects of its use. A bone-dry fiber placed in a humid atmosphere will absorb moisture, a property called its *moisture regain*. Textile technologists will take a sample of fibers or fabric, dry it thoroughly, and return the sample to an atmosphere in which a temperature of 70°F

FIGURE 3.6

Superabsorbent fibers; (a) placed in water; (b) water absorbed after five minutes, forming a gel (c).

and a humidity of 65 percent are accurately maintained. The amount of moisture taken up by the sample is then measured to determine the percentage *standard regain*. This value is calculated using this formula:

regain = (moist weight - dry weight)
$$\times$$
 100/dry weight

Saturation regain, measured at 95 to 100 percent relative humidity, is also reported occasionally.

A fiber that has a high regain is *hydrophilic*, meaning "water loving." Conversely, fibers that do not absorb moisture readily are *hydrophobic*, or "water hating." Hydrophilic fibers accept waterborne dyes and special finishes readily and shed oily dirt in laundering. However, they dry slowly and may be stained by waterborne soils. Fabrics made from them tend to shrink more readily.

Moisture regain also affects comfort, although comfort is a complex property. Cotton, a hydrophilic fiber, is comfortable to wear in warm weather. The fiber absorbs moisture vapor or liquid water from the skin of the wearer, who feels dryer. Polyester, with low regain, is less comfortable in those conditions as the perspiration is not absorbed and the wearer feels clammy.

Superabsorbent fibers are used in some applications such as disposable diapers and incontinence products. These fibers quickly absorb a large amount of liquid and form a gel, holding the liquid until the product is disposed of. (See Figure 3.6.)

The discussion of moisture and comfort also includes the concept of wicking. Some fibers *adsorb* moisture rather than absorb it. (See Figure 3.7.) Adsorbed

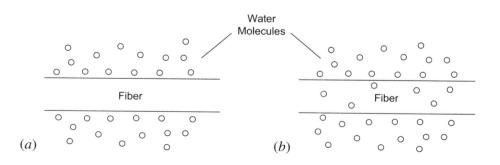

FIGURE 3.7

(a) Adsorption of water molecules on fiber surface; (b) Absorption of water molecules into fiber.

water is held on the surface of the fiber rather than being taken into the fiber itself, and wicking takes place when that liquid moisture travels along the surface of the fiber. Most synthetics have low absorbency, but some have excellent wicking properties, often related to their shape, that make them comfortable to wear because perspiration can travel to the surface of the fabric, where it can evaporate or be held in an absorbent fiber away from the skin. Thus, runners will often wear a polyester top and shorts to encourage such wicking and evaporation, rather than wear a cotton T-shirt that would quickly become dripping wet. In winter sports such as skiing, highly absorbent underwear would become cold and wet (and possibly dangerous) when the exercise ceases, so polyester or olefin with low absorbency and good wicking ability are used.

Another factor to consider is that when water is absorbed, heat is given off. For fibers with low regain, this heat, called the *heat of sorption*, is negligible. Wool fibers, though, which are extremely absorbent, can liberate much more heat when going from a dry to a wet atmosphere, providing additional warmth.

Electrical Conductivity

Electrical conductivity is the ability of a fiber to carry or transfer electrical charges. Fabrics with low or poor conductivity build up electrical charges with the result that these fabrics cling or produce electric shocks. The mechanical action of automatic dryers also serves to build up static electricity on fabrics of low conductivity, thereby producing static cling. Many synthetic fibers have low conductivity, and when several layers of clothing of low electrical conductivity are worn, the problem of charge buildup is aggravated.

Poor conductivity is related to low moisture regain. Water is an excellent conductor of electricity, and the water regained by hydrophilic fibers will allow static charges to disperse. If the atmosphere is very dry (indoors in winter, for example) even fibers with fairly good moisture absorbency display static buildup. Treatments to decrease static accumulation involve finishes that enable fibers to hold moisture on the surface or to absorb more moisture. Some manufactured fibers are modified in chemical structure during manufacture to increase electrical conductivity. In very specialized cases (electronic manufacture, for example), highly conductive fabrics are produced by including metal fibers.

Effect of Heat

Textile products may be subjected to heat not only during manufacture and processing, but also in use. In home care, for example, fabrics may be pressed or dried in a hot dryer. Some specific uses involve heat (e.g., an ironing board cover or a filter for a hot gas). The specific behavior exhibited by each fiber will, of course, determine the way in which the fiber must be handled during manufacture and use. The way in which various fibers respond to the application of heat depends on their chemical composition, and they tend to fall into two categories.

Many synthetic fibers are thermoplastic and soften or melt at elevated temperatures. If they are used at too high a temperature, they can fail as soon as that temperature is reached. A manufacturer might thus indicate that a fiber "retains 50% of its

strength at 180°C." In fabrics made from thermoplastic fibers, heat may be used to permanently set pleats or shape into the fabric, fuse seams, and make buttonholes.

Nonthermoplastic fibers, especially cellulosic and protein fibers, scorch or turn brown and ultimately weaken if subjected to excessive heat. This may happen quickly at high temperature or more slowly at lower temperatures. A manufacturer might thus indicate that a fiber "retains 50% of its strength after 80 hours at 180°C."

Flammability

Some fibers ignite and burn, some smolder, and others are noncombustible. Fibers that ignite but then do not continue to burn, whether or not the ignition source is removed, are designated as *flame resistant*. Fibers that do not shrink or burn readily when heat is applied are said to have high *thermal stability*.

One means of comparing the relative flammability of fibers is a Limiting Oxygen Index (LOI). Air contains 21 percent oxygen. Something that burns in air will not burn if the amount of oxygen is reduced sufficiently. Likewise, something that does not burn in air may burn if the amount of oxygen is increased. The LOI is the percentage of oxygen that just allows burning to take place. Cotton and olefin burn readily and have LOIs of 18 and 19, respectively. Polyester and nylon have LOI values of 21. Wool is self-extinguishing and has an LOI of 25. Aramids are inherently flame retardant and have LOI values of 28 to 30.

The flammability of textile fibers may affect their selection for use in particular products. Some fibers are inherently noncombustible, whereas others exhibit flame-retardant or flame-resistant properties. Manufactured fibers can include flame retardants as they are spun, and flame-retardant finishes are applied to fabrics.

It is not simple to relate fiber burning characteristics as measured by LOI with those of the fabric into which they are made. The tests used on the fabrics may limit the time of ignition or may vary the angle at which the material is held. A thick fabric, for example, may not ignite easily, even though it is made from fibers that burn rapidly. Thus, flammability (meaning the property that will make an item acceptable or not) is specific to the fabric being tested and cannot be judged from the LOI of the fiber used.

Children's sleepwear and certain household products, such as carpets and mattresses, must, by law, be tested to determine whether they pass established test standards relating to flammability. (See chapter 25.)

Burning of small quantities of textile fibers may be used as a means of differentiating one fiber group from another. Although precise identification of individual fibers by burning is not usually possible, burning behavior can readily establish the general fiber group to which the fiber belongs. Cellulosic fibers, for example, exhibit flammability characteristics much like those of paper, protein fibers burn in a manner similar to hair, and some synthetics melt when they burn. The odor produced when a fiber burns and the kind of ash that remains after burning aid in the identification of the fiber.

Chemical Reactivity and Resistance

Many of the substances used in the manufacture of fibers, in their finishing, and in the care of fabrics in the home are common household chemicals. Therefore, the behavior of textiles when they are exposed to these chemical substances is important to the consumer as well as to the textile technologist. Acids, bases, oxidizing agents, and solvents are the broad categories of chemicals that are of concern. In each case the specific chemical, its concentration, the temperature, and time of exposure (How hot? How strong? How long?) will all change the degree to which the fiber is affected.

Acids and bases can break polymer molecules of some fibers into shorter chains, a reaction called *hydrolysis*. In these cases the result is a loss of tensile strength. If the reaction goes on for a sufficiently long time, susceptible fibers will actually be dissolved. Solvents tend to dissolve the polymer without breaking the chains, but the fiber (or the fabric) will be ruined.

Effect of Acids

Cellulosic fibers are damaged by strong mineral acids and are harmed even by diluted concentrations of these substances. Acid hydrolysis, in a highly controlled process, is used to make permanently stiffened sheer cotton fabrics ("parchmentizing"). The acid is applied so it breaks down the outermost layer of fabric. The outer layer softens, the reaction is stopped, and the fabric is given a hard press that forms the outer fabric layer into a smooth, clear, permanently stiffened finish.

Because acids break down cellulose but do not readily harm protein fibers, especially wool, acid treatments can be used to clean vegetable matter from wool before spinning or after fabrication into cloth. The acid destroys ("carbonizes") the sticks and burrs caught in the wool, but wool is left unharmed. (See the discussion of carbonization of wool in chapter 21.) Such processes are carried out under rigidly controlled conditions to avoid any harm to the fibers.

Effect of Bases

Sodium hydroxide is a chemical *base* or *alkali* that is used in several textile finishing processes. Bases, even strong bases at high temperatures, do not appreciably harm natural cellulosic fibers. Strongly alkaline solutions are used to scour and bleach cotton. In even higher concentrations, alkalis cause radical physical changes that improve the strength and appearance of natural cellulosic fibers in a process called "mercerization." (See chapter 21.)

Sensitivity to bases is important in the care of protein fibers (silk, wool, and animal hair fibers) in which the bonds between the subunits are broken by the alkali. Many strong soaps and detergents have alkaline material added to increase their cleaning power. These soaps and detergents should be avoided for use with fibers that are sensitive to the action of bases. Washing wool free of the grease with which it is contaminated on the sheep requires careful control of the low amounts of alkali used. Some synthetic fibers are also affected by bases: polyester can be made finer and more hydrophilic by a treatment with hot alkaline solutions.

Oxidation

Many fibers are not white enough in their natural state or after manufacture to allow pale pastel shades to be dyed. Colors and/or stains accumulated during spinning and weaving or in use by the consumer are removed by the action of bleaches

that *oxidize* the stains or colors into a colorless substance. However, the oxidizing agent may also react with the fiber itself. If the fiber is sensitive to the action of the oxidizing agent, the fiber may be damaged.

Chlorine bleach (sodium hypochlorite) is an oxidizing agent, largely confined to home use, that may damage protein fibers and spandex. It will also destroy some dyes, especially indigo and the sulfur dyes used to dye dull colors on cellulose. Care labels indicate when and how chlorine bleach can safely be used.

Industrial bleaching, widely carried out on cotton, is usually achieved with hydrogen peroxide. Care is required to avoid damage to the cellulose. Nonchlorine bleaches used by the consumer are usually based on substances such as sodium perborate and are generally "color safe." Both the consumer and the manufacturer benefit from understanding the action of oxidizing agents on different fibers.

Effect of Chemical Solvents

Most textile processing and cleaning is carried out in water, and the action of water on textile materials is widely understood. The acids, bases, and oxidizing agents discussed above are dissolved in water when they are applied to textiles. Dyeing and finishing of textiles, as well as laundering, involve water. However, in processing and use, textiles may meet other liquid substances, chemical solvents, that can affect them. Indeed, in chapter 2 we discussed the use of solvents to dissolve polymers to allow fiber spinning.

The use of solvents in textile processing has been explored extensively, mostly as a way to reduce the cost of energy (because most solvents evaporate much more easily than water). Solvents readily remove knitting oils, for example. However, the cost of the solvents and their environmental effects (see chapter 27) has rendered their use impractical.

In dry cleaning, a nonwater solvent is used to remove dirt and stains. The most common solvent used is still perchloroethylene, although alternatives are sought because the health effects of "perc" are of concern. Some fibers and fabrics are negatively affected by perc, and care labels will indicate if it is safe to use.

Fabrics may be designed for use in industrial situations where solvents are used, and the fiber used would be carefully chosen. A textile may also come into incidental contact with solvents used by the consumer. Rubbing alcohol, lighter fluid (used as a spot remover in the past), gasoline, and paint stripper are examples. In most cases these will not affect the fiber, but nail polish remover such as acetone will dissolve acetate fibers.

RESPONSE TO ENVIRONMENTAL EXPOSURE

A number of general environmental conditions may have an adverse effect on textile fibers. These include exposure to sunlight (plus oxygen) and air pollution. Certain dyes used on acetate fibers may be discolored by air pollution, and some fibers lose strength or degrade as they age outdoors. Manufactured fibers may contain additives to slow this: olefin degrades in sunlight but, with stabilizers, can be used to make outdoor carpet and artificial turf. Acrylic and modacrylic fibers are notably stable and are used in high-quality awnings and sunshades.

Some fibers support the growth of microorganisms (such as molds or mildew) that will deteriorate the fibers. Others may permit such bacterial growth without damage to the fabric. Still other fibers do not support bacterial growth at all. Fiber characteristics in this respect will affect the choice of fibers for certain uses. Sandbags must resist rotting. Boat sails may develop mildew when they become wet and are stored. Synthetics, which resist mildew, have largely replaced cotton and linen in making sails for boats. Mildew will develop on most fabrics if they are stored in warm, dark, damp areas.

Carpet beetles, clothes moths, and silverfish are the most common insect pests that attack textile fibers. Special finishes may be given to vulnerable fabrics to make them resistant to insects. Proper care and storage of susceptible fabrics, notably wool, can prevent insect damage.

As concerns over adverse environmental effects have grown (see chapter 27), degradation of discarded textile items is seen as advantageous. Those made from natural fibers are usually biodegradable and recently several new manufactured fibers have been developed from natural sources such as corn. The susceptibility of textile products made from these fibers to degradation is a property that is increasingly measured and monitored.

OTHER PROPERTIES

Dimensional Stability

This is a property that is associated more with fabrics than with fibers, although the particular fiber will obviously affect the potential for a fabric to shrink. Shrinkage is discussed more fully in chapters 25 and 26. Fibers that absorb moisture readily will lead to fabrics that tend to shrink. This fabric shrinkage results from the stretching of fabrics during their construction and/or finishing. Fabrics that are distorted during processing tend to relax to their natural dimensions after the first few launderings. These fabrics require manufacturers to take special care to make sure that shrinkage is low. This does not always happen, and few consumers are surprised when a rayon garment shrinks.

On the other hand, many fibers (especially those that do not absorb moisture) are described as being inherently dimensionally stable, yet the fabrics into which they are made may still shrink. Manufactured fibers that are thermoplastic or heat sensitive may shrink when subjected to heat. Special treatment with heat called heat setting (discussed in chapter 21) can, however, be used to set the fiber and make it dimensionally stable. The manufactured fibers or fabrics that have been heat-set do not shrink unless the heat-setting temperature is exceeded.

Abrasion Resistance

One of the most important properties of textile products is an ability to withstand abrasion. Abrasion is the rubbing or friction of fiber against fiber or fiber against other materials. Fibers with poor abrasion resistance break and splinter, which produces worn or broken areas in fabrics. Abrasion of fabrics may take place when they are flat, folded, or curved, so fibers can be subjected to three types of abrasion: flat, flex, and edge abrasion. For example, flat abrasion may be seen on carpets as

the feet of passersby constantly rub against the surface; flex abrasion takes place at the back of the knee in trousers or with the folding and unfolding of linens as they are stored; and edge abrasion occurs at the permanently folded edges of collars, cuffs, and hems. Color change in dyed textiles as a result of abrasive wear is known as *frosting*.

Many factors influence abrasion, and prediction of durability is difficult. Morton and Hearle (1995), who note that abrasion depends largely on construction of yarn and fabric, state that no way has been found to eliminate the influences of these factors and calculate a basic fiber property. Nonetheless, for equivalent fabrics, some fibers have better abrasion resistance than others. Cotton is relatively poor: jeans are regarded as hard wearing, but largely because they are constructed of heavy materials. The abrasion is revealed by the classic faded denim look. Nylon has good abrasion resistance, and for that reason it is used in luggage and jacket shells.

An intrinsic fiber property that is related to abrasion resistance is *toughness*. Toughness takes into account both the tenacity and elongation to break of a material. Flax, for example, has high strength but low elongation. Consequently the abrasion resistance of a linen fabric would be lower than one made from polyester that has similar fiber tenacity and much higher elongation.

Pilling takes place when a fabric has been subjected to abrasion that causes fiber ends to break, migrate to the surface, and form into a small ball that clings to the surface of the fabric. (See Figure 3.8.) Pilling is a more serious problem in strong fibers as weaker fibers tend to break and fall off the surface of the fabric when pills are formed, whereas the stronger fibers do not break away, and the pills stay on the surface of the cloth.

Table 3.2 summarizes properties of the most commonly used fibers.

Figure 3.8
Photograph of badly pilled fabric.

Table 3.2
Selected Properties of Some Manufactured and Natural Fibers

	BREAKING TENACITY ^a (G/D)		Specific	Standard Moisture	
Fibers	Standard	Wet	Specific Gravity ^b	Regain (%)°	Effects of Heat
Acetate (filament and staple)	1.2–1.5	0.8-1.2	1.32	6.0	Sticks at 350°F (175°C)– 375°F (190°C) Softens at 400°F (205°C)– 445°F (230°C) Melts at 500°F (260°C) Burns relatively slowly
Acrylic (staple)	2.0–3.5	1.8-3.3	1.14–1.19	1.3–2.5	Sticks at 450°F (230°C)– 500°F (260°C), depending on type
Aramid Meta	5.3	4.1	1.38	4.5	Does not melt Decomposes above 700°F (370°C)
Para	26-28		1.44	4.5	Does not melt Decomposes above 660°F (350°C)
Flax	5.5-6.5	6.0-7.2	1.54	8.0-12.0	Burns, does not melt
Cotton	3.0-5.0	3.3-6.4	1.54	7.0-11.0	Burns, does not melt
Modacrylic	2.0–3.5	2.0-3.5	1.30–1.37	0.4–4.0	Will not support combustion Shrinks at 250°F (120°C) Stiffens at 300°F (150°C)
Nylon Nylon 66 (filament)	3.0-9.5	2.6-8.0	1.14	4.0-4.5	Sticks at 445°F (230°C) Melts at 500°F (260°C)
Nylon 66 (staple) Nylon 6 (filament)	3.5–7.2 6.0–9.5	3.2-6.5 5.0-8.0	1.14 1.14	4.0–4.5 4.5	Same as above Melts at 415°F (210°C)- 430°F (220°C)
Nylon 6 (staple)	2.5	2.0	1.14	4.5	Same as above
Olefin (polypropylene filament and staple)	4.8–7.0	4.8-7.0	0.91	0.01	Melts at 325°F (165°C)- 335°F (170°C)
Polyester (filament)	4.0-9.5	4.0-9.4	1.38	0.4	Melts at 480°F (250°C)- 550°F (290°C)
(staple)	2.5-6.5	2.5-6.4	1.38	0.4	Same as above
Rayon (filament and staple) Regular tenacity	0.73-2.6	0.7-1.8	1.50-1.53	13.0	Does not melt Decomposes at 350°F
High wet modulus	2.5-5.5	1.8-4.0	1.50-1.53	13.0	(175°C)-465°F (240°C) Burns readily Same as above

TABLE 3.2 CONTINUED
Selected Properties of Some Manufactured and Natural Fibers

		BREAKING TENACITY ^a (G/D)			
Fibers	Standard	Wet	Specific S Gravity ^b	Standard Moisture Regain (%) ^c	Effects of Heat
Silk	2.4-5.1	1.8-4.2	1.25 (degummed)	10.0–11.0	Burns slowly, sometimes self-extinguishing when flame is removed
Spandex (filament)	0.6–0.9	0.6-0.9	1.20–1.21	0.75-1.3	Degrades slowly at 300°F (150°C) Melts at 445°F (230°C)– 520°F (270°C)
Wool	1.0–1.7	0.8-1.6	1.32	15.0–18.0	Burns slowly, sometimes self-extinguishing when flame is removed

Source: Manufactured fiber data from American Fiber Manufacturers' Association.

Note: Standard laboratory conditions for fiber tests were 70°F and 65 percent relative humidity. Data given in ranges may fluctuate according to fiber modifications or additions and deletions of fiber types.

Cost

Selection of fibers for particular end use products is based not only on the physical and chemical properties discussed above, but also with an eye to cost. The textile business is highly price competitive, and fiber choice can have a small but significant effect on the price of an item and, thus, its salability. Broadly, olefin is the cheapest fiber (think of plastic bags and disposable food containers); its wide use, though, is limited by its lack of dyeability and low melting point. Polyester and cotton are almost as cheap as olefin. The price of cotton is subject to the amount that is planted and the vagaries of the weather, while the synthetics are affected by the price of the petroleum products from which they are made, but over the past decade, the two have remained at similar price levels. As a result, cotton and polyester have come to dominate the textile market, together making up almost three quarters of the fibers used and are the first choice for a designer.

An ideal fiber might be substituted with one that is simply good enough but is significantly cheaper. Thus, polyester has replaced nylon in cheaper items of exercise wear and backpacks, for example, and more and more sweaters are made of cotton rather than wool or acrylic. These less common fibers (wool, silk, flax, spandex, and high-performance fibers such as aramids) are more expensive.

The trade journal *Women's Wear Daily* publishes the prices of the most commonly used fibers the last Tuesday of each month. More detailed information is available in the *Textile Organon*, an industrial publication.

^aBreaking tenacity: the stress at which a fiber breaks, expressed in grams per denier.

bSpecific gravity: the ratio of the weight of a given volume of fiber to an equal volume of water at 4°C.

^cStandard moisture regain: the moisture regain of a fiber (expressed as a percentage of the dry weight) at 70°F and 65 percent relative humidity.

SUMMARY POINTS

- Fiber properties and cost determine their use of different fibers in specific textile products
- · Physical properties are color, shape, length, density, and fineness
- Mechanical properties are tenacity, modulus, flexibility, elongation, elastic recovery, and resiliency
- Chemical properties are absorbency, electrical conductivity, response to heat, and reaction to chemicals
- The primary environmental properties are resistance to degradation by sunlight, pollutants, and microorganisms
- Other important properties are dimensional stability and abrasion resistance

Questions

- 1. List and define those properties that describe how a textile fiber looks either to the naked eye or under the microscope.
- 2. Differentiate between/among the following:
 - a. Fiber strength and fiber modulus
 - b. Elongation, elastic recovery, and resiliency
 - c. Electrical conductivity, the effect of heat, and flammability
- Describe some ways in which chemical reactions between textile fibers and chemical substances such as acids, bases, and oxidizing agents can be used in textile processing.
- 4. What fiber properties affect the dimensional stability of fabrics?
- 5. Using Table 3.2, compare the properties of cotton, rayon, and polyester and recommend the most appropriate fiber for a knitted top. Include current cost estimates for each fiber.

References

Morris, W. J. "Fiber Shape and Fabric Properties." Textiles 18, no. 1 (1989): 6.

Morton, W. E., and J. W. S. Hearle. *Physical Properties of Textile Fibers*. New York: Wiley, 1995.

Warner, S. B. "Structure and Properties of Natural and Synthetic Spider Silk." In *AATCC Book of Papers*, 454–460. Research Triangle Park, NC: American Association of Textile Chemists and Colorists, 1996.

Recommended Readings

Cook, J. G. *Handbook of Textile Fibers*. 2 vols. Watford, England: Merrow Textile Books, 1984.

Ford, J. E. "Textile Units for Fibers and Yarns." Textiles 14 (Spring 1985): 17.

Gohl, E. P. H., and D. Vilensky. *Textile Science: An Explanation of Fiber Properties*. London: Longman, 1981.

Warner, S. B. Fiber Science. Englewood Cliffs, NJ: Prentice Hall, 1995.

4

NATURAL CELLULOSIC FIBERS

Learning Objectives

- 1. Describe the chemical structure of cellulose and how it affects the properties of natural cellulosic fibers.
- 2. Describe the physical structure of the different natural cellulosic fibers and how this structure provides different properties.
- 3. Explain the processes used to extract the different fibers from plants.
- 4. Determine end uses appropriate for the different cellulosic fibers.

ellulosic fibers can be composed of natural cellulose, regenerated cellulose, or regenerated chemical variants of cellulose. Natural cellulosic fibers are derived from a wide variety of plant sources, which are classified as follows:

- 1. Seed hair fibers, or those fibers that grow in a seed pod on plants
- 2. Bast fibers, or those fibers that are removed from the stems of plants
- 3. Leaf fibers, or those fibers that are found on the leaves of plants
- 4. Miscellaneous fibers from mosses, roots, and the like

Manufactured cellulosic fibers (discussed in chapter 6) include rayon and lyocell, which are regenerated cellulosic fibers, and acetate and triacetate, which are modified cellulosic fibers.

The current focus on sustainability and renewable materials has stimulated interest in natural cellulosic fibers (Thiry 2004). Cotton has long been a commodity fiber worldwide, and its environmental advantages over synthetics are being advertised. Other natural cellulosic fibers, which had declined in use or not been fully explored for textile uses, are enjoying higher levels of consumer interest. An appreciation of the value and distinctiveness of these fibers will help

not only consumers, but also product developers and merchandisers as they attempt to appeal to ever-widening and more diverse markets.

THE CELLULOSE FAMILY

Table 4.1 lists fibers of the cellulose family. Included in this list are not only those fibers that have extensive commercial production and distribution, but also fibers that have little or no importance to the consumer.

Each of these cellulosic fibers possesses qualities or properties that distinguish it from others and make it especially suitable for certain end uses. Most cellulosic fibers also share a "family resemblance" in their physical and chemical properties.

As pointed out in chapter 3, statements about fiber characteristics are made in relation to the characteristics of other fibers. For example, when flax (the fiber from which linen is made) is said to be a relatively strong fiber, what is meant is that, in comparison with other fibers, flax is fairly strong. If the strength of flax were measured against that of a strand of steel or aluminum wire, for example, it would seem relatively weak.

General Characteristics of Cellulosic Fibers

The following discussion summarizes the general characteristics of natural and regenerated cellulosic fibers as a class or group. Cellulose acetate and cellulose triacetate are chemical variants of cellulose and, as such, do not share in many of

TABLE 4.1
Fibers of the Cellulose Family

Natural Fibers	Rayon Viscose rayon High-wet-modulus rayon Cuprammonium rayon Lyocell		
Seed hair fibers Cotton Kapok Milkweed ^a Bast fibers			
Flax (linen) Jute Ramie Hemp Kenaf	Modified cellulose fibers Acetate Triacetate		
Leaf fibers Abaca ^a Sisal Henequen ^a Piña			
Miscellaneous Coir Spanish moss ^a Sacaton (root fiber) ^a			

^a Of limited use.

the family characteristics. Their specific fiber characteristics are discussed at length later, in chapter 6.

The density of cellulosic fibers tends to be relatively high, making fabrics woven from yarns of these fibers feel comparatively heavy. Cellulosic fibers have relatively low elasticity and resilience. As a result, they wrinkle easily and do not recover from wrinkling readily. Absorbency and moisture regain are generally high. Most cellulosic fibers are, therefore, slow to dry after wetting, comfortable to wear, and easy to dye.

Cellulosic fibers are good conductors of heat and electricity. As good conductors of heat, they carry warmth away from the body and are favored for use in hot weather and warm climates. Because they conduct electricity, cellulosic fibers do not exhibit static buildup, which produces shocks when garments are worn.

Cellulosic fibers tend to burn easily, with a steady, fuzzy-edged, orange flame, much as paper (which is also cellulose). Most cellulosic fibers can, however, withstand fairly high dry heat or ironing temperatures before they scorch. On an electric iron, cotton and linen settings are the highest settings on the dial.

Chemical properties of cellulosic fibers include good resistance to bases. Excessive bleaching will harm cellulosic fibers, although carefully controlled bleaching is not detrimental. Strong mineral acids are extremely damaging. Most natural cellulosic fibers will withstand high water temperatures. Such properties permit laundering of cellulosic fibers with strong detergents, controlled bleaching, and hot water temperatures. Manufactured cellulosic fibers are more sensitive to chemicals and require more careful handling and gentle agitation with lower water temperatures.

Most insects do not attack cellulosic fibers. However, silverfish are likely to attack heavily starched cellulosic fabrics. Most cellulosic fabrics are susceptible to attack by fungi, especially mildew. Extended exposure to sunlight tends to damage the fibers. An important environmental advantage of cellulosic fibers is that they are biodegradable.

SEED HAIR FIBERS

Seed hair fibers belong to a class in which the fibers grow from the seeds that are formed in pods on certain plants. The most widely used seed hair fiber is cotton. Other seed hair fibers include kapok, milkweed, and cattail.

COTTON

Cotton in the Global Market

Worldwide cotton is a fiber of significant economic importance. For many years it was more used than any other single fiber, but it has now been surpassed in production and use by the synthetic fiber polyester. In 2002 there were nineteen million metric tons of cotton produced, compared to twenty-one million metric tons of polyester (Adams, et al., 2004; American Fiber Manufacturers Association, n.d.). Despite the growth of synthetics, however, cotton has continued its large share of the world market and its image as a comfortable natural fiber.

^{1.} A metric ton is 2,204 pounds, which is about 4.6 bales of cotton.

Table 4.2
World Cotton Producers (2003-04)

Country	Bales Produced \times 1000	Percentage of World Production
China	25,500	29
United States	17,559	20
India	12,500	14
Pakistan	8,350	9.5
Others	24,125	27.5

Source: U.S. Department of Agriculture

Agricultural production of cotton continues to spread throughout the world. Table 4.2 shows the largest producers of cotton in 2003–04. China was the number one producer, with the United States second. India, Pakistan, and Brazil are also significant producers. The cotton producers and importers in the United States support a global marketing program marked by the familiar Seal of Cotton logo (Figure 4.1). The seal is licensed by its developer, Cotton Incorporated, which also conducts research on better-quality fiber varieties as well as finishes and treatments to enhance cotton's properties. Much of the U.S. cotton crop is exported to other countries, where it is manufactured into yarns, fabrics, and end products. China is an especially important target market for promotion efforts not only for raw fiber, but also increasingly for product developers who decide what fibers to include in their products.

The Cotton Plant

Cotton fibers grow on the seeds within the boll, or seed pod, a plant of the botanical genus *Gossypium*. (See Figure 4.2) This plant is a member of the mallow family, related to the common garden hollyhock, hibiscus, and okra. Each fiber is a single plant cell that develops as an elongation of a cell in the

FIGURE 4.1
Seal of Cotton. Reproduced with permission of Cotton Incorporated.

FIGURE 4.2

(a) Cross-section of a cotton flower showing seeds in boll at the bottom of the flower, (b) closed boll, (c) mature, open boll. (a): Micrograph by J. McD. Stewart, (b) and (c): courtesy of U.S. Department of Agriculture.

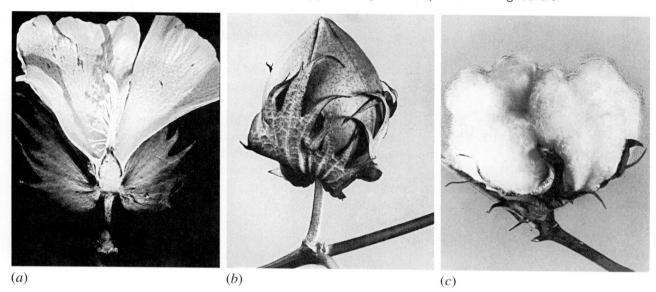

outer layer, or epidermis, of the cotton seed. (See Figure 4.3) These seed hairs are called *lint*. A secondary growth of much shorter fibers accompanies the growth of cotton lint. These fibers, which are too short to be spun into yarn, are called *linters*.

Types of Cotton

Many different species are included within the genus *Gossypium*, and each species of cotton includes many varieties that will produce different results under various field and weather conditions. Cotton breeders are continually working to develop new varieties with stronger and finer fibers.

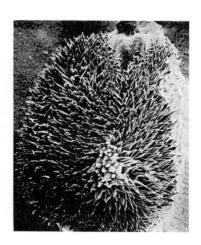

FIGURE 4.3

Cotton seed showing fibers growing, two days after flowering. Micrograph by J. McD. Stewart.

Cotton fibers are sometimes classified according to the length to which they grow. Longer fibers command higher prices because they are usually also finer. Major classifications are listed here:

- 1. Short-staple fiber: $\frac{3}{8}$ to $\frac{3}{4}$ inches in length. Short fibers come from Asiatic species of cotton that are both short and coarse.
- 2. Intermediate-staple fiber: $\frac{13}{16}$ to $1\frac{1}{4}$ inches in length. The variety known as American Upland is of intermediate length and coarseness. This variety of cotton makes up by far the largest quantity of cotton fiber grown in the United States.
- 3. Long-staple fiber: $1\frac{1}{2}$ to $2\frac{1}{2}$ inches. This includes varieties known as Sea Island, Egyptian, and pima (or American-Egyptian), all of which are used for good-quality cotton fabric. Peruvian and Brazilian fibers also fall into this classification. However, the Peruvian variety, known as *tanguis*, has a slight crimp and rougher feel, somewhat like that of wool, with which it is sometimes blended.

Cultivation

For optimum growth, the cotton plant requires a warm climate with adequate rain or other water supply. A favorable distribution of rain is more important than is the quantity of rain because the plant needs plenty of moisture during the growing season and warm, dry weather during harvesting. For this reason, cotton is also grown successfully in warm, dry climates with adequate water for irrigation.

Blooms appear on the plant from eighty to 110 days after planting. The blooms are creamy white or yellow when they first appear. From twelve hours to three days after the blooms have appeared, they have changed in color to pink, lavender, or red and have fallen off the plant, leaving the developing boll on the stem. (See Figure 4.2b.) Fifty to eighty days later, the pod matures and bursts open, and the cotton is ready to be picked. The mechanism that causes the opening of the cotton boll is not fully understood. It is believed to be related to hormonal changes in the maturing plant. Whatever the specific cause, the result is that the boll walls crack, the boll dries, and the cotton fiber is exposed, mature and ready for picking. (See Figure 4.2c.) Failure to pick the ripened cotton promptly detracts from the quality of the fiber.

A particular problem in growing cotton is the susceptibility of the plant to insect pests such as the boll weevil, necessitating the extensive use of pesticides. Over the past decade in the United States, the federal government partnered with cotton-producing states in a boll weevil eradication program that included targeted pesticide application and use of pheromone traps in an initial year. The success of the program is seen in significantly reduced use of pesticides in subsequent years, providing both environmental and economic benefits.

To facilitate harvesting, plants are treated with defoliants that cause a shedding of the leaves and prevent further development of the plant, or they are treated with desiccants that kill the plant by causing a loss of water from the tissue. When desiccants are used, the leaves remain on the plant and contribute to the trash

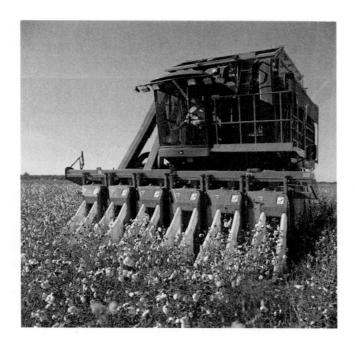

Figure 4.4

Cotton harvesting machine. Photograph courtesy of U.S. Department of Agriculture.

Agricultural Research Service.

content of harvested cotton, whereas defoliants remove and, thereby, decrease this material.

Concern for the impact of pesticides on the environment has spawned interest in *organic cotton*. The United States has established criteria for cultivation practices for cotton that can be labeled *organic*. These include no use of pesticides or synthetic fertilizers and weed management without commonly used weed killers. Defoliation is accomplished through burning or frost. While organic cotton is preferred by some consumers, it is much more expensive and comparatively little is produced.

Picking of the cotton is done by either hand or machine. In the United States, cotton production and harvesting have been mechanized (see Figure 4.4), but in other parts of the world, cotton planting, cultivation, or harvesting may still be done by hand. Technological and agronomic advances here have vastly improved cotton cultivation to the point that the same amount of cotton can be grown on only one-third of the land area that was required sixty years ago.

Production of the Fiber

Once the cotton fiber has been picked, it is separated from the cottonseeds by ginning. The cotton gin removes the fibers from the seeds. Cotton linters, too short for spinning, are used in making manufactured cellulosic fibers; as stuffing materials for mattresses, upholstery, and pillows; and in nontextile materials such as paper. Seeds are used for cottonseed oil and fertilizer.

The quality of cotton fiber varies not only as to the length and variety of fiber, but also as to physical condition from ginning; the amount of vegetable matter,

dirt, and sand present; and color. The U.S. Department of Agriculture has established a classification system that provides information to the sellers and buyers of unprocessed cotton so they can determine its value and the requirements for further processing. Raw cotton is "graded" according to the trash content, color, ginning preparation, and brightness. Standards for length of staple fiber have also been established. Evaluation of cotton quality has been made easier with the introduction of high-volume instruments (HVI) for the automated measurement of length, strength, fineness, and color. Every bale of cotton ginned in the United States carries with it HVI data on the fibers in the bale. This is a major advantage for U.S. cotton in both domestic and foreign markets because yarn spinners can know the characteristics of the fibers they are buying and, therefore, how those fibers will process.

Measures for fineness and maturity are made by an indirect method known as *micronaire* fineness. This is based on the air flow past a standard weight of cotton compressed to a standard volume. Under these conditions, fine and immature fibers will impede the air flow more than coarser fibers because they present a more tortuous path for the air through the sample. Lower readings indicate immaturity, and higher readings may be produced by fibers that lack the fineness required for some high-quality products. Micronaire ranges can be specified in developing cotton products for targeted end uses.

In the past many individuals working in jobs where they came into contact with large quantities of cotton contracted a serious lung disease called "brown lung." Known medically as *byssinosis*, the disease is caused by toxins from bacteria or fungi associated with small fibers that are inhaled. Recent developments of machinery for processing cotton have focused on closed systems that protect workers from cotton dust exposure. Air quality is monitored, and legislative requirements for safe levels of exposure have been established under the Occupational Safety and Health Act (OSHA), so what was once seen as a pervasive problem in the cotton industry has been largely brought under control.

Molecular Structure

Cotton is composed of polymer chains of cellulose. The repeating unit of cellulose, which is the basic polymer for all cellulosic fibers, is:

The cellulosic polymers in cotton have a high degree of polymerization. The hydroxyl (—OH) groups on the chains are responsible for many of the properties

of cellulosic fibers. They attract water and dyes, making cotton absorptive and easy to dye. They also enable hydrogen bonding between adjacent cellulosic chains in the crystalline areas of the fiber.

Cotton is about 70 percent crystalline and 30 percent amorphous. Although the degree of crystallinity is high, the crystalline portions are often not oriented but are at an angle to the fiber axis.

Properties of Cotton

Physical Properties

Color. Cotton fiber is generally white to tan in color. During the 1990s naturally colored cotton fibers were developed by Sally Fox of Natural Cotton Colours, Inc., through selective breeding. Brown, tan, and green fibers were marketed under the name FoxFibre[®]. Naturally colored cottons do not require either dyeing or bleaching, processes that generate significant levels of waste water. (See figure CP5B on Color Plate 5.)

Shape. The length of an individual cotton fiber is usually from one thousand to three thousand times its diameter, which may range from sixteen to twenty microns. The fiber has a *U*-shaped or kidney bean–shaped cross-section with a central canal known as the *lumen*. (See Figure 4.5.) During growth this channel carries nutrients to the developing fiber.

After the fiber has reached its full length, layers of cellulose are deposited on the inside of the thin, waxy, exterior wall. The fiber grows much as a tree does, with concentric rings of growth. (See Figure 4.6.) Each layer is made up of small fibrils, or minute fibrous segments. As these fibril layers are deposited, they form a complex series of spirals that reverse direction at some points. When the boll opens and the fiber is exposed to air, it dries and collapses into the flat shape seen in the microscopic view of cotton in Figure 4.5. The spiraling of the cellulose fibrils

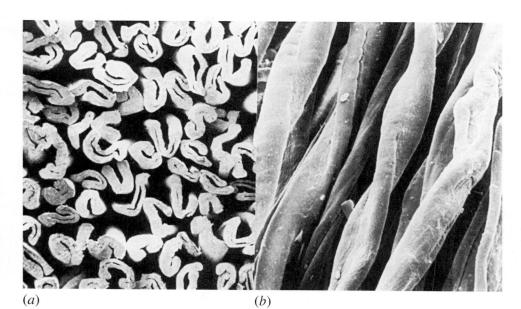

Scanning electron micrographs of cotton fibers; (a) cross-section and (b) longitudinal

FIGURE 4.5

and (b) longitudinal view. Reproduced by courtesy of the British Textile Technology Group (BTTG).

FIGURE 4.6

The structure of cotton fiber. As the cotton fiber matures, the cell formed by the primary wall (a) is filled by successive daily deposits of cellulose in layers; (d) is the first layer deposited within the original cell; (b) shows the central layers; (c) is the innermost layer; (e) is the lumen. Courtesy of the National Cotton Council of America.

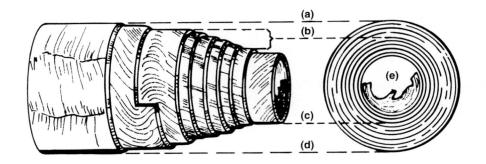

causes the characteristic twists, or *convolutions*, in the lengthwise direction of the fiber. These twists give the magnified cotton fiber the appearance of a twisted ribbon, and they make cotton easier to spin into yarns. Long staple cotton has about three hundred twists per inch; short cotton has less than two hundred. In spite of the twisted shape of the cotton fiber, it is relatively uniform in its size.

Luster. The luster of cotton is low unless it has been given special treatments or finishes. This is, in part, a consequence of the natural twist of cotton and its resultant uneven surface that breaks up and scatters light rays reflected from the fiber surface.

Specific Gravity. Cotton has a specific gravity of 1.54. (Compare with that of polyester at 1.38 or nylon at 1.14.) This means that cotton fabrics feel heavier in weight than comparable fabrics made from polyester or nylon.

Mechanical Properties

Strength. Strength of cotton on a scale of high, medium, and low would rank as medium. (Tenacity is 3.0 to 4.9 g/d.) It has a fairly high degree of crystallinity but somewhat lower orientation. The strength is increased by the length of the polymer chains. In comparison with other cellulosic fibers, cotton is weaker than flax and stronger than rayon. Cotton is 10 to 20 percent stronger when wet than when dry.

Modulus. Cotton fibers have a moderately high modulus, similar to that of polyester. This helps the two fibers to blend well. It also means that cotton fibers are not very stretchable.

Elongation and Recovery. Like most other cellulosic fibers, cotton has low elongation and elastic recovery. Knitted cotton cuffs and bands may stretch during wear and care and may not recover fully.

Resilience. Cotton fabrics also wrinkle easily and do not recover well from wrinkling. In stretching or wrinkling, hydrogen bonds between chains are broken then reformed in the new position, holding in the wrinkle or other deformation. Through the application of durable press finishes, however, resilience can be improved. Unfinished cotton fabrics generally must be ironed after laundering.

Flexibility. Compared to many other fibers, cotton is fairly flexible. However, when fineness is taken into account, its bending resistance on a relative scale is high, affecting the drapability of cotton fabrics.

Chemical Properties

Absorbency and Moisture Regain. Because of its many hydroxyl groups, which attract water, cotton is an absorbent fiber. Its good absorbency makes cotton comfortable in hot weather and suitable for materials where absorbency is important (such as towels). Cotton dries slowly because the absorbed moisture must be evaporated from the fiber. Due to their high absorbency, cotton fibers take waterborne dyes readily. The percentage moisture regain of cotton is 7 to 8 percent at standard testing conditions of temperature and humidity.

Heat and Electrical Conductivity. Cotton conducts electricity and, thus, does not build up static electrical charges. It has moderately high heat conductivity, which makes the fabric comfortable in hot weather.

Effect of Heat; Combustibility. Cotton is not thermoplastic and, therefore, does not melt. Exposure to dry heat at temperatures about 300° F, however, causes gradual decomposition and deterioration of the fiber. Excessively high ironing temperatures cause cotton to scorch or turn yellow.

Cotton is combustible. It burns upon exposure to a flame and continues to burn when the flame has been removed. Burning cotton fabric smells like burning paper, and a fluffy, gray ash residue remains. It is not possible to distinguish cotton from other cellulosic fibers by burning.

Chemical Reactivity. Table 4.3 lists the reactions of cotton to treatment with chemical substances. Strong acids degrade the fibers, producing holes in cotton

Table 4.3
Reaction of Cotton to Selected Chemicals

Substance	Effect on Cotton Fiber	
Acids		
Mineral acids: sulfuric, hydrochloric, nitric, etc.	Concentrated acids destroy. Cold concentrated acids, if not neutralized and washed out, degrade and destroy.	
Volatile organic acids: formic, acetic Nonvolatile organic acids: oxalic, citric, etc.	No harmful effect. Degrade fiber slightly if not removed.	
Bases		
Strong bases: sodium hydroxide, etc.	No harmful effect. High concentra- tions used in <i>mercerization</i> cause fiber to swell and become stronger.	
Weak bases: borax, soap, etc.	No harmful effect.	
Oxidizing agents Chlorine bleaches	Destroy if uncontrolled.	
Organic solvents (used in spot and stain removal)		
Perchloroethylene Naptha	No harmful effect. No harmful effect.	

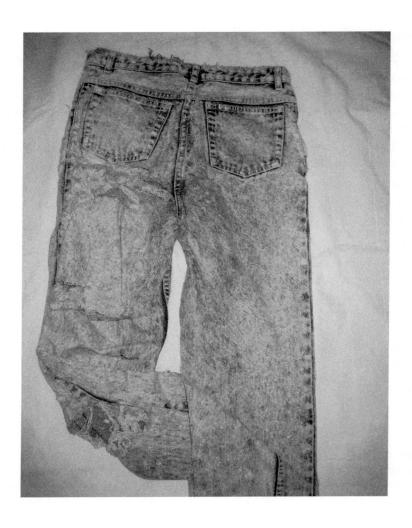

FIGURE 4.7

Cotton jeans showing holes where acid has contacted the fabric.

fabrics. (See Figure 4.7.) Organic solvents have no harmful effect, allowing cotton fabrics to be dry cleaned.

Some of the chemicals listed in Table 4.3 are used in the finishing of cotton. For example, acids may be employed to stiffen permanently the cotton fabric called organdy. The reaction of cotton to strong bases, in which the fiber swells and becomes stronger with (when the process is carried out under tension) an increase in luster as well, is used for *mercerization*. (See chapter 21 for a fuller discussion of mercerization.) The same process done without tension and under slightly different conditions has been used to make stretch fabrics. Dyestuffs that are too acidic in reaction cannot be applied to cotton fabrics.

Environmental Properties

Resistance to Microorganisms and Insects. Mildew grows on cotton fibers, especially if they are stored under conditions of dampness, warmth, and darkness. This fungus stains the fiber and eventually rots and degrades it. Other bacteria and fungi that grow in soiled, moist areas will also deteriorate or rot cotton fabrics.

Moths and carpet beetles do not attack cotton, but silverfish may eat the fiber. Heavily starched fabrics are liable to be damaged by silverfish.

Resistance to Environmental Conditions. Although cotton shows better resistance to sunlight than do many fibers, extended exposure to sun will cause weakening and deterioration of cotton fabrics. Cotton draperies will last longer if lined with another layer of fabric.

Age does not seriously affect cotton fabrics; however, it is important that the fabrics be stored in clean condition and in dry areas to prevent mildew. Special acid-free tissue paper can be used to store antique cotton garments, cotton quilts, and spreads. Ordinary tissue paper should not be used for wrapping fabrics for long-term storage because the paper contains an acid residue that may damage or yellow the cloth.

Other Properties

Dimensional Stability. Cotton fibers swell considerably in the transverse direction when wet. Unfinished woven or knitted cotton fabrics will shrink in the first few launderings because the laundering releases tensions created during weaving or finishing. The relaxation of these tensions may cause changes in the fabric dimensions. Cotton fabrics can be given special finishes to prevent this *relaxation shrinkage*.

Abrasion Resistance. Fabrics made from cotton generally have low abrasion resistance. Garments will show wear at hems, cuffs, and collars; all-cotton sheets will not be as durable as those that are blends with more abrasion-resistant fibers such as polyester. Cotton fabrics will not, however, pill badly.

Uses

The range of items for which cotton fabrics are used is enormous. Its versatility and reasonable cost make it a popular fiber for many products. In wearing apparel, the qualities of comfort, dyeability, and launderability have led to its wide use in articles ranging from underwear to evening gowns. The familiar denim jeans, seen throughout the world, are made of all cotton, or mostly cotton, fabric. Many home furnishings such as sheets, towels, tablecloths and napkins, draperies, and upholstery and slipcover fabrics are composed entirely or predominantly of cotton, and all-cotton items are often considered premium products.

Cotton is frequently blended with other fibers, especially with manufactured fibers. This blending may be done to create cottonlike fabrics with better wrinkle resistance and dimensional stability. Increasingly cotton is blended with spandex to provide stretch for many apparel items. Various finishes developed for cotton can also compensate for less desirable qualities. Special finishes are discussed in chapters 24 and 25.

Care Procedures

Cotton can be cleaned successfully using either detergents or natural soaps, which are generally quite alkaline. The alkalinity of the detergents has no effect on the fiber. Dry cleaning solvents do not harm cotton, so where construction details or trim would make wet laundering undesirable, or when shrinkage is likely to occur, dry cleaning could be used.

Cotton's lack of resiliency causes significant wrinkling in laundering. Care labels may recommend that consumers dry knitted cotton items flat because when hung on clotheslines they may stretch and not recover.

Stains can be removed from white cotton using strong bleaches as long as water temperature, concentration of bleaching agent, and time of exposure are controlled. Strong chlorine bleaches should not be poured directly on cotton because pinholes can be formed in the fabric from direct contact with the bleach.

MINOR SEED HAIR FIBERS

Kapok

Kapok, like cotton, grows in a seed pod. The kapok, or ceiba, tree, sometimes called the silk cotton tree, is native to the tropics, often being found in rain forests. Seed pods are gathered when they fall or are cut from the tree. The dried fiber is easily separated from the seeds.

Kapok has exceptional resiliency and buoyancy. Its uses have been limited chiefly to stuffings and insulation materials, though, because it is too brittle to be spun readily into yarns. Because of its buoyancy and resistance to wetting, kapok has been used as a filling for life preservers, but other materials have largely supplanted it in flotation devices. It can be found in pillows as an alternative to down or polyester fiber filling. Some consumers may prefer a natural fiber filling that is cellulosic and, therefore, less likely to trigger allergic reactions.

Milkweed

The light, airy fibers on the common milkweed plant have been used for some time in textile structures. Composed of 100 percent cellulose, these are classified as seed fibers because they grow as single cells on the large "seed" of the plant. The limited uses of milkweed fibers are strongly related to their unique structural features. The fibers are hollow with a thin wall relative to their diameter and are, therefore, lightweight. The smooth, straight fiber contour of milkweed makes the fibers difficult to spin into yarns. They may be blended with other fibers to increase cohesion in the blended yarns, but because they also have low strength because of the thin fiber wall, there is little incentive to produce such yarns.

Milkweed had been tried in a number of uses where good insulation or buoyancy properties were needed: as filling fibers for comforters, life vests, and winter jackets. A disadvantage is the high moisture regain of milkweed, which can cause the fiber masses in these items to become damp and clump together. The remaining use of milkweed today is as an additional stuffing material for down pillows. Interestingly, a primary value of the milkweed plant is as a natural host for the monarch butterfly.

BAST FIBERS

Bast fibers are those that grow in the stems of plants. Located in the inner bark of the stalk, these fibers can be several feet in length. The best known of the bast fibers is linen, which comes from the flax plant. Other important bast fibers are

jute, ramie, kenaf, and hemp. Minor fibers of historical interest but of little or no commercial importance are urena and nettle.

FLAX

Flax fibers are used to produce linen yarns and fabrics. The widespread use of linen for many purposes is reflected in terminology still employed, such as *bed linens* or *table linens*. Modern bed linens and table linens are, however, usually made from fibers other than flax.

Interest in linen was stimulated in the early 1990s by ecological concerns of consumers because flax is grown virtually free of herbicides and pesticides. The United States imports linen fibers, yarns, fabrics, and completed garments, although flax for fibers is not commercially cultivated here. It is, however, being grown here experimentally, and new processing methods are being investigated. Countries producing large quantities of flax fiber are Poland, Belgium, France, the Netherlands, and the Czech Republic.

The Flax Plant

The botanical name of the flax plant is *Linum usitatissimum*. *Usitatissimum* is Latin for "most useful." Before cotton was available in Western Europe, linen was used extensively in household textiles, for practical and washable garments, and for tents and sails for boats. Its many uses are clearly reflected in the Latin name given to the plant. Some varieties of the plant are grown for fiber, whereas others are grown for seeds. The plant grows to a height of two to four feet and produces flowers with blue or white petals.

The fibers grow in bundles in the bast layer of the stem, just underneath the bark. Figure 4.8 shows the location of the fibers in the stalk and the large amount of woody material that must be removed to extract the fibers.

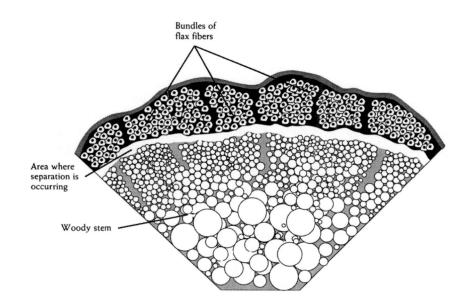

FIGURE 4.8

Diagram of a portion of a cross-section of a flax stem. As a result of retting, clumps of fibers along the outer edge are starting to separate from the woody core.

FIGURE 4.9

(a)

Flax harvesting and processing. (a) Pulling machine used during the harvesting of flax plants. (b) Worker scutches flax during fiber processing. Photos courtesy of Masters of Linen.

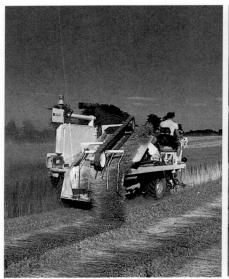

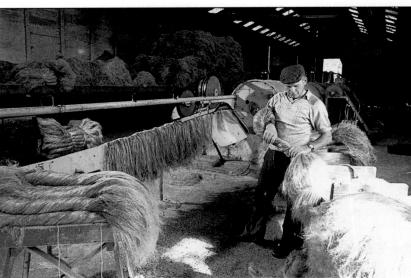

Cultivation

(b)

Different varieties of flax are grown for seed and fiber. Plants for fibers are taller with fewer branches (Foulk, Akin, and Dodd 2006). The plant thrives best in temperate climates with adequate rainfall, with cultivation throughout Europe and in Russia. Limited quantities are grown in the United States, primarily as an experimental crop.

Harvesting is done about eighty to one hundred days after sowing when about one-half of the seeds are ripe and leaves have fallen from the lower two-thirds of the stem. In those countries where inexpensive labor is readily available, flax is still harvested by hand, but in developed countries, much of the labor of flax pulling is now done by machine. (See Figure 4.9a.) Whether done by hand or machine, the flax plant is pulled completely from the ground. Removing plants from the ground retains as long a stem as possible and prevents discoloration of fibers through wicking.

Stalks are dried sufficiently so they can be threshed, combed, or beaten to remove the flax seeds, which are used for sowing future crops or for making linseed oil or livestock feed.

Preparation of the Fiber

Bast fibers require extensive processing to remove the fibers from the woody stem in which they are held, a factor that adds considerably to the cost. The procedure is similar for all bast fibers. The deseeded flax straw has to be partially rotted to dissolve the substances that hold the fiber in the stem. This first step in preparing the fiber is called *retting*.

Retting is accomplished through the breakdown of the materials that bind the fibers into the plant stems. Highly specific enzymes that attack only the binding materials and not the fibers are secreted by fungi and bacteria. Retting processes are of three types:

- 1. Dew (or ground) retting is the most common method today. The flax is laid out in swaths in a field where the action of rain and dew together with soil-borne fungi and bacteria cause the bark of the stems to loosen. This may take from three to six weeks, depending on weather conditions. After retting, the bark is removed, and retted straw bundles are set up in the fields to dry. Disadvantages of dew retting that affect fiber quality are variable weather and lack of control because the process is dependent on naturally occurring microorganisms. On the other hand, it is environmentally benign and can be easily mechanized (Hann 2005).
- 2. Water retting takes place when flax is submerged in water for six to twenty days, with warmer water temperatures decreasing the time required. Water retting may be done in ponds, in vats, or in sluggish streams. As in dew retting, the bacterial action causes the bark to loosen. Water retting yields finer fibers but is more costly and produces odors and pollutants in the retting water; therefore, the less expensive and more easily mechanized dew retting process is generally preferred.
- 3. *Chemical retting* processes using sodium hydroxide or oxalic acid have been developed but currently are rarely used.
- 4. Enzyme retting, a recent development, exposes the flax stems under controlled conditions to enzymes that act specifically on the material holding the fibers to the bark. While not commercially implemented, enzyme retting is a promising process because it yields a high-quality fiber without the disadvantages of water retting (Akin, Epps, Archibald, and Sharma 2000).

Retting only loosens the bark from the stem. Following retting, *breaking* and *scutching* finish the job of separating the fiber from the stem. In breaking, the flax straw is passed over fluted rollers or crushed between slatted frames. This breaks up the brittle, woody parts of the stem, called *shive*, but does not harm the fiber. In scutching, the broken straw is passed through beaters that knock off the broken pieces of stem. (See Figure 4.9b.) The fibers are baled and shipped to spinning mills.

At the mill the fibers go through yet another process before they are ready for spinning. The fibers are *hackled*, or combed, to separate shorter fibers (called *tow*) from longer fibers (called *line fibers*) and to align fibers parallel preparatory to spinning. Even with all this processing, individual fibers do not separate out, and bundles of fibers continue to cling together.

Flax fibers are long; therefore, they must be processed on specialized machinery. (See chapter 14 for a discussion of spinning flax fibers.)

Properties of Flax

Physical Properties

Color. Unbleached flax varies in color from a light cream to a dark tan. The different retting methods produce differences in fiber color. Dew retted fibers are grayer and darker. Water and enzyme retting produce whiter fibers.

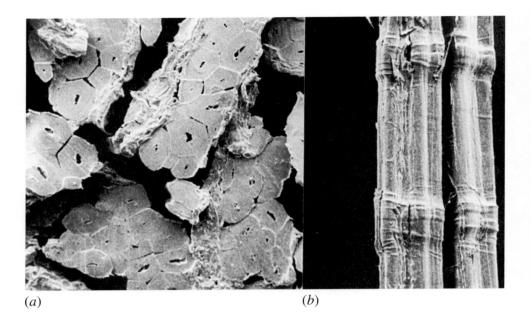

FIGURE 4.10

Scanning electron micrographs of flax fibers; (a) cross-section and (b) longitudinal view. Reproduced by courtesy of the British Textile Technology

Group (BTTG).

Shape. Fiber bundle length may be anywhere from five to thirty inches, but most line (longer) fiber averages from twenty to thirty inches, whereas tow (shorter fiber) is less than fifteen inches. Recent interest in cotton/linen blended fabrics has led to cutting of flax fibers to shorter lengths, a process step referred to as "cottonizing." Single fiber diameter averages fifteen to eighteen microns.

In microscopic cross section, flax has a somewhat irregular, many-sided shape. Like cotton, it has a central canal, but its lumen is smaller and less distinguishable than that of cotton. Looking at the lengthwise direction of fiber under the microscope is rather like looking at a stalk of bamboo. Flax has crosswise markings spaced along its length that are called *nodes* or *joints*. (See Figure 4.10.)

Luster. Because it is a straight, smooth fiber, flax is more lustrous than cotton, but it does not have the smooth surface that most manufactured fibers display. A special finishing technique called *beetling* can be employed to increase the luster of linen fabrics. (See chapter 24.)

Specific Gravity. The specific gravity of flax is the same as that of cotton (1.54). Linen fabrics are, therefore, comparable in weight to cotton fabrics but are heavier than silk, polyester, or nylon, even in cloth of similar weave.

Mechanical Properties

Strength. Flax is stronger than cotton, being one of the strongest of the natural fibers. It is more crystalline and more oriented than cotton. It is as much as 20 percent stronger wet than dry.

Modulus. Flax fibers have a high modulus. In former days sails were made of linen because it resisted the wind forces without deforming greatly.

Elasticity and Resilience. The elongation, elasticity, and resilience of flax are lower than those of cotton because linen lacks the fibril structure that gives some resilience to cotton. Linens crease and wrinkle badly unless given special finishes.

Flexibility. Just as flax fibers resemble bamboo stalks, they also display the brittleness one associates with bamboo. Although fairly soft fabrics can be made from very fine yarns, generally linen fabrics feel stiff because the fibers have high resistance to bending.

Chemical Properties

Absorbency and Moisture Regain. Moisture regain of linens is higher than that of cotton (11 to 12 percent). Unlike cotton, linen has very good wicking ability; that is, moisture travels readily along the fiber as well as being absorbed into the fiber. Both absorbency and good wicking ability make linen useful for towels and for warm-weather garments.

Heat and Electrical Conductivity. Linen conducts heat more readily than does cotton and is even more comfortable for summer wear. Conductivity of electricity prevents static electricity buildup.

Effect of Heat; Combustibility. Linen is slightly more resistant to damage from heat than is cotton, and higher temperatures are required to scorch linen fabric. The burning characteristics of linen are similar to those of cotton; it is combustible, continues to burn when the flame is removed, and burns with an odor like that of burning paper.

Chemical Reactivity. The chemical reactions of linen closely parallel those of cotton because both are composed of cellulose. Like cotton, linen is destroyed by concentrated mineral acids, not harmed by bases or decomposed by oxidizing agents, and not harmed by organic solvents used in dry cleaning. Linen could be mercerized, but because the flax is naturally stronger and more lustrous, mercerization offers few advantages.

Environmental Properties

Resistance to Microorganisms and Insects. If linen is stored damp and in a warm place, mildew will attack and harm the fabric. Dry linen is not susceptible to attack. It generally resists rot and bacterial deterioration unless it is stored in wet, dirty areas. Moths, carpet beetles, and silverfish do not usually harm unstarched linen fabrics.

Resistance to Environmental Conditions. Linen has better resistance to sunlight than cotton does. There is a loss of strength over a period of time, but it is gradual and not severe. Linen drapery and curtain fabrics are quite serviceable.

The resistance of linen to deterioration from age is good, especially if fabrics are stored properly. Linen, however, has poor flex abrasion resistance. To avoid abrasion and cracking at folded edges, a linen fabric should not be repeatedly folded at the same place.

Other Properties

Dimensional Stability. Like cotton, linen has poor dimensional stability because the fibers swell when exposed to water. Tension from manufacturing, therefore, results in often considerable relaxation shrinkage of fabrics. Preshrinkage treatments can be applied to linen fabrics to prevent relaxation shrinkage.

Abrasion Resistance. Linen fabrics have fairly low abrasion resistance. Because of their high bending stiffness, their flex abrasion is also low.

Table 4.4 compares characteristics of cotton and linen.

Uses

Linen has enjoyed somewhat of a renaissance beginning in the latter decades of the twentieth century. Traditionally found most often in household textiles, linen

Table 4.4
Selected Properties of Cotton and Flax Fibers

Property	Cotton	Flax
Specific gravity	1.54	1.54
Tenacity (g/d) Dry Wet	3.0-5.0 3.3-6.4	5.5–6.5 6.0–7.2
Breaking elongation	5–7%	3%
Modulus	Moderate	High
Resiliency	Poor	Poor
Moisture regain	7–11%	11-12%
Burning	Burns, does not melt	Burns, does not melt
Conductivity of Heat Electricity	High High	High High
Resistance to Fungi Insects Prolonged exposure to sunlight	Damaged Silverfish damage Loss of strength	Damaged Silverfish may eat sizing Loss of strength
Chemical resistance to Strong acids Strong bases Oxidizing agents Solvents	Poor Excellent Good Good	Poor Excellent Good Good

Source: Data on this and subsequent fiber characteristics tables from Man-made Fiber Fact Book (Washington, D.C.: American Fiber Manufacturers Association, 1978); R. W. Moncrieff, Man-made Fibers (New York: Wiley, 1975); W. E. Morton and J. W. S. Hearle, Physical Properties of Textile Fibres (Manchester, UK: The Textile Institute, 1993); J. E. McIntyre, ed., Synthetic Fibres: Nylon, Polyester, Acrylic, Olefin (Cambridge, UK: Woodhead Publishing, 2005); and "Textile World Man-made Fiber Chart," Textile World 134 (June 1994).

FIGURE 4.11

Masters of Linen logo

fabrics saw expanded markets in apparel in the 1980s and 1990s as a result of new developments in processing equipment and a renewed interest in natural fibers (Hann 2005). Yarns spun from flax range from extremely fine for weaving into sheer, soft "handkerchief" linens to coarse, large-diameter yarns for suiting fabrics, enabling a wide range of choices for apparel. Linen moved into knitted garments as higher-quality yarns were produced and advances in knitting technology were made. The European Linen and Hemp Confederation developed a promotional program for both apparel and home furnishings linen textiles using the *Masters of Linen* logo. (See Figure 4.11.)

Because of their high moisture absorbency and wicking ability, linen fabrics are popular for summer clothing. The major disadvantage of linen clothing, its wrinkling, may be somewhat overcome by giving the fabrics special wrinkle-resistant finishes and is less of a problem in knits. Blending of fabrics with synthetics can also improve wrinkle recovery. Many casual linen garments today are prewashed for a soft, slightly wrinkled look. A softer look can also be achieved by blending short staple cottonized flax with other fibers.

Linen fabrics have regained some of their volume in household textiles after losing ground to manufactured fibers. (See Figure 4.12.) The launderability of linen combined with its good luster and attractive appearance make it popular for use in tablecloths, napkins, and place mats. Linen is a favorite for tea towels; because flax fibers are longer, linen produces less lint (small bits of fiber that break off from the yarn) than does cotton and is, therefore, preferred for drying glassware. Linen is used alone or in blends for household products such as curtains and in slipcover and upholstery fabric. Heavy yarns can provide interesting textures for these fabrics, but poor abrasion resistance is a disadvantage.

An increasing market for flax, as well as the other bast fibers described in this chapter, is industrial products. The primary application is as fiber reinforcement for molded plastic parts such as interior panels in cars. The embedded fibers make the panels stronger and more impact resistant. (See chapter 20.) Linen is also used in vintage aircraft for making the wings and bodies of biplanes.

Because the fabric is in relatively short supply and the fibers require extensive processing, linen tends to be rather expensive. Both the cost factor and desirability of increasing wrinkle resistance have led to blending flax with other fibers.

Figure 4.12

High quality household linens are often made from flax fiber and take advantage of the high luster of this fiber. Photo courtesy of Masters of Linen.

Care Procedures

Linen can be dry-cleaned or laundered at home. Being stronger wet than dry, the fabric requires no special handling during laundering. Excessive chlorine bleaching damages linen, but linen fabrics can be whitened by the periodic, controlled use of chlorine or other bleaches.

Even though linen can be laundered, many care labels on linen textiles carry the instructions "Dry Clean Only." This is because the fabrics are likely to exhibit considerable shrinkage and to wrinkle badly. Fabrics do not wrinkle or suffer as much color loss after dry cleaning as they do after laundering.

Ironing temperatures for linen are at the highest end of the dial on electric irons. Linen fabrics can be ironed safely at a temperature of 450° F and usually require steam to remove the wrinkles. Dryer drying at the highest setting is satisfactory.

OTHER BAST FIBERS

Ramie

Ramie, or China grass, comes from a plant in the nettle family. Like flax, the fibers are found in the outer layer of the stalk. A perennial shrub, the ramie plant grows in semitropical regions. At the present time, ramie growth and processing are concentrated in the Philippines, Brazil, and China. Hong Kong, Taiwan, Korea, and Japan process but do not grow ramie.

Ramie stalks are planted, and the fiber is harvested the third year after planting. Three crops may be cut each year. After cutting the stems, the leaves of the plant are beaten off, the stems are split lengthwise, and the bark is stripped from them. This yields "ribbons" of bast that are soaked in water until the green outer layer can be scraped off. After drying, this substance, sometimes called China grass, is bundled and shipped.

Before spinning, the fiber must be retted out of the ribbons. Both dew and wet retting, similar to that used with flax, can be done. A chemical retting process that uses sodium hydroxide and an acid rinse has been patented and is used in industrially developed countries.

Ramie has properties similar to flax but is stronger and more lustrous. It is the strongest of the natural fibers and the most crystalline. Like flax, it has fairly low resilience and flexibility and a high modulus. It is white in color, its absorbency is excellent, it dyes rapidly, and it has good resistance to attack by microorganisms.

The commercial use of ramie had been limited by processing difficulties that made it expensive to produce. Until the chemical retting process was developed, only hand methods could be employed to remove the fiber from the stem. Controlling fiber quality was also difficult. Researchers have developed controls for growth and processing that have made possible the production of uniform quality fibers. Advances in the processing of ramie fibers are proprietary; that is, they are not made available to the public by the manufacturers.

Ramie is used alone or in blends. It is most frequently blended with cotton, linen, or polyester. Ramie fabrics are machine washable but require ironing and may shrink. If blended with adequate quantities of polyester or other synthetics, these fabrics will have easy-care characteristics and little shrinkage. The major use of ramie fabrics, especially ramie blends, in wearing apparel is in sweaters, suits, and pants. (See Figure 4.13.) It is also used in table linens and fabrics for home furnishings.

The case of ramie is an example of the effect that international trade agreements described in chapter 1 can have on production and distribution of textile products. It became a popular fiber in the 1970s and 1980s after the Multifibre Arrangement (MFA) was enacted. Because it was excluded from import quotas, blended fiber textile items that were more than 50 percent ramie could be shipped to large markets such as the United States. Indeed many ramie/cotton and ramie/linen blended apparel items were imported and sold. In 1986, however, ramie was included in the group of fibers covered under MFA agreements between trading countries, and this economic incentive for ramie production was reduced.

Jute

Jute fiber is taken from the stem of the jute plant. Successful cultivation of the plant requires fertile soil and a hot, moist climate. Jute is grown in India and Bangladesh and, to a lesser extent, in Thailand and other southeast Asian countries. It is the most commercially important of the bast fibers.

Jute plants grow from six to sixteen feet high. The stalks are cut just after the flowers begin to fade. Like other bast fibers, separation of the fiber requires retting. Many jute producers use chemical retting processes with chlorine compounds. After retting, the stems are broken and the fiber is removed. (See Figure 4.14.)

Jute and other bast fibers such as kenaf and hemp are shorter than flax. The actual fibers in the plant stalk, called "ultimate fibers," have aspect ratios (length

FIGURE 4.13

"Ancestral Heritage," 3piece ensemble in ramie
designed by Kue Nam
Shim, Mokpoo National
University and Nancy
Bryant, Oregon State
University. Winner, Best in
Show Award, at Runway
show of ITAA, Dallas, TX,
November 1998.

divided by width) of only about 150, which makes them difficult to spin. Compare this to the aspect ratio of cotton fibers, which is considerably greater than one thousand. Because the ultimate fibers are so short, jute is not processed to separate out individual fibers, but only to separate fiber bundles, which can be quite long. The fibers in the bundles are held together by lignin and other substances that act as glues.

Jute ranges in color from light to dark brown. Its strength is somewhat lower than that of other bast fibers, but it has similar bending properties. On exposure to air, jute becomes somewhat brittle. It absorbs moisture readily, resists deterioration by microorganisms more than some cellulosic fibers, and is weakened by exposure to sunlight.

Jute has long been in demand as a cheap, useful packaging material. Burlap is one of the major jute bagging fabrics. Jute has also traditionally been used for carpet backings and cordage. In recent years polypropylene, a manufactured fiber, has become a major competitor for jute in many of these uses. As a result, the jute-producing countries have been looking for additional and innovative applications. Some of these have been as geotextiles in erosion control, as a cheap replacement for cotton filling yarns in handwoven fabrics in India, and as reinforcement fiber in composite plastic structures.

FIGURE 4.14

Jute fiber ready for spinning.

Continued competitive success for jute will depend on economical production to keep costs down and on marketing strategies. Recently efforts have been made to promote jute for apparel and decorative household fabrics.² One advantage jute enjoys is that spinning processes for the fiber are more developed than those for other bast fibers such as kenaf and hemp.

Kenaf

Kenaf is also a bast fiber, similar to jute in that it is composed of short ultimate fibers that are separated from the stalk as fiber bundles. Botanically, it is related to both cotton and okra. Grown predominantly in Africa and India, kenaf has sparked renewed interest as an alternative crop in the South and West of the United States. When harvested, the plant stems are decorticated to remove the inner part of the stalk then retted to obtain the fiber bundles. (See Figure 4.15.)

Mechanical fiber properties are similar to those of jute, but kenaf is stronger. It is also whiter, more lustrous, and can be bleached and dyed more easily. While kenaf has a high moisture regain, it is not wet as quickly as cotton.

Traditionally, kenaf was used in making rope and twine, for which its high strength was important. Recent developments have focused on the use of these fibers in paper making because paper of kenaf fibers is smoother and whiter than that made from wood pulp. New methods for processing the kenaf stalks to obtain longer fibers have led to the production of nonwoven and woven textiles. For example, a nonwoven mat of kenaf fibers containing grass seeds is now marketed as a lawn starter. Apparel, wall coverings, and awning and tent fabrics have been constructed of kenaf and kenaf blends. The woody core of the kenaf plant can be used for animal bedding, packing, and as an absorptive material for oil spill cleanup.

^{2.} Fantasy in Jute—The Golden Fibre, Indian Jute Industries (Calcutta, India: Indian Jute Industries' Research Association, n.d.).

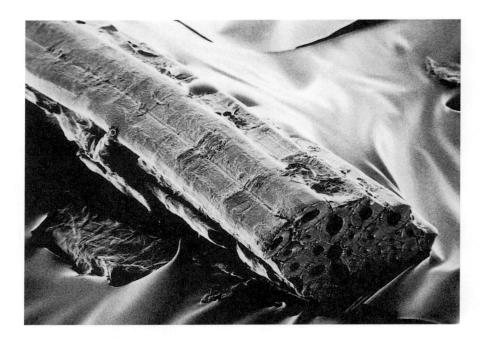

Figure 4.15

Scanning electron micrograph of kenaf fiber bundle. Reproduced from W. Tao, J. P. Moreau, & T. A. Calamari: Properties of nonwoven mats from kenaf fiber, *TAPPI Journal*, vol. 78, no. 8, 165–169.

Hemp

The hemp plant, *Cannabis sativa*, is a member of the mulberry family and a type of marijuana plant. The fiber bundles come from the bast layer of the stem. Mature plants are cut off and spread on the ground, where they are left to dry for five or six days. Leaves and seeds are beaten off, and bundles or sheaves of hemp are formed after additional drying. Retting, breaking, and scutching complete the fiber extraction process.

Hemp has high tensile strength comparable to that of linen. It has good absorbency but poor elasticity. In its chemical properties, hemp is similar to cotton and flax.

The major uses of hemp are in the production of industrial fabrics, twine, and ropes because of its good tensile strength and high modulus that provide initial resistance to force. Interest in apparel and household fabrics made from hemp, as well as craft items, has increased over the past decade. Designers have added designs containing hemp fibers and fabrics to their lines, and it continues to appear in novelty uses.

Although it is legal to import hemp fibers and fabrics into the United States, cultivation of hemp plants is illegal because the U.S. Drug Enforcement Administration does not differentiate among the various subspecies of cannabis plants. Those who are trying to have this plant (which they call "industrial hemp") legalized say that it contains too little of the hallucinogenic substance found in marijuana to have any effect and that, furthermore, trying to smoke the plant would make a person ill. Canada has legalized cultivation of hemp, and its first hemp crop came onto the market in 1998 (Gross 1997).

LEAF FIBERS

Leaf fibers are of limited usefulness and, for the most part, are made into cordage. They are taken from a variety of plants, most of which are perennials that produce fiber for five to twenty years. The leaves are harvested, and through mechanical methods, the extraneous matter is scraped and broken away from the fiber.

Figure 4.16

Handmade basket from Zimbabwe constructed of spun sisal yarns. (Photo by Madalina Romanoschi.)

The most widely used leaf fibers are those from cactuslike plants, such as those that have long, fleshy leaves with spiny edges (agave, henequen, sisal), yuccas, the banana family (abaca or Manila hemp), and the bromeliad family (piña, or pineapple). Piña cloth is used in the Philippine Islands to make a sheer, lustrous fabric that is often used in Philippine national costumes. Spun yarns from leaf fibers can also be fashioned into baskets, place mats, and other craft items. (See Figure 4.16.)

MISCELLANEOUS FIBERS

The most well-known fiber in this group is coir, a fiber obtained from the outer hull of the coconut. The production of the fiber is carried out by hand using primitive methods. The coconut is picked, the nut is removed, and the husks are collected. Fiber is separated from the husks by a process that includes soaking to loosen the fiber, drying, and pulling the fiber from the husks.

The brown coir fibers, which are from five to ten inches long, are used for brushes, ropes, and mats. Among the useful qualities of coir are resistance to rot, lightness coupled with elasticity, and resistance to abrasion. These properties have spurred its use in rugs. Coconut fibers are also used in geotextiles, primarily for erosion control. (See Figure 4.17.)

A few fibers are obtained from roots and mosses. Sacaton, a coarse, stiff, root fiber from Mexico, has been used as bristle for brushes. Spanish moss, an air plant, has been used for inexpensive upholstered furniture and mattress filler. In recent years synthetic fibers have, to a large extent, replaced these materials.

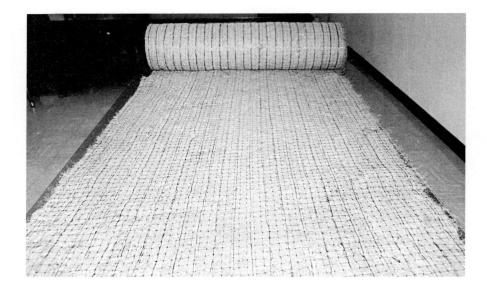

FIGURE 4.17

Coconut fiber geotextile blanket. Product of North American Green. Photo by Julia Thames.

SUMMARY POINTS

- Natural cellulosic fibers come from the seeds, stalks, or leaves of plants
- Cotton
 - Seed fiber
 - Most widely used natural cellulosic fiber, but second to polyester in worldwide use
- Bast fibers come from the stalks of plants
 - · Flax is made into linen fabrics
 - o Other bast fibers are ramie, jute, kenaf, and hemp
- Piña is the best-known leaf fiber
- Common characteristics of natural cellulosic fibers
 - High moisture absorbency
 - · High modulus and moderate to high strength
 - Low elastic recovery and wrinkle resistance
 - Washable but may shrink or fade
 - · Biodegradable

Questions

- What are some of the physical and chemical properties common to natural cellulosic fibers?
- 2. Define the following terms used in conjunction with cotton growing and processing:

boll byssinosis ginning convolutions linters organic cotton

3. What are the major economic and environmental concerns in cotton production?

- 4. What care procedures are recommended for cotton garments? How are these related to the chemical properties of cotton?
- 5. Compare the structural differences of cotton and flax. How do these differences affect fiber properties?
- 6. List the steps in processing flax. What is the purpose of each step?
- 7. What are some of the specific properties of ramie, jute, kenaf, and hemp that determine their uses in particular end products?
- 8. Identify some of the uses of the minor cellulosic fibers coir and piña.

References

- Adams, G., S. Slinksy, S. Boyd, and M. Huffman. "Solutions Through Strength. The Economic Outlook for U.S. Cotton in 2004." http://www.cotton.org/econ/upload/ Economic-Outlook—for-U-S-Cotton-2004-pdf (accessed January 5, 2008).
- Akin, D. E., H. H. Epps, D. D. Archibald, and H. S. Shekhar Sharma. "Color Measurement of Flax Retted by Various Means." *Textile Research Journal* 70 (2000): 852.
- American Fiber Manufacturers Association. "Fiber Facts." http://www.fibersource.com/f-info/fiber%production.htm (accessed January 5, 2008).
- Foulk, J. A., D. E. Akin, and R. B. Dodd. "Fiber Flax Farming Practices in the Southeastern United States." *Plant Management Network*. http://www.plantmanagementnetwork.org/pub/cm/management/2003/flax (accessed June 31, 2006).
- Gross, E. "Hemp: Historic Fiber Remains Controversial." *Textile World* 147, no. 11 (1997): 42.
- Hann, M. A. "Innovation in Linen Manufacture." *Textile Progress* 37, no. 3 (2005): 1.
- Thiry, M. C. "Back to Nature—Textiles Fibers Come Full Circle." *AATCC Review* 4, no. 1 (2004): 7

Recommended Readings

- Batra, S. "Other Long Vegetable Fibers." In *Handbook of Fiber Science and Technology*. Vol. IV, *Fiber Chemistry*, edited by M. Lewin and E. M. Pearce, 728. New York: Marcel Dekker, 1985.
- Gordon, S., and Y-L. Hsieh. *Cotton: Science and Technology*. Boca Raton, FL: CRC Press, 2007.
- Jacobson, T. C., and G. D. Smith. *Cotton's Renaissance*. Cambridge, UK: Cambridge University Press, 2001.
- Kohel, R. J., and C. F. Lewis. *Cotton*. Madison, WI: American Society of Agronomy, Crop Science Society of America, Soil Science Society of America, 1984.
- Rajan, A., and T. E. Abraham. "Coir Fiber—Process and Opportunities." *Journal of Natural Fibers* 3, no. 4 (2006): 29.
- Stout, H. P. "Jute and Kenaf." In *Handbook of Fiber Science and Technology*. Vol. IV, *Fiber Chemistry*, edited by M. Lewin and E. M. Pearce, 702–726. New York: Marcel Dekker, 1985.
- Thompson, J. "King of Fibers [Cotton]." *National Geographic* 185 (June 1994): 60–87.

A legislation of the contract and appropriate and a second second

and the second of the second of

PROTEIN FIBERS

Learning Objectives

- 1. Describe the chemical structure of protein and what properties it confers on protein fibers.
- 2. Distinguish among the different sources of animal hair and fur fibers.
- 3. Compare the properties of wool and silk fibers.
- 4. Describe care procedures for natural protein fibers.

Protein fibers are those fibers in which the basic chemical structure is composed of amino acids joined in polypeptide chains. They may be separated into two basic groups:

- 1. Animal hair fibers. The major fiber in this group is sheep's wool. Other fibers of commercial importance come from animals such as the alpaca, camel, cashmere goat, llama, vicuña, guanaco, and the angora goat, whose fleece provides mohair. Also used are qiviut, or hair from the musk ox; angora rabbit hair; fur fiber from animals such as beaver, mink, and rabbit; and cow and horsehair.
- 2. Fibers formed from extruded filaments. Silk, produced by the silkworm caterpillar, is the only important fiber in this group. Spider silk, whether naturally or artificially produced, is now being studied for textile uses.

In the past manufactured fibers were produced from a variety of protein sources such as corn, soybeans, and milk. While these early attempts were not commercially successful, manufactured protein fibers are now made from tofu, a soy-derived product. See Table 5.1 for a list of protein fibers.

As with the natural cellulosic fibers, textile products made of protein fibers are renewable materials. This can give them a marketing advantage, which has stimulated research and product development on wool and other natural protein fibers. Further, study of protein fibers from animals has provided researchers with insight into engineering fibers of the future.

TABLE 5.1
Fibers of the Protein Family

Animal hair fibers	Extruded fibers	
Wool (from sheep) Specialty hair fibers Camel family	Natural Silk (from the silkworm) Spider silk	
Camel Alpaca Llama Vicuña Huarizo Guanaco Misti Goat family Cashmere Mohair (from the angora goat) Qiviut (from the musk ox)	Manufactured Soysilk [®]	
Fur fibers Beaver Fox Mink Chinchilla Rabbit (especially angora rabbit)		
Other Horsehair Cow hair		

All protein fibers contain the elements carbon, hydrogen, oxygen, and nitrogen. Wool contains sulfur as well. In each protein fiber, these elements are combined in different arrangements. As a result, properties of the various protein fibers may show some striking differences.

Even so, these fibers share a number of common properties. Protein fibers, except silk, tend to be weaker than cellulosic fibers, and they are weaker wet than dry. Fabrics made from protein fibers must be handled with care during laundering or wet processing. They do, however, as a general rule have greater resilience and elongation than cellulosic fibers. They are more resistant to wrinkling and hold their shape better.

Specific gravity of protein fibers tends to be lower than that of cellulose. Fabrics made from these fibers feel lighter in weight than do comparable fabrics made from cellulosic fibers.

Fibers from the protein family do not burn as readily as the cellulosics. When set aflame, they may extinguish themselves. Burned fibers smell like burning hair, flesh, or feathers. Protein fibers tend to be damaged by dry heat and should be ironed with a press cloth or steam. Wool and silk require lower ironing temperatures than do cotton and linen.

Chemical properties common to most protein fibers include susceptibility to damage by bases and by oxidizing agents, especially chlorine bleach. Like human hair, they should be cleaned with solutions that are "pH balanced," that is, that are neutral or slightly acidic. Strongly alkaline soaps and detergents can damage fabrics made of protein fibers, but acids have less effect than on cellulosic fibers. Fabrics can be bleached safely with hydrogen peroxide, as can human hair, but chlorine bleaches are harmful to these fibers.

Sunlight discolors white fabrics made from protein fibers, turning them yellow after extended exposure. Although wool has better resistance to sunlight than cotton, it will degrade on prolonged exposure. Silk degrades readily on exposure to sunlight.

ANIMAL HAIR FIBERS

For centuries sheep, goats, and other animals such as camels, llamas, alpacas, and the like were domesticated in different parts of the world, and their hair was removed for spinning and weaving. Of the many varieties of animal hair from which textile fibers are derived today, the fleece of the sheep is most widely used. In central Asia the camel is an important source of textile fiber, and South America is the home of a number of camel-like animals that produce fibers used for spinning and weaving. The alpaca and llama are native to the Andes Mountains regions and have been domesticated. Vicuña and guanaco are wild or semiwild animals from the same geographic region. Other animal hair fiber comes from domesticated goats such as the angora goat and the cashmere goat.

Hair from other wild or domesticated animals such as rabbits, musk oxen, horses, and cows have some minimal use in textile products.

SHEEP'S WOOL

Under the U.S Wool Products Labeling Act of 1939, wool is defined as "the fiber from the fleece of the sheep or lamb or hair of the angora or cashmere goat (and may include the so-called specialty fibers from the hair of the camel, alpaca, llama, and vicuña)" (Federal Trade Commission 1986). Fiber taken from the domesticated sheep makes up by far the largest quantity of fiber sold under the name of *wool*.

Types of Wool

Approximately two hundred different breeds and crossbreeds of sheep produce wool fiber. The fiber produced by these animals varies widely in quality not only because of the conditions under which the sheep may graze and the quality of the pastureland, but also because some breeds of sheep produce finer-quality wool than do others.

The sheep that produces the most valuable and finest wool is the merino variety. (See Figure 5.1.) Merino sheep originated in Spain but are now prevalent all over the world, the largest proportion of merino fleeces today coming from Australia. Merino

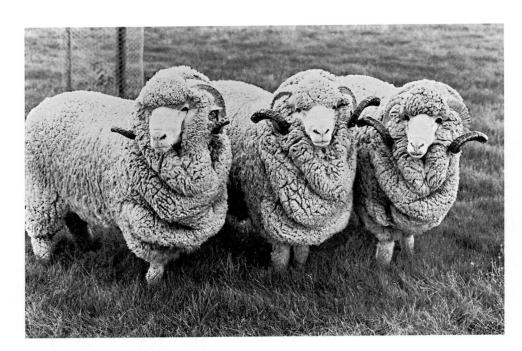

FIGURE 5.1

Merino rams with full coats of wool prior to shearing. Photograph courtesy of the Wool Bureau, Inc.

wool is fine and elastic, though relatively short—from one to five inches. French rambouillet sheep, descendants of the merino bloodline imported to the United States in 1840, also produce fine, high-quality wool.

A second group of sheep that originated in the British Isles produces fibers that are not as fine as merino and rambouillet but are also of good quality. Fibers range from two to eight inches in length. Some of the breeds of sheep from this group are Devonshire, Dorset, Hampshire, oxford, Southdown, and Wiltshire. Like merino sheep, these breeds are raised worldwide.

Coarser, longer fiber is produced by a group of sheep known as Long British or Long Crossbreeds. The fiber length is four to sixteen inches, and the better-known breeds include Leicester, Lincoln, Cotswold, Romney Marsh, and cheviot. Much of this fiber is made into outerwear.

A fourth group of sheep is made up of a variety of crossbred sheep that produce fibers, from one to sixteen inches in length, that are coarse and have lower elasticity and strength. These wools are used largely for carpets and inexpensive, low-grade cloth.

Climatic conditions can adversely affect the quality of the wool, as can the condition of the grazing area. Australian flocks are enclosed in large, fenced areas where underbrush and burrs are kept to a minimum, whereas American sheep are permitted to graze on open ranges. This free grazing results in fleece in which sticks, leaves, burrs, and other vegetable matter may be caught.

Wool in the Global Market

In 2005 around 1.25 million metric tons of clean wool were produced worldwide. Australia was the main producer, with more than one-quarter of the total, fol-

lowed by China and New Zealand.¹ In absolute terms, wool consumption has changed little over the past fifty years, but its percentage share of the fiber market has declined from 10 percent to less than 3 percent (Thiry 2005).

Wool Harvesting and Processing

Shearing

Sheep are sheared to remove the fleece in the spring season. (See Figure 5.2.) Expert shearers move from place to place, removing fleece or clip wool. In Australia fleece is removed in sections, with the underbelly section kept separate from the sides. This is done because the fleece from the undersection and legs tends to be inferior in quality to that of the sides; it contains more vegetable matter and is more tangled, matted, and torn. In the United States, shearers remove the fleece in one piece.

Fleece that is sheared from sheep at eight months of age or younger is called *lamb's wool*. Because this is the first growth of hair with tapered ends, it tends to be softer and finer. Products made from this soft, fine wool are generally labeled "lamb's wool."

A biological shearing process, called "Bioclip," was developed in Australia in 1998. The sheep is injected with a growth protein that stops hair growth temporarily. The point where growth stopped creates a weak place in each hair of the fleece. When this weak point reaches the surface, the fleece can be removed by hand. This method requires less than half the time that shearing requires, and the fibers are more uniform with less damage and fewer skin pieces. The sheep, however, lack adequate covering to protect them from the sun if the fleece is removed too soon.

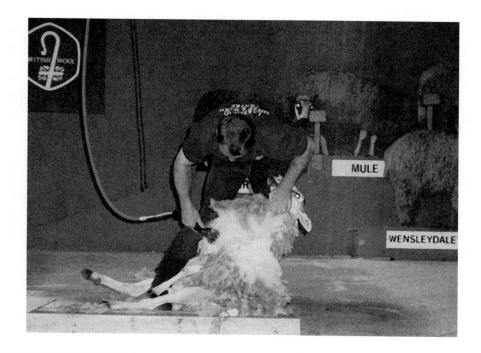

FIGURE 5.2
Worker shearing wool from a sheep.

^{1.} Statistics from the British Wool Marketing Board.

Wool removed from animals that have been slaughtered for meat is referred to as *pulled wool*. A chemical depilatory loosens the wool without seriously damaging the hide. Pulled wool is inferior in quality to fleece or clip wool because it is less lustrous and elastic. Pulled wool is generally blended with other types of wool. The chemical treatment given to the pulled wool in its removal from the skin degrades the fiber and allows the fiber to swell more readily in the dyebath. For this reason, pulled wool dyes more unevenly than does sheared wool.

Grading

Grading of wool is done at the time the fleece is sheared. In grading, the fleece is judged for its overall fiber fineness and length. An alternative to grading is found in *sorting*, in which the fleece is divided into sections of differing quality. The best fiber comes from the sides and shoulders; the poorest comes from the lower legs.

Preparation for Spinning

The first step taken to prepare the fleece for use is *scouring*, which removes oil, grease, perspiration, and some of the dirt and impurities from the fleece. The fleece is washed a number of times in a warm, soapy, alkaline solution. A fleece of about eight pounds will be reduced by scouring to about five pounds. Much of the weight loss results from the removal of lanolin, a natural oil secreted by the sheep, which keeps the fleece soft and waterproof. This lanolin is recovered for use in cosmetics and other oil-based preparations. Even though lanolin can be recovered, the refuse produced by scouring of wool may be a cause of water pollution in areas where wool is processed.

If wool retains significant quantities of vegetable matter after scouring, it must be carbonized to remove this substance. *Carbonization* is the treatment of the fleece or fabric with sulfuric acid to destroy burrs, sticks, or other cellulosic material. Careful control is maintained to ensure that fibers are not damaged by the process. An alternative method is to lower the temperature of the fleece below freezing so dirt, burrs, or vegetable matter become brittle and can be knocked or brushed from the fleece.

As a result of these processes, the wool may become overly dry and brittle. To avoid this, a small amount of oil is added to the fiber to keep it flexible, and the wool is kept somewhat moist during handling.

All wool fibers are *carded*. Fine wire teeth, mounted on a cylinder, separate the fibers and make them somewhat, although not completely, parallel. This procedure also helps to remove remaining vegetable matter from the fiber. (See chapter 14 for a fuller discussion of carding.)

Wool Products Labeling Act

Wool fabrics can be made from new or from used wool, but one cannot tell by looking at the fabric whether the wool it contains is new or reused. To ensure that products made from used fibers are clearly labeled as such, the Wool Products

Labeling Act of 1939 was enacted. This legislation regulated the labeling of sheep's wool and other animal hair fibers. The provisions of this act may be summarized as follows:

- 1. All wool products must be labeled.
- 2. The fibers contained in the product, except for ornamentation, must be identified.
- 3. The following terms, defined by the statute, should be used in identifying wool products (Federal Trade Commission 1986, 28).
 - a. The term *wool* means fiber that "has never been reclaimed from any woven or felted wool product."
 - b. The term *recycled wool* means (1) "the resulting fiber when wool has been woven or felted into a wool product which, without ever having been utilized in any way by the ultimate consumer, subsequently has been made into a fibrous state," or (2) "the resulting fiber when wool or reprocessed wool has been spun, woven, knitted, or felted into a wool product which, after having been used in any way by the ultimate consumer, subsequently is made into a fibrous state."
 - c. The terms new wool or virgin wool shall not be used when "the product or part (of a product) so described is not composed wholly of new or virgin fiber which has never been reclaimed from any spun, woven, knitted, felted, bonded or otherwise manufactured or used product."

Recycled wools are often made from the cutting scraps left from the manufacture of wool items. The fibers are pulled apart and returned to the fibrous state through a process known as *garnetting*. In the garnetting procedure, fibers may be damaged and can, therefore, be lower in quality than some new wool. Less frequently, wool is recycled from fabrics used by the ultimate consumer. These fabrics are also returned to the fibrous state by garnetting. Because these fibers have been subject to wear not only from the garnetting process, but also by the normal wear and tear of a garment or product in use, these are the lowest-quality wool fibers. Recycled wools are often made into interlining materials for coats and jackets or other inexpensive wool products. They are sometimes referred to as *shoddy*. Because wool fibers are longer than cotton, they are more likely to be recycled into useful textile items, adding to the sustainability advantages of wool. The shorter cellulose fibers are more typically recycled into paper products.

Although the terms *virgin wool* and *new wool* guarantee that fabrics are made from wool that has not been previously fabricated, the terms carry no guarantee of quality. It is possible that a fabric made from poor-quality virgin wool may be inferior to one made from excellent-quality recycled wool.

In pile fabrics the face and the backing may be made of different fibers. The contents of the face and the backing may be listed separately, such as "100% wool face, 100% cotton back." If listed separately, the proportion of these fibers must also be indicated in percentages, so in addition to the designation of "100% wool face, 100% cotton back," the label must also say "Back constitutes 60% of the fabric and pile 40%." The contents of paddings, linings, or stuffings are designated separately from the face fabric and must be listed.

The 1984 amendments to the Wool Products Labeling Act requiring country of origin labeling are the same as those required by the Textile Fibers Products Identification Act (TFPIA) and are described in chapter 2.

Molecular Structure

Wool is made of a protein substance called *keratin*, a polymer composed of eighteen different amino acids connected by peptide bonds. Molecules composed of more than two different amino acids joined by peptide bonds are called polypeptides; therefore, the wool molecule is a *polypeptide*. The peptide bonds are *amide* linkages made up of carbon, nitrogen, oxygen, and hydrogen:

The relative amounts of amino acids vary from one type of wool to another. Within the fiber the polypeptide molecules are arranged in a helical (spiral) form, which under a tensile force can be stretched to an extended, pleated structure. The wool molecule contains three types of intermolecular and intramolecular bonds. (See Figure 5.3.) Listed in order of bond strength, these are as follows:

- 1. Cystine or sulfur crosslinks where the sulfur atoms of two amino acids are covalently bonded
- 2. Ionic bonds or salt bridges between two oppositely charged amino acids
- 3. Hydrogen bonds

The sulfur bonds can be broken by chemical treatment then reformed with the molecules in an altered position. This is the principle behind the permanent waving of hair, where hair is formed into curls; a solution is applied to break the sulfur bonds, and a neutralizer reforms the sulfur linkages in the curled position.

The hydrogen bonds are important in shaping wool fabrics during apparel construction and also in imparting pleats and creases. The bonds can be broken by moisture and reformed in the new position when the fabric is dried. Also, because these bonds contribute to the strength of the wool, the fiber is weaker when it is wet and the hydrogen bonds are broken. The ionic bonds are broken under either acidic or basic conditions.

Because of the helical structure and bulky side chains on the polymers, wool is only about 30 percent crystalline. The high amount of amorphous material decreases the strength but increases the absorption of water and dyes. It also causes wool fibers to be less dense and, therefore, lighter weight.

Properties of Wool

Physical Properties

Color. Wool fibers vary in natural color from white to creamy white to light beige, yellow, brown, and black. Wool may be dyed easily; however, it is difficult

CO
$$CH - CH_2 - S - S - CH_2 - CH$$
 $CO - CH - CH_2 - S - S - CH_2 - CH$ $CO - CH - CH - CH_2 - CH_2$

FIGURE 5.3
Structural formula for the wool molecule.

to keep white wool snow-white. The fiber tends to yellow from exposure to sunlight and with age. Bleaching is not a fully satisfactory means of keeping wool white because chlorine bleaches are harmful to the fiber and bleaching itself tends to cause some yellowing. Among the bleaches used in textile manufacture are oxygen bleaches such as hydrogen peroxide, sodium peroxide, and sodium perborate. An alternative bleaching process is called reduction bleaching; one such process, *stoving*, uses sulfur dioxide. Peroxide is the most common treatment.

Shape. The length of the fiber depends on the breed of sheep from which it comes and on the fiber's growing time. In general, fiber length ranges from one to fourteen or more inches, with finer fibers usually being shorter and coarser fibers usually being longer.

Wool fibers range from eight to seventy microns in diameter. Merino fleece fibers are usually seventeen to twenty-three microns in width, and the trend in breeding is toward production of animals with finer hair fibers. In cross section the fiber is oval or elliptical. The cross section may show three parts, the innermost part of which is called the *medulla*. Not all wool fibers possess a medulla, which is the section in which the pigment or color is carried and which provides air space. Most finer wools do not have a medulla. The next segment is the *cortex*, which makes up most of the fiber. Research has shown that the cortex is made up of microscopic cells that pack this area. The outer layer consists of a fine network of

FIGURE 5.4 Wool fiber micrograph: (a) cross-sectional; (b) longitudinal view showing scale structure along the fiber length. Photographs courtesy of the U.S. Department of Agriculture, Agricultural Research Service.

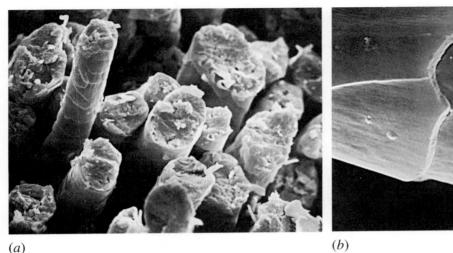

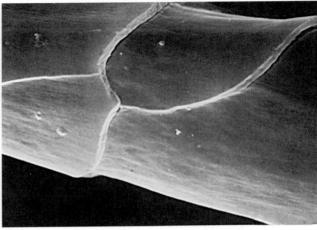

small, overlapping scales. The scale structure is responsible for the behavior of wool in felting and in shrinkage. (See Figure 5.4.)

The scales on the surface of the fiber overlap "like the tiles on a roof, with the protruding end of the scales pointing toward the fiber tip" (Boston 1984, 523). Because of the way the scales are arranged, the fiber can move in only one direction. As fibers are placed close together in a mass of fiber, or in yarns, or in fabrics, they entangle with one another. During washing, the cloth is compressed and manipulated, and the individual fibers are bent. The fiber, being highly elastic, slides through the entanglement but can move in only one direction. As all the fibers exhibit this unidirectional movement, the fibers are drawn closer together, causing the whole structure to become smaller, or shrink.

The scales also contribute to the dry feel of wool, even when it has absorbed a lot of water, and require the use of boiling temperatures to allow dyes into the fiber.

Wool fiber possesses one further quality that is important in its physical appearance and behavior: most types have a natural crimp, or curly, wavy shape. The crimp is due to chemical differences in the two halves of the cortex that cause them to react differently to environmental conditions. One side swells and stretches more, resulting in slight curvature. The bilateral structure of the cortex spirals around the fiber, producing a three-dimensional crimp. (See Figure 3.4.) The crimp increases the bulk and springiness of wool and makes it resilient. It also makes wool fiber relatively easy to spin into yarns. The manufactured bicomponent fibers produced today mimic wool, nature's bicomponent fiber.

Mixed into wool fleece are a number of kemp hairs. Kemp hairs are coarse, straight hairs that are often white and shiny and do not absorb dye easily. A large proportion of kemp hairs lowers the quality of the fleece and contributes to the scratchy feel of some wools that wearers often complain about.

Luster. The luster of wool is low because of the scaly, rough surface. Luster varies among different breeds of sheep, different sections of the fleece, and the conditions under which an animal has been raised. In general, the luster of poorquality wool is greater than the luster of better grades of wool.

Specific Gravity. The specific gravity of wool is 1.32. This relatively low density makes wool fabrics feel light in relation to their bulk. The ability of wool fibers to trap air also gives them an ability to provide warmth without excessive weight.

Mechanical Properties

Strength. Wool is a relatively weak fiber (tenacity is 1.0 to 1.7 g/d). The low strength is mainly due to the low degrees of crystallinity and orientation in the fiber. The strength decreases in wet wool because the hydrogen bonds are broken by water. Although the strength of wool is low, the fiber has high elongation owing to the helical structure.

Modulus. Wool fabrics stretch easily because of the low modulus of the fibers.

Elongation and Elastic Recovery. Wool is easily extended. The helical structure of the molecules allows them to be straightened when the fiber is stretched. It has fairly low recovery however, and as a result, garments that are stretched at the elbows or knees will often bag.

Resilience. The resilience of wool is excellent, a result of its natural crimp. Elasticity and resilience contribute to the appearance of wool products by giving them good resistance to, and recovery from, wrinkling. Wrinkles will hang out of wool garments, especially if they are hung in a damp atmosphere, as will creases, pleats, or other shape provided by pressing.

Chemical Properties

Absorbency and Moisture Regain. The sorptive properties of wool are among its most desirable features. It is an extremely absorbent fiber because it has a number of chemical groups that attract water and also because it has such an amorphous molecular structure. The moisture is held inside the fiber, not on the surface, so wool can absorb a significant amount of moisture without feeling wet to the touch. Yet wool is also water repellent. Spilled liquids run off its surface because the scale structure of wool inhibits wicking of moisture along the fiber surface. Surface moisture is absorbed slowly. Wool also gives up its moisture slowly. A further advantage is that wool retains its resilience even when wet, so it can become wet yet still insulate the wearer from cold.

The sorption and desorption process itself contributes to the comfort of wool fabrics. The fiber releases heat when it absorbs moisture, providing additional warmth to the wearer under humid, wet conditions. Conversely, wool absorbs heat when it dries. This gives it a cool feel when moisture is desorbed.

Heat and Electrical Conductivity. The conductivity of wool of both heat and electricity are low. Both the poor heat conductivity of wool fiber and its ability to trap air between the fibers contribute to its excellent qualities for cold-weather

clothing. Even though the electrical conductivity of wool is rated as poor, wool fibers do not build up static electrical charges unless the atmosphere is very dry. The ability of the fiber to absorb moisture improves its conductivity when humidity is present in the atmosphere. For this reason, wool garments sometimes generate static electrical charges indoors in winter when central heating of homes makes them warm and dry.

Effect of Heat; Combustibility. Wool will burn if a flame is held to the fabric, but it burns slowly, and when the flame is removed, the fabric may self-extinguish. The danger of flammability exists, but this factor is not as great as with many other fabrics. Wool can be treated for fire retardancy and is then useful in highly critical areas such as upholstery fabrics in airplanes and suits for race car drivers. Dry heat damages the fiber, producing a negative effect on both appearance and strength.

Chemical Reactivity. Wool fibers are damaged quickly by strong basic solutions; even relatively weak bases have a deleterious effect. Strong laundry detergents and soaps have "free" alkali added to increase their cleaning power, and extended exposure to this additional alkali may be harmful to wool. Wool fabrics should, therefore, be washed with special mild detergents. Acids do not harm wool except in very strong concentrations. This makes it possible to carbonize wool fleece to remove vegetable matter without harming the wool fiber.

Chlorine compounds used for bleaching damage wool. Hydrogen peroxide or sodium perborate bleaches can be used safely. Organic dry-cleaning solvents will not harm the fiber.

Environmental Properties

Resistance to Microorganisms and Insects. Mildew will not form on wool unless the fabric has been stored in a damp condition for an extended period of time. Fabrics should be put away only after they are completely dry.

One of the major problems in the care of wool is its susceptibility to damage from insect pests. Moths and carpet beetles are particularly destructive because the chemical structure of the crosslinks in wool is especially attractive to these insects. Care in the storage of wool is required to minimize attack by insects. Soiled clothing is damaged more readily than are clean fabrics as the insects may attack the spilled food as well as the wool. Wool fabrics with special finishes that prevent moth attack are referred to as being "mothproofed." Some of these finishes can be applied at the time of dry cleaning.

Consumers must exercise caution when using moth-repellents such as paradichlorobenzene crystals or napthalene flakes. These substances are poisonous if ingested by children or animals. Because prolonged inhalation of the fumes is also dangerous, treated textiles must be placed in airtight storage containers or in areas separated from living or working space. These chemicals should be placed above the garments because their vapors are heavier than air.

Resistance to Environmental Conditions. Exposure to sunlight will cause deterioration of wool, although it is less severely affected than cotton. Sunlight also

yellows white wool fabrics. Age will not affect wool adversely. However, because of their susceptibility to attack by moths, wool fabrics require careful storage.

Other Properties

Dimensional Stability. Wool has poor dimensional stability. As mentioned earlier, the tendency of wool to shrink and felt can cause fabrics and garments to decrease in size. The shrinkage of wool is progressive. In the first laundering, fabrics stretched in the weaving process tend to relax. But wool will continue to shrink with subsequent launderings if it is not washed in cool water with a minimum of handling.

Consumers should preshrink wool fabrics before sewing unless the fabric is labeled as having been treated to prevent shrinkage. Purchasers of wool ready-to-wear garments should look for labels indicating shrinkage control. Finishes can be given to wool to render the fabric washable. Such finishes are discussed at length in chapter 25.

Abrasion Resistance. Wool is not an inherently abrasion-resistant fiber. However, its resilience and flexibility in fabric structures help to absorb energy and provide durability. This property as well as wool's resistance to pilling are dependent on yarn and fabric construction. Loose yarn and fabric constructions will allow individual fibers to pull out and form pills that can be held onto the fabric surface by the rough fiber scales (Hopkins 1953).

Uses

The excellent insulating qualities of wool lead to its use for cold-weather clothing. Winter coats, warm sweaters, and men's and women's suits are frequently made of wool fabrics or blends of wool and other fibers. By using different kinds of wool yarns and variations in weave, a wide variety of attractive garments and accessories can be manufactured from wool. Wool's capacity for temporary setting makes the fiber ideal for tailored garments that are shaped through pressing techniques. Increasingly, wool is seen in lighter-weight garments made with finer fibers.

In the home, wool fabrics are made into carpets, blankets, upholstery fabrics, and sometimes draperies. Special coarse, resilient, durable wool fibers are produced for manufacture into carpets. Blankets of wool are warm without excessive weight and have the advantage of inherent flame resistance. The durability of upholstery fabrics will depend on the construction of the yarn and fabric, and those fabrics made from tightly twisted yarns with close, even weaves are most serviceable.

The disadvantages of wool used for apparel and in the home center on the tendency of fabrics to shrink and the susceptibility of wool to moth damage. Fabrics that have been finished to overcome both these problems are available, and appropriate handling during use and care will minimize these disadvantages. A disadvantage of wool for some individuals is that they may have allergic reactions from contact with the fiber. Some wool fabrics may have a rough or "scratchy" feel because of short, coarse fibers that stick out of the yarn.

See Take a Closer Look on page 102 for a discussion of some new wool products and interests.

TAKE A CLOSER LOOK

What's New with Wool?

Wool remains a premium fiber. Its price, varying over the past few years between \$2.50 and \$3.50 per pound, is a factor of supply and the cost of processing. While the consumption of wool worldwide has remained steady, product development and marketing have changed. As environmental awareness increases, wool's biodegradability and natural properties are seen as advantages. These properties have stimulated its use in a wider range of products than has traditionally been the case. In addition, many developments are aimed at altering some of the less positive characteristics of wool. Better spinning processes remove short, coarse fibers, leaving apparel fabrics of higher quality. Shrink-proof and moth-resistant finishes have been improved to make these fabrics more acceptable to consumers.

Consumer preferences for the traditional, tailored wool suits waned during the past decade, but renewed interest in more formal business attire has recently stimulated the wool market (Azoulay 2005). And the current production trend toward finer and finer wool fibers opens up the wool market to lighterweight apparel worn next to the skin. In addition, finer fibers have stimulated advances in processing to yield yarns that are quite smooth, unlike the fuzzy, hairy surface that has often been associated with wool. The very smooth fabrics are promoted as "cool wool" because they feel cool to the touch. This sense is heightened in a warm environment when the wool releases moisture and absorbs heat. So wool garments do not have to be relegated to winter wear and cold climates, but can be comfortable in warmer weather as well.

A further technological advance was the development of $Optim^{TM}$. In this process, wool fibers are stretched to reduce the diameter and remove the crimp. A steam treatment sets in this altered shape, producing a fine, silky fiber that is very smooth next to the skin.

Blends, especially wool/polyester blends, have stayed popular because the synthetic fiber can add strength and wrinkle resistance. Wool/cashmere blends are a high-price-point alternative, with considerable consumer appeal. The blend is cheaper than 100% percent cashmere, and when very fine wool fibers are used, they come close to the soft luxury of cashmere. A caveat for these, mainly imported, wool/cashmere blends is accuracy of labeling. The percentage of cashmere may be overstated by unscrupulous exporters, and the actual blend ratio can be hard to determine. Another blend that is being produced is with cotton for jeans. The wool in the denim fabric adds warmth and bulk. And for athletes, there is SportwoolTM. This fabric is a layered structure with fine Mmerino wool on the inside and polyester on the outside. The wool regulates the skin/fabric interface, while the synthetic outer layer protects and prevents the penetration of water.

Shrink-proof wools that can be machine washed and tumble dried remain popular and are being continuously improved. There are enzyme and other treatments that alter the scale structure of wool fibers to prevent felting while maintaining a soft fabric hand through multiple launderings.

Wool has long been used in handwoven oriental carpets and rugs. As a natural alternative to nylon carpeting, wool is popular for commercial buildings and for woven carpets. Its natural affinity for dyes makes wool, and other animal hair fibers with which it is sometimes blended, ideal for printed and woven patterns.

One of the widely publicized scientific breakthroughs of the last century was the cloning of the sheep Dolly in the United Kingdom. When Dolly was sheared, the precious ninety ounces of fiber from her fleece were carefully dyed and spun at Leeds University, and a national competition was conducted to design a sweater memorializing this discovery.

Care Procedures

Wool fabrics can be either laundered or dry-cleaned, although dry cleaning is preferable for wool fabrics that have not been specially finished to make them "washable." Dry cleaning minimizes shrinkage problems and is also recommended for lined and tailored garments. Commercial dry-cleaning solvents may include mothproof finishes that will protect wool garments from moth attack during storage.

Fabrics that have been given special finishes to render them washable should be laundered according to care directions attached to the fabric. Fabrics without special finishes must be handled gently because the fabric is weaker wet than dry and also to prevent felting of fibers because of friction. Wool products can be washed in lukewarm water using synthetic detergents that do not have added alkali. These detergents are labeled as safe for wool fabrics. Washing can be done by hand or machine, provided that the fabrics are submitted to minimal agitation. Agitation and friction produced in handling wool are more detrimental to the fabric than are high washing temperatures, so care must be taken to avoid placing undue stress on wool fabrics during laundering. Knitted garments, such as sweaters, should be measured before laundering, and while the garments are drying, they can be gently reshaped into their original size.

Chlorine bleach will damage wool fabrics, but hydrogen peroxide may be used for bleaching. Solvents used for spot and stain removal do not harm wool fabrics. However, care should be taken in the application of spot remover. Excessive friction or rubbing on the fabric surface may cause matting and felting of fibers in the treated spot. Pat the fabric gently rather than rubbing hard.

Wool fabrics should not be dried in an automatic dryer. The pounding action caused by tumbling damp fabrics may cause excessive felting shrinkage of the fabric. The dryer provides all the conditions conducive to felting: heat, moisture, and friction. Drying fabrics flat will prevent strain on any one part of the garment.

Because of the detrimental effect of heat on wool fibers, ironing temperatures should not exceed 300°F, and fabrics should always be pressed with a press cloth or steam.

SPECIALTY HAIR FIBERS

Many hair fibers possess qualities similar to those of wool. These fibers are produced in comparatively small quantities, but they do have an important place in the textile industry, particularly in high-status, prestige clothing items. Because of their limited production and use in luxury textile items, they are sometimes called "noble animal fibers" (Ghituleasa, Visileanu, and Ciocoiu 2004).

Cashmere

Cashmere fiber comes from the fleece of the cashmere (or kashmir) goat, an animal that is native to the Himalaya Mountains region of India, China, and Tibet. (See Figure 5.5.) Today India no longer produces any significant amounts of cashmere; China and Mongolia are the primary producers. Iran, Afghanistan, New Zealand, and Australia also produce cashmere.

The goats are "double-coated" with fine underhairs and longer, coarser guard hairs. In contrast sheep have been bred so they are (apart from a few kemps) single-coated. Only the fine underhair is useful for cashmere fabrics, and one goat can produce four to sixteen ounces of usable fiber. These fine fibers can be gathered by combing hairs from the animals during the shedding season. Alternatively, the entire coat can be sheared as is done with sheep. Shearing results in a fleece of mixed guard and fine fibers, so the fleece must then undergo "dehairing," a hand or mechanical process to remove the coarse guard hairs.

FIGURE 5.5

(a) Cashmere goat. (b) Female worker in Inner Mongolia removes fleece from a cashmere goat, using a special handmade comb with a wood handle and an adjustable bar that allows the iron comb to open wider as the supply of fleece increases. Photographs courtesy of Kairalla Agency

(b)

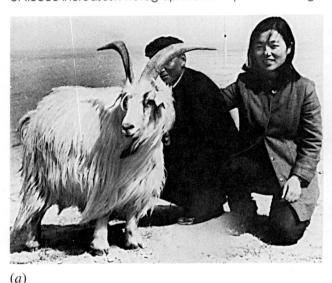

The softest fibers are 1.5 to 3.5 inches in length. Coarser and stiffer fibers range from two to five inches. Fibers are finer than are those in wool, about fifteen microns in diameter. It is this fineness that gives cashmere fabrics their soft, luxurious hand. Finer wool fibers, however, are now within the range of cashmere, and without documentation of origin, it can be difficult to distinguish these two fibers in blends. This becomes a labeling problem for imported textile items. The natural color of cashmere is gray, brown, or—less often— white.

Microscopically, cashmere displays a scale structure like that of wool, but the scales are thinner. When appropriately measured, scale thickness (or scale height, as it is sometimes referred to) can be used to distinguish cashmere from wool (Varley 2006). The cross section of cashmere fibers is round.

The chemical and physical behavior of cashmere is much like that of wool, although cashmere is more quickly damaged by bases.

The softness and luster of cashmere combined with its scarcity put this fiber in the category of luxury fibers that are expensive. The fiber abrades easily because of its softness, and because many of these fabrics are constructed with napped or fleecy surfaces, they require careful handling. Uses are sweaters, coats, jackets, and scarves for men and women. Cashmere is often blended with wool to decrease the cost of the item. It can also be blended with nylon for knits where higher strength and durability are desired.

Camel Hair

The two-humped Bactrian camel of central Asia is the source of camel hair fiber. (See Figure 5.6.) Camels are both a means of transportation and a source of fibers

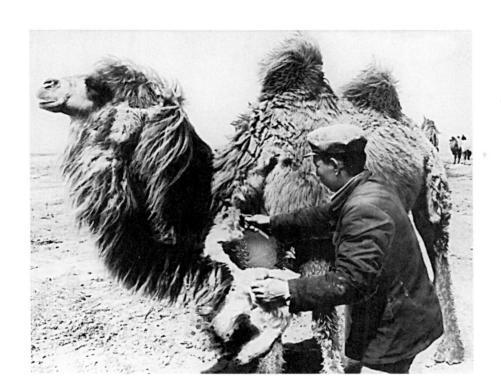

Figure 5.6

Two-humped Bactrian camel being sheared by Chinese worker. Courtesy of Kairalla Agency. Photograph by Boris Schlomm (Americale Industries).

in China, Mongolia, Iran, and Afghanistan. The traditional method of harvesting camel hair was gathering the hair shed during the molting season in the spring, and for the most part that is still the process used. Within the collected hair are found both fine, soft down called *noils*, and coarse, bristly hairs. Adult camels produce up to ten kilograms of fiber. As with cashmere, the clumps of fibers are dehaired to separate the fine and coarse hairs. The soft noils, which make up about 30 percent of the fiber, are used for making apparel. Rougher fabrics can be made with some of the coarser grades.

Under the microscope, camel's hair shows a scale structure similar to that of wool, but the scales are less visible and less distinctly seen. The cortex is distinct; the medulla is discontinuous. Both the cortex and medulla are pigmented. This pigment produces the light brown or tan color associated with camel cloth, and because it is not discolored by oxidation, it cannot be removed by bleaching. Therefore, camel fabrics are usually left in their natural color or are dyed to darker shades.

Camel hair provides excellent warmth without weight. It is said to have better insulating qualities than any of the other hair fibers, being designed by nature to protect the camel from the extremes of heat and cold in its indigenous mountain habitats. The fiber is relatively weak, however, and is subject to damage from abrasion because of its softness. Other physical and chemical properties of camel hair are like those of wool.

Most fine camel hair fiber is used for clothing, especially coating fabrics. Like other hair fibers, there is great variety in quality of camel hair fibers, and the consumer must evaluate these products carefully. Because it is easy to dye wool camel

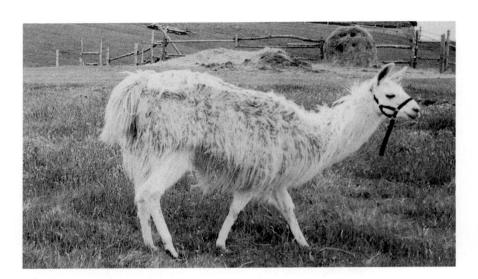

FIGURE 5.7 Llama.

color to blend it with camel hair, a final product may be misrepresented as "camel hair" when, in fact, the quantity of camel hair is relatively low. Camel hair fabric is expensive and should not be selected for its durability as it tends to wear readily. Coarse camel hair is used for industrial fiber, ropes, and paintbrushes.

Other Members of the Camel Family

There are several other animal species, related to the camel, from which textile fibers are obtained. These fibers represent only minor markets, but because they occasionally appear in specialty fabrics, they are briefly described. The llama and alpaca are domesticated animals; vicuña and guanaco are wild varieties.

Llama

The llama, reportedly native to North America, has been for centuries a source of fiber in the mountainous countries of South America. (See Figure 5.7.) Today raising llamas has spread once again to the northern hemisphere, with small farms in the United States, Canada, and Europe. They are raised not only for their fibers, but also as pets, pack animals, and even guard animals for livestock.

Like cashmere and camel, llama fleece consists of outer guard, or "coat," hairs and finer under hairs that are used for textile fabrics. The animals can be sheared, clipped, or brushed; the latter method is easily accomplished during shedding. These undercoat fibers are soft and lustrous. They are predominantly black and brown, but some lighter colors are found. Llama fleece is used by many Indian artisans to produce decorative shawls, ponchos, and other products. The fibers, which are often blended, are used for coatings, suitings, and dress fabrics.

Alpaca

Native to Peru, Bolivia, Ecuador, and Argentina, the domesticated alpaca produces a fleece of fine, strong fibers that have a glossy luster. (See Figure 5.8.) Recently, raising of alpacas has begun in other countries as well. The alpaca is sheared once

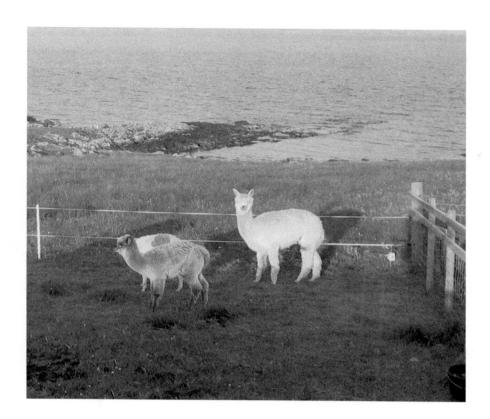

FIGURE 5.8 Alpacas.

every two years in the spring (November and December in the southern hemisphere). Alpacas do not have the coat of coarser guard hairs of their llama cousins, so separation of finer fibers from the sheared fleece is not necessary. Hairs average eight to twelve inches in length and range in color from white to brown to black.

Alpaca fiber is stronger and finer than llama or camel hair. (See figure CP6A on Color Plate 6.) It is used in suits, dresses, and upholstery fabrics. It may be made into blends with other fibers.

Llamas and alpacas have been crossbred, and the resulting animals have fleece with many of the same qualities and characteristics as those of the parents. An animal with a llama sire and an alpaca dam is called an *huarizo*. One with a llama dam and an alpaca sire is a *misti*.

Vicuña

A wild animal, the vicuña lives at very high altitudes in the Andes Mountains. Since the 1970s the Peruvian government has protected the vicuña, and the population has now stabilized to a healthy level. Highland farmers now herd and shear the animals, no longer killing them for their luxurious fibers.

The vicuña grows a fleece of very fine under hairs and a coat of guard hairs that are also fine and, therefore, difficult to distinguish. One vicuña yields about four ounces of extremely fine fiber and ten to twelve ounces of less fine fiber. The fibers are very light and short, so spinning is a challenge. One of the softest fibers

Table 5.2

Physical Dimensions of Animal Hair Fibers

Fiber	Diameter (µ)	Length (in)
Alpaca	22-34	
Angora Rabbit	12-13	2–3
Camel	15-22	1–3
Cashmere	11-18	1–2
Guanaco	14-18	1.8-2.2
Llama	20-30	
Silk	9-11	Continuous
Vicuña	11-14	<1
Wool (Merino)	12-24	1–14
Yak	12–24	1.2

known, vicuña is also the costliest. A vicuña coat is comparable in cost to a good fur coat. Its use is limited to luxury items. The natural color—a light tan or chestnut brown—is usually retained as the fiber is hard to dye.

Guanaco

Another wild animal, the guanaco, is herded and sheared in the same manner as the vicuña. Although supplies of the fiber are more readily available than vicuña, it remains a relatively expensive fiber. The guanaco is double coated with a layer of guard hairs, which are separated to leave the finer under hairs. They are premium fibers because they are soft and fine and the animal is a rare, protected species. Guanaco fibers are finer than alpaca and shorter than vicuña. (See Table 5.2.) They are usually reddish brown in color.

Mohair

Mohair fiber is taken from the angora goat. (See Figure 5.9.) The world's supply of mohair has declined dramatically over the past two decades and stands at less than 1 percent of natural fibers. South Africa is the largest producer, with 3.5 to 4 million kilograms annually (Schreiber 2006). The United States follows with two million kilograms, mainly from goats raised in Texas.

Angora goats, unlike their cashmere counterparts, have a single coat of hairs and so are sheared in the same way as sheep. Fleece is removed twice a year. Each animal yields from three to five pounds a year of four- to six-inch fiber. To obtain a supply of slightly longer fiber, some goats are sheared only once a year, in which case the fibers are nine to twelve inches in length.

The natural color of unscoured fleece is yellow to grayish white. Cleaning removes 15 to 25 percent of the weight. The clean fibers are white in color, silky, and fine in feel and appearance. Fibers are graded, with kids' or young goats' fleeces especially valued for their fineness. The cross section of the fiber is round, with the medulla being only rarely visible. Small air ducts are present between the cells of the fiber, which give it a light, fluffy feeling. The microscopic appearance of mohair is similar to that of wool.

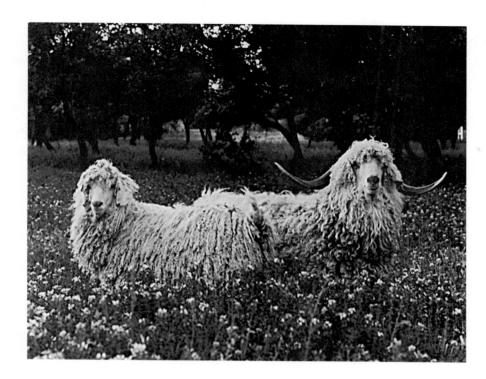

Angora goats, source of mohair fleece. Courtesy of the Mohair Council of America.

Most of the physical and chemical properties of mohair are very similar to those of wool. Mohair's high affinity for dyes makes it especially attractive for blending with wool and other animal hair fibers. The major differences between wool and mohair are the very high luster of mohair and its slippery, smooth surface. Mohair is especially resistant to abrasion. When viewed under the microscope, mohair shows fewer scales than wool. As a result, the fiber sheds dust and soil and neither shrinks nor felts as readily as wool. Mohair is easier to launder, as well.

The current uses of mohair stress products where its luster can be used to good advantage, and these include men's and women's suitings, upholstery fabrics, carpets, and draperies. Novelty yarns, such as looped or bouclé yarns, are often made of mohair, and mohair is blended with other fibers.

The cost of mohair fabrics tends to be higher than that of wool. The quality of mohair can vary a good deal, so the consumer must evaluate mohair products carefully.

Qiviut

Qiviut is the underwool of the domesticated musk ox. (See Figure 5.10.) Herds of musk oxen are cultivated in Alaska. These animals shed in the spring, at which time they are combed and the fine underwool is machine spun. Yarns are sent to Eskimo women in about fifty to sixty villages in the region, and they hand-knit a variety of products. Each village has a distinctive pattern unique to that settlement. The fiber is similar to cashmere in texture and softness. One-half pound of qiviut

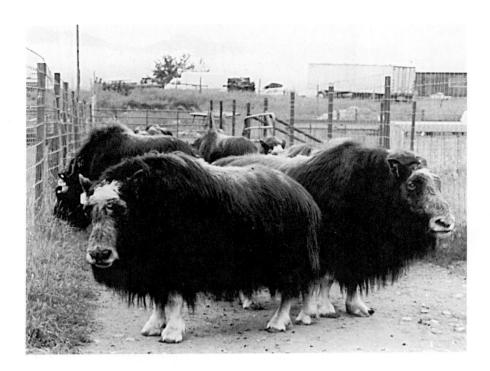

FIGURE **5.10**Domesticated musk oxen (with horns removed) being raised in Alaska.

will make a large, warm sweater. An equivalent garment in sheep's wool would require six pounds of fiber. Qiviut, like many specialty hair fibers that are in short supply, is very expensive.

Fur Fiber

Fibers from the pelts of fur-bearing animals are usually left on the skin, which must be treated in a process similar to tanning. (See chapter 15.) The fibers can, however, be removed and blended with other wool fibers to provide interest and soft texture. Fur fibers from animals such as the beaver, fox, mink, chinchilla, rabbit, and the like are used.

Fur Products Labeling Act

Relatively small quantities of fur fibers are used in the production of textiles. If fur fiber has been removed from the skin and incorporated in a textile product, it is designated as "fur fiber" and is subject to regulation under the TFPIA and the Wool Products Labeling Act of 1939. Fur that is attached to the animal skin is regulated by the Fur Products Labeling Act of 1951. This legislation requires that all fur products carry the true English name of the fur-bearing animal from which the fur comes. It also requires that furs be labeled with the country of their origin.

No fur may be given a trademark name of a fictitious or nonexistent animal. If furs have been worn or used by the ultimate consumer, they must be designated as "used fur." When fur is damaged from natural causes or from processing, it must be labeled as containing damaged fur. Any dyeing or bleaching or other treatments given to artificially color the fur must be disclosed.

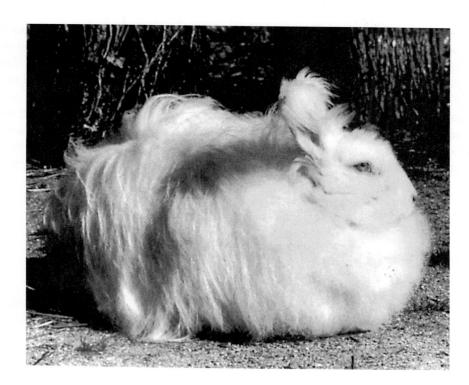

FIGURE 5.11

Angora rabbit. Courtesy of Amicale Industries.

Angora

Angora is the fiber from Angora rabbits. These rabbits have long, fine, silky, white hair. (See Figure 5.11.) The rabbits are raised in France, Italy, Japan, and the United States. The fiber is obtained by combing or clipping the rabbits. Angora rabbit fiber is exceptionally fine (thirteen microns), but is slippery and hard to spin. Angora is used chiefly in novelty items and is often knitted. Sweaters are often made of angora blended with nylon and wool. The fibers tend to slip out of the yarns and increase in length on the surface of the fabrics so some persons have the mistaken notion that angora hair "grows."

Cow Hair and Horsehair

Cow hair is sometimes blended with wool in low-grade fabrics used for carpeting and blankets and in felts. Horsehair serves as a filling or stuffing material for mattresses and upholstered pieces. In the past it was woven into a stiff braid for use in millinery or dressmaking, but this use has been replaced, for the most part, by synthetic fibers. Rubberized horsehair has been used to make carpet underlays.

SILK

History of Silk Culture

Silk originated in China, the first habitat of the silkworm, which grew wild and lived on the leaves of a species of mulberry tree. Although some animal hair and flax fibers can grow to considerable length, silk is the only natural fiber that is hundreds of meters long.

Silk is made by the silkworm as it builds its cocoon. The substance is *extruded* from its body in one continuous strand from beginning to end. It is possible to unwind the cocoons and obtain long silk filaments. The Chinese discovered this process and, recognizing the potential value of the fiber it produced, guarded the method closely for hundreds of years. Silk has a natural beauty, and its history has been surrounded by legends. Chinese folklore credits the discovery of silk to Princess Si Ling Chi, who reigned about 2650 BC. According to legend, after watching a silkworm spin its cocoon in her garden, she attempted to unwind the long filaments. After much experimentation, she succeeded. She instructed her serving women in the art of weaving rich and beautiful fabrics from the long silk threads. So grateful for her discovery were the Chinese that they transformed Princess Si Ling Chi into a goddess and made her the patron deity of weaving (Lewis 1937).

Silk Production

Cultivation of the Silkworm

Silk is the only natural filament fiber that has significant commercial value. Produced by a caterpillar known as a "silkworm," silk can be obtained either from cultivated silkworms (*Bombyx mori*) or wild species.

Silk from wild species is limited in quantity and produces a coarser, stronger, short fiber known as *tussah silk*. Tussah silk has short fibers because the cocoons from which it is taken have been broken or pierced. When wild silk is spun by caterpillars that feed on oak leaves, the silk is light brown or tan in color and cannot be bleached.

By far the largest quantity of silk comes from *sericulture*, the controlled growth of domesticated silkworms to produce the silk fiber. Whether the silkworms be domesticated or wild, they go through four basic stages of development:

- 1. Laying of the eggs by the silk moth
- 2. Hatching of the eggs into caterpillars, which feed on mulberry leaves
- 3. Spinning of a cocoon by the caterpillar
- 4. Emerging of the silk moth from the cocoon

The science of sericulture has been perfected over many thousands of years. Today all stages of development are carefully controlled, and only the healthiest eggs, worms, and moths are used for the production of silk. (See Figure 5.12.)

Selected moths of superior size lay from four hundred to six hundred eggs or seeds on prepared cards or strips of cloth. Each seed is about the size of a pinhead. These eggs can be stored in cool, dry places until the manufacturer wishes to begin their incubation.

Incubation is done in a mildly warm atmosphere and requires about thirty days. At the end of this time, the silkworms hatch. They are about one-eighth inch in length. The young silkworms require constant care and carefully controlled diets. Shredded or chopped young mulberry leaves are fed to the worms five times each day. Worms that appear to be weak or deformed are discarded. The areas in which worms are grown are kept scrupulously clean. For about a month, the worm grows, shedding its skin four times. When fully grown, worms are about three and a half inches in length.

FIGURE 5.12

- (a) Silk moth laying eggs; (b) silkworms on a bed of mulberry leaves; (c) silkworm beginning to spin cocoon;
- (d) completed cocoon. Photographs courtesy of the Japan Silk Association.

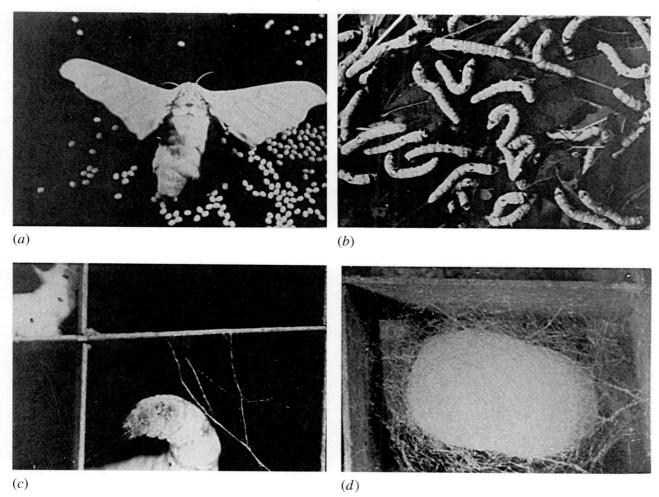

When its size and activity show that the worm is about ready to begin to spin a cocoon, the silkworm is transferred to a surface of twigs or straw. From two sacs located in the lower jaw, the worm extrudes a substance made up of two strands of silk (fibroin) and a gummy material (sericin) that holds them together. Moving its head in the shape of a figure eight, the worm surrounds itself with a cocoon of up to sixteen hundred meters of fiber. The completed cocoon is about the size of a peanut shell and takes two to three days to spin. If the worm is permitted to live, it will change into a pupa or chrysalis then to a moth. After two weeks, the moth breaks through the cocoon and emerges, mates, lays eggs, and begins the cycle again.

Only those moths selected as breeding stock are permitted to complete the cycle. These are selected from the largest and heaviest cocoons. The rest of the cocoons are subjected to dry heat that kills the pupa.

Occasionally, two silkworms will spin a cocoon together. This produces a cocoon made of a double strand of silk and is known as *doupion* silk (*doupioni*, in Italian).

Reeling of Silk

The whole, unbroken cocoons are sorted according to color, texture, size, shape, and other factors that will affect the quality of the fiber. Reeling of silk is, to a large extent, a hand operation done in a factory called a *filature*. Several cocoons are placed in a container of water at about 140°F. This warm water serves to soften the *sericin*, the gum that holds the filaments of silk together. Little of this gum is actually removed in reeling. The outer fibers are coarse and short and not useful in filament silk. They are separated and are used for spun silk, which is made from short fiber lengths.

The filaments from four or more cocoons are held together to form a strand of yarn. As the reeling continues, a skilled operator adds or lets off filaments as needed to make a smoother strand of uniform size. Several skeins of silk weighing fifty to one hundred grams each are combined into a bundle. Each bundle is called a *book* and weighs from five to ten pounds. These are packaged into bales for shipping.

Silk Yarns

The making of silk filament yarns is called *throwing*. Reeled silk filaments can be combined into yarns immediately. Short, staple-length silk fibers must be spun. Short outside fibers of the silkworm's cocoon, the inner fibers from the cocoon, and the fiber from pierced cocoons are known as *frisons* and are made into spun silk yarns. Fibers are cut into fairly uniform lengths, combed, and twisted into yarns in the same way that other staple fibers are spun.

Gum Removal

As mentioned earlier, the sericin that holds the silk filaments in place in the cocoon is softened but not removed in reeling. This gummy material makes up about 25 percent of the weight of raw silk. It is removed before throwing, after throwing, or after the fabric has been woven. A soap solution is used to wash the gum from the silk. In some silk fabrics, called *raw silk*, the sericin has not been removed.

Regulation of Silk Weighting

During the latter part of the nineteenth century, the technique of *weighting* was employed extensively to add body and weight to silk fabrics after removal of the gum. In passing silk through a solution of metallic salts, the salts are absorbed by the fiber, with a corresponding increase in the weight of the fabric. Silk can absorb more than its own weight in metallic salts, so this excess weight on the fiber will, eventually, cause the fabric to break.

This practice had become so widespread that a good deal of poor-quality fabric was being sold. Because the buyer could not tell from its appearance or hand that the silk had been weighted, the Federal Trade Commission (FTC), in 1938, began overseeing silk weighting by passing its pure silk regulations.

These FTC regulations are still in effect. Other than some weighting of silk for neckties and for products requiring especially heavy fabrics, few silk fabrics are now weighted. The regulations require that fabrics labeled "silk" or "pure dye silk" contain from 0 to 10 percent weighting. All silk fabrics that have more than 10 percent weighting must be labeled as weighted silk unless they are black in color. Black silks are able to hold a greater quantity of weighting than are other colors without degradation, so black silks can be weighted up to 15 percent.

Locale of Production

Because the culture of silkworms requires so much hand labor, sericulture has been most successful in countries where labor is less expensive. No silk is produced in the United States. China is the largest silk producer in the world, followed by India, Japan, and Brazil. Only China and Brazil export silk fiber; India and Japan consume most of theirs domestically. Although Japan is the world's largest consumer of silk per capita, it produces almost no silk for export. Italy is the largest exporter of finished silk goods but imports the silk fiber from which those goods are made. This is also true of England and France, which produce finished silk fabrics. Increasingly, though, China is engaged in processing silk fibers in addition to producing raw silk (Currie 2001).

Molecular Structure

Like wool, silk is composed of polypeptide chains, but it has fewer amino acids and no sulfur linkages. The polymer molecules are not coiled but are extended. This structure allows the chains to be more tightly packed, increasing the crystallinity of the fiber. Hydrogen bonds and salt bridges crosslink adjacent molecules, contributing to the strength.

Properties of Silk

Physical Properties

Color. The natural color of cultivated silk is off-white to cream. Wild silk is brown.

Shape. The cross section of silk is triangular in shape. (See Figure 5.13.) The double silk filaments lie with the flat sides of the triangles together, surrounded by the sericin coating. (See Figure 5.14.)

The fiber has a smooth, transparent, rodlike shape with occasional swelling or irregularities along its length. It is fine, having a diameter of nine to eleven microns, and filaments may be as short as three hundred meters or as long as one thousand meters. Individual filaments as long as three thousand meters have been measured.

Luster. The luster of degummed silk is high but not as bright as manufactured fibers with round cross sections. Although the surface of the fiber is smooth, the roughly triangular shape changes the pattern of light reflection.

Specific Gravity. The specific gravity of silk is less than that of cellulose fibers and is similar to that of wool. Lightweight fabrics can be made of silk because of the fine diameter of the fiber and its high tenacity.

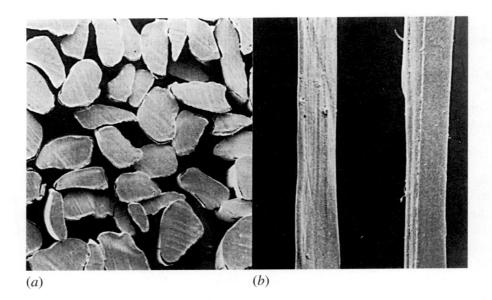

FIGURE 5.13

Micrographs of (a) cross-sectional and (b) longitudinal view of silk fibers.

Reproduced courtesy of the British Textile

Technology Group.

Mechanical Properties

Strength. Silk is one of the strongest of the natural fibers. (Its tenacity is 2.8 to 5.2 g/d.) It is stronger than wool because of its higher crystallinity. Its wet strength is slightly less than its dry strength because the hydrogen bonds between protein polymers are broken by moisture.

Modulus. Silk has a moderately high modulus. This means that it will resist an initial tensile force more than will wool and will not stretch as easily.

Elongation and Recovery. The elongation of silk fibers before breaking is about half that of wool but considerably higher than cotton. It has fairly good recovery if stretched only slightly but will not recover completely from high extensions.

Resilience. Silk has a moderate degree of resilience. Creases will hang out of silk, particularly under moist conditions, but its wrinkle recovery is slower and not as good as that of wool.

Chemical Properties

Absorbency and Moisture Regain. The absorbency of silk is good (the moisture regain is 11 percent), making it a comfortable fiber to wear. Silk can be printed and dyed easily to bright, clear colors if appropriate dyes are used.

Heat and Electrical Conductivity. The heat conductivity of silk is low, so densely woven fabrics can be relatively warm. However, because sheer, lightweight fabrics also can be woven from silk, it can be used for lightweight, summer clothing.

FIGURE 5.14

Position of silk fibers within "gum" before processing.

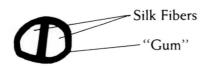

Because the electrical conductivity of silk is not high, silk tends to build up static electricity charges, especially in dry atmospheres.

Effect of Heat; Combustibility. When placed in a direct flame, silk will burn, but when the flame is removed, the silk may self-extinguish. Therefore, silk is not considered an especially combustible fabric. Like wool, silk is damaged by dry heat and should be ironed damp, at low temperatures and using a press cloth.

Chemical Reactivity. Like other protein fibers, silk is sensitive to the action of bases. Acids will harm silk more quickly than they harm wool. Chlorine bleach deteriorates the fiber, but hydrogen peroxide or other oxygen bleaches can be used. Organic chemical solvents used in dry cleaning will not affect silk. Perspiration will cause deterioration of the fabric. Perspiration can have a negative effect on dyes, causing discoloration after repeated exposure; therefore, silk fabrics should always be cleaned before they are stored.

Environmental Properties

Resistance to Microorganisms and Insects. Mildew is not a problem with silk. Moths do not harm clean silk, but carpet beetles will attack the fabric.

Resistance to Environmental Conditions. Sunlight deteriorates silk even more rapidly than it does wool, causing white fabrics to yellow. Age will lead to eventual deterioration of fabric strength. Silk fabrics should be stored away from light. Antique fabrics should be sealed off from the air.

Weighting of silk causes it to crack, split, and deteriorate much more quickly than it would otherwise. (See Figure 5.15.) Historic items made of silk before silk weighting was introduced may still be in good condition. Weighted silk garments dating from the 1870s to the 1930s often shred and break apart.

FIGURE 5.15
Silk fabric from the skirt of a historic garment of the 1890s that has deteriorated as a result of silk weighting.

Other Properties

Dimensional Stability. The dimensional stability of silk is moderate. It does not stretch to any significant extent but may exhibit relaxation shrinkage because of its higher moisture absorbency.

Abrasion Resistance. Silk is not resistant to abrasion. While the fibers themselves have some ability to absorb energy, their fineness makes them vulnerable to wear. Filament silk fabrics will not pill under abrasive action.

Special Finishes Applied to Silk

Silk has long been considered a luxury fabric, delicate and requiring special care. Popular casual silk garments, such as shirts and jeans, introduced in the 1970s were given a special finish called *sandwashing* (see the discussion of sueding in chapter 24). These garments had an attractive faded appearance; they were soft; supple; and most important, washable. Washed silks, even though expensive, became popular, and by the 1980s, major American designers had put them into their collections.

As washable silks gained in popularity, other finishes were used to alter their hand. *Sueded silk* was finished with a slight nap. Treatment with alkali broke down the sericin coating, caused small pits in the fibers, and raised short fibers during tumble drying. To make apparel easier to care for, soil- and stain-resistant finishes were applied.

Uses

The beauty of silk fabrics is legendary. For many centuries silk was synonymous with luxury and was used for garments worn on feast days, festivals, and other occasions of great importance. Wall hangings of silk were used to decorate the homes of the wealthy, and carpets woven of silk were used in the homes of the rich in Persia and China.

The increased use of washable silk in casual clothing and larger supplies worldwide as a result of silk's exclusion from textile import limitations have made silk items increasingly available to most consumers. Although the quality may vary, the range of apparel for which silk is used has expanded in recent years, and silk or silk blends can be found in women's dresses, blouses, slacks, and lingerie; men's trousers, shirts, and neckties; knitted cold-weather underwear; and various accessories. Raw silk is popular for summer-weight suits and jackets.

Silk may also be found in some high-priced drapery and upholstery fabrics. The performance of silk fabrics in these uses is rather poor. Upholstery fabrics of silk are often made in weaves that show up the luster of the fabric but abrade easily. Sunlight will deteriorate drapery fabrics of silk. Draperies made of silk should be lined with some other fabric to protect the silk from constant exposure to the sun.

Table 5.3 offers a comparison of the two major protein fibers: silk and wool.

TABLE 5.3
Selected Properties of Wool and Silk Fibers

Property	Wool	Silk
Specific gravity	1.32	1.25 (degummed)
Tenacity (g/d) Dry Wet	1.0–1.7 0.8–1.6	2.4-5.1 1.8-4.2
Breaking elongation (%)	30-40	24
Modulus	Low	Moderate
Resiliency	Good	Moderate
Moisture regain	≈15%	11-12%
Burning	Burns, does not melt	Burns, does not melt
Conductivity of Heat Electricity	Low Low	Low Low
Resistance to Fungi Insects	Good Damaged by moths	Good Damaged by moths
Prolonged exposure to sunlight	Loss of strength	Significant loss of strength
Chemical resistance to Strong acids Strong bases Oxidizing agents Solvents	Good Poor Poor Good	Poor Poor Poor Good

Care Procedures

Silk fabrics should be stored away from direct sunlight both to avoid yellowing of white fabrics and to prevent loss of strength. Long-term storage of silk wedding gowns or other items is best done in containers that are sealed against air and carpet beetles. Care labels should be followed to determine the best care procedures for individual silk garments. Some dyes used on silk are susceptible to bleeding or loss of the dye. Check by wetting a small and inconspicuous spot (perhaps a seam or facing area) and blot the damp area between paper towels, pressing hard. If color appears on the paper towel, the fabric is not colorfast and should be dry-cleaned.

Today many silks have been dyed with dyes that do not fade in water, making the items washable. Even for silk items labeled as washable, though, care labels should be followed closely to avoid problems. When washing the textiles by hand, launder in a mild detergent that contains no added alkali. Do not wring or scrub, especially on fabrics made from smooth, solid color filaments where wear is more likely to show. Chlorine bleach should never be used on silk. Rinse garments thoroughly; then roll them in a clean bath towel to absorb excess moisture.

If machine washing is recommended, use a gentle, two-minute wash cycle; lukewarm water; and mild detergent. Do not tumble dry unless care labels direct as the surface may be abraded or the fabric may be more likely to shrink. To dry, place garment on plastic hangers (wire hangers can cause rust stains). Iron while still damp at low ironing temperatures of 300°F or lower. Although badly wrinkled silk fabrics will require pressing, many creases will hang out of silk fabrics without ironing, especially those with a soft, casual look. Washable silks should not be drycleaned because their dyes can be removed or lightened by dry-cleaning solvents.

Spider Silk

Protein filaments are spun not only by wild and cultured silkworms, but also by many species of spiders. The chemical makeup of spider silk is determined not only by the spider species, but also by diet, weather, and other factors. It is similar to silk from silkworms in that it contains no sulfur.

Spider silk has some unique features, which have spurred researchers to attempt to produce an artificial spider silk. Spider silk fibers are round in cross section and, with a diameter of about five microns, are much finer than filaments spun by silkworms. The fibers that anchor the web and support the spider are known as *dragline silk*. (See Figure 5.16.)

The fibers in spiderwebs have higher tenacity and elongation than silk, giving them the ability to absorb the impact energy needed to catch and hold the spider's prey. The fibers would thus be very desirable, especially for high-performance end uses where impact resistance is important.

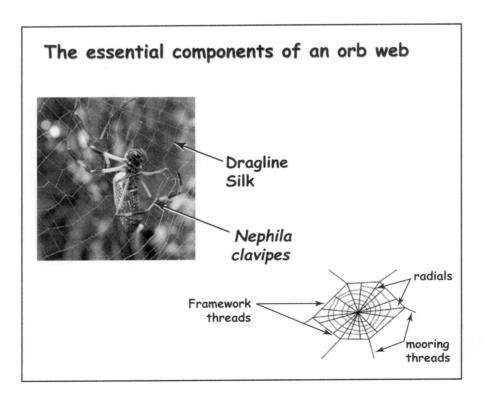

Photograph and diagram of spiderweb showing different types of filament fibers. Photograph courtesy of Michael Ellison.

Although domesticating spiders for production of fibers is not a realistic endeavor, researchers have attempted to mimic the process of spinning spider silk to produce fibers with this unique combination of high strength, high elongation, and very low weight. Using molecular genetics, spider silk proteins have been synthesized by injecting genes from the spiders into yeasts, plants, or animals. Currently, all such efforts are still experimental in nature, but there is much to be gained from producing such an advanced material by a sustainable method.

REGENERATED PROTEIN FIBERS

Some years ago corn, peanuts, and soybeans were used as starting materials for regenerated protein fibers. The generic name for these fibers is *azlon*. Although these earlier attempts were not commercially successful, renewed interest in environmentally sustainable products has resulted in the manufacture of a fiber branded as Soysilk[®]. The starting material is the protein remaining after production of tofu, a soy product. The fibers are advertised as soft, smooth, and lustrous. They are sold in yarns for hand knitting.

SUMMARY POINTS

- Protein fibers are animal hair fibers or silk filaments extruded by worms or spiders
- Wool
 - o Most widely used animal hair fiber is wool from sheep
- · Other commercial animal hair fibers
 - · Cashmere and mohair from goats
 - o Fibers from camel family: camel, llama, alpaca, vicuña, and guanaco
 - Rabbit hair from angora rabbit
- Distinctive features of animal hair fibers
 - Outer layer of overlapping scales and some degree of three-dimensional crimp
 - High bulk and low weight
 - Low fiber strength and modulus
 - High moisture absorbency
 - Not washable due to high shrinkage
 - Harmed by bleach
 - o Biodegradable
- · Extruded protein fibers
 - Silk from silkworms
 - Only commercial protein filament fiber
 - Luxury fiber
 - Spider silk is being cultivated experimentally
- Distinctive features of extruded protein fibers
 - Higher strength and modulus than animal hair fibers
 - Smooth surface
 - · Washable but may shrink or fade

122

Questions

1. What are some of the physical and chemical properties common to most protein fibers?

2. Define the following terms that are applied to wool: *lamb's wool, pulled wool, virgin wool, recycled wool, shoddy.*

3. Explain how the chemical structure of wool accounts for (1) its ability to be set into pleats and creases and (2) its resiliency.

4. How does the physical structure of wool affect its properties?

5. What are the distinguishing characteristics of each of the following specialty hair fibers?

cashmere alpaca camel hair vicuña mohair Angora rabbit

- 6. Define the following terms that are applied to silk: *degumming, raw silk, tussah silk, doupion, throwing, weighting, sandwashing, spun silk.*
- 7. Under what conditions should silk products be dry-cleaned? Under what conditions should they be washed?
- 8. What are the differences in mechanical properties between spider silk and silk from silkworms?

References

Azoulay, J. F. "The Natural Brilliance of Wool." *AATCC Review* 5, no. 10 (2005): 24. Boston, W. S. "Wool." In *Encyclopedia of Textiles, Fibers, and Nonwoven Fabrics*, edited by M. Grayson, 523. New York: Wiley, 1984.

Currie, R. "Silk." In *Silk, Mohair, Cashmere and Other Luxury Fibers*, edited by R. R. Franck. Camgridge, UK: Woodhead Publishing, 2001.

Federal Trade Commission. Rules and Regulations under the Wool Products Labeling Act of 1939. Washington, D.C.: Federal Trade Commission, 1986.

Ghituleasa, C., E. Visileanu, and M. Ciocoiu. "Aspects Regarding Romanian Angora Mohair Fibres, Characteristics, Application Fields." *Journal of Natural Fibers* 1, no. 2 (2004): 13.

Hopkins, G. E. Wool as an Apparel Fiber. New York: Rinehart and Co, 1953.

Lewis, E. The Romance of Textiles. New York: Macmillan, 1937.

Schreiber, C. "South African Mohair Producers Find Much to Like in U.S. Visit." *Mohair SA Newsletter* November (2006).

Thiry, M. C. "A Wooly Conundrum." AATCC Review 5, no. 10 (2005): 19.

Varley, A. R. "A Modified Method of Cuticle Scale Height Determination for Animal Fibers." *AATCC Review* 6, no. 5 (2006): 39.

Recommended Readings

Franck, R. R., ed. *Silk, Mohair, Cashmere and Other Luxury Fibres*. Cambridge, UK: Woodhead Publishing, 2000.

123

- Hyde, N. "The Queen of Textiles [Silk]." *National Geographic* 165 (January 1984): 2.
- Hyde, N. "Wool-Fabric of History. National Geographic 173 (May 1988): 554.
- Mahish, S. S., and S. K. Laddha. "Spider Silk: The Miracle Material." *AATCC Review* 5, no. 1 (2005): 14.
- Simpson, W. S., and G. H. Crawshaw, eds. *Wool: Science and Technology.* Cambridge, UK: Woodhead Publishing, 2002.

Together the commence of the second (ABE) as the Commence of the Acceptance of the A

TO A PER MORE CLASSIC CONTROL OF THE CONTROL OF THE

The specific control of the control

MANUFACTURED CELLULOSIC FIBERS

Learning Objectives

- 1. Describe the production processes for regenerated and modified manufactured cellulosic fibers.
- Relate the distinctive properties of each manufactured cellulosic fiber to its textile end uses.
- 3. Describe care procedures for manufactured cellulosic fibers.

or thousands of years, the only fibers used for textiles were those found in nature, even though, as early as 1664, English scientist Robert Hooke suggested that people ought to be able to create fibrous materials that had the same qualities as natural fibers. However, neither Hooke nor any of his contemporaries were equal to the task. In the nineteenth century, a number of scientists had begun to look seriously for techniques for creating fibers, attempting to imitate the silkworm in extruding a material that would harden into fiber form. Their search was successful when nitrocellulose, the first rayon fiber, was obtained as early as 1832. Further experimentation and development followed, resulting in a number of different commercial fibers produced during the twentieth century.

Although they were the first manufactured fibers, production of the cellulosics has declined rapidly over the past decades as the synthetic fibers (polyester, nylon, and olefin) have grown. From 1982 to 2002, manufactured cellulosic fibers decreased from 21 percent of all manufactured fibers to 6 percent (American Fiber Manufacturers Association n.d.). As plants in the United States and Europe closed, production shifted to countries in Asia.

RAYON

Rayon was the first regenerated fiber. While nitrocellulose-based rayon was developed in the mid-1800s, large-scale manufacture based on alternative methods started around 1900. These fibers were all referred to as "artificial silk," the name "rayon" not being officially adopted until 1924. The basic principle of taking a natural material that is not usable in its original form and regenerating it into usable textile form remains the same. These, and other fibers developed later, whether they used natural or synthetic sources, were for many years known as "man-made" fibers. They are now more correctly referred to as "manufactured" fibers. (See chapter 2.)

The FTC definition of rayon identifies rayon as "a manufactured fiber composed of regenerated cellulose, as well as manufactured fibers composed of regenerated cellulose in which substituents have replaced not more than 15 percent of the hydrogen of the hydroxyl groups." As Table 6.1 shows, these are the unmodified cellulosic fibers. The major fiber groups that fall within this definition are viscose rayon, cuprammonium rayon, and high-wet-modulus (HWM) rayon. Although no longer produced in the United States, viscose rayon accounts for by far the largest amount of rayon manufactured worldwide. The modified cellulosic fibers acetate and triacetate will be described later.

VISCOSE RAYON

Raw Materials

Wood pulp is the major source of cellulose used to produce viscose rayon and other manufactured cellulosic fibers. Cotton fibers, especially the short cotton linters, can also be used. Most of the timber used comes from eucalyptus, beech,

TABLE 6.1
Regenerated Cellulose Fibers

	Process	Fibers	Uses
Unmodified cellulose	Viscose	"Regular" rayon (called "viscose" in Europe)	Apparel, alone and in blends
		High-wet-modulus or polynosic rayon (called "modal" in Europe)	Apparel, especially blends with polyester
		High-tenacity rayon	Industrial uses, especially tire cords
	Cuprammonium	Bemberg rayon, or "cupro"	Apparel and lining fabrics
	Lyocell	Lyocell	Apparel
Modified cellulose	Acetate	Acetate	Apparel and linings, cigarette filters
		Triacetate	Heat-settable apparel, often blended with polyester

^{1.} The source for this and all subsequent fiber definitions is the Textile Fiber Products Identification Act, section 303.7.

FIGURE 6.1 Small sheets of dissolving pulp.

or pine trees that are raised in nurseries. Harvested trees are stripped of their bark, sun-dried, then cut into strips, and finally reduced to chips. Chips are treated to remove lignin (binding agents) and to remove as much of the resin as possible.

The resulting dissolving pulp is more than 95 percent cellulose, a purer grade than the wood pulp used for making paper. It is pressed and cut into blotterlike sheets for further processing. (See Figure 6.1.)

Manufacture

The following steps are employed in the process for manufacturing viscose rayon from these sheets of cellulose. Because cellulose is not easily dissolved, it is treated to produce a soluble form that can be spun into fibers. Figure 6.2 shows the process in a flowchart.

- 1. Steeping or Slurrying. The quantity of cellulose is measured carefully by weight then placed in a soaking press, or slurry press, where it remains immersed in a solution of sodium hydroxide (caustic soda) for about an hour. The action of the sodium hydroxide is similar to that in mercerization in that it swells the structure and separates the polymer chains. The excess solution is pressed out of the pulp material, leaving a slurry consisting of a substance called alkali cellulose.
- 2. Aging. Alkali cellulose is shredded into small, fluffy particles called white crumbs. These are aged under carefully controlled conditions for several days. During this time the cellulose chains are broken into shorter polymers that can be dissolved more easily.
- 3. Xanthation. Carbon disulfide is added to the white crumbs, which produces sodium cellulose xanthate and changes the color to bright orangeyellow. The large xanthate groups push the polymers farther apart, and the cellulose xanthate is then soluble in sodium hydroxide.

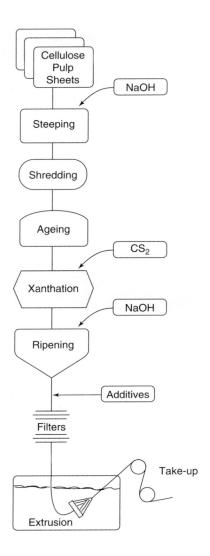

Flowchart showing the manufacture of viscose rayon fiber.

- 4. *Dissolving and Ripening*. The orange-yellow crumbs are placed in dissolving tanks of dilute sodium hydroxide and aged for a time. The resulting solution is thick and viscous and is known as *viscose*, the term from which this fiber process derives its name. In color, the solution is gold with a consistency similar to that of honey.
- 5. Filtration. The viscose solution is filtered to remove any insoluble particles. This is important because the particles would clog the spinneret holes and interfere with the spinning process. It is at this point that delustering agents (such as titanium dioxide) or pigments for coloring the fiber may be added.
- 6. *Extrusion*. The final step in the formation of the fiber is the forcing of the viscous liquid through the spinneret. The solution is wet spun into a dilute sulfuric acid bath. The acid hydrolyzes the xanthate, thereby reversing the xanthate formation and regenerating the cellulose in the form of long, continuous filaments that are then washed to remove chemicals or other impurities.

This basic viscose process is used to make regular rayon fibers. However, it is easy to understand that the process is capable of much modification—for example, in the aging and ripening steps and the composition of the spinning bath—and these changes form the basis of other types of rayon made from viscose.

Because of environmental problems associated with the process, viscose rayon is no longer manufactured in the United States. The evolution of hydrogen sulfide and carbon disulfide gas during the regeneration step and the runoff from the sulfuric acid bath are difficult and expensive to control. The viscose process is still, however, the most commonly used and economical production method worldwide.

High-wet-modulus Rayon

A Japanese researcher, S. Tachikawa, modified the viscose process to develop a fiber with a physical structure more like that of cotton. In this process the alkali cellulose is not aged after the steeping step, the cellulose xanthate is dissolved in water rather than in caustic soda, and the ripening step is eliminated. A lower concentration of acid is used in the spinning bath with little or no salts. The fibers are stretched more during spinning than are regular rayon fibers.

These rayons are known as high-wet-modulus (HWM), which means that they, like cotton, have greater resistance to deformation when wet. Other names for HWM rayon are polynosic rayon and modal. The Lenzing Group of Austria, a leading producer of cellulosic fibers worldwide, manufactures Modal[®] fibers under its own brand name. There are also high-tenacity rayons made, primarily for tire cords.

Molecular Structure

Rayon is composed of cellulose, like cotton. In viscose rayon, however, the cellulosic chains are much shorter. The degree of polymerization is only about four hundred to seven hundred, compared to six thousand to ten thousand for cotton. The molecules are also less ordered, the crystalline areas are smaller in size, and the fiber has a higher amount of amorphous material. HWM fibers have longer polymer chains and a more crystalline structure, but the degree of polymerization is still less than one thousand.

Properties of Viscose Rayon

In the production of manufactured fibers, many qualities can be built into the fiber. For this reason, it is difficult to generalize about all rayon fibers because each manufacturer may produce viscose rayons that differ somewhat.

Rayons have generally been used in many of the same kind of products for which cotton is used. When compared with cotton, rayon fabrics display certain disadvantages. They are not equal in firmness and crispness, have poorer dimensional stability, and stretch and shrink more than cotton. They lose strength when wet, so rayons must be handled carefully both in industrial processing and in home laundering. An advantage of rayon, however, is its superior drapability, a quality desired by many designers. Table 6.2 gives the properties of the major manufactured cellulosic fibers.

 $_{\mbox{\scriptsize TABLE}}$ 6.2 Comparison of Characteristics of Regenerated Cellulosic Fibers and Cellulose Derivative Fibers

Property	Regular Viscose Rayon	High-Wet- Modulus Rayon	Lyocell	Acetate	Triacetate
Specific gravity	1.51	1.51	1.56	1.32	1.3
Tenacity (g/d)		u u	C		
Vet Wet	0.5-1.5	1.8-4.0	5.0 4.3	0.8-1.0	0.8-1.0
Moisture regain (%)	11-15	11-14	=======================================	9	4
Resilience	Poor	Fair	Good	Poor	Fair
Burning	Burns, does not melt	Burns, does not melt	Burns, does not melt	Burns, melts at 500°F	Burns, melts at 575°F
Conductivity of Heat Flectricity	High High	E E E	High Figh	Moderate	Moderate Moderate to high
Resistance to					
damage Irom Funai	Damaged	Damaged	Damaged	Fair	Resistant
Insects	Attacked by	Attacked by	Attacked by	Silverfish may	Silverfish may
Sunlight	Loss of strength	Some loss of strength	Some loss of strength	Some loss of strength	Moderate
Chemical					
resistance to					
Strong acids	Poor	Poor	Poor	Poor	Poor
Strong bases	Poor	Excellent	Excellent	Causes saponification	Causes saponification
Oxidizing agents	Good	Good	Good	Good	Good
Solvents	Good	Good	Good	Dissolved	Damaged
				by dcetone	by acetone

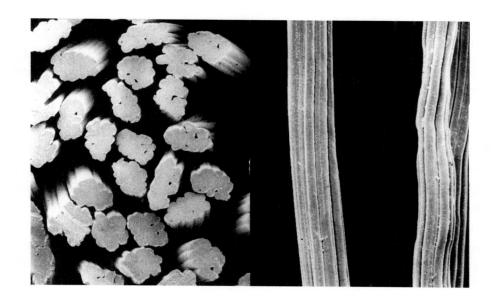

FIGURE 6.3 Photomicrograph of regular viscose rayon in cross-sectional (left) and longitudinal view (right). **Photomicrographs** courtesy of British Textile Technology Group.

Physical Properties

Color and Luster. As spun, rayon fibers are white in color. Their luster can be modified by adding titanium dioxide, a delustering agent, to the solution before the fibers are extruded.

Shape. The cross section of regular viscose rayon fibers is circular with serrated edges. When lengthwise fibers are examined microscopically, longitudinal lines called striations are seen. (See Figure 6.3.) The striations on the surface of viscose rayon are a visual effect caused by the appearance of the serrations created when the skin of the fiber formed at a faster rate than the core. When the core is formed, the skin, which is larger, collapses slightly to form an irregular, "wrinkled" surface. HWM rayons have a less crenulated cross section because the regeneration of the cellulose is retarded in the spinning bath, resulting in less of a skin and core structure.

Specific Gravity. The specific gravity of rayon is 1.51, comparable to that of cotton and linen (1.54), which are also composed of cellulose. Viscose, cotton, and linen fabrics of similar weave and construction will be of comparable weight.

Mechanical Properties

Strength. The strength of viscose rayon is low because of its lower polymer chain length (when compared with cotton and flax). (See Take a Closer Look in chapter 2.) Furthermore, rayon is weaker than cotton because its physical structure is different. During the growing process, cotton develops a fibril structure, the layers or rings of which protect the fiber and provide greater strength. Ordinary rayon has no fibril layers in which the crystallinity of the physical structure is increased. Instead, rayon has a more amorphous inner structure. There is a considerable decrease in strength when the fiber is wet. Rayon fabrics must be handled carefully during laundering. The tenacity of regular rayon ranges from 1.0 to 2.5 g/d for dry fibers and 0.5 to 1.5 g/d for wet fibers.

HWM rayons have higher strengths: from 3.0 to 5.7 g/d, dry, and 1.9 to 4.3 g/d, wet. The higher tenacity is due to their longer polymer chains and more crystalline structure. It should be noted that, while these fibers are stronger than regular rayons, their tenacities are similar to, or lower than, those of most nylon and polyester fibers.

Modulus. Viscose rayon fibers have a fairly low resistance to stretching. HWM fibers, on the other hand, were specifically designed to have a high modulus, more comparable to that of cotton and polyester. This makes HWM rayon a good choice for blending with polyester.

Elongation and Recovery. Viscose rayons stretch and, having low elastic recovery, tend to remain stretched. For some time after stretching, the distorted fabric tends to "creep" toward, but not completely to, its original length.

Resilience. The elastic recovery of rayon is low, as is its resiliency. Untreated rayons tend to stretch and wrinkle badly. Wrinkle-resistant finishes are generally not applied to viscose rayon because they weaken the fiber.

Chemical Properties

Absorbency and Moisture Regain. The molecular structure of viscose is more amorphous than that of cotton or linen, making viscose fibers more absorbent than the natural cellulosics. Moisture regain is 11 percent. Viscose accepts dyes readily because of its increased accessibility. Also, fibers with larger surface areas dye more readily, and the serrated edge of the rayon fiber provides greater surface area. The absorbency of the fiber makes clothing of viscose comfortable to wear.

Heat and Electrical Conductivity. The conductivity of both heat and electricity of viscose rayon is satisfactory, so the fiber is reasonably comfortable in hot weather and does not build up static electricity.

Effect of Heat; Combustibility. Viscose fabrics must be ironed at lower temperatures than cotton. Too-high ironing temperatures will produce scorching; rayons should be ironed at temperatures below 350°F. Long exposure to high temperatures deteriorates the fiber.

The fibers burn with characteristics similar to those of cotton. Viscose rayon fabrics continue to burn after the source of the flame has been removed, and burning fabrics have the odor of burning paper. A soft, gray ash remains after burning.

Chemical Reactivity. The amorphous molecular structure of viscose makes it more susceptible to the actions of acids and bases. Acids attack viscose more readily than cotton or other cellulosic fibers. Viscose is more susceptible to damage from bases as well.

Environmental Properties

Resistance to Microorganisms and Insects. Viscose is subject to damage from mildew and rot-producing bacteria. Silverfish will attack the fiber. Care in storage is necessary to prevent exposure of the fabric to conditions that encourage mildew and silverfish.

Resistance to Environmental Conditions. Exposure to sunlight will deteriorate viscose rayons more rapidly than cotton. Although it is often used in curtains and draperies, viscose rayon is not especially satisfactory for these products unless they are lined to protect against sunlight. Age does not have a deleterious effect on viscose rayons if care is taken to be sure fabrics are stored in a clean, dry condition.

Other Properties

Dimensional Stability. Rayon fabrics may be stretched during processing and exhibit relaxation shrinkage upon a first laundering. Because the moisture regain of rayon is high, the amount of shrinkage is usually fairly high as well. Fibers may continue to shrink in subsequent launderings. Special finishes can be given to viscose to overcome some of the problems of shrinkage. Rayon fabrics can be prewashed or treated with special finishes to stabilize them.

Abrasion Resistance. The resistance of rayon fibers to abrasion is extremely low, and the resistance decreases when the fibers are wet. Durability is not a quality generally associated with rayon.

Uses

Viscose rayon is used in fashionable wearing apparel, ranging from lingerie to suits, dresses, and sportswear. Its use is dictated by its aesthetic rather than its durability properties. Especially notable is the drape of rayon fabrics. Because rayon is among the denser of the commonly used fibers and has a lower modulus, the weight of the fabric and its low stiffness help to develop the pleasing folds associated with good drapability. The HWM rayon Modal[®], increasingly produced in finer deniers, is marketed in intimate apparel and loungewear for its softness.

To compensate for its lower strength and abrasion resistance, viscose rayon is often blended with other fibers that may be more durable. Modal® fibers are blended with cotton for knits and towels. Blends of rayon and polyester are seen in soft, drapable fabrics for apparel and in men's dress pants where these blends provide a worsted effect at a lower price point. Another common blend is rayon with acetate for women's apparel. Regular and HWM rayons are not distinguished in U.S. labels, so without a brand name, it is not always possible to know which rayon is contained in the blend. In the home, rayon fabrics or blends of rayon with other fibers can be found in tablecloths, slipcovers, upholstery, bedspreads, blankets, curtains, and draperies.

Because of their absorbency, rayon fibers are used in the manufacture of a wide variety of nonwoven fabrics, both disposable and durable. Often they make up the "cotton balls" sold for cosmetic uses and are being blended with other fibers in diapers and disposable hygiene products. In the industrial realm, rayon fibers have been experimented with as a starting material for carbon fibers and are also used in tire cord.

Care Procedures

Fabrics made from rayon have had a broad range of quality and price. Dry cleaning is usually recommended for regular viscose fabrics because of their low strength,

abrasion resistance, and dimensional stability. Consumers should be sure to follow care label instructions closely.

Some rayon fabrics may be washed, but caution should be observed in laundering because the fiber is weaker when wet and can be damaged more easily by rough handling. Hand washing is often recommended. HWM rayons have better wet strength and are more suitable for regular laundering. Drying in an automatic dryer may accentuate rayon's tendency to shrink. When pressing rayon fabrics, use lower ironing temperatures. Chlorine bleaches must be controlled carefully to avoid fabric deterioration. Oxygen (or perborate) bleaches are safer for rayon fabrics, if bleaching must be done.

CUPRAMMONIUM RAYON

Cuprammonium rayon is different from viscose rayon in that it is made by dissolving cellulose in a copper ammonium solution and extruding the fiber into a water bath. The manufacture of cuprammonium rayon was discontinued in the United States in 1975. It is still being manufactured in Italy, Japan, and eastern Germany. Water waste from the cuprammonium process is contaminated with chemicals, mainly copper, that must be removed to meet clean-water standards in the United States. The cost of removing chemical pollutants from the water is significant, and this factor has resulted in discontinuance of its manufacture in the United States.

Properties of Cuprammonium Rayon

Properties of this type of rayon are similar to those of viscose rayon. The fiber has a somewhat more silklike appearance and feel and is often manufactured in finer diameters. It is also slightly stronger.

Under the microscope cuprammonium rayon appears to have a round cross section and a smooth longitudinal appearance. No striations, or extremely fine striations, appear on the surface.

The fiber can be made into lightweight fabrics. A brand name fabric, Bemberg Rayon, often used in linings, is made of cuprammonium fibers. Good conductors of heat and fairly absorbent, these fibers are especially suitable for use in warmweather clothing. Consumers may find cuprammonium rayon fibers labeled as *cupro*. Films and hollow fibers of cuprammonium rayon are used in making artificial kidneys as they exhibit superior performance in removing impurities and cause less blood clotting than do other manufactured fibers.

LYOCELL

The fiber *lyocell* represents a new generation of manufactured cellulosic fibers. It was developed by Courtaulds, a European fiber manufacturer, and first produced commercially under the brand name Tencel[®]. The process is sometimes referred to as solvent spinning, where the cellulosic starting material is directly dissolved in an organic solvent and the fiber is regenerated from that solvent. The Lenzing Group acquired Tencel[®] in 2005 and is currently the only producer of lyocell fibers.

The fiber is designated as a subcategory of rayon. Specifically the FTC states that, "where the fiber is composed of cellulose precipitated from an organic solution in which no substitution of the hydroxyl groups takes place and no chemical intermediates are formed, the term lyocell may be used as a generic description of the fiber."

Manufacture

The raw material for lyocell, like that for viscose rayon, is dissolving pulp. The solvent N-methylmorpholine oxide (NMMO) is mixed with the pulp, and when the mixture is heated, the cellulose dissolves. There is no degradation of the polymer, as is necessary in the viscose process, because the cellulose dissolves directly at the high temperature. The resulting clear, viscous solution is filtered then extruded through an air gap into a bath of dilute NMMO in which the cellulose is precipitated as a fiber. (See Figure 6.4.)

A major advantage of this process is that it is self-contained. The solvent is not toxic and also has low volatility during processing, so there are almost no harmful emissions. Further, the NMMO is reclaimed from the spinning bath and recycled. Because this solvent-spinning technology can more readily meet environmental regulations, lyocell is often billed as the "green" fiber.

Properties of Lyocell

Chemical and environmental properties of lyocell are similar to those of rayon. It has high moisture regain, is comfortable to wear, and dyes readily. Physical structure, however, is somewhat different, and lyocell has better mechanical properties.

Physical Properties

Tencel® lyocell has a smooth cross section, without the serrations characteristic of viscose rayon. Because of the manner in which the fibers form during spinning,

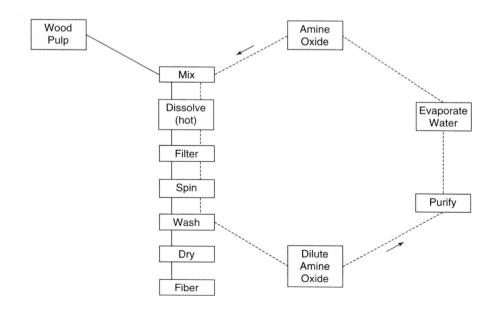

FIGURE 6.4

Flowchart showing the spinning process for Tencel[®] lyocell fibers. Illustration courtesy of Courtaulds Fibers, Inc.

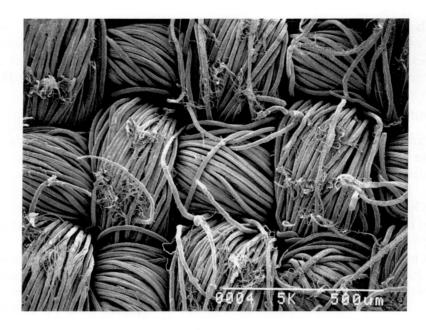

Photomicrograph of fabric with lyocell yarns (vertical) and viscose rayon yarns (horizontal). Fibrillation of the lyocell fibers and striations in the rayon fibers are visible.

they are highly crystalline, and as a result, small fibrils tend to splinter off from the surface. This *fibrillation*, which is enhanced under conditions of wet abrasion, gives lyocell a fuzzy appearance and reduces the luster of the fibers. (See Figure 6.5.) It also makes dyeing the fabric challenging. The amount of fibrillation can be controlled by finishing treatments to give a soft or "peach skin" effect (White 2001).

Mechanical Properties

Lyocell has high strength for a regenerated cellulosic fiber. The tenacity of Tencel[®] lyocell is 5.0 g/d dry and up to 4.3 g/d when wet. This compares favorably with polyester, which can vary from 4.0 to 7.0 g/d when dry or wet. Lyocell has a higher modulus than rayon, making it a good fiber for blending with cotton. Elongation is between that of regular and HWM rayon, and wrinkle recovery is better. In addition, lyocell can be treated with wrinkle-resistant finishes without diminishing its strength severely.

Other Properties

Lyocell fabrics do not exhibit the high shrinkage of rayon fibers. Their durability is also higher, but abrasion, especially wet abrasion, will increase the fibrillation of the fibers.

Uses

Lyocell is used in men's and women's apparel such as shirts, blouses, pants, jackets, and dresses. (See Figure 6.6.) Soft, denim-look shirts and pants will often be made of lyocell, where the peach-skin surface effect is very appealing. Increasingly lyocell is seen in household linens and is even a fibrous filling for pillows. Its combination of

FIGURE 6.6 Casual dress of Tencel® Ivocell fibers. Dress by Fresh Produce. Photograph by Robert L. Brewer, Jr.

mechanical properties has enabled textile producers to successfully blend it not only with cotton, but also with wool, linen, silk, nylon, and polyester.

Lyocell fibers were originally used only in fairly tightly woven structures to inhibit fibrillation. New versions have been produced by crosslinking the fibers as they are spun to control fibrillation. They can, therefore, be used in a wide variety of knits, which are looser fabric structures.

Care Procedures

Easy-care properties are a significant advantage for lyocell fabrics. They have good dimensional stability and moderately good wrinkle resistance and so can be washed, although dry cleaning may be recommended for some items. Finishes can be applied to increase wrinkle recovery, and lyocell fabrics require less finish than does cotton or rayon.

A problem in laundering that must be considered is the fibrillation that can occur. Fabrics rub against each other in laundering, and in the wet state, this can increase the fibrillation, altering the appearance and ultimately the strength of the fabrics. The severe conditions in commercial laundering may accelerate this effect. More information on lyocell's use and care is provided in the Take a Closer Look section of this chapter.

TAKE A CLOSER LOOK

Lvocell: The "Green" Fiber

Lyocell was the first new manufactured fiber to be developed in many years. The name was derived from *lyo*, meaning solution, and *cell*, for cellulose, in recognition of the fact that the fiber is cellulose spun from a solution. The process for making lyocell is environmentally benign in that the solvent used to dissolve the cellulose is nontoxic and has actually been used in a number of cosmetic and hair products. In addition, the solvent is almost completely recycled during the manufacturing of the fiber. Tencel® has received a number of awards for its environmentally benign manufacturing process, including the ecolabel of the European Union.

Lenzing AG, which makes Tencel[®], manufactures fibers for higher-end apparel and home furnishings where the aesthetics of rayon, with added durability qualities, have appeal. Lyocell fabrics have good drape, even in heavy weights, and are comfortable to wear because of their high moisture absorbency. They can also be dyed in a wide range of colors.

The tendency of lyocell to fibrillate, that is, to have very small microfibrils break off from the fiber surface, is utilized to produce various surface textures. The fibrils create a fine, soft finish that is variously referred to as "peach skin," "mill wash," or "soft touch." The amount of fibrillation can be controlled by fiber spinning processes and by finishing treatments that deliberately cause fibrillation by subjecting wet fabric to agitation and abrasion then shearing it to produce a fine, even surface. The intensity of the treatment and

the manner of shearing can be controlled to produce a range of fabric surface textures. Lyocell fabrics with these finishes are made into shirts, jackets, and pants. The soft hand gives a casual look to the garments, and they have the added advantage over regular rayon of being machine washable.

The propensity of lyocell to fibrillate is considered an aesthetic advantage but can be a drawback when items are laundered. After numerous washings the fibrillation becomes worse and can cause changes in surface appearance as well as decreases in strength. Because fibrillation is increased under conditions of wetting and agitation, treatments to the fabrics during dyeing must be carefully controlled.

Fortunately, there are nonfibrillating versions of Tencel® available; they give a smoother fabric hand that is desired for household linens, a growing market for lyocell. Sheets, comforter covers, and pillowcases of lyocell are made from fine yarns, allowing for a higher thread count. As expected, these are luxury items, due to the cost of lyocell relative to other fibers. The lower fibrillating lyocell fibers are also used in knits, where the fibers will retain their original appearance better in the looser fabric structure.

Lyocell fibers are considerably stronger than rayon, both wet and dry, and therefore, can be laundered. Fabrics are usually given a finishing treatment to stabilize them so they will have low shrinkage. This is especially important for bedding fabrics.

Вамвоо

A new regenerated cellulosic fiber is being manufactured using bamboo as a starting material. The bamboo stalks are pulped in an alkaline process then spun into fibers using a proprietary method. The production is claimed to be environmentally benign and yields a fine, soft fiber with antibacterial properties. (See figure CP2A on Color Plate 2.) Viscose rayon fibers are also made from bamboo pulp.

ACETATE AND TRIACETATE

A chemical derivative of cellulose, cellulose acetate, was used as a coating for the fabric wings of World War I airplanes. It caused the fabric to tighten up and become impervious to air. After the war, the demand for this material decreased, and the manufacturers of cellulose acetate sought another market for their product.

Intensive research yielded a process for converting cellulose acetate into a fiber with high luster and excellent draping qualities. The fiber was known at the time as "acetate silk."

The resulting confusion between real silk and artificial silk led the FTC to establish a separate name for the manufactured fibers. In 1924 the term rayon was established to include both regenerated cellulose and cellulose acetate. In 1953 an FTC ruling established separate categories for rayon and acetate and for triacetate, another derivative cellulose fiber.

Cellulose acetate and cellulose triacetate are classified as derivative cellulose fibers, distinguished from the rayons and lyocell, which are regenerated cellulose fibers. Both types of acetate are based on cellulose, but while rayon and lyocell are simply cellulose, some or all of the —OH groups on the cellulose molecules in acetate and triacetate are esterified (converted into ester groups), which modifies the behavior and properties of these fibers. In particular, the modification makes the acetate fibers thermoplastic.

Manufacture

In the chemical reactions that take place during the manufacture of cellulose acetate (and cellulose triacetate), acetyl groups (-OCOCH3) are substituted for -OH groups on the cellulose molecule. This process is known as acetylation.

All three available hydroxyl groups in the cellulose molecule are acetylated. When a substance is formed from cellulose in which all three hydroxyl groups have been acetylated, the material is called cellulose triacetate. If one-third of the acetyls are removed by hydrolysis, the substance is called cellulose acetate or cellulose diacetate. Both are used in forming textile fibers, but triacetate is no longer produced in the United States.

The initial stages of formation of both acetate and triacetate are the same. (See Figure 6.7.) Dissolving pulp is steeped in acetic acid for a time to make the material more reactive. After further treatment with still more acetic acid, acetic anhydride is added. This mixture is stirred until it is thoroughly blended, but no reaction takes place until sulfuric acid is added to the mixture. The sulfuric acid begins the acetylation reaction. The temperature is kept low because the reaction gives off a great amount of heat, and the mixture stands for seven or eight hours until it takes on a thick, gelatinous consistency. The material formed is triacetate, also known as primary acetate because it is made first. From this point, the procedure differs, depending on whether acetate or triacetate is being made.

Triacetate

To produce triacetate fibers, water is added to the viscous solution. The triacetate can no longer be held in this weak solution and precipitates out in the form of small, white flakes. These flakes are collected, dried, and dissolved in a solution of methylene chloride and a small quantity of alcohol. The fibers are dry spun through a spinneret into warm air, solidified, and formed into yarns. The hazards associated with methylene chloride and the engineering challenges of recovering the solvent were the primary reasons for discontinuing production of this fiber in the United States.

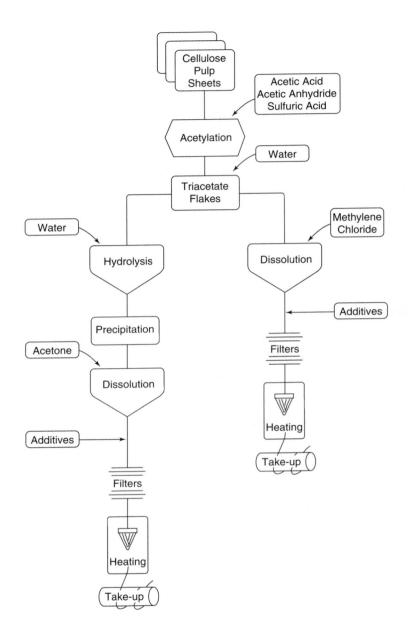

Flowchart showing the manufacture of acetate and triacetate.

Acetate

To follow the steps in the spinning of regular acetate, we must return to the formation of triacetate, or the primary acetate. The next step is the conversion of the base acetate into a diacetate. The primary acetate, excess acetic acid, and acetic anhydride from the first reaction are combined with sufficient water to produce a 95 percent solution of acetic acid. This mixture stands for twenty hours, during which time acid hydrolysis takes place and some of the acetylated hydroxyl groups are reconverted to their original form. This mixture is tested constantly so the reaction is stopped at the appropriate point. The mixture is poured into water, and the cellulose acetate precipitates into chalky, white flakes that are collected, washed, and

dried. This is the secondary acetate, so called because it is produced in a secondary step. Because it is the predominant fiber in this class, however, it is usually referred to as just acetate.

Flakes from different batches are mixed together to maintain a uniform quality of acetate. The flakes are dissolved in acetone, a common, nontoxic solvent. Before spinning, the flakes are dissolved in acetone to form the spinning solution, or "dope." This takes about twenty-four hours. The solution is filtered then extruded through spinnerets into warm air that evaporates the acetone. When filament yarns are being produced, the extruded fibers are given a slight stretch that orients the cellulose molecules, making the fiber somewhat stronger. For other uses a "tow" of thousands of fibers is collected.

Properties of Acetate and Triacetate

The properties of acetate and triacetate are summarized in Table 6.2.

Physical Properties

Shape. In microscopic appearance, acetate and triacetate are similar. Normally, both fibers are clear and have an irregular, multilobed shape in cross section rather like popcorn. Acetate may be manufactured in other cross sections as well; however, most commercially available acetate fibers with unusual cross-sectional shapes have been withdrawn from manufacture.

The longitudinal appearance of regular acetate and triacetate fibers shows broad striations. It is not possible to distinguish regular acetate fibers from triacetate fibers by microscopic examination. (See Figures 6.8 and 6.9.)

Luster and Color. If acetate and triacetate have not been treated to decrease luster, both fibers will have a bright appearance and good luster. Fibers that have been delustered show small, black spots of pigment in the microscopic longitudinal view and cross section. Fibers are white unless pigments have been added to the spinning.

Specific Gravity. Acetate and triacetate are both lower in specific gravity, at 1.32 and 1.3, respectively, than rayon or cotton. Comparable fabrics, therefore, feel lighter when made of acetates or triacetates than if they are woven of cotton, linen, or rayon.

FIGURE 6.8 **Photomicrographs** of acetate fiber in: (a) cross-sectional and (b) longitudinal view. Photomicrographs courtesy of the DuPont Company.

Photomicrographs of delustered triacetate fiber in: (a) cross-sectional and (b) longitudinal view. Photomicrographs courtesy of the DuPont Company.

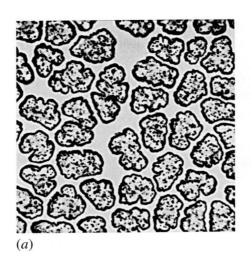

Mechanical Properties

Strength. Both acetate and triacetate have very low strength. These fibers were, however, developed for end uses where strength is not a primary consideration. Both are weaker wet than dry, but the effect is not as great for triacetate because it is less absorbent.

Modulus. Both fibers have a low modulus, similar to that of rayon and lower than cotton. They stretch easily and feel soft to the touch.

Elongation and Recovery. Acetate and triacetate differ in their abilities to recover from stretching. That of acetate is much lower if it is extended more than 5 percent.

Resilience. Triacetate has better wrinkle resistance than acetate and better recovery, especially after wetting.

Chemical Properties

Absorbency and Moisture Regain. Acetate is more absorbent than is triacetate. Acetate has a moisture regain of 6.3 to 6.5 percent, whereas triacetate regains only 3.5 percent of moisture. Acetate has more of the cellulose hydroxyl groups remaining for attracting water.

Heat and Electrical Conductivity. Neither heat nor electrical conductivity of acetate and triacetate are as good as the conductivity of other cellulosic fibers. Both fibers tend to build up static electricity charges, and neither acetate nor triacetate is as cool to wear as cotton, linen, or rayon.

Effect of Heat; Combustibility. Both acetate and triacetate are thermoplastic fibers; they soften and melt with the application of heat. Acetate is particularly sensitive to heat and melts at a lower temperature. Triacetate is normally given a special heat-setting treatment that makes it much less sensitive to heat than acetate. Surface designs such as moiré (see chapter 24) can be heat-set in acetate. If triacetate is stretched during heat treatment, the crystallinity of the molecule can be increased. Heat-treated triacetate can be permanently set into pleats or other shapes.

If ignited, acetate and triacetate burn with melting. When the flame has been put out, a small, hard, beadlike residue remains at the edge of the burned area.

Chemical Reactivity. Acetate and triacetate are fairly resistant to acids and bases, although acetate can be converted back to cellulose with strong bases. Both fibers can be bleached with oxygen bleaches. Acetate dissolves in acetone, and triacetate is also affected by this solvent.

Environmental Resistance

Resistance to Microorganisms and Insects. Mildew will grow on acetate or triacetate if the fabrics are stored in a soiled condition. The growth causes discoloration of the fabric but no serious loss of strength. Triacetate is more resistant to mildew than is acetate. Moths or carpet beetles do not attack either fiber.

Resistance to Environmental Conditions. Extended exposure to sunlight will cause a loss of strength and deterioration of acetate fabrics. Draperies should be lined to protect them from the sun. Triacetate has moderate resistance to sunlight. The resistance of acetate to ultraviolet light is decreased if the fiber has been delustered.

Acid fumes in the atmosphere may adversely affect some dyes used for acetates. The chemical nature of acetates requires that they be dyed with a type of dye known as disperse dye. Certain of these dyes are subject to atmospheric fading, or fume fading. Blue and gray shades, after exposure to atmospheric gases produced by heating homes with gas, turn pink or reddish. Greens may turn brown.

To overcome this problem, acetate fibers may be colored in the solution before the fiber is extruded from the spinneret. Pigment that is added to the acetate solution is locked into the fiber permanently and cannot change in color. In addition to solution dyeing, special finishing agents can be applied to acetate and triacetate fabrics to stabilize colors and prevent fume fading. Also, some blue dyes that are not reddened by gas fumes have been developed.

Acetate does lose some strength through aging. Triacetates resist deterioration with age.

Other Properties

Dimensional Stability. Triacetate fibers have good resistance to stretch or shrinkage. Acetate fabrics may exhibit relaxation shrinkage on laundering unless they are pretreated. Knit fabrics are especially prone to relaxation shrinkage, showing as much as 10 percent shrinkage during laundering. Exposure to high temperatures may also cause acetates to shrink.

Abrasion Resistance. Neither acetate nor triacetate is abrasion resistant. They are not generally used in items for which durability is an important property, but abrasion can be a problem in acetate linings. Nylon hosiery wearing against acetate satin linings in coats provides sufficient abrasion to cut these fibers.

Uses

Acetate is used for many household and apparel textiles because it has an attractive appearance and pleasant hand and is inexpensive. Decorative fabrics, such as brocade, taffeta, or satin, are woven to take advantage of the high luster and wide color range available in acetate fabrics. They often can be seen in formal wear for women and in handsome drapery and upholstery fabrics. Velvets, too, are often fabricated from acetate yarns. Acetate is also used extensively in linings for suits and jackets. While acetate has an advantage over polyester in terms of comfort for linings (McCullough 1999), it has poorer abrasion resistance. This susceptibility to abrasion is also a problem for acetate in upholstery. Acetate yarns are used in some fabrics together with yarns of other fibers to provide a contrast between the luster of acetate and dull appearance of, for example, cotton or rayon.

Other interesting applications are in ribbons, casket linings, and choir and graduation robes. One of the highest volume uses of acetate is cigarette filters. The tiny fibers of acetate tow in the filter provide a large surface area for absorbing compounds from the burning tobacco.

Filament acetate is produced by Eastman Chemical Company under the trademarks of Chromspun[®], a producer-colored fiber, and Estron[®]. Celanese Acetate makes acetate tow fibers. Mitsubishi makes Lynda[®] filament yarns for apparel and linings, and Carolan[®] for cigarette tow. SK Chemicals in Korea produces both filament yarns and acetate tow. In 2002 acetate producers formed the Global Acetate Manufacturers Association (GAMA) to promote the image and use of the fiber.

Triacetate fabrics have the advantage of being able to be heat-set. Apparel in which pleat or shape retention is important is often made from triacetate. The major use of this fabric is in wearing apparel: lingerie, dresses, and suits; it can also be found in fabrics for comforters, bedspreads, draperies, and throw pillows. Triacetate is often blended with polyester and made into crepe fabrics for lightweight dresses and women's suits. (See Figure 6.10.) Mitsubishi produces Soalon® triacetate, which is sold only as finished products.

FIGURE 6.10
Triacetate and polyester blend crepe suit.

Care Procedures

Acetate

If handled with care, acetates can be laundered successfully. However, dry cleaning is usually recommended. Woven acetate fabrics may shrink as much as 5 percent and knits as much as 10 percent in laundering. During laundering, acetate fabrics should not be subjected to undue stress through wringing or twisting. Fibers are weaker wet than dry, and acetates will wrinkle badly if creased or folded when wet.

Hydrogen peroxide or sodium perborate bleaches can be used if necessary for whitening of fabrics. Bleaching should be carefully controlled. Ironing temperatures for acetates must be kept low. The fabric will stick if ironed at temperatures about 350°F to 375°F and will melt at 500°F.

Acetone, a component of some fingernail polishes and polish removers, will dissolve acetate. Care should be taken to avoid spilling acetone-containing substances on the fabric.

Triacetate

Triacetate fabrics can be hand or machine washed. Hydrogen peroxide and sodium perborate bleaches can be used. Triacetates have better wrinkle recovery and crease resistance than acetates. If the fabrics require touch-up ironing after laundering, triacetates can be ironed at the rayon setting on the iron dial.

Dry-cleaning solvents will not harm triacetates. Acetone will damage triacetate fabrics. Spills from nail polish or remover that contains acetone will swell and may dissolve the fabric.

SUMMARY POINTS

- Viscose rayon
 - The first commercially successful manufactured fiber
 - Fiber is wet spun from a solution of cellulose xanthate in sodium hydroxide
 - o Properties are good drape and aesthetics, low strength, and low wrinkle resistance
 - o A higher-strength version is produced by modifying the manufacturing process
- Cuprammonium rayon
 - Fiber is wet spun from cellulose dissolved directly in cuprammonium
 - Properties similar to viscose rayon
- Lyocell
 - Newer type of rayon
 - Dry-jet wet spun from cellulose dissolved directly in N-methylmorpholine
 - o Good drape and hand of viscose but higher strength and wrinkle resistance

- · Acetate and triacetate
 - · Made from modified cellulose that has acetate groups
 - Both are dry spun: acetate is dissolved in acetone; triacetate is dissolved in methylene chloride
 - o Properties are desirable aesthetics but low strength and abrasion resistance

Questions

1. Describe how each of the following fibers is produced:

viscose rayon acetate
HWM rayon triacetate
lyocell

- 2. Compare the properties of viscose rayon and cotton.
- 3. What was the reason for the development of HWM rayon? What advantages does it offer?
- 4. How do the mechanical properties of lyocell differ from those of regular viscose and HWM rayon? Why do lyocell fibers fibrillate, and how can this be controlled?
- 5. What is the difference in chemical composition of regenerated cellulosic fibers and cellulose derivative fibers? What generalizations can you make about the differences in properties of those fibers that are regenerated and those that are derivative?
- 6. What differences in fiber properties of acetate and triacetate can be explained by differences in chemical structure?

References

- American Fiber Manufacturers Association. "Fiber Facts." http://www.fibersource.com/f-info/fiber%20production.htm (accessed January 5, 2008).
- McCullough, E. A. "A Comparison of the Comfort and Hand Characteristics of Lining Fabrics." Technical Report #99-08. Brussels: Global Acetate Manufacturers Association, 1999.
- White, P. "Lyocell: The Production Process and Market Development." In *Regenerated Cellulose Fibres*, edited by C. Woodings. Cambridge, UK: Woodhead Publishing, 2001.

Recommended Readings

- Summers, T. A., B. J. Collier, J. R. Collier, and J. L. Haynes. "History of Viscose Rayon. In *Manmade Fibers: Their Origin and Development*, edited by R. B. Seymour and R. S. Porter, 72. London: Elsevier, 1993.
- Woodings, C., ed. *Regenerated Cellulose Fibres*. Cambridge, UK: Woodhead Publishing, 2001.

Nylon and Aramid Fibers

Learning Objectives

- 1. Describe nylon 66, nylon 6, and aramid fibers.
- 2. Explain the manufacturing processes for nylon and aramid fibers.
- Relate the properties of nylon and aramid fibers to current end uses for these fibers.

nder the most recent Federal Trade Commission (FTC) definition, *nylon* is "a manufactured fiber in which the fiber-forming substance is a long-chain synthetic polyamide in which less than 85 percent of the amide

linkages are attached directly to two aromatic rings." This definition covers a variety of structures, two main classifications of which are used in the United States: nylon 6 and nylon 66. In a 1974 revision of generic fiber categories, the FTC established a separate category of fibers that is designated *aramids*. Like nylons, aramid fibers are polyamides; but in aramids 85 percent or *more* of the amide linkages are attached to two aromatic rings.

Nylon was the first synthetic fiber produced. The inventor was Wallace Carothers, a chemist working for the DuPont Company in Delaware. He and his team of scientists synthesized a number of other polymers but decided to concentrate on the polyamides for producing fibers.

NYLON

Nylon 66 and nylon 6 are isomers; that is, each polymer contains the same elements by weight, but the polymers' molecules are arranged differently. Such differences in structural arrangements cause some differences in fiber properties (Moore 1989). Although the processes for making both nylon 66 and nylon 6 have been known since the earliest experimentation on nylon, DuPont, which pioneered the development of nylon in the United States, chose to utilize the nylon 66 process.

The generic name *nylon* was proposed in 1938 by DuPont, which produced the first commercially made fibers in that year. The company had considered such names as *Delawear* (for the state in which the DuPont laboratories were located) and *Duparooh* (for "DuPont pulls a rabbit out of a hat") before settling on *nylon* (Meikle and Spivak 1988). Although nylon production has grown in volume over the past several decades, its share of the synthetic fiber market has declined as other synthetics such as polyester and olefin have grown significantly.

Some of the chemical companies that were prominent in the development of nylon and other synthetics no longer produce fibers. DuPont Chemical Company spun off its commodity fibers division into a separate company, INVISTA. Honeywell, which had acquired nylon producer Allied Signal, sold its American fiber business to Shaw Industries, a carpet manufacturer, thus integrating the fiber and fabric components of the supply chain. DuPont and Honeywell do, however, continue to manufacture the chemicals that are used to make the nylon polymers. Nylon was for many years the second most widely used synthetic fiber, but it has now been overtaken by olefin fibers (described in chapter 10).

Manufacture

Figure 7.1 shows the primary steps in producing nylon. The chemicals from which nylon 66 is synthesized are adipic acid and hexamethylene diamine:

Adipic acid Hexamethylene diamine
$$COOH(CH_2)_4COOH$$
 $NH_2(CH_2)_6NH_2$ 6

Note that there are six carbon atoms in each molecule of adipic acid and six carbon atoms in each molecule of hexamethylene diamine. This nylon is, therefore, designated as nylon 66 (six carbons in each molecule of reacting chemical). It is sometimes written as nylon 6,6.

Nylon 6 is made from caprolactam, which has the following chemical structure:

$$CH_2$$
 $C=O$
 CH_2
 CH_2
 CH_2
 CH_2

^{1.} American Fiber Manufacturers Association, "Fiber Facts," www.fibersource.com.

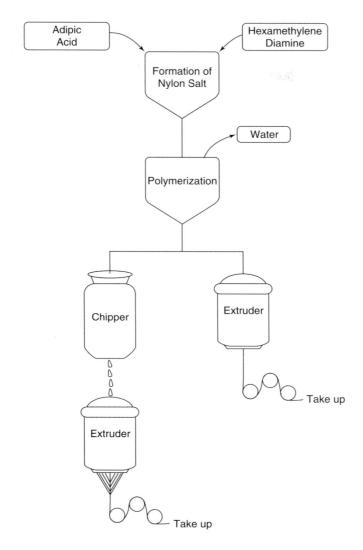

FIGURE 7.1
Flowchart for nylon production.

Because there are six carbons in caprolactam, the fiber is known as nylon 6. Variants of the nylon 6 structure, nylon 7 and nylon 11, are produced in Russia but are used in films, not fibers.

Polymerization of Nylon 66

The first step in the manufacturing process is preparation of a nylon "salt," which is a compound, but not a polymer, of adipic acid and hexamethylene diamine. The salt is prepared first to ensure the proper ratio of the acid and the amine in the subsequent polymerization step. This condensation polymerization takes place in an air-free atmosphere. Water, which is split off during polymerization, is allowed to escape from the reacting tank. If the manufacturer wishes to produce a delustered nylon, titanium dioxide can be added to the material during this step.

In earlier processes, the molten polymer that formed was extruded from the tank as a ribbon, several inches in width. It was quenched in cold water then broken into smaller nylon "chips." More common today is a continuous process where the nylon is synthesized then extruded directly as fibers.

Polymerization of Nylon 6

Caprolactam is polymerized by one of two methods. In one, caprolactam is melted, heated, and filtered under high pressure, during which process condensation polymerization takes place. In the second method, water in the amount of 10 percent of the weight of the caprolactam is added, after which the water and caprolactam are heated to a high temperature, steam escapes, and polymerization takes place.

Spinning

Both nylon 66 and nylon 6 are melt spun, although nylon 66 has a higher melting point (500°F) than does nylon 6 (430°F). The melted polymer is delivered from an extruder or directly from a polymerizer and passes through a filter to remove any impurities. It is fed to a metering pump that delivers a measured amount of polymer to the *pack*, which consists of a small filter and spinneret.

As they exit from the spinneret, the molten filaments enter a chimney where they are air-cooled and simultaneously stretched to orient the molecules. Spin finish (a complex mixture of oil lubricants emulsified in water together with additional materials such as wetting agents, antistatic agents, and adhesives) is coated onto the fiber. The finish lubricates fibers for subsequent processing and disperses static electrical charges that would interfere with yarn formation. The finish is eventually washed from the fabric.

Drawing

After addition of the finish, the fiber is wound onto a bobbin. In this state, nylon is not especially strong or lustrous, so fibers are stretched to 400 to 600 percent of their original length. The stretching orients the molecules, making the fiber more crystalline, increasing luster, and improving tensile strength. Because nylon has a low glass transition temperature, little heat is required to orient the molecules during this step, and thus, nylon fibers are said to be "cold drawn."

Molecular Structure

The polyamide chains in drawn nylon are fairly highly oriented in a crystalline structure. When the molecules are straightened during the drawing process, they have no bulky side groups to prevent them from packing closely together. So the crystalline areas form easily, and hydrogen bonds form between the amide links of adjacent polymers. The fibers are 50 to 80 percent crystalline, depending on the amount of drawing. In the amorphous areas, the polymers are coiled, allowing for fiber stretch and recovery. Nylon 66 and 6 differ in the chain packing because of differences in the order of groups in the amide linkages.

Properties of Nylon

Physical Properties

Appearance. Normal nylon in microscopic appearance looks like a long, smooth cylinder. Its cross section is circular, and it is naturally lustrous unless it is delustered. (See Figure 7.2.) The cross-sectional shape of nylon 66 or nylon 6 can be varied to produce fibers with a particularly desirable appearance or performance

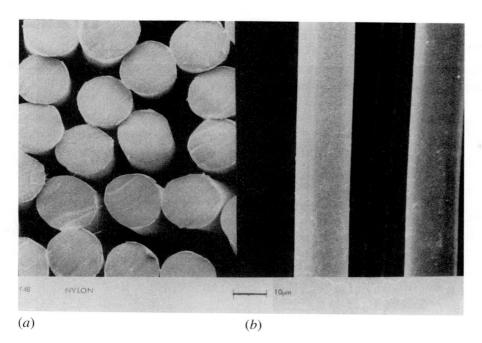

Photomicrograph of regular nylon in (a) cross-sectional and (b) longitudinal view. Photographs courtesy of British Textile Technology Group.

quality. For example, nylon 66 is sometimes made in trilobal or multilobal forms. The trilobal shape, similar to that of silk, reflects more light, thereby increasing luster, and the smaller effective cross section allows the fiber to bend more easily, providing better fabric drape.

Specific Gravity. A relatively low-density fiber, nylon has a specific gravity of 1.14, which is lower than most other fibers. In comparison, the specific gravity of rayon is 1.5 and that of polyester is 1.38. Nylon can be made into very light, sheer fabrics of good strength.

Mechanical Properties

Strength. The strength of nylon is excellent, and it can be produced in a variety of tenacities depending on the intended end use. The regular tenacity of nylon 66 is 3 to 6 g/d; that of regular nylon 6, 4 to 7 g/d. High-tenacity nylon 66 that has been drawn more during spinning can range from 6.0 to 9.5 g/d. The exceptional strength of nylon has led to its use in a variety of industrial items, such as seat belts and soft-sided luggage. It also predominates in the field of women's hosiery. Because the fibers are so strong, they can be made in the very fine deniers required for sheer hosiery and lingerie.

Modulus. Even though it is a strong fiber, nylon has a low modulus, so it stretches easily with little force. This is in contrast to polyester, which has a higher modulus. Although nylons are generally strong compared to many other fibers, their use in some industrial products such as geotextiles and sailcloth is limited by their low modulus. On the other hand, this is a plus for sweaters, swimwear, and activewear, where low resistance to stretch provides comfort and fit.

Elongation and Recovery. Nylon exhibits fairly high elongation before breaking, but when extended short of the breaking point, it will recover well. This helps

garments made of nylon, or nylon blended with elastic fibers such as spandex, to retain their shape and dimensions.

Resilience. Not only does nylon recover well from stretching, it also has excellent recovery from compression. This feature makes it ideal for carpets and rugs. Nylon is also wrinkle resistant and was used in some of the first "drip dry" garments. Elastic recovery of nylon 6 is claimed to be slightly better than that of nylon 66.

Flexibility. Nylon has low resistance to bending and can be flexed easily. Nylon fabrics are usually fairly drapable depending on their weight and construction.

Chemical Properties

Absorbency and Moisture Regain. Nylon is moderately hydrophilic, having better moisture regain than many manufactured fibers. Nevertheless, nylon fabrics dry quickly after laundering.

Heat and Electrical Conductivity. Nylon is a poor conductor of electricity and builds up static electricity, especially when humidity is low. It is a good insulator in electrical materials because of its nonconducting qualities. Special nylons have been manufactured to improve conductivity and decrease static electricity. Nylon's heat conductivity is also low.

Effect of Heat; Combustibility. The melting point of nylon 66 is about 500°F. It will soften and may start to stick at 445°F. Nylon 6 is even more heat sensitive. If a hot iron is used on nylons, the fibers may glaze, soften, or stick. The fiber burns in a flame but usually self-extinguishes when the flame is removed. However, nylon fibers do melt, and as with any fiber that melts, if the molten fiber drips onto the skin, it may cause serious burns.

Nylon's reactions to heat can be taken advantage of in manufacturing products. Its thermoplasticity allows it to be heat-set. (See chapter 2.) Because its softening, or glass transition, temperature is lower than polyester's, nylon can be dyed more easily; the dyes can penetrate into the regions of the fiber that have become less crystalline and more open. These effects are more significant in nylon 6, which melts at a lower temperature than does nylon 66, and place some limitations on its uses. Unlike its aramid cousins, described later in this chapter, it is not used in industrial applications in which thermal resistance is essential.

Chemical Reactivity. Like most synthetics, nylon is chemically stable. Dry-cleaning solvents will not harm the fiber. It is not seriously affected by dilute acids but is soluble in strong acids. Treatment with concentrated hydrochloric acid at high temperatures will break down nylon 66 into adipic acid and hexamethylene diamine, the substances from which it is made. This reaction could be used to reclaim these basic materials and permit this fiber to be recycled after use. Prolonged exposure to acidic fumes from pollution will damage the fiber.

Environmental Properties

Resistance to Microorganisms and Insects. Moths, mildew, and bacteria will not attack nylon.

Resistance to Environmental Conditions. Nylon is less affected by light than are natural fibers. It may degrade after long exposure to sunlight, but age has no

appreciable effect if fabrics are stored away from sunlight. Sheer nylon fabrics are unsuitable for use in curtains.

Other Properties

Dimensional Stability. Nylon has good dimensional stability at low to moderate temperatures, neither shrinking nor stretching out of shape. At high temperatures nylon fabrics may shrink. Washing and drying temperatures should be kept low. Nylon's moderate regain prevents a high degree of relaxation shrinkage when fabrics are wet.

Abrasion Resistance. This is one of nylon's advantages in many end uses, such as luggage, upholstery, and sportswear. It is a tough fiber, with extremely good abrasion resistance. In addition, nylon fabrics can be folded or flexed repeatedly without showing wear.

A disadvantage is that nylon fabrics have a tendency to pill under abrasive conditions. Because of the high strength of the fibers, the pills remain on the fabric, making wearing apparel unsightly.

Uses

The availability of a wide variety of types (from fine to coarse, from soft to crisp, from sheer to opaque) has resulted in the use of nylon in a large range of products for apparel, the home, and industry. It is important to remember, however, that nylon is more expensive than other synthetic fibers and, therefore, is targeted for products where its unique combination of properties is critical. Thus, in some product areas, cheaper items might be made of polyester, while higher-priced or higher-quality items would be nylon. Luggage and backpack fabrics, jacket shells, and stretch fabrics for activewear are examples.

Nylon has long been of major importance in the manufacture of women's hosiery because it is strong and stretches and recovers easily. Sheer fabrics made of nylon have been popular because of their inherent strength and abrasion resistance. Its light weight and durability make it ideal for jackets and running suits and especially for soft-sided luggage. Because it is resilient and abrasion resistant, it dominates the carpet and rug market. Its combination of strength and recovery make nylon especially useful for "dynamic" applications where large, repeated stresses are applied. These properties are advantages for ropes for mooring boats or mountain climbing, parachutes, seat belts, airbags, sleeping bags, and even fishing lines. (See Figure 7.3.) Nylon is often used in blends to contribute abrasion resistance and elasticity. Once dominant in tire cords, it has lost much of that market to polyester, which has a higher modulus and glass transition temperature. The problem of "flat spotting," where a tire sits and cools overnight and gets a flat spot that thumps until it rewarms, is also a reason for the decline of nylon in tire cords.

Nylon has been used with polyester in bicomponent structures to produce microfibers. In one type, the nylon fibers are islands in a sea of polyester, with the latter dissolved away in a later step. Another process uses the citrus or wedge configuration of alternating nylon and polyester segments. They are split by mechanical or chemical action, which preserves both fibers.

FIGURE 7.3

Photographs of a few of the diverse uses of nylon fibers: (a) tires made with nylon tire cord, (b) nylon carpet fibers, (c) luggage made of sturdy nylon fabric. Photographs courtesy of AlliedSignal Fibers.

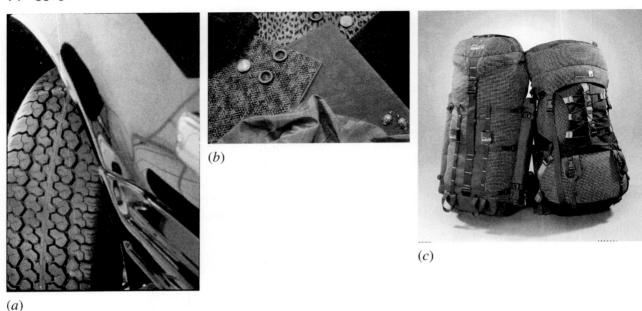

Nylon Trademarks

Companies producing nylon fibers establish one or more trademark names for their different fiber variants. These trademarks change often, with new trademarks being instituted and older ones being discontinued. Acquisitions and divestments among polymer and fiber producers affect the use of, and rights to, fiber brand names. The following are a few examples of trademarks that have been in use for extended periods of time. Antron® for carpets and Tactel® for apparel are nylon 66 fibers now made by INVISTA. Solutia Inc. (formerly Monsanto Corporation) produces Ultron® carpet fiber and Ultron Renew®, a recycled version. Honeywell Nylon manufactures the nylon 6 polymer Anso®, which it supplies to carpet maker Shaw Industries. Nylstar, a European firm, makes a number of nylons, including microfibers, with its Meryl® trademark. Zeftron® is a well-known nylon brand name. Formerly part of BASF, it is now a separate company with a large presence in the carpet market.

Care Procedures

Nylon is an easy-care fiber. Most nylon items are machine washable and can be tumble dried at normal drying temperatures. However, nylon, like many synthetics, has an affinity for oil-borne stains. These should be removed with a grease solvent before laundering.

Just as nylon is easily dyed, it also has a tendency to "scavenge" colors, picking up surface color easily from other fabrics. This is why many white nylons gradually become gray or yellowed after repeated laundering. Therefore, it is advisable to wash white nylons alone, never with other colored items, especially if high laundering and drying temperatures are used.

Nylon's resilience usually precludes ironing, but if pressing seems necessary, the heat sensitivity of nylon requires that it be pressed with a warm, not hot, iron. Also, nylon items should be removed from the dryer as soon as the cycle is ended. Nylons that remain in a hot dryer in a wrinkled condition may retain these wrinkles until the item is pressed.

ARAMID

Aramid fibers are composed of polyamides in which at least 85 percent of the amide linkages are attached to two *aromatic rings*. Aromatic rings have six carbon atoms linked together in a hexagonal structure; they add stiffness when incorporated into polymer chains. For aramids the rings can be linked through the carbons at different positions on the ring. If the linkages are two carbons apart, the polymer is a *meta-*aramid, whereas in *para-*aramids, the linkages are three carbons apart. The aromatic rings make the aramid polymers stiff and inflexible, putting them in a class of polymers known as "rigid rod polymers." This terminology describes the behavior of such polymers in melt or solutions where they will form regions of parallel chains rather than entangle or fold, like the polymers in commonly used fibers (Hearle 2001).

DuPont produces the meta-aramid Nomex® and the para-substituted aramid Kevlar®. The Japanese company Teijin manufactures Twaron®, a para-aramid, and Teijinconex®, a meta-aramid fiber.

Manufacture

Because aramid polymers have such high melting points, they are made by a different process than other synthetics that are heated to effect polymerization. Instead of acids, the more reactive acid chlorides are used so the polymers can be formed in solution at much lower temperatures. The polymer for Nomex[®] is dissolved in dimethyl formamide, dry spun, then drawn to produce an extremely crystalline fiber.

The para-aramid for Kevlar[®] fibers is dissolved in sulfuric acid and spun using the dry-jet wet spinning method. During the spinning process, the rigid polymers form *liquid crystals*. As rigid rods, they become aligned in the direction of the fiber axis, but are still able to slide past each other. The fibers are stretched as they leave the spinneret and enter the air gap then the coagulation bath. The drawing completes the very high degree of orientation and crystallinity in the fibers.

Properties of Aramids

Aramid fibers were engineered for high strength and/or thermal stability. The aromatic rings make the polymer chains stiffer, and more energy is required to break or decompose them. The two types of aramids are nevertheless different, especially in their mechanical properties. (See Table 7.1.)

Para-aramid fibers have extremely high modulus and tenacity because of the liquid crystalline stage that occurs during spinning. Tenacity can range from twenty-two to twenty-eight g/d, compared to less than ten g/d for even the highest-strength nylon fibers. The strength of meta-aramid fibers is much less, around five g/d; they also have a lower modulus, making them less stiff. The combination of

Table 7.1
Selected Properties of Nylon and Aramid Fibers

Property	Nylon 66	Nylon 6	Meta-aramid	Para-aramid
Specific gravity	1.14	1.14	1.38	1.44
Tenacity (g/d)	3.0-9.5	2.5-9.5	4.8-5.8	22-28
Modulus (g/d)	23-57	2.5-9.5	65-100	500-1000
Elongation (%)	20-30	20-40	20-45	2-4
Moisture regain (%)	4.0-4.5	4.5	4.5	4.5
Resiliency	Excellent	Excellent	Excellent	Excellent
Burning characteristics	Burns and melts, usually self- extinguishing when flame is removed	Burns and melts, usually self- extinguishing when flame is removed	Decomposes at high temperature	Decomposes at high temperature
Melting point (°F)	500°	428°	Does not melt, decomposes above 700°	Does not melt, decomposes above 660°
Conductivity of Heat Electricity	Low Low	Low Low	Low Low	Low Low
Resistance to damage from Fungi Insects Prolonged exposure to sunlight	Excellent Excellent Degrades	Excellent Excellent Degrades	Excellent Excellent Degrades	Excellent Excellent Degrades
Acids Bases	Degraded by concentrated acids Degraded by hot,	Degraded by concentrated acids Degraded by hot,	Degraded by hot, concentrated acids Degraded by hot,	Degraded by hot, concentrated acids Degraded by hot,
	concentrated bases	concentrated bases	concentrated bases	concentrated bases

high strength and modulus makes para-aramids extremely tough fibers for specialty products (see later discussion).

Figure 7.4 shows a cross-sectional view of Nomex[®] meta-aramid fibers, which are peanut shaped. Para-aramid fibers have a rounder cross section. The color range of aramid fibers was originally fairly limited, but meta-aramids are now available in a number of colors, including bright fluorescents for added safety protection. The color range for para-aramid fibers is more limited, generally being restricted to gold, sage green, royal blue, and black.

Moisture regain of aramids is 5 percent, a moderate degree of absorbency. The more crystalline para-aramids have lower regain.

Aramid fibers have no melting point because they decompose before melting, and they have extremely low combustibility. The fibers decompose at a temperature

Photomicrograph of a cross section of Nomex® aramid fiber. Photomicrograph courtesy of the DuPont Company.

above 700° F, and meta-aramid fibers decompose at a slightly higher temperature. This property determines their use in fire-resistant garments. The lower-modulus meta-aramids are more comfortable in these garments, but they are often reinforced with a small amount of a para-aramid fiber, which retains better char strength after burning.

Aramids degrade and lose strength on exposure to ultraviolet rays. Their resistance to radiation from gamma, beta, and X-rays is, however, excellent, and this resistance is utilized for some industrial applications. Their resistance to most chemicals and organic solvents is generally good, but like nylons, they are degraded by strong acids.

Uses

Aramid fibers are used in industrial products and protective clothing, where their high cost is justified by the necessity for specific performance properties. Meta-aramids, with their excellent thermal stability, are fabricated into clothing for fire-fighters, race car drivers, petrochemical and refinery workers, power and utility workers, military flight personnel, and astronauts. Fabrics are used in a wide variety of garments, including hoods, shirts, lab coats, jackets, parkas, aprons, gloves, pants, coveralls, jumpsuits, and socks. The fiber's light weight, lower modulus, and moderate absorbency make it more comfortable than other materials that might be used. Highly temperature-resistant papers are also made from meta-aramid fibers.

Para-aramids, with high strength and modulus, are used in protective apparel such as safety gloves, boots, clothing, chain saw chaps, and bullet-resistant vests. They can also be seen as reinforcing fibers in helmets and building structures and have replaced glass fiber in some aircraft because they are lighter in weight than glass. Another use is as protective covers in fiber-optic cables. The toughness of para-aramids is an advantage in these products where impact resistance and ability to absorb energy are important. Sports equipment, such as boats, hockey sticks, tennis racquets, fishing rods, and golf clubs, make use of para-aramid fibers as well. The advantage here is the light weight of the aramid fiber compared to

Figure 7.5

Canoeist easily portages light-weight Kevlar® aramid fiber-reinforced canoe between lakes or around impassable stretches of water. Photo courtesy of We-no-nah Canoe. Inc.

other reinforcing fibers such as carbon or glass. (See Figure 7.5.) Para-aramids are also used in tire cords, ropes, cables, industrial belts and hoses, and sailcloth. Strength and light weight are again important here, while the fiber has the added advantage of good resistance to creep, so line, ties, and sails stay taut. Aramids are expensive fibers, though, so they are limited to uses where their specific advantages in terms of strength, impact resistance, and/or fire resistance are vital.

Care Procedures

With increased usage of aramid fibers in protective clothing, consumers and professional launderers and dry cleaners are encountering garments made from these fibers. The International Fabricare Institute makes the following recommendations about caring for garments made from aramid fibers (IFI 1991). Aramid garments can be machine washed and dried when laundered at home, but they must be washed separately so they do not pick up lint from other garments. The lint will impair their flame resistance. Garments soiled with grease or oil can be drycleaned. Chlorine bleach should not be used, but oxygen bleaches are safe.

SUMMARY POINTS

- Nylon (polyamide) fibers were the first synthetic fibers produced commercially
- Properties of nylon fibers
 - · High strength
 - · Low modulus
 - Good elasticity and recovery
 - Good resilience
 - More expensive than other synthetics
- Used in carpets, hosiery, swimwear, and activewear
- Aramids are specialty polyamide fibers that differ in molecular structure from nylon
- Properties of aramids
 - o High thermal stability
 - High strength and modulus for para-aramids
 - Used mainly in industrial and specialty products

Questions

- 1. Compare the characteristics of nylon 66 and nylon 6. In what ways are they different? In what ways similar?
- 2. What properties of nylon make it especially useful in (a) women's hosiery and (b) carpets?
- 3. How do the processes for making nylon and aramid differ? Why are they different?
- 4. Identify some of the products in which meta-aramid fibers are used and some in which para-aramid fibers are used. What differences in the properties of these two fibers account for the different kinds of products in which they are used?

References

Hearle, J. W. S. "Introduction." In *High-Performance Fibres*, edited by J. W. S. Hearle. Cambridge, UK: Woodhead Publishing, 2001.

IFI. "Nomex[®] and Kevlar[®]." *International Fabricare Institute Bulletin*, September (1991).

- Meikle, J. L., and S. M. Spivak. "Nylon: What's in a Name?" *Textile Chemist and Colorist* 20 (June 1988): 13.
- Moore, R. A. F. "Nylon 6 and Nylon 66: How Different Are They?" *Textile Chemist and Colorist* 21 (February 1989): 19.

Recommended Readings

- Gabara, V. "High Performance Fibres 1: Aramid Fibres." In *Synthetic Fibre Materials*, edited by H. Brody, 239. Essex, UK: Longman Scientific and Technical, 1994.
- Morris, W. J. "Nylon at 50: An Industrial Success and a Personal Tragedy." *Chemtech* 18 (December 1988): 725.
- Rebouillat, S. "Aramids." In *High-Performance Fibres*, edited by J. W. S. Hearle, 23. Cambridge, UK: Woodhead Publishing, 2001.
- Scott, B. "Stopping Bullets." Scientific American (March 1997): 132.
- Yang, H. H. Aromatic High Strength Fibers. New York: Wiley Interscience, 1989.

POLYESTER FIBERS

Learning Objectives

- 1. Describe the various types of polyester fibers.
- 2. Explain the manufacturing processes for polyester fibers.
- Relate the properties of different polyester fibers to current end uses for these fibers.

In his first experiments with the synthesis of polymers, W. H. Carothers concentrated his attention on compounds called polyesters. Encountering some difficulties in this research, he then turned to polyamides, from which he synthesized nylon.

After the discovery of nylon, English researchers at Calico Printers Association concentrated on the polyester group. Their experimentation led to the development and subsequent manufacture of polyester fibers. DuPont bought the English patent, and the first DuPont plant for the production of Dacron® polyester in the United States opened in March 1953. It was produced by Imperial Chemical Industries (ICI) in Britain under the name Terylene®.

The FTC defines polyester as "a manufactured fiber in which the fiber-forming substance is any long-chain synthetic polymer composed of at least 85 percent by weight of an ester of a substituted aromatic carboxylic acid, including but not restricted to substituted terephthalate units

or parasubstituted hydroxybenzoate units

$$p(\text{---}R\text{---}O\text{---}C_6H_4\text{----}C\text{----}O\text{---})"$$

(as amended September 12, 1973). The polyester made from the hydroxybenzoate compound, trademarked as Kodel[®] in the United States, is no longer produced.

MANUFACTURE

The starting materials for polyesters are an organic acid and an alcohol, both derived from petroleum, although some of the newer polyesters described below are derived in whole or in part from renewable agricultural resources. The most commonly used acid is terephthalic acid or its dimethyl ester. The processes that are used for manufacturing different types of polyesters vary. Many of the details of these processes are proprietary and specific to different producers, but a generalized description can serve to introduce the manufacturing steps.

The major polyester in manufacture and use is polyethylene terephthalate, abbreviated PET. It is formed by the reaction of terephthalic acid and ethylene glycol. At high temperatures and under vacuum the two compounds react, with an antimony catalyst, in a series of steps to build up a polymer chain of considerable length. Older production plants used dimethyl terephthalate, the ester of terephthalic acid, because it was difficult to obtain pure terephthalic acid (Gupta and Bashir 2002). Most producers today begin with the acid, reacting it with ethylene glycol in a *direct esterification* process.

As with nylon, in earlier manufacturing processes, the melted polymer was extruded as ribbons, cooled, and broken into chips, which were then remelted and spun into fibers. It is much more common today to make the polymerization and spinning steps one continuous process. The polymer is produced at high temperature, and the melt is pumped directly to the spinnerets. When the fibers exit the spinneret, they solidify on hitting cool air and are wound loosely onto cylinders. How the solidified filaments are processed in the drawing step depends on the projected end use of the fiber.

Cross-sectional shape can be modified to create fabrics for special purposes. Hollow polyester fibers are made into fiberfill with good insulating qualities. Multilobed fibers enhance wicking.

Drawing

If filaments of polyester are to be made into staple fiber, several sets of filaments, each containing 250 to 3,000 filaments, are brought together and coiled in a large can in preparation for drawing. The yarns are then heated and drawn to several times their original length to orient the molecular structure then allowed to relax to release stresses and strains and reduce shrinkage of drawn fibers. Drawn tow is crimped, dried, and heat-set for stability. At this point, tow may be cut into required staple lengths, usually 38 to 152 millimeters (1.5 to 6 inches) in length, and baled, ready for sale.

Fiber intended for continuous filament yarn is either drawn directly and packaged for sale or wound on bobbins in preparation for draw twisting or draw texturing. Yarn for weaving or knitting or yarn intended for texturing is often processed on a draw twister that heats and draws the fibers and imparts a small amount of

163

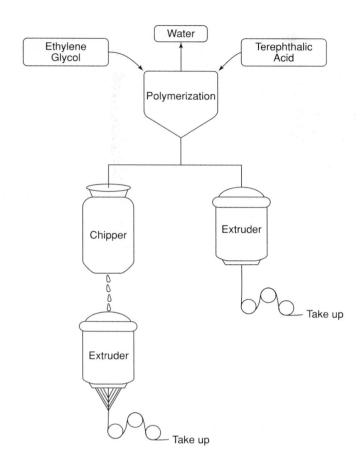

Flowchart for polyester production.

base twist. Additional heating and drawing is given to high-strength industrial yarns in a second stage of processing.

Although draw-twisted yarns can also be textured, recent developments in spinning polyester have led to the use of an alternative process. High-speed spinning processes yield partially oriented yarn (POY), as described in chapter 2. The yarns can then be both drawn and textured in the same operation, one in which the drawing, texturing, and heat-setting operations are carried out in an integrated manner. Chapter 14 gives a fuller discussion of texturing. The diagram in Figure 8.1 summarizes the manufacture of polyester.

OTHER POLYESTER FIBERS

PTT Fibers

A new polyester, polytrimethylene terephthalate (PTT), was developed and produced by Shell Chemical Company in the 1990s. PTT is made with the same acid as PET but a different alcohol: propanediol, which has an additional —CH₃ group. PTT has been known as a polyester of promise for some time and was included in the original PET patent, but until recently it was not commercially

164

feasible to produce because propanediol was so expensive. Propanediol has now been made by cheaper processes from petroleum and by fermentation of glycerol, and PTT is now cost competitive (Schultz and Wu 2002). PTT producers have applied to the FTC for a new generic name, which would be a subcategory of polyester. The polymerization and spinning processes for PTT are similar to those used for making PET.

PBT Fibers

Another polymer used for making both fibers and plastics is polybutylene terephthalate (PBT). It differs from PET and PTT in that there are four —CH₃ groups in the alcohol from which the polymer is made.

PEN Fibers

Another polyester that is commanding some attention is polyethylene naphthalate (PEN). This polymer has back-to-back joined aromatic rings in its structure, making it stiffer than PET and giving it a higher melting point. Polymerization proceeds along the same lines as that for PET and PTT.

PLA Fibers

Interest in sustainable products stimulated the commercial development of polylactic acid (PLA) fibers. Although they are polymers with repeating ester units, they do not meet the FTC definition of polyester because they do not contain aromatic rings. Consequently fibers made from PLA were designated as a separate generic group defined as "a manufactured fiber in which the fiber-forming substance is composed of at least 85 percent by weight of lactic acid ester units derived from naturally occurring sugars."

Currently the source of these sugars as the starting material for PLA fibers is corn. The dextrose from corn is fermented to yield lactic acid, which is then polymerized. It is an *aliphatic* polyester, which means that the polymer has no aromatic rings. The polymer chains are, thus, more flexible, and the polymer has a lower melting temperature. The appeal of PLA is that it is a natural, biodegradable material that can be melt spun.

MOLECULAR STRUCTURE

In polyester fibers the long polymers are arranged in amorphous and crystalline regions, the extent of which is dependent on the chemical structure and the amount of drawing during manufacture. Polyester does not crystallize as easily as nylon because of its aromatic rings, which are bulky and inhibit alignment of the molecules. In addition, there are no polar groups in the polyester polymers to form hydrogen bonds between the polymers. The aromatic rings do, however, provide stiffness to the polymer chains, which contributes to modulus, strength, and thermal stability. The polymer chains in PTT have a zigzag configuration, making the fiber more flexible.

PROPERTIES OF POLYESTER

Table 8.1 summarizes selected characteristics of PET, PTT, PEN, and PLA.

Physical Properties

Appearance

Polyester fibers can be manufactured in a variety of cross sections, including round, trilobal, pentalobal, and hollow shapes. Under the microscope, round fibers appear as long, smooth rods, with spots of pigment if the fiber has been delustered. This pigmented appearance decreases the luster or brightness of polyesters. Longitudinally, multilobal fibers appear striated. (See Figure 8.2.)

Mechanical Properties

Strength

The strength, or tenacity, of polyester varies with the type of fiber; however, as a general category, polyesters are relatively strong fibers and their strength is not affected by moisture. Hence, polyester fabrics have good launderability and shrinkage. PET

Table 8.1
Selected Properties of Polyester and PLA Fibers

Property	PET	PTT	PEN	PLA
Specific gravity Tenacity (g/d)	1.38 4.0-7.0 (regular tenacity); 6.3-9.5 (high tenacity)	1.34 3.9–4.2	9.1	1.25 3.5–3.7
Modulus (g/d)	100-150	≈25	250	30-50
Moisture regain (%)	0.4	0.4	0.4	0.4-0.6
Resiliency	Excellent	Excellent	Excellent	Excellent
Burning characteristics	Burns slowly with melting	Burns slowly with melting	Burns slowly with melting	Burns slowly with melting
Melting point (°F)	480-550	450	520	320-340
Conductivity of Heat Electricity	Low Low	Low Low	Low Low	Low Low
Resistance to damage from Fungi Insects	Excellent Excellent	Excellent	Excellent	Good
Prolonged exposure to sunlight Acids Bases	Moderate to good Good Harmed by strong bases	Good Harmed by strong bases	Good	Very good Lower Harmed by base

Specific Gravity. Specific gravity of PET is moderate at 1.38. Polyesters have a specific gravity greater than nylon (1.14) and lower than rayon (1.50). Fabrics made from polyesters are medium in weight.

Figure 8.2

Scanning electron micrographs of polyester fibers: (a) cross-section; (b) longitudinal view.

Reproduced courtesy of the British Textile

Technology Group.

fibers can be produced with a range of tenacities, depending on the intended end use. Staple fibers have lower strength, while high-tenacity filaments, particularly for industrial uses, have significantly higher tenacities. PEN fibers have high inherent strength, while the strength of PTT and PLA fibers is lower.

Modulus

A high modulus distinguishes polyester from other commonly used synthetics: PET has a modulus of more than 100 g/d, whereas nylon is much lower, varying between 20 and 40 g/d, depending on the type of nylon. The aromatic rings, which provide stiffness in aramid fibers, also increase the modulus of polyester. PTT has a lower modulus, similar to that of nylon, and, consequently, stretches more easily. PEN, with its joined aromatic rings, has a very high modulus, making it appropriate for its primary end use, tire cords.

Elongation and Recovery

Polyester fibers will stretch a moderate amount before breaking, with their elongation being primarily dependent on the amount they are drawn during processing. Staple fibers usually undergo less drawing and, therefore, will have higher elongation. Polyester recovers well from stretching but is inferior to nylon in its elasticity. It has good recovery from low stretch, but recovery decreases when the fiber is highly extended. With its lower modulus, PTT has higher elongation than PET and excellent recovery. PLA fibers have good recovery from low stretch but do not recover well when highly elongated.

Resilience

Resilience of polyester fibers is excellent. For this reason, they are often blended with less wrinkle-resistant fibers to make easy-care fabrics. The recovery from compression of PET is not as good as that of nylon, but PTT has much better resilience, making it a competitive choice for carpets.

Chemical Properties

Absorbency and Moisture Regain

The moisture regain of all polyesters is low, only 0.2 to 0.8 percent. Although polyesters are nonabsorbent, they do have wicking ability. This quality increases polyester's comfort in warm weather as perspiration is carried along the surface of the fiber and evaporated. Multilobal fiber cross sections improve the wicking qualities of polyesters as liquid moisture is carried down the channels between the lobes. Special finishes can be applied to polyester to make it more hydrophilic.

Effect of Heat; Combustibility

The melting point of PET is close to that of nylon, ranging from 480°F to 550°F. PTT has a lower melting point because of its more flexible polymer chain. PEN has a higher melting point. Polyesters usually need no pressing because of their excellent wrinkle recovery. If they must be pressed, it should be with a warm, not hot, iron. Polyesters can be heat-set into pleats with especially good results. Indeed, a fashion trend that contributed to polyester's early success in the 1950s was women's pleated skirts. Not only will heat setting stabilize size and shape, but wrinkle resistance of polyesters is enhanced by heat setting.

Polyester shrinks from flame and will melt, leaving a hard, black residue. The fabric will burn with a strong, pungent odor. Melted polyester fiber can produce severe burns.

Chemical Reactivity

Polyesters are not harmed by solvents used in professional dry cleaning nor are they susceptible to damage from bleaching. Although polyesters are not harmed by acids, they may be adversely affected by strong bases. PLA is more susceptible than its polyester cousins. Alkalinity encountered in detergents is not harmful.

Environmental Properties

Resistance to Microorganisms and Insects

Polyesters are resistant to attack by microorganisms, but bacteria will grow in soiled items, particularly those that have absorbed perspiration. PLA is an exception to the microbial resistance, being developed and marketed particularly for its biodegradability.

Resistance to Environmental Conditions

Although the fibers will degrade after long exposure to sunlight, they have better sun resistance than do most fibers. This resistance is enhanced when the fibers are placed behind glass that screens out some of the harmful ultraviolet rays. Polyesters are, therefore, highly suitable for use in curtains and draperies. Age has no appreciable effect on polyesters.

Other Properties

Dimensional Stability

Polyesters that have been given heat-setting treatments have excellent dimensional stability, so long as the heat-setting temperature is not exceeded. If polyester fabrics have not been heat-set, they may shrink at high temperatures. Because of its low moisture regain, polyester does not shrink when wet and can stabilize fabrics when it is blended with other fibers.

Abrasion Resistance

Polyester fibers have good abrasion resistance and are often selected for products where durability is a consideration. The abrasion resistance of PLA is lower.

Polyester Trademarks

There are quite a number of manufacturers of polyester fiber worldwide, and industrial players change frequently as new products are developed and spin-off companies are formed. Table 8.2 provides information on some commercial fibers and end uses. The brand names presented are representative of fibers in the market today but are not inclusive of all such products.

USES

Polyester is used in a wide range of wearing apparel, home furnishings, and industrial products, either alone or in blends. (See Table 8.2.) The excellent resilience of the fiber makes it especially suitable for use in easy-care fabrics. Because polyester is a manufactured fiber, its physical and chemical properties can be tailored for specific end uses as diverse as microfiber rainwear and industrial tire cords.

Blends of polyester with other fibers are made to take advantage of durability and easy maintenance. Wrinkle-resistant fabrics are frequently made from blends of cotton and polyester. PET is ideal for blending with cotton because the moduli of the two fibers are similar. Wool and polyester blends have a wool-like feel and appearance and some of the easy-care aspects of polyester. Furthermore, creases and pleats can be heat-set through the thermoplastic properties of polyester. Other blends with rayon, acetate, and triacetate as well as blends with other synthetics such as acrylics and with natural fibers such as silk, flax, and ramie are produced.

A large volume of polyester and polyester-blend fabrics is used in curtains, draperies, sheets, and pillowcases for the home furnishings market. Increasingly polyester is also seen in carpets. Because of its higher resilience and lower modulus, PTT is more competitive with nylon for carpets and home furnishings. Sleeping bags, insulated outdoor clothing, and pillow and comforter fillings of polyester are being promoted by manufacturers as easy-care, nonal-lergenic substitutes for goose down. Hollow polyester fibers are said to offer advantages in this use over traditional polyester fiber forms. Polyester also

TABLE 8.2 Polyester Brand Names and End Uses

Trade Name	Chemical Type	Form	Producer	End Uses
A.C.E.	PET	Filament fibers	Performance Fibers, Inc.	Tire cords Seat belts Industrial hoses
Comforel	PET	Staple fibers	Invista	Bedding products
Coolmax	PET	Fabric	Invista	Sports and athletic wear
Corterra	PTT	Fiber	PTT Poly Canada	Carpets
Dacron	PET	Filament and staple fibers	Invista	Apparel Home furnishings Fiberfill
Dacron Plus	PET	Staple fibers	DAK Americas	Apparel
Delcron	PET	Staple fibers	DAK Americas	Apparel Hosiery
ESP	PET	Textured filament	Invista	Knits Stretch fabrics
Fortrel	PET	Staple fibers	Wellman, Inc.	Apparel Home furnishings
ingeo	PLA	Filament and staple fibers	Natureworks	Apparel Home furnishings Biodegradable nonwovens
PenTec	PEN	Filament fibers	Performance Fibers, Inc.	High-performance tire cords
Polarguard	PET	Filament fibers	Invista	High-performance apparel Sleeping bags insulation
Sensura	PET	Staple fiber	Wellman, Inc.	Apparel Knitwear Cotton blends
Sorona	PTT	Filament, staple fiber	DuPont	Apparel Carpet
Spunnaire	PET	Staple fibers	Wellman, Inc.	Knitwear Socks Blankets
Substraight	PET	Filament fibers	Performance Fibers	Awnings Tarps Outdoor furniture and umbrellas
Teonex	PEN	Filament fibers	Teijin	Tire cords Industrial products
Tetoron	PET	Filament and staple fibers	Teijin	Apparel Industrial fabrics

Figure 8.3

Stuffed toys of all polyester materials.

Photograph by Robert L. Brewer, Jr.

dominates the market for both the outer fabric as well as the filling for stuffed toys. (See Figure 8.3.)

Industrial uses of polyesters include fire hoses, power belting, ropes, base fabrics for coating, and nets. Tire cords for automotive uses and sails for sports are also made from polyester fibers, where their high modulus is an advantage. The newer PEN fibers are even better for many of these uses because they exceed PET in strength and modulus.

PLA fibers are beginning to appear in nonwoven disposable products such as wipes and diapers. Copolymers of PLA and other compounds are used as dissolvable surgical sutures.

See Take a Closer Look in this chapter for an expanded discussion of polyesters in the market today.

CARE PROCEDURES

Polyester is blended with so many other fibers that consumers should consult labels for specific instructions on care. Those procedures that are appropriate for 100 percent polyester fabrics may not be suitable for the fibers with which polyester is blended.

Polyester fabrics are generally machine washable. Water temperatures should be warm, not excessively hot. Ordinary laundry detergents can be used. Household bleaches will not harm white fabrics. Oily stains should be removed before laundering by treatment with a grease solvent.

Polyesters should be dried at moderate temperatures, and items should be removed from the dryer as soon as the cycle is complete to avoid creases that must be removed by ironing. As a general rule, polyesters should not require pressing

TAKE A CLOSER LOOK

Polyester Today: Clotheshorse, Workhorse

Polyester has come a long way. Once shunned and relegated to cheaper items, and suffering the negative image of double knits of the 1970s, polyester today now parades the world, inspiring designers and engineers alike. It is the most widely used fiber worldwide, and this wide use is a reflection of its range of properties and versatility. Its advantageous properties have spawned the development of the newer versions, PTT and PEN. Scientists and engineers are constantly at work improving polyester's less desirable properties, such as low absorbency and the tendency to pill.

The fiber has long been a natural for blending with cotton because it has a similar modulus, which aids in processing the blended yarns. Its resilience and dimensional stability compensate for cotton's disadvantages in these areas. Cotton/polyester blends still remain one of the most popular fabrics on the market. They are seen not only in many types of fashion apparel, but also in sheets, comforters, curtains, and other home furnishings. (See Figure 8.4.) While cotton/polyester blends tend to pill, low-pilling polyester staple fibers are produced for use in blended spun yarns.

Aesthetic appeal of polyester has been enhanced by spinning and finishing techniques. Most of the microfibers produced today are polyester and are used in a number of products. Rainwear of polyester microfibers is soft and comfortable and provides water resistance both because of the low absorbency of the fibers and also because the tight

FIGURE 8.4

Decorative knit top by Dana Buchman of 65% polyester/35% cotton. Photograph by Robert L. Brewer, Jr.

packing of the fine microfibers inhibits penetration of water. Microfiber suits, jackets, and pants for both men and women are advertised as ideal for traveling. They are durable, look smart, and will retain their wrinkle-free appearance. Some jackets are being made with a mesh lining to allow the fabric to wick away perspiration in the tiny channels between the fibers. Microfiber fleeces are also being made to provide warmth for outdoor clothing.

The wicking properties of polyester have promoted its use in high-tech clothing for sportswear. In addition, the absorbency of the fiber can be increased by treatment with sodium hydroxide, which slightly degrades the fiber surface, making it more wettable. Polyesters have also been exposed to plasma, a gas with reactive ions, to create absorbent and dyeable sites on the fiber surface. Finally, absorbent compounds can be added to the polymer during polymerization.

Other shape and finish modifications of polyester have enabled it to mimic many different fibers. Fabrics made of trilobal polyester fibers have the look, drape, and feel of silk and the added advantage of being machine washable. Polyester and polyester blends can be spun into yarns with small irregularities to make "linen look" fabrics. The fibers can be given crimp for blending with wool for tailored suits and jackets.

Polyester has almost replaced nylon as the fiber of choice for tire cord. PEN and high-tenacity, high-modulus PET provide the strength, as well as the stretch and impact resistance, that contribute to tire durability. High modulus also makes polyester a good partner with Kevlar® for sailcloth, and with its high strength, it is a primary candidate for use in architectural structures such as lightweight roofs, stadium covers, and the like.

For many years polyester was a symbol of the throwaway society, but now several polyester manufacturers have introduced fibers made from recycled plastic soda bottles. These fibers are used in fabrics for outdoor clothing and other apparel, as well as in blankets. They are advertised as environmentally friendly and are popular with consumers.

Polyester has not only increased its role as the workhorse of the textile industry, but as a result of innovative processes, it has regained its stature as an apparel and interior furnishings fiber. The wide range of tenacities, sizes, and shapes in which it can be produced, as well as its competitive price, ensure its continued versatility and consumer acceptance.

after drying, although polyester fabrics may be ironed with a moderately warm iron. Some blends of polyesters and cottons can be difficult to iron because the suitable ironing temperature for polyester fibers may not be high enough to press wrinkles from cotton, whereas the cotton temperature is too high for the polyester.

Most fabrics made from polyesters can be dry-cleaned safely. Care labels should be checked to determine whether dry cleaning should be avoided.

SUMMARY POINTS

- Generic polyesters include polymers with different chemical structures
 - · Polyethylene terephthalate (PET) is the most widely used fiber worldwide
 - Other polyesters of note are polytrimethylene terephthalate (PTT) and polyethylene naphthalate (PEN)
- Polylactic acid (PLA) is chemically a polyester but has its own generic name
- · All polyesters are produced by melt spinning
- Common properties are as follows:
 - · Good strength
 - Dimensional stability
 - · Wrinkle resistance
 - · Low moisture regain
- Distinctive properties of different polyesters are as follows:
 - o High resilience, stretch, and recovery for PTT
 - Very high strength for PEN
 - Biodegradability for PLA
- End uses
 - o Apparel
 - Home furnishings
 - · Industrial products
- PET is often blended with other fibers

Questions

- What are the different types of polyesters produced today? How do they differ?
- 2. What is POY, and why is it preferred over other forms of the fiber for draw texturing?
- 3. If you had three fabrics that were the same in all other respects but one was made of polyester, one of nylon, and one of rayon, which would feel heaviest? Why?
- 4. Describe step-by-step care procedures that could be used for a 100 percent polyester garment that can be laundered at home. For each step that you describe, identify one or more properties of polyester that make this type of care appropriate.
- 5. Compare the mechanical properties of PET, PTT, and nylon fibers. How are the properties related to their molecular structures?

6. What polyester fibers would be the best choice for the following end uses and why? (Use Table 8.2 to investigate specific properties of the different types and modifications of polyester fibers.)

cotton-blend T-shirt

activewear

carpet

tire cord

stuffing

bedsheets

References

- Gupta, V. B., and Z. Bashir. "PET Fibers, Films, and Bottles." In *Handbook of Thermoplastic Polyesters*, edited by S. Fakirov, 1:317. Weinheim, Germany: Wiley-VCH Verlag, 2002.
- Schultz, J. M., and J. Wu. Poly(trimethylene terephthalate)—A Newly Commercialized Member of the Polyester Family. In *Handbook of Thermoplastic Polyesters*, edited by S. Fakirov, 1:551. Weinheim, Germany: Wiley-VCH Verlag, 2002.

Recommended Readings

- Brunnschweiler, D., and J. W. S. Hearle. *Polyester: 50 Years of Achievement*. Manchester, UK: The Textile Institute, 1993.
- East, A. J. "Polyester Fibres." In *Synthetic Fibres: Nylon, Polyester, Acrylic, Olefin,* edited by J. E. McIntyre. Cambridge, UK: Woodhead Publishing, 2005.
- Farrington, D. W., J. Lunt, S. Davies, and R. S. Blackburn. "Poly(lactic acid) Fibers." In *Biodegradable and Sustainable Fibres*, edited by R. S. Blackburn, 191. Cambridge, UK: Woodhead Publishing, 2002.
- Janeck, C., and H. Lunde. "Hydrophilic Finishes: Effect on Selected Properties of Polyester Fabric." Clothing and Textiles Research Journal 2 (Fall/Winter 1983–84): 31.
- Meyer, D. G., and H. Koopman. "Marketing Polyester in the 1990s. Part 7: Business and Economics." In *Polyester: 50 Years of Achievement*, edited by D. Brunnschweiler and J. W. S. Hearle, 323. Manchester, UK: The Textile Institute, 1993.

ika pangangan Perlaman mengangan pengangan pengangan pengangan pengangan berangan berangan pengangan pengangan

ges des la la balante reposition

ACRYLIC FIBERS

Learning Objectives

- 1. Describe the types of acrylic fibers.
- 2. Explain the manufacturing processes for acrylic and modacrylic fibers.
- 3. Relate the properties of acrylic fibers to their current end uses.

A crylics are copolymers of acrylonitrile and another material incorporated into the polymer chain. The basic acrylonitrile unit is

The FTC differentiates between two types of acrylic fibers by the amount of acrylonitrile in the polymer. Acrylic is defined as "a manufactured fiber in which the fiber-forming substance is any long-chain synthetic polymer composed of at least 85 percent by weight of acrylonitrile units." Modacrylic is "a manufactured fiber in which the fiber-forming substance is any synthetic polymer composed of less than 85 percent but at least 35 percent by weight of acrylonitrile units . . . except fibers under category (2) of paragraph (j) of Rule 7 of the Textile Fiber Products Identification Act." One hundred percent acrylonitrile fibers, referred to as PAN (for polyacrylonitrile), are produced for limited industrial uses. Note, however, that PAN is commonly used in Europe as an abbreviation for acrylic fibers in general.

^{1.} This exception refers to certain synthetic rubber products that have a substantial quantity of acrylonitrile in their composition.

ACRYLIC

Although polyacrylonitrile, the polymer of which acrylic fibers are composed, had been synthesized earlier, it could not be melt spun because it tends to decompose before it melts. Suitable solvents for the polymer were not found until the 1940s. A number of different fiber producers had been working independently to develop and patent processes for spinning fibers from the acrylonitrile polymer, each proceeding along somewhat different lines. As a result, seven separate production processes were patented: six using wet spinning and one using dry spinning.

The second synthetic fiber to be produced commercially by DuPont, Orlon® acrylic fiber, entered production in 1950. Monsanto entered the acrylic field in 1952 with Acrilan® acrylic, and American Cyanamid introduced Creslan® acrylic in 1958. None of these fibers are produced any longer as acrylic has been declining as a proportion of world fiber production, down from 15 percent to 5 percent from 1982 to 2002 (American Fiber Manufacturers Association 2002). Manufacturing has moved from the United States and Europe to China, Taiwan, and India.

Manufacture

Manufacturing of acrylic fibers starts with synthesis of the polymer from acrylonitrile and other monomers, which make up less than 15 percent of the polymer. Producers select the comonomers for their different processes to enhance both the solubility of the polymer and the dyeability of the fibers. PAN polymers have no comonomer added. After the acrylic polymer is synthesized, it is dissolved in an appropriate solvent to create the solution for spinning.

Both dry and wet spinning methods are used for manufacturing acrylics. (See Figure 9.1.) For wet spinning, the polymer is dissolved in dimethyl formamide (DMF) or dimethyl acetamide (DMAc) and spun into a bath of water and a low concentration of the solvent. DMF is the solvent used for dry spinning because it has a lower ignition point than DMAc and, therefore, less energy is needed to evaporate it in the spinning chamber.

Freshly spun acrylic fibers are porous, often retaining some of the solvent, and as a result have very little orientation. Dye is readily absorbed in this state, and "gel dyeing" processes have been used to color the fiber. The fibers must be drawn to develop the orientation and crystalline structure desired. Drawing takes place in a bath of hot water where the filaments are stretched between two rollers. After drawing, the fibers are then washed to remove any residual solvent, crimped, and cut into staple lengths. A final step is heat-setting the fibers in a relaxed state using steam. If they are not relaxed, the fibers will have a high degree of latent shrinkage, which could affect their performance in textile products.

A recent development is the production of acrylic filament fibers using a dryjet wet spinning process similar to that for lyocell. The vast majority of acrylic, however, is still produced and sold as staple fibers.

To a great extent, the properties of acrylic fibers are dependent on the processing conditions employed. The general characteristics common to most acrylic fibers are as follows.

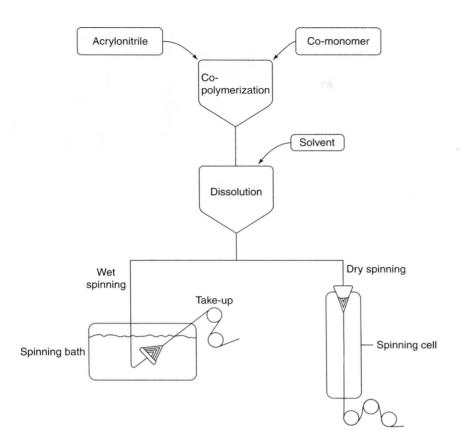

Flowchart for acrylic production.

Molecular Structure

In PAN fibers, made of 100 percent acrylonitrile, the polymer chains pack together closely, forming a highly crystalline structure. The resulting fibers are very strong but also extremely brittle, making them unacceptable for most processing and uses. They have, however, found an important use as a starting material for producing carbon fibers. (See chapter 12.)

For other acrylics the inclusion of other monomers in the acrylonitrile polymer interrupts the regular packing of the polymer molecules and reduces the brittleness of the fiber. As a result the molecular structure is moderately crystalline and can be controlled by the spinning process and subsequent drawing of the fiber. Different producers use different comonomers, resulting in some variation of fiber properties and processing.

Properties of Acrylics

Physical Properties

Shape. Wet-spun acrylic fibers can have cross sections varying from approximately round to bean shaped. Dry-spun fibers generally have a dog-bone shape. The nonround shapes are produced during spinning by formation of an outer "skin" before the inner core of the fibers solidifies. When the core solidifies, it shrinks and the skin collapses against it. The effect is more pronounced in dry-spun

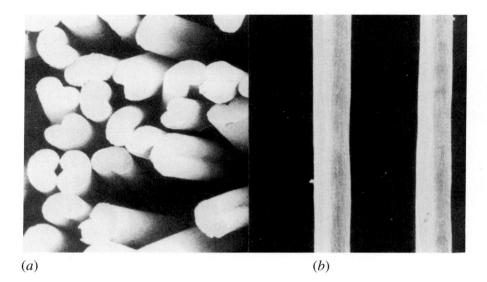

Figure 9.2

Scanning electron micrographs of acrylic fibers: (a) cross-section; (b) longitudinal view.

Reproduced courtesy of the British Textile Technology Group.

fibers, resulting in the dog-bone rather than the bean-shaped cross section. Indentations or deviations from the round will show up as wide, lengthwise markings in the longitudinal view of the fiber. (See Figure 9.2.)

Luster. Acrylics are usually delustered with titanium dioxide, and the crimp that is imparted after spinning further decreases the apparent luster. The new filament acrylic fibers have a high luster to make them more like silk.

Specific Gravity. Specific gravity ranges from 1.14 to 1.19, making acrylic yarns and fabric lightweight. Voids in the fibers make them less dense than other fibers such as polyester and cotton.

Mechanical Properties

Strength. Standard breaking tenacities of acrylic fibers are reported as ranging from 2.0 to 3.6 g/d. The fibers are relatively weak and are, therefore, not appropriate for end uses requiring high strength. Because acrylic is not very absorbent, however, its strength is not appreciably lower when the fiber is wet. PAN fibers, with their high crystallinity, are stronger.

Modulus. The range of moduli for acrylic fibers is moderate to low, making them compatible with a number of other fibers, such as wool and nylon, and they are often seen in blends.

Elongation and Recovery. Acrylics stretch fairly easily and will extend up to 25 percent before breaking. The degree of elongation depends on the amount of drawing the fiber has undergone. The elastic recovery of acrylic fibers varies from one trademarked fiber to another. In general, however, it is lower than that for most other synthetics.

Resilience. Acrylic has lower wrinkle resistance than nylon or polyester, which is why it is found more commonly in knitted fabrics, which resist wrinkling better. Crimped fibers and bulked yarns enhance compressional and bending recovery.

Chemical Properties

Absorbency and Moisture Regain. The moisture absorption of acrylics is low, ranging from regains of 1.0 to 2.5 percent. This is an important comfort aspect in which acrylics differ significantly from wool but can be compensated for by nonround fiber shapes that prevent close packing of fibers in yarns and allow moisture to move along fibers and away from the body (Lulay 1995).

Electrical Conductivity. The low electrical conductivity of acrylics is related to their low moisture absorption. Antistatic finishes may be added to fibers to eliminate static electricity buildup.

Effect of Heat; Combustibility. Acrylics do not exhibit typical melting points, but rather tend to decompose over a wide temperature range and eventually char to a brittle residue. Untreated acrylic fibers ignite and burn, leaving a hard, black bead residue at the edge of the fabric. Fibers shrink in steam but can be safely ironed at 300°F. Exposure to high, dry heat causes yellowing or further darkening of the fibers.

Chemical Reactivity. Acrylics are very resistant to acids, except to nitric acid, in which they dissolve. Resistance to bases is good. Solvents used in commercial dry cleaning do not affect the fiber adversely, and most acrylics are not harmed by household bleaches.

Environmental Properties

Resistance to Microorganisms. Mildew, microorganisms, and moths will not harm acrylic fibers.

Resistance to Environmental Conditions. Resistance to sunlight ranges from very good to excellent. This characteristic, which is superior to polyester and nylon, has promoted the use of acrylics in awnings and outdoor furniture. Age has no detrimental effect on fabric strength.

Other Properties

Dimensional Stability. Because of the fiber's low moisture absorbency, acrylic fabrics generally have good dimensional stability. They do, however, relax under hot, moist conditions. This property is used in manufacturing of some acrylic yarns where stretched fibers are subjected to steam to relax them and develop bulk. The degree of stretch and relaxation varies among the different acrylics produced, and therefore, instructions on care labels should be followed carefully in laundering. For example, some fabrics are manufactured from specially crimped fibers that require machine drying after laundering to restore the crimp. If hung wet on a line, some of these fabrics may stretch out of shape.

Abrasion Resistance. The abrasion resistance of acrylics is somewhat lower than that of other synthetics.

Bicomponent Acrylic Fibers and Yarns

Acrylic fibers may be made in bicomponent varieties. (See chapter 2 for fuller discussion of bicomponent fibers.) Bicomponent acrylic fibers are created by extruding two

different types of acrylic material together as one fiber from the spinneret. Each has somewhat different shrinkage properties, and when the fiber is subjected to heat and moisture during processing, one polymer shrinks more than the other and produces a permanent spiral crimp, similar to that in wool. The crimp provides increased bulk and resilience. Bicomponent acrylics are most often used in knitted goods such as sweaters and socks. Care instructions provided with bicomponent acrylic fibers often indicate that they must be laundered and tumble dried. During laundering the fibers swell, relieving tensions placed on the fibers during use, and the tumble drying is necessary to return fibers to their crimped and bulked shapes. Because line drying will not produce the same results, consumers should be sure to follow care instructions.

Bicomponent yarns can be constructed by combining two acrylic fibers with different shrinkage properties. High-shrinkage fibers that have not been steam relaxed are blended with those that have had the steam after-treatment. When the blended yarn is subjected to wet heat, the high-shrinkage fibers will shrink, bulking up the structure and increasing its softness.

Uses

Acrylic fibers have found a market in areas where wool has traditionally been used. A glimpse at Table 9.1 shows why acrylic is a lower-cost competitor for wool. It has similar mechanical properties: low strength and modulus, high elongation, and moderate recovery. These properties make it a good fiber for sweaters, suits, coats, and socks. Acrylic does not, however, have the high moisture absorbency of wool and so does not display the comfort characteristics associated with absorbent fibers. Crimp, which is natural in wool, can be imparted to acrylic for high bulk and resilience.

Acrylic fibers are fabricated into woven and knitted fabric constructions in a variety of textures and weights appropriate for different end uses. They are often blended with other fibers, particularly wool. Their wool-like hand and bulk combined with easy-care characteristics make them popular for use in sweaters, fleece fabrics, hand-knitting yarns, and blankets. Their bulk also makes them appropriate for socks, where they can provide both warmth and cushioning for the feet. (See Figure 9.3.)

TABLE 9.1				
Comparison	of Acr	ylic and	Wool	Properties

Property	Acrylic	Wool
Dry strength	Low	Low
Wet strength	Low	Lower
Modulus	Low	Low
Elongation	High	High
Crimp (for bulk and resilience)	Imparted during manufacturing	Natural
Weight	Low	Low
Absorbency	Low	High
Cost	Low	High

FIGURE 9.3 Acrylic apparel uses. (a) hosiery, courtesy of the Acrylic Council; (b) sweater; (c) acrylic blend sweater.

Resistance to degradation by sunlight leads to use of acrylics in drapery and upholstery fabrics, and increasingly in outdoor products such as awnings and furniture. Not only is their light resistance an advantage, but also their low moisture absorbency helps to protect the fabrics under a variety of weather conditions. (See Figure 9.4.) Producers can add antimicrobial and antistatic properties during manufacturing of the fibers. The latter property is important for the use of acrylics in carpets and rugs.

Industrial uses of acrylic include insulation as a replacement for asbestos and reinforcement for concrete and stucco structures.

Acrylic Trademarks

The only acrylic manufacturer remaining in the United States is Sterling Fibers, which makes Creslan® and Cresloft®. A number of companies in Japan, China, and Taiwan produce acrylic fibers. Examples are Toraylon by Toray and Vonnel by Mitsubishi. Specialty acrylics are Sterling Fibers' Conductrol®, which incorporates electrically conducting carbon into the acrylic structure; Tafel Parclean®, an antimicrobial fiber by Mitsubishi; and Silpalon®, a filament acrylic for women's knitwear also made by Mitsubishi.

Care Procedures

Different acrylic fibers may vary in their care requirements. For this reason, it is especially important to follow care labels of these fabrics. In general, acrylic fabrics can be laundered and dry-cleaned. They do not shrink in laundering but may be sensitive to heat, so when machine drying is recommended for acrylic products, low heat settings should be used and fabrics should be removed from the dryer immediately after tumbling. Pressing temperatures should not exceed 250°F to 300°F.

FIGURE 9.4
Wicker outdoor furniture upholstered in fabric made from acrylic fiber. Photograph courtesy of Outdoor Wicker from Frontgate.

MODACRYLIC

Modacrylic fibers were first manufactured commercially by Union Carbide Company in 1949 before the production of acrylics. Because the composition of modacrylics is similar to that of acrylics, both fibers were at first included in the acrylic classification, but in 1960 the FTC ruled that a separate generic category should be established for modacrylics. Increasingly, though, the generic name acrylic is used in the global industry to refer to modacrylic as well.

Manufacture

Modacrylic fibers are made from copolymers of acrylonitrile with other compounds, such as vinyl chloride, vinylidene chloride, or vinyl bromide. The manufacturing process for modacrylic is similar to that for acrylic. The polymer formed in the polymerization reactor is dissolved in an appropriate solvent, dry or wet spun, then drawn and cut into staple lengths. Varying degrees of crimp may be added to the fiber depending on its projected end uses.

Properties of Modacrylics

Physical Properties

The cross section of modacrylic fibers is slightly irregular in shape. The longitudinal appearance usually shows some striations, or it may have a grainy effect. (See Figure 9.5.) The specific gravity of modacrylics is 1.3, which is comparable to wool, so the fibers feel light but also have good insulating qualities.

Mechanical Properties

Modacrylics are similar to acrylic fibers in their mechanical properties. Strength is low; modulus and elongation are slightly higher than acrylics. Modacrylics have good recovery from stretching and bending.

FIGURE 9.5 Scanning electron micrographs of modacrylic fibers: (a) cross-section; (b) longitudinal view. Reproduced courtesy of the British Textile Technology Group.

Chemical Properties

The absorbency of the fibers is low, and the moisture regain is between 1.5 and 3.5 percent. With this regain, the stain resistance to waterborne soil is fairly good.

A significant advantage of modacrylic, which determines many product end uses of the fiber, is its flame resistance. Modacrylic fabrics will burn when placed in a direct flame but will self-extinguish as soon as the flame is removed. The other monomers in the acrylonitrile polymer contain chlorine or bromine, which retard burning. Inclusion of amounts of these monomers greater than 15 percent in the polymer are necessary to confer flame resistance to the fiber, hence the distinction drawn between modacrylic and acrylic fibers.

The melting point of modacrylics is low (about 370°F to 410°F). They are more heat sensitive than acrylics. If modacrylic fabrics are ironed, very low temperature settings must be used. If a dryer is used, temperatures should be set for low or no heat.

Chemical resistance of modacrylics is good. Dry-cleaning solvents will not affect them adversely. Some modacrylics may be discolored by strong bases, but their resistance to acids is good to excellent.

Environmental Properties

The resistance to deterioration from light is fairly good. Neither moths nor mildew attack modacrylics. Age has no apparent effect.

Other Properties

Modacrylics have good dimensional stability. However, their sensitivity to heat may result in some shrinkage if they are dried in a dryer at high temperatures. The resistance to abrasion of modacrylic fibers is moderate.

Table 9.2 compares selected properties of acrylic and modacrylic fibers.

Uses

The major areas of use for modacrylic fibers include pile and fleece fabrics for apparel and blankets. Flame-resistant draperies and curtains, paint roller covers, and filters are also made from modacrylics. In past years modacrylic was used extensively as the outer furlike fabric for stuffed toys, as well as in such specialty uses as airline blankets. Despite the advantages of flame resistane and washability, however, its use is declining in favor of polyester that has been treated with a flame retardant.

Because these fibers have a low softening temperature and a high thermal shrinkage potential, a variety of texturizing treatments can be applied to simulate the textures and characteristics of fur fibers. Many fake fur fabrics are made from modacrylic fibers. The combination of good resilience with abrasion resistance makes modacrylic fibers especially suitable for use in high-pile fabrics, where they can simulate luxurious furs. They are also used in some industrial fabrics that take advantage of their flame resistance and good chemical resistance.

Table 9.2
Selected Properties of Acrylic and Modacrylic Fibers

Property	Acrylic	Modacrylic		
Specific gravity	1.14-1.19	1.3		
Tenacity (g/d)				
Dry	3.0-9.5	2.3		
Wet	2.6-8.0	2.3		
Moisture regain (%)	4.0-4.5	1.0		
Resiliency	Good	Good		
Burning characteristics	In flame, burns with melting, continues after flame removed	In flame, burns very slowly with melting; self-extinguishing after flame removed		
Melting point (°F)	Softens at 450° to 497°; indeterminate melting point	Approximately 400°		
Conductivity of				
Heat	Low	Low		
Electricity	Low	Low		
Resistance to damage from				
Fungi	Excellent	Excellent		
Insects	Excellent	Excellent		
Prolonged exposure to sunlight	Excellent	Excellent		
Acids	Good, except nitric	Good		
Bases	Good to weak bases	Moderate		

Modacrylic Trademarks

The Kaneka Corporation of Japan makes a modacrylic fiber called Kanecaron, which is used in fake fur products, and Kanekalon, for wigs and stuffed toys.

Care Procedures

Deep-pile garments must be cleaned professionally to avoid crushing or altering the appearance of the pile. Other modacrylic fabrics are machine washable, but special care should be taken to avoid exposing them to very high temperatures because of their heat sensitivity. Stuffed toys with modacrylic exteriors can usually be washed and air dried. Low dryer temperatures must be used, and ironing should be done with only a warm, not hot, iron. Some modacrylic fibers are discolored by the use of chlorine bleaches.

SUMMARY POINTS

- Acrylic and modacrylic fibers both are based on polyacrylonitrile polymers
 - $\circ\,$ Acrylics are more than 85 percent polyacrylonitrile
 - Modacrylic fibers are between 35 and 85 percent
- · Acrylic fibers are wet or dry spun
- Acrylic properties

- Bulk, warmth at low weight, low strength, and high elongation are similar to wool
- o Other properties are low moisture regain and good sunlight resistance
- Modacrylic is flame resistant and found predominantly in simulated fur items.

Questions

- 1. Describe the steps in wet spinning and dry spinning. How do the two processes differ, and how do they affect fiber properties?
- 2. What are the distinctive properties of acrylic fibers that determine their use in specific products?
- 3. What cautions must be exercised in caring for acrylics?
- 4. What is the most distinctive property of modacrylic fibers, and how does that determine its end uses?
- 5. What cautions must be exercised in caring for modacrylics?

References

American Fiber Manufacturers Association, "Fiber Facts," http://www.fibersource.com/f-info/fiber%20production.htm (accessed January 5, 2008).

Lulay, A. "Apparel End Uses." In *Acrylic Fiber Technology and Applications*, edited by J. C. Masson, 313. New York: Marcel Dekker, 1995.

Recommended Readings

Cox, R. "Acrylic Fibres." In *Synthetic Fibres: Nylon, Polyester, Acrylic, Polyolefin*, edited by J. E. McIntyre, 167. Cambridge, UK: Woodhead Publishing, 2005. Ford, J. E. "Acrylic Fibres." *Textiles* 21, no. 2 (1992): 12.

Masson, J. C. Acrylic Fiber Technology and Applications. New York: Marcel Dekker, 1995.

Mastura, R. "History of Acrylonitrile Fibers." In *Manmade Fibers: Their Origin and Development*, edited by R. B. Seymour and R. S. Porter, 183. London: Elsevier, 1993.

OLEFIN FIBERS

Learning Objectives

- 1. Describe olefin fibers.
- 2. Explain the manufacturing processes for polypropylene and polyethylene fibers.
- 3. Relate the properties of polypropylene and polyethylene fibers to current end uses for these fibers.

applications since 1949, the widespread use of olefin fibers for a variety of textile products dates to the 1960s. These fibers are often called polyolefins, but the FTC specifies the generic name *olefin*. According to the FTC, an *olefin fiber* is "a manufactured fiber in which the fiber-forming substance is any long-chain synthetic polymer composed of at least 85 percent weight of ethylene, propylene, or other olefin units, except amorphous polyolefins qualifying under category (1) of paragraph (j) of rule 7."

It is worthwhile pointing out that chemists use the term *olefin* to refer to the monomer as well as polyolefins that are described in this chapter. Further, polyolefin plastics in many forms most widely used in products such as supermarket bags, yogurt pots, detergent bottles, and various olefin plastics may be familiar as #2, #4, and #5 recycle symbols.

Two major categories of olefin fibers exist. One is polypropylene; the other is polyethylene. Of the two, polypropylene is used far more extensively for textiles and constitutes the larger quantity of olefin fibers in use today, primarily because of its higher thermal stability. Worldwide the production of olefin fibers has increased significantly. They have gone from fourth among the synthetic fibers in the 1980s to second today after polyester, with almost six million metric tons produced in 2002. Much of the growth is attributable to the extensive use of polypropylene in nonwovens. (See chapter 19.)

^{1.} This exception refers to a type of synthetic rubber with a substantial proportion of polyolefin material.

POLYPROPYLENE FIBERS

Manufacture

Propylene, the starting material for polypropylene, is produced during the refining of petroleum for gasoline. Production of the polymer, therefore, has pretty much been the purview of the chemical divisions of the large oil companies. They have a ready supply of propylene for polymerization. (This is also the case for polyethylene, discussed later.)

In the polymerization step, specialized catalysts are used to produce polymer molecules that are capable of crystallizing when formed into fibers. Two chemists, Karl Ziegler and Giulio Natta, won a Nobel Prize in 1963 for developing the catalyst system (Stevens 1999). A newer catalyst, the *metallocene* system, is now also used by several producers. The metallocene system produces purer polymers that are more uniform in size (Mather 2005). After polymerization the polymer is extruded and cut into pellets, which are shipped as *resin* to fiber or film producers. (See Figure 10.1.)

Polypropylene may be melt spun into fiber filaments for subsequent conversion to yarns, or laid down in a fiber web to form a nonwoven fabric. Another form, fibrillated fibers, can be created by first extruding a film of polypropylene. The film is then either stretched and split or slit and drawn into a network of fibers. (See chapter 14 for a discussion of yarn formation and film fibrillation and chapter 19 for a description of nonwoven fabrics.)

The polyolefin supply chain differs from that of most of the other manufactured fibers. Instead of one firm making the polymer and the fiber, polypropylene fiber manufacturing plants buy their resin from a large chemical supplier. Hence, they have lower capital investment than do vertically organized manufacturers and so tend to be smaller in scale. Because polypropylene fibers are difficult to dye, it is easier to add pigment colors during spinning, and there is an economic incentive

Figure 10.1
Polypropylene pellets before melting and spinning.

for smaller runs of differently colored fibers. Additives to alter fiber properties such as light or flame resistance may be either put in before spinning or incorporated into the polymer resin at the polymerization stage.

Molecular Structure

The polypropylene molecule has methyl groups (—CH₃) on every other carbon in the polymer backbone. For high crystallinity, and optimum fiber properties, the methyl groups are all on one side:

This configuration is called isotactic, for *iso*, meaning uniform, and *tactic*, meaning arrangement or order. Both catalyst systems produce this polymer arrangement that allows tight chain packing and crystalline areas. Within the fiber the polymer chains assume a three-dimensional helical configuration.

Properties of Polypropylene Fibers

Physical Properties

Shape. In microscopic appearance melt-spun polypropylene fibers may have any of several cross-sectional configurations, depending on the shape of the holes of the spinneret used in extruding the fibers. Under the microscope, the surfaces of polypropylene fibers appear to be smooth; however, under the greater magnification of electron microscopy, pigmented fibers may have protuberances along the fiber surface that are thought to be either clumps of pigment particles or part of the fiber structure. (See Figure 10.2.)

The properties of the melt-spun fibers and fibrillated fibers differ somewhat. The denier (size) range of melt-spun fibers is greater than is that of fibrillated fibers. Fibrillated fibers have a branchlike structure that may eliminate the need to add texture to the fiber. Also, fiber-to-fiber interlocking is better in fibrillated

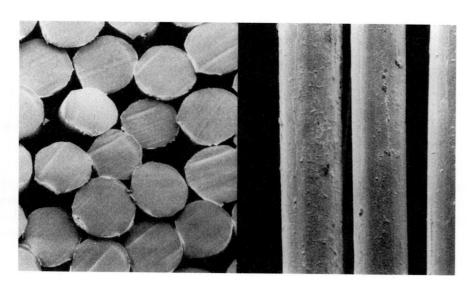

Figure 10.2

Scanning electron micrographs of polypropylene fibers:

(a) cross-section;

(b) longitudinal view.

Reproduced courtesy of the British Textile Technology Group (BTTG)

films, but fiber length is not so uniform, and fibrillated fibers are less regular in shape than melt-spun fibers. They are often flat rather than round.

Specific Gravity. The density of polypropylene is especially low. Its specific gravity is 0.92, or less than that of water. As a result, olefin fabrics float on water when they are washed. The low density of polypropylene also is related to the relatively low cost of olefin fiber; a small weight of raw materials can be used to produce a large volume of fiber.

Color. Because polypropylene fibers are hard to dye, pigments are usually added to the melted polymer before the fibers are spun. Unpigmented fibers, which are clear, are used in many nonwoven products.

Mechanical Properties

Strength. Polypropylene fibers can vary in tenacity, ranging from 2.5 to 5.5 g/d depending on the amount of stretching the fiber undergoes after extrusion. End use dictates this, with higher strength required for ropes and other industrial products. Olefin fibers are generally weaker than equivalent nylon or polyester fibers but are still strong enough to be used in applications where strength is important, such as ropes.

Modulus. Polypropylene fibers have low initial resistance to stretch, compared to cotton and polyester. This is due to the helical form of the polymer, which straightens when the fiber is stretched.

Elongation and Recovery. The elastic recovery of polypropylene fibers is excellent. They will stretch a moderate amount before breaking. High-strength polypropylenes for industrial uses have lower elongation.

Resilience. The resilience of polypropylene is lower than nylon and polyester, and carpet made from the fiber will have a higher tendency to mat. Newer variants of polypropylene, however, have better resilience.

Chemical Properties

Absorbency. Polypropylene is almost completely nonabsorbent. This low absorbency makes it difficult to dye but gives the fiber exceptional resistance to waterborne soil and stains. Grease and oil do stain polypropylene fabrics, and because they are oleophilic (or oil attracting), stains may be difficult to remove. Depending on their construction, olefin fabrics have good wickability, enabling them to transport liquid moisture away from the body.

Electrical Conductivity. The electrical conductivity of polypropylene is poor. Its low absorbency contributes to problems of static electricity buildup, although finishes used in the spinning and processing of the fiber can overcome this problem in the finished product.

Effect of Heat; Combustibility. The melting point of polypropylene is low: 330°F. While this may be an advantage during production, where lower heat is required for melt spinning, it can be a problem in product use. Hot bacon fat dropped on olefin carpets will melt fibers. Hot dryers and heaters can also affect them. Olefins are combustible and melt as they burn. They produce a sooty smoke. Some flame-resistant polypropylenes are available.

Chemical Reactivity. Polypropylene's resistance to bases and to acids is very good. This chemical resistance, combined with low moisture absorbency, have spurred its use in protective clothing and implanted medical devices. Some organic solvents used in dry cleaning may affect the fabrics adversely. Home laundering is preferable to dry cleaning in the care of polypropylene fabrics.

Environmental Properties

Mold, mildew, and insects do not attack olefins. Age has no appreciable effect, but sunlight can significantly deteriorate the fabric. This property can be altered by incorporation of ultraviolet stabilizers in the polymer melt before spinning.

Other Properties

Dimensional Stability. The wet dimensional stability of polypropylene is good because of the fiber's low moisture absorbency. Its low melting point, however, makes it susceptible to thermal shrinkage at temperatures above 250°F.

Abrasion Resistance. Polypropylene fibers have moderate abrasion resistance, lower than polyester and nylon.

The characteristics of polypropylene fibers are summarized in Table 10.1.

Uses

Polypropylene is the fiber of choice for many nonwovens, from industrial filters to parts of disposable diapers. (See Figure 10.3.) The easy processability of the

Table 10.1
Selected Properties of Polypropylene and Polyethylene Fiber

Property	Polypropylene	Polyethylene ^a	
Specific gravity	0.92	0.90	
Tenacity (g/d)	2.5–5.5	30–45	
Moisture regain (%)	0.04	0	
Resiliency	Good	Good	
Burning characteristics	In flame, burns with melting; continues after flame removed	In flame, burns very slowly with melting; self-extinguishing after flame removed	
Melting point (°F)	320-330	250-260	
Conductivity of Heat Electricity	Low Low	Low Low	
Resistance to damage from Fungi Insects Prolonged exposure to sunlight Acids Bases	Excellent Excellent Poor Excellent Excellent	Excellent Excellent Poor Excellent Excellent	

^a Gel-spun polyethylene fibers.

FIGURE 10.3
Polypropylene
nonwovens in
disposable diapers

polymer makes it ideal for forming nonwovens directly by melt spinning. In addition, the fiber is inexpensive and light weight. Polypropylene nonwovens for filters and wipes can be given an electrical charge to enhance their ability to attract dust and dirt particles. As diaper liners, they wick moisture away from the skin to the inner absorbent layer of the diaper.

Other industrial applications of polypropylene include ropes, cordage, netting, and bagging. Nonwoven olefin geotextile materials are used in road construction and in other engineering projects. Polypropylene geotextiles are placed under the soil or roadbeds, where their strength and chemical resistance are advantages and they will not be degraded by light. They are also used as stitching in geotextiles for control of erosion. These products, placed on top of the soil, should biodegrade after vegetation is established. Ropes and cords made from polypropylene are light weight, water resistant, and can be very strong when higher-tenacity fibers are used.

Another significant use for polypropylene is in carpets. It has virtually replaced jute in carpet backing because of its resistance to microorganisms. This is a large use of fibrillated fibers. Being nonabsorbent and having good weather resistance, polypropylene can be made into carpets that will withstand exposure to outdoor conditions in areas where sunlight is not intense or prolonged. However, without ultraviolet light stabilizers, such carpets will deteriorate in climates such as those of the American Southwest. When polypropylene is used for traditional indoor carpets, soil- and waterborne stain resistance are exceptional, and the carpets have good lightfastness and resistance to moths. A drawback has been its lower resilience, which can affect the stability of the carpet pile.

For many years upholstery fabric manufacturers made extensive use of polypropylene in a variety of fabrics including velvets. Stain resistance was a particular advantage. Changes in home furnishing fashions, as well as other expanding markets such as nonwovens, have resulted in a decline in the amount of polypropylene used in upholstery. It is still often seen in contract and office furniture, though.

Although industrial and home furnishings areas are the major outlets for polypropylene fiber, it is also an apparel fiber. It enjoys a good proportion of the market for activewear products because of its excellent wicking qualities, transmitting moisture to the outer surface and reducing the cold, clammy feeling next to the skin. Use in other apparel fabrics is limited. Fine-denier filament polyolefin is difficult to produce as high-quality filament yarn, although research in this area continues. Staple fiber yarns are more easily produced, and most apparel is made from staple yarns. Because the polymer must be colored before it is extruded, polypropylene has the advantage of excellent colorfastness but the disadvantage that decisions about color must be made long before the fabrication of final products. Given the structure of the olefin industry today, however, with its smaller, more flexible manufacturers and the quick-response ability of most of the textile supply chain, opportunities for specialty and fashion-oriented apparel products are increasing.

Polypropylene fibers are also being used as insulation materials for gloves, footwear, and apparel. Fine olefin and polyester fibers are made into a nonwoven batting that the manufacturer, 3M, calls Thinsulate[®]. The batting provides good insulation because the high surface area and low density of the material trap air. The fine size and light weight of the fibers contribute to warmth without excessive bulk or weight.

DuPont manufactures Tyvek[®], a nonwoven polyolefin for use in barrier garments such as clean suits, protective garments for toxic waste cleanup, and the like. One of the major advantages of the fiber is the low cost of production.

Polypropylene Trademarks

As mentioned under manufacturing, a large number of different firms throughout the world make polypropylene fibers and products for the varied end uses described above. American Fibers and Yarns produces a number of polypropylene fibers including the brand names Marquesa[®], Impressa[®], and Innova[®]. FiberVisions[®] manufactures several polypropylene fibers under the company trademark.

Care Procedures

Polypropylene carpet and upholstery fabrics are relatively care free, and great strides in improving stain resistance have been made. For most of these fabrics, stains can be wiped off with a damp cloth. Routine vacuuming and periodic shampooing will help to maintain and preserve both appearance and durability.

Garments and other items can be laundered at moderate temperatures. The fiber, however, is heat sensitive at about 250°F. Most dryers do not exceed temperatures of 180°F to 190°F, so drying at low temperatures is permissible; however, line drying may be preferable as it generally eliminates any need for pressing. Hot irons will damage these fabrics, so only cool iron temperatures should be used for pressing. Polypropylene fibers are affected by some dry-cleaning fluids. Care labels should be checked carefully as blends of polypropylene with other fibers may require special care.

Many polypropylene nonwoven fabrics are used in disposable products that are designed for one or a few uses for sanitary or durability reasons. Procedures for caring for these products are, therefore, not an issue.

POLYETHYLENE FIBERS

Polyethylene shares many qualities with polypropylene and exhibits some differences, including a lower melting point and some tendency to be deformed if stretched more than 10 percent. Melt-spun polyethylene has not been a textile fiber of major importance; the polymer has been used mostly for plastic films and packing materials. The plastic bags used by so many are usually made of polyethylene.

In the late 1960s, high-strength polyethylene fibers were developed using the gel-spinning process. The fibers are stretched to a great length while in the gel state, resulting in a nearly perfect alignment of the polymer chains. This high degree of crystallinity and orientation confer extremely high strength to the fibers. Indeed, they are among the strongest fibers known: fifteen times stronger than steel (on a strength-to-weight ratio) and more than twice the strength of the para-aramids (Miraftab 2000). The modulus of gel-spun polyethylene fibers is likewise exceedingly high relative to other fibers, and these polyethylene fibers are less brittle. They resist moisture, chemicals, and ultraviolet light and are light weight. Disadvantages are a low melting point (300°F, or 147°C) and, for some varieties of the fiber, a tendency to "creep," or elongate, under load over a long period of time.

Products for which these fibers are being used include ropes, cables, cut-resistant gloves, backpacks, ballistic vests and helmets, surgical sutures, and a wide range of fiber composite materials for industry. (See Figure 10.4.) Spectra[®] polyethylene fibers are produced by Honeywell, and Dyneema[®] is manufactured by DSM.

FIGURE 10.4

High-strength products made from Spectra® polyethylene fiber range from (a) protective gloves and sleeves to (b) backpacks considered to be the toughest, lightest internal-frame packs ever produced. (a) courtesy of Golden Needle Knitting & Glove Company, (b) courtesy of AlliedSignal, Inc.

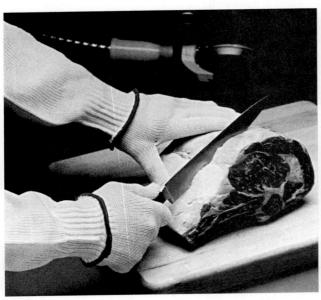

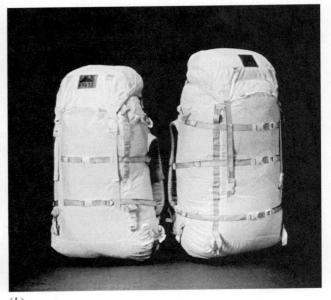

SUMMARY POINTS

- Polyolefin fibers are composed of polymers similar to those used for plastic films and bags
- Polypropylene is the predominant olefin fiber; distinctive properties are the following:
 - · Lower melting point than other synthetic fibers
 - · Low specific gravity and moisture absorbency
- Uses include the following:
 - Nonwoven disposable items
 - Carpet backing and outdoor carpets
 - Ropes, cords, and geotextiles
 - · Activewear and protective garments
- Usable polyethylene fibers are produced by the gel-spinning process
 - Properties are ultra high strength combined with low specific gravity and low moisture absorbency
 - Uses include ropes and cables, ballistic vests, and surgical sutures

Questions

- 1. How does the production process for polypropylene relate to the structure of the industry?
- 2. Which properties of polypropylene fibers contribute to their use in the following products:

carpets

carpet backing

diapers

upholstery

activewear

geotextiles

- 3. What care procedures are recommended for polypropylene garments?
- 4. What properties of high-strength polyethylene fibers contribute to their use in the following products?

cut-resistant clothing

ballistic vests

References

Miraftab, M. "Technical Fibres." In *Handbook of Technical Textiles*, edited by A. R. Horrocks and S. C. Anand, 24. Cambridge, UK: Woodhead Publishing, 2000.

Mather, R. R. "Polyolefin Fibres." In *Synthetic Fibres: Nylon, Polyester, Acrylic, Polyolefin*, edited by J. E. McIntyre, 235. Cambridge, UK: Woodhead Publishing, 2005.

Stevens, M. P. Polymer Chemistry. New York: Oxford University Press, 1999.

Recommended Readings

Barish, L. "Sunlight Degradation of Polypropylene Textile Fibers: A Microscopial Study." *Journal of the Textile Institute* 80, no. 1 (1989): 107.

Van Dingenen, J. L. "Gel-spun High-Performance Polyethylene Fibres." In *High-Performance Fibres*, edited by J. W. S. Hearle. Cambridge, UK: Woodhead Publishing, 2001.

en profesion de la proposición de la companya de la proposición de la companya de la companya de la companya d La companya de la co

a de la companya de la co

To the property of the second state of the sec

la distanti en la incidenta in alta en una ancia destilla incidenta para la contra qui en la idil 1985.

The common series of the commo

2301 (1930)

700

original balmentarion

and Andrew Company of the Company o

ELASTOMERIC FIBERS

Learning Objectives

- 1. Describe the structure of elastomeric fibers.
- 2. Differentiate between spandex and rubber fibers.
- 3. Relate the properties of spandex fibers to current end uses.

Lastomeric fiber is defined as fiber made of "a natural or synthetic polymer which at room temperature can be stretched repeatedly to at least twice its original length and which after removal of the tensile load will immediately and forcibly return to approximately its original length" (ASTM 1986, 262). These materials have extremely low glass transition temperatures and, as is indicated in the definition, will exhibit plastic, or deformable, behavior at room temperature. Stretch and recovery are highly desired features of many apparel products today.

Several generic fiber classifications have been established for elastomeric fibers: spandex, rubber, anidex, and elastoester. Of these generic fiber groups, anidex is no longer produced, and the newest generic fiber, elastoester, is manufactured in Japan.

Rubber was the original elastomeric fiber, and several types of rubber are defined by the FTC, but these have only limited uses today, such as in elastic bands. Spandex was the first commercially successful synthetic elastomeric fiber and dominates the market today.

SPANDEX

Manufactured in the United States since 1959, spandex fibers have attained extensive use in stretch fabrics for foundation garments, sports apparel, fashionable clothing, and other products where elasticity is important.

The FTC defines *spandex fiber* as "a manufactured fiber in which the fiber-forming substance is a long-chain synthetic polymer comprised of at least 85 percent

FIGURE 11.1

Diagram of polyurethane polymers. Hard segments provide rigidity, while soft segments stretch.

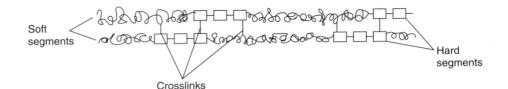

of a segmented polyurethane." The generic name *elastane* is used globally for these fibers. Spandex is a block copolymer with rigid aromatic segments connected by urethane linkages to polyether or polyester segments. The different types of polymers can sometimes be referred to as "polyether spandex" or "polyester spandex." The latter should not be confused with polyester/spandex blended fabric, where polyester fibers are blended with spandex fibers. (See page 201 for a discussion of spandex blends.)

In the polyurethane structure, the polyether or polyester segments of the polymer are amorphous and assume a randomly coiled position when fibers are relaxed. When fibers are stretched, the coils straighten, thereby providing the high elongation characteristic of spandex. Upon the release of tension, the amorphous, or "soft," segments coil up again, returning the fibers to their prestretched position. The rigid urethane segments form highly hydrogen-bonded crystalline areas that prevent the polymers from sliding past each other and permanently deforming when stretched. The chains can also be crosslinked to provide further integrity. (See Figure 11.1.)

Manufacture

Spandex is manufactured in a process similar to that of aramid fibers. For DuPont's Lycra® spandex, the constituents for the block copolymer of polyether and urethane are reacted in solution at a fairly low temperature. The fibers are then dry spun from a solution of dimethyl formamide. They come into contact with each other while they are still somewhat soft and tacky, resulting in a random fusing or sticking together of individual fibers. (See Figure 11.2.) This fusing of fibers into bundles strengthens them for subsequent processing (Couper 1985).

Another production method is used by RadiciSpandex for their Glospan[®] fibers. In this process, called reaction spinning, a prepolymer of shorter length is extruded into a wet spinning bath. It contacts a compound that completes the polymerization of the long-chain molecules and partially coagulates them into fibers. A subsequent heating step completes the fiber formation. Because the fibers are brought into contact while they are still somewhat soft, they adhere to each other, forming fused bundles, as with dry-spun spandex fibers.

Properties of Spandex

The characteristics of spandex fibers are summarized in Table 11.1.

Physical Properties

Lycra[®] spandex fibers are round in cross section and smooth in the longitudinal view. (See Figure 11.2.) Other spandex fibers may have peanut or dog-bone shapes.

FIGURE 11.2 Two cross-sectional views of Lycra® spandex fibers: (a) magnified 500 times; (b) magnified 150 times. Courtesy of DuPont Company.

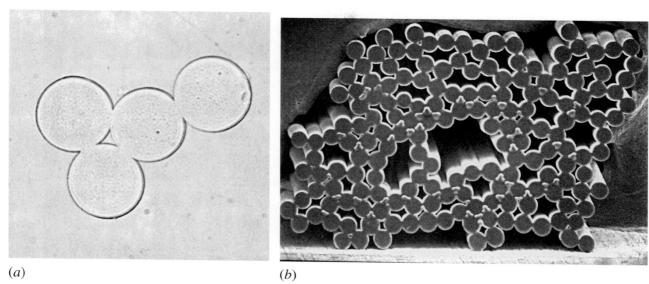

TABLE 11.1 Selected Properties of Spandex a

Property	Spandex
Specific gravity	1.21
Tenacity (g/d)	0.7
Moisture regain (%)	1.3
Resiliency	Excellent
Burning characteristics	In flame, burns with melting, continues after flame removed; sticks at 370°F
Conductivity of Heat Electricity	Difficult to assess because fiber is used in combination with other fibers Difficult to assess because fiber is used in combination with other fibers
Resistance to damage from Fungi Insects Prolonged exposure to sunlight Acids Bases	Excellent Excellent Resists degradation, but may discolor Good; acid fumes may cause yellowing Fair

 $^{{}^}a\mathsf{Properties}$ are for $\mathsf{Lycra}^{\mathsf{B}}$ spandex fibers.

Rubber monofilaments have a rectangular cross section. Spandex fibers can be made in much finer deniers than rubber, giving them a significant advantage for many end uses. Spandex has a moderate density. Specific gravity is 1.0 to 1.2, depending on pigmentation.

Mechanical Properties

Strength. Spandex is quite weak when compared with nonelastomeric fibers but is much stronger than rubber. Breaking strength is around 0.7 g/d.

Modulus. The modulus of spandex, as that of rubber, is extremely low. It can be easily stretched.

Elongation and Recovery. The most important properties of spandex are its high elongation and excellent recovery. It can stretch 500 to 600 percent without breaking. This amount of stretching is comparable to rubber, and the recovery is also similar.

Chemical Properties

Absorbency and Moisture Regain. Although the moisture regain of spandex fibers is low (less than 1.0 percent), water will penetrate the fiber.

Effect of Heat; Combustibility. Spandex fibers will burn. They melt at temperatures of about 450°F and will become sticky at temperatures around 340°F. Spandex can be heat-set, and the fibers can be dried safely in an automatic dryer.

Chemical Reactivity. The resistance to chemicals of spandex fibers is generally good and is another distinct advantage that these fibers have over rubber. Chlorine compounds in strong concentrations will cause the fiber to be degraded and yellowed, but polyether-based fibers especially can withstand chlorine concentrations such as those used in swimming pools. Chlorine bleaches should be avoided.

Seawater has no deleterious effect on spandex fibers. Perspiration and oil-based sunscreens do not seriously affect spandex, although some may cause yellowing of white fibers.

Spandex is dyeable with the same dyes that dye nylon. This is in contrast to rubber fibers, which are not dyeable, and therefore, the white rubber fibers may "grin" through in a stretch fabric.

Environmental Properties

Spandex has satisfactory resistance to microorganisms. Extended exposure to light may cause discoloration of some types of white spandex but does not deteriorate the fiber seriously.

Uses

Spandex fibers are always used in conjunction with other fibers. This combination with other fibers may be made in one of several ways. The spandex fiber may be used as bare yarn, single-covered wrapped yarn, double-covered yarn, or corespun yarn. Fine-denier spandex is used to give stretch with sheerness in products such as ladies' hosiery.

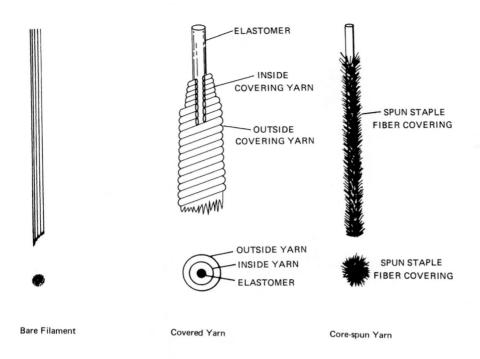

Figure 11.3

Types of elastomeric yarns (length and cross-section).

Bare-core spandex yarns are uncovered filaments. They may be woven or knitted into fabrics in combination with other yarns. This provides additional strength to the spandex and gives stretch to the fabric. To make the monofilament more comfortable and more comparable to other yarns, a spandex filament core is often covered with another fiber. Single-covered yarns have one layer of another filament fiber wrapped around the spandex core. In double-covered yarns, one layer is twisted around the core in one direction, and the second layer is twisted around the core in the opposite direction. (See Figure 11.3.) These yarns can be very sheer and are often used for support hose. Where desirable, two different types of fibers can be used, one in each layer. The wrapped yarns will stretch and recover with the spandex core. Core-spun yarns are made by holding spandex filaments under tension while a staple fiber is spun around the core.

Spandex yarns are woven or knitted into a variety of garments in which stretch is desirable. For some time these have included power nets for foundation garments; woven or crocheted fabrics for underwear waistbands; tricot or circular knits for lingerie; and activewear used in sports such as swimming, skiing, golf, and tennis. (See Figure 11.4.) One factor to consider in selecting fiber blends is that spandex is damaged in water at temperatures higher than 220°F, so if a synthetic fiber blend is needed, cheaper polyester/spandex blends are less widely used than nylon. Spandex/nylon blends can be dyed with the same dye at a lower temperature and give better stretch and recovery properties as well.

Increasingly spandex is seen in a great array of everyday and special-occasion apparel. In cotton denim jeans, casual and dress pants, and knitted and woven shirts and tops, a small amount of spandex provides extra comfort and fit. Formerly, stretch-textured yarns of nylon or polyester (see chapter 14) were adequate, but with the current preference for the look and feel of natural fiber fabrics,

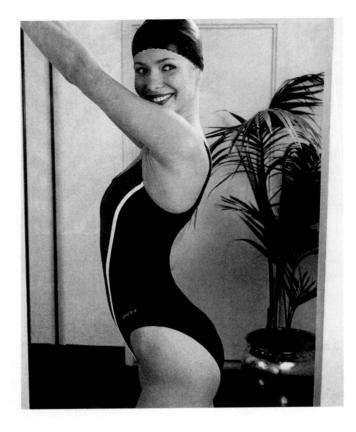

FIGURE 11.4

Swimwear made from Glospan® spandex type S-17 by Globe Manufacturing Corporation.
Chlorine-resistant
Clospan® provides improved protection from damage caused by chlorine, ultraviolet rays, sunscreen, and perspiration. Photograph courtesy of Christina Swimwear.

this alternative to low stretch for comfort and fit is appealing. (See Figure 11.5.) Spandex, however, is an expensive fiber, and its cost should be factored in when developing apparel products.

The high cost is reflected in how much spandex is included in blends. Jeans or a sport coat may have only 2 to 5 percent spandex, where the effect is to give a slightly better fit. Activewear and swimwear often contain 10 to 15 percent spandex, while support garments would have greater amounts.

Spandex Trademarks

Lycra® fibers, produced by DuPont, dominate the spandex market (McIntyre 2005). Other brand names are Roica®, developed by Bayer and now produced in Germany by the Asahi Kasei Group, and Glospan®, manufactured by RadiciSpandex. In the past ten years, the number of spandex producers has greatly increased from the branded days of DuPont, Radici, and Bayer as spandex has started to become a commodity product. The response of these better-known manufacturers has been to market the quality of their products as, for example, the Lycra® hangtag seen on many garments.

Care Procedures

Because spandex fibers are used in combination with other fibers, care must take into account not only the characteristics of spandex, but also those of the other

FIGURE 11.5

Casual wear containing spandex. Coat and pants are 96% cotton/4% spandex; knit top is 91% nylon/6% spandex/3% metallic. Ensemble from Jones New York.

fibers. Spandex should not be subjected to very hot water or to excessive heat in ironing. It is recommended that ironing temperatures not exceed 300°F, or the "synthetic" setting on a hand iron. Dryer temperatures should be moderate. Chlorine bleaches should not be used in laundering spandex because they can degrade the fiber.

OTHER MANUFACTURED ELASTOMERIC FIBERS

In recent years other synthetic elastomeric fibers have been developed and given generic fiber names by the FTC. Most exhibit less stretch than spandex but have equally good recovery.

Elastoester is "a manufactured fiber in which the fiber-forming substance is a long-chain synthetic polymer composed of at least 50% by weight of aliphatic polyether and at least 35% by weight of polyester." It differs from spandex in that the rigid sections are polyester rather than urethane. Fibers of this type have been used to fabricate elastic nonwovens. Elasterell-P is an elastomeric fiber classifed by the FTC as a subcategory of polyester. The fiber is "formed by the interaction of two or more chemically distinct polymers (of which none exceeds 85% by weight) which contains ester groups as the dominant functional unit (at least 85% by weight of the total polymer content of the fiber) and which, if stretched at least 100%, durably and rapidly reverts substantially to its unstretched length when the

tension is removed." Invista produces the elasterell-p fiber $T400^{\$}$. It is being promoted for blends with cotton in denim jeans to provide fit and shaping.

The FTC has recently recognized another subclass of elastomeric fibers. *Lastol* is a subclass of olefin fibers and denotes fibers "where the fiber-forming substance is a cross-linked synthetic polymer, with low but significant crystallinity, composed of at least 95% by weight of ethylene and at least one other olefin unit, and the fiber is substantially elastic and heat resistant." Dow XLATM is the prototype for lastol fibers. It has somewhat lower maximum elongation than spandex but higher thermal stability and, therefore, is able to be blended with fibers that dye at higher temperatures.

RUBBER FIBERS

Rubber is probably the most important and widely used natural polymer for industrial products (Stevens 1999), primarily in tires. Fibers can be made from natural rubber or from several synthetic rubber polymers. Natural rubber comes from rubber plants. The polymer in natural rubber, with the repeating unit of isoprene,

does not have sufficient long-term recovery from stretch. It is, therefore, crosslinked in a process called *vulcanization* that provides a "memory" to the material. Fibers are formed by splitting thin films of crosslinked rubber polymers into fine strands.

For many years natural rubber was used as the core for fiber-covered elastic materials. Its advantages include high stretch, elasticity, flexibility, good strength, and nonabsorbency. Its disadvantages include deterioration by temperatures above 200°F and by sunlight, oils, petroleum, and aging. Many of these problems are caused by other compounds, such as proteins, that are present in natural rubber.

Synthetic rubber products can be produced in purer forms to improve some of the disadvantages of natural rubber. The most common of these, polyisoprene, is classified by the FTC in the same subcategory as natural rubber along with polybutadiene and noncrystalline polyolefins. Another subcategory of synthetic rubbers is for those made of acrylonitrile and butadiene. These materials, called *lastrile* or *nitrile rubbers*, are particularly resistant to oils. The third type of synthetic rubber fibers designated by the FTC is those that are "polychloroprene or a copolymer of chloroprene in which at least 35 percent by weight of the fiber-forming substance is composed of chloroprene units." Synthetic rubbers exhibit similar characteristics to natural rubber in their behavior but in general show better resistance to deterioration.

Rubber fibers, whether natural or synthetic, have limited use today, primarily in elastic bands. Synthetic rubber, as a film rather than a fiber, can be used as a fabric coating where its low resistance to stretching and elastic recovery provide a coating layer that deforms with the fabric and is, therefore, not constraining.

SUMMARY POINTS

- Elastomeric fibers exhibit high elongation and good recovery
- Spandex
 - Polyurethane polymer
 - Elastic properties provided by coiled segments of polyether or polyester
 - Fiber integrity provided by urethane links
 - Properties
 - Very high elongation and excellent recovery
 - Good chemical and environmental resistance
 - Cost is high compared to other fibers
 - · Used in blends with other fibers
- Other elastomeric fibers
 - Elastoester, elasterell-p, and lastol
 - Lower elongation but higher heat stability than spandex
- Rubber
 - Produced from natural and synthetic materials
 - · Main uses today are in elastic bands

Questions

- 1. What is the definition of an elastomeric fiber? How do elastomeric fibers provide high elongation and recovery?
- 2. What are the different types of spandex fibers?
- 3. What are the advantages of using spandex fibers instead of rubber fibers in swimwear?
- 4. Describe the various ways in which spandex is used in combination with other fibers.
- 5. How are care procedures for fabrics that include spandex determined?
- 6. Describe the newer synthetic elastomeric fibers, and predict some appropriate end uses.

References

American Society for Testing and Materials. *Compilation of ASTM Standard Definitions*, 6th ed. Philadelphia: ASTM, 1986.

Couper, M. "Polyurethane Elastomeric Fibers." In *High Technology Fibers*, edited by M. Lewin and J. Preston, 51. New York: Marcel Dekker, 1985.

McIntyre, J. E. "Historical Background." In *Synthetic Fibres: Nylon, Polyester, Acrylic, Polyolefin*, edited by J. E. McIntyre, 1. Cambridge, UK: Woodhead Publishing, 2005.

Stevens, M. P. Polymer Chemistry, 3rd ed. New York: Oxford University Press, 1999.

Recommended Readings

Morton, M. Rubber Technology. New York: Van Nostrand Reinhold, 1973.

Shivers, J. C. "The Search for a Superior Elastic Fiber." *Textile Chemist and Colorist* 30, no. 12 (1998): 17.

y compartment in a majora meta reliaza azona nen acida al dega

Produces from estimate and sample means as a second second

What is a second of the distribution of the second of the

Describe the various greek in which police is a contract to the contract of th

The first of the second of the

And the Windowski State of the control of the Contr

Care of All 1 Colversions & Textures in Principle 1 for the Color of Color

restricted but represent

en de la companya de la com

HIGH-PERFORMANCE AND SPECIALTY FIBERS

Learning Objectives

- 1. Distinguish the factors that classify fibers as high performance.
- 2. Relate the properties of high-strength, high-modulus fibers to their end uses.
- 3. Relate the properties of heat-resistant fibers to their end uses.
- 4. Describe the distinctive properties of currently used specialty fibers.

n addition to the manufactured fibers discussed in earlier chapters, there are other types of fibers that have somewhat limited use or represent relatively recent developments in the technology of manufactured fiber production. These include the high-performance fibers that have been engineered for or used in industrial and specialty products. They also include mineral and metallic fibers that have been used for many years for particular functional or aesthetic purposes, as well as several recognized generic types that may appear in only a small number of products.

Most of the applications of the fibers discussed in this chapter are to be found in products used in industry, in building and construction materials, by the law enforcement community and the military, in transportation, in recreational equipment, or in geotextiles. While most consumers may not ordinarily select or purchase many of the products made from these fibers, we increasingly depend on the machines, equipment, automobiles, tools, and structures that incorporate these fibers in our homes, our work environments, and our leisure time pursuits. As these segments of the textile industry grow, larger numbers of graduates of textile programs are likely to find employment in the management, manufacture, and distribution of high-performance and specialty textiles. For the discussion below, these fibers are grouped according to their distinctive or special characteristics. Characteristics of selected high-performance fibers used today are presented in Table 12.1.

208

TABLE 12.1
Selected Properties of High-performance Fibers

Fiber	Melting Temperature (°F)	Decomposition Temperature (°F)	Tenacity (g/d)	Modulus (g/d)	Compressive Strength (g/d)
Glass	1,300-2,900	1 2 2	11-20	330-415	≈3.5–5.0
Gel-spun polyethylene	212		30-35	1,400-2,000	2.0
Meta-aramid	Does not melt	700	5.3	1,150	
Para-aramid	Does not melt	660	26-28	980-1,425	2.5-3.8
PBI	Does not melt	625	3.1	360	
PBO	Does not melt	1,100	42	1,300-2,000	1.4-2.8
Sulfar	545		3.0-3.5	30-40	
Melamine	Does not melt	700	1.8		
Carbon (PAN)	Does not melt	<1,500	13-27	1,500	1.6-2.9
Carbon (pitch)	Does not melt	<1,500	16-28	950-4,600	2.5-6.9
Ceramic		1,000-1,600	5.2	1,100-1,200	21.2

Sources: Data from Kumar, S. "Advances in High Performance Fibres." Indian Journal of Fibre and Textile Research 16 (March 1991): 52; Lewin, M., and J. Preston. High Technology Fibers, parts A-D. New York: Marcel Dekker, 1985-96; and Warner, S. B. Fiber Science. Englewood Cliffs, NJ: Prentice Hall, 1995.

Note: PAN = polyacrylonitrile.

HIGH-STRENGTH, HIGH-MODULUS FIBERS

Much of the development and interest in high-performance fibers has been focused on those with both high tenacity and high modulus. They are very strong and usually also very stiff and resistant to bending and stretching. The para-aramids described in chapter 7 and the gel-spun polyethylene fibers in chapter 10 are two types of high-strength, high-tenacity fibers. Several of the high-strength, high-modulus fibers discussed below are also very thermally stable and, hence, find application in heat-resistant products as well.

Carbon Fibers

Carbon fibers find their major applications in industrial uses. Within the industry, the terms *carbon fibers* and *graphite fibers* are sometimes used interchangeably, but graphite fibers are actually a special type of carbon fiber that has a crystal, or *graphitic*, structure unique to true graphite fibers.

Manufacture

Carbon fibers are made by first spinning a *precursor* fiber that is later converted to 100 percent carbon. One precursor that has been frequently used is pitch, a material derived from coal tar or petroleum tar. Pitch can be melt spun into fibers with a range of crystallinities. The more crystalline and oriented the precursor fibers, the stronger the final carbon fibers will be. Other manufactured fibers are

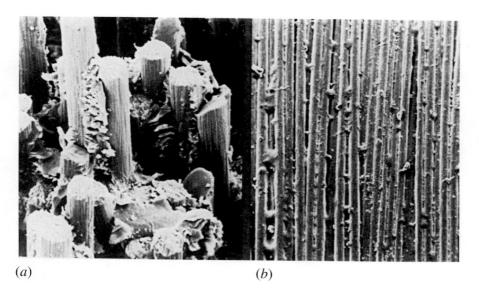

FIGURE 12.1

Scanning electron micrographs of carbon fibers in a composite structure; (a) cross-section; (b) longitudinal view. Reproduced courtesy of the British Textile Technology Group.

also used as carbon *precursors*. Rayon was used at one time, and now lyocell fibers, which are very crystalline, are being produced for making carbon fibers. The most common starting material now, however, is polyacrylonitrile (PAN), as described in chapter 9.

To convert the PAN fibers to carbon fibers, they are heated to temperatures greater than 1,800°F (1,000°C), driving off most of the hydrogen, nitrogen, and other atoms to leave only carbon. On further heating to 4,500°F (2,500°C), a crystalline graphite structure, which produces extremely high-modulus graphite fibers, develops. Similar high-heat treatment is given to melt-spun pitch fibers to eliminate the hydrogen atoms. Because the raw material is less expensive, substantial quantities of industrial- and general-grade materials are manufactured from pitch.

Properties of Carbon Fibers

Carbon fibers are black in color, with a fairly smooth appearance. (See Figure 12.1.) They have a very high modulus and tenacity (13 to 28 g/d) due to the crystalline structure of the fiber. Carbon fibers are heavier than other manufactured fibers but lighter weight than glass fibers or steel, materials with which they compete for many end uses.

Uses

Carbon fibers are most often used as a reinforcing material in plastic composites. The high strength of the fiber increases the toughness of the composite material, and the black color is not a detriment because the fibers are embedded in the matrix. Carbon fiber–reinforced composites are used in lightweight structures for aircraft and spacecraft and as brake discs for jet airplanes. The new 787 Dreamliner airplane made by Boeing contains a large proportion of carbon fiber–based structure. The lighter-weight construction, versus all-metal body materials, saves fuel during flight. Carbon fibers also are used in such diverse areas as sporting goods, the construction industry, the automotive industry, and medicine. Golf club

FIGURE 12.2

(a) Kayak paddle made of carbon fiber reinforced plastic; (b) close-up view of paddle structure.

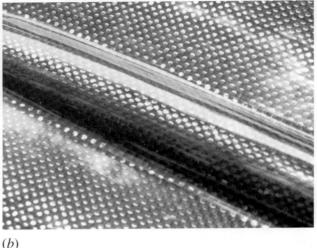

handles, tennis racquets, fishing poles, skis, canoes, and kayaks all benefit from carbon fiber reinforcement. (See Figure 12.2.) Bridges and buildings are also reinforced with carbon fibers, and graphite materials have been used for implantation to replace bone.

Carbon fibers add to the cost of many items because they are expensive (about five times the cost of PET polyester) (Hearle 2001). The cost is, however, less than that of the aramids and some of the other high-tenacity, high-modulus fibers described below.

Glass Fiber

During World War I, the Germans found that they were running short of asbestos fiber. In an effort to find a substitute fiber that was noncombustible, they attempted to make fibers from glass, with only limited success. Following World War I, researchers continued to look into ways of using glass to produce fibers. This technology had been sufficiently advanced by the late 1930s, when the Owens-Corning Glass Company initiated the mass production of glass fiber.

Glass fiber is made from glass that has been melted and extruded into long, fine filaments. Glass is made from silica sand and limestone, plus small amounts of other constituents such as soda ash, borax, and aluminum hydroxide. The quantities of these ingredients are varied depending on the qualities desired in the glass fiber.

Manufacture

Glass fiber can be produced in both continuous filament form and in staple lengths. Selected ingredients are mixed together, and the mixture is melted in a

high-temperature furnace. Molten glass is then drawn from the furnace in the form of filaments, the diameter of which is controlled by the viscosity of the glass melt, the rate of extrusion, and the size of the spinneret hole. Filament fibers are collected into a bundle called a *roving*. This term will be encountered later when the process for making staple yarns is described in chapter 14. If staple fiber lengths are required, an air jet "cuts" the filaments and pulls the fibers onto a revolving drum from which they are gathered into a strand.

Bare glass fibers have poor abrasion resistance, so a sizing or lubricating material is applied to fibers to provide some degree of protection. Fibers made of glass are subject to the usual textile processes for making yarns and for weaving. (See Figure 12.3.)

FIGURE 12.3

Strands of glass fiber roving are woven into fabric which is used in reinforced plastic boats, containers, parts for trucks and recreational vehices, home furnishings equipment, sporting goods, and corrosions-resistant products such as storage tanks. Courtesy of PPG Industries, Glass Group.

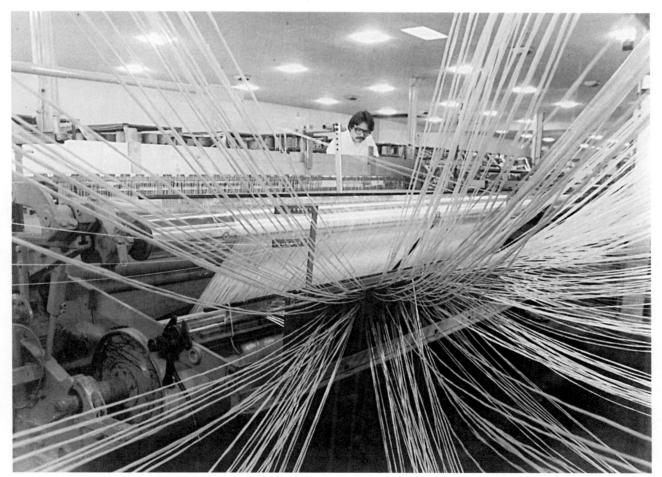

Properties of Glass Fiber

Physical Properties. Under the microscope, glass fibers look like small glass rods (which is exactly what glass fibers are). Most glass fibers are manufactured in extremely small diameters (around five to fifteen micrometers) to provide the flexibility required for textile applications. The longitudinal view of the fiber shows a smooth, round surface that produces a high luster. The fiber is colorless, unless a ceramic pigment is added to the glass melt before it is formed into fibers. Glass fibers have a specific gravity of 2.5 to 2.7, making them very heavy relative to other fibers.

Mechanical Properties. Glass fibers have high breaking strength and modulus but low elongation. The high modulus and low elongation make them very brittle. Resilience is also extremely low.

Chemical Properties. Glass fiber is completely nonabsorbent and, therefore, has no affinity for dyes. Both acids and bases can affect glass fiber, while organic solvents do not.

Glass conducts neither heat nor electricity. For this reason, it is used in staple form in a variety of insulation materials. The fiber is completely noncombustible. When held in a flame, the finish of the fabric darkens as the pigments and resins used in finishing are destroyed, but the fibers, yarns, and woven structure of the fabric remain intact. Glass fiber softens at 1,350°F (700°C) or above.

Other Properties. Glass fiber is attacked by neither mildew nor insect pests. Sunlight does not damage the fabric nor is it harmed by aging. Because of their low absorbency and high melting point, glass fibers have excellent resistance to shrinkage.

One of the major problems encountered in glass fabrics is their low abrasion resistance. They tend to break where creased and to wear at points where the fabric rubs against other objects.

Uses

Except for special items of protective clothing in which it is one component, glass fiber has never been used for wearing apparel. If the ends of the fibers are broken, they scratch or irritate the skin. Also, glass fiber has poor resistance to abrasion, is not absorbent, and lacks stretch. At one time glass fiber was used fairly extensively in draperies, curtains, lampshades, and window shades; however, at the present time, except for some institutional curtain and drapery products, the only significant application of glass fibers for home use is in vertical blinds. The glass fiber batting material used for insulation in buildings is not classified by the glass fiber industry as a textile fiber.

Today glass fiber is most widely used as reinforcement in composites in the aerospace, construction, and transportation industries. The glass fibers can be included in composites as chopped fibers, yarns, or fabrics. (Chapter 18 gives a detailed discussion of such fiber-reinforced composites.)

Glass fibers also find applications in the field of fiber optics because of their electrical conductivity. Scientists learned that light could be transmitted over long distances through fine strands of transparent materials. These beams of light can

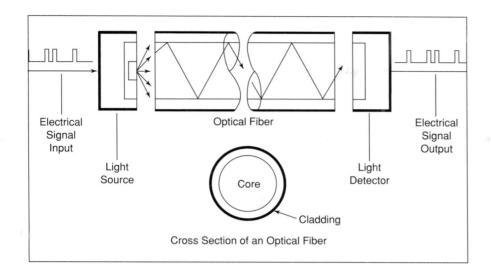

FIGURE 12.4

Schematic of optical fiber. Electrical signals are converted into light, which can be transmitted by the fiber; the light, can then be converted back into an electrical signal. Cladding helps keep most of the light inside the fiber by reflecting light waves toward its center as they pass through it. Reprinted courtesy of the National Science Foundation.

be used to carry messages. Glass fiber has proved to be a particularly effective carrier. The strands of glass fiber that form the light-transmitting core of fiber-optic cable are surrounded by a sheath that keeps the light from dispersing or straying. (See Figure 12.4.)

Manufactured Fibers

Several types of manufactured fibers have been developed for various uses where high strength and modulus justify the added cost.

Polyphenylene Benzobisoxazole Fibers

PBO fibers are recently developed fibers composed of the polymer polyphenylene benzobisoxazole. Like the aramids, PBO is a rigid rod polymer that is extremely stiff and forms highly ordered crystalline structures. PBO is synthesized from benzene dihydrochloride and terephthalic acid, the acid also used in the manufacture of polyester. It is spun from a strong acid solution through an air gap into a water bath. Zylon® PBO fibers are manufactured by the Toyobo Company in Japan.

Because of its rigid structure, PBO exhibits very high strength and modulus, as well as excellent thermal stability. Its tenacity and modulus are the highest of the present-day commercial high-performance fibers. PBO does not melt and will not decompose below temperatures of 1,200°F. PBO fabrics are light and flexible but are not easily dyed. They are a gold color as produced.

The fibers are appropriate for many industrial end uses such as high-performance tires, high-temperature devices, sporting goods, ropes, and cables. At the same time, the heat resistance and light weight of PBO make it a good choice for protective clothing for firefighters, industrial workers, and race car drivers.

Ceramic Fibers

Composed of aluminum, or other oxides, ceramic fibers have lower tensile strength than many inorganic fibers but higher compressive strength. This makes them useful as reinforcing materials in aircraft, space shuttles, and submarines, where high pressures are encountered.

Boron Fibers

Made by depositing boron vapor onto fine tungsten wire, these fibers have uses in reinforcement, especially of aluminum. Cloth made in part from boron fibers was used in the drill stems for collecting lunar rock samples during NASA's moon missions.

HEAT-RESISTANT FIBERS

Some fibers, natural and manufactured, organic and inorganic, have extremely high (or no) melting points. They thus provide high thermal stability or resistance to heat. Several of the fibers discussed as high tenacity, high modulus are also very heat resistant. The primary end uses of the fibers described below are determined by their thermal stability.

Asbestos

Asbestos is no longer being made into textile products, but it is of historical interest both because it is the only natural mineral fiber and because it still remains as an insulating material in many buildings. Because it is naturally fireproof, it was used alone or in blends to make textile products in which fire resistance was important, for example, in insulating materials, protective clothing, fire curtains for theaters, and household products such as ironing board covers or pot holders.

Continued inhalation of asbestos fiber can cause serious lung disease, and asbestos fiber is carcinogenic. For this reason, it is no longer used in textile applications in the United States, although it may still be used in other countries. Asbestos fiber insulation, which was placed in many commercial buildings in the 1950s and 1960s, must be removed if renovation or structural modification of these buildings occurs. This is usually expensive.

Manufactured Fibers

The most widely recognized fibers in this category are the aramids, described in chapter 7. There are, however, several other aromatic fibers that exhibit excellent heat resistance. The thermal characteristics of these fibers are compared in Table 12.1.

Polybenzimidazole (PBI)

Polybenzimidazole (PBI) is defined by the FTC as "a manufactured fiber in which the fiber-forming substance is a long-chain aromatic polymer having reoccurring imidazole groups as an integral part of the polymer chain."

PBI entered commercial production in May 1983. The fiber is manufactured by first making the PBI polymer then dissolving it in dimethyl acteamide. The solution is dry spun into an oxygen-free atmosphere to evaporate the solvent.

PBI is nonflammable in air; emits little or no toxic gases or smoke up to temperatures of 1,040°F; and has excellent resistance to acids, organic solvents, and fuels. It has a low modulus and high moisture regain, making it more comfortable for apparel than some other thermally resistant fibers.

The largest present end use of PBI is in civilian and military protective apparel. It is being used as a successful alternative to asbestos in protective gloves, gaskets, and packing materials in industrial applications and to construct fire-blocking material in places such as aircraft. PBI is currently produced by Celanese Corporation in staple form.

Sulfar

Another heat-resistant fiber that was previously made was *sulfar*, defined by the FTC as "a manufactured fiber in which the fiber-forming substance is a long synthetic polysulfide in which at least 85% of the sulfide (—S—) linkages are attached directly to two (2) aromatic rings." The fiber had tenacity, elongation, modulus, elastic recovery, and moisture regain that were satisfactory for textile applications. Chemical resistance was excellent.

Sulfar fibers were manufactured under the trademark name Ryton[®] by Amoco Fabrics and Fibers Company and intended for use in filtration and protective clothing. While it is currently not seen much in textile products, sulfar is still used as a heat-resistant plastic.

Melamine

A newer generic fiber is melamine, recognized by the FTC as "a manufactured fiber in which the fiber-forming substance is a synthetic polymer composed of at least 50% by weight of a cross-linked melamine polymer." Unlike many synthetic manufactured fibers, melamine is not thermoplastic. Rather it is *thermosetting*. This means that, once formed, the fibers do not deform when heat is imposed. The polymers are in a three-dimensional crosslinked network, similar to the material in melamine dinnerware and Formica countertops.

Because of the rigid structure, melamine fibers have low thermal conductivity and high heat resistance. They are weak, however, compared to fibers made from rigid-rod polymers and have a modulus similar to cotton. Melamine fibers are very resistant to chemical degradation. They have applications in protective clothing for firefighters and industrial workers, in airplane seating, upholstered furniture, and high-temperature filters, and they are cheaper than some other fibers for these products. (See Figure 12.5.) Melamine is produced by BASF Corporation under the brand name Basofil[®].

Novoloid

Novoloid is a "manufactured fiber containing at least 85 percent by weight of a cross-linked novolac," a three-dimensional amorphous network of phenol-aldehyde. Because the polymer is composed of only carbon, oxygen, and hydrogen, the products of decomposition at high temperature are not hazardous. This is an attractive feature of novoloid fabrics. In addition, because the fiber has very low thermal conductivity, it protects from both heat and cold.

Currently manufactured by Gun-ei Chemical Industry in Japan under the brand name Kynol[®], novoloid fibers are used in heat-resistant clothing and industrial felts and fabrics. They are also good precursors for carbon fibers, and novoloid fabrics can be converted to activated carbon for filtration (Horrocks et al. 2001)

OTHER SPECIALTY FIBERS

Metallic Fibers

Metallic fibers were the first manufactured fibers. Gold and silver "threads" have long been used to decorate costly garments, tapestries, carpets, and the like. These threads were made either by cutting thin sheets of metal into narrow strips and weaving these strips into decorative patterns or by winding a thin filament of metal around a central core of another material.

Examination of historic costumes and fabrics reveals the disadvantage of using metals in this way. Except for gold, the metals tended to tarnish and become discolored. Yarns were relatively weak and broke readily. Durability was limited, and, of course, the cost of precious metals was high.

Fashion fabrics today make use of a variety of metallic fibers that are both inexpensive and decorative. Metallic fibers are also used in products for purely practical purposes. Many decorative metallic fibers are made in the form of large monofilaments. Monofilament yarns are described in chapter 13.

Forming fibers from metal is difficult; therefore, metal fibers are largely limited to those made from steel, aluminum, iron, nickel, and cobalt-based superalloys. These particular metals lend themselves most readily to fiber formation. The manufacture of fibers from metal is usually done by several methods. A rod of metal is used as the starting material, and from it fine-dimension metal wire is drawn to form fibers. A more common method begins with the formation of metal foil that is sheared or slit into fibers. Copper scrubs, commonly used in cleaning, demonstrate this method on a macro scale. The metal foil can be coated with a colored adhesive and transparent film for added color and durability of the split fibers. A commonly used and inexpensive decorative fiber is aluminum coated with polyester. In a more costly process, gold can be plated on aluminum-covered yarns of polyester or other fibers.

Most applications of metal fibers are for aerospace and other industrial applications where such products as filters, seals, abrasives, and insulation are used. The automotive industry uses metal fibers in tires and brake linings. (See chapter 13 for a discussion of tire cords.) There are limited applications of metal fibers in consumer products, particularly in certain household textile products, decorative apparel, military uniform decorations, and others.

Superfine filaments of stainless steel and aluminum are made and added to fabrics in a number of ways. Metal fibers are used as the core of yarns, wrapped around other core yarns, or used alone. Steel and copper and aluminum fibers are blended into some industrial carpets where they cut down on static electricity buildup and have the side effect of decreasing flammability. As the heat of a fire increases, the metallic fibers conduct some of the heat away from the fire, thereby decreasing the heat of the flame. This tends to slow the rate of burning or to lower temperatures below the kindling point. Other projected end uses for metal fibers include upholstery, blankets, work clothing, and in blends with polyester for hospital gowns.

Chlorofibers

Chlorofibers, made from polymers containing chlorine atoms, were among the first synthetic fibers produced in Europe and the United States. With the development of nylon, acrylic, and polyester, which have better overall properties, chlorofibers became limited to a few end uses based on the distinctive characteristics of each.

Saran

Saran is defined by the FTC as "a manufactured fiber in which the fiber-forming substance is any long-chain synthetic polymer composed of at least 80 percent by weight of vinylidene chloride units (—CH₂—CCl₂—)." Introduced by Dow Chemical Company in 1941, saran is no longer made in fiber form the United States. It is much more commonly seen as the plastic film used for the storage of food.

Saran is a stiff, nondrapable fiber with a number of specialized uses. It has a higher specific gravity than most other synthetics (1.70) and has good strength and excellent elastic recovery and resiliency. The chlorine in the polymer structure, like modacrylic, imparts a level of flame resistance to the fibers.

Saran fibers were used for a time in outdoor furniture and upholstery for public conveyances because of their chemical and flame resistance. Lighter-weight fibers such as acrylic and polypropylene have supplanted saran for some of these applications. Other uses are as diverse as filters, scouring pads, fishing nets, and doll hair. (See Figure 12.6.) For the latter, the shiny character of the fibers is appealing. Saran is manufactured under the trade name Saran[®] by Asahi Kasei of Japan.

Vinyon

The FTC defines *vinyon* as "a manufactured fiber in which the fiber-forming substance is any long-chain synthetic polymer composed of at least 85 percent by weight of vinyl chloride units (—CH₂—CHCl—)." They are called polyvinyl chloride (PVC) fibers in other countries.

Figure 12.6

Doll with saran fiber hair.

The low melting point of vinyon has prevented its use to any extent in apparel in the United States but has made it useful as a heat-sensitive binder in nonwoven applications. One very familiar such product is tea bags. Vinyon fibers are also used in industrial products because of their high resistance to chemicals, and indeed, this property has determined the use of PVC polymer in plastic pipes (a much higher market). Rhovyl[®] vinyon fibers are manufactured in France and provided to customers for use in a wide variety of products including underwear, socks, bedding, filters, and flame-resistant wall coverings and drapes.

Fluoropolymer

Polymers containing fluorine, based on the substance polytetrafluoroethylene (PTFE), have been used for some time in textile and other applications. The FTC has now approved the generic name of *fluoropolymer* for these fibers. The polymeric material may be formed into fibers by the emulsion spinning process or may be formed into sheets, extruded in molded form, or applied as a coating to other substances.

Fluoropolymer fibers have excellent chemical and flame resistance, are usable over a wide temperature range, resist abrasion, and are nonabsorbent. Strength is low to moderate, and melting points vary from low to high depending on the particular polymer. Industrial uses include pump and valve packing, gaskets, filtration materials, bearings, and office copy equipment. Fluoropolymer fibers are expensive and so are confined to products where the cost is justified.

Consumers may know Teflon[®], a fluorocarbon manufactured by DuPont, as a coating for cooking utensils. Teflon[®] is also the trade name for DuPont's fluoropolymer fibers. Teflon[®] fluorocarbon membranes with very tiny openings, or pores, are used in making Gore-Tex[®] fabrics, which have wide use in outdoor apparel. (See chapters 20 and 25.) Albany International produces several fluoropolymer fibers.

Vinal

The FTC defines *vinal* as "a manufactured fiber in which the fiber-forming substance is any long-chain synthetic polymer composed of at least 50 percent by weight of vinyl alcohol units (—CH₂—CHOH—) and in which the total of the vinyl alcohol units and any one or more of the various acetal units is at least 85 percent by weight of the fiber." In some countries vinal fibers are called polyvinyl alcohol (PVA) fibers.

Most of the development of vinal has taken place in Japan. The fiber has a melting point close to that of nylon 6 (around 425°F) and extremely good chemical resistance and is especially resistant to rot-producing microorganisms. The use of vinal fibers is largely in industrial applications, although some blends of vinal fiber with cotton, rayon, or silk have been used abroad.

In a preliminary step during manufacture, a soluble form of vinal fiber is created. Insoluble PVA fibers for regular use are formed by crosslinking with formaldehyde.

The water-soluble form of vinal fibers has found specialty end uses. Soluble yarns of PVA may be used as "support" yarns in fabric constructions where open, sheer, or lacelike effects are desired but are not attainable through normal weaving processes. The fabric is woven then laundered, causing the soluble yarns to dissolve, leaving only the insoluble yarns in a lacy, open pattern. Narrow strips of lace can be separated from a wider web by including water-soluble PVA at intervals. Soluble yarns may also be used when socks are manufactured in a continuous "string" with a few rows of stitches between the toe of one sock and the top of the next. The socks are cut apart, and when subjected to finishing processes, the remaining soluble threads dissolve out, leaving a smoothly finished edge. Only hot water is required to dissolve the PVA fibers.

Medical devices are another growing field for soluble PVA fibers. Examples are dissolving sutures and temporary tissue supports that allow the body to grow replacement ligaments then disappear.

THE FUTURE OF HIGH-PERFORMANCE AND SPECIALTY FIBERS

Hearle (2001) alludes to three generations of manufactured fibers. The first generation comprised those commercialized during the first three-quarters of the twentieth century, those with which we are most familiar. Second-generation fibers, referred to as high-performance fibers and described in this chapter, appeared through the last quarter of the century. While there will continue to be improvements in the high-tenacity, high-modulus and chemically resistant fibers, the new third generation will be the *smart fibers*. A good description of these is "active" systems "that sense and react to environmental stimuli, such as those from mechanical, thermal, chemical, magnetic, or others" (Lewis 2000).

220

Many of these new fibers and materials will be developed for military usage initially, and certainly this is a significant source of funding for research. Development is driven also by the revolution in information technology. The first wave of these materials has sensors, or even electrical circuits, included in fabrics and garments, that behave as wearable computers.

As scientists further tackle the challenge of developing third-generation fibers, they are looking more closely at nature's creatures that are sophisticated manufacturing machines. Examples are silkworms and spiders, which can synthesize and spin very complex fibers in one operation. They work at the nanoscale level, assembling polymer molecules with special features for protection and survival. Analytical instruments today allow scientists and engineers to work on this level too, incorporating the sensors and conductivity into the polymer. The electrical activity can not only transmit information, but can also induce activity in artificial muscles.

A mandate in developing third-generation fibers will most likely be environmental compatibility and sustainability. Mimicking natural fiber production will yield materials that are biodegradable. As protecting the environment becomes increasingly important, fibers made from recycled materials and environmentally friendly processes are likely to thrive.

SUMMARY POINTS

- High-tenacity, high-modulus fibers are used where strength and impact resistance are required
 - · Carbon fibers have high strength and modulus with lower weight
 - Glass fibers have high strength and modulus with higher weight
 - o Manufactured fibers in this group are PBO, ceramic, and boron
- · Heat-resistant fibers have high thermal stability but lower strength
 - Asbestos is a naturally fireproof fiber but is rarely used
 - o Manufactured fibers are PBI, sulfar, melamine, and novoloid
- · Specialty fibers
 - Metallic fibers can be decorative or functional
 - o Chlorofibers, saran and vinyon, have flame resistance
 - Fluoropolymer fibers provide water and stain resistance
 - Vinal fibers can be made water soluble

Questions

- 1. How do high-performance fibers provide heat resistance or high strength and modulus?
- 2. Which of the following fibers are consumers likely to find in apparel? Which in household products? Which ones are consumers unlikely to encounter in products they purchase and why?

PBO fluoropolymer
PBI metallic fiber
novoloid vinyon
vinal carbon

- 3. What properties of glass fiber prevent it from being used in wearing apparel?
- 4. Identify at least three uses of carbon fibers, and explain which properties make carbon fibers a good choice for these uses.
- 5. What are some uses for soluble fibers?
- 6. What will the third generation of manufactured fibers be like?

References

- Hearle, J. W. S. "Introduction." In *High-Performance Fibres*, edited by J. W. S. Hearle, 1. Cambridge, UK: Woodhead Publishing, 2001.
- Horrocks, A. R., H. Eichorn, H. Schwarnke, N. Saville, and C. Thomas. "Thermally Resistant Fibres." In *High-Performance Fibres*, edited by J. W. S. Hearle, 281. Cambridge, UK: Woodhead Publishing, 2001.
- Lewis, R. W. "Forward." In *Smart Fibres, Fabrics and Clothing*, edited by X. Tao, xi. Cambridge, UK: Woodhead Publishing, 2000.

Recommended Readings

- Brody, H. Synthetic Fibre Materials. Essex, UK: Longman Scientific and Technical, 1994.
- Donnet, J.-B., T. K. Wang, S. Rebouillat, and J. C. M. Peng, eds. *Carbon Fibers*. New York: Marcel Dekker, 1998.
- Hongu, T., G. O. Phillips, and M. Takigami. *New Millennium Fibers*. Cambridge, UK: Woodhead Publishing, 2005.
- Lewin, M., and J. Preston. *High Technology Fibers*, parts A–D. New York: Marcel Dekker, 1985–96.
- Mukhopadhyay, S. K. "High Performance Fibers." *Textile Progress* 25, no. 3/4 (1993): 1.

The state of the s

The second of th

数数数数 J. C. C. C. C. Phillippi Like to L. L. Crysigni, S. C. C. C. Creen C. C. Pregg, Clysical Media. 2007年第1日 - MacAbarda Basto Like to Like 1003

Parallel Show with the A. The A. The Show the Control of the Contr

And the first state of the control o

YARN STRUCTURES

Learning Objectives

- 1. Identify the primary yarn structures.
- 2. Describe the systems by which yarns are classified.
- 3. Relate yarn structure to the fabric appearance, comfort, and durability.

f fibers are to be woven or knitted into cloth, they must be formed into long, continuous strands called *yarns*. Fiber for yarns is supplied in either long filaments or short staple lengths. The type of yarn chosen for a fabric affects its appearance and durability, as well as how it feels and drapes. Yarn structure can serve to either enhance or detract from the inherent qualities of the fiber from which the yarn is made and is, therefore, a key consideration in developing and marketing textile products.

There is a wide variety of structures and processes that can be selected to achieve a desired yarn product. Understanding these helps product developers select yarns for end uses and communicate performance specifications to spinning mills or to fabric producers who will use the yarns. In the global supply chain, where sourcing of yarns is increasingly separated from product manufacturing, a common language for describing yarn characteristics and performance is necessary.

This chapter introduces the physical structures and types of yarns, as well as the terminology used to describe and specify them. Chapter 14 explains the processes used to make the various types of yarns.

TYPES OF YARNS

The primary classification of yarns is as filament or staple. These terms were introduced in chapter 2 to describe the length of fibers but are also used to distinguish yarns.

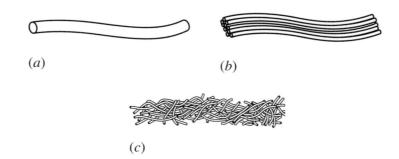

FIGURE 13.1

Basic yarn types:
(a) monofilament yarn
(b) multifilament yarn
(c) staple yarn.

Filament Yarns

Filament yarns are made from long, continuous strands of fiber. *Monofilament yarns*, those made from a single filament, find limited use in nylon hosiery (where an exceptionally sheer fabric is wanted), in some open-work decorative fabrics, in fabric webbing (used in some lightweight beach or casual furniture), and in a variety of industrial uses. Monofilament yarns can be made by the extrusion of large single filaments from spinnerets or by the slit-film technique described in chapter 14.

More commonly, many filaments are joined to form *multifilament yarns*. Multifilament yarns can be made more cohesive by twisting them together loosely or more tightly. (See Figure 13.1.) The amount of twist together with the characteristics of the fibers, such as luster, hand, and cross-sectional shape, determine the appearance and feel of the yarn. For example, a loosely twisted, smooth filament yarn made from a bright fiber would be characterized by marked luster, resistance to pilling, and a smooth surface. Sometimes filament yarns are put through an additional process called *texturing*. Texturing modifies the feel and bulk of filament yarns.

Staple Yarns

Staple, or *spun*, yarns are made from staple-length fibers. Being short, staple fibers must be held together by some means in order to be formed into a long, continuous yarn. Although the multiple processes required for making staple yarn add significantly to the cost of the yarn, the aesthetic qualities such as comfort, warmth, softness, and appearance make these yarns highly desirable in many products. Before the invention of manufactured fibers, all yarns except those made from silk had to be spun from short, staple fibers. At first these staple fibers were twisted together by hand. A simple experiment will easily demonstrate how this can be done. Take a small bunch of fibers from a roll of absorbent cotton. Pull off a long strand and begin to twist the fibers in one direction. You will soon find that you have a rather short, coarse, but recognizable, cotton yarn.

In addition to identifying yarns as being made from either filament or staple fibers, yarns are also classified based on a number of other characteristics. Following are the most common classifications.

Yarns Classified by Number of Parts

Yarns that have been classified by the number of parts they possess are divided into *single*, *ply*, and *cord yarns*. A *single yarn* is made from a group of filament or

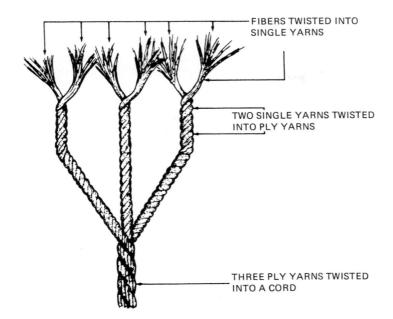

Figure 13.2 Single, ply, and cord yarns.

staple fibers twisted together. If a single yarn is untwisted, it will separate into fibers. A single yarn might be identified as either a single yarn of staple fibers or a single yarn of filament fibers.

Ply yarns are made by twisting together two or more single yarns. If ply yarns are untwisted, they will divide into two or more single yarns, which, in turn, can be untwisted into fibers. (See Figure 13.2 and figure CP2A on Color Plate 2.) Each single yarn twisted into a ply yarn is called a *ply*.

Cord yarns are made by twisting together two or more ply yarns. Cord yarns can be identified by untwisting the yarn to form two or more ply yarns. Cord yarns are used in making ropes, sewing thread, and cordage and are woven as decorative yarns into some heavyweight novelty fabrics.

Yarns Classified by Similarity of Parts

Simple yarns are those yarns with uniform size and regular surface. They have varying degrees of twist, ranging from loose to moderate, tight, or hard twist. Single, ply, and cord yarns can all be simple yarns if their components are uniform in size and have a regular surface. When one strand of fibers is twisted together evenly, it is classified as a simple single yarn. Two simple single yarns twisted together create a simple ply yarn. (See Figure 13.2.)

Yarns made to create interesting decorative effects in the fabrics are known as *novelty yarns*. They may also be called *fancy yarns* or *complex yarns*. Complex yarns, though, usually have more than one part, whereas novelty yarns can be single, ply, or cord, staple or filament. Most novelty yarns are weaker than their simple counterparts and, hence, are usually placed in the crosswise direction of woven fabrics where strength is not as critical. They can also be used in knitted or other fabric constructions to add texture and decoration.

Terminology identifying novelty yarns can sometimes be confusing. The following list of terms and their definitions represents an attempt to define these terms as they appear to be accepted by most authorities. Yarns, and fabrics made using these yarns, are shown in figures CP2B, CP2C, CP2D, CP3C on Color Plates 2 and 3.

- 1. Bouclé yarns, also called loop yarns, are multi-ply yarns. An effect yarn (so called because it is used to create decorative effects) forms irregular loops around a base yarn. Another yarn binds or ties the effect yarn to the base. The loops are visible in the yarn and in fabrics made from those yarns. Ratiné yarns are similar to bouclé in construction except that the effect yarn is wound irregularly and more tightly around the base yarn.
- 2. *Flake*, or *flock*, *yarns* are made of loosely twisted yarns with fibers of another color included in the structure. These give a tweed effect in a fabric.
- 3. *Nub yarns*, also known as *knot* or *spot yarns*, are ply yarns in which an effect yarn is twisted around a base yarn a number of times in a small area to cause an enlarged bump or "nub." Sometimes a binder yarn is used to hold the nubs in place. The spacing of the nubs may be at regular or irregular intervals. Nubs can be different colors than the base yarn.
- 4. *Slub yarns* may be either ply or single yarns of staple fibers. The slub effect is created by varying the twist in the yarn, allowing areas of looser twist to be created. This produces a long, thick, soft area in the fabric called a *slub*, creating an irregular diameter along the yarn. The surface of fabrics woven with slub yarns shows these irregularities. Yarns made in this way have areas of varying twist, causing weaker areas in the yarn. Slubs are the same color as the rest of the yarn and cannot be pulled out of the fabric without damaging the structure of the fabric. Filament yarns can be spun with varying degrees of twist. These yarns also create a slubbed appearance in fabrics. Such filament yarns are known as *thick-and-thin yarns*.
- 5. *Spiral*, or *corkscrew*, *yarns* are made of two plies, one soft and heavy, the other fine. The heavy yarn winds around the fine yarn.
- 6. Chenille yarns are made by a totally different process and require several steps in their preparation. First, leno-weave fabric is woven. (See chapter 17.) This fabric is cut into strips, and these strips, which have a soft pile on all sides, are used as yarns. These are not yarns in the traditional sense of twisted fiber, but have been taken through a series of preliminary stages before being readied for use.

Core-spun Yarns

Core-spun yarns do not fall into the category of novelty yarns, but are yarns made with a central core of one fiber around which is wrapped or twisted an exterior layer of another fiber. Core-spun yarns may be made with an elastomer core, such as spandex, covered by another fiber to produce a stretch yarn. (See Figure 11.3.) Other core-spun yarns include sewing thread made with polyester cores and cotton cover.

THREAD

The terms *yarn* and *thread* are sometimes used interchangeably. However, a distinction should be made between yarns, which are fiber assemblies intended for weaving, knitting, or otherwise combining into a textile fabric, and sewing threads, which are used for sewing together sections of garments or other products.

Sewing threads may be made from one or more kinds of fiber. The most important threads have been those made from cotton or from a multifilament core of polyester covered with a cotton or spun polyester. Except for yarns made from nylon or polyester, single yarns are not suitable for sewing threads; therefore, two or more plies are used.

To perform well, sewing threads must have high stability to bending, good strength, limited elongation, minimal shrinkage, and good abrasion resistance. Consider the stresses to which sewing thread is exposed. On the sewing machine, it must slide through various thread guides, it is hit back and forth under tension by the sewing machine needle, and it is permanently held in a bent position as it interlocks with the thread from the bobbin. Seams in tarpaulins, shoes, pants, and safety belts are subject to considerable tension and abrasion. If threads used shrink more or less than the fabrics in garments, puckering and wrinkling will appear at seam lines.

Home sewers purchase thread for their personal use, but 95 percent of the sewing thread produced goes to industry. The development of high-speed industrial sewing machines requires that manufacturers of sewing thread constantly improve the quality and performance of these products. A surface lubricating finish must be applied to industrial thread to minimize frictional heating of the sewing needle that could fuse or damage thermoplastic materials.

YARN TWIST

All staple yarns and some filament yarns have twist applied to them to hold the fibers together. The degree of twist given to a yarn affects a number of aspects of its appearance, behavior, and durability. The amount of twist in a given yarn can be measured and expressed as turns per meter (tpm), turns per centimeter (tpcm), or turns per inch (tpi).

Effects of Twist

The amount of twist affects a number of yarn properties, especially for staple yarns. Bulkiness is one such property. As a general rule, increasing twist decreases apparent yarn size. Think again of the crude formation of a yarn by twisting a loose strand of cotton fibers. The more one twists, the smaller in diameter the yarn will become.

Strength increases in staple yarns as twist increases up to a certain point. Beyond this point, the strength of the yarn begins to decrease, and yarns with exceptionally high, tight twist may become brittle and weak.

Elasticity is increased if yarns are twisted tightly. Tightly twisted yarns are known as *crepe yarns*, which are generally very fine. The twist of crepe yarns is so

high that they curl up unless they are held under tension, as they would be on a loom during weaving. A simple and easy test to identify crepe yarns is to unravel a yarn from the fabric and run it between the fingernails, thus removing the tension produced by sizing material. If the yarn curls up into corkscrewlike curls, it has been creped. This tendency of crepe yarn to twist makes fabrics constructed from these yarns less dimensionally stable than other fabrics as they are more elastic and have an uneven fabric surface.

More tightly twisted yarns shed soil more easily. Because their surface is smoother, there are fewer loose fiber ends to attract and hold soil. In yarns made from absorbent fibers, absorbency is lower in more tightly twisted yarns.

Abrasion resistance is increased by tighter twist. This is a logical result because in a more tightly twisted yarn, many fibers are held in such a way that they appear on the surface, then sink into the center of the yarn, then come back to the surface again. As a result, more fibers are subject to a relatively even distribution of abrasion. Loose surface fibers in low-twist yarns also snag and pull up, creating points of wear.

The appearance of a fabric can be determined to a large extent by the twist of the yarn. For example, if filament yarns of higher luster are given only low twist, they will reflect greater quantities of light in mirrorlike fashion and, therefore, appear brighter than the same yarns when they are more tightly twisted. Crepe fabrics achieve a nubby, somewhat crinkled effect by using creped yarns that have a less even surface texture. Unevenly twisted slub yarns can also produce a rough surface. The fabric designer takes advantage of these effects to create a wide variety of surface textures and designs. (See Figure 13.3.)

FIGURE 13.3 (a) Tightly twisted crepe yarns are used to create a pebbly surface texture; (b) loosely twisted silk slub yarns are used to produce a fabric of the shantung type.

(b)

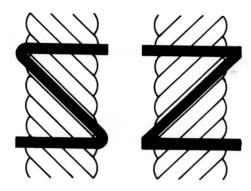

FIGURE 13.4
S and Z twist.

Direction of Twist

In twisting fibers together to form yarns, the fibers can be twisted either to the right or to the left. In textile industry terminology, this twist is called *S* or *Z twist*. (See Figure 13.4.) Z-twisted yarns are twisted so the direction of the twist follows the center bar of the letter *Z*. Z twist is also known as *right twist*. In S-twist yarn, the twist direction follows the center bar of the letter *S*. S twist is also known as *left twist*. This concept will be more easily understood if the reader takes a small bunch of absorbent cotton and makes a vertical line on the fibers with a pen. Then, suspending the fibers from the thumb and forefinger of the left hand to that of the right, rotate the fibers to the right with the upper left-hand fingers. The line you have made will take a diagonal direction similar to that of the bar in a *Z*. If the upper fingers are twisted to the left, the line will follow the bar of the *S*.

Most yarns are made with a Z twist. However, in certain fabric constructions, special effects can be achieved by combining yarns in which the fibers have been twisted in either the same or opposite directions.

YARN SIZE

Because the textile industry requires some means of distinguishing among yarns of different sizes, standards of measurement have been established. There are different systems of measurement for cotton-type yarns and wool-type yarns and still other systems for filament yarns.

This variety of measurement systems may seem unnecessarily complicated. The systems had their origins in measurements that were appropriate for particular uses in isolated textile manufacturing localities and may go back for hundreds of years. The present trend is toward use of metric measurements, but traditional terminology is still used.

The basic principles underlying these systems that should be borne in mind are these: the system is different for staple and filament yarns, may vary by type of fiber and may be either a direct measure of size or an indirect measure.

Direct Numbering Systems

Direct methods of measurement rely on the measurement of fixed lengths of yarn. A specified length of yarn is measured, and this length is weighed. The measurements

used are tex or denier. As explained earlier, tex is the weight in grams of a 1-kilometer (1,000-meter) length of yarn, and denier is the weight in grams of 9,000 meters of yarn. Yarns may also be specified in *decitex*, which is the weight of 10,000 meters. In all these measurements, the higher the number, the coarser the yarn.

The size of filament yarns may be designated by giving the denier or tex of the total yarn or by the denier per filament (dpf). This last measure, in conjunction with the number of filaments, provides additional information about the yarn.

Indirect Numbering Systems

Indirect methods of yarn numbering rely on the measurement of fixed weights of yarn. Each system establishes a number of hanks (skeins) of yarn that make up either a pound or a kilogram of yarn weight. Pounds are used for measurements in the English system and kilograms for measurements in the metric system. The size of the hanks used is different for the different natural fibers, with the measures being as follows: cotton count equals the number of hanks of 840 yards in 1 pound; linen count (also called linen lea) equals the number of hanks of 300 yards in 1 pound; woolen count equals the number of hanks of 1,600 yards per pound; worsted count equals the number of hanks of 560 yards per pound. All these yarn numbers are reported in the technical or research literature followed by the abbreviation Ne, which stands for "number in the English system." Metric yarn numbers in the indirect measurement system equal the number of 1,000-meter hanks in each kilogram, and this measurement is followed by the abbreviation Nm, which stands for "number in the metric system."

Because different lengths of yarns are used to establish yarn numbers in the varying systems, yarn numbers are not directly comparable unless one uses a table such as Table 13.1. Looking at that table, one can see, reading across the table, that depending on the system being used, comparably sized yarns can have widely divergent numbers assigned. Nevertheless, regardless of the specific yarn numbers, certain basic principles apply. In the direct system, the lower numbers indicate finer yarns; higher numbers indicate coarser yarns. Just the opposite is true in the indirect system, where higher numbers indicate finer yarns and lower numbers coarser yarns. For example, if 7 hanks of one linen yarn weigh 1 pound, and 50 hanks of another linen yarn weigh 1 pound, obviously the yarn with the higher number (50) would be finer than the yarn with the lower number (7).

EFFECTS OF YARN STRUCTURE ON FABRIC PERFORMANCE

Performance of textile products is affected by interactions among the fibers used, the yarn structure, fabric construction, and any finishes applied. Properties of yarns are summarized in Table 13.2, and their effects on the *durability, appearance*, and *comfort* of textile fabrics are presented below.

Durability Factors

Yarn strength is of primary importance in determining ultimate fabric strength. Yarn strength is due not only to the inherent strength of the fibers in the yarn, but

TABLE 13.1 Comparable Yarn Numbers in Direct and Indirect Systems of Yarn Numbering

	Direct Methods		Indirect Methods				
	Tex (weight in grams of 1,000 m of yarn)	Denier (weight in grams of 9,000 m of yarn)	Cotton (no. of 840-yd hanks per lb)	Linen (no. of 300-yd hanks per lb)	Worsted (no. of 560 -yd hanks per lb)	Woolen (no. of 1,600-yd hanks per lb)	Metric (no. of 1,000-m hanks per kg)
Finest	5.6	50	106	298	160	56	180
1	8.3	75	71	198	106	37	120
	11.1	100	53	149	80	28	90
	16.6	150	35	99	53	19	60
	22.2	200	27	74	40	14	45
	33.4	300	18	50	27	9.3	30
	44.4	400	13	37	20	7.0	37
	55.5	500	11	30	16	5.6	18
	77.7	700	7.6	21	11	4.0	13
	111	1,000	5.3	15	8.0	2.8	9
\downarrow	166	1,500	3.5	9.9	5.3	1.9	6
Coarsest	222	2,000	2.7	7.4	4.0	1.4	4.5

Source: Adapted from J. Pizzuto, Fabric Science (New York: Fairchild, 1974), 88; data from Annual Book of ASTM Standards, Vol. 7,01 (West Conshohocken, PA: ASTM, 1998), Standard D2260.

also to the yarn structure. Filament yarns are stronger than spun yarns because all of these continuous fibers are contributing to yarn strength. The yarn breaks when the fibers are ruptured. Spun yarns, which are held together by their twist, are broken by breaking some fibers and by overcoming the twist frictional force holding the fibers together. This takes less force than breaking all the fibers in a comparable filament yarn. As twist is increased in spun yarns, the strength increases (up to a point) because the increased frictional force between fibers prevents slipping. Overtwisting, however, will decrease strength due to increased strain on the yarn. Coarser yarns can withstand tensile forces better than finer yarns and normally contribute more to fabric strength.

The elongation and recovery of fabrics are important in determining their end use and performance. Fabrics that stretch and recover are comfortable and are especially appropriate in products such as hosiery or swimwear. In order to produce yarns with maximum elongation, elastomeric fibers such as spandex or rubber that stretch up to five times their length (500 percent) and recover can be used. Filament yarns can be textured to provide stretch.

Resistance to abrasion is determined by the ability of a material to absorb the energy applied during abrasion. A number of textile properties affect the resistance

TABLE 13.2
Properties of Staple, Filament, and Textured Yarns

Property	Staple	Flat Filament	Textured Filament
Appearance and hand	Dull, fuzzy	Lustrous, smooth	Dull, rough
Tenacity	Lowest	Highest	High
Elongation	Low	Lowest	Higher
Bulk	Medium to high, depending on twist	Low	High
Pilling	Can be high	Low	Low
Snagging	Low	High	Highest

Note: Comparison assumes that other factors such as fiber content and yarn size are constant.

of a fabric to abrasion, yarn construction being one. Loosely twisted yarns abrade more easily than do tightly twisted yarns. In the loosely twisted yarns, individual fibers are more likely to be plucked out of the fabric surface.

Appearance

Drape and hand, wrinkle resistance, dimensional stability, and covering power all contribute to satisfaction with the appearance of textile products. *Drape* refers to the ability of fabric to form pleasing folds when bent under its own weight. Drape is improved by yarn structures that allow movement or bending within the fabric. Twist also affects the bending of yarns. Highly twisted yarns bend more easily because the fibers are oriented at a sharper angle to the yarn length. This behavior is especially apparent in crepe yarns, which are highly twisted. True crepe fabrics, those made from crepe yarns, have high drapability.

Fabric hand refers to the "tactile sensations or impressions that arise when fabrics are touched, squeezed, rubbed, or otherwise handled" (AATCC 1997, 376). Hand is an important consideration in consumer selection and acceptance of apparel fabrics. Like drape and other properties, it is a complex phenomenon involving a number of different fabric characteristics. One important factor in the assessment of hand is the smoothness of the material. Filament yarns and combed spun yarns feel smoother than textured or crepe yarns. In addition, a fabric that compresses easily and recovers from compression or squeezing will feel soft. This feeling is enhanced by resilient fibers and high-bulk yarns that are not compact.

Yarn properties must be considered in relation to wrinkle recovery. When a crease forms in woven or knitted fabric, the yarns bend. Yarn stiffness, or resistance to bending, is related to twist and size. In looser yarn structures, with lower twist, fibers are freer to move to relieve the stresses of bending. They will, therefore, bend relatively easily. In more tightly twisted yarns, the frictional forces

within the yarn tend to keep fibers from shifting position, and they tend to return to their original configuration and resist wrinkling. As described earlier, however, overtwisted yarns bend more easily. The most flexible yarn of all should be one in which filaments are combined with little or no twist. The least flexible yarns should be those in which the fibers are bonded together by an adhesive or fused by heat or chemical means.

Yarn size affects stiffness as well. Heavier yarns resist wrinkling more than finer yarns. Yarn size can be increased by putting a larger number of fibers into a yarn, by using fibers of larger diameter, or by plying several yarns. Extremely fine fibers, even in coarse yarns, however, reduce resistance to bending.

The terms *covering power* and *cover factor* refer to both the optical and geometric properties of fabrics. *Optical covering power* is the ability of the fabric to hide what is placed under it. Fiber characteristics affect the optical covering power. So, too, does yarn structure. Smaller-diameter yarns or smoother yarns cover less well, depending on how tightly packed the yarns are in the fabric structure.

Comfort Factors

Heat transfer is the transfer of heat energy from a generating body to the surrounding atmosphere. Textile fabrics can provide resistance to heat transfer from a body, or in the case of some interior furnishings, from buildings. As noted earlier, trapped air keeps heat near the body. Yarn structure and its related property of fabric thickness are extremely important in determining the thermal comfort of fabrics. A spun yarn or textured filament yarn entraps more air than a flat filament yarn and, therefore, offers more resistance to heat transfer. The degree of twist also affects thermal comfort as the higher-twist yarns hold less air volume.

Air permeability is the ability of air to pass through a fabric. Where openings between yarns or between fibers within yarns are large, a good deal of air will pass through the fabric. Conversely, when compact yarns are packed tightly into fabrics, with little air space between them, the flow of air through the fabric is diminished. It follows, then, that closely woven fabrics with compact, tightly twisted yarns have lower permeability.

Yarns contribute to fabric softness. Loosely twisted yarns and many novelty yarns have rougher surfaces that decrease the smoothness of fabrics. Filament yarns are generally smoother than spun yarns. Sheets made of filament silk yarns are softer and more luxurious than those of staple linen or cotton fibers.

Putting it all together for ...

Tire Cords

As the summary discussion of the effects of yarn structure on fabric performance indicates, the selection of textiles with particular end uses must take into account the properties contributed by the various components of the structure. Tire cords are manufactured to exhibit specific properties, and selection of fiber and yarn features is important in providing optimum performance. This is the first of a

234

FIGURE 13.5Diagram of tire cross section, showing tread, belts, and plys. Courtesy of Bridgestone/Firestone.

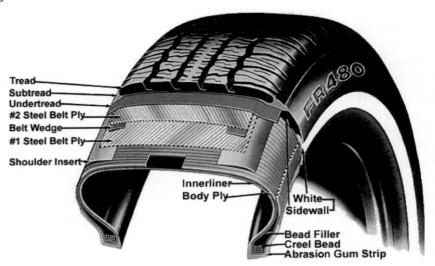

series of case studies that looks at the performance characteristics of a particular textile product and is presented here as an example of how the properties of each component, fiber and yarn, must be carefully selected. (See Figure 13.5 for a diagram of a tire cross section showing the placement of tire cords.) In the discussion below, and as the figure shows, the term *ply* is used not only in its conventional textile meaning, but also to refer to the adhesive sheet in which the tire cords are embedded. Thus, cord yarns of several plies are placed in an adhesive sheet, also called a *ply* in the tire industry. Sheets of steel fibers are called "belts."

Tensile Properties

Perhaps the most important property one thinks of for tire cords is strength. Cords in tires are embedded in the rubber matrix to reinforce it. As noted in the ASTM test method for tire cords from manufactured fibers, "the force-bearing ability of a reinforced rubber product is related to the strength of the yarn or cord used as a reinforcing material" (ASTM 1998, 243).

In most tires currently produced, both manufactured fiber and steel cords are used. Steel is known for its strength, but it is also heavier than synthetic fibers. Therefore, tires are not reinforced with steel cords alone, but also with high-tenacity polyester, nylon, rayon, or aramid fibers. The steel belts are placed parallel to the tread, so they can aid in bearing the load as the tire turns. The textile fiber cord piles are perpendicular to the head. Polyester, nylon, and rayon are the most commonly used nonsteel fibers, and a number of fiber manufacturers make versions of these fibers specifically for tire cords. The extremely high-strength fibers such as aramid or PBO are not used in passenger or light truck tires, primarily because of cost.

Two other tensile properties, modulus and elongation, are also important in tire performance. Higher-modulus fibers, which resist initial tensile forces better, are preferred. This is one reason many tire producers have replaced nylon with polyester in the body of most tires.

Tire cords should also resist elongation and deformation so they are dimensionally stable. When a car is parked for some time, tires with nylon cord reinforcement may flatten slightly where the tire contacts the road surface. When the car is driven again, this "flat spot" will initially make for a bumpy ride until the tire warms up and resumes its round shape. Polyesters are more dimensionally stable, and several companies make high-modulus, high-tenacity polyester fibers specifically for tire cords. (See Table 8.2.) In some standard passenger and light truck tires and in high-performance tires for high-speed vehicles, however, nylon "cap" plies are placed over the steel belts. The nylon cap plies have higher shrinkage than polyester at high running temperatures and will pull down over the steel belts. This belt section of the tire is then better able to withstand the radial forces and high temperatures generated at high speeds.

In regard to overall body cord strength (or carcass strength) for load carrying capacity, larger passenger and light truck tires are designed with two body plies to support the higher vehicle loads, whereas, most smaller standard vehicles, which will bear smaller loads, tend to use smaller tires designed with only one body ply (monoply tires).

The yarn structure and type are also selected to maximize the strength of tire cords. As the name implies, a cord structure is best because it is stronger than single-yarn structures. The yarns are ply twisted; then the plies are twisted to form a cord. In most passenger and light truck tires, two-ply yarns are typically used, and in some cases, for extra-load tires, three-ply yarns are used (where two body plies of two-ply yarn are not appropriate for load or tire handling properties).

The yarn ply structure will also affect the flat spot performance of the tire. Two-ply yarn nylon cap plies are typically used for most passenger tires; however, one-yarn ply of nylon is becoming increasingly popular for some cap plies to improve the flat spotting condition of the tire.

The yarn twist level will also affect the quality of the tire cord. All tire cords are made from filament yarns, which are much stronger than staple yarns. The yarns are twisted to increase strength. Tire cord twist levels are optimized for the best combination of tensile strength and cord fatigue (best retained tensile strength over the life of the tire cord).

Size affects strength as well, and tire cords are large (often five hundred tex and greater) compared to most yarns used for apparel or home furnishings. It is not desirable, however, to use very large yarns because the surface area for bonding to the rubber will be decreased.

Linear Density

The weight per length, or linear density, of fibers used in tire cords affects the weight of the tire. This precludes reinforcement of tires entirely with steel cords. Steel fibers have a specific gravity of about 7.8, more than five times those of polyester and nylon. Nylon has a slightly lower density than polyester, which might be a slight advantage.

Adhesion

Because tire cords are used to make the rubber tires stronger and more resistant to force, it is important for the cords to adhere to the rubber. Good adhesion results in better transmission of the applied forces to the reinforcing material, in this case the steel or manufactured fiber cords. Textile tire cords have an advantage over steel because they have a larger surface area for bonding. In common manufacturing processes, the textile cords are woven into a sheet and dipped into an adhesive, then heated under tension to set their cord properties to specified tensile, elongation, modulus, and shrinkage levels. A good coating of the fibers by the adhesive helps to stabilize them and decrease elongation. The rougher surface of the twisted and/or plied filament fibers increases the penetration and pickup of the adhesive, which is usually a *latex*, or water emulsion.

SUMMARY POINTS

- The two primary yarn structures are filament and staple
 - Filament yarns are composed of continuous fibers that can be smooth or textured
 - Staple yarns are short fiber lengths twisted together
- Yarns can be formed as single, ply, or cord yarns, depending on the number of strands twisted together
- Novelty, or fancy, yarns are made by combining different types of yarns in ply or cord structures
- · Amount and direction of twist affect yarn properties
- Yarn size
 - o Direct measuring systems are tex and denier
 - Indirect systems are cotton count, woolen count, or lea

Questions

- What are the differences between filament and staple yarns? Single, ply, and cord yarns? Simple and fancy, or novelty, yarns? Thread and yarn? S- and Z-twist yarns?
- 2. What differences in behavior would you expect to find between low-twist and high-twist yarns?
- 3. How do direct and indirect yarn numbering systems differ?
- 4. How does yarn structure contribute to the following:

strength wrinkle recovery abrasion resistance softness comfort

References

AATCC. *Technical Manual*. Research Triangle Park, NC: American Association of Textile Chemists and Colorists, 1997.

Recommended Readings

- Backer, S. "Staple Fibers—The Story of Blends, Part 2: Development and the Future." In *Polyester—50 Years of Achievement*, edited by D. Brunnschweiler and J. W. S. Hearle, 94. Manchester, England: The Textile Institute, 1993.
- Goswami, B. C., J. G. Martindale, and F. L. Scardino. *Textile Yarns: Technology, Structure and Applications*. New York: Wiley, 1977.
- Nikolic, M., J. Cerkvenic, and Z. Stejepanovic. "Formation Models: Comparing Yarn Qualities and Properties." *Textile Horizons* 47 (December 1993).
- Sawhney, A. P. S., R. J. Harper, G. F. Ruppenicker, and K. Q. Robert. "Comparison of Fabrics Made with Cotton Covered Polyester Staple Core Yarn and 100 Percent Cotton Yarn." *Textile Research Journal* 61, no. 2 (1991): 71.

ed la la company de la comp

MANUFACTURING YARNS

Learning Objectives

- 1. Describe the steps in manufacturing filament and staple yarns.
- 2. Explain processes for texturing filament yarns.
- 3. Compare the processing of cotton, wool, and flax into yarns.
- 4. Describe the features of ring spinning, open-end spinning, and wrap spinning.
- 5. Summarize the processing and properties of blended yarns.

his chapter describes the techniques used to transform fibers into yarns. As the structures of filament and staple yarns differ, so too do the methods for manufacturing these two types of yarns. The properties of the different yarns must be balanced against the production costs in designing and developing textile items.

In the chapters devoted to various types of fibers, the term spinning was used to describe the formation of manufactured fibers by extruding them through a spinneret. This use of the word should not be confused with the term spinning as it is used to describe the formation of a yarn from fibers. Newly formed manufactured fibers were also described as being drawn. This term also has two meanings:

- (1) the drawing of manufactured fibers to orient the molecules within the fiber and
- (2) a step in certain of the processes for creating yarns from staple fibers.

MAKING FILAMENT YARNS

In creating manufactured fibers for use in filament yarns, spinnerets are used that have the exact number of holes (from about thirty to several thousand) needed for a particular type of yarn. Following extrusion, the fibers may be drawn, or alternatively, the drawing may take place during a subsequent texturing step. This is true, for example, of partially oriented yarns (POY) of polyester. The drawn filaments may be twisted together either tightly or loosely, depending on the characteristics

desired in the resulting yarn. (See chapter 2 for a fuller discussion of manufactured filament fibers.) Compared to the processing required for staple yarns, manufacturing filament yarns is simpler and less expensive.

Much of the silk fiber produced is processed into filament yarns, although short silk fibers can also be made into staple yarns, referred to as *spun silk* yarns. Creation of filament yarns of silk can be done immediately after reeling fibers from cocoons or later, after the gum has been removed.

Texturing Filament Yarns

Yarns made from straight filament fibers are smooth and slippery to the touch. They lack the comfort, bulk, and feel of yarns spun from staple fibers. Bulky yarns are formed from fibers that are inherently bulky and cannot be closely packed because of such characteristics as crimp, cross-sectional shape, fiber resilience, or some other quality. Manufactured yarns can be treated with processes that use heat setting or mechanical entangling of fibers to alter their bulk, texture, and stretch.

Yarns can be textured primarily to increase bulk for comfort, resiliency, and feel, or to provide stretch to the yarn. Texturing may be done by the fiber manufacturer or at some later step in the manufacture of the yarn. In the early stages of development, texturing processes were carried out separately from fiber spinning and drawing. The steps of drawing and texturing then became continuous and now are more commonly carried out in a simultaneous operation using POY yarns (Demir and Behery 1997).

Texturing filament yarns is much less expensive than spinning staple yarns. Consumers seem to show a preference for spun yarns in many applications; thus, texturing filament yarns, especially those of polyester, has become an important manufacturing step. With the widespread use of POY (see chapter 2 for a fuller discussion), the texturer, who may also be the fiber producer, simultaneously draws and textures the yarn.

Texturing techniques were developed in the 1950s as more manufactured fibers were coming on line. The successful commercial processes were *false-twist*, *stuffer-box*, *edge-crimping*, and *air-jet* texturing. The first three of these are often referred to as stretch-texturing methods because they introduce a crimp or curl in the fibers that can be pulled out when the yarn is stretched. The yarn recovers its crimp upon relaxation. Air-jet yarns, on the other hand, are textured for bulk and have very little recoverable stretch. Consumers as well as those in the textile industry may use the term *stretch* more broadly, applying it to any yarn or fabric that exhibits stretch and recovery. Most of these alternative routes to provision of stretch are discussed elsewhere, and they include the use of elastomeric fibers (chapter 11), bicomponent fibers with differential shrinkage (chapter 2), and treatment of fabrics to provide moderate amounts of stretch (chapter 21).

Another way to classify texturing methods is to distinguish between those that are *mechanical* and those that are *thermomechanical*. This distinction is more descriptive of the process than the product, although both will be described in the following discussion. Processes and methods are summarized in Table 14.1.

TABLE 14.1
Processes and Methods for Textured Yarns

Process	Method	Product		
False-twist	Thermomechanical	Stretch-textured yarn		
Stuffer-box	Thermomechanical	Stretch-textured yarn		
Gear-crimping	Thermomechanical	Stretch-textured yarn		
Edge-crimping	Thermomechanical	Stretch-textured yarn		
Air-jet	Mechanical	Bulk-textured yarn		
Hot-fluid jet	Thermomechanical	Bulk-textured yarn		

Mechanical Methods

Mechanically textured yarns are so named because only mechanical action is used to entangle the fibers in the yarn. They are produced primarily through air-jet texturing in which texture is produced not by heat, but by feeding yarns into a system in which slack filaments are formed into loops by jets of air. (See Figure 14.1.) The resultant yarns have a relatively large number of randomly spaced and sized loops along the filaments or fibers and very little stretch because many of the fibers retain their straight or slightly twisted conformation. These yarns do, however, more closely resemble staple yarns than some of the stretch-textured yarns described below. Air-jet texturing can be used for filament yarns of any fiber.

Thermomechanical Methods

If fibers in a yarn are mechanically deformed under heat, the resulting yarns have not only increased bulk, but greater stretch as well. The fibers are twisted, crimped,

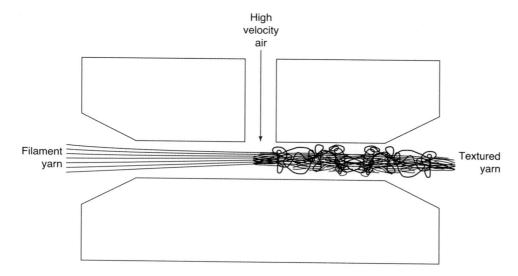

FIGURE 14.1
Air-jet texturing.

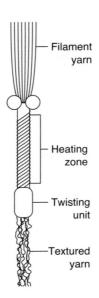

Figure 14.2
False-twist texturing process.

or curled, subjected to heat to set in the modified conformation, then relaxed. Only thermoplastic fibers, which deform on imposition of heat, can be durably textured in this way.

False-twist Texturing. False-twist is by far the most common method used today to texture yarns for apparel. In this process yarn is twisted in a heated zone and allowed to untwist as it cools. (See Figure 14.2.) Because the yarn is moving rather than being held stationary at the exit end, the twisted structure is relaxed. Bending and crimp are set in in the heating zone, and the fibers assume a wavy shape or develop snarls when the tension is relieved.

To understand the principle at work here, cut a rubber band and twist the two ends between your fingers. Then release the tension, still holding both ends and you will see a snarl form. (See Figure 14.3.) In the twisting operation, fibers may also be wrapped around each other, much like the cylindrical coils in a telephone cord—but not quite as regular (Hearle, Hollick, and Wilson 2001). If the telephone cord is stretched, it twists; if the twist is removed and the cord allowed to contract, it will assume a wavy shape, with some helical twist that reverses along the cord length. (See Figure 14.4.) Imagine this and the snarling occurring with dozens, or hundreds, of fibers in a yarn, to give both

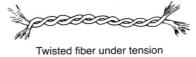

Twisted fiber relaxed, showing sharl

FIGURE 14.3

Development of snarl in false-twist textured yarn.

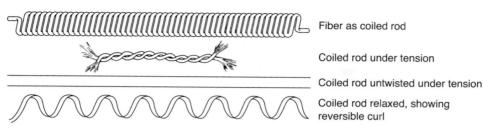

"Adapted from Hearle, J. W. S., L. Hollick, and D. K. Wilson. Yarn Texturing Technology, Cambridge, UK: Woodhead Publishing, 2001."

FIGURE 14.4

Development of helical curl in false-twist textured yarn.

stretch and bulk. When placed under stress, the yarn will stretch, flattening the curls, but when stress is removed, the fibers in the yarn return to the permanent heat-set shape.

The heated twist can be applied by different mechanisms. The simplest and oldest was a spindle with the yarn wound around a pin. As the spindle turned, twist was imparted and set in the heating zone. The twist insertion method most commonly used today is a series of stacked disks that use friction to twist the yarn that is fed between them. As the yarn moves through the systems, the disks rotate, inserting the twist, which is then removed at the exit. (See Figure 14.5.)

Hot-fluid Jet Texturing. The bulk continuous filament (BCF) yarns used in carpets are made using this texturing process. Fibers are fed into a chamber and subjected to hot air or steam. The "fluid" air or steam causes the filaments to blow around and entangle and the yarn expands, creating a fuller structure. The yarn thus forms a plug, bunching up the fibers in the chamber, which, in their softened state, develop a three-dimensional crimp. The air or steam stream can be either bled off or dissipated

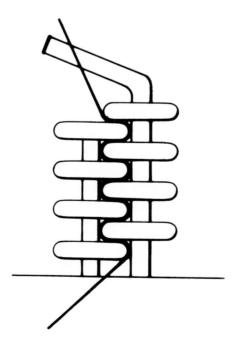

FIGURE 14.5Disk system for insertion of false twist.

FIGURE 14.6

Simplified schematic of hot-fluid jet system for texturing. Yarn enters at bottom of iet, where high-pressure steam is introduced; a "valve" releases the pressure in the jet, creating turbulent flow around the filaments, causing them to curl and entangle. **Entanaled filaments** form a "plug of fibers" that is heated by the released steam. In the upper zone, the crimped and curled configuration is set in.

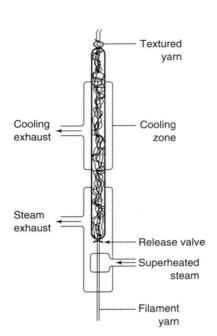

to cool the crimped fibers. (See Figure 14.6.) Nylon, polyester, or olefin carpet yarns textured by this method have increased bulk, contributing to their resilience. The effect is similar to that of the three-dimensional crimp in wool fibers.

Other Thermomechanical Methods. In the stuffer box method, fibers are fed into a small, heated chamber faster than they are withdrawn, inducing a permanent crimp in the cooled fibers. The hot-fluid technique described above derived from this now rarely used process. Passing filaments between the teeth of two heated gears is the basis of the gear-crimping method, mostly applied to fiber tow to yield crimped staple fibers that have better cohesion. The fibers in the yarn have a saw-tooth configuration. Fibers can also be crimped by passing them over a heated knife edge (much like curling of ribbon for wrapping packages). This process, too, has been mostly abandoned in favor of false-twisting (Hearle, Hollick, and Wilson 2001).

MAKING STAPLE YARNS

Making yarns from staple fibers is more complex and expensive than making filament yarns. From the time staple fibers are supplied to the manufacturer until they have been made into yarns, they go through a series of steps. Some steps are required for all yarns and fibers, and some are optional.

Preparation of Staple Fibers for Spinning

Blending Staple Fibers

It is sometimes desirable to blend two or more different fibers into one yarn. Frequently, manufactured fibers are blended with natural fibers to take advantage of the best qualities of each fiber. In other blends the combination may be made to

reduce the cost of the fabric by blending a less expensive fiber with a more expensive one, as in the cashmere/wool blends described in chapter 5, or blending may be done to achieve decorative effects.

Blending may be done at one of several steps in the preparation of yarns from staple fibers: during opening, during carding, or during drawing out. For 100 percent cotton yarns, blending of fibers from different bales is done to even out bale-to-bale differences. The dust and dirt remaining in cotton bales, however, make it undesirable to blend in a manufactured fiber such as polyester at this stage. So blending is usually done during the later, drawing, step. No matter when blending is done, quantities of each fiber to be used are measured carefully, and the proportions of one fiber to another are consistently maintained.

Breaking and Opening Bundles

Bales of fiber may be opened either by hand or by machine. (See Figure 14.7.) Many modern textile mills have completely mechanized this process. The trend toward mechanization of opening cotton bales has been accelerated by the requirements of the Occupational Safety and Health Act that workers' exposure to cotton dust be limited. As noted earlier, high levels of cotton dust are associated with a lung disease called byssinosis.

Cleaning Fibers

Cotton contains impurities such as sand or grit and particles of leaf, stalk, and seeds. Many of these are removed during opening, and further removal occurs

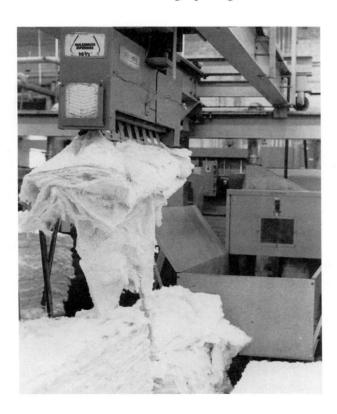

FIGURE 14.7
Bales of fiber are opened. Courtesy of American Textile
Manufacturers Institute.

246

during the carding step described below. New wool that has not previously been cleaned contains vegetable matter, sand, dirt, and grease. As described in chapter 5, raw wool is scoured in warm, soapy water to remove the dirt and grease.

Manufactured fibers do not require cleaning, but if they have been compressed for packing and shipping, they need to be opened and the fibers separated so bunches of fibers do not cling together and form thick areas, or *slubs*, in the yarn.

Systems for Processing Different Types of Staple Fibers

Processing of fibers in preparation for spinning may be done on one of three major spinning systems: the cotton, the woolen, or the worsted (also called long-staple) system. These systems were developed at the time when only natural fibers were in use; therefore, the different characteristics of the fibers, including their length, helped to shape the processes used. Manufactured staple fibers can be handled on any of these systems. More yarn is produced on the cotton system than on the worsted or woolen system.

Fiber Preparation by the Cotton System

Increased automation in yarn production has largely eliminated initial steps of loosening and separating lumps of fiber and the subsequent formation of a *lap*, a flattened, fairly uniform layer of fibers. Instead, the opening and transport of fiber to the carding machine are done in a more or less closed system.

Carding. The carding machine consists of an inner cylinder and an outer belt, both set with hundreds of fine wires. The intermeshing wires separate the fibers and pull them into somewhat parallel form. The wire teeth also remove trash and entangled lumps of fibers called *neps*. A thin web of fiber is formed in this machine, and as the web is moved along, it passes through a funnel-shaped device that forms it into the *sliver*, which is a ropelike strand of roughly parallel fibers. (See Figure 14.8.)

Blending can take place at the point of carding by joining quantities of different fibers. Carding mixes the blend fibers together, distributing them evenly throughout the mass of fiber. (See Figure 14.9a.)

Combing. Whereas carding is a step in the production of all fibers, combing is an optional step in the preparation of some yarns. When a smoother, finer yarn is wanted, fibers are subjected to a further paralleling called *combing*. A comblike device arranges fibers into parallel form. At the same time, it removes the short fibers as well as most remaining neps or impurities. (See Figure 14.9b.)

Combed yarns have smooth surfaces and finer diameters than do carded yarns. Because the shorter fibers have been removed, fewer short ends show on the surface of the fabric, and the luster is increased. Combed yarns are more expensive to produce, and fabrics made from combed yarns are, therefore, higher in price. Far more of the yarn produced on the cotton system is carded than that which is both carded and combed. When products are made from fabric with combed yarns, this is often advertised to the consumer.

Drawing. Several slivers are combined in the drawing process. Blending of fibers can be done by combining slivers of different fibers, and this is where cotton is

FIGURE 14.8 Carding machine, showing web of fibers being formed into a sliver.

FIGURE 14.9 (a) Carded sliver; (b) combed sliver.

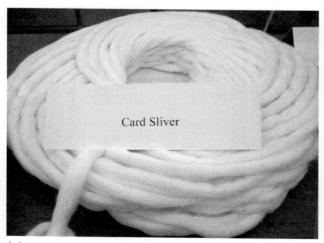

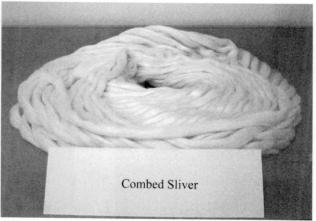

(a)

(*b*)

usually blended with manufactured fibers. During the drawing, a series of rollers rotating at different rates of speed elongates or draws out and attenuates the sliver into a single, more uniform strand that is fed into large cans. Uniformity is important because a slightly thin place in a fat sliver will become a very thin and weak spot when the final yarn is made.

Within the card sliver is a substantial proportion of fibers with hooked ends. These hooks are formed as the fibers are moved along by the carding machinery. Their presence reduces the effective length of the fiber, and if these hooks are not removed, the yarns produced will be weaker. Subsequent drawing steps help to eliminate some hooks. Carded slivers are drawn twice following carding. Combed slivers are drawn once before combing and twice more after combing. It is at this point in the process that the sliver can be converted into yarn by first forming a *roving* then forming a yarn through traditional ring spinning, or alternatively, yarns can be made directly by the open-end methods described later.

Roving. The sliver is fed to a machine called the *roving frame*. Here, the strands of fiber are elongated still more by a series of rollers. As they are wound on the bobbins, they are given a slight twist. The product of the roving frame, an elongated, slightly twisted strand of fibers, is called the *roving*. (See Figure 14.10.)

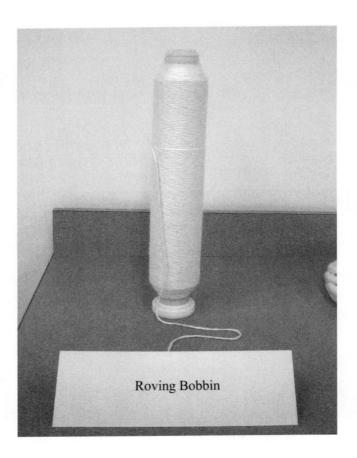

FIGURE 14.10

Sliver that has been given some twist is wound onto bobbins.

Fiber Preparation by the Woolen System

A wide range of wool types, but generally the shorter fiber varieties, can be spun on the woolen system. Manufactured staple fibers can be blended with the wool fibers and spun on the woolen system as well.

Because they have been scoured and contain no grease, as the fibers are blended, a small amount of oil is added to the fiber to facilitate processing, and the fibers are carded. Because wool fibers are longer and have better cohesion and wool carding is a more thorough process, rovings can be produced directly from the carding machine. Thus, the carded web is divided into strips by a *condenser*, following which a slight amount of twist is introduced by subjecting the strips to a rubbing motion to form rovings. Final twist and yarn formation are subsequently imparted, usually on a ring spinner. Some authors prefer to call the woolen system the "condenser system" because fibers other than wool are often prepared by this system.

Woolen yarns are soft and bulky. They have many fiber ends on the surface of the yarn, giving them a fuzzy appearance and hand. This results from omission of the drawing processes that would have straightened the fibers. Woolen yarns are weak and have poor abrasion resistance.

Fiber Preparation by the Worsted System

The worsted system is used for longer and finer varieties of wool and can also be used for manufactured staple fibers in appropriate lengths. If wool fiber is being processed, it is cleaned then processed either dry or with oil added to lubricate the fibers. Carding is followed by preparation of fibers for combing. Before combing, the fibers are subjected to *gilling* (comparable to drawing). The fibers pass through gill boxes in which pins control the movement of short fibers and minimize the development of unevenness in slivers while also assisting in straightening of fibers. The initial product of wool combing is the separation of shorter fibers, called *noils* (which are still long enough to be useful in the manufacture of woolen yarns). The remaining ropelike strand of fibers is called *top*. Wool tops may be dyed or printed to achieve multicolor effects in the final yarn. Tops are gilled, combed, and finally drawn into roving and spun into yarns.

Worsted yarns are smooth, sleek, and compact in appearance, with few fiber ends on the surface of the yarn. Their strength is better than that of woolen yarns, and their hand is crisper. Figure 14.11 illustrates the appearance of woolen and worsted yarns.

The *semiworsted system* is a variation of worsted spinning that omits combing. Yarns produced are not as smooth, lean, or lustrous as worsted yarns, but processing is cheaper.

Processing of Flax Fibers

The length of flax fibers requires that they be processed somewhat differently from either wool or cotton. The final cleaning of flax is accomplished by a hackling machine, a device that has a revolving belt set with pins that remove short fibers, entangled fibers, and vegetable matter. The pins bring the linen fibers into alignment.

FIGURE 14.11

Diagrams of (a) yarn spun on the woolen system; (b) yarn spun on the worsted system. Illustrations courtesy of the American Wool Council.

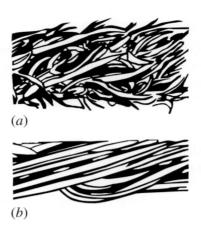

Flax fibers that are comparable to carded fiber after hackling are referred to as *tow* or *hackled fibers*; those comparable to combed fibers are referred to as *line* or *well-hackled fibers*. The same terms are applied to the yarns made from these fibers. Table 14.2 summarizes the terms used in referring to combed and carded yarns from different fibers and some of the properties of the yarns.

The processes used in preparing flax fiber for spinning are intended to take advantage of the strength and luster of these long fibers. Precise steps vary, depending on whether tow or line fibers are being handled. Also, either a wet or dry processing can be utilized. Wet processing produces the finest, strongest, and smoothest yarns.

Figure 14.12 compares steps in the major yarn preparation processes.

Transforming Filaments into Tow

Tow is a bundle of filaments that will be broken or cut into staple lengths. One of the advantages of starting with tow for spinning a staple yarn is that, unlike cotton, wool, and other natural fibers, the tow fibers are aligned and parallel and need not be combed or carded to make them ready for spinning. The fibers can be said to go from tow to sliver, or "tow-to-top" in one operation. Specialized machines, called converters, cut a flat web of tow into the desired staple length. (See Figure 14.13.)

Table 14.2

Terms and Characteristics of Combed and Carded Yarns

	Carded Yarn	Combed Yarn
Term for:		
Flax	Tow or hackled yarn	Line or well-hackled yarn
Wool	Woolen yarn	Worsted yarn
Cotton and other staple fibers	Carded yarn	Combed yarn
Properties		
Appearance	Rough	Smooth
Hairiness	High	Low
Strength	Lower	Higher
Twist	Lower	Higher

FIGURE 14.12

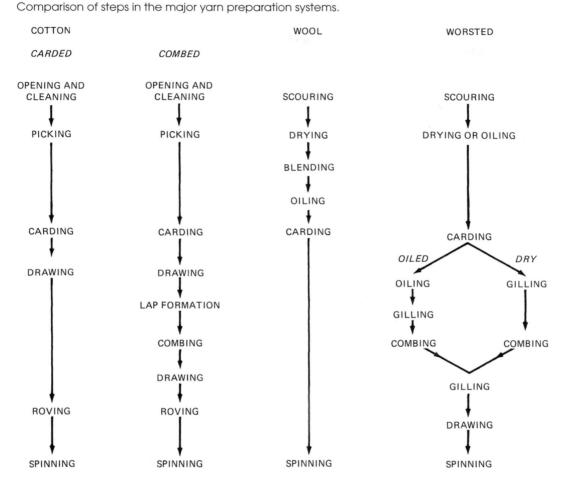

Fibers may be cut into uniform or variable lengths and crimped to provide better cohesion in subsequent processing. The web of cut fibers is then rolled into a sliver of staple fibers.

A second method of converting tow-to-top is to break the fibers into staple lengths. Tension is applied to pull the stretched tow across a breaker wheel, a cog wheel with sharp, protruding edges. The filaments break on the sharp edges.

FIGURE 14.13

Filaments are converted to tow by feeding under a roller (a) with sharp blades that cut the filaments into short lengths, (b) Cut fiber is rolled into a sliver.

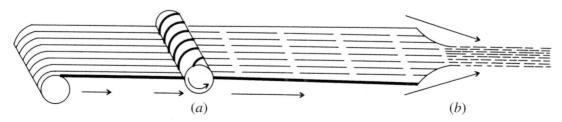

Stretch breaking is most effective with synthetic fibers but less useful in cutting manufactured cellulosic fibers. During stretch breaking, the fibers are extended and must be treated to relax them or yarns will show a good deal of relaxation shrinkage. If a sliver of stretch-broken, crimped, relaxed staple is blended with a sliver of stretch-broken, crimped, but not relaxed staple, the bulking properties of the resulting yarns are much improved.

Insertion of Twist into Yarn

The systems described above for preparation of fibers for spinning are preliminary to the final yarn formation. A variety of different means can be used to join fibers together to form a yarn. The predominant commercial systems of yarn formation are ring spinning and open-end spinning.

Ring Spinning

The ring spinner is made up of the following parts:

- 1. Spools on which the roving is wound
- 2. A series of drafting rollers through which the roving passes
- 3. A guiding ring or eyelet
- 4. A stationary ring around the spindle
- 5. A traveler—a small, U-shaped clip on the ring
- 6. A spindle
- 7. A bobbin

The roving is fed from the spool through the drafting rollers. The rollers elongate the roving, which passes through the guiding ring, moving down and through the traveler. The traveler moves freely around the stationary ring. The spindle turns the bobbin at a constant speed. This turning of the bobbin and the movement of the traveler impart the twist to the yarn. The yarn is twisted and wound onto a bobbin in one operation. (See Figures 14.14 and 14.15.)

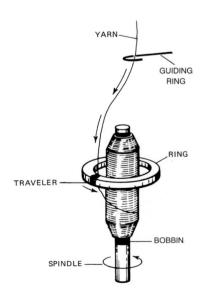

FIGURE 14.14
Diagram of ring spinner.

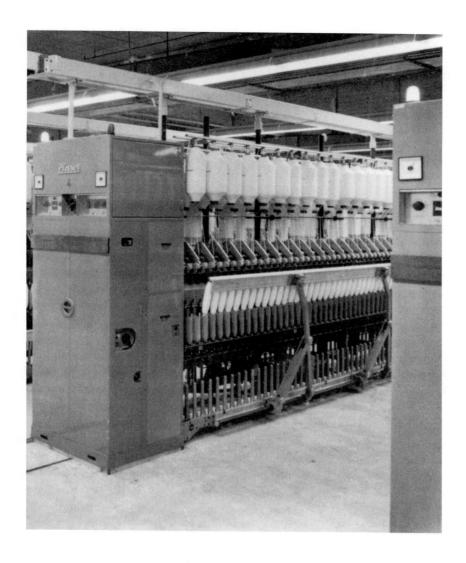

FIGURE 14.15
Ring spinning frame.

Bobbins must be removed from the machine when full, a process called *doffing*. From here, bobbins are transported to a *winding* machine where yarn is wound onto packages. Automated systems for doffing and winding have been developed and are widely used. Winding is considered an important step. It provides an opportunity to *condition* yarn, that is, to bring the yarn into equilibrium with the moisture in the atmosphere, and to add wax or other coatings that will facilitate weaving. Winding also allows the identification of flaws in the yarn and formation of yarn packages larger than the spindles on the spinning frame.

The ring-spinning technique produces finer and stronger yarns than can be made by other competing processes. However, by the 1960s, the rotation speed of the spindle (which began at four thousand revolutions per minute (rpm)) seemed to have reached an upper limit at about twelve thousand rpm. At higher speeds the traveler burns and must be replaced frequently. These maximum speed limitations gave impetus to the development of alternate twisting systems that operated at higher speeds. Although ring spinning continued to hold an important place in the

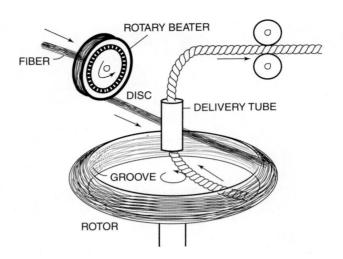

FIGURE 14.16

Open-end rotor spinning.

production of yarns, other systems, most notably the open-end spinning systems, seemed likely to replace ring spinning for certain sizes and types of yarns. Recently, ring spinning has made a comeback, however, for the following reasons. Speeds have increased to twenty-one thousand rpm. Demand for finer-count yarns has increased in the past several years. Increased automation and improved quality control have helped to lower costs of manufacturing.

Open-end Spinning

Because of the speed limitations in ring spinning, researchers concentrated on developing techniques for inserting twist into yarns that would permit more rapid production. A result of this search was the introduction, in the 1960s, of the open-end *rotor spinning machine*, which operated at higher speeds but produced a yarn with slightly different characteristics than conventional ring-spun yarns.

Open-end spinning omits the step of forming the roving. Instead, a sliver of fibers is fed into the spinner by a stream of air. Figure 14.16 shows an open-end spinner of the rotor type. The sliver is delivered to a rotary beater that separates the fibers into a thin stream. (See Figure 14.17.) They are carried into the rotor by a current of air through a duct and deposited in a V-shaped groove along the outer edge of the rotor. Twist is provided by the rapid spinning of the rotor.

Fibers fed to the rotor are incorporated into the rapidly rotating "open end" of a previously formed yarn that extends out of the delivery tube; hence, the name open-end spinning. As the fibers join the yarn, which is constantly being pulled out of the delivery tube, twist from the movement of the rotor is conveyed to the fibers. A constant stream of new fibers enters the rotor, is distributed in the groove, and is removed at the end of the formed yarn, becoming part of the yarn itself. The process is roughly analogous to the spinning and take-up of cotton candy.

The fineness of the yarn is determined by the rate at which it is drawn out of the rotor relative to the rate at which fibers are being fed into the rotor. In other words, if fewer fibers are being fed in while fibers are being withdrawn rapidly, a thinner yarn will result, and vice versa. The twist is determined by the ratio of the

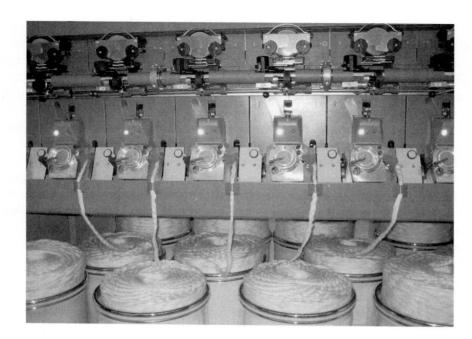

FIGURE 14.17

Sliver pulled from large cans is fed into open-end spinning frame.

rotor turning speed to the linear or withdrawal speed of the yarn (that is, the higher the speed of the rotor, the greater the twist).

Open-end friction spinning systems use friction to insert twist. A mixture of air and fibers is fed to the surface of a moving, perforated drum. Suction holds the fibers against the surface while a second drum rotates in the opposite direction. Twist is inserted and the yarn begins forming as the fibers pass between the two drums. The newly forming yarn is added to the open end of an already formed yarn, and the completed yarn is continuously drawn away. (See Figure 14.18.)

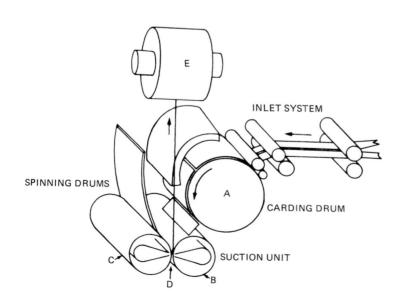

FIGURE 14.18

DREF-2 friction spinning system. Drawing courtesy of Fehrer AG.

The advantages of open-end spinning are that it increases the speed of production, eliminates the step of drawing out the roving before spinning, and permits finished yarns to be wound on any sized bobbin or spool. As a result, it is less expensive. It produces yarns that are more uniform in size and strength than ringspun yarns. They are also bulkier, rougher, and more absorbent. Neither friction nor rotor spinning will produce yarns as fine and strong as ring-spun yarns, although recent advances have extended the range of yarn sizes possible. Ring spinning is also more versatile for producing complex/fancy yarns.

Fabrics made from open-end-spun yarns compared with ring-spun yarns are more uniform and more opaque in appearance, lower in strength, less likely to pill, and inferior in crease recovery and hand. Products that seem to be especially well suited to the use of open-end-spun yarns are toweling, denim, and heavier weights of bed sheeting. The yarns' even surface makes them desirable as base fabrics for plastic-coated materials. On the other hand, the more acceptable feel of ring-spun yarns has led knitwear manufacturers to prefer them, and they are better for fine blends of polyester and cotton.

PLY YARNS

Ply yarns were described in chapter 13 as two or more single yarns that are twisted together. Ply yarns are much more expensive than single yarns but are nevertheless often produced to achieve certain benefits. They are more often used in the lengthwise direction of woven fabrics, where their added strength and uniformity are advantageous. Ply yarns made from identical single yarns are more regular in diameter and are stronger. Ply yarns are often made to achieve particular decorative effects.

In general, the steps involved in creating ply yarns include the following:

- 1. Winding single yarns and clearing any flaws
- 2. Placing the required number of component yarns alongside each other, in place, ready for supplying to the machine
- 3. Insertion of twist to form the ply yarn by any of a number of different machines
- 4. Winding the finished yarn on a cone or package for delivery to the customer

A number of different machines are used in making ply yarns, which may also be referred to as *folded yarns*. Ring-folding machines, for example, operate on the same principle as ring-spinning machines except that instead of a roving being fed to the traveler, the single yarns to be combined are both fed together for twisting.

A variant on this process is *Sirospun yarn*. To strengthen worsted warp yarns sufficiently to withstand the stresses of weaving, the yarns generally must be *two-folded* or double ply. Instead of feeding two single yarns into the spinning system, two rovings are fed into the ring-spinning machine. Naturally occurring variations in the density of fiber strands and in tension cause randomly inserted levels of twist to be incorporated. The end result, Sirospun yarn, is similar to a single yarn yet has enough of the characteristics of a ply yarn to be satisfactory for weaving.

OTHER METHODS OF MANUFACTURING YARNS

In addition to ring and open-end spinning, techniques that insert true twist into yarn, there are other types of yarn construction. Three of those that have some current commercial application are described in the following sections: false-twist, or self-twist, spinning; yarn wrapping; and splitting or slitting films made from synthetic polymers.

False-twist, or Self-twist, Spinning

Self-twist spinning, also called false-twist spinning, is used to make ply yarns. In this process two rovings are used. Each one is passed through a pair of rollers that are both rotating and oscillating. Each set of rollers twists its roving in a direction opposite to the other. The uneven motion of the rollers forms a yarn that has both twisted and untwisted areas. Adjacent ends of the two yarns are allowed to untwist around each other. Care must be taken to space the untwisted areas of each yarn in such a way that a loosely twisted section of one yarn never coincides with a loosely twisted section of the other yarn, or a weak spot would result.

Self-twist yarns can, of course, be used only in those fabrics that require twoply yarns. The process also requires that fiber lengths not be too short. Wool and long-staple manufactured fibers are especially suitable.

Yarn Wrapping

Yarns can be made from a bundle of parallel fibers held in place by surface wrapping of other staple or filament fibers. The first of these wrapped yarns were made by DuPont and were called *fasciated yarns*. (See Figure 14.19.) The term derives from the Latin word *fasces*, meaning "a bundle of rods wrapped with ribbons." Such yarns are no longer made by DuPont; however, wrapped or covered yarns, similar in concept, are being produced.

Air-jet Spinning

In air-jet spinning a largely untwisted sliver is fed into the machine. Two nozzles, each forcing an air jet against the sliver from opposite directions, cause fibers from the outer layer of the sliver to wrap around the interior fibers, thereby forming the yarn. (See Figure 14.20.) Air-jet yarns are bulky and less uniform than open-end or ring-spun yarns, but the process is efficient and inexpensive. They are, therefore, used in some of the same fabric end uses.

Hollow-spindle Spinning

In hollow-spindle spinning, a sliver of core fibers is fed through a hollow spindle where it is wrapped by a filament yarn unwinding from the spindle.

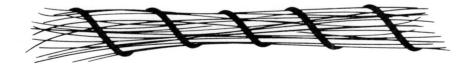

FIGURE 14.19

Diagram of structure of a fasciated yarn.

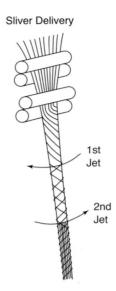

FIGURE 14.20
Diagram of Murata air-jet spinner.

An interesting application of the technique has been in the manufacture of towels and other fabrics, in which the wrapped yarns are used in the pile. In this instance, the wrapping yarn is made from soluble polyvinyl alcohol (PVA) fibers. After the fabric has been put through the finishing processes, these yarns dissolve, leaving a soft, all-cotton twistless, and absorbent yarn in the pile. Figure 14.21 illustrates the differences in appearance of ring-spun and wrap-spun yarns.

Core Spinning

Core-spun yarns are usually made with a continuous filament core surrounded by twisted fibers or other yarns. (See Figure 11.3.) Recently, core-spun yarns with a staple core of one fiber and an outer sheath of another fiber have been produced by an adaptation of ring spinning. Two rovings, one of polyester and one of cotton, are fed through drafting rollers then pass through separate channels before being wound on the spindle. The channel for the cotton sheath is longer, ensuring that it will wrap around the polyester core as the twist is inserted. Fabrics from staple core yarns are more durable and have more easy-care features than those of 100 percent cotton yarns.

Other examples of core-spun yarns are spandex or rubber cores for stretch, sewing thread with a polyester core and cotton covering, hiding brown PBI fibers as a core, and using a soluble core to temporarily strengthen yarns to weave exceptionally fine wool/cashmere fabrics.

Making Yarns from Films

Yarns can be formed directly from synthetic polymers without the formation of fibers or the twisting of fibers into yarns. These processes include the split-film and slit-film processes. Slit-film yarns could be classified as monofilaments. Yarns made by the split-film process do not fit neatly into the categories of staple or filament yarns.

CP1A Gordon Covell of the Islay Woollen Mill in Scotland at a hand loom showing shed formed by warp yarns and harnesses holding heddles. The Mill produced fabrics for the

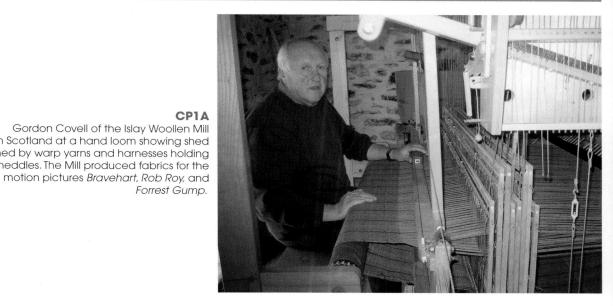

CP1B

Twill fabric being woven; filling yarn has been inserted but not beaten up; openings in the reed are visible.

CP1C Fabric showing take up and heddles.

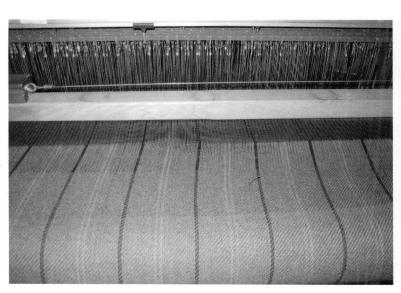

CP2A

Yarn made from manufactured bamboo fibers. Ply structure of yarn is visible.

CP2B Spun silk plain wave with course slub yarns in the filling direction.

CP2C

Cotton plain weave with boucle yarns in warp and filling directions. Reproduced with permission of Cotton Incorporated.

CP2D

Examples of novelty yarns. Left to right: Boucle or loop; knot or spot; flake; slub; chenille.

CP3A
Patterned weft knit showing
lifferent colored yarns (face).

CP3C Fine rib weave with flake yarns in the fillling direction.

CP3BPatterned weft knit (back).

CP3D Velour knit with design.

CP3E
Jacket of cotton/polyester/acetate
jacquard weave.

CP4APique fabric showing face and back.

CP4B Embroidered design on bedspread.

CP4C Hand made pieced quilt.

Yarns made in India from strips of discarded silk saris; left, yarn before washing and drying; right, yarn after washing and drying.

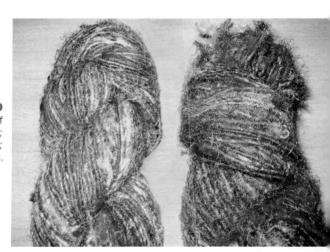

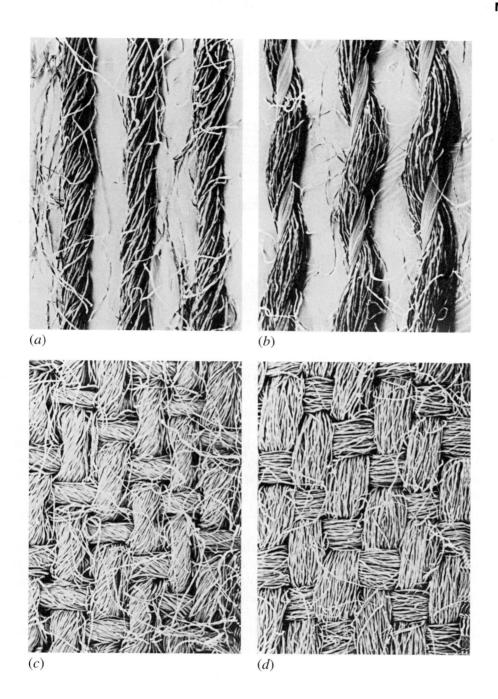

FIGURE 14.21

Comparison of ring-spun and wrap-spun yarns:
(a) ring-spun yarns;
(b) wrap-spun yarns with soluble filament wrapping; (c) plain weave fabric of ring-spun yarns; (d) plain weave fabric of wrapspun yarns with filament wrapping dissoloved.
Micrographs courtesy of G. F. Ruppenicker, personal communication.

Split Films

In this process polymer film is formed and stretched in the lengthwise direction. The molecules are oriented in the direction of the draw, causing the film to be strengthened in the lengthwise direction and weakened in the crosswise direction. This causes a breakdown of the film into a mass of interconnected fibers, most of which are aligned in the direction of the drawing, but some of which also connect in the crosswise direction. The phenomenon is known as *fibrillation*. (See Figure 14.22.)

FIGURE 14.22
Diagram of steps in film fibrillation.

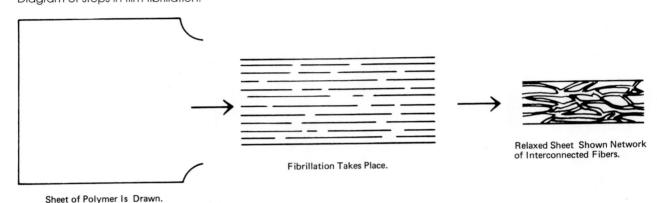

The fibrillated materials can be twisted into strings or twines or other coarse, yarnlike materials. The usefulness of split-film yarns is limited because the yarns created are coarse. Olefins are made into split-film yarns for use in making bags, sacks, ropes, and other industrial products.

Slit Films

Slit films are made by cutting film into narrow, ribbonlike sections. Depending on the process used for cutting and drawing the film, the tapes may display some degree of fibrillation, like that described for split films. When tapes are made that do not fibrillate, they are flatter and are more suitable for certain uses. Flat tapes are used as warp yarns in weaving and can be made into carpet backings that will be very stable, remaining flat and even. All types of tape yarns are used in making wall coverings, packaging materials, carpet backing, and as a replacement for jute in bags and sacks.

Lurex[®], a flat, ribbonlike yarn with a metallic appearance, is a slit-film yarn that is often used to add decorative touches to apparel or household textiles. Lurex[®] is made from single or multiple layers of polyester film. Multilayered types are made by placing a layer of aluminum foil between two layers of polyester film. Monoply types are cut from metallized polyester film, protected by a clear or colored resin coating. The natural color of Lurex[®] is silver. Other colors are produced by adding pigments to the lacquer coating or to the bonding adhesive. The width of these yarns ranges from 0.069 to 0.010 inch. The manufacturer claims that the use of polyester film yields a strong, flexible yarn that can be woven or knitted without support but notes that these yarns are decorative rather than functional.

BLENDS

Blending is the process of mixing fibers together. As noted earlier, it can take place at any of several points during the preparation of a yarn. The purposes of blending are (1) the thorough intermixing of fibers and/or (2) combining fibers with different properties to produce yarns with characteristics that cannot be obtained by

using one type of fiber alone. For successful blending of different fibers, fiber lengths should be similar. Self-blending of bales of the same fiber is done routinely in processing natural fibers because the fibers may vary from bale to bale. In this type of blending, the mixing of as many bales as possible is done early in the processes preparatory to spinning so the subsequent steps can help to mix the fiber still more completely.

Yarn manufacturers can also blend fibers that have been dyed different colors, giving interesting effects in the final fabric. Examples are the well-known "heather" effect produced by different shades of dyed fibers and tweed fabrics, which are made from yarns of different-colored fibers. Black-and-white wool tops have been blended to yield a multicolor "salt and pepper" look.

Even when two or more different fiber types are combined, blending is done as early as possible. Carding helps to break up fiber clusters and mix fibers more thoroughly. However, if the fibers being blended require different techniques for opening, cleaning, and carding, as with polyester and cotton, then slivers can be blended. For blended yarns of different fibers, the blend level is the percentage by weight of each fiber. For a 65 percent polyester/35 percent cotton yarn, five slivers of polyester would be mixed with three slivers of cotton at the drawing stage.

Blending is not limited to staple-length fibers. Filament fibers of different generic types can be combined into a single yarn. This can be done either by extruding these fibers side by side, during drawing, or during texturing.

As described earlier, a blended yarn can be core spun with one fiber at the center and a different fiber as the covering, or it can be wrapped with one fiber making up the central section and another the wrapping yarn. As yarn spinning and texturing technologies grow more sophisticated, we expand the possibilities of combining several different fibers into one yarn. Multiple-input texturing machines can produce specialty yarn blends.

Fabrics woven from two or more yarns each made of different fibers are not considered blends. These fabrics are, instead, called combination fabrics. (See Figure 6.5.) They do not behave in the same way as those fabrics in which the fibers are more intimately blended and may require special care procedures. Regrettably, the Textile Fibers Products Identification Act (TFPIA) labeling requirements do not distinguish between blended fabrics and combination fabrics when fiber percentage contents of fabrics are given.

Properties of Blended Yarns

Fibers with different characteristics, blended into a yarn, can each contribute desirable properties to the final textile material. The ultimate performance is an average of the properties of the component fibers. For example, a fabric of 50 percent cotton and 50 percent polyester would have an absorbency intermediately between that of cotton or polyester. In some cases, however, the observed fabric property is not determined simply by the relative amounts of each fiber in the blend. In blends of nylon with cotton, the tenacity of the blended yarn initially decreases with increasing amounts of nylon because of differences in the breaking elongation of the two fibers. At the breaking elongation of the cotton fibers, the nylon fibers are not assuming their share of the stress, leaving the cotton to bear the load.

The stage at which blending occurs also affects the properties of the fabrics. In general, the more intimate the mixing of fibers in the blends, the better the resulting properties. Yarns blended at the fiber stage exhibit a more effective averaging of properties than ply-blended yarns.

Even though considerable study and evaluation have been made of optimum fiber proportions required to achieve desired results in blends, no certain conclusions have been reached. It is clear that extremely small proportions of fibers have no appreciable influence on performance, although they may have some effect on appearance.

SUMMARY POINTS

- Filament yarns are made from continuous fibers twisted together loosely or more tightly
- Filament yarns can be textured to increase their stretch and/or bulk
 - Air-jet is a mechanical bulk texturing process
 - Commonly used thermomechanical texturing processes are false-twist for apparel yarns and hot-fluid jet for BCF carpet yarns
- Staple yarns are made from staple fibers, with the processing system dependent on the fiber length and type: cotton, wool, linen
- Primary steps in staple fiber manufacturing, starting with clean fibers are as follows:
 - · Carding
 - Combing—optional
 - Drawing or gilling
 - Forming the roving
 - Ring spinning or open-end spinning
- Ply yarns are made by folding or twisting two or more yarns together
- Other techniques for making yarns are wrapping fibers or yarn around a sliver or untwisted yarn and cutting a film into narrow strips
- · Blends are mixtures of fibers in a yarn
 - Blends offer the advantages and disadvantages of each of the fibers in the blend
 - Fibers can be blended at different stages of the manufacturing process

Questions

- What are textured yarns? What are the different texturing methods? What properties of manufactured fibers are used in texturing yarn?
- 2. Compare the steps in the cotton spinning system, the woolen spinning system, the worsted spinning system, and the system for spinning flax.
- 3. Compare the advantages of ring-spun and open-end-spun yarns.
- 4. List methods of making yarns other than ring and open-end spinning.
- 5. What is the purpose of blending fibers? What are some of the factors that affect the properties of blended yarns?

References

- Demir, A., and H. M. Behery. *Synthetic Filament Yarn Texturing Technology*. Upper Saddle River, NJ: Prentice Hall, 1997.
- Hearle, J. W. S., L. Hollick, and D. K. Wilson. *Yarn Texturing Technology*. Cambridge, UK: Woodhead Publishing, 2001.

Recommended Readings

- Backer, S. "Staple Fibers—The Story of Blends, Part 2: Development and the Future." In *Polyester—50 Years of Achievement*, edited by D. Brunnschweiler and J. W. S. Hearle, 94. Manchester, England: The Textile Institute, 1993.
- Dyson, E., ed. *Rotor Spinning: Technical and Economic Aspects.* New Mills, Stockport, UK: Textile Trade Press, 1975.
- Lawrence, C. A. *Spun Yarn Technology*. Cambridge, UK: Woodhead Publishing, 2002.

is again and a second of the comment of the transfer of the page o

property and the property of the control of the con

THE SECTION OF DAMPING HERSELD

FABRICS AND RELATED STRUCTURES

Learning Objectives

- 1. Categorize and describe the different fabric construction methods.
- 2. Explain the basic physical parameters for describing fabrics.
- 3. Describe structures of materials related to fabrics.

he textile components studied thus far come together in the making of fabrics. According to ASTM, a fabric is a "planar structure consisting of yarns or fibers" (ASTM 2007). *Planar* implies a structure in which the length and width are much higher than the thickness. Fabrics can take many forms and be constructed in a variety of ways, ranging from the matting together of fibrous materials to the intricate interlacing of complex yarn systems. This chapter introduces broad categories of fabric constructions and some considerations in describing fabrics. Specific fabric structures and processes and the effect of structure on fabric properties are discussed in the chapters that follow.

There are other materials that are essentially planar in form and have the flexibility of fabrics but are not technically considered to be fabrics. Among these are films and leather, which are used in textile products and will be described in this chapter as structures related to fabrics.

FABRIC CONSTRUCTION METHODS

Table 15.1 summarizes fabrics and related structures by the form of starting material and the distinctive technique used in each. The primary classifications of fabrics are briefly described below.

1. Woven Fabrics. Weaving of fabrics consists of interlacing yarns at right angles. By varying the pattern of interlacing, a wide variety of different

TABLE 15.1
Fabrics and Construction Methods

Fabric/Structure	Variations	Starting Material	Construction Technique
Woven Fabrics	-	Yarns	Interlacing
Looped Fabrics		Yarns	Interlocking loops
	Knitted Fabrics		
	Crocheted Fabrics		
Nonwovens		Fibers	Entangling and/ or bonding
Knotted Fabrics		Yarns	Knotting
	Lace		
	Net		
	Macramé		
Stitch-through Fabrics		Yarns, Fibers	Stitching
Braided Fabrics		Yarns	Braiding
Composites		Fibers, Yarns, Fabrics	Molding
Leather		Animal skin	
Films		Polymers	Extrusion or casting

- fabric constructions can be produced. Woven fabrics do not have much stretch unless elastic fibers or stretchable yarns are used.
- 2. Looped Fabrics. Fabrics can be constructed from one or more continuous yarns by the formation of a series of interconnected loops. Knitting is the best known type of looping construction. Crochet is another. Knits are stretchable because the loops can be elongated.
- 3. *Knotted Fabrics*. Some fabrics are created by knotting yarns together. Lace, nets, macramé, and tatting are examples of this construction method.
- 4. *Nonwoven Fabrics*. Webs of fibers can be held together into a fabric by interlocking of fibers without the necessity of first forming yarns. Felt and bark cloth, older fabric-making techniques, are also constructed from webs of fibers but are not technically defined as nonwovens.
- 5. Stitch-through Fabrics. Stitch through or stitch bonding is a technique for constructing fabrics in which two sets of yarns or masses of fibers are stitched together into a fabric structure by another set of yarns.
- 6. *Braided Fabrics*. Fabrics may be created by plaiting together yarns or strips of fabrics. The components are interlaced in a diagonal pattern over and under one another to form a flat or tubular fabric of relatively narrow width.
- 7. *Films*. Films are polymeric sheets. Because they are not made from fibers, they are not considered to be true textiles even though they are often used

- in products that have traditionally been made from textiles such as shower curtains or upholstery. They are sometimes laminated to textiles and, therefore, may be part of the structure of some textile products.
- 8. *Textile Composites*. These materials generally consist of one or more textile components impregnated with or embedded in a resin matrix. Textile composites are generally used for high-technology products for industry, the military, and aerospace.

Over time, machinery for constructing all these types of fabrics has been developed. One of the oldest methods of construction, the matting together of wool or hair fibers, is enjoying a resurgence in the fast-growing nonwovens market. Different types of looms for making woven fabrics have been in existence for centuries, and hand knitting is a craft of long standing. Many of these methods and instruments are familiar, while new processes are less well known.

YARN PREPARATION

A glance at the table shows that most fabrics are made with yarns. Thus, not only the fiber selected, but also the yarn structure, affect the properties of the fabric. After yarns, either filament or spun, are manufactured, they must undergo additional preparation before being used to form fabrics. Generally this preparation involves rewinding the yarns onto bigger packages and also includes inspection and removing thick and thin spots in the yarn (Schwartz, Rhodes, and Mohamed 1982). (See Figure 15.1.) Many fabrics are also made with yarns that are colored before being used to construct fabrics.

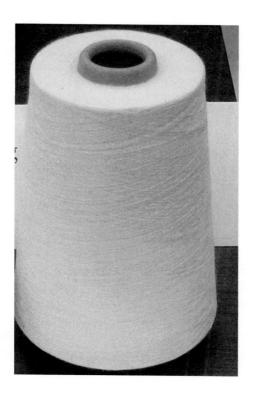

Figure 15.1

Package of cotton yarn, ready for making fabric.

DESCRIBING FABRICS

After selecting fibers and yarn types, product developers are presented with many choices for fabric structures to achieve a desired textile product. Function and end use dictate the selection of a fabric construction method. In many instances today, there are fairly specific properties a fabric must have to fulfill its performance expectations. Some of these are a feature of the fiber and/or yarn selected, but for others fabric construction plays a primary role. Understanding how fabric structure affects performance is an objective of the following chapters, which focus on the different construction processes. Performance properties for each fabric type will be discussed in detail.

Within the textile and apparel industries, comparative measurement systems are necessary for designing, specifying, and sourcing products. The concept of yarn size expressed as yarn number was discussed in chapter 13. When dealing with fabrics, it is often important to specify the width of the fabric, the weight and thickness of the cloth, its reversibility, and where appropriate, the number of yarns in a given fabric area. Systems for counting yarns, which are specific to woven and knitted fabrics, are described in chapters 16 and 18.

Weight, thickness and symmetry, plus fiber type, yarn type (filament or staple), color use, yarn packing, and interlacing pattern together are summarized in the textile trade as a fabric name. Thus, if someone says, "This is a gingham," you can immediately assume a top weight, plain weave, cotton or cotton-blend fabric with a colored check pattern.

Fabric Weight

Weight is one of the most important characteristics, especially for woven, knitted, and nonwoven fabrics. Fabric weight is usually expressed as ounces per square yard or grams per square meter. For both of these systems, the higher the number, the heavier the fabric. The metric measure is used internationally and is the standard in the scientific literature dealing with textiles. In the United States, however, reporting fabric weight in ounces per square yard is still common. A fabric may be advertised as "5-ounce" or "8-ounce," meaning the weight of a square yard of that fabric. In some cases this may be a quality indicator, as for example, a rugby shirt constructed of an eight-ounce knitted fabric would be sturdier than one made from a six-ounce knitted fabric.

Fabric weight is a function of the weight and thickness of the yarns used and how closely they are packed in the fabric structure. Weights may range widely. Fabrics weighing less than one ounce per square yard would be very light weight, as for example, in some sheer curtain fabrics, gauzes, or even mosquito netting. Fabrics weighing from two to four ounces per square yard are also relatively light weight. These are often referred to in the industry as topweight fabrics and are typically used for shirts or blouses. Medium-weight fabrics, five to seven ounces per square yard, are referred to as bottom-weight fabrics and are used for items such as skirts or slacks. Heavyweight fabrics range from nine to eleven ounces (for example, some jeans), and weights

FIGURE 15.2
"Lightweight (a), medium weight (b), and heavyweight (c) fabrics of the same construction."

greater than fourteen ounces are classified as *very heavyweight* (perhaps for upholstery or coats). (See Figure 15.2.)

Other systems used to designate fabric weight are ounces per linear (running) yard and yards per pound. Yards per pound is a measure of the number of yards of fabric in one pound. In this measure, higher numbers indicate lighter-weight fabrics. This system of measurement is used mostly for cottons, cotton blends, or lightweight manufactured fabrics. When measuring ounces per yard or yards per pound, the width of the fabric is not taken into account. These measures are, therefore, less precise than are the measures of ounces per square yard and grams per square meter.

Fabric Thickness

Fabric thickness is a key characteristic in determining product end use, especially where comfort is concerned, and therefore, it is essential to specify thickness when considering a selection of fabrics. Thickness is measured by gauges that compress the fabric under a standard weight and is reported in thousandths of an inch or in millimeters.

Fabric Width

Fabric widths will vary with the size of the machine on which they are made. Some weaving, knitting, and nonwovens machines can produce fabric several meters wide. Other fabrics, such as braids or ribbons, are purposely constructed in narrow widths. Some fabrics are knitted in tubes, with a diameter appropriate for the end use, such as socks or T-shirts. A buyer will specify a fabric width necessary for making the final textile product.

Fabric Symmetry

When fabrics are used to construct apparel, home furnishings, or other textile products, differences in appearance from front to back or top to bottom become important. A fabric that has the same appearance on both front and back is *reversible*. If the two sides are different, it is not reversible. For fabrics that are not reversible, the side to be displayed in the finished textile is termed the *face* of the fabric, and the other side is the *back*. In addition, certain constructions look different along the length of the fabric depending on which end is considered the top. The pile fabrics described in chapter 17 are an example of this.

RELATED STRUCTURES

Structures that are related to fabrics but are not technically classified as textiles are leather, fur, and films. These materials are used in apparel, furnishings, and other such items—or they may be included as a component in a textile product. Fur was described in chapter 5; leather and films are presented here.

Leather

Leather products, made from the skins of animals, are not considered textiles, although they are often used alone or in combination with fabrics in apparel, upholstery, and other products. The skins of large animals are called *hides*, while those from young and small animals are *skins*. Leather is a skin or hide that has been *tanned*, that is, treated to avoid decomposition and putrefaction. It is a fibrous material composed of tightly meshed collagen fibers. Collagen is the protein found in the connective tissues of the body.

Leather processing consists first of soaking the freshly removed skin in a salt solution to inhibit the bacterial decomposition of the proteins and fat. The flesh underlayer and any hair on the top surface are then removed. Traditionally the skins and hides were treated with tannin, extracted from plants, to remove the protein between the collagen fibers. Hence, the processing of skins into leather was called *tanning*. In modern tanneries, however, it is much more common to use chrome solutions, which are easier to obtain and control.

The outer layer of the leather is porous, with tiny holes where the hairs were removed. This porous surface is the *grain*, which differs from animal to animal. Split leather, which has been cut into layers, does not show the grain and is smoother. The inner, or flesh, side is the softer *suede* face. (See Figure 15.3.)

Leathers are made into many different products for both apparel and interior and automobile furnishings. Because of the extensive processing and the limited size of skin pieces, leather products are expensive. Exotic skins, such as alligator, snake, eel, ostrich, and others are extremely costly. The quality of leathers can vary depending on the animal source and the processing.

Films

The polymers from which fibers are made can also be made into film form. In processes analogous to melt spinning or dry spinning, a melted polymer is extruded

FIGURE 15.3
Leather (left) and suede (right).

through a slit or a dissolved polymer is "cast" onto a surface and the solvent is evaporated. Mylar $^{\circledR}$ is a polyester (PET) film.

Films are produced from a wide variety of polymers and in a range of thicknesses. They can also be embossed to impart surface texture and are often laminated to other textile fabrics to provide special properties. (See Figure 15.4 and chapter 20.) Films can confer a protective layer on fabrics for protective apparel for chemical workers, pesticide applicators, and others. Films laminated to fabrics can also provide water resistance, as witness the "slickers" that were standard rain gear for many years. Microporous films are produced today for use in composite fabrics that will "breathe."

FIGURE 15.4
Embossed film bonded to knit fabric.

SUMMARY POINTS

- · Fabrics are planar structures made with fibers or yarns
- The most widely used fabric constructions are woven, knitted, and nonwoven
- · Fabrics can be described by weight, thickness, width, and symmetry
- · Related structures that are not considered textiles
 - Leather from the skin of animals
 - Films

Questions

- 1. Which fabrics are made from yarns? Directly from fibers? From fibers or yarns?
- 2. What are the considerations in preparing yarns for fabric construction?
- 3. How is fabric weight specified?
- 4. How are fabric weight and thickness related?
- 5. How are leathers processed?

References

ASTM. Annual Book of ASTM Standards. Vol. 7.01. West Conshohocken, PA: American Society for Testing and Materials, 2007.

Schwartz, P., T. Rhodes, and M. Mohamed. *Fabric Forming Systems*. Park Ridge, NJ: Noyes Publications, 1982.

Recommended Readings

Horrocks, A. R., and S. C. Anand. *Handbook of Technical Textiles*. Cambridge, UK: Woodhead Publishing, 2000.

WOVEN FABRICS

Learning Objectives

- 1. Define the basic terms for describing woven fabrics.
- 2. Describe the basic parts of a loom and the different types of looms and weaving machines.
- 3. Explain the steps in the weaving process.

BASIC WEAVING CONCEPTS AND TERMINOLOGY

Woven fabrics, with a few exceptions (such as triaxial fabrics, discussed later in chapter 17) are constructed by interlacing lengthwise yarns and crosswise yarns at right angles. The lengthwise-direction yarns are called *warp yarns* or *ends*. Crosswise yarns are called *filling yarns*, *weft yarns*, or *picks*.

Fabric Grain

In theory, warp and filling yarns should intersect at right angles. When this relationship is perfect, the fabric is said to be on *true grain* or *grain perfect*. As a result of the stresses and strains imposed during weaving or finishing, the yarns may not lie in the proper position, and when this occurs, the fabric is said to be *off-grain*. The extent to which a fabric is on true grain is an indicator of fabric quality.

The off-grain relationship of warp and filling yarns is described by different terms, depending on how the distortion lies. Warp yarns are usually straight as they are subject to lengthwise tension throughout the processing of fabrics. Filling yarns are usually responsible for the distortion, but they may be distorted in a straight line (*skewed*) or in a curved line (*bowed*). (See Figure 16.1.)

The diagonal line in a woven fabric is the *bias* direction. The fabric stretches more in the bias direction than in the warp or filling direction.

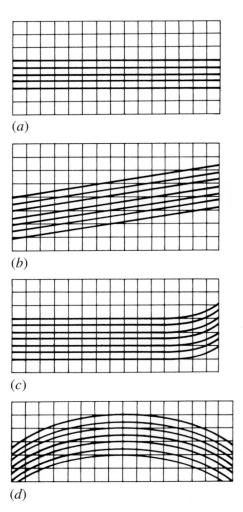

FIGURE 16.1

Grain positions. (a) Warp and filling interlace at 90° angle; fabric is on true grain. (b) Filling is off the square or skewed; though straight, the filling is not at 90° to the warp. (c) Filling is bowed—straight for part of the way, then curved toward one side. (d) Filling is bowed or curved from one side to the other.

Fabric Count

The closeness of the weave is expressed as the *fabric count*. Sometimes called *thread* count, this is the number of yarns in one inch or centimeter of warp and in one inch or centimeter of filling. When the number of yarns in the warp is similar to the number of yarns in the filling, the weave is said to be a *balanced weave*. The fabric count is often expressed in numerical form as 80×64 , indicating that there are 80 warp yarns per inch and 64 fillings per inch. When warp and filling are perfectly balanced, or equal, the count may be stated as 80 square, meaning there are 80 yarns per inch in the warp and 80 yarns per inch in the filling. Alternatively, the number may be doubled, in which case a count of 180 would indicate a count of 90 yarns per inch in each direction. Clarifying exactly what is being counted and reported is important. Recently some manufacturers were "counting" a two-ply yarn as two yarns and describing a 100×100 fabric of two-ply yarns as a 400 thread count.

Pick counter used to determine yarns per inch or yarns per centimeter. Photograph courtesy of Alfred Suter Co., inc.

Fabric count is usually measured with a calibrated, square magnifying glass called either a *linen tester* or a *pick glass*. (See Figure 16.2.) The glass is marked off in fractions of an inch or in centimeters, and the number of warp and filling yarns beside these calibrations can be viewed in magnified form with the glass and counted.

In those fabrics where fabric counts are not balanced, the larger number of yarns will usually be found in the warp direction. This can be one way to determine warp direction in a small sample of fabric. Unbalanced fabrics usually exhibit so-called rib effects created when numerous finer warp yarns cross over coarser filling yarns. Costs increase more rapidly as the number of picks (filling yarns) per inch increases; therefore, fabrics with balanced weaves or those with more yarns in the filling than in the warp are more costly to manufacture.

Counts are taken in the *greige* (that is, unfinished) goods, and because fabrics may shrink during finishing, the count provided may not be exactly accurate. If only one number appears, it can generally be assumed that the fabric has a balanced weave.

Selvages

The side edges of woven fabrics are termed *selvages*. In the shuttle type of loom, the filling yarn travels back and forth across the fabric, creating a closed selvage edge, with no loose yarn ends to fray or ravel. In shuttleless looms, separate lengths of filling yarn are inserted, resulting in fringed selvages. It is necessary to reinforce this edge if the fabric is not to fray at the edges. Methods of reinforcement include providing for tucking the yarns at the open edge or use of a *leno selvage*, a self-selvage in which two warp yarns at the edges of the fabric twist around each filling. The tucked-in finish is the more durable. For heavy industrial fabrics made from heat-sensitive or thermoplastic fibers, hot melting devices cause the yarns to fuse together to form a tight selvage. (See Figure 16.3.)

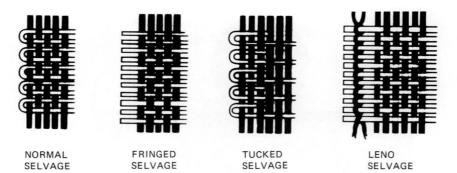

Figure 16.3

Types of selvage edges.

THE LOOM

Weaving is done on a *loom*, which—whatever its age or mode of operation—includes a number of basic parts, as shown in the diagram in Figure 16.4.

- 1. A mechanism for holding the warp yarns under tension. As anyone who has tried interlacing yarns knows, tension on one set of yarns is necessary. For the ancient Greeks, tension was provided by stones tied to the bottom of the warp yarns. Today's looms have warp yarns wound tightly onto a large roll, the *warp beam*. The finished fabric on the other side of the loom is wound up on a *cloth beam*. Appropriate tension for weaving is applied between the two beams.
- 2. A method for manipulating the warp yarns so the filling yarn can be inserted. Originally accomplished by raising each warp yarn by hand, the process progressed through use of a stick to hold up alternate warp yarns, to threading the yarns through metal wires with holes. With these wires, called *heddles*, fastened onto a frame, called a *harness*, a whole set of warp yarns can be raised or lowered at one time.
- 3. A carrier for inserting the filling yarn. Early weavers used their hands to interlace the filling yarn but soon found it easier to use a needle or to wrap the yarns around a stick. The yarn could be unwound from the stick as it moved through the warps. Ultimately, yarn was wound onto a bobbin, and

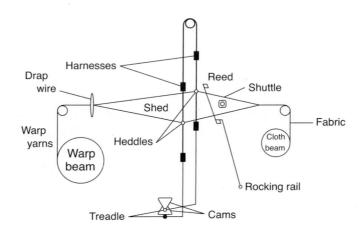

FIGURE 16.4
Profile of basic loom showing components.

- the bobbin was placed into a boatlike *shuttle*. The pointed end of the shuttle allowed the carrier to move smoothly, while the bobbin allowed the yarn to unwind as it was needed.
- 4. A means of tightening the filling yarns against each other. In early hand weaving, filling yarns tended to be somewhat loose in placement and had to be pushed into place more firmly. A wooden stick shaped like a sword was used, eventually evolving into a comblike device called a *reed* that was mounted on a frame, the *batten*.

MODERN WEAVING PROCESSES

Present-day looms can be divided into two major classifications: those that produce cloth in flat form and those that produce cloth in tubular form. Looms that produce flat woven cloth are predominant. Flat looms can be further subdivided into two categories: (1) those that use a shuttle to transport filling yarns and (2) shuttleless weaving machines, those that use some other means for carrying the filling from side to side.

Preliminary Steps

Preparing the Warp Yarns for Weaving

Before their use on the loom, warp and filling yarns must be prepared for weaving. The essential characteristics of suitable warp and filling yarns differ. Warp yarns undergo greater stress and abrasion during weaving than do filling yarns; therefore, warp yarns must be strong enough to withstand these pressures. Warp yarns must be clean, free from knots, and uniform in size.

These yarns are wound onto the warp beam from many cylindrical packages of yarn, which are called *cheeses*. These are held on a *creel*. (See Figure 16.5.) For

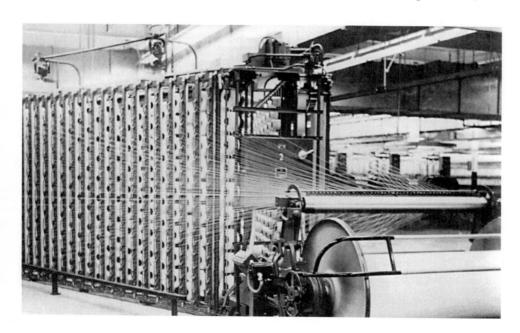

Figure 16.5

Warp beam prepared from several hundred cheeses of yarn.

Photograph courtesy of the National Cotton Council of America.

example, if a fabric is to be woven sixty inches wide with one hundred yarns per inch, six thousand separate ends must be wound onto the beam. For long runs of plain fabric, all the ends are wound on at one time. For shorter runs of patterned warps, the beam may be wound in groups of a few hundred ends at a time.

To strengthen warp yarns and make them smoother, a sizing is added. Size is made up of starches or synthetic polymers such as polyvinyl alcohol (PVA). Sized yarns are less likely to break as a result of tension and abrasion during the weaving process. The yarns are passed from one warp beam through a solution of sizing material then squeezed out in a process known as *slashing*. The sized yarns are dried immediately after treatment and are wound onto another warp beam. Sizing is not always required on filament yarn warps.

The warp beam containing the sized yarns is placed on the loom. In preparation for weaving, each warp end (yarn) must be threaded through its own drop wire, heddle eye, and reed dent. The *drop wire* is a small metal plate with a hole; if a warp yarn breaks, the plate will drop, stopping the loom motion. The *heddle eye* is the opening in a heddle that carries the yarn, and the *reed dent* is an opening in the reed, the comblike device that will push each filling yarn close against the completed fabric.

If the new warp is different from that previously woven or if there is no warp on the loom, then the warps must be *drawn-in*. To draw-in, or tie-in, each end by hand would be enormously time consuming; therefore, a variety of machines were developed for drawing-in. A separate machine can be used for each step (that is, drawing through the drop wire, the heddle eye, and the reed dent), or one machine can perform all three steps. Drawing-in is also referred to as "dressing" a loom and is typically accomplished away from the loom itself, allowing weaving to take place at the same time as the new warp is being threaded. When ready to be woven, the beam, harnesses, reed, and drop wires are moved as a unit and attached to the weaving machine.

If warp yarns from a previously woven fabric are in place and if that fabric had the same number of warps, the new warps are tied into place by attaching them to the warps already on the loom. This process is called *tying-in*, and is much simpler than rethreading each warp yarn! In the simplest pattern of weaving, where the filling yarn runs over one warp and under the next, two harnesses are required. Every other warp yarn is threaded through the heddles of one harness and the alternating warps through the heddles of the second harness. More complicated weave patterns (described in chapter 17) use more harnesses.

Preparing the Filling Yarns for Weaving

Yarn that is to be used for the filling must be packaged in some form that allows it to be unwound easily for transport through the shed. In shuttle looms the device that carries the yarn across the shed is called a shuttle and is made up of a wooden carrier into which a *quill*, or *pirn*, is placed. (See Figure 16.6.) The filling yarn is wound onto the quills from larger packages of yarn. For shuttleless looms this step of winding quills is unnecessary because filling yarn is drawn directly from large packages carrying two to three pounds of yarn that are mounted on the sides of the loom. If yarn that has been prepared for use in the filling is not to be used immediately, it is usually conditioned, kept in a room with hot, humid air. Conditioning allows yarn to relax and helps to prevent the formation of kinks.

Figure 16.6
Wooden shuttle with quill showing size.

Basic Motions of Weaving

Once the filling yarns have been prepared and the warp yarns have been set into place, the loom goes through a repeated series of motions to form the fabric. (See figures CP1A, CP1B and CP1C on Color Plate 1 for further illustration of weaving operations.)

Shedding

Raising the harnesses through which different warp yarns are threaded creates an open area, called a *shed*, between the sets of warps. The formation of the shed is known as *shedding*. (See figure CP1A on Color Plate 1.)

Picking

While the shed is open, the yarn is transported across the opening, laying a filling yarn, or pick, across the width of the loom. (See figure CP1B on Color Plate 1.) The insertion of the filling is known as *picking*. In shuttle looms, the knocking of the shuttle up against the stop box at each side of the loom is responsible for much of the noise associated with weaving.

Speed of weaving machines is generally expressed as the number of picks per minute, yards or meters of filling inserted per minute, or yards or meters of fabric per hour. Speed obviously is related to the width of the loom. Wider looms, weaving wider fabrics, would require more time for one filling insertion.

Beating Up

Beating up is done by the reed that pushes the newly inserted filling yarn close against the woven fabric. This again can be a noisy step in the weaving process.

Taking up/Letting Off

As the woven fabric is formed, it must be moved or *taken up* on the cloth beam to make room for the formation of more fabric. (See figure CP1C on Color Plate 1.) At the same time, more warp yarn must be unwound or *let off*. All these functions are synchronized so they occur in the appropriate sequence and do not interfere with one another.

Monitoring Yarn Breakage

There is always the danger that a warp or filling yarn may break during weaving, resulting in a flaw in the fabric. The drop wires fall down when a yarn breaks or they may be monitored by electronic scanners that indicate when a yarn is broken. Through signals resulting from either the drop wires or a break in the electronic contact, the loom is shut off, allowing the broken yarn to be repaired.

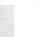

YARN TRANSPORT METHODS

The carrier used for transporting the filling yarn may differ from one kind of loom to another. The different devices used form the basis for classifying different types of looms. Within the industry many people refer to newer equipment as *weaving machines* rather than looms. Weaving machines vary from older, shuttle looms to modern shuttleless machines, which are now predominant in much of the global commercial textile industry.

Shuttle Looms

In shuttle looms the shuttle traverses the cloth, and the filling yarn unwinds from the quill. Quills in the shuttle must be replaced when the yarn supply is exhausted. The frequency with which a quill has to be replaced depends on the fineness of the filling yarn. Coarse yarns require more frequent replacement; finer yarns need to be replaced less often.

In the mechanical changer, full quills are kept ready in a revolving case. (See Figure 16.7.) The machine rams them into the shuttle when the shuttle comes to rest briefly after crossing the yarn. The pressure of the full quill crowds the empty quill out of the shuttle. It falls through a slot into a container under the loom. The new quill is pushed mechanically into place in the shuttle, which has a self-threading device that automatically picks up the yarn when the new quill is inserted. This allows the weaving to continue without a stop.

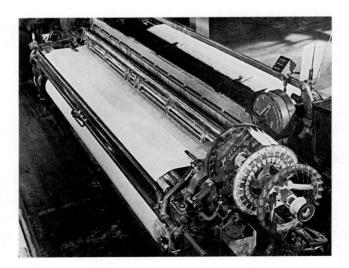

Figure 16.7
Filled quills are mounted, ready for insertion into the shuttle, which is not visible. Photograph courtesy of Masters of Linen

Picking when two or more different colors or types of filling yarn are used requires two or more shuttles and a more complex and costly type of loom arrangement. To insert yarns of different colors or types, a number of shuttle boxes must be moved up and down to bring shuttles into position to create the pattern. Such looms are often called *pick and pick looms*. Among the advantages of most shuttleless looms is that they draw yarn for each pick directly from yarn packages, making it easier and less costly to insert a number of different colors or types of yarn.

The rapid crossing of the shed by the shuttle leaves a layer of filling yarn. When the shed is changed, the yarn is locked into place by the change in warp positioning. However, to make the yarn lie flat and in its proper position, it must be beaten into place.

Shuttleless Weaving Machines

Shuttleless weaving machines were developed to increase the speed of weaving and reduce the literally deafening noise of the shuttle passing back and forth. The modern loom with a shuttle, although much faster in operation than the earliest automatic looms, is not susceptible to further increases in speed because of the variety of operations that the machine must perform. Time is required for stopping the shuttle and accelerating it in the other direction, and the weight of yarn on the quill that must be carried across the shed limits the speed.

Shuttleless machines may be classified by the method used in inserting the filling yarns. Four basic types are as follows:

- 1. Machines with grippers or projectiles (throw across)
- 2. Machines with mechanically operated gripper arms or rapiers (reach across)
- 3. Machines employing water or air jets to carry the filling (spit or blow across)
- 4. Machines that form multiple sheds (multiphase)

In hand weaving and automatic shuttle weaving, the filling yarn is continuous and runs back and forth across the fabric, but in most shuttleless weaving, the filling yarn extends only from selvage to selvage as it is cut off before it passes across the shed. In all shuttleless weaving, the yarn for the filling is unwound from large, stationary packages of yarn that are set on either one side or both sides of the loom. Because weaving speed depends on fabric width, there is every incentive to build wider machines for more efficient filling insertion. Widths do vary; therefore, weaving speeds are generally reported as meters of filling yarn inserted per minute. A comparison of the speeds of the different types of shuttleless looms is presented in Table 16.1 (Seyam 2003).

Projectile or Gripper Loom

In the gripper or projectile type of weaving machine, a small, hooklike device grips the end of the filling yarn. (See Figure 16.8.) As the gripper is projected across the warp shed, it tows the filling behind it. The gripper can move more quickly than a conventional shuttle because of its decreased size; it can travel farther

TABLE 16.1

Comparison of Weaving Speeds¹

Type of Loom	Potential Range of Speeds Reported in Meters of Filling Inserted per Minute	
Projectile weaving machines	about 1,400	
Rapier weaving machines	1,300–2,000	
Water-jet weaving machines	2,000–2,700	
Air-jet weaving machines	2,100-2,400	
Multiphase weaving machines	2,400-6,000	
Conventional shuttle loom	300 ²	

Seyam, A. M. "Weaving Technology: Advances and Challenges II." *Journal of Textile and Apparel, Technology and Management* 3, no. 1 (2003): 1.

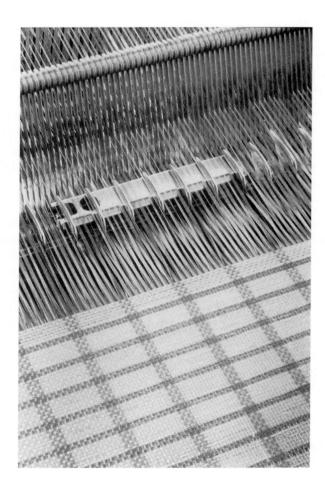

FIGURE 16.8

Gripper projectile carries the filling yarn into the shed. Photograph courtesy of SulzerTextil.

more easily, thereby making possible the weaving of wider fabrics, and it does not require the step of filling the shuttle; it pulls the yarn directly from a prepared yarn package.

Two types of gripper looms are used. In one the gripper travels in only one direction. It is returned to the starting point by a conveyor belt. To maintain the weaving speed, each machine must have several grippers, although only one is in use at any one time.

In the other type of gripper machine, a single gripper inserts one filling yarn alternately from the right- and left-hand sides of the loom. The gripper serves the same function as a conventional shuttle, but instead of holding a quill, it carries the yarn behind it. Packages of yarn must, therefore, be placed on both sides of the machine.

The gripper machine not only weaves fabric more quickly than does the shuttle loom, but it runs with less noise, making it possible for manufacturers to comply more easily with government regulations that restrict noise levels.

There is also a saving in power costs for wide-width fabrics. Narrow fabrics are not economically woven on this machine because too much time is spent in periods of acceleration of the gripper. Wide fabric widths are quite productive as the power consumed is less than that for a conventional shuttle loom of the same size. Sheets are woven side by side on some of these machines to take advantage of these savings.

Rapier Loom

As in the gripper loom, a stationary package of yarn is used to supply the filling yarns to the rapier machine. One end of a *rapier*, a rod or steel tape, carries the filling. The other end of the rapier is connected to the control system. The rapier moves across the width of the fabric, carrying the filling across through the shed to the opposite side. The rapier is then retracted, leaving the new filling in place.

In some versions of the machine, two rapiers are used, each half the width of the fabric in size. One rapier carries the yarn to the center of the shed, where the opposing rapier picks up the yarn and carries it the remainder of the way across the shed. (See Figure 16.9.) A disadvantage of both these techniques is the space required for the machine if a rigid rapier is used. The housing for the rapiers must take up as much space as the width of the machine. To overcome this problem, looms with flexible rapiers have been devised. The flexible rapier can be coiled as it is withdrawn and will, therefore, require less space. However, if the rapier is too stiff, it will not coil; if it is too flexible, it will buckle. The double rapier is used more frequently than the single rapier.

Water-jet Loom

Water-soluble warp sizings are used on most staple warp yarns. Therefore, the use of water-jet looms is restricted to filament yarns, yarns that are nonabsorbent, and those that do not lose strength when wet. Furthermore, these fabrics come off the loom wet and must be dried. In this technique a water jet is shot under force and, with it, a filling yarn. The force of the water as it is propelled across the shed

FIGURE 16.9

(a) In the two-rapier type of shuttleless machine, one rapier carries the yarn to the center of the shed where a second rapier grasps the yarn and (b) carries it across the rest of the width of the fabric. Photographs courtesy of American Dornier Machinery Corporation.

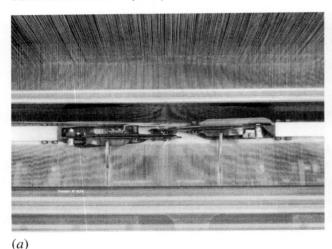

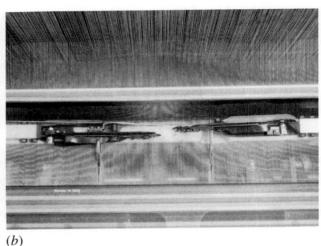

carries the yarn to the opposite side. This machine is economical in its operation.

A water jet of only 0.1 centimeter in diameter is sufficient to carry a yarn across a forty-eight-inch shed. The amount of water required for each filling yarn is less than 2.0 cubic centimeters.

Air-jet Loom

Air-jet looms operate in a manner similar to water-jet machines. Instead of projecting a stream of water across the shed, a jet of air is projected. The initial propulsive force is provided by a main nozzle. (See Figure 16.10.) Electronically

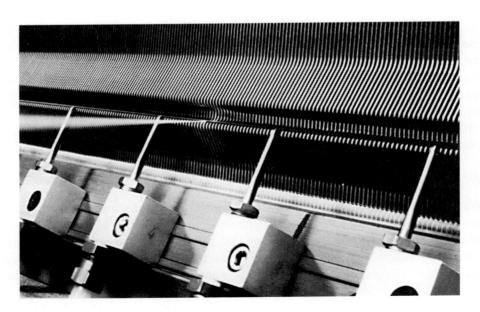

FIGURE 16.10

Air-jet nozzles spaced across the weaving machine transport filling yarns. Photograph courtesy of SulzerTextil.

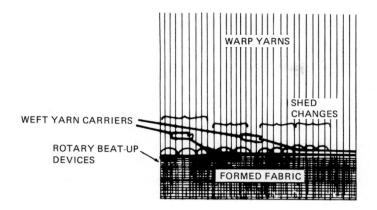

FIGURE 16.11

Multiphase loom continually inserts filling yarns from yarn carriers. Rotary beat-up devices press inserted yarn firmly against previously formed fabric.

controlled relay nozzles provide additional booster jets to carry the yarn across the shed. They can weave multicolored yarns to make plaids and are available with different patterning mechanisms.

Multiphase Loom

All the weaving techniques discussed thus far require that the shed be open all the way across the machine for the device carrying the filling yarns to pass through the shed. This imposes a limit on loom speed.

The multiphase machine overcomes this limitation by forming many different sheds at different places across the machine and forming these only as the filling yarn is inserted. In this way a number of filling yarns can be inserted, one behind the other. As a section of the shed opens, the filling passes, and the shed closes, opening again in the new pattern as the next filling yarn arrives. (See Figure 16.11.) If the weave pattern changes, small groups of yarns are changed into a new shedding position after each new yarn carrier has passed. Speed is increased because of the number of yarns that can be inserted almost simultaneously one right after the other, but the actual speed of movement of the filling yarns is lower than in other types of machines. For this reason, filling yarns that are weaker can be used.

Advantages of Shuttleless Weaving Machines

When patterned fabrics are woven on shuttleless weaving machines, colors can be changed more easily. Unlike shuttle looms, in which a different shuttle must be provided for each different color, the shuttleless machines can be provided with a variety of colors directly from yarn packages. Other advantages include lower power requirements, lower sound levels, smaller space requirements, and higher speeds of fabric production. (See Table 16.1.) Therefore, shuttleless weaving machines are replacing shuttle looms in many mills worldwide.

It should be noted that the higher production rates of shuttleless machines require that yarn quality be high to ensure trouble-free operation. In addition, shuttle looms can be more economical for short and specialty runs of fabric.

CONTROL OF LOOM MOTIONS

The essential motions in loom operation are the motion of the harnesses to form the shed and the activation of devices for carrying the filling through the shed.

Cam Loom

In the past the motions in most simple weaves were controlled by mechanical devices called *cams*. (See Figure 16.4.) The shape or profile of the cam is followed by a device called the cam follower, and the irregularities in the cam shape are translated by the cam follower into the motions of the loom, raising the harnesses for a particular weave. In this way simple repeat patterns can be created. Repeats are limited to six or fewer picks, but this includes a substantial majority of the most commonly used fabrics. More complex designs require dobby or jacquard looms. Such looms are rapidly being replaced by more modern machines with electronic control of motions.

Dobby Loom

The *dobby loom* is a conventional loom with a somewhat enlarged dobby "head." (See Figure 16.12.) The traditional dobby mechanism uses a pattern chain on which there are pegs. Needles, or feelers, contact the pegs in the pattern chain and are positioned by the pegs. The feelers cause hooks within the dobby head to be connected or disconnected, and the motion of the hooks is translated to the harnesses that move from up to down or to in-between positions as dictated by the pattern.

From twenty-four to thirty shedding combinations are controlled in this way, so the repeats are limited to about thirty rows in size. A machine called the double-

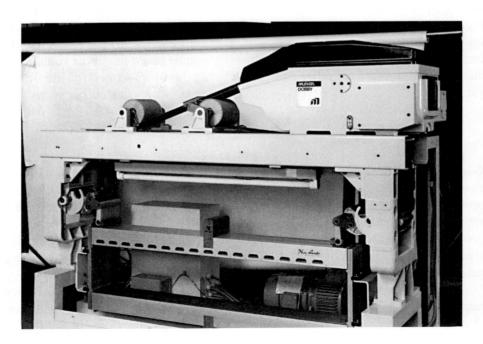

FIGURE 16.12

Electronically controlled dobby head that uses a memory card instead of a pattern card to control loom movements. Photograph of Murata MX-8E machine courtesy of Murata Machinery Ltd.

FIGURE 16.13

Dornier rapier weaving machine, Type HTVS 8/J, eight-jacquard type. Photograph courtesy of American Dornier Machinery Corporation. (b) Bonas U.S.A. electronically operated jacquard loom. Photograph courtesy of Bonas U.S.A., Inc.

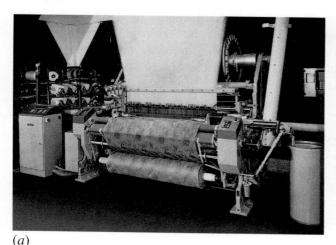

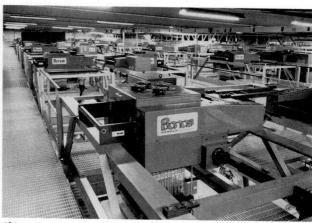

(b)

cylinder dobby loom approximately doubles the size of the repeat that can be made. The fabrics woven on this loom are less complex than are jacquard patterns and usually consist of small fancy or geometrical figures or designs. Plain terry cloth towels are also woven on dobby looms. With the development of electronic jacquard looms that can make both jacquard and dobby fabrics, dobby looms have become less important.

Jacquard Loom

The *jacquard loom* is the descendant of an oriental loom, the draw loom, which was used to weave complex patterned fabrics. Operation of the draw loom required two workers: the weaver, who threw the shuttle and operated the batten, and a *drawboy*, who raised and lowered a series of cords that controlled the pattern. The drawboy had to work from a platform above the loom while the weaver sat below.

Because the drawboy could make mistakes in the selection of cords, later modifications of the loom structure introduced a mechanical device for raising and lowering the cords. In 1805 Joseph Jacquard, a Frenchman, perfected the principle of the mechanical draw loom. To this day, this same type of loom for complex patterns is known as the jacquard loom and the weave is known as the *jacquard weave*. (See Figure 16.13a.)

The jacquard loom controls each warp yarn separately by threading it through a loop in the end of a leash or cord. Before the loom is set up, a design is worked out on graph paper or on a computer, and the position of each of the yarns in the design is analyzed. A punched card is prepared that corresponds to each of the filling yarns. The card contains a set of punched holes that will determine which warp yarns must be lifted for each passage of the filling. The punched cards are laced

together in the correct order for the design. As each card advances to the operating position, needles rest against the card. The needles are held under the pressure of a spring. When a needle position coincides with a hole in the card, the needle moves through the hole. The movement of the needle engages a hook, which in turn lifts the cords attached to the hook. The cords raise the yarns they hold to form the shed. When the filling has been inserted, the needles retract, the cards move to the next position, and different sets of needles engage holes in the next card. This, in turn, causes other warp yarns to be lifted to form a different shed. The process is analogous to the operation of the old player pianos, where holes in a metal cylinder raised and lowered the piano keys in the desired combinations.

Electronically operated jacquard machines require far less space than mechanically operated jacquards. (See Figure 16.13b.) Other advantages of electronic machines are increased speed of operation; the ability to change patterns with greater ease, which makes possible the production of short runs of fabric; and computer interfacing to rapidly translate design to production.

- Woven fabrics are made by interlacing lengthwise (warp) yarns with crosswise (filling) yarns
- Woven fabrics are made on looms, or weaving machines, which contain the following:
 - Method for tensioning yarns
 - Method for raising and lowering warp yarns (shedding)
 - Method for inserting filling yarns (picking)
 - Method for tightening filling yarns in structure (beating)
 - Method for rolling up finished fabric (taking up/letting off)
- Traditional looms use a shuttle to insert the filling yarns
- Shuttleless looms have different methods for inserting filling yarns
 - o Projectile, rapier, air jet, or water jet
 - Shuttleless looms are faster and can weave wider fabrics
- · Jacquard and dobby looms allow the production of more complex weaves

Questions

1. Define the following terms:

warp selvage filling bow fabric count skew

- 2. Describe the basic parts of a loom or weaving machine.
- 3. What are the steps in weaving?
- 4. Identify the various methods of transporting the filling yarns through the shed in shuttleless machines.
- 5. What are the advantages and disadvantages of shuttleless weaving as compared with weaving with a shuttle?
- 6. When would it be necessary to use a jacquard loom? A dobby loom?

References

Seyam, A. M. "Weaving Technology: Advances and Challenges II." *Journal of Textile and Apparel, Technology and Management* 3, no. 1 (2003): 1.

Recommended Readings

Broudy, E. The Book of Looms. New York: Van Nostrand Reinhold, 1979.

Chadwick, A. "Weaving." Textiles 16, no. 3 (1987): 63.

Ishida, T. "Historical Developments in Weaving Machinery, Part 3: Modern Weaving Machinery, Today and Tomorrow." *JTN The International Textile Magazine* 458 (January 1993): 108.

"Machinery Investment Upsurge Confirmed." Textile Month (August 1998): 6.

Marks, R., and A. T. C. Robinson. *Principles of Weaving*. Manchester, England: The Textile Institute, 1986.

Schwartz, P., T. Rhodes, and M. Mohamed. *Fabric Forming Systems*. Park Ridge, NJ: Noyes, 1982.

e in a transmitter and in the second of the proposed Association and the second of the second of

politica de la companya de la compa La companya de la companya dela companya de la companya dela companya de la companya del companya de la companya del companya

THE WEAVES

Learning Objectives

- 1. Recognize the patterns of the basic weaves.
- 2. Describe variations of the basic weaves.
- 3. Relate fabric names to structural characteristics.
- 4. Explain the effect of weave on fabric properties.

hree types of weave structure are woven on simple looms (ones with twelve or fewer harnesses) and also form the basis of even the most complex weaves. Known as basic weaves, these are the plain weave, the twill weave, and the satin weave. Woven fabrics, more so than other fabrics, are given names that summarize a number of structural features: weight, fiber type, yarn type, yarn count, fabric count, and color or pattern. Use of these common fabric names, such as denim, velvet, or batiste, efficiently conveys fabric properties of interest.

Diagrams of weaves in this chapter will follow the convention of black strips representing warp yarns and white strips representing filling yarns. Thus can the pattern of interlacing be clearly seen. Weaves can also be shown on graph paper, where each square of the paper represents the yarn that appears on the face of the fabric. Darkened squares show warp yarns crossing over filling yarns; white squares indicate filling yarns on the face.

BASIC WEAVES

Plain Weave

The plain weave is the simplest of the weaves and the most common. It consists of interlacing warp and filling yarns in a pattern of over one and under one. Imagine a small hand loom with the warp yarns held firmly in place. The filling yarn moves over the first warp yarn, under the second, over the third, under the fourth, and so on.

FIGURE 17.1

(a) Diagram of the plain weave. (b) Close-up photograph of cheesecloth, a plain weave fabric.

In the next row, the filling yarn goes under the first warp yarn, over the second, under the third, and so on. In the third row, the filling moves over the first warp, under the second, and so on, just as it did in the first row. (See Figure 17.1.)

The weave can be made with any type of yarn. Made with tightly twisted, single yarns that are placed close together both in the warp and filling, and with the same number of yarns in both directions, the resulting fabric will be a durable, simple, serviceable fabric. If, however, the warp were to be made from a single yarn and the filling from a colorful bouclé yarn, a quite different, much more decorative fabric would result. Both are the product of the same, basic, plain weave.

Plain-weave fabrics are constructed from many fibers and in weights ranging from light to heavy. Weaves may be balanced or unbalanced. Decorative effects can be achieved by using novelty yarns or yarns of different colors. Together with many of these novelty fabrics, a number of standard fabric types are made in the plain weave. In the past these standard fabrics were always constructed from specific fibers. At present suitable manufactured fibers are also woven into many of the standard fabric constructions.

Balanced Plain-weave Fabrics

The balanced weaves are the most common. Unbalanced weaves, or *rib weaves*, and another variation, *basket weaves*, will be discussed later. It is helpful to classify balanced plain weaves by weight as light, medium, or heavy.

Lightweight Plain-weave Fabrics. Lightweight plain-weave fabrics may be light in weight because they either have a low fabric count or are constructed of fine yarns and are usually sheer. The following low-fabric-count balanced plain weaves have somewhat specialized uses.

- 1. *Cheesecloth* is open-weave soft fabric originally used in producing cheese, serving as a wrapper or strainer for curds. (See Figure 17.1b.)
- 2. Crinoline and buckram are heavily sized to serve as stiffening fabrics.
- 3. *Gauze*, with a higher count than cheesecloth, is used in theatrical costumes and medical dressings, as well as for blouses and dresses.

The following are high-count balanced plain weaves with fine yarns.

- 1. *Chiffon* is made from fine, highly twisted filament yarns. Because of the tightly twisted crepe yarns, chiffon has excellent drape, and although it is delicate in appearance, it is relatively durable. Sheer evening dresses, blouses, lingerie, and other dressy apparel are constructed from the fabric.
- 2. *Organdy* is a sheer cotton fabric that is given a temporarily or permanently stiffened finish.
- 3. Organza is a stiff, sheer fabric made of filament yarns.
- 4. *Voile*, a soft fabric with somewhat lower fabric count and higher-twist yarns, has a distinctive two-ply warp and good drapability.

Medium-weight Plain-weave Fabrics. Medium-weight balanced plain weaves usually have fairly high fabric counts, contain medium-weight yarns (twelve to twenty-nine tex), and are opaque. Distinguishing characteristics may be design, color, finish, or fabric count.

- 1. Calico is a closely woven fabric with a small printed design.
- 2. *Chambray* fabrics have colored warp yarns and white filling yarns that produce a heather appearance. Some contemporary chambrays may have warp and filling yarns of different colors.
- 3. *Chintz* is a fabric printed with large designs that is often given a polished or glazed finish. Solid-color glazed fabrics are called *polished cotton*.
- 4. *Gingham* is a woven check or plaid design made with yarns of different colors.
- 5. *Muslin*, generally woven from cotton or cotton blends, can be sold as bleached or unbleached goods and is usually designated as such. Higher grades are used for sheets and pillow cases. Muslin sheets are made with yarns that are carded only and have a lower thread count (125 to 140 total yarns per inch) than do percale sheets.
- 6. *Percale*, a closely woven, plain weave of cotton or blended fibers, is made from yarns of moderate twist. Percale sheets, made with fine, combed yarns and thread counts ranging from two hundred to three hundred yarns per inch, have a more luxurious feel than do muslin sheets.

Heavyweight Plain-weave Fabrics. The following are common heavyweight plain-weave fabrics.

- 1. Butcher linen is a plain, stiff, white fabric made from heavy yarn.
- 2. Crash is made from thick and thin yarns, giving the fabric a nubby look.
- 3. *Homespun* is a furnishing fabric made with irregular yarns to resemble hand-spun and hand-woven fabrics.
- 4. *Osnaburg* is made of low-quality cotton for industrial use and in interior fabrics for curtains and upholstered furniture.

Rib Variations

Ribbed fabrics have an unbalanced weave with many small yarns crossing over fewer large yarns. Most unbalanced weaves have a larger number of warp yarns than filling yarns, forming a crosswise rib. Ribs can be relatively small or quite

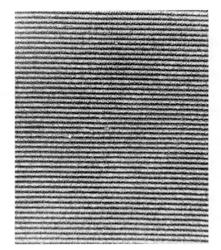

Figure 17.2
Faille fabric with pronounced crosswise rib.

pronounced. (See Figure 17.2.) *Corded fabrics* can be created by grouping yarns together in one direction before they are crossed by yarns in the other direction or by using large yarns at intervals. (See Figure 17.3.) The following are some standard rib-weave fabrics.

- 1. *Bengaline* and *ottoman*, heavyweight fabrics with large ribs, are used mostly in upholstery and other home furnishings.
- 2. *Broadcloth* is a medium-weight unbalanced plain weave with fine ribs. The rib weave makes it crisper than medium-weight balanced weaves. Often made from cotton or cotton blends, broadcloth is seen in shirts and blouses.
- 3. *Poplin* is a heavier-weight rib weave than broadcloth, usually made from cotton or cotton blends.

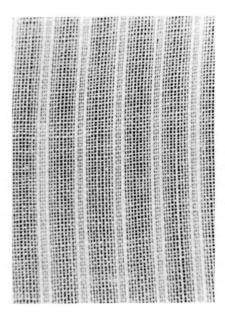

FIGURE 17.3

Dimity fabric with pronounced lengthwise cord.

- 4. *Faille* has a prominent rib and is made with fine filament yarns in the warp and heavy spun yarns in the filling. It is usually heavyweight, although lighter-weight *tissue failles* are also produced.
- 5. *Grosgrain* has very prominent ribs and is usually woven in narrow widths for ribbons.
- 6. *Shantung* has a nubby, irregular rib in the filling. Formerly made almost exclusively of silk, shantung is now made from a variety of manufactured fibers as well.
- 7. *Taffeta* is a medium-weight weave made from filament yarns that is often used for evening wear.
- 8. *Bedford cord* is a sturdy fabric constructed with a pronounced lengthwise cord.
- 9. *Dimity*, a sheer cotton fabric, is often made with a lengthwise cord effect. Some dimity fabrics use larger yarns in both the warp and filling directions to achieve a checked, or *barred*, effect.

Basket Weave

The basket weave, a variation of the plain weave, uses two or more warp and/or two or more filling yarns side by side as one yarn. (See Figure 17.4a.) The resultant cloth is fairly loose in weave. Basket weaves are not as durable as regular plain weaves because it is easier to pull the yarns out of the structure. At the same time, these fabrics are more flexible than other plain weaves because the interlaced structure is not as tight.

Basket weaves are usually designated by the number of yarns that are interlaced side by side. For example, a fabric with two warp yarns interlaced together over and under two filling yarns would be specified as a 2-2 basket weave. The warp and filling directions can have the same or different numbers of yarns in the interlacing pattern. The following are among the more common basket-weave fabrics:

1. *Monk's cloth* is a coarse cloth of large yarns. (See Figure 17.4b.) Monk's cloth uses four or more yarns as one in both directions in the weave. Its major uses are in household textiles such as curtains, spreads, and the like.

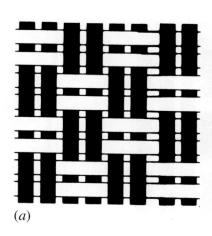

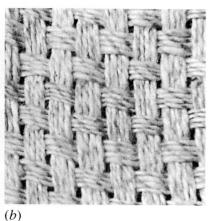

FIGURE 17.4

(a) Basket weave variation of the plain weave. (b) Monk's cloth, a basket weave fabric with four warp and four filling yarns.

- 2. *Hopsacking* is made of many different fibers. This fabric simulates the fabrics used in bags for gathering hops. It has a 2-2 or 3-3 basket weave and is commonly used in upholstery.
- 3. Oxford cloth is an uneven basket weave, with a 2-1 or 3-2 interlaced structure. It is a soft fabric, often made of cotton or cotton blends, that is used for shirts. Frequently, it is made with narrow, colored stripes in the warp or a colored warp.
- 4. *Duck* and *canvas* are heavy, tightly woven, and very stiff plain-weave fabrics made of even yarn for industrial use. They usually have an uneven weave pattern. Because of the tight weave, these fabrics are often used for outdoor purposes.

Twill Weave

Twill fabrics are readily identified by the diagonal lines that the weave creates on the surface of the fabric. Because there are fewer interlacings, the yarns in twill fabrics can be spaced closely together, packed tightly, and held firmly in place. Therefore, twill fabrics are usually strong and durable; they are also supple and drape well. Most twill-weave fabrics are made in bottom weight. The compact structure of twill fabrics enables them to shed soil readily, although when soiled, they may be difficult to get clean. Depending on their construction, twill fabrics generally show good resistance to abrasion. Twill fabrics are often used for tailored garments, particularly those made of worsted wool yarns.

The simplest twill weave is created by the warp yarn crossing over two filling yarns, then under one, over two, under one, and so on. In the next row, the sequence begins one yarn down. (See Figure 17.5.) The area in which one yarn crosses over several yarns in the opposite direction is called a *float*.

The lines created by this pattern are called *wales*. When the cloth is held in the position in which it was woven, the wales (diagonal lines) will be seen to run either from the lower-left corner to the upper-right corner or from the lower right to the upper left. If the diagonal runs from the lower left to the upper right, the twill is known as a *right-hand twill*. The majority of twill fabrics are right-hand twills. When the twill runs from the lower right to the upper left, the twill is known as a *left-hand twill*. (See Figure 17.6.)

There are a number of types of twill weaves. All use the same principle of crossing more than one yarn at a regular, even progression. Descriptions of twills

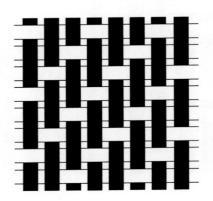

Figure 17.5
Right-hand, warp-faced twill weave.

FIGURE 17.6
Left-hand twill weave.

may be made in terms of the pattern of warp yarns crossing filling yarns. The weaves are notated as 2/1, 2/2, 3/2, and so on. The first digit refers to the number of filling yarns crossed over by the warp and the second digit to the number of filling yarns the warp passes under before returning to cross the filling again, or more simply, it is the sequence of warp up/warp down. When the crossing is over and under the same number of yarns, the fabric is called an *even* or *even-sided twill*. When warps pass over a larger or smaller number of filling yarns than they pass under, the fabric is called an *uneven twill*.

Even-sided Twill

The even-sided twill has the same number of warp and filling yarns showing on the face of the fabric. Figure 17.7 shows how such a weave is achieved in a 2/2 twill. Even-sided twills are reversible unless printed or finished on one side.

1. *Serge* is a basic twill fabric that was traditionally made of solid-colored worsted wool yarns and was often used for men's suits. It tailored well but tended to become shiny with wear.

FIGURE 17.7
Right-hand even-sided twill weave, 2/2.

FIGURE 17.8
Herringbone twill fabric.

- 2. *Surah* is an even-sided twill made with filament yarns. Silk surah, often printed, is used in scarves, ties, and blouses.
- 3. *Flannel*, if made of wool, is a twill weave with a brushed fuzzy finish. (See chapter 24.) Cotton flannels are also brushed but are not usually twill weaves.
- 4. Plaids or tartan patterns are yarn-dyed even-sided twills.
- 5. In a *herringbone twill*, the direction of the twill reverses itself to form a broken diagonal that appears like a series of *Vs*; herringbone patterns create a decorative effect. (See Figure 17.8.) Herringbone twills are common in suiting fabrics.

Warp-faced Twill

Warp-faced twills have a predominance of warp yarns on the surface of the fabric, with patterns of 2/1, 3/1, 3/2, and so on. (See Figure 17.9.)

1. *Denim* is a durable, heavyweight twill with colored warp yarns and white filling yarns. Because it is a warp-faced twill, the colored warp yarns are

Figure 17.9 Right-handed, warpfaced twill (2/1).

- predominant on the face and the white filling yarns on the back. Most often the warp yarns are indigo dyed, creating the fabric in "blue jeans."
- 2. Drill is another heavyweight fabric, usually of a solid color.
- 3. *Jean* is a lighter-weight twill, usually with colored warp yarns and white filling yarns.
- 4. *Gabardine* is durable and closely woven. It is made into a variety of weights from both natural and manufactured fibers and used in tailored garments, pants, and slacks.

Cotton and cotton-blend warp-faced twills are common for men's and women's casual pants.

Filling-faced Twill

Filling-faced twills have a predominance of filling yarns on the surface of the fabric. Filling yarns are generally weaker than are warp yarns, so relatively few filling-faced twills are made.

Twill Angle

When the face of a twill fabric is examined, the diagonal of the wales will be seen to move at a more or less steep angle. The steepness of the angle is dependent on two factors in the construction of the fabric: the number of warp yarns per inch of fabric and the number of steps between movement of yarns when they interlace.

The more warp yarns in the construction, the steeper the angle of the wales, provided that the number of filling yarns per inch remains the same. This is because the points of interlacing of the yarns will be closer together, and therefore, the diagonal of the wales will make a steep climb upward. When the steepness of the angle is the result of close spacing of warp yarns, these steeper angles are an indication of good strength. If the angle the wale makes with the filling yarn is about forty-five degrees, the fabric is a *regular twill*. Fabrics with higher angles are *steep twills*, and those with smaller angles are *reclining twills*.

Generally, the interlacing of yarns in a twill changes with each filling yarn. There are, however, fabrics in which the interlacing of yarns changes only every two filling yarns or every three filling yarns. The less often the interlacing changes, the steeper the angle of the twill will be.

Satin Weave

Satin-weave fabrics are made by allowing yarns to float over a number of yarns from the opposite direction. Interlacings are made at intervals such as over four, under one (using five harnesses); over seven, under one (eight harnesses); or over eleven, under one (twelve harnesses). Harnesses are also called shafts; hence, these satin fabrics may be called five-shaft satin, eight-shaft satin, or twelve-shaft satin. Floats in satin fabrics may cross from four to twelve yarns before interlacing with another yarn. No pronounced diagonal line is formed on the surface of the fabric because the points of intersection are spaced in such a way that no regular progression is formed from one yarn to that lying next to it.

FIGURE 17.10

Warp-faced satin weave. Warp yarns form floats, crossing over seven filling yarns between every interlacing.

When warp yarns form the floats on the face of the fabric, the fabric is a warp-faced satin. (See Figure 17.10.) When filling yarns float on the face, the fabric is a filling-faced satin. (See Figure 17.11.) Satin-weave fabrics made from filament yarns are called satins; those from spun yarns are sateen. Most warp-faced weaves have filament yarns because filament yarns do not require a tight twist to serve as warp yarns, whereas cotton, being a staple fiber, must be given a fairly high degree of twist if it is to serve as a strong warp yarn. Therefore, sateen fabrics are usually filling faced, although some warp sateens are made.

Satin-weave fabrics are highly decorative. They are usually made from filament yarns with high luster to produce a shiny, lustrous surface and tend to have high fabric counts. They are smooth and slippery in texture and tend to shed dirt easily. The long floats on the surface are, of course, subject to abrasion and snagging. The longer the float, the greater the likelihood of snags and pulls. Satins are often used as lining fabrics for coats and suits because they slide easily over other fabrics. The durability of satin-weave fabrics is related to the density of the weave, with closely woven, high-count fabrics having good durability. Satins made from stronger fibers are, of course, more durable than those made from weaker fibers.

The following are some names given to satin fabrics:

- 1. Antique satin, a satin made to imitate silk satin of an earlier period, often uses slubbed filling yarns for decorative effect. A variety of products are made with antique satin, including draperies, upholstery, and formal wear.
- 2. Peau de soie is a soft, closely woven satin with a flat, mellow luster.
- 3. *Slipper satin* is a strong, compact satin, heavy in weight. It is often used for evening shoes.

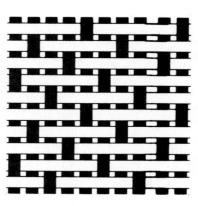

FIGURE 17.11

Filling-faced satin weave. Filling yarns form floats, crossing over four warp yarns between every interlacing. 4. In crepe-backed satin, loosely twisted, lustrous warp yarns are combined with tightly twisted, creped filling yarns. The floats on the surface are created by the warp, so the face of the fabric is chiefly made up of warp yarns with a satin appearance, whereas the back of the fabric is made up largely of tightly twisted filling yarns that produce a crepe or rougher surface texture with a flat, less shiny appearance.

Novelty Fabrics from Basic Weaves

Novelty effects in fabrics are in large part a result of selection of novelty yarns for incorporation into fabrics made in one of the basic weaves.

Crepe Fabrics

Crepe fabrics may be defined as fabrics characterized by a crinkled, pebbly surface. Originally, crepe fabrics were made from crepe yarns, that is, yarns with an exceptionally high degree of twist, up to sixty-five turns per inch. Most standard crepe fabrics were made in the plain weave, some with rib effects, and some in satin weave, as in crepe-backed satin. With the advent of synthetic fibers, however, many crepe effects are achieved through the use of textured yarns or embossing or stamping a crepelike texture on the surface of the fabric. Most fabrics made from these more recent processes will be durable only if they are made from heattreated thermoplastic fibers. Another common method uses a special crepe weave that breaks up the surface of the cloth into a random sequence of interlacings. (See Figure 17.12.) Also called momie or granite weaves, these fabrics are popular in many women's dress fabrics and in table linens.

FIGURE 17.12 Close-up photograph of crepe weave fabric made with crepe yarns.

Seersucker

Seersucker, another plain-weave fabric, is created by holding some warp yarns at tight tension, some at slack tension. When the filling yarns are beaten up, the wrap yarns under slack tension puff up to form a sort of "blister effect." Seersucker surface effects are permanent. Often the slack and tight yarns are each made from a different-colored yarn to provide a decorative, striped effect. Seersucker should not be confused with fabrics having puffed effects created by chemical finishes, such as *plissé* or *embossing*, which are much less durable.

Dobby Fabrics

Dobby weaves have small, repeated patterns that are usually geometric. (See Figure 17.13.) Weaving a design into a fabric is more expensive but also more durable than printing designs on the fabric. Following are some of the fabrics made on the dobby loom.

- 1. *Bird's-eye*, a cloth made with small, diamond-shaped figures, has a weave that is said to resemble the eye of a bird. Bird's-eye is also called *diaper cloth* because it was used extensively for this purpose before the advent of disposable diapers.
- 2. *Piqué* is a medium- to heavyweight fabric, often of cotton, with raised surface areas created by yarn floats on the back and/or stuffer yarns that provide a three-dimensional effect. (See figure CP4A on Color Plate 4.) Piqués are usually stiff fabrics used in vests, collars, cuffs, and lightweight women's jackets. They are often starched to enhance the stiff appearance.
- 3. White-on-white has a white dobby figure woven on a white background and is often used for men's shirting.

Jacquard Fabrics

The operation of the jacquard loom was described in chapter 16. Jacquard patterns, when carefully analyzed, may be seen to contain combinations of plain,

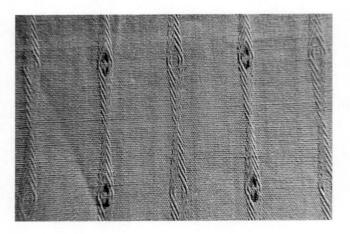

Figure 17.13
Fabric woven on dobby loom.

twill, and satin weaves, even in the same crosswise yarn. Many decorative fabrics are made by the jacquard technique. Jacquard-woven tapestry fabrics should not be confused with true tapestries (see below) even though some fashion promotions may refer to jacquard fabrics as "tapestry fabrics." (See figure CP3E on Color Plate 3.)

The following are some of the best-known jacquard patterns:

- 1. *Brocade* features an embossed or embroidered appearance. Elaborate patterns, often of flowers and figures, stand out from the background. Pattern and ground are usually different weaves. Brocades are made from a wide range of fibers and with a wide range of prices and qualities. Fabrics are used for upholstery, draperies, and evening and formal clothing.
- 2. *Brocatelle* is similar to brocade but with figures or patterns standing out in high relief. Brocatelle is used mostly for upholstery fabrics and draperies.
- 3. Damask is a flatter fabric than brocade and often has a fine weave. Patterns are created by alternating a satin weave with a background that is a plain or twill construction. Even if the damask is a solid color, the light reflection differences between the satin and other weaves will make the design evident. Damasks are reversible because a warp-faced satin on one side will appear as a filling-faced satin on the other side. Linen damasks have long been used for luxurious tablecloths. Longer floats in the satin weave are more lustrous, but the shorter floats are more durable as they are less likely to snag or be subject to abrasion. (See Figure 17.14.)
- 4. *Tapestrylike fabrics* have an appearance that simulates hand-woven tapestries. Used extensively in fabrics for interiors, these jacquard-woven fabrics have highly patterned designs on the face. Although the back is also figured, the colors within the design differ. For example, a leaf that appears on the face as green will be some other color on the back. (See Figure 17.15.)

FIGURE 17.14

Damask fabric woven on jacquard loom.

FIGURE 17.15

Tapestry-type fabric woven on a jacquard loom: (a) face; (b) back. Note that design is identical on face and back, but that the colors are reversed.

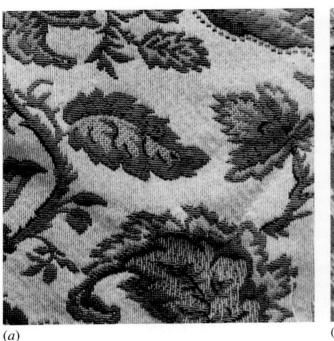

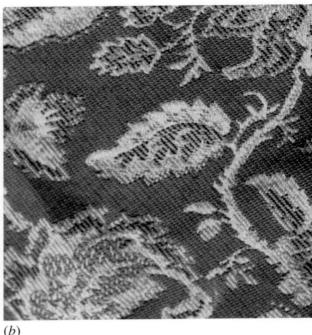

Hand-woven Tapestries

Tapestries woven by traditional methods differ from jacquard-woven fabrics having the appearance of a tapestry in that the traditionally woven tapestries are made using hand techniques. Jacquard-woven tapestry fabrics generally use repeated patterns of finite size. Traditional tapestry weaving is used to produce enormous fabrics that can form one large picture. Tapestry weaving may be compared to painting with yarn. Because it is basically a hand technique, tapestry is made on an elementary loom.

In the weaving of European tapestries, the loom followed the basic form of the two-bar loom. The loom was set up either vertically or horizontally, and warp yarns were measured and affixed to the loom. Filling yarns were prepared in the appropriate colors. The design of the tapestry was first worked out in a drawing, or *cartoon*, as it was called. The artist who created the drawing may have been one of great stature, and painters such as Raphael and Rubens served as designers of sixteenth- and seventeenth-century tapestries. The cartoon was sometimes traced onto the warp yarns. In other instances it was mounted behind the loom, and the tapestry weaver looked through the warp yarns to the design, following the plan of the drawing. The tapestry was woven with the wrong side facing the weaver. Sometimes a mirror was set up beneath the tapestry so the weaver could check the progress on the correct side.

The various colors of yarns were wound onto sharp, pointed bobbins that were introduced into the warp, and the weaver proceeded to fill in the area of that particular color. When the weaver reached the end of one color, a new bobbin was used for the next section. This created a problem because as the weaver worked back and forth in a particular segment of the design, the yarns of one color did not join with the yarns of the adjacent color. This produced slits in the fabric at the places where new colors began. Sections of the tapestry could be sewn shut, but this caused the fabric to be weaker at the spots where the fabric was seamed together. Two other methods were also used to prevent the formation of slits. Where the color of one section ended and another began, both the old and the new color could be twisted around the same warp yarns. This system worked well except that it created a slightly indistinct or shadowy line. Where clear, well-defined lines were required, the yarns of adjacent colors were fastened together by looping one yarn around the other.

In traditional tapestry weaving, all the warp yarns are completely covered by filling yarns, so it is the filling yarns that carry the design. The warp yarns serve only as the base.

Leno-weave Fabrics

The *leno weave* is the modern descendant of a technique called *twining* that was used thousands of years ago for making fabrics. In leno-weave fabrics, the warp yarns are paired. A special attachment—the *doup*, or *leno*, attachment—crosses or laps the paired warp yarns over each other, while the filling passes through the opening between the two warp yarns. (See Figure 17.16.)

Leno-weave fabrics are made in open, gauzelike constructions. The twined (not twisted) warp yarns prevent the filling yarns of these open fabrics from slipping. Curtain fabrics are often made with leno weave. Two of the more popular lenoweave fabrics are *marquisette* and *grenadine*. Fruit and potato sacks are usually very open leno weaves.

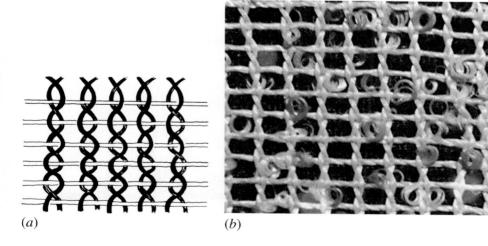

(a) Structure of a leno-weave fabric; (b) micrograph of a leno-weave fabric with bouclé yarns in the crosswise direction.

FIGURE 17.16

Woven Pile Fabrics

Pile fabrics have "cut or uncut loops which stand up densely on the surface" (Klapper 1967, 64). Pile fabrics may be created by weaving or through other construction techniques, such as tufting, knitting, or stitch through. To create the loops that appear on the surface of woven pile fabrics, the weaving process incorporates an extra set of yarns that form the pile. Construction of woven pile fabrics, therefore, represents a complex form of weaving in which there are at least three sets of yarns.

Woven pile fabrics are divided into two categories depending on whether the extra set of yarns is in the warp direction or the filling direction. Warp pile fabrics have two sets of warp yarns and one set of filling yarns. Filling pile fabrics have two sets of filling yarns. The weaving method used is dependent on which type of pile fabric is being made.

Pile fabrics are woven by one of several methods, depending on whether they are warp pile or filling pile fabrics.

Warp Pile Fabrics

Warp pile can be made by the wire method, the double-cloth method, or by slack tension weaving.

In the wire method, one set of warp yarns and the filling yarn interlace in the usual manner and form the "ground" fabric in either a plain or twill weave. The extra set of warp yarns forms the pile. When the pile yarns are raised by the heddles, the machine inserts a wire across the loom in the filling direction. When the warps are lowered, they loop over the wire to make a raised area. The next several filling yarns are inserted in the usual manner. The wire is then withdrawn, leaving the loop, which is held firmly in place by the other yarns. *Frieze*, a fabric often used for upholstery, is an example of an uncut, looped pile fabric that can be made by the wire method. If the fabric is to have a cut pile, the wire has a knife blade at the end that cuts the yarns as the wire is withdrawn. (See Figure 17.17.) If the fabric is to have an uncut pile, the wire has no cutting edge. A variety of decorative effects can be produced by controlling the wire insertion and cutting of the loops. (See Figure 17.18.)

Cut pile fabrics may also be made by the double-cloth method. Here, two sets of warps and two sets of fillings are woven simultaneously into a layer of fabric. A third set of warp yarns moves back and forth between the two layers of

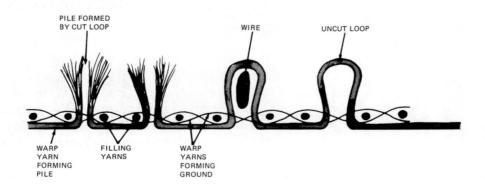

Figure 17.17

Construction of pile fabrics by the pile method.

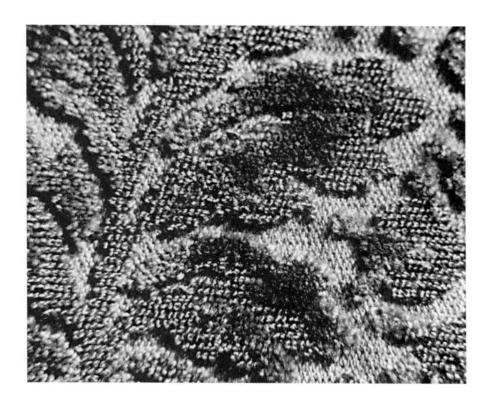

FIGURE 17.18

Velvet fabric in which figure is created by alternating section of cut pile (darker areas, which reflect more light) with uncut section's (the loops of which are visible in the photograph).

fabric, holding them together and being held by each fabric. The resultant fabric is cut apart as it leaves the loom by a sharp knife, thereby creating two lengths of fabric, each with a cut pile. (See Figure 17.19.) *Velvet* is usually made with the double-cloth method and is distinguished by having filament yarns. Other nonpile fabrics can be made by the double-cloth method and are discussed later.

Terry cloth, which has uncut loops, is made by another technique called *slack tension weaving*. Two sets of warps and one set of filling yarns are used; however,

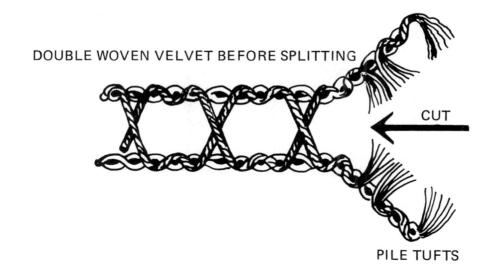

FIGURE 17.19

Drawing showing construction of pile fabric by the double-cloth method. Courtesy of the Crompton Company, Inc.

FIGURE 17.20
Terrycloth fabric. Ground is visible in the spaces between the uncut loops of the pile.

more expensive fabrics may use two sets of yarns in each direction. The ground of the fabric is of warp yarns held under tension, while the pile is of warp yarns that are allowed to relax. Periodically (usually after every three picks), tension is released on the warp pile yarns at the same time as the next three filling yarns are pushed firmly into place. The first two of each three picks are beaten up only partway. The loose warp yarns loop up on the surface to form the terry pile. Loops may remain uncut to form the traditional terry cloth with loops on both sides. (See Figure 17.20.)

Sometimes one side is sheared to make an attractive *velour* face. Such fabrics do not wear as well as uncut loop fabrics. Pile yarns in velour toweling tend to become dislodged more easily, thereby shortening the wear life of the material. Terry pile may appear on one or both sides of the fabric.

Filling Pile Fabrics

Filling pile fabrics are woven by the filling pile method. In this method there are two sets of filling yarns and one set of warp yarns. The extra set of filling yarns forms floats that are from four to six yarns in length. The floating yarns are cut at the center of the float, and these ends are brushed up on the surface of the fabric. (See Figure 17.21.)

In some filling pile constructions, the filling yarn that makes the pile is interlaced with the ground one time before it is cut; in others the filling pile interlaces twice. Those fabrics in which there are two interlacings are more durable than when only one interlacing has taken place.

309

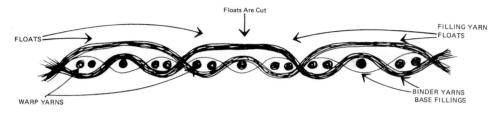

Cut Floats Form Pile

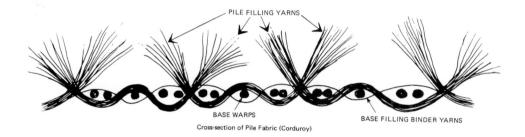

FIGURE 17.21

Construction of corduroy by the filling pile method.

Floats for *corduroy* are placed in lengthwise rows, and floats for *velveteen* are spaced to produce an overall pile effect. Velveteens are characterized by a uniform, overall pile. The even spacing of corduroy floats produces a strip or wale characteristic of this fabric. Corduroys are given names according to the numbers of wales. *Feathercord* corduroy has about twenty to twenty-five lengthwise wales per inch; *fine wale* or *pinwale* corduroy, about sixteen to twenty-three wales; *mid, medium,* or *regular wale* corduroy, about fourteen wales; *wide wale* corduroy, about six to ten wales; and *broad wale* corduroy, about three to five ribs per inch. Novelty wale corduroys are also produced in which thick and thin wales are arranged in varying patterns. (See Figure 17.22.) Some corduroy fabrics are now made with 100 percent cotton yarns in the pile filling and polyester and cotton blends in the ground yarns. Other decorative effects can be achieved by cutting floats selectively to vary pattern and texture. Most filling pile fabrics are made from spun yarns.

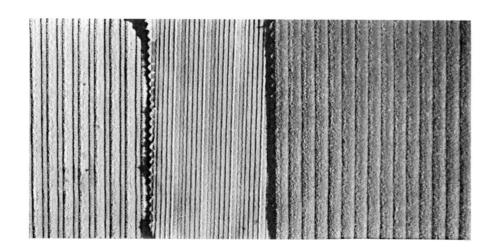

Figure 17.22

Corduroy fabric made with wales of three different widths and types.

Chenille

Chenille fabrics have a pile that is created by the use of chenille yarns. (See chapter 13.) The loose yarn ends that fluff up on the surface of the chenille yarn to form "caterpillars" create a soft, cut pile when woven into fabrics. The pile in this case is created not by the fabric structure, but by the characteristics of the yarn, which is itself a narrow strip of leno-woven fabric. Chenille fabrics may be woven or knitted.

DECORATIVE SURFACE EFFECTS

Woven Effects

Hand embroidery has been used for many centuries to add decoration to fabrics. With the development of automated looms came the ability to create ornamental effects similar to that of embroidery.

Clipped or Unclipped Spot Weave

Embroiderylike designs may be achieved through the use of extra warp and/or extra filling yarns. In the clipped spot weave, either an extra shuttle or an extra set of warp yarns interlace to create a simple woven design. The extra yarns are carried along as a float on the wrong side of the fabric when they do not appear in the design. After the cloth is completed, the long floats may be cut away (clipped) or left uncut (unclipped). If clipped, which is the most common practice, the yarns form a characteristic "eyelash" effect. Sometimes these fabrics are used inside out for design interest. (See Figure 17.23.)

The durability of the design depends on the closeness of the weave of the fabric into which it is woven. Some domestic *dotted swiss* fabric is constructed by the clipped spot weave. This sheer cotton fabric uses small clipped spot yarns in contrasting colors to create a dotted surface design (Figure 17.24a). Dotted swiss may also be made with flocking or with plastic dots, much cheaper options.

Swivel Weave

Similar fabrics can be made in the swivel weave, which is sometimes used in decorative fabrics for interiors. The design is made by supplying an extra filling yarn

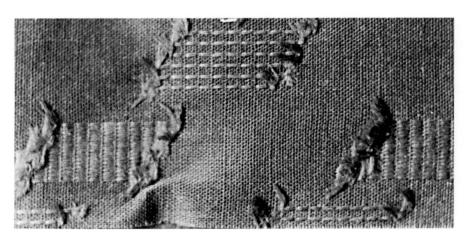

FIGURE 17.23
Clipped spot design.

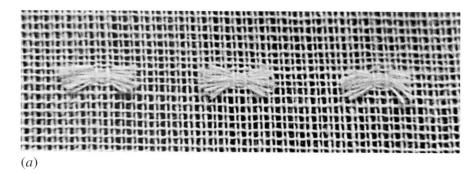

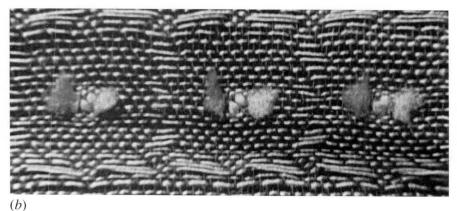

FIGURE 17.24

(a) Close-up of dotted swiss made by the clipped spot method. (b) Close-up of dotted swiss made by the swivel weave. Note that in (a) the extra yarns only interlace under one warp yarn, whereas in (b) the yarns wrap around the warp yarns.

on a small shuttle or swivel. The filling design yarns are carried several times around a group of warps by the motion of the swivel to prevent the yarn from pulling out of the background fabric. The long floats between designs are knotted and clipped off. Occasionally, imported dotted swiss fabrics may use a swivel weave rather than a clipped spot weave. The swivel weave is more durable than the clipped spot weave because the design yarns are woven in and cannot pull out of the fabric as easily as in the latter method. (See Figure 17.24b.)

Lappet Weave

Lappet weaves have an extra warp yarn that may interlace in both the warp and filling directions with the ground fabric. The extra set of warps is threaded through needles set in front of the reed. The yarns are carried in a zigzag direction, back and forth to form an embroiderylike design. The design is created on the right side of the fabric, the excess yarn being carried along on the wrong side. Extra yarn is not clipped away from the back of the fabric, but can be seen as it is carried from one design area to another. Imported Swiss braids often use the lappet weave, which is seldom found on merchandise sold in the United States.

Interwoven, or Double-cloth, Fabrics

Interwoven fabrics are also called double-cloth fabrics. They are made with three, four, or five sets of yarns.

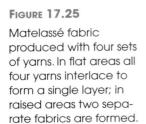

Double-faced fabrics are made with three sets of yarns. Woven either from two sets of warp yarns and one filling yarn or from two sets of filling yarns and one warp yarn, the effect of the weave is to produce the same appearance on both sides of the fabric. Some blankets and double-faced satins are examples of fabrics that are woven in this way. The fashionable cotton throws with scenes or logos are often double cloth.

Fabrics made with four sets of yarns use two sets of warp yarns and two sets of filling yarns. Yarns from both layers move back and forth from one layer to another, as required by the design. In some areas the two fabrics are totally separated; in others, all four sets of yarns are interwoven. *Matelassé* is one fabric made by this process. (See Figure 17.25.) The two layers of these fabrics cannot be separated without destroying the fabric. The cut edge of the fabric will show small "pockets" where fabric layers are separate. The pocket boundaries are the point at which yarn sets interchange from one side of the fabric to the other.

Fabrics with five sets of yarns are produced in the same way as double-woven pile fabrics. Two separate fabric layers are constructed. Extra yarns travel back and forth between the two layers to hold them together. These fabrics are often reversible, with one side being of one color and one side of another color. If the connecting yarn is cut, the two segments of the fabric can be separated into two individual pieces of cloth. (See Figure 17.26.)

Double-woven fabric made with five sets of yarns. Each side of the fabric is a different color, and at the lower right corner the two layers have been pulled apart and the yarns that hold them together can be seen.

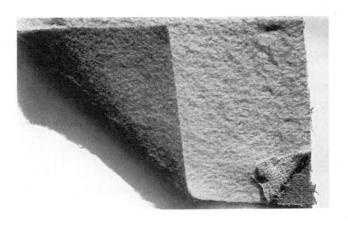

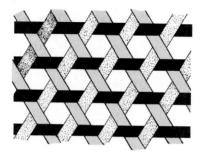

FIGURE 17.27
Triaxial fabric structure.

n Fabrics

of constructing fabrics that is closely related to traditional weaving is *triaxial weaving*. The term is derived from *tri*-, meaning "three," and *axial*, meaning "of or pertaining to the axis or center line." In other words, triaxial fabrics have three axes or center lines. (See Figure 17.27.) Traditionally, woven fabrics have a biaxial form, or two axes, the lengthwise and crosswise axes. Triaxial fabrics are usually woven by interlacing two sets of lengthwise yarns with one set of crosswise yarns. Special cams in the loom manipulate the yarns so the double set of yarns is carried in a diagonal direction. All three sets of yarns interlace.

Triaxial weaves are not entirely new. Snowshoes and some forms of basket-work sometimes have been made using a triaxial construction. The major advantage of triaxial weaving is in its stability against stretching not only in the length and crosswise directions, but also in the bias. Even those biaxial fabrics with good stability in the warp and filling will stretch in the bias direction. Triaxially woven fabrics have high bursting strength resistance and strong resistance to tearing and raveling. Strength is uniform in all directions.

EFFECTS OF WOVEN STRUCTURE ON FABRIC PERFORMANCE

Durability Factors

The contributions to strength of fibers and yarns have been discussed in chapters 3 and 13. Fabric structure also plays a critical role. Two of the most important fabric variables affecting strength of woven fabrics are weave and fabric count. The more interlacings in a fabric, the higher the fabric count. Fabric weaves with a high number of interlacings, such as plain weaves, can transfer and thereby share the tensile stresses at the intersection points. As a result, if fibers and yarns of comparable strength are used, plain weaves tend to have higher breaking strengths than fabrics with fewer intersection points, such as satin weaves. On the other hand, tearing strengths of fabrics with many interlacings may be reduced. In tightly woven plain weaves, the yarns are bound in position and are unable to move to group together to share the stress imposed in tearing. They, therefore, exhibit a lower tearing strength than twills, oxfords, or satins, all of which have fewer lacing points.

The effect of weave can be altered by changing the fabric count of a woven fabric. A plain-weave fabric with an extremely low fabric count, such as cheese-cloth, has a low breaking strength but a high tearing strength. The breaking strength is low because there are few yarns to share the load applied. The yarns in this structure, however, can slide around easily and group together to share the load during tearing. Try to tear a piece of cheesecloth, and the strength of this type of structure becomes apparent.

Yarns and fabric structure work together in determining elongation and recovery of textile fabrics. Crimp added to yarns, as in textured yarns, and the natural crimp created in all fabrics when yarns interlace are also related to extensibility. When warp and filling yarns cross each other, they cannot continue to move in an absolutely straight line, but each set of yarns must bend over and under yarns in the other set. Each yarn, therefore, develops a wavy configuration. (See Figure 17.28.) As the fabric is stretched, the crimp in the direction of the stretch is removed, permitting the fabric structure to reach its maximum extensibility. The greater the yarn crimp, the more extensible the fabric. Because warp yarns are under more tension during weaving, there is usually more crimp, and greater extensibility, in the filling direction. In unbalanced weaves, however, where there are many warp yarns interlacing with fewer filling yarns, the warp yarns will have more crimp.

In woven fabric construction, the aspect of crimp distribution seems to be particularly important in durability. The crown—the part of the yarn that protrudes above the surface of the fabric—receives the pressure of abrasion. The more crowns of the same height there are in a given area of cloth, the more evenly the wear will be distributed over the surface of the fabric. Prominently ribbed fabrics, such as faille or grosgrain, tend to abrade easily because the crowns of the warp yarns are so exposed. Interrelationships of construction and yarn structure may be observed in a fabric such as shantung, in which uneven, loosely twisted slubbed yarns present higher crowns that are unevenly spaced; this is an example of a fabric that has poor abrasion resistance.

Weave also enters into abrasion resistance. In fabrics with floats, yarns and fibers are freer to move to absorb energy and are less consistently exposed to abradants. For this reason, twills and some tightly woven satin fabrics show superior abrasion resistance.

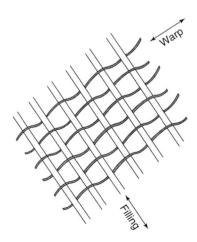

FIGURE 17.28

As warp and filling yarns pass over and under each other, they develop crimp. Smaller warp yarns (black) develop greater crimp as they pass over larger filling yarns (white).

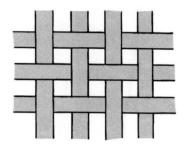

A. NORMAL STATE

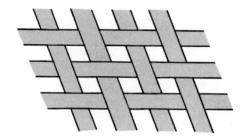

B. SHEARED

D. HIGH SHEARABILITY

Shear deformation is the movement of yarns from a normal position (a) where yarns run at right angles to each other, to (b) where interlacing is deformed to less than a ninety degree angle. Fabrics with low shearability (c) are not as soft and drapable as fabrics with high shearability (d).

C. LOW SHEARABILITY

Appearance

Drape, or the ability of fabric to form pleasing folds, is related to bending and shearing behavior, which are in turn affected by yarn and fabric properties. Shearing is the deformation of a structure in which a rectangle becomes lozenge shaped. In woven fabrics this results from movement of yarns from what one might call a normal position, in which they run horizontally and vertically and interlace at right angles, to other positions, in which the interlacing is deformed away from the ninety degree angle. (See Figure 17.29.) Yarn and fabric structures that allow movement at the yarn intersections increase shearing. Woven fabrics with smooth yarns, low fabric counts, and higher crimp exhibit lower resistance to shearing.

Fabrics that shear easily are softer and more drapable. To illustrate this principle, think about cutting a half-circle skirt from a fabric. Parts of the garment will lie along the true grain, but other parts will lie along other directions, including the bias. In the bias direction, fabric is particularly subject to shear deformation.

If the fabric is unable to shear, it remains stiff and will not mold or drape softly. In general, because of the ways in which yarns are combined, woven fabrics shear more easily than other fabric structures.

To form the graceful folds desirable in draping, fabrics also must have low resistance to bending. Lower fabric counts and fine yarns with flexible fibers give fabrics the ability to bend easily and contribute to draping. Fabrics such as satins that have long floats in the weave are more flexible, bending more easily and improving draping qualities.

FIGURE 17.30

Cotton cheesecloth
(left) and cotton print
cloth (right) after
wrinkling.

In general, woven fabrics with few interlacings wrinkle less than do other fabrics. This is because loosely constructed fabrics allow movement of yarns and fibers within the structure. It follows, then, that plain weaves wrinkle more than twill or satin weaves, and fabrics with higher fabric counts also wrinkle more. Cheesecloth, with an extremely low fabric count, does not wrinkle as much as higher-count plain weaves. (See Figure 17.30.)

Dimensional stability problems are often related to unreleased stresses introduced during fabric manufacturing. Fabrics, and the yarns in them, must be kept under tension during weaving. As a result they may be stretched beyond their natural dimensions. Later, when the fabric is subjected to moisture, or heat in the case of thermoplastic fibers, the stresses within the fibers, yarns, and fabrics are relieved, and the whole fabric relaxes. Fabrics containing moisture-absorbent fibers will shrink more in laundering because the fibers absorb a significant amount of water and swell. (See chapter 24, page 448 for a discussion of relaxation shrinkage.)

Shrinkage can also be affected by fabric count in woven fabrics. Generally, if there is room in the structure for the yarns to swell without moving closer together, then the fabric will be more dimensionally stable. If there is not much room between the yarns, they move closer together when the fibers swell. Therefore, fabrics with higher fabric counts will shrink more until they reach the point where they are forced together into a "jammed" construction and can no longer move.

Optical covering power is also influenced by weaves. An open-construction fabric will obviously cover less well than a densely constructed fabric. Sheer fabrics are often desired and can be achieved by fine yarns and/or low fabric counts. Differences in covering power can be seen among the three woven fabrics in Figure 17.31. Fabric crimp is also related to covering power in woven fabrics. As yarns in one direction cross and exert pressure on the yarns in the opposite direction, these yarns may be flattened somewhat. Flatter yarns provide better cover.

Comfort Factors

Fabric construction plays an important role in regulating temperature and moisture around the body. Pile or napped constructions are especially good for cold weather

FIGURE 17.31

Effects of fabric construction and cover factor on air permeability. Fabric (a) has the highest permeability and highest cover factor. Micrographs by Helen H. Epps, reprinted by permission of the International Textiles and Apparel Association.

because the yarns or fibers perpendicular to the surface provide numerous small spaces for the dead air that increases insulation. This effect is maximized if such fabrics are worn with the napped or pile surface next to the body or if they are covered with another layer.

Moisture vapor transmission and water repellency affect comfort. Most fibers are not naturally water repellent but must be given special treatments to render them so. Dense cotton fabrics, by contrast, may provide water repellency through both fabric structure and fiber properties. The hydrophilic cotton fibers swell on exposure to water, jamming the construction and forming a barrier to keep out water.

In a hot climate, thin, porous fabrics allow higher air permeability, so fabrics with high fabric counts are not as comfortable. To make garments that are warm enough for sports such as skiing in which moving air may cool the athlete, a fabric with low air permeability (such as closely woven nylon) may be combined with materials of low thermal conductivity (such as a polyester or acrylic fiberfill or a pile fabric) that trap air close to the body.

In these and other products, fiber, yarn, and fabric structure can be seen to work together to create the desired effect.

Putting it all together for ...

Upholstery Fabrics

Appearance is often the single most influential factor in selection of upholstery fabric. In selecting the appropriate fabric, the purchaser must assess the uses to which the furniture will be put. A sofa for a family room where food and beverages will be served, where children will drag toys across the surface, and where cats and dogs will jump up and down must meet far different demands than a period

reproduction chair in a formal living room that is rarely used. Careful evaluation of the expected functions and how fiber, yarn, and fabric construction fulfill those functions can result in selecting upholstery fabrics that will satisfy the buyer's needs and expectations.

Reflecting on the range of uses for upholstered furniture, the most important considerations in evaluating the durability of upholstery fabrics are its resistance to abrasion, resistance to soil and stains, and colorfastness to light.

Abrasion Resistance

Upholstered furniture is constantly subjected to abrasion as people sit on it. Some fibers have better abrasion resistance than others. In fabric structures where one set of yarns is predominant on the surface, the abrasion resistance of the fibers in that yarn would be a very important factor in durability. Cotton and rayon are not abrasion resistant, whereas polyester and nylon are. In many upholstery fabrics, however, yarn and fabric construction may compensate for lower fiber strength.

Yarns with high twist and even diameter resist abrasion better than those with low twist and/or uneven diameter. Yarns with loops, knots, or slubs, often used because of their attractive texture, are especially subject to abrasive wear. Heavier yarns result in thicker fabrics that are more abrasion resistant.

In closely woven fabrics with balanced weaves, wear is evenly distributed across the surface of the fabric. If fibers are strong and yarns have high twist and uniform diameter, these fabrics can be very durable. In plain-weave fabrics with large ribs or cords, the raised rib or cord area has the potential for uneven wear.

Twill-woven fabric structures are generally strong and durable and resist abrasion. In satin-weave fabrics, the long floats may catch or snag. Furthermore, to capitalize on the attractive appearance of satin-weave fabrics, manufacturers often use acetate, silk, or nylon fibers in low-twist yarns that are not very durable.

In pile fabrics such as velvet or velveteen, abrasion resistance depends on fiber choice and density of pile. Nylon velvet, for example, can be quite durable thanks to its excellent abrasion resistance and good resilience, whereas silk or rayon pile fabrics are more likely not only to abrade, but also to remain flat and worn looking after the pile has been flattened by sitting on it. Uncut pile fabrics tend to wear better, especially if yarns are tightly twisted and made from abrasion-resistant fibers.

Dobby and jacquard woven fabrics are frequently used in upholstery. Their resistance to abrasion is variable. Factors to assess include fiber content, tightness of twist of the yarns, presence of long floats or raised areas that may catch or wear unevenly, and denseness of the weave.

Soil and Stain Resistance

Most stains on upholstered furniture are water borne or liquid borne. Hydrophobic fibers such as polypropylene, which is almost completely nonabsorbent, resist staining best. It is important to note, however, that even though the upholstery fabric may not absorb moisture, the padding materials underneath may. A moisture-proof

barrier between the upholstery fabric and the padding materials can minimize the transport of liquids through to the padding. When present, this barrier is often a non-woven layer of nonabsorbent material such as polypropylene. Upholstery fabrics made from fibers that do absorb moisture can have stain-resistant finishes applied to them. (See chapter 25.)

Colorfastness to Light

Upholstery on furnishings that are placed close to windows may undergo color loss or color change after long exposure to sunlight. A textile fabric that retains its color under such exposure is said to be *colorfast*. Information about colorfastness is generally not available to consumers at the point of purchase. Those designing and developing upholstery fabrics, however, are able to specify levels of colorfastness in the materials being considered. Chapter 22 describes how colorfastness is assessed and how this information is used in product development.

SUMMARY POINTS

- · Three basic weaves are plain, twill, and satin
- Fabric names often specify type of weave as well as other structural features
- · Plain weaves
 - May be balanced or unbalanced depending on differences in warp and filling counts
 - Basket weaves have two or more yarns following the same interlacing pattern
- · Twill weaves
 - Show a diagonal weave pattern
 - May be even sided (reversible) or warp faced
- · Satin weaves
 - Yarns float over several other yarns before interlacing
 - May be warp faced or filling faced
- Variations of basic weaves
 - Dobby weaves have small, decorative woven patterns
 - Jacquard weaves have large, decorative woven patterns
 - Pile fabrics have an extra set of yarns that form a pile perpendicular to the fabric plane
 - Warp pile fabrics have an extra set of warp yarns
 - Filling pile fabrics have an extra set of filling yarns
 - Double cloths have three, four, or five sets of yarns interwoven
 - Triaxial weaves have two lengthwise yarns diagonally placed and one set of filling yarns
- Type of weave, fabric count, and yarn crimp affect fabric durability
- Appearance factors affected by weave are drape, shrinkage, and surface properties
- Fabric thickness and density determine comfort

Questions

1. Explain the differences among a plain weave, basket weave, twill weave, satin weave, jacquard weave, and leno weave.

2. List the distinctive features of each of the following fabrics:

broadcloth oxford cloth sateen corduroy gabardine damask voile chambray velvet satin

- 2. Describe the different methods by which pile fabrics can be made.
- Explain what is meant by each of the following: clipped spot weave, swivel
 weave, lappet weave, double-cloth fabric, triaxial weave. Give one example
 of some type of product in which fabrics made with these weaves might be
 used.
- 4. Analyze the probable contributions of fiber, yarn, and weave to the durability, appearance, and comfort of the following products:
 - a. A pair of twill weave, denim blue jeans made of 95 percent cotton and 5 percent spandex. Yarns used have a moderately high twist, and the cotton has been combed. The fabric has a high fabric count.
 - b. A gauze-type fabric blouse for summer made of fine, 100 percent linen yarn.

References

Klapper, M. Fabric Almanac. New York: Fairchild, 1967.

Recommended Readings

Emery, I. *The Primary Structure of Fabrics*. Washington, D.C.: The Textile Museum, 1966.

Mueller, C., and O. Bissmann. "Letters, Figures, Interweaving: An Easy Task." *Textile World* 143 (November 1993): 61.

Sondhelm, W. S. "Technical Fabric Structures—1. Woven Fabrics." In *Handbook of Technical Textiles*, edited by A. R. Horrocks and S. C. Anand, 62. Cambridge, UK: Woodhead Publishing, 2000.

KNITTED FABRICS

Learning Objectives

- 1. Describe the knitting process.
- 2. Distinguish between weft and warp knits.
- 3. Describe variations of the two types of knits.
- 4. Relate knit fabric structures to fabric properties.

ew segments of the textile industry have grown so rapidly in recent years as has the knitting industry. Advances in knitting production techniques along with the use of synthetic fabrics, such as acrylics and polyesters, for knit goods have led to the manufacture of knitted items, including such diverse products as blankets, bed-spreads, carpeting, wall coverings, upholstery, shipping sacks, and paint rollers. The desire of consumers for comfort and casual wear has made knits a staple in the apparel market.

The knitting industry may be divided into four branches: knitted fabric, knitted outerwear, knitted hosiery, and knitted underwear and nightwear. Knitted fabric mills produce a wide variety of fabrics in either flat or circular form that can be cut and sewn into apparel and other items. Those mills that produce outerwear, hosiery, underwear, or nightwear may knit the item directly or may knit sections of a garment (such as sleeves, body sections, and the like) that are sewn, or cut and sewn, together. These mills complete the garment from knitting right through to assembly in the same mill.

BASIC CONCEPTS

Knitted fabrics are formed by interlocking loops of yarns. The interlocking of these loops can be done by either vertical or horizontal movement. When the yarns are introduced in a crosswise direction, at right angles to the direction of growth of

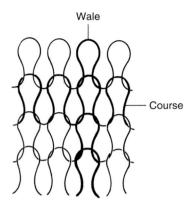

FIGURE 18.1

Courses and wales in knitted fabric.

the fabric, and run or interlock across the fabric, the knit is known as a *weft knit*. (Some sources may refer to these knits as *filling knits*, but the term *weft knit* is used in the knitting industry.) When the yarns run lengthwise or up and down, the knit is known as a *warp knit*.

In knitting terminology, the rows of stitches that run in columns along the lengthwise direction of the fabric are known as *wales*. This corresponds to the warp direction of woven fabrics. Crosswise rows of stitches or loops are called *courses*. The direction of the courses corresponds to the filling of woven goods. (See Figure 18.1.) The number of courses and wales in a knitted fabric can be counted with the pick glass (described in chapter 16) and reported for fabric specifications.

Weft knits may be hand or machine made, and indeed hand knitting is still a craft of interest. Warp knits can be produced by machine only. Knitting machines may be either flat or circular. The flat-type knitting machine has needles arranged in one or two straight lines and held on a flat needlebed. (See Figure 18.2a.) The cloth is made by forming stitches on these needles. The resulting fabric is flat. Machines with flatbeds are used to make both warp and weft knits.

The circular knitting machine has needles arranged in a circle on a rotating cylinder. (See Figure 18.2b.) The resulting fabric is formed into a tube. Circular knitting machines produce weft knits almost exclusively.

Loop Formation

Loops are formed in machine knitting by hooked "needles." The *latch* needle, with a crook top and a latch that opens and closes is the most commonly used. The steps in formation of loops with the latch needle are shown in Figure 18.3 and described below:

- 1. The old loop is held on the stem of the needle. The latch is open (a).
- 2. The hook grasps the yarn to begin forming a new loop (b).
- 3. The needle falls, the old loop rises, closing the latch of the needle (c).
- 4. The old loop is cast off (d and e).
- 5. The needle rises, and the new loop slides down to the stem of the needle, pushing the latch open again, and the needle is ready to repeat the cycle (f).

FIGURE 18.2

Electronically controlled weft knitting machines. (a) Flat machine. Courtesy of H. Stoll GmbH & Co. (b) Circular machine, model Monarch F-LPJ/3A, 72 feed 37 step. Courtesy of Monarch Knitted Machine Company, photographed at Alandale Knitting Co., In., Troy, NC.

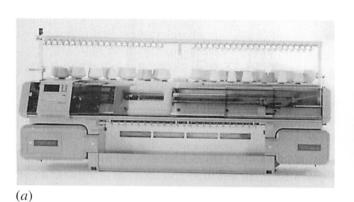

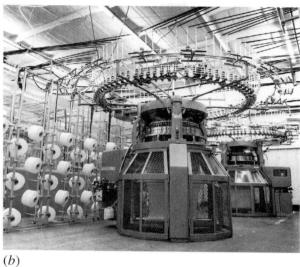

FIGURE 18.3

Formation of a loop by a latch needle.

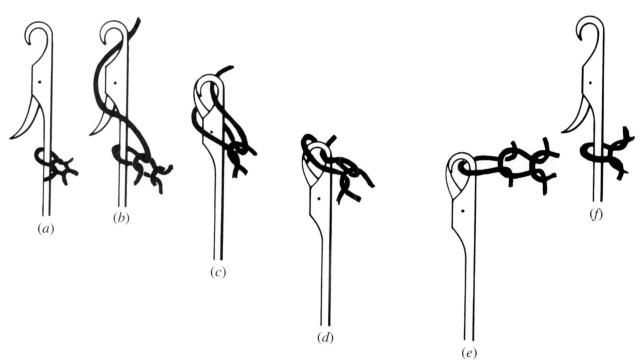

Figure 18.4

Tongue (a) of compound needle moves into position against the hook (b) in order to close the needle.

Another type of needle, the compound needle, is used almost exclusively for warp knitting. The compound needle has two components: a hook and a tongue. (See Figure 18.4.) During loop formation, the hook and tongues move up and down, but at different speeds, with the tongue performing essentially the same function as the latch in the latch needle. The steps in forming loops with compound needles are described later in the discussion of warp knitting.

The needles in knitting machines are held in a needlebed, or needle bar. Cam systems provide the action for lifting the needles as the yarn is fed in. The engaging by the needle of a new piece of yarn is called *feeding*. Devices called feeders are located to introduce the yarn to the needles. The number of feeders can vary, but obviously the more feeders a machine has, the higher will be the speed of fabric forming on the machine because each needle produces a loop each time it is activated, and if many needles are activated more frequently, many courses can be formed at the same time.

Another important element of some knitting machines is the sinker. The already formed fabric may need to be controlled as the subsequent knitting action takes place. A thin steel device called the sinker may be used to hold the fabric as the needle rises, support the fabric as the needle descends, and push the fabric away from the needle after the new loop has been formed. Sinkers are generally mounted between the needles. (See Figure 18.5.) Some machines, however, do not use sinkers but instead use the tensions placed on the completed fabrics for control.

Gauge and Quality

The size of the needle and the spacing of the needles on knitting machines determine the number and size of the knit stitches and their closeness. Each wale is

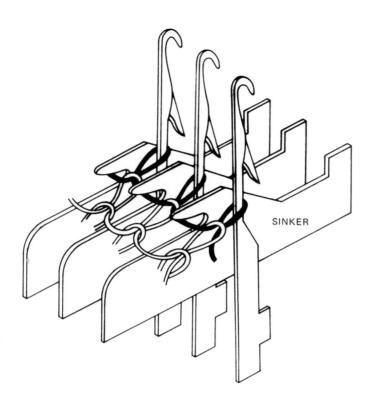

Figure 18.5
Sinkers used for weft knits, with latch needles in position ready for formation of new loop.

formed on one needle. The number of needles is equal to the number of wales. The closeness of the stitches determines whether a knit fabric will be light weight and open or heavier and denser. The term *gauge* is used to describe the closeness of knit stitches. Gauge is the number of needles in a measured space on the knitting machine. Higher-gauge fabrics (those with more stitches) are made with finer needles; lower-gauge fabrics are made with coarser or larger needles.

The term *cut* is also used to designate the number of needles per inch in the needlebed of a circular weft-knitting machine. To describe the stitch density of a single- or double-knit fabric, the fabric may be designated as an eighteen-, twenty-, twenty-two-, or twenty-four-cut fabric. The higher the cut, the closer the stitches; the lower the cut, the coarser the fabric.

Varying types of knitting machines measure gauge over different distances on the machine. For example, circular knit hosiery measures the number of needles in 1.0 inch, full-fashioned knitting in 1.5 inches, and Raschel knits in 2.0 inches. Because of these differences, it is best to keep in mind the generalized principle that the higher the gauge, the closer the stitches.

The quality of needles used in manufacturing knit goods is related directly to the quality of the fabric produced. Needles of uneven size and quality will produce knit fabrics with uneven-sized stitches and imperfect surface appearance.

In warp knits, those knits in which the yarns interlace in the long direction, one or more yarns are allotted to each needle on the machine, and those yarns follow the long direction of the fabric. For weft knits, those in which the yarns

interlace crosswise or horizontally, one or more yarns are used for each course, and these yarns move across the fabric. In weft knits, one yarn may have from twenty to several hundred needles associated with it. To summarize, weft knits can be made with one yarn, but warp knits must have a whole set of warp yarns, that is, one or more for each needle.

Once the basic distinction between warp and weft knits has been made, further subdivisions of knit classifications are usually based on the types of machines used in their production. The majority of knit fabrics are named after the machines on which they are constructed. For this reason, the discussion of knitted fabrics that follows is organized around the types of machines used in manufacturing knit fabrics and the types of knit fabrics made on these machines.

WEFT KNITS

The most important difference among weft-knitting machines is the number of needlebeds and the number of sets of needles used. On these bases, weft knits are divided among those made on each of these machines:

- 1. Flat- or circular-jersey, or single-knit, machine: one needlebed and one set of needles.
- 2. Flat- or circular-rib machine: two needlebeds and two sets of needles.
- 3. Flat- or circular-purl, or links-links, machine: two needlebeds and one set of needles.

Jersey, or Single, Knits

Machines with one needlebed and one set of needles are called jersey machines or single-knit machines. With one set of needles and one needlebed, all needles face the same direction; all stitches are pulled to the same side of the fabric. As a result, jersey fabrics have a smooth face with wales prominent on the fabric face and courses prominent on the back side. The loops formed by the jersey machine are formed in one direction only, which gives a different appearance to each side of the fabric. (See Figure 18.6.) The basic fabric produced by this machine is known alternately as a *plain*, *single*, or *jersey knit*; the terms are interchangeable.

Jersey stretches slightly more in the crosswise than the lengthwise direction. If one stitch breaks, the fabric may ladder, or *run*. Jersey fabrics tend to curl at the edges and are less stable than are some other types of knits. This is the result of the pressures exerted during knitting. In addition, jersey knits may twist or skew after laundering as the twisting tensions imposed during the knitting process are relaxed. Special finishes, such as starches or resins, are used to overcome these tendencies and maintain fabric stability.

A great many items of hosiery, sweaters, and other wearing apparel are made from plain jersey knits. The Take a Closer Look box in this chapter highlights one of the common uses of jersey-knit fabrics: T-shirts. Plain-knit fabrics can also be made into designs of two or more colors by use of a patterning mechanism that controls the selection and feeding of yarns and types of stitches to create jacquard knits.

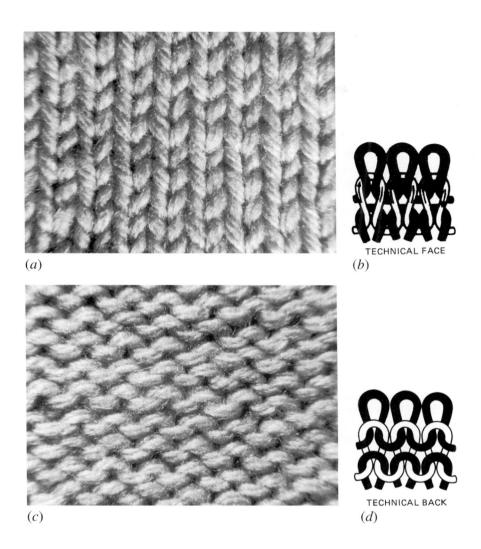

Figure 18.6

Plain or jersey knit stitch.

Diagrams courtesy
of the National

Knitwear Manufacturers

Association.

The yarns forming the design on the fabric face float over other stitches on the back of the fabric. (See Figure 18.7 and figure CP3A, and CP3B on Color Plate 3.)

High-pile Fabrics

High-pile fabrics, such as imitation furs and plushes, are usually knitted by a jersey machine. While the knitting is taking place, a sliver of staple fiber is fed into the machine. These fibers are caught in the tight knit and are held firmly in place. Although any staple fiber can be used for the pile, the greatest quantities of these fabrics are made with acrylic and modacrylic fibers in the pile. (See Figure 18.8 on page 329.)

By using staple fibers of varying lengths, adding color through fiber dyeing or printing on the surface of the pile, and shearing or brushing the pile, an enormous variety of effects can be achieved. (See figure CP3D on Color Plate 3.) The use of knitted pile fabric ranges from excellent imitations of furs, such as leopard, tiger, mink, or mouton, to colorful pile outerwear, coat linings, or pile carpet fabrics.

TAKE A CLOSER LOOK

T-shirts

T-shirts began life as white knitted cotton undergarments for men during World War II. By the 1990s they were being worn as undergarments and outergarments by men, women, and children; printed with logos and messages; dyed to a wide range of colors; decorated with embroidery, sequins, and beading; and cut to fit loosely or tightly.

The classic T-shirt is constructed of tubular jersey fabric. It has short sleeves set into the body of the garment. Sleeve and bottom hems are usually sewn flat. The neckline consists of a 1×1 rib knit strip sewn onto the body of the shirt. Some shirts have pockets sewn onto one or both sides of the front. T-shirts are sometimes made of fine rib knits that, even on close examination, are hard to distinguish from jersey knits. Long-sleeved T-shirts are also made, and these usually have an attached 1×1 rib-knit cuff.

The characteristics of jersey and rib knits make them the fabric of choice for T-shirts. Jersey knits stretch, moving comfortably with the body. They are resilient, returning to their original shape after stretching. If laundered and tumble dried, they generally require no ironing. The widthwise elasticity of rib knits allows the T-shirt to stretch as it is pulled over the head or wrists then return to a close fit.

Although many fibers can and have been used to make T-shirt-like garments, the classic T-shirt is usually made from 100 percent cotton or from blends of cotton and polyester. The most common blend is 50/50. T-shirts of cotton with a small percent of spandex for increased stretch and recovery are also being manufactured.

The quality of T-shirts depends on the quality of the fibers, yarns, fabric, and construction. Long-staple pima cotton may be used for high-quality products. Cotton yarns may be mercerized for increased strength, luster, and durability. Yarns may be carded, which will leave fuzzier fiber ends on the surface of the fabric, or combed for a smoother surface.

Jersey knits can be made in various weights. Those with more stitches per inch and heavier yarns will feel heavier and will be more durable, although in hot weather they will also feel warmer because they allow less air penetration. Less densely constructed knits are likely to snag and pull more readily. If a knit stitch breaks, a run can form, but unlike sheer nylon stockings where the slippery nature of the fiber allows runs to form quickly, the friction of cotton yarns makes runs travel less readily and for less distance.

The major performance problem consumers experience with T-shirts is shrinkage, which occurs during the first several launderings. Jersey knits undergo relaxation shrinkage as a result of the relaxation of tensions placed on fabrics during processing. Shrinkage is usually more pronounced in the lengthwise direction and is often accompanied by growth in the crosswise direction as the knitted loops broaden. Retailers generally anticipate shrinkage of 8 to 10 percent in both width and length, although high-quality knit goods manufacturers try to limit product shrinkage to 5 percent. To ensure satisfactory performance, consumers should look for labels that indicate fabrics have been treated to prevent shrinkage.

The garments may also twist or become "skewed" with laundering, presenting an unattractive appearance. Heavier-knit fabrics and higher-quality goods will generally exhibit less skew with laundering. Skew is described more fully in chapter 28.

In satisfactory construction, seams are sewn flat and not puckered, and stitches are close and even. Seams at the back of the neck and also at the shoulder may be covered with a strip of knitted tape, which is more comfortable against the skin than a seam. The tape also prevents the shoulder seam from stretching excessively.

T-shirts can generally be machine washed and tumble dried; however, printing of logos and slogans and novelty trimmings such as sequins, beads, or embroidery may require special handling. Consult care labels for recommended procedures.

Knitted Terry, Velour, and Fleece

Jersey knits can also be made in the form of knitted terry fabrics and knitted velours. Two yarns are fed into the machine simultaneously, picked up by the same needle, and knitted in such a way that one of the yarns appears on the face of the fabric, the other on the back. The yarn that forms the pile is pulled up to the surface

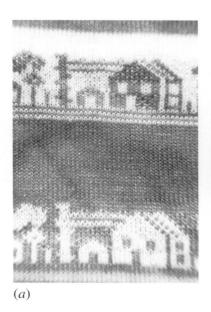

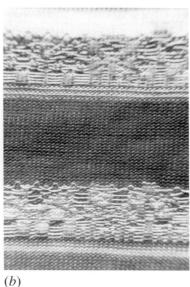

FIGURE 18.7

Jacquard patterned plain knit fabric;
(a) face; (b) back.

of the fabric. If the pile remains uncut, the resulting cloth is like a one-sided terry cloth. If the pile is cut, the fabric is called *velour*. (See Figure 18.9.)

Terry fabrics made by this process are not as durable as are woven terry cloths nor do they hold their shape as well. On the other hand, they have better draping qualities. The knitted velours are softer and more flexible than are woven pile fabrics, such as velveteen. Major uses for both fabrics are for sports- and loungewear, for infants' and children's clothing, and for household items such as towels and slipcovers.

The soft, fleecy effect produced on the inside of sweatshirts is achieved by much the same techniques as in making velours. The fleece is created by cutting and brushing the loops that are formed on the underside of the fabric.

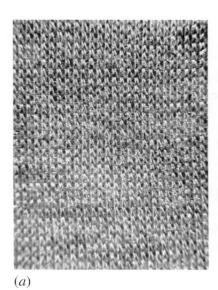

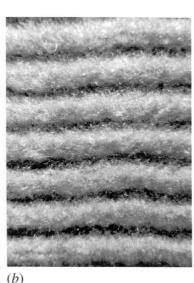

Figure 18.8

Jersey knit, high-pile fabric; (a) back; (b) face.

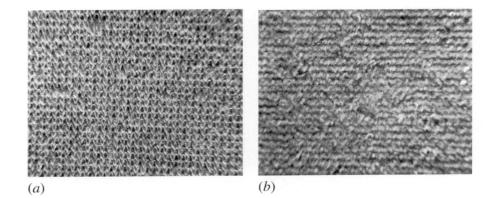

Figure 18.9

Jersey knit velour fabric;
(a) back; (b) face.

Plated Fabrics

In creating plated fabrics, the knitting machine feeds two separate yarns at the same time. The two yarns are in the same loop, one behind the other. By varying the color, texture, or type of yarn, interesting decorative effects can be achieved. It is also possible to use one yarn as the face yarn and another as a backing yarn. Using an expensive face yarn with an inexpensive backing yarn can help to keep the cost of the fabric lower. Plating varies from relatively simple construction to intricate pattern designs.

Two-bed Knits

The *Knitting Encyclopedia* states, "From a purely technical point of view, a double knit fabric is any knitted cloth or garment section that has been produced on any type of opposed bed knitting machine with two sets of needles of any range of fineness or coarseness" (Reichman 1972, 96). Those that have the greatest commercial interest can be classified as follows:

- 1. Narrow and broad rib knits
- 2. Nonjacquard and jacquard double jersey (commonly called double knits)
- 3. Interlock knits

The machines used to produce rib knits, double jerseys, and interlock knits differ from the machines used for plain knits in that they have two needle-holding beds and two sets of needles. For circular machines one set of needles is located on the needle cylinder in the same way as in plain-knit machines, and the second set is placed in a dial positioned over the cylinder much as a lid would be placed over a cylindrical jar. The dial is grooved, as is the cylinder, and needles lie within the grooves, called *tricks*, in such a way that the hooks of the horizontal dial needles and those of the vertical cylinder needles are perpendicular to each other. (See Figure 18.10.) The fabric created between the two sets of needles will have the appearance of the face fabric on both sides.

In flat-bed machines the needlebeds are placed so the two rows of needles form an inverted *V*. These machines are known as *vee bed machines*. (See Figure 18.11.)

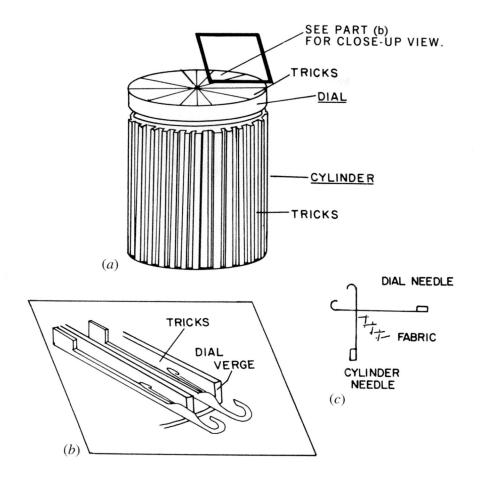

FIGURE 18.10

(a) Diagram of a cyclinder and dial arrangement for a circular knitting machine; (b) needles are placed inside the tricks in close-up; (c) diagram of the relative positions of dial and cylinder needles. Diagrams from P. Schwartz, T. Rhodes, and M. Mohamed, Fabric Forming Systems. Reproduced courtesy of Noyes Publications.

Rib Knits

"A rib knit fabric is characterized by lengthwise ribs formed by wales alternating on the face and back of the cloth. If every other stitch alternates from front to back, it is called a 1×1 rib. If every two stitches alternate, it is called a 2×2 rib" (Reichman 1972, 354). The larger the number of stitches that alternate, the more pronounced the rib. A 1×1 rib made in a fine gauge may be hardly visible to the eye. Fabrics may appear to be a jersey on both sides. (See Figure 18.12.) Rib knits are made on a two-bed machine with one set of needles forming the loops for one wale and the other set of needles forming the alternating wale.

Rib knits have greater elasticity in the width than in the length. They are stable and do not curl or stretch out of shape as do the jersey knits. For this reason, they are often used to make cuffs and necklines on weft-knitted garments. Rib knits are reversible unless the number of stitches in the alternating wales is uneven, as in a 2×3 rib.

Double Jersey Fabrics

The term *double knit* is generally applied by consumers to fabrics that are, technically, double jersey fabrics. Double jersey fabrics are also made on two-bed knitting machines, but the arrangement of the needles is different from that for

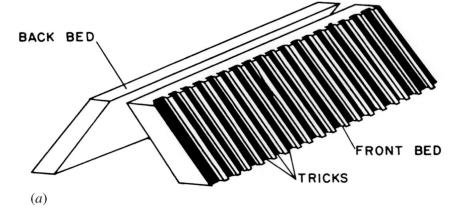

FIGURE 18.11

(a) Diagram of a vee bed; (b) diagram showing relative positions of needles from front and back beds. Diagrams from P. Schwartz, T. Rhodes, and M. Mohamed, Fabric Forming Systems. Reproduced courtesy of Noyes Publications.

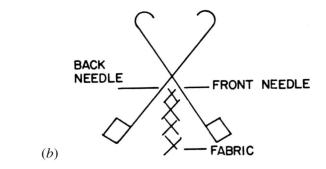

knitting rib fabrics. The layers of loops alternate from one side to the other, locking the two layers together. (See Figure 18.13.) Double-knit fabrics have the same appearance on both sides of the fabric, that is, exhibiting the appearance of the face or outer side of a single knit on both sides. Twice as much yarn is incorporated into double-knit fabrics as into comparable single knits.

Double-knit fabrics are more stable than plain knits. When made from synthetic yarns, double knits should be heat-set for better dimensional stability. They do not run and are easier for the home sewer to handle. During periods when double knits were

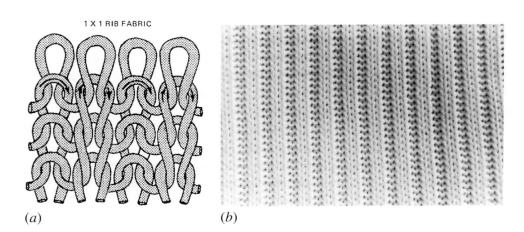

FIGURE 18.12

(a) 1×1 rib fabric structure. Diagram courtesy of National Knitwear Manufacturers Association. (b) 2×2 rib fabric.

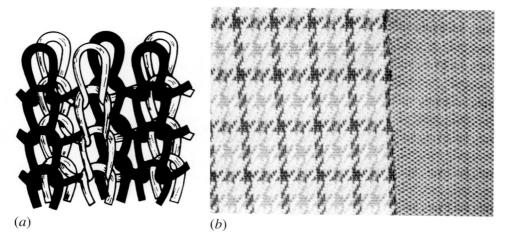

FIGURE 18.13
(a) Diggram of

(a) Diagram of a double knit; (b) close-up photograph of front and back sides of a double knit.

fashionable, textured synthetic yarns and wool were favored for double-knit apparel. The home furnishings industry also has utilized double-knit fabrics for upholstery.

A wide variety of decorative effects are possible in double jersey fabrics. These include "blister" fabrics with sculptured or raised surface effects and elaborate patterns called "jacquard" patterns because of their similarity to jacquard-woven patterns.

Interlock Knits

Interlock knits are produced on a special machine that has alternating long and short needles on both beds. Long and short needles are placed opposite each other. Long needles knit the first feeder yarn; short needles knit the second feeder yarn. The fabric created is an interlocking of two 1×1 rib structures. (See Figure 18.14.)

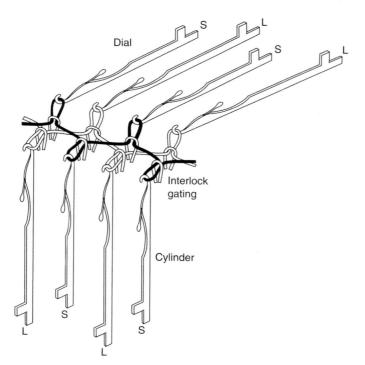

FIGURE 18.14

Diagram of interlock knitting. Short needles are labeled "S" and long needles "L." The first feeder yarn is white, the second is dark. Reprinted from D. J. Spence, Knitting Technology, 3rd Edition. ISBN 1 85573 3311. Courtesy of Woodhead Publishing Ltd., UK. 334

(a) Diagrammatic representation of an interlock knit; (b) photograph showing both sides of an interlock knit fabric. (Left is underside of fabric, right is topside.) Diagram reprinted by permission from D. J. Spencer, Knitting Technology, 3rd Edition. ISBN 1# 85573 331 1. Courtesy of Woodhead Publishing Ltd., UK.

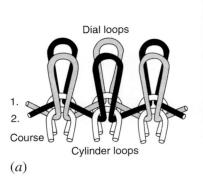

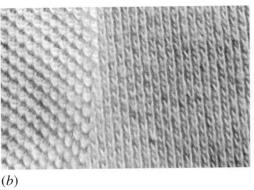

The resulting fabric, like double-knit fabrics, is thicker than single-knit fabric and more stable in the widthwise direction. Interlock fabrics have been traditionally used for underwear. They are produced more slowly than are other rib knits and are generally made in plain colors or simple patterns because the addition of pattern slows down the manufacture even further. (See Figure 18.15.)

Purl Knits

Purl machines have two needlebeds and one set of needles. Because the machine moves only to the left, it is also called a *links-links machine*. *Links* is the German word for *left*.

The links-links machine operates somewhat more slowly than do other knitting machines, causing the price of purl fabrics to be higher than that of other knits. The machine has a latch-type knitting needle with a hook on either end that allows the needle to pull stitches to either the back or the face of the fabric. This makes possible the construction of stitches on alternate sides of the fabric. The double needle arrangement makes this the most versatile of the weft-knitting machines as it can make plain, purl, or rib knits.

The simplest purl fabric is made by alternating courses so every other course is drawn to the opposite side of the fabric, thereby producing a fabric with the same appearance on both sides. (See Figure 18.16.) The raised courses produce a somewhat uneven texture. Purl fabrics were originally named "pearl" fabrics because the fabric surface resembled pearl drops (Spencer 2001).

Purl knit fabrics have high crosswise and lengthwise stretch. They are often made into a variety of decorative sweaters. Interesting textures can be achieved by the use of fluffy, soft yarns. The versatility of the machine makes possible the creation of a variety of patterns in these knits; however, relatively small quantities of fabrics are made in the purl stitch.

Weft-knit Stitch Variations

The basic loop formed in the plain knit serves as the starting point for a wide range of weft-knit stitches that can be used to vary the surface texture of weft knits. These include miss or float stitches, tuck stitches, and open stitches variously known as transfer or spread stitches. (See Figure 18.17.)

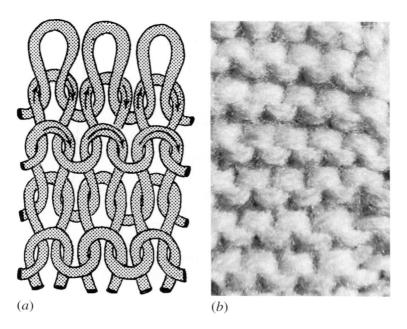

Figure 18.16

(a) Purl knit structure.
Courtesy of National
Knitwear Manufacturers
Association. (b) Close-up
view of stitches in a purl
knit fabric.

FIGURE 18.17

Basic weft-knitted stitches viewed from the front of the fabric. (Note that only a single purl stitch is shown here. This should not be confused with a purl fabric, show in Figure 18.16, which is made from many purl stitches.) From J. A. Smirfitt, *An introduction to warp knitting*. Copyright © Watford, Herts, U.K., 1975 Merrow Publishing Company, Ltd. Reproduced by permission.

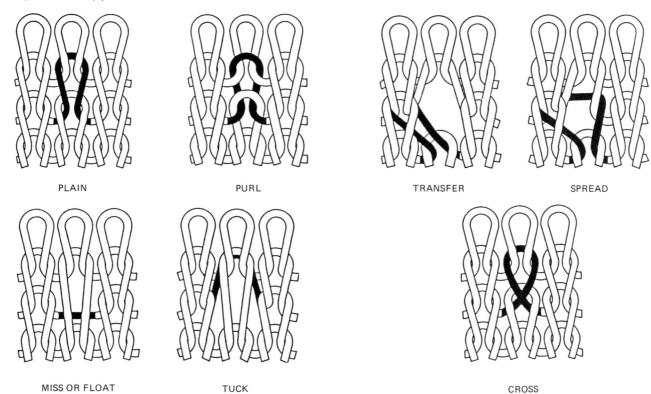

In miss or float stitches, some needles are immobilized, and instead of catching the stitch, they allow the yarn to be carried across the back of the fabric. The float stitch can be used to hide colored yarns at the back of the fabric when they do not appear in the design on the face. When long, straight floats are used, the elasticity of the fabric is reduced, and long floats are likely to be caught or snagged in use.

The tuck stitch is made by programming certain needles to hold both an old loop and a new yarn without casting off the old stitch. This creates an elongated stitch that appears in the fabric as an opening or variation in the surface pattern.

Loops can be transferred sideways to create decorative effects or open spaces. Transfer of loops can also be used in shaping of knits, as in *full-fashioning*, which is accomplished on specialized machines. Combinations of the tuck, miss, and other stitches with basic rib, plain, or purl knit stitches can create such varied effects as raised cables, open work alternating with plain knit, and a wide range of other decorative fabrics. An almost infinite variety of patterns can be created by combining yarns of different colors or textures and various stitches.

Weft knits are usually circular unless they are made on full-fashioning machines. In hosiery and sweaters, the item itself or sections of the item are made on the specialized knitting machines. When sweaters or stockings are knitted, the desired shape of the fabric piece may be created by increasing or decreasing the number of stitches.

Where stitches have been dropped or added, *fashion marks* appear. Fashion marks—small alterations in the surface caused by the shifting of the needles and the change in position of the yarns—are an indication of better quality in that the consumer can be sure that the shaping of the garment is permanent. Items made in this way are referred to as *full-fashioned*. (See Figure 18.18.) Some manufacturers create mock fashion marks at seamed areas to give the appearance of better quality. A careful examination of the area will show that in a true full-fashioned item,

FIGURE 18.18

Close-up photograph of fashion marks in sweater.

FIGURE 18.19

Computer-aided three-dimensionally knitted upholstery fabric in which a two-tone effect is achieved by using both lower-luster and bright yarn of the same color and different stitch structures. Photograph courtesy of Teknit, producers of three-dimensional knitted covers for the office furnishing industry in Europe and America.

the number and direction of stitches change. In mock fashion marks, this does not occur. Mock fashion marks are usually produced by embroidery and have a long yarn float on the wrong side between marks.

Three-dimensional Knitting

The techniques employed for full-fashioned garments are also being used to produce three-dimensional knitted structures. Complex shapes that serve as reinforcement in molded parts for industrial applications can be knitted. Covers for chairs and seats can be knitted as one piece, eliminating the cutting and sewing of fabric pieces to fit the forms. (See Figure 18.19.)

WARP KNITS

In warp knitting, each yarn is looped around one needle at a time. Warp yarns wound on a warp beam are threaded through metal guides with holes. The guides are attached to a guide bar, which moves sideways as well as forward and back so the yarns are carried both lengthwise and, to a limited extent, diagonally. (See Figure 18.20.) This diagonal motion is needed to ensure that the yarns interlace not only with the loop directly below in the same wale, but also with loops to the side in adjacent wales. If the yarn interlaced only vertically, there would be no point at which each individual chain of stitches was attached to its neighboring chain.

This construction of warp knits provides resistance to running because each stitch is most directly connected not only with the stitch beneath, but also with a stitch placed diagonally and lower. In forming the stitch, diagonal underlay moves the yarn from loop to loop.

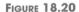

Guide bars on warp knitting machine move from side to side while needles move up and down. Follow the path of each yarn as it changes its position in the fabric structure.

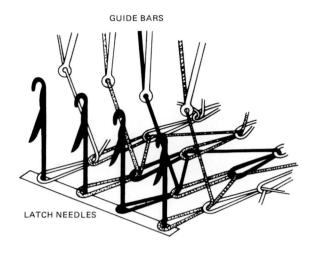

Several types of warp knits are made on a number of different warp-knitting machines.

Tricot

Tricot machines account for the largest quantity of warp knits. Tricot fabric is knit flat. On the face side, the wales create the appearance of a fine, lengthwise line. On the back side, crosswise ribs appear in a horizontal position. Tricot machines may have from one to four guide bars. The greater the number of bars, the greater the distance the yarn moves between stitches. In moving from one placement to the next, underlay yarns are carried across the back of the fabric. This extra yarn creates heavier-weight fabrics.

The steps in the formation of a warp loop with a compound needle are shown in Figure 18.21 (Spencer 2001).

- 1. Both hook and tongue rise, with the former rising faster, opening the hook. The guides swing to the front of the hook.
- 2. The guides swing, or *shog*, around the hook. The hook and tongue move down, with the hook descending faster to close the needle.
- 3. With the hook closed, the formed loop slides off.

Tricot fabrics are identified as one-bar, two-bar, three-bar, or four-bar, depending on the number of guide bars used in their manufacture. One-bar, or single-bar, tricot is relatively unstable and is seldom used for garments. It is, however, used as backing for some bonded fabrics. It will run because the loops interlace close together. Two-bar tricot is stable and fairly light in weight and is used extensively in lingerie, blouses, and the like. Three- and four-bar tricots are used for dresses and men's wear and are heavier than two-bar tricot. (See Figure 18.22.)

In addition to the basic tricot fabric, a number of variations can be made. A tricot satin is produced by allowing yarns to float farther across the back surface of

FIGURE 18.21

Basic steps in formation of a warp loop with a compound needle. Diagram reprinted by permission from D. J. *Knitting Technology,* 3rd Edition, ISBN 1 85573 331 1. Courtesy of Woodhead Publishing Ltd, UK

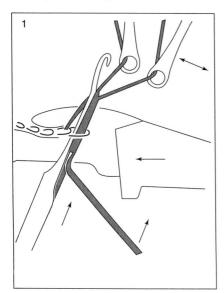

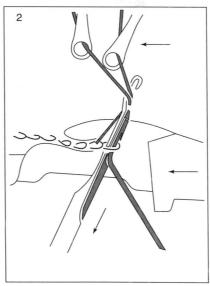

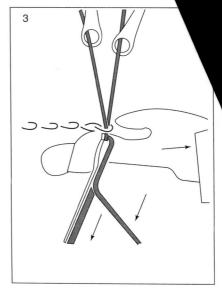

the fabric before they interlace. Other textured tricots known as *brushed tricots* are made with raised, napped surfaces or with small loops. The fabric as knitted is smooth on both sides. The surface effects are achieved during finishing, when the fabric is passed through a special machine equipped with wire rollers that either pull loops to the surface of the fabric or break some of the filaments to give a "brushed," soft, napped surface. Brushed and looped tricot fabrics are made with long underlaps that form the pile or loops.

Three- and four-bar tricot constructions permit the carrying of hidden yarns through the fabric. Monofilaments that stabilize the fabric or spandex filaments for stretch may be concealed in the complex structure of the tricot fabric.

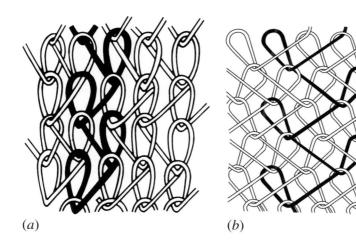

FIGURE 18.22

(a) The simplest single guide bar tricot construction; (b) diagram of three-bar tricot. Darker areas show how one yarn is carried throughout the fabric. Diagrams courtesy of National Knitwear and Sportswear Association.

Scencer.

urp knitting
ine. Example
win is Type HKS-2/3.
Photograph courtesy of
Karl Mayer Textilmaschinenfabrik GmbH.

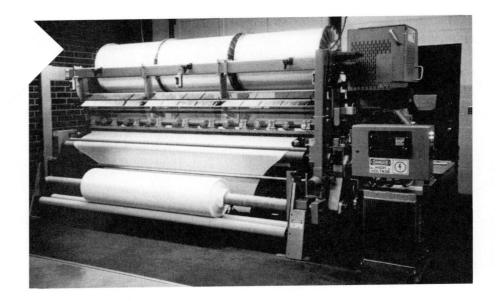

Tricot fabrics can be made with a variety of open effects to create interesting, lacelike patterns as well. Figure 18.23 depicts a tricot knitting machine.

Simplex Knits

Simplex knitting machines create warp knits similar to tricot but with a denser, thicker texture—a sort of double-knit tricot. Simplex knits are used in products requiring heavier fabrics, such as women's gloves, handbags, and simulated suedetextured apparel fabrics.

Raschel Knits

Raschel knits can range from finely knitted laces to heavy-duty fabrics. Elaborately patterned surface effects can also be achieved with the Raschel machine. The fabrics have lengthwise rows of loops held together by laid-in yarns and may, to the eye, have the appearance of woven goods or lace.

Raschel-knitting machines are flat beds with two to forty-eight guide bars. A mechanism called a *fall plate* controls the placement of the laid-in yarns. In the normal knit stitch formation, the needle moves up and down, looping yarns on and off the needle to form a continuous chain. In Raschel machines the fall plate is lowered to prevent the laid-in yarn behind it from forming a normal loop. Instead, the yarn is carried along in the fabric in a horizontal or diagonal direction, according to the pattern desired. In some fabrics this technique is used to simulate the effect of embroidery; in others, it gives a woven appearance. (See Figure 18.24.)

Among the most popular types of Raschel fabrics are power nets of elastomeric yarns for foundation garments and swimwear, thermal cloth for cold-weather underwear, and lace. In power nets for foundation garments, the laid-in yarns are

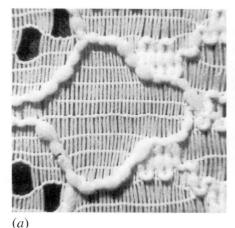

Close-up views of two open-structured Raschel knit fabrics.

spandex core yarns. Pile warp knits for fake fur fabrics are made by incorporating an extra yarn in the structure then brushing the pile surface.

Crochet Knits

An especially versatile variation of the Raschel-knitting machine is used to make fabrics that simulate hand-crocheted fabrics. Although the mechanism of the machine varies slightly from that of an ordinary Raschel-knitting machine, the principle of forming lengthwise loops held together by laid-in yarns is the same in both machines. The resulting textiles range from narrow trimmings, including those with fancy fringes, to wider fabrics (twenty-five to seventy-five inches) used for apparel or household textiles.

CREATING PATTERN AND DESIGN IN KNITTED GOODS

Finished knit goods can be dyed. Patterns can be created by printing on the fabric or through the manipulation of differently colored yarns.

Weft knits are easily knitted into stripes. These stripes always run across the fabric because the pattern is achieved through varying the colors of the yarns in the different courses. Because the yarns interlace horizontally, it is not possible to knit a vertical stripe in weft single knits.

A jacquard attachment for weft-knit machines makes it possible to knit a wide variety of patterned fabrics. Like woven jacquard patterns, jacquard-knit designs are plotted on paper and are transferred to the jacquard mechanisms, where the machine automatically activates the appropriate needles and colored yarns. Electronically controlled machines are widely used in the knitting industry. (See Figure 18.2.)

The structure of patterns in warp knitting is determined by a system known as the *link-chain system*. Chains with links of variable heights control the movement of the guide bars. The height of the link transfers a motion to the guide bars. The guide bars set the yarn in position over a group of needles to form the pattern, but pattern variations are limited.

FIGURE 18.25

Structure of weft insertion knit fabric. Diagram reprinted by permission of the National Knitwear and Sportwear Association.

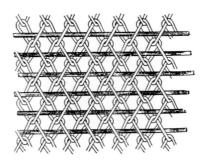

WARP AND WEFT INSERTION

Processes have been developed that allow the insertion of warp or weft yarns into knitted structures. Some of these variations of knitting have been purely experimental, while others have been implemented successfully. Their purpose is to provide increased stability to knitted structures. This is accomplished by integrating warp or filling yarns part or all of the way into the lengthwise or crosswise direction of a knitted structure, which holds them in place.

Presently, only weft insertion systems have any substantial commercial distribution. A separate magazine feeds weft yarns to a tricot or Raschel warp-knitting machine. The weft yarn crosses the entire width of the fabric. When the fabric is viewed from the back side, it can be seen that the weft always passes under the underlap of the knit stitch and over the loops, as shown in Figure 18.25.

Manufacturers of magazine weft insertion machines recommend the fabrics for a wide variety of apparel, household textile, and industrial applications. The textile literature describes their potential for use in processing high-tenacity yarns that are difficult to handle in ordinary weaving. High-tenacity yarns will lose some strength as a result of stresses imposed by the interlacing of yarns required in weaving. In weft insertion, the knitting yarns serve to hold the weft yarn in place, and full advantage can be taken of the strength of the inserted yarn.

CARE OF KNITTED FABRICS

Although there is a great variety in the quality of knitted goods sold, and the performance of any individual knit may differ markedly from that of other knits, some general guidelines for the care of knitted goods can be observed. The problems that consumers seem to encounter most often in the performance of knitted fabrics are in the areas of dimensional stability, snagging, and pilling.

Dimensional Stability

One reason for the popularity of knits for wearing apparel is their comfort. The looped construction of knit fabrics permits the fabric to give with the body as it moves. But the stretchiness of knits also results in lessened dimensional stability. Consumers have complained about shrinkage, stretching, and distortion of knits, although interlock and double-knit fabrics are usually more stable and display less shrinkage. Similarly, fabrics with weft or warp inserted yarns are more stable.

Shrinkage control treatments, heat setting of synthetics, and special resin finishes can provide good dimensional stability for knits. Unfortunately, not all manufacturers provide such treatment for their products. Consumers should check labels for percentage of shrinkage or for other special treatments to judge potential dimensional stability. (About 3 percent shrinkage is one garment size.) If products fail to live up to specified performance standards, items should be returned to the retailer or the manufacturer.

Knits are considered to be easy-care fabrics, and many care labels recommend machine washing. Some labels will also specify that the fabric can be dried in an automatic dryer. In general, however, knits will shrink more in the dryer than if air dried. Knits maintain their shape best if they are dried flat. The weight of a wet knit, hung on a line, may cause the fabric to stretch out of shape. The dimensions of knits usually will be retained best by professional dry cleaning.

Hand knits, sweaters of wool or animal hair fiber, and other knits with an open construction may require special hand laundering and blocking (stretching back into shape). Such items should be laid on a sheet of wrapping paper before washing, and the outlines should be traced. After washing, the garment should be stretched out on the paper to dry. While still damp, the garment should be gently stretched to fit the outline of the original dimensions.

Aside from stretching or shrinking, an additional problem with knitted items is skewing or twisting as the fabric is relaxed during laundering. Side seams of garments may pull to the front or back, and hems may hang unevenly. In general, knits made of synthetics will have better resistance to stretching out of shape than will cotton, acetate, and rayon. Blending of synthetics with cottons, acetates, and rayons will improve the resiliency and dimensional stability of knitted fabrics made from these fibers. Price is a good guide—especially for children's knits.

Knit fabrics have better wrinkle recovery than woven fabrics because the yarns can move more freely. Heavier knits resist wrinkling more than lighter-weight single knits.

Mechanical Damage

The loop structure of knitted fabrics makes them especially susceptible to snagging. If a loop catches on another object, it may be pulled up from the fabric surface and a long snag, or pull, of yarn may be formed. If the yarn that has been snagged is not broken, it can be pulled to the back of the fabric. It may be possible to gently stretch the fabric and work the pulled yarn back into place. This is difficult to do with tightly knitted fabric structures.

If the yarn has been broken, the snag may produce a hole or run in the fabric. A few hand stitches with needle and matching thread should be made to secure the yarns so the hole does not become enlarged during wearing or laundering.

Synthetic double knits or knits made from loosely twisted yarns may be subject to pilling. Weaker fibers, such as cotton, rayon, acetate, and wool, generally break off the fabric, but the stronger synthetic fibers cling to the fabric, making an unsightly area on the fabric surface. The use of textured yarns for knitting synthetics decreases the likelihood of pilling.

Knits may be damaged by sharp objects puncturing the fabric. If yarns are cut, a hole will result, and further pressure and strain on the fabric may enlarge the open area as loops are dropped in the interlocking structure.

EFFECTS OF KNIT STRUCTURE ON FABRIC PERFORMANCE Durability Factors

Strength of knitted fabrics is considered to be less important for durability than it is in woven goods. Knitted fabrics are easily stretched to accommodate changes of shape as a result of stresses imposed in wear and care. When knits are made from resilient fibers and yarns, the ability to stretch and recover from stretching will be enhanced. In comparison to knitted fabrics, woven fabrics are generally firmer and have less elongation. In knits the loops in the structure can be deformed horizontally or vertically, increasing the stretch in both directions. But as noted earlier, variations in knitting techniques can increase or decrease extensibility of knitted fabrics. Double-knit fabrics and warp-knit fabrics are usually less extensible than single-knit fabrics.

A major problem in the durability of knits is the runs that can develop in weft knits when one of the loops is broken. If stronger fibers and yarns are used in these knits, they will be less likely to run.

Appearance

The ability of a fabric to shear easily, discussed in chapter 17, is an important factor in the appearance of textiles. In general, because of the ways in which yarns are combined, woven fabrics shear more easily than do knitted fabrics. Knitted fabrics have good flexibility and are easily extended. Warp knits do not shear as easily as weft knits.

These qualities must be taken into account by designers, although they may not be aware of the technical terminology used to describe the fabric properties. For example, a warp-knit tricot fabric, which resists shearing, would not be the best choice for a bias-cut garment in which the intention is to take advantage of high shearing. Instead, the designer would be likely to use a soft, gathered construction where the high flexibility of the fabric would work to good advantage but where most of the draping would fall in the vertical direction of the fabric.

In general, knits wrinkle less than do other fabrics. This is because loosely constructed fabrics allow more fiber redistribution and motion. However, knitted fabrics, because of their greater extensibility, are more likely to lose their shape in laundering. The stresses applied in knitting distort the shapes of the loops rather than just stretching the yarns as in weaving. On relaxation, the loops broaden, shrinking the fabric length and increasing the width. As with woven fabrics, the tighter the structure, the higher the shrinkage until the structure becomes so tight that further shrinkage is not possible. Such fabrics may, however, buckle.

Knitted fabrics tend to have lower cover than do woven fabrics, with weft knits having substantially more porous structures than warp knits unless the fabric is deliberately made to have an open, lacy construction, as in some Raschel knits. Use of thinner or thicker yarns can increase the cover of knitted fabrics.

Comfort Factors

Knits usually entrap more air than do woven fabrics, although the tightness of the knit is a factor as well. Pile or napped knit constructions are especially good for cold weather because the yarns or fibers perpendicular to the surface provide numerous spaces for dead air. This effect is maximized if such fabrics are worn with the napped or pile surface next to the body or if they are covered with another layer.

The flexibility of knits contributes to a feeling of fabric softness. Fibers and yarns used can enhance or detract from the smoothness of knitted fabrics.

SUMMARY POINTS

- Knit fabrics are made by interlocking loops of yarn
 - Rows of loops in the lengthwise direction are wales
 - Rows of loops in the crosswise direction are courses
- · Weft knits
 - Most common type of knitted fabric
 - Yarns are introduced in the crosswise direction
 - Can be single or double knits
 - Examples are jersey, rib, double knit, and purl
- Warp knits
 - Yarns run in the lengthwise direction
 - Examples are tricot and Raschel
- Properties of knits
 - · Stretch in both directions
 - Wrinkle less than woven fabrics
 - · Susceptibility to shrinkage or growth depending on fibers used
 - · Loops may snag, creating a pulled area in the fabric

Questions

- 1. What is the difference between a weft knit and a warp knit?
- 2. What determines the number, size, and closeness of knitting stitches? What terms are used to describe the closeness of knit stitches?
- 3. Describe the various ways that differences in pattern and surface texture can be achieved in weft knits.
- 4. Which of the following weft knits are made with one needlebed and one set of needles, which are made with two needlebeds and two sets of needles, and which are made with two needlebeds and one set of needles?

jersey knits velour knits
purl knits high-pile knits
interlock knits double knits

wile lead to

rib knits

5. Explain the differences in weft knit and warp knit structures that make warp knits less subject to developing runs.

346

- Identify some common end uses of Raschel-knit fabrics, and explain why Raschel knits are often used for these products.
- 7. Assuming comparable quality and fiber content, compare knitted and woven fabrics in terms of their performance in regard to comfort during physical activity, dimensional stability, snagging, wrinkle recovery, and pilling. Explain what accounts for these differences.

References

- Reichman, C., ed. *Knitting Encyclopedia*. New York: National Knitted Outerwear Association, 1972.
- Spencer, D. J. *Knitting Technology*, 3rd ed. Cambridge, UK: Woodhead Publishing, 2001.

Recommended Readings

- Ghosh, S., and P. K. Banerjee. "Mechanics of Single Jersey Weft Knitting Process." *Textile Research Journal* 60 (April 1990): 203.
- O'Brien, M. "Flat Knitting: Past, Present, and Future—2." *Textiles Magazine* 3 (1997): 5.
- Schwartz, P., T. Rhodes, and M. Mohamed. "Knitting and Knit Fabrics." In *Fabric Forming Systems*, 76–151. Park Ridge, NJ: Noyes, 1982.
- Smith, S. "The History of Hosiery in America." Southern Textile News August 8 (1994): 2.

Nonwoven Fabrics

Learning Objectives

- 1. Define nonwovens and distinguish them from other fabric structures.
- 2. Compare the different web-forming and web-bonding processes.
- 3. Analyze the nonwoven properties desired for particular end use products.

echniques by which fabrics are made directly from fibers, bypassing both spinning and weaving, have been used for centuries in the production of felt and bark cloth. With the development of manufactured fibers and, in particular, the synthesis of thermoplastic fibers, technologies have evolved that have made possible the large-scale production of nonwoven fabrics. The first nonwoven consumer product, an interlining fabric for the apparel industry, was introduced in 1952 (INDA 1992). Marketed extensively for both durable and disposable items, nonwoven fabrics range from disposable diapers to geotextiles, from industrial filters to tea-bag covers.

NONWOVENS DEFINED

Nonwoven fabrics, sometimes called *fiber webs*, are textile structures "produced by bonding or interlocking of fibers, or both, accomplished by mechanical, chemical, thermal or solvent means and combinations thereof" (ASTM 1998). This excludes fabrics that have been woven, knitted, or produced by other means described in chapter 15. The Association of the Nonwovens Fabrics Industry (INDA) in the United States and the European Disposables and Nonwovens Association (EDANA) help to further define what may be called a nonwoven fabric (Jirsák and Wadsworth 1999). More than 50 percent of the weight of a nonwoven must be composed of fibers with an aspect ratio (length-to-diameter ratio) of three hundred. This excludes paper products that are normally made of extremely short fibers. In addition, nonwovens must have a density less than 0.4 grams per cubic centimeter, and felted fabrics are usually much heavier.

Polymer Producer

Wood Pulper

Fiber Manufacturer

Fiber Manufacturer

Roll Goods Product Manufacturer

FIGURE 19.1
Flowchart of nonwovens industry.

Nonwovens can be classified in several ways. The most common categorization today is based on the method used to manufacture the nonwoven fabric. These methods are discussed below. Nonwovens are also classified as durable products or disposable products. Durable products are designed to be used multiple times. Examples of this type of product are blankets, carpet backings, and interfacings and interlinings for apparel. Many nonwoven products today are made to be disposed of after one or a few uses. The many types of wipes on the market are examples of this class of nonwovens, as are disposable diapers and feminine hygiene products. Some items are disposable not because they are not durable, but because of their purpose. Surgical gowns and caps, for example, might withstand multiple uses, but for sanitary reasons they have limited use periods.

THE GLOBAL INDUSTRY

Nonwovens production is one of the fastest-growing segments of the global textile industry. It encompasses a unique set of industrial players. (See Figure 19.1.) Starting materials can range from wood pulp made by paper companies to polymer pellets, called *resins* in the trade, produced by large, multinational chemical companies. Manufacturers of the nonwoven fabrics, or *roll goods*, have a variety of processes from which to choose (see descriptions below). The supply chain ends with developers and producers of the many consumer and industrial nonwoven products. The different segments of the nonwovens industry may be integrated; for example, a product manufacturer can also produce its roll goods in-house.

MANUFACTURE

There are two steps involved in manufacturing nonwoven fabrics: (1) preparation of the fiber web and (2) bonding of the fibers in the web. A number of possibilities exist for each step, and in addition, the two stages may be distinct or can be carried out as a more or less continuous process. The various combinations are described below and summarized in Table 19.1.

Fiber Web Formation

Staple Fiber Webs

Staple fiber webs are produced by either *dry forming* or *wet forming*. Dry-forming processes are carding, also called dry laying, and air laying. Carded webs are made

Table 19.1
Nonwoven Fabric Production Methods

	Web Formation	141
Dry Laid	Wet Laid	Spun Laid
Carded Air laid	Wet laid	Spunbonded Melt blown
	Web Bonding	
Chemical	Mechanical	Thermal
Adhesive bonded Solution bonded	Needlepunched Spunlaced Stitchbonded	Calender bonded Air bonded Infrared bonded Ultrasound bonded

in a manner similar to the process for slivers for yarn spinning, except that the thin film of fibers removed from the card is not drawn together into a sliver, but is laid onto a conveyor. (See Figure 19.2a.) Often, several carding machines work side by side and feed several such thin fiber films to the conveyor. The direction in which the fibers are laid down is the *machine direction*. Perpendicular to that is the *cross direction*. Thicker webs can be built up by layering the carded webs.

In air laying the fibers are opened, suspended by air, then collected on a moving screen. (See Figure 19.2b.) Think of how dryer lint accumulates; then imagine fibers being tumbled around a space the size of a large room and collected on a wide screen.

The wet-laid process is similar to paper making in that a mixture of fibers in water is collected on a screen, drained, and dried. (See Figure 19.2c.) Wood pulp, with short cellulosic fibers, is the most commonly used raw material for wet-laid nonwovens. Staple-length manufactured fibers can also be used but are more expensive and usually harder to disperse in water (Williamson 1993). Another expense in wet laying is that the water used in making the suspension of fibers must be removed during drying.

Direct Extrusion Processes

Webs can also be made by the direct extrusion processes of *spunbonding* and *melt blowing*. These are the fastest processes for making fabrics. According to Rory Holmes, president of INDA, "one 3.5-m nonwovens line will turn out approximately the same amount of yardage as 3,000 57-inch weaving machines operating at 1,000 ppm" (Isaacs 2005).

Spunbonded fabrics are manufactured from synthetic filament fibers. The polymer is melted in an extruder, and the melt is pumped through a rectangular spinneret with thousands of holes, called a *die*. Upon exiting the die, the fibers

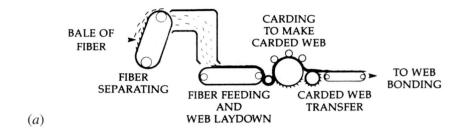

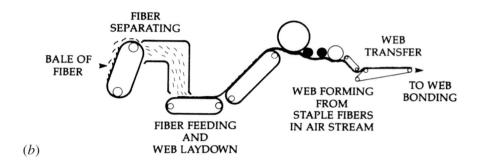

Figure 19.2

Schematic representation of methods for forming staple fiber webs. (a) Web forming by the carding method. (b) Web forming by the air laying method. (c) Web forming by the wet laying method. Diagram reproduced courtesy of INDA, Association of the Nonwovens Industry.

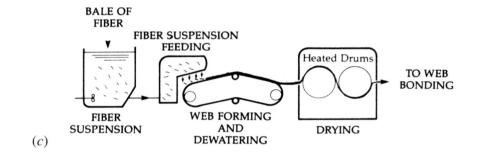

enter a chimney where turbulent air cools and entangles the filaments, which are then deposited in a random pattern on a moving belt. A vacuum under the belt assists the lay down of the fibers. The resulting nonwoven fabric is thus produced in a fast, continuous process from polymer to fabric. (See Figure 19.3.) The polymers most commonly used for spunbonded nonwovens are polypropylene and polyester.

To complete the operation, the spun-laid web is passed through heated rolls to bond the fibers, giving the fabric more integrity. Considerations in this bonding process are discussed below.

Melt blowing also forms fabrics directly from fibers, but it differs from spunbonding in several respects. Melt blowing dies have one row of spinneret holes, rather than multiple rows. Molten filaments extruded from the die are immediately hit with high-velocity hot air blown at an angle from each side. The high-speed air not only entangles the fibers prior to deposition on the moving belt, but also draws and attenuates the fibers. Originally fibers were extruded horizontally and collected on a revolving drum. (See Figure 19.4a.) Newer machines extrude vertically onto a moving web. (See Figure 19.4b.) The fibers

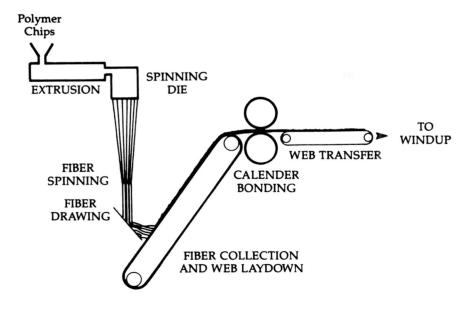

FIGURE 19.3

Schematic of spunbonding process. Reproduced courtesy of INDA, Association of the Nonwovens Industry.

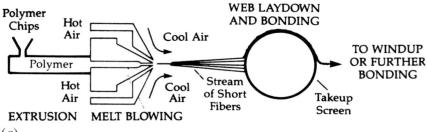

(a)

FIGURE 19.4

(a) Schematic of melt blowing process showing horizontal collection. Reproduced courtesy of INDA, Association of the Nonwovens Industry. (b) Photograph of melt blowing showing vertical collection. Courtesy of TANDEC, University of Tennessee. Photograph by Jack Wyrick.

in melt-blown fabrics are finer than those in spunbonded webs. A final difference is that melt-blown fabrics are not bonded after web formation; they are, therefore, weaker than their spunbonded counterparts, but with the fine fibers, which are not heat bonded, they have a higher surface area within the fabric. This makes melt-blown nonwovens ideal as filters, and indeed filtration is one of their main applications.

Spunbonded fabrics are strong because of the filament fibers and are not easily torn. They are used for a wide variety of products ranging from apparel interlinings, furniture, and bedding to dryer sheets, disposable diapers, and express mail envelopes. Spunbonded fabrics may be used in geotextiles to control erosion or in constructing roads. Some spunbonds made from olefins are used as a tough, especially durable substitute for paper in wall coverings, charts, maps, tags, and labels.

Specialty products can also be made by layering spunbonded and melt-blown fabrics or by entrapping absorbent fibers or other materials within the melt-blown structure. Layered structures are named by designating spunbonded layers as "S" and melt-blown layers as "M." A fabric with a melt-blown component in between two spunbonded layers would thus be described as an SMS nonwoven. The filtering properties of melt-blown fabrics are enhanced by entrapping carbon particles or small fibers within the structure. The carbon absorbs odors, chemicals, and other harmful agents.

Fiber Bonding/Entangling

Once a web has been formed, some treatment must be given to most nonwovens to bind the fibers together. This can be done by mechanical, thermal, or chemical means.

Mechanical Bonding

Fiber webs produced by dry-laying methods may be joined by entangling or stitching the fibers in some way. Three such methods used are *needlepunching*, *spunlacing*, and *stitch bonding*.

In needlepunching the web is fed into a machine with a bed of barbed needles, like fishhooks. The needles move in and out of the web, entangling the fibers. (See Figure 19.5a.) The resulting fabrics are bulky and soft, yet retain their integrity. Products typically made from needlepunched nonwovens are blankets, filters, carpets, interlinings, road underlays, and automobile trunk liners.

Spunlaced, or *hydroentangled*, goods are made by fluid entanglement. High-speed jets of water hitting a fibrous web bind fibers together by causing them to knot or curl around each other. No binder is required. (See Figure 19.5b.) Patterns can be created by the use of perforated, patterned screens that support the fiber web. As the fibers become entangled, they assume the pattern of the supports. Depending on the patterns used, spunlaced fabrics may have an appearance similar to fabrics woven from yarns or may resemble lace.

Spunlacing is often used in making kitchen wipes. The wipes have a regular pattern of holes surrounded by tightly entangled fibers. Many wipes are also adhesively bonded for increased wet strength.

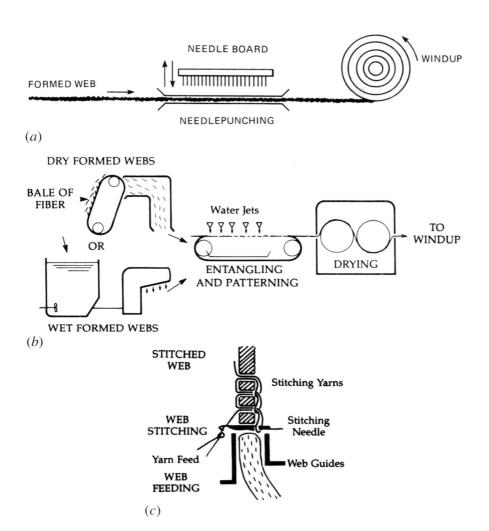

FIGURE 19.5

(a) Needlepunching process.
(b) Web forming and bonding by the spunlacing or hydroentangling process.
(c) Schematic showing how fiber webs may be held together by stitchbonding. Diagram reproduced courtesy of INDA, Association of the Nonwovens Industry.

For the stitch-bonding technique, fiber webs are stitched through to hold the fibers together. (See Figure 19.5c.) This stitching can take several forms and variations provide for use of stitch-bonded nonwovens in a wide range of products. Maliwatt fabrics are fiber webs that have been stitched together. (See Figure 19.6a.) The resulting fabrics are used as lining fabrics, furnishing fabrics, insulating materials, base fabrics for tufted goods, and in industrial products and geotextiles. Malivlies fabrics, used in felts, packing materials, insulation materials, and utility textiles, are created by forming stitches from the fibers of the web itself. No additional yarns are required. (See Figure 19.6b.)

Other branded processes are kunit and multiknit. Kunit fabrics are formed by feeding a web of fibers into a machine where a type of compound knitting needle (see chapter 18) forms knitting stitches from the fiber web. These stitches hold the web together and form a fabric that may have either a plushlike, furlike, or flat appearance. (See Figure 19.6c.) Uses include linings for clothing and shoes, plush for toys, automotive interior fabrics, acoustical and thermal insulation,

(a) Maliwatt

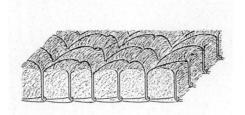

Cross-lapped carded fleece with mechanical compacting by additional stitchbonding.

(b) Malivlies

Cross-lapped carded fleece. The mechanical compacting is effected by partial stitching of the fiber structure.

FIGURE 19.6

Cross-section diagrams of pile fabrics made by stitchbonding processes. (a) Maliwatt: crosslapped carded fleece with mechanical compacting by additional stitchbonding. (b) Malivlies: crosslapped carded fleece with mechanical compacting by partial stitching. (c) Kunit lengthoriented carded fleece with mechanical compacting by stitching of fiber structure to pile loops. (d) Multiknit: ground fabric is Kunit and in a connected process, it is stitched on top of the loops, resulting in two identical plain fabric surfaces. Drawings courtesy of Karl Mayer Textilmachinenfabrik GmbH.

(c) Kunit

Length-oriented carded fleece. The mechanical compacting is effected by stitching of the fiber structure to pile loops of pre-determined height.

(d) Multiknit

The ground fabric is Kunit and in a connected process it is subsequently stitched on top of the loops, resulting in two identical plain fabric surfaces.

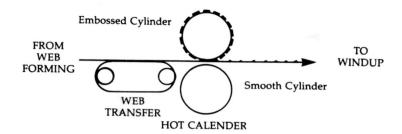

FIGURE 19.7

Calender bonding.
Diagram reproduced
courtesy of INDA, Association of the Nonwovens
Industry.

packaging material, and base fabrics to which coatings may be applied. In the multiknit process, two fabrics formed by the kunit process are united into a double-sided, multilayered fabric with knitting stitches made by a compound needle with a sharp point that can penetrate both fabrics. (See Figure 19.6d.) Applications include insulation materials, garment interlinings, base materials for molded textile composites, and as a replacement for foam in car and furniture upholstery.

Thermal Bonding

Nonwoven webs made of, or containing, thermoplastic fibers may be bonded by heat. The application of heat causes the fusing together of the heat-sensitive fibers, which effectively fastens them together.

Heat bonding of nonwoven webs is accomplished by passing the web between a pair of heated rolls called *calender rolls*. (See Figure 19.7.) Most commonly today, one of the calender rolls is embossed with raised areas to apply the heat in a pattern of small areas across the fabric. The fibers in these areas are fused together, providing strength to the nonwoven web, yet retaining a degree of flexibility and softness. Such fabrics are said to be *point bonded*. (See Figure 19.8.) If the calender roll is smooth, the entire surface is bonded and the fabric becomes stiffer and more like paper.

Nonwovens can also be formed with a small percentage of *binder fibers* that have a lower melting point than the predominant fibers. When the web is thermally bonded, the binder fibers melt, providing the necessary adhesion.

FIGURE 19.8

Photomicrograph of point-bonded nonwoven. Photograph courtesy of Dr. Dong Zhang

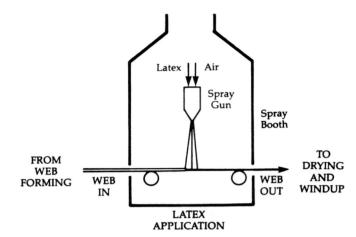

FIGURE 19.9

Application of latex adhesive. Diagram reproduced courtesy of INDA, Association of the Nonwovens Industry.

The temperature of the calender rolls is set to melt the binder fibers but not to soften the primary fibers in the web.

Heat can also be applied to webs by hot air, infrared radiation, or ultrasound.

Chemical Bonding

Bonding may be achieved by applying an adhesive material to the web then setting the adhesive. This, in essence, "glues" the fibers together. Latex adhesives, in which the adhesive substance is suspended in water, are most often used. The fabric web is passed through a bath in which it is impregnated with the latex then dried. (See Figure 19.9.)

When adhesive is applied to the surface of the fiber web, it tends to make the fabric stiff and more rigid. Also, fabrics exhibit the characteristics of the adhesive material on the surface rather than those of the original fiber. To overcome this disadvantage, adhesives may be imprinted onto the surface in selected areas. The printing patterns are developed carefully to ensure that adequate bonding takes place among fibers to maintain fabric strength. Like point-bonded nonwovens, such fabrics are less rigid and have better drapability and a more pleasant surface texture than do those that have been completely coated by an adhesive.

Instead of adhesive bonding, fibers may be *solution bonded* by spraying a mixture of chemicals and water onto the surface of the fibers. When subjected to heat, the water evaporates and the chemical vaporizes, dissolving a small amount of fiber, usually where one fiber crosses another. When the dissolved fibers resolidify, bonds are formed that hold the fibers together.

USES

Table 19.2 provides a summary of the pervasive use of nonwovens in products worldwide, with new end uses cropping up continually. Many of the applications would be considered industrial fabrics as they are not used for clothing or home furnishings but still touch our lives daily. Disposable nonwovens are particularly

TABLE 19.2

Common Nonwoven Products

Personal hygiene	Disposable diapers Sanitary napkins and tampons Wipes
Medical	Surgical gowns, caps, and masks Drapes
Household products	Wipes Dryer sheets Insulation Filters
Home furnishings	Carpeting and carpet backing Wall coverings
Apparel	Interfacings and interlinings Labels
Geotextiles	Agricultural coverings Erosion- control mats Seed strips

Source: INDA, Association of the Nonwovens Fabrics Industry.

prominent in the area of medical, personal hygiene, and cleaning products. Made cheaply from manufactured fibers, they can be easily sanitized and disposed of. Cleaning wipes on the market today can be impregnated with soaps or other detergent agents. Disposable face wipes may also contain lotions for softness. Dryer sheets have fabric softeners that vaporize when heat is applied.

Nonwoven fabrics continue to see uses in household products and furniture. Wipes for a wide variety of cleaning purposes were mentioned above. Many upholstered furniture pieces have nonwoven underlays beneath the decorative fashion fabric. They stabilize the structure and hold the stuffing in. Sturdy nonwovens are used as carpet backing.

An area of strong growth in industrial textiles has been the products known as *geotextiles*. Geotextiles perform functions such as filtration, separation, or reinforcement in ground and soil applications. Geotextiles can be woven or nonwoven fabrics of polyester, nylon, or polyolefin. The cheaper processing and the wide variety of possible products of nonwovens make them ideal for the large-volume applications in geotextiles. Rugged nonwoven fabrics can be used to stabilize roads by providing a separation layer between the asphalt and the soil roadbed. The geotextile prevents the asphalt aggregate from mixing into the soil and weakening the road surface. (See Figure 19.10.)

Another high-volume application for nonwoven geotextiles is in soil erosion control. The geotextile fabric, when placed under the sand or gravel cover on an embankment, can prevent soil erosion by holding the soil underneath. Nonwoven geotextile mats of biodegradable natural fibers can also be placed on top of newly seeded construction sites to hold the soil until vegetation can grow. (See Figure 4.17.)

FIGURE 19.10

Typar® nonwoven geotexide provides a tough, durable permeable separation layer, used here in road construction. (a) Road surface without Typar® layer. Soil contaminates and weakens aggregate base placed beneath pavement. (b) Road surface with Typar® Aggregate will not sink into and intermix with subsoil. Diagram reproduced courtesy of LINQ Industrial Fabrics, Inc.

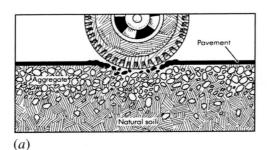

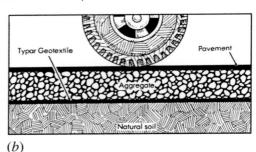

OTHER FABRICS MADE FROM FIBERS

Although not included in the technical definition of nonwovens, felt and bark cloth are two other fabrics that are made directly from fibers without first constructing yarns.

Felt

Evidence is scanty, but it is believed that the first means of making fibers into cloth was through felting. To understand the process by which felt is formed, it is necessary to review the structure of the wool fiber from which it is made.

The surface of the wool fiber is covered with a fine network of small scales. (See Figure 5.4.) This scaly structure causes wool fibers to cling closely together as the scales from one fiber interlock with the scales of another. Furthermore, the natural crimp of wool assists in felting. When masses of wool fiber are placed together, the crimped fibers become entangled. Friction increases this tangling. If the wool is subjected to conditions of heat and moisture, the scales open wider, interlocking with still more scales from neighboring fibers. Wool scales are so oriented that each fiber moves in its root direction, causing the mass to hold together more tightly. When pressure is added, the mass is flattened, producing a web of tightly joined fibers, or felt. The factors essential for producing natural felt from wool are pressure, which increases the tangling; heat; and moisture.

It is not too difficult to imagine a situation in which felt might have been produced accidentally. Suppose a horse rider placed a sheep fleece on the back of a horse as cushioning material. The body of the horse is both warm and moist; the rider provides the pressure and the friction. Over time, the fleece becomes matted, producing a primitive form of felt. Frequent repetition of the procedure could lead to the recognition that this material had potential for some of the same uses as the fleece from which it was made.

In the commercial production of felt, a batt (or mass) of cleaned wool fiber is fed into a carding machine that lays down a web of fairly even thickness. To improve strength and dimensional stability, two webs of carded fiber are laid across each other with the fibers of one web at right angles to the fibers of the other web. Steam is forced through the mass of fiber, after which a heavy, heated plate or

rollers are lowered onto the fibers and moved about to produce mechanical motion. The moisture, heat, and friction effectively interlock the fibers.

Following this operation, the fabric is passed through a solution of soap or acid that causes the fabric to compact further. From this stage the fabric goes to a finishing mill in which the fabric is subjected to further agitation, pounding, and shrinkage. This is similar to the fulling finish given to woolen fabrics. (See chapter 24.) After felting is complete, the fabric can be dyed or given any of the traditional finishes used on wool.

To decrease costs, manufacturers may blend other fibers with wool. A woven scrim (a plain, open, woven fabric) may sometimes be added as a framework to support felt to increase its strength.

Felt has the advantage of being easily cut, and because it has no yarns, it will not fray at the edges. It can be molded into shape and so has wide use in making hats. Because of its densely packed fibers, felt provides a good deal of warmth, and it is not easily penetrated by water. On the other hand, felt is a relatively weak fabric, may tear under pressure, and is subject to pilling. Being rather stiff, felt does not fall into graceful folds. Its uses, therefore, are somewhat limited. Modern manufacturers of wool felt supply material not only for hats and fashion accessories, but also for some industrial uses.

Bark Cloth

A process similar to that used for felt produces bark cloth or, as it is called in the Polynesian Islands, *tapa*. Made from certain trees, among them the paper mulberry, breadfruit, fig, or related species, bark cloth is produced by first removing strips of the inner layer of bark from the tree. This substance is softened by soaking it in water. The softened bark is placed on an anvil or other flat surface, and special beaters are used to pound the bark strips to interlace the fibers. When the mass is sufficiently integrated, the material is dried, producing a sheet of fabric. Special texture or surface markings are achieved by pounding the material with incised hammers or embossing the flat surface on which the fibrous materials are spread to be beaten and to dry.

The resulting fabric is somewhat like a soft, supple paper. Pieces of tapa can be joined without sewing. Simply by wetting the edge of two pieces and pounding them together, large pieces of fabric can be made without seams.

Tapa does not drape or sew particularly well and was used chiefly for simple, unsewn garments such as ponchos, sarongs, loincloths, or turbans. Small quantities are still made for native religious garb and as native craft items.

EFFECTS OF NONWOVEN STRUCTURE ON FABRIC PERFORMANCE

Durability Factors

In nonwoven fabrics that do not contain yarns, strength comes from fiber entanglement and adhesion, as well as inherent fiber tenacity. Fiber webs of coarser and stronger fibers will have greater strength than those made from finer, weaker

360

fibers. The bonding of the fibers in the nonwoven structure also provides strength. Fabrics with a large number of bonding points are stronger, and the strength also depends on the strength of the individual bonds. Fiber webs with only fiber entanglement for adhesion, such as needlepunched nonwovens, derive their strength from the frictional forces among the entangled fibers and can be torn apart more easily. Reinforcing scrims can add strength, and more densely entangled webs are stronger. Melt-blown fabrics have lower strength but are not used alone in products where strength is a primary consideration.

A factor in nonwoven fabric strength is the orientation of the fibers. The more fibers are oriented in the machine direction, the greater will be the strength in that direction. The strength in the cross direction will, however, be lower. Tearing strength is important in many end uses, and a random fiber pattern will give a more balanced tearing strength in both directions.

Some nonwoven fabrics may show lower abrasion resistance if the fibers are not tightly held in the structure. Abrasion will pull fibers out, and the fabric will wear.

Appearance

Nonwoven fabrics made by bonding fibers together rarely resemble woven or knitted fabrics in their appearance. An exception is spunlaced nonwovens, which have an open pattern.

Nonwoven fabrics also lack drapability, which affects their appearance. Shearing behavior plays an important role in the drapability of a fabric; therefore, a skirt made from felt or a nonwoven fabric appears stiff. Because the fibers are strongly bonded and not able to move at the crossover points, the structure cannot accommodate the shearing force. Instead, when a shearing force is applied, the fabric buckles, much as paper does. Stitch-bonded fabrics will vary in their shearing and bending behavior.

While nonwovens are generally more functional than decorative, there is current interest among those in the various segments of the nonwovens industry in moving into apparel and more home furnishings uses. Pigmented spun-laid fabrics have been around for some time, produced by adding color to the polymer melt before extrusion. Hydorentangling and point bonding can provide pattern and texture. Varying the fibers and yarns in stitch-bonded fabrics can add unique and interesting decorative effects.

Comfort Factors

The interest in apparel uses has also put new emphasis on the comfort aspects of nonwovens. They have been used for some time as interlinings to provide warmth and more recently in protective apparel for workers in the chemical and agricultural industries. Depending on their thickness, many nonwovens and felt have a high internal surface area because the fibers are not densely packed, as they are with some other fabric structures. This high surface area, which is increased with finer fibers, traps air for warmth and insulation and can also filter and entrap hazardous agents and particulates. In addition, the low density of the nonwoven provides the insulative

and protective properties without added weight. Nonwoven fabrics are specified by their *basis weight*, which is the fabric weight in grams per square meter.

As fabrics for apparel, however, nonwovens can be uncomfortable both because they may not breathe and also because of their resistance to shearing. The latter disadvantage can be overcome by introducing stretch into the fabric so it has some ability to shear and conform to the body. This is currently being accomplished by making spun-laid fabrics from elastomeric fibers. The nonwoven fabric has stretch in all directions and can, therefore, conform to the curves of the body. As processing improves and these fabrics can be made with ever finer fibers, they also have increased softness for comfort.

Nonwovens made from absorbent fibers such as rayon and, increasingly, cotton are more comfortable than those composed of synthetics. Most are not appropriate for apparel, however, because they are thicker than the spun-laid fabrics, with high resistance to shearing and drape.

SUMMARY POINTS

- Nonwovens are fabrics made directly from fibers
- Natural fibers, manufactured fibers, and wood pulp are used to make nonwovens
- Two steps in nonwovens manufacturing are web formation and bonding
 - Webs can be formed by dry laying, wet laying, or spun laying
 - Webs are bonded by thermal, mechanical, or chemical methods
- Nonwoven products are used in personal hygiene, medical, household, home furnishing, apparel, and geotextile products
- Leather and bark cloth are fabrics made from fibers directly but are not classified as nonwovens
- · Nonwoven fabric properties
 - Lower strength than other fabric types
 - High resistance to shearing
 - · High ability to trap air

Questions

- 1. What fabric structures are considered nonwovens? What structures are not?
- 2. List and describe the combination of web forming and bonding methods that are used to make nonwoven fabrics.
- 3. For the application categories listed in the first column of Table 19.2, give the type of nonwoven that would provide the optimum properties.
- Explain how the physical properties of wool fibers make the production of felt possible.
- 5. What are the economic advantages of spunbonding and melt blowing over other nonwoven production methods?
- 6. Explain the basic principles of forming fabrics by stitch bonding.
- 7. What are some disadvantages of nonwovens that need to be overcome for apparel and home furnishing applications?

References

ASTM. Annual Book of ASTM Standards. Vol. 7.01. West Conshohocken, PA: American Society for Testing and Materials, 1998.

INDA. *The Nonwoven Fabrics Handbook*. Cary, NC: Association of the Nonwovens Fabric Industry, 1992.

Isaacs, M. "Nonwoven Fabrics Wipe Out the Doldrums." AATCC Review 5, no. 9 (2005): 14.

Jirsák, O., and L. C. Wadsworth. Nonwoven Textiles. Durham, NC: Carolina Academic Press, 1999.

Williamson, J. E. "Wet-laid Systems." In *Nonwovens: Theory, Practice, Performance, and Testing*, edited by A. F. Turbak, 139. Atlanta: TAPPI Press, 1993.

Recommended Readings

"Bark Fabrics." CIBA Review May (1940).

"Felt." CIBA Review 129 (November 1958).

Turbak, A. F. *Nonwovens: Theory, Process, Performance, and Testing.* Atlanta: TAPPI Press, 1993.

OTHER FABRIC CONSTRUCTION METHODS

Learning Objectives

- 1. Distinguish multicomponent fabrics from other textile structures.
- 2. Compare different methods for making carpets.
- 3. Describe the materials and processes for making other multicomponent textiles.
- 4. Contrast the methods for making the various knotted fabrics.

Although woven, knitted, and nonwoven fabrics make up the largest quantity produced, various other construction methods are also used for the fabrication of textiles. Many of these techniques derive from processes used since prehistoric times, others have been developed more recently, and some are the result of new technology within the textile industry. The fabrication methods discussed in this chapter were introduced briefly in chapter 15. They are described here in more detail.

MULTICOMPONENT FABRICS

When readers reach this point in the text, they will have learned how fibers are produced, how yarns are made from those fibers, and how fabrics can be made from yarns or fibers. It is also possible to create products by combining two or more of these textile materials (fibers, yarns, and fabrics) into textile products that can be called *multicomponent fabrics*. Some multicomponent materials, such as quilts, have been used for centuries. Other multicomponent fabrics may rely on high technology to create composite structures used in the aerospace and construction industries.

The two most widely used, and widely different, composite structures are carpets and textile composites.

CARPETS

Carpets have three-dimensional structures that are achieved by stitching pile yarns into a base fabric or by special weaving processes that include base yarns and pile yarns. The first technique is called *tufting*, and more than 90 percent of the carpet produced in the United States is constructed by this method. The weaving methods for carpets are variations of the pile weaves described in chapter 17 but are presented here to include all common carpet construction techniques in one section.

Tufting

Tufting is the process of punching a first component, loops of yarn, through a second component, a woven or nonwoven backing material. It grew out of the hand craft of "candlewicking" that was practiced in the mountain areas of Georgia, Tennessee, and North Carolina in the early twentieth century. In candlewicking and in hand-tufting, a hook is passed through the backing material, a loop is formed on the outside of the backing, and the needle is pulled back to the wrong side, leaving the loop to form the pile on the surface of the fabric. Loops can be left uncut or can be cut to create a fluffy surface. As this process became mechanized in the 1950s, its roots remained in the same area in the southeast, which is why the tufted carpet industry in the United States today is concentrated in northeast Georgia (Walters and Wheeler 1984).

Machine-made tufted fabrics are created in much the same way as hand-tufted fabrics except that many needles punch through the fabric at the same time. A hook holds the loop in place when the needle is withdrawn. If a cut pile is being made, this hook has a small blade that cuts the loop. (See Figure 20.1.) Tufted fabrics are easily identified by the parallel rows of stitches on the wrong side of the fabric.

For carpeting, tufts of pile yarn are stitched into a woven primary backing. For many years the primary backing was composed of coarse jute yarns but now is almost exclusively polypropylene. (See Figure 20.2.) The back of the carpet is given a coating of latex for greater stability and strength and to hold in the tufts. A secondary backing fabric, also usually of polypropylene, may be applied and bonded by the latex.

Compared to more traditional methods of pile carpet construction, tufting is faster, does not require such highly skilled craftspersons, and requires less expensive equipment to manufacture. Although lower in cost than most other constructions, tufted carpet is not necessarily inferior in quality. The quality of carpets is more dependent on the fibers, yarns, backing materials, and the closeness of the pile than on the construction. Types of pile seen in tufted carpets are shown in Figure 20.3.

The major limitations in tufting are in the area of design. Jacquard-type designs cannot be made, although design variations can incorporate cut and uncut pile or higher and lower levels of loops or cut pile. Recent innovations in tufting machines now make possible the use of different-colored yarns to create patterns in the carpet. Designs can also be printed on the surface of the carpet.

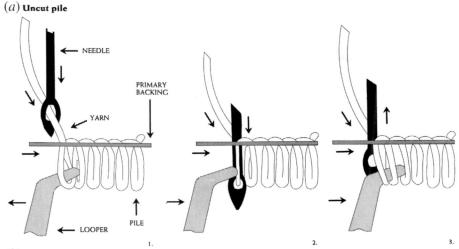

(b) Cut pile

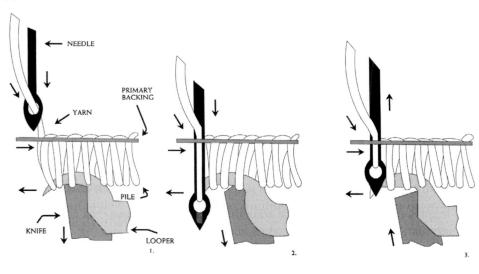

FIGURE 20.1

In tuffing process, looper below primary backing holds loop of yarn as needle withdraws (a). For cut pile carpet (b), a knife cuts across the loop as the needle withdraws.

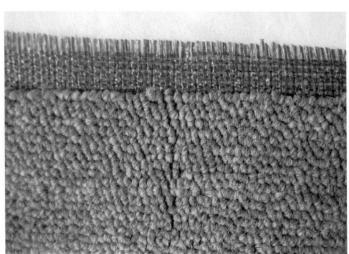

FIGURE 20.2

Tufted carpet showing polyproplyene carpet backing.

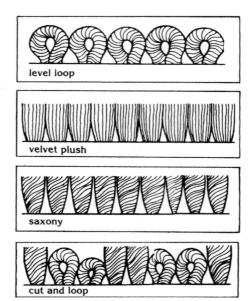

FIGURE 20.3

Various types of carpet pile. Reprinted from How to Choose Carpets and Rugs. Courtesy of the Carpet and Rug Institute.

Other Machine Carpet Constructions

In addition to tufting, several other major types of pile carpet construction are available. The names of the processes used for weaving carpets have become standard terminology in the carpet industry. Many of these are very sturdy and can be woven in intricate designs that help hide wear and soiling.

Velvet-weave Carpets

Velvet-weave carpets should not be confused with velvet-surface carpets. The term *velvet weave* refers to the construction of the carpet, the pile of which may be either cut or uncut. Simple in construction, the weave is similar to the construction of lighter-weight pile fabrics made by the wire method. (See Figure 20.4.) The

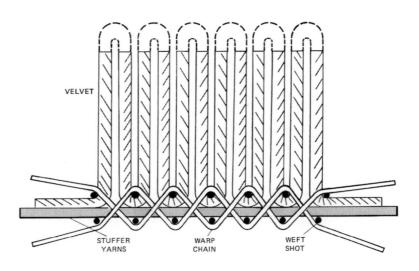

Velvet carpet construction. Courtesy of Bigelow-Sanford, Inc.

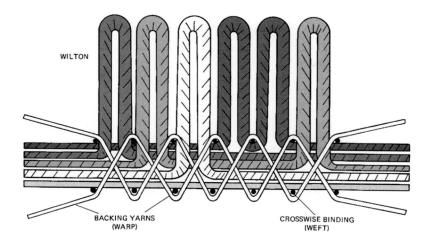

FIGURE 20.5
Wilton carpet construction. Courtesy of
Bigelow-Sanford, Inc.

pile is formed by wires inserted between the pile warp and ground yarns. The loops that are formed are held in place by the interlocking of filling yarns with the pile. The ground warps are also interlocked with the filling. Velvet-weave carpets are usually made in solid colors, but tweed effects can be created with multicolored tweed yarns. The cost of these carpets is moderate to low.

Wilton Carpets

Wilton carpets are made on a special Wilton loom. This loom is essentially a velvet loom with a jacquard attachment that can work with up to six different colors. Patterns in Wilton carpets are woven, not printed. When yarns are not utilized in the surface design, they are carried along on the back of the carpet. (See Figure 20.5.) This makes for a dense, strong construction. Wilton carpets of good quality are among the longest-wearing machine-made domestic rugs. Piles may be cut or uncut; loops may be high or low.

Both velvet-weave and Wilton carpets are extremely durable and are often found in offices and public buildings ("contract installations" as opposed to home, or "domestic," use).

Axminster Carpets

Axminster carpets have the greatest versatility in machine-produced carpets in utilizing color. The loom draws pile yarns from small spools wound with yarns of various colors as they are needed for the design. These carpets have a one-level, cut pile, although textured effects may be attained by varying the twist or type of yarn used. (See Figure 20.6.) Carpets made on an Axminster loom are readily identifiable because the construction produces a heavy ridge across the back of the carpet, and the carpet can be rolled in only the lengthwise direction. The quality of carpets made on the Axminster loom is medium, but they are the only machinemade carpets that can have woven-in designs similar to those in oriental carpets. Recent advances in gripper weaving technology have increased the speed of Axminster looms, making this method more competitive with tufting.

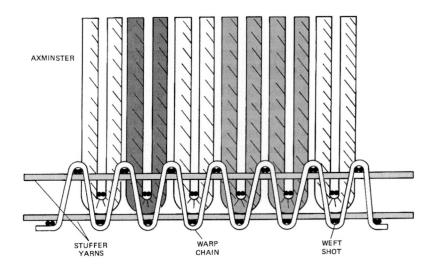

FIGURE 20.6

Axminster carpet construction. Courtesy of Bigelow-Sanford, Inc.

Chenille Carpets

Chenille carpets are the most expensive and the most luxurious of all machine-made carpets and are rarely found. They are constructed by first making chenille yarns, called *caterpillars*, in a separate operation. (See chapter 13.) The caterpillars are then woven into the carpet. The chenille yarns are used in the filling direction and are actually sewn into place. Chenille carpet pile is cut; carpets are made in solid colors; and the pile is dense, close, and velvety in texture.

Carpets can also be made by knitting; needlepunching, as discussed in chapter 19; and flocking, as described later in this chapter. Designs can be added to carpets by printing as well as by weaving. Plain-colored carpets can be achieved by using colored yarns or by dyeing the carpet itself.

See Take a Closer Look in this chapter for more information on the construction and use of residential wall-to-wall carpet.

Handmade Carpets

In addition to mass-produced, machine-made carpets, one-of-a-kind, handwoven carpets are also made. Many handwoven carpets are made in the Near or Far East, using traditional designs, and are known as *oriental carpets*. Both antique and contemporary versions of these traditional design carpets can be purchased. Oriental designs can be printed or woven into machine-made carpets, but true orientals are made by hand-knotting a pile of wool or silk yarns to a woven base of cotton or wool. The quality of these carpets depends on the density rather than the length of the pile. There is a lively trade in new and antique oriental carpets, and prices are high. Purchasers should deal with only reputable merchants who can be depended on not to sell counterfeit merchandise.

Rya rugs, another handmade area rug type, are imported from the Scandinavian countries. These rugs have a long "shag" pile and are generally woven in contemporary designs.

Some traditional early-American-style rugs are made not by weaving, but from strips of cloth braided or sewn together. Still others are made by hooking, a

TAKE A CLOSER LOOK

Residential Wall-to-Wall Carpet

Textile floor coverings are generally referred to as carpets or rugs, terms that are often used interchangeably. The term wall-to-wall carpet is used to distinguish carpeting that covers the entire floor of a room from an area carpet, a rug that covers only part of the floor. Although the following discussion focuses on wall-to-wall carpet for residential interiors, the principles would apply to area rugs of the same construction as well. Carpeting is one of the most costly textile products considered in designing interiors. For such a major investment, informed purchase is essential.

The first step in making an informed choice is to analyze the area to be carpeted. What kinds of activities will take place in the area? What will the traffic patterns be? Who will use the area—adults, children, and/or pets? Armed with a thorough understanding of the demands that will be made on the carpet, the designer or consumer can move on to examine available alternatives.

Carpet is usually made from nylon, olefin, polyester, acrylic, or wool fibers. Individual chapters on fibers give detailed descriptions of their properties. The qualities of these fibers contribute to their use in carpets.

Nylon accounts for about 80 percent of carpet pile fibers. It resists abrasion, wear, and staining; dyes to a wide variety of colors; and is easy to clean. Olefin (polypropylene) resists abrasion and is readily cleaned. Generally, the color is added before the fiber is formed, making it colorfast. Resistant to stains, moisture, and mildew, olefin carpeting is often used outdoors as well as indoors, especially in areas such as playrooms and kitchens. Polyester can have an attractive texture, clear colors, and high luster. It is resilient, resists water-soluble stains, and is easily cleaned. The newer polyester, PTT, has superior resilience, similar to that of nylon. Acrylic fibers resist moisture, mildew, and water-soluble stains. They can look and feel much like wool. The vast majority of carpets are made from manufactured fibers such as these; only about 3 percent are wool, which is generally more expensive. Wool is resilient and durable, can be dyed a wide range of colors, and has a luxurious appearance.

Many fiber manufacturers produce trademarked fibers especially for carpet use. Vendors and retailers can readily supply information about whether fibers have been engineered or carpets finished to incorporate antistatic or antisoiling qualities.

This chapter describes in detail the manufacture and construction of the various types of carpet. The type of pile will affect the appearance and performance of the carpet. Pile can be cut or uncut (also called loop pile) or a combination of cut and loop pile, which produces a sculptured surface effect. Single-level loop pile has a smooth surface with all loops the same size. In multilevel loop pile, the loops are two or three different heights, often producing an interesting patterned effect on the surface. Cut-pile carpets include velvet (not to be confused with velvet construction), or plush, surfaces. Their yarns have little twist and a level surface. Saxony-pile carpets, made with yarns of two or more plies heat-set to lock in twist, produce a texture in which individual yarns are more distinct than in velvet pile. Frieze-pile varns are tightly twisted to produce a nubby effect. Figure 20.3 illustrates some common varieties of carpet pile.

The most important factor in durability is pile density: the closer and denser the pile yarns, the better a carpet will wear. To evaluate pile density, fold the carpet back on itself and look through the pile at the backing. The more visible the carpet backing, the lower the density of the pile. Pile with yarns of the same length distributes wear evenly across the surface of the pile. Footprints do not cause flattening or shading of pile made with tightly twisted yarns, as do those in frieze and some uncut-pile carpet, which tend to be more durable and suitable for high-traffic areas.

Generally, wall-to-wall carpet is installed over a carpet pad or cushion. The carpet manufacturer will have information on the type of padding appropriate for a particular carpet. Incorrect installation or use of improper padding may void carpet warranties; therefore, purchase from and installation by a reputable dealer is essential.

Although construction, fiber content, and installation determine the wear life of a carpet, its selection is based to a significant extent on color, texture, or printed or woven design. A natural characteristic of cut-pile fabrics is the "shaded" effect that results from light reflecting off different areas of pile, which do not all fall in the same direction. Footprints are more apparent in cut-pile carpets.

Color and design are related not only to appearance, but also to performance. Soil is generally tracked onto carpets from uncarpeted areas or from the outdoors. Those living in geographic locations where the soil is dark will find darker-colored carpets

TAKE A CLOSER LOOK

continued

more practical, but those with light-colored soil will notice that dark carpets will show soil, dust, and lint, and lighter colors may be more practical. Tweeds, multicolored patterns, and nubby textures tend to hide soil. Many carpets sold today have been treated with a stain-blocking finish.

Other than soiling, the most serious consumer concern with cut-pile carpeting is wear. In heavy-traffic areas, carpet will begin, after some time, to look worn down and matted. This is because the tips of the pile yarns untwist and flatten, becoming entangled with their neighbors. When this happens, the yarns have lost their "tuft definition," and the carpet has lost its new appearance. Carpets with higher twist pile yarns and higher pile densities will retain a better appearance longer because the yarns will not untwist

as easily. Carpet yarn manufacturers produce yarns today to maintain their tuft definition.

Proper care can extend the wear life of carpeting. Soil accumulating at the base of carpet pile abrades and cuts the fibers, so frequent vacuuming to remove soil particles is important. Stains should be removed immediately. Carpets also require periodic cleaning that goes beyond vacuuming. The Carpet and Rug Institute recommends that deep cleaning be done once every twelve to eighteen months. If you do it yourself, check with your retailer about procedures. Do not rub carpeting vigorously, either to remove stains or for general cleaning, as this will accelerate the loss of tuft definition and result in a matted appearance. Most communities have reputable professional carpet cleaning services.

hand process similar to tufting in which yarn or fabric strips are punched or pulled through a woven backing with a special hook.

TEXTILE-REINFORCED COMPOSITES

Textile-reinforced composites are a technological development of the last quarter of the twentieth century. They generally consist of one or more textile components impregnated with or embedded in a resin matrix. (See Figure 20.7.) The textile components may be fibers; yarns; nonwoven mats; or woven, knitted, or braided fabric structures. Any of a number of high-technology fibers can be used, but at present these are most likely to be high-strength, high-modulus glass, carbon, ceramic, or aramid fibers. Glass fiber predominates as a reinforcing fiber (Ogin 2000). Polymers commonly found in the matrix phase of composites are polyester, polypropylene, polyethylene, and epoxy. Generally the cheaper composites are glass in a polyester, while higher-tech, higher-cost composites are carbon in epoxy.

The resulting products have high strength and light weight and can be molded into a variety of shapes. In most reinforced composites, the fibrous materials make up 65 percent or less of the total volume.

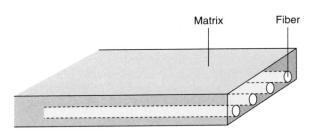

Several different methods can be used to produce textile composites.

- 1. Yarns or fabrics are impregnated and mixed with the resin, forming what are called *pre-pregs*. The pre-preg is then placed in a mold or on a flat or shaped surface. Heat is applied to cure the resin and set the shape.
- 2. Fibers, yarns, or fabrics are placed in a mold, and the resin is added and cured. Layers can be arranged as required for purposes of the final product. For example, reinforcing fibers may be laid one over the other with fibers running in the same or different directions to provide strength in a particular area.
- 3. In a process known as reaction injection molding (RIM), the textile reinforcement is placed in the mold, and the monomers that will make up the polymer resin are injected. They react to form the polymer then fill the mold around the fibers, where they are cured.
- 4. If hollow or spherical composites are required, an alternate construction method called *filament winding* may be used. In this process a continuous yarn or roving is fed through a resin bath then wound on a form of the correct shape. When the desired thickness is reached, the resin is cured.

Like the reinforcing cords in tires, one of the most important factors in composite production is the adhesion between the reinforcing material and the matrix. The reinforcing textile is added to the composite to increase the tensile, compressional, or impact strength of the matrix material. To do this, the load must be transmitted from the matrix phase to the fiber phase. If the fiber and resin phases separate, the load sharing is not maximized. Glass fibers, for example, are treated with coupling agents to increase their adhesion to polyethylene and polyester resins.

Uses for textile-reinforced composites were discussed in chapter 12 under high-performance fibers. They can be seen not only in aerospace structures, but also in sporting equipment and molded parts for automobile interiors. As governments mandate recyclable materials for cars, high-modulus cellulosic fibers such as flax and kenaf are being investigated as reinforcing fibers in a matrix of a biodegradable plastic.

OTHER MULTICOMPONENT FABRICS

Embroidery

The technique of embroidery, which is a method not of constructing fabrics, but of decorating them, uses two components: a fabric base and a yarn that decorates it. The effects it produces are similar to those achieved by the surface weaves discussed in chapter 17.

Embroidery is the use of yarns applied with a needle in a variety of stitches to form a decorative pattern. Embroidery is a skill that has been practiced for many centuries. Translations of writings from classical Greece include many references to fine embroideries. The ancient Greeks considered weaving and embroidery to be fitting occupations for goddesses and noblewomen. One Greek textile showing evidence of embroidery has been dated at 500 BC and provides some of the earliest evidence of the embroidery skills. It is believed, however, that embroidery was practiced long before this date (Wace 1948).

Embroidery is often used in conjunction with *appliqué*. Appliqué also uses two components: a fabric base and small, decorative pieces of cloth. The cloth is cut and attached to the surface of the larger textile to create a design. The decoration of fabrics by appliqué is an old technique. Archeologists have identified appliqués from as early as the fifth century BC. These early forms were wall hangings or carpets in which the base material was felt and the designs were formed with other, smaller pieces of multicolored felt. Because appliqués are most often attached to the base fabric by hand stitches, it is common to see them combined with embroidery.

A wide variety of different types of embroidery and embroidery stitches has been developed in all parts of the world. Each area originated a style with a distinctive repertoire of stitches and decorative motifs. One of the most famous decorated textiles ever made was created by embroidery. Called the Bayeux Tapestry, this representation of the conquest of Britain by the Normans is actually a large embroidery, not a tapestry. On its 231-foot length and 20-inch width, seventy-two embroidered pictures show the sequence of events that led to the Battle of Hastings and the conquest of England by William the Conqueror in 1066. The embroidery, made almost nine hundred years ago and now discolored with age, is displayed in a museum in Bayeux, France.

American embroidery forms originated in Europe, especially in England. From the general category of embroidery, a number of specialized forms have broken off to become separate art crafts. These include crewel embroidery, cross-stitch embroidery, and needlepoint.

In embroidery different stitches are used to outline and fill in the design. The choice of stitch is usually related to the effect the sewer wants to achieve. Different fiber and yarn combinations can provide a variety of fabric effects. Some better known embroidery stitches are the following:

- 1. *Crewel* embroidery is done with crewel wool, a loosely twisted fine yarn that was probably named after the English town of Crewel. Traditional crewel embroidery uses stylized forms and a repertoire of specific basic stitches.
- 2. *Cross-stitch* is made of two stitches that cross in the center to form an *X*. One of the simplest of the embroidery forms, it was the first embroidery technique taught to young girls in colonial times to make samplers or to decorate all kinds of household articles. Cross-stitch is still a popular hand craft today.
- 3. Needlepoint embroidery covers a canvas base with thousands of tiny stitches. It is seen in many antique chair covers and other articles. Needlepoint has its own repertoire of specialized stitches that are selected according to the pattern they will make in the often complex needlepoint design.

Machine Embroidery

When machines create embroidery, the embroidery is not accomplished as an integral part of the weaving process but is applied to the cloth after it is completed. (See Figure 20.8 and figure CP4B on Color Plate 4.) The Schiffli embroidery process, developed in Switzerland, requires as many as a thousand needles. Designs can be applied to all weights and types of fabrics. When used on sheer fabrics, these

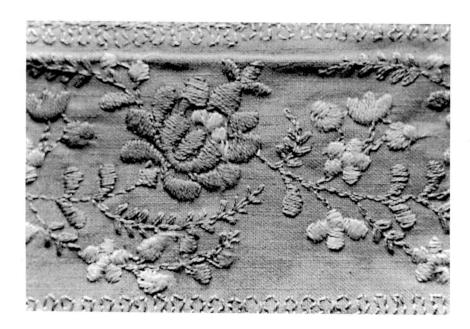

FIGURE 20.8

Machine-made Schiffli embroidery

embroideries can have the appearance of lace. Schiffli is the predominant method used for applying embroidered designs to fabric yardage.

Other machines are used to embroider individual apparel items or decorative textiles. A recently developed embroidery process can create designs from a number of colored threads with only a single needle as it automatically changes colors and splices yarns together. (See Figure 20.9.) Not all hand embroidery stitches can be created by machines, but through computer technology, design changes and stitch variations can be accomplished quickly and easily. Embroidered logos on shirts, caps, and other items have largely replaced less permanent screen and transfer prints (Anderson 2005).

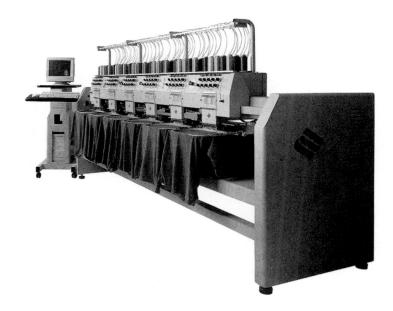

FIGURE 20.9

Six-head embroidery machine that can embroider up to 1,200 stitches per minute. Courtesy of Melco Embroidery Systems.

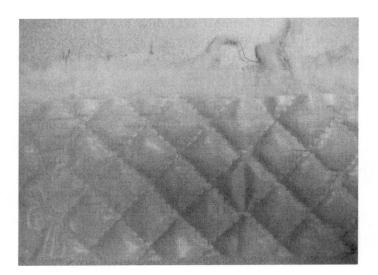

FIGURE 20.10

Quilted fabric showing face fabric and batting.

Quilted Fabrics

Quilted fabrics have been made for centuries. Quilted fabrics use at least three components, as a general rule. A filling material (usually cotton batting, wool, or down) is sandwiched between two layers of decorative outer fabric. (See Figure 20.10.) The top decorative fabric is traditionally constructed of small patches of fabric pieced together to form a design. The layers of the quilt are sewn together with strong thread in selected areas to keep the filling material from shifting about. The location of the stitches forms a padded design that might take geometric, floral, or other shapes. (See figure CP4C on Color Plate 4.)

Many quilted fabrics are produced commercially for apparel or household use. The performance of quilted fabrics is related to the closeness of the quilting stitches, the size of the stitches, the type of thread used for stitching, the durability of the outer fabric, and the type of filling or batting.

If stitches are spaced too far apart, the filling will shift about and become uneven. If quilting stitches are too large, stretching of the cloth will tend to break the thread. The outer fabric layer should have high fabric count and a balanced weave. Well-balanced fabrics will have better abrasion resistance and durability. A close weave is also important if the filling is not to work its way out through the covering fabric. Polyester fiberfill has, to a large extent, replaced cotton and other natural fillers because of its easy-care aspects. Down-filled comforters or quilts require the use of an inner layer of downproof ticking, a dense, closely woven fabric that prevents the escape of small bits of down.

Quilting has enjoyed somewhat of a renaissance as a hand craft, elevated to an art form. Quilt designers compete in shows throughout the world, and quilts from earlier days are valued as antiques. A number of companies supply materials specifically to the hand-quilting market.

New Commercial Quilting Techniques

Changes have taken place in the methods by which some quilted fabrics are produced. Instead of sewing quilted fabrics with thread, bonding may be done

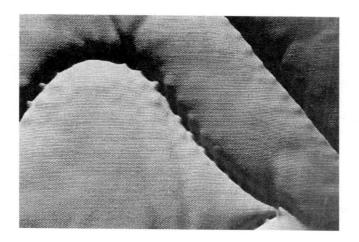

FIGURE 20.11

Close-up photograph of sonically quilted fabric, where heat was used to fuse thermoplastic elements of the quilt.

with heat or adhesives. Thermal bonding requires that all components be thermoplastic. The heat application causes the components to fuse together in the heat-stitched areas. One of these techniques uses high-frequency, ultrasonic vibrations to generate the heat in the stitching device. (See Figure 20.11.) This sonic sewing can be used to construct apparel and household textiles made from synthetic fibers.

Another technique used to produce raised surface patterns with layered fabrics places a layer of fabric that is not thermoplastic over fabric, foam, or fiberfill that is thermoplastic. A design is printed on the fabric with a special chemical, which holds the layers together in the printed area. The fabric is subjected to heat, which causes the backing fabric to shrink, thereby producing a raised pattern on the face fabric.

Laminated or Bonded Fabrics

The terms laminated and bonded are defined by the ASTM (1998) as follows:

bonded fabric—a layered fabric structure wherein a face or shell fabric is joined to a backing fabric, such as tricot, with an adhesive that does not significantly add to the thickness of the combined fabrics.

laminated fabric—a layered fabric structure wherein a face or outer fabric is joined to a continuous sheet material, such as polyurethane foam, in such a way that the identity of the continuous sheet material is retained, either by the flame method or by an adhesive, and this in turn normally, but not always, is joined on the back with a backing fabric such as tricot.

Several different methods can be used to join fabric to fabric, fabric to foam, or fabric to foam to fabric.

Fabric-to-Fabric Bondina

When two layers of fabric are joined, the purpose is to provide greater stability and body to the face fabric or to create a self-lined fabric. The underlayer in bonded fabrics is often knitted tricot or jersey, used because they have good flexibility, are relatively inexpensive, and slide readily, making them easy to don over

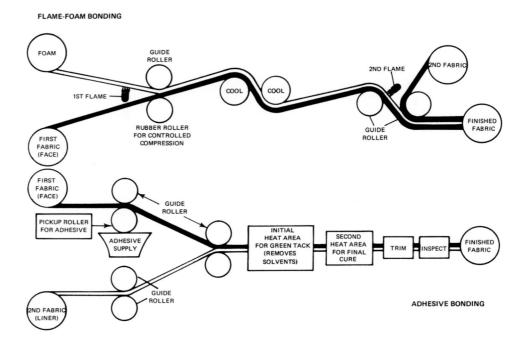

Flame-foam and adhesive bonding of laminated fabrics.
Courtesy of Hoechst-Celanese Corporation.

other garments. For the most part, fabrics used in bonding are less expensive and lower-quality fabrics that can be upgraded by this process.

Two methods can be used for attaching fabric to fabric. The *wet-adhesive method* places an adhesive material on the back of the face fabric, and together the fabrics are passed between heated rollers that activate and set the adhesive. (See Figure 20.12.) In the *flame-foam method*, a thin layer of polyurethane foam is melted slightly by passing it over a flame. The two layers of fabric are sandwiched around the foam, which then dries, forming the bond between the two layers of fabric. Ideally, the layer of foam should be so thin that it virtually disappears. (The foam in the finished fabric is about 0.010 inch thick.) The foam does, however, add body to the fabric and produces a somewhat stiffer fabric than does the wet-adhesive method. It is preferable that the flame-foam method not be used with open-weave fabrics because of the possibility that some of the foam may appear on the surface of the fabric.

Fabric-to-Foam Lamination

Fabrics are laminated to polyurethane foam when it is desirable to provide some degree of insulation. Winter coats and sportswear, for example, are made from these fabrics. The flame-foam process can be used to manufacture such fabrics. A thick layer of foam is utilized. Only one side of the foam, that to which the fabric attaches, must be heated. Still another foam process flows the sticky foam onto the fabric, cures the fabric, and causes the foam to solidify and adhere to the fabric at the same time.

When laminates first entered the retail market, customers found wide variation in the permanence of the bonding. Some fabrics separated during laundering,

others separated during dry cleaning, and still others separated during use. Often the backing and face fabrics shrank unevenly, causing wrinkling and puckering. Many of these problems have been overcome.

Recent Developments in Lamination

The older technique of lamination has been applied to some newer materials. With the success of Gore-Tex[®], special attention has been given to the creation of fabrics made by layering conventional fabrics with thin, microporous films that transmit moisture. (See discussion of water repellency in chapter 25.) Such fabrics require extreme precision in application of adhesive materials if the finished product is to transmit vapor and also drape well. In addition to its use in rainwear, vaportransmitting film laminates are used in clean-room clothing (that must be free of all contaminants), medical barrier products, and molded automotive parts.

Molded automobile seats traditionally required a labor-intensive sewn upholstery process. In the laminated process, molded seats are covered with a film component to which a urethane foam is attached, and the upholstery fabric is laminated to the urethane foam.

Flocked Fabrics

A surface effect that is similar to a nap or a pile may be created by flocking, a process in which short fibers are "glued" onto the surface of fabrics by an adhesive material. If the adhesive coats the entire surface of the fabric, the flocking will cover the entire surface of the fabric, but if the adhesive is printed onto the fabric in a pattern of some sort, the flock will adhere only in the printed areas. All-over flocked fabrics may have a suedelike appearance.

Short lengths of fiber flocking can be made from any generic fiber type. Rayon is often used for flocking. Nylon may be selected for situations that require good abrasion resistance.

Fibers for flocking are made from bundles of tow fiber (continuous filament fibers without twist). The tow is fed through a finish-removal bath then into a bank of cutters that cut flock of the desired length. The fibers may be dyed as tow after they are cut but before they are attached to the fabric, or the completed fabric may be dyed.

The base fabric for flocking is often a relatively coarse, unbleached cotton. The flock is applied to the fabric in one of two methods. The mechanical flocking process sifts loose flock onto the surface of the fabric to be coated. A series of beaters agitate the fabric, causing most of the fibers to be set in an upright position, with one end of each fiber "locked" into the adhesive. (See Figure 20.13.)

The second method causes the fibers to be attached in an upright position by passing them through an electrostatic field. The fibers pick up the electric charge and align themselves vertically. One end penetrates into the adhesive, and the flock is formed. Electrostatic flocking ensures more complete vertical positioning, and the resultant fabrics are of better quality. It is a more costly process. When buying fabrics, a consumer cannot tell which process was used.

The durability of flocked fabrics depends largely on the adhesives that hold the flock firmly during either laundering or dry cleaning. In some cases flock may

Figure 20.13
Application of flock to fabrics.

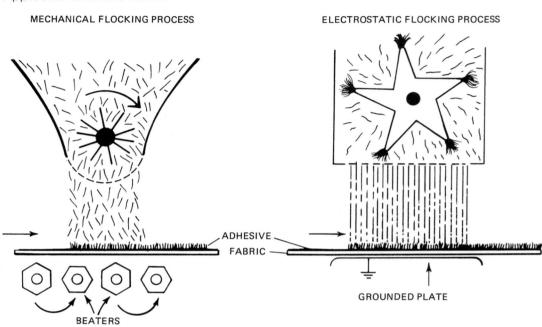

be removed by dry-cleaning solvents. Permanent-care labels should tell the consumer how to handle flocked fabrics. A second factor in the durability of flocked fabrics has to do with the fiber from which the flock has been made.

Flocked fabrics can be printed, or designs can be embossed into them. An additional means of decoration is by playing jets of air onto the fabrics before the adhesive is cured, giving rise to a pile that lies in different directions.

Fiber and Textile Wall Coverings

Textile products used in interior design include laminated materials that are affixed to walls. They are generally made by attaching fibers or fabrics to cloth, foam, or paper backings. The backing is attached to the wall with adhesives. Fibers often used include linen, silk, cotton, wool, jute, manufactured fibers, or blends. Other popular materials are simulated suede produced by flocking and flocked printed designs.

When selecting textile wall coverings, consumers should avoid those made in wide sections as the fabrics may sag. Fibers or fabrics that do not shrink are important if climates are humid and because moisture from the water-based adhesives can pass through to the surface. Woven fabrics should have a close weave and be of at least medium weight so stains from the adhesive will not pass through the fabric.

Many of these wall coverings are treated so they are washable. Selection of fiber or fabric wall coverings should take into account the properties and characteristics of fibers, yarns, and fabric structure as they relate to the anticipated use of the areas where they are placed. For example, if fabrics, especially simulated suede or flocked materials, are located in high-traffic areas where they are subject

Figure 20.14

Fabric wall covering showing fibers pulled from the surface due to abrasion.

to abrasion, the surface fibers may wear off. (See Figure 20.14.) Wall coverings made from fibers that are damaged by sunlight or fabrics colored with dyes that are not colorfast to sunlight should not be used in areas that have extended exposure to direct sunlight.

Hybrid Fabrics Using Polymer Films

Fabrics coated with polymer films are used for a variety of products ranging from apparel to tablecloths. ASTM defines a *coated fabric* as "a flexible material composed of a textile fabric and an adherent polymeric material applied to one or both surfaces" (ASTM 1998, 14). Coatings may be solid films or *poromerics*, products with microscopic, open-celled structures used to produce leatherlike materials. These multicomponent coated fabrics should be distinguished from fabrics that may have a special finish applied. (See chapter 25 for a discussion of chemical finishes.)

Coated Fabrics

Fabrics can be coated with thin polymer films to provide protection or to simulate leather or other materials. Polymers most often used are polyvinyl chloride (PVC) and polyurethane. The coating provides much of the "performance" of the total fabric, and pigments or flame retardants can be included in the coating layer. The coating is often applied as a viscous melt or solution with a stationary knife spreading it onto a moving fabric, rather like a knife spreading butter.

PVC-coated fabrics, often just called vinyls, are used to produce leatherlike and protective materials. Vinyl-coated fabrics may have an imitation leatherlike grain embossed on the surface. These are the least satisfactory leather imitations in terms of both aesthetics and performance. Fabrics are cold and hard to the touch and do not allow the transmission of moisture vapor. Expanded vinyls are manufactured so as to have internal air bubbles that improve flexibility and cause the material to feel warmer and softer. Urethane-coated fabrics are even more leatherlike in their qualities.

Lamination of extremely thin films to fabrics of Lycra[®] spandex/nylon has been used in the manufacture of lightweight, stretchable fabrics. The Lycra[®]/nylon layer is bonded to a urethane film with a special urethane adhesive system. Marketed under the trademark of Darlexx[®], these fabrics are capable of passing moisture vapor for comfort. The fabrics are particularly suitable for active sportswear where warmth as well as stretch are important.

Garments for weather and water protection or protection from harmful substances are often made from coated fabrics. Vinyl films may be bonded to fabrics for rainwear, or more resistant polymer materials can be used. Elastomeric polymers can provide more stretch, and therefore comfort, than vinyl coatings. Chloroprene synthetic rubber is a good coating for garment fabrics for industrial workers who may be exposed to chemical spills or splashes.

Apparel items made from film-coated fabrics vary in their care requirements. Consumers should follow care label instructions carefully as some products must be laundered; others can withstand dry cleaning.

Coated fabrics are used in luggage, sailcloth, tent materials, and tarps. There is a large use of coated fabrics in architectural textiles and as substrates for printed banners.

Poromerics

Poromeric structures more closely match the moisture vapor permeability and other qualities of real leather. Poromerics are produced by forming a microporous web of urethane, which is extruded onto a suitable support, usually a woven, knitted, or nonwoven fabric structure. A suedelike finish may be achieved by brushing and napping the polyurethane surface.

Certain of the techniques for creating suedelike fabrics, however, rely on more sophisticated fiber-forming technologies. Ultrasuede[®], the trademark name of a suede-type fabric, was developed by Toray in Japan. It is a multicomponent nonwoven fabric composed of polyester microfibers. The nonwoven web is mechanically bonded by needlepunching or hydroentangling and impregnated with polyurethane and the surface brushed to create the suedelike texture.

The soft hand and smooth suede appearance of the fabric are attributable to the microfibers in the structure. As a nonwoven, it will not stretch out of shape or fray at the edges. Ultrasuede[®] also has good resistance to wrinkling, pilling, and color loss. It is hand or machine washable, dry-cleanable, colorfast, and will not water spot. It is used in coats, jackets, and hats and for furniture, wall coverings, and luggage. Like some of the woven pile fabrics described in chapter 17, this simulated suede fabric has a nap, so special care must be used by home sewers using this fabric. Needle and pin holes will remain, as is the case with leather, so care must be taken to avoid ripping and pinning in areas where holes would be evident.

FIBRILLATED FILMS

Film fibrillation as a means of forming yarns was discussed in chapter 14. Film fibrillation can also be used to create fabrics directly from polymer films. After extrusion the films are embossed, thereby thinning them in selected areas. The embossed film

is then stretched in the lengthwise and crosswise directions, and the film breaks apart in the weak areas to form a netting. The fabrics produced by this means may be used alone, as facings for other fabrics, or as supporting scrims between layers of fabric.

STITCH-BONDED FABRICS

Stitch bonding is not only used for mechanically bonding nonwovens, but it is also a technique for producing and reinforcing other fabrics. Known variously as *stitch bonding, stitch through, stitch knitting,* or *mali* (from one machine used in its manufacture), it produces fabrics for industrial; household; and to a lesser extent, apparel uses. Heinrich Mauersberger, an East German inventor, developed the stitch-bonding concept after observing his wife mending a fabric in which the filling yarns had been worn away. Mauersberger assigned the trademark Malimo to his process and the fabric it produced.

Stitch bonding offers manufacturers the advantages of faster speeds than knitting or weaving and can be produced at lower costs, not only because of increased volume of production, but also because less fiber or yarn is required. Some stitch-bonded fabrics have greater bursting strength and tearing strength than comparable woven fabrics.

One group of stitch-bonding machines constructs fabrics from yarn. Warp and filling yarns are laid loosely, one over the other. A third set of yarns stitches the warp and weft yarns together. (See Figure 20.15.) It is also possible to use filling yarns alone, holding them in place with overstitching. These fabrics are called Malimo fabrics by the Mayer Textile Machine Corporation, which has acquired the Malimo Company. The fabrics are used as industrial textiles, furnishing fabrics, and household textiles. (See Figure 20.16.)

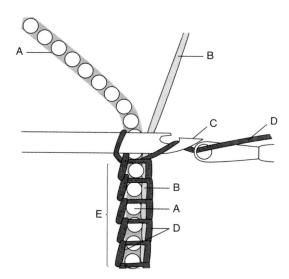

FIGURE 20.15

Schematic showing how stitchbonded fabrics are made from warp and filling yarns. A. Filling yarns, shown in cross-section, being fed into the mechanism; B. Warp yarn; C. Compound loop-forming hook; D. Stitch-bonding yarn; E. Completed fabric with warp and filling yarns held together by stitch-bonding yarn.

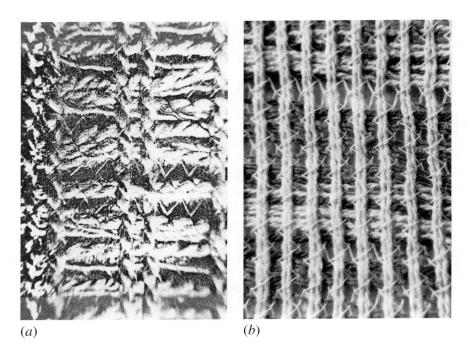

Figure 20.16
Fabrics constructed by the stitch-through technique.

Another yarn-based stitch-bonding technique, Malipol, creates single-sided pile fabrics by stitching pile yarns onto a woven, knitted, nonwoven, or stitch-bonded fabric base. The resulting fabrics have the appearance of plush, terry cloth, or velour and are used in apparel and as lining fabrics, upholstery fabrics, and imitation fur fabrics. The Schusspol stitch-bonding machine also produces pile fabrics by stitching warp, filling, and pile yarns together at the same time, and it does not require a preformed base fabric. Applications include carpets and other floor coverings, upholstery, and terry fabrics.

Nets

Nets are created by looping and knotting a continuous strand of yarn into an open mesh. In use since prehistoric times for trapping fish, birds, and other small animals, nets also have a long history as decorative fabrics. Egyptian burial chambers, for example, contained fabric made from open-work net with embroideries of pearls and precious stones.

Most netted fabrics are made with either a square or diamond-shaped mesh. The hand process is a fairly simple one of looping and knotting to form an open-work fabric. True nets have knots, not just loops. Contrast this with Raschel knitting (as described in chapter 18), which produces open-mesh fabrics without knotting. The decorativeness of the net can be increased by embroidering designs on the open mesh. The terms *filet* work or *lacis* are applied to decorated nets, which are often classified as a type of lace.

Machine-made nets are manufactured on a bobbinet lace machine. Raschel or compound-needle tricot knitting machines also produce fabrics similar in

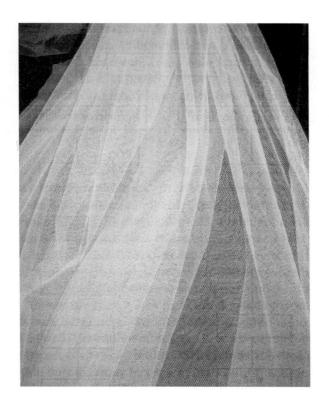

FIGURE 20.17
Tulle fabric.

appearance but with different structures. Net fabrics range from lightweight tulles to heavy fishing nets. Tulle is a favorite for wedding veils and parts of formal dresses. (See Figure 20.17.)

Macramé

Macramé might be considered a variation of the principle used in making nets. Like netting, macramé uses the techniques of looping and knotting yarns. Unlike netting, however, the decorative qualities of macramé are determined by the selection and use of a variety of ornamental knots. In netting, it is the open area that is important. In macramé the closed or knotted areas are emphasized.

The word *macramé* seems to be Arabic in origin, and the process itself probably was brought to Europe from the Arab world. Like filet or lacis, macramé may be classified as a lace. Its first use was in finishing off the unwoven yarns at the end of a fabric. In time, macramé was constructed separately and attached to linens or garments in the same way that other trimmings were sewn into place.

Because macramé does not require specialized tools, it can be made with a minimum of equipment. The yarns or cords that are used in macramé are fastened to a holding cord, which in turn is clamped or pinned securely so the cords will not slip. For complex work, the yarns are wound onto bobbins so they do not become entangled. The work is done by creating a variety of knots that join the cords at different intervals. Placement of the knots and judicious selection of the types of knots make possible the creation of a variety of textures and decorative effects. Macramé is essentially a handcraft technique.

Lace

Because of its delicate beauty, lace has been one of the most sought-after fabrics. The precise origins of lace making are unknown, but its development was related not only to knotting and netting, but also to embroidery. Laces are generally divided into two categories, according to their construction. One is called *needlepoint lace*; the other, *bobbin lace*.

Needlepoint lace, which is slightly older than bobbin lace, probably originated in Venice sometime before the sixteenth century (Goldenberg 1904). In making needlepoint laces, the design for the lace was first drawn on parchment or heavy paper. A piece of heavy linen was sewn to the back of the parchment to hold it straight. Threads were then laid along the lines of the pattern and basted lightly onto the parchment and linen. None of these threads was attached to any other. The lace was created by embroidering over the base threads with decorative stitches. These embroideries connected the base threads. The areas between the threads could also be filled in with fancy needlework, according to the requirements of the pattern. When the embroidery was complete, the basting threads that held the lace to the paper were clipped, and the finished lace was released.

Bobbin lace or, as it is also termed, *pillow lace* uses twisted and plaited threads. It is more closely related to netting and knotting, whereas needlepoint lace stems more from embroidery. Again the design is drawn on stiff paper. Holes are pricked into the paper in the area of the pattern. This pattern is then stretched over a pillow, and small pins are placed at close intervals through the holes in the paper. The pins go through the paper and into the pillow. The thread is wound onto bobbins, and the threads are worked around the pins to form meshes, openings, and closed areas. (See Figure 20.18.) Bobbin lace seems to have originated in Flanders or Belgium.

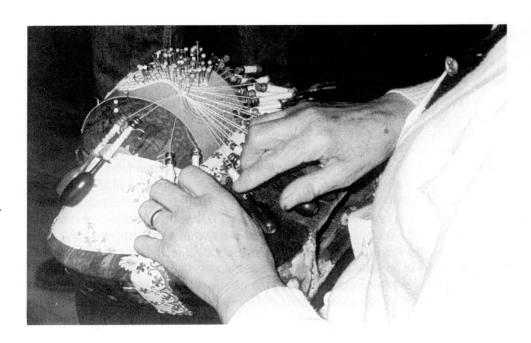

FIGURE 20.18

Lace-making using a lace pillow and bobbins. Yarns from the various bobbins are knotted together following the pattern drawn on a paper sheet placed over the pillow. Pins hold the knotted yarn in place.

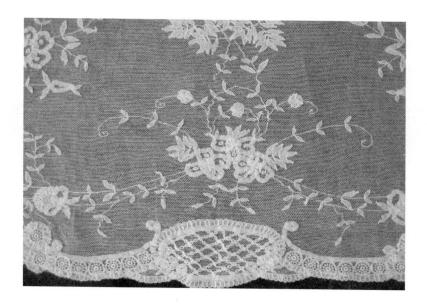

Figure 20.19

Wedding lace from

Brussels made with fine linen yarn.

The techniques for making both bobbin lace and needlepoint lace quickly spread throughout Europe. Each town developed its own style of lace, which had its traditional patterns and construction features. It is this localization of design that has given us the names for most laces. Chantilly lace, for example, was first made in the French city of Chantilly; Venice point lace originated in Venice, Italy; and Val lace was first made in Valenciennes, France.

The production of lace by machine began soon after 1800. Although an earlier machine had had good success in producing manufactured nets, machine-made laces were not perfected until John Leavers invented a machine that could make as much lace in one day as a skilled handworker would produce in six months (Schwab 1951). Only an expert can tell the difference between machine-made and handmade lace. Most modern laces are produced by machine on the Leavers machine. (See Figure 20.19.) Knitted laces may be made on the Raschel machine, and some lacelike embroidered fabrics are produced by the Schiffli machine.

Crochet

The origins of crochet are obscure. The technique of creating fabric by pulling one loop of yarn through another with a hook was brought to the United States by Irish immigrants of the nineteenth century. Crocheting is closely related to knitting. Both join together a series of interlocked yarn loops into a variety of open and/or closed patterns. Crochet is made with a single needle or hook, whereas knitting uses several needles.

BRAIDED FABRICS

Braided fabrics are made by intertwining yarns, strips of fabric, or groups of fibers, in the same way that dancers rounding a maypole weave in and out while moving in opposite directions. The structure is familiar as hair braids and as the

FIGURE 20.20
Braided bamboo Chinese finger trap. Braid lengthens when pulled, shortens when compressed.

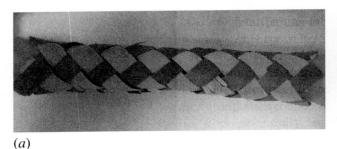

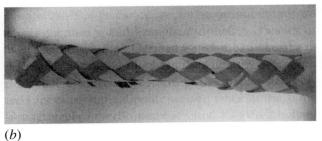

Chinese finger trap that narrows as it is pulled. (See Figure 20.20.) In a similar vein, fibers peeled from plants were used centuries ago for braided sandals. (See Figure 20.21.) This ancient technique is now among the modern methods used to form reinforcing structures for textile composites. The shearing ability of the diagonal-braided fabric allows it to be shaped into a form that is useful for the ultimate composite product. Both two-dimensional and three-dimensional (tubular) braids are made for these purposes.

Braiding produces a wide range of structures, from sutures (including very fine ones) to cables for anchoring huge ships. Reinforcement for hoses is often braided. A central core can be included inside the braid and produce, for example, bungee cords where the central core is rubber. The process can also be modified to make flat, narrow fabrics such as shoelaces, drawstrings, and trims. There are no ends to fray and, unlike woven ribbons, the flexibility and shearing of the braid will allow it to conform to many shapes.

EFFECTS OF STRUCTURE ON FABRIC PERFORMANCE

The fabric constructions described in this chapter vary widely, and it is difficult to generalize properties and performance. The following discussion highlights some areas to be considered when assessing the performance of the various fabrics.

FIGURE 20.21

Prehistoric fibrous sandal recovered from Arnold Research Cave, Missouri; approximately 8,000 years old, it is made from the fibrous leaves of the rattlesnake master plant (Eryngium yuccifolium). Photograph courtesy of Jenna Tedrick Kuttruff, Louisiana State University; speciment from the collection of the Museum of Anthropology, University of Missouri-Columbia.

Durability Factors

In multicomponent fabrics each part of the structure plays a role in the durability of the final product. For carpets, fiber and yarn structure, as well as the type of construction, all contribute to the durability of a carpet. (See Take a Closer Look in this chapter for a larger discussion of carpet performance factors.) Textile-reinforced composites are engineered for strength and durability. In some products, however, one part of the fabric may be subjected to the greatest amount of wear. For example, in a multilayered quilt, the external fabric will be subject to abrasion to a far greater extent than the fibers within the quilt. Consumers must, therefore, look at durability of fibers, yarns, and fabrics that are likely to be subjected to the greatest stress.

Laces and nets are often delicate because of their loose construction and fine yarns, whereas macramé products, with heavier yarns and tight knotting, are stronger and more durable.

Appearance

The visible part of a multicomponent fabric requires evaluation in relation to how well its fiber, yarn, and fabric components can be expected to maintain an attractive appearance. Appearance is an important feature for embroidered, quilted, and carpeting fabrics, less so for those that are primarily functional or have industrial uses. When carpeting shows wear, its appearance is significantly affected as well.

Lace, crocheted, macramé, and some braided structures are made to be decorative, and this is usually more important than durability and comfort. Stitch-bonded fabrics will vary in their shearing and bending behavior. Varying the fibers and yarns in stitch-bonded, lace, crocheted, and macramé fabrics can provide unique and interesting decorative effects.

Comfort Factors

Multicomponent fabrics are often used in clothing or household products to maintain warmth. Fabric thickness is usually considered to be the most important single variable in determining thermal comfort. However, there is a limit to how thick the fabric can be without adding too much weight. Multicomponent fabrics such as quilts are thick, but their inner layers of fibers or down have a high volume of air and, therefore, little weight. This is why down comforters and jackets are so warm. The down feathers between the outer layers allow for a larger volume of dead air to serve as resistance to heat transfer. The glass fiber insulation in buildings is in a loose mat form for the same reason—to provide a significant volume of dead air space.

The ability of fabrics to breathe is a significant comfort factor. Coated and some bonded and laminated fabrics have decreased breathability, and this characteristic must be balanced against safety in selecting materials for protective clothing. Poromeric laminates can provide both comfort and weather protection. The feel of many of these products may also be of interest to consumers. Here the fibers and exterior fabrics used will play an important role.

SUMMARY POINTS

- Multicomponent fabrics are combinations of two or more separate textile materials
 - Carpets have a base fabric and a pile
 - Tufting involves stitching pile yarns into the base fabric
 - Machine-woven and handwoven carpets are also made
 - Textile-reinforced composites have a textile structure embedded in a polymer matrix
 - High-performance fibers are generally used
 - Composites are used in the construction and transportation industries
 - Other multicomponent fabrics are embroidered, quilted, laminated, and flocked
 - Hybrid fabrics are textile structures laminated to films
 - Textile wall coverings are fibers or fabrics laminated to paper or other substrates
- Stitch-bonded fabrics have yarns held together by stitching
- · Knotted fabrics are nets, macramé, lace, and crochet
- · Braids are intertwined fabric structures

Questions

- 1. What types of designs are possible on carpets that are made by tufting?
- 2. What should a consumer look for when examining a carpet sample to determine its probable quality and durability?
- 3. Describe three processes used to produce fiber-reinforced composites. What properties are important in selecting the textile reinforcement in composites?
- 4. What should a consumer look for when examining a quilt to determine its probable quality and durability?
- What are the differences among a laminated fabric, a bonded fabric, and a coated fabric? Give an example of one kind of product in which each process would be used.
- 6. How have new fiber-forming technologies been used to create suedelike fabrics?
- 7. Explain the basic principles of forming fabrics by stitch bonding.
- 8. What are the differences in the techniques for making pillow lace and needle-point lace by hand?
- 9. What are the differences between the techniques for making macramé and crochet?

References

Anderson, K. M. "Machine Embroidery Tools, Techniques and Technologies." *AATCC Review* 8 (2005): 27.

ASTM. Annual Book of ASTM Standards. Vol. 7.01. West Conshohocken, PA: American Society for Testing and Materials, 1998.

- Goldenberg, S. L. Lace: Its Origin and History. New York: Brentanos, 1904.
- Ogin, S. L. "Textile-reinforced Composite Materials." In Handbook of Technical Textiles, edited by A. R. Horrocks and S. C. Anand, 264. Cambridge, UK: Woodhead Publishing, 2000.
- Schwab, F. R. The Story of Lace and Embroidery. New York: Fairchild, 1951.
- Wace, A. T. B. "Weaving or Embroidery? Homeric References to Textiles." American Journal of Archeology 52, no. 1 (1948): 51.
- Walters, B. J., and J. O. Wheeler. "Localization Economies in American Carpet Manufacturing." Geographical Review 74 (1984): 183.

Recommended Readings

Griggs, D. "Machine Lace Manufacture." Textiles 18, no. 2 (1989): 32. Levey, S. M. Lace: A History. London: Victoria and Albert Museum, 1983.

Introduction to Textile Wet Processing: Preparation of Fabrics for Dyeing and Finishing

Learning Objectives

- 1. Distinguish between batch and continuous methods for textile wet processing.
- 2. Describe the process and purpose of the standard preparation steps for fabrics made from different fibers.

extile materials, especially fabrics, undergo a range of treatments before being constructed into useful articles such as apparel or home furnishings. This chapter deals with *preparation*, the washing and bleaching of materials to remove dirt and size and improve absorbency and whiteness.

Other steps fabrics may go through are covered in the next chapters dealing with the following:

- · Dyeing to make them colored
- · Printing to achieve a decorative design
- Finishing to change performance and aesthetics

Because these processes almost invariably involve the use of water, they are collectively known as "textile wet processing." Confusingly, given the use of the word above, they may also be collectively known as "finishing."

Several of the principles involved in wet processing are common to all steps and can be explained here.

BATCH VERSUS CONTINUOUS PROCESSING

Textile wet processing can be carried out in batch or continuous processes. The choice is usually based on the volume of material to be processed, and continuous methods are generally more efficient when large amounts of material need to be given the same treatment. So a large volume of fabric might be prepared for dyeing *continuously*, divided into *batches* for dyeing in many different colors, then recombined to go through a common *continuous* finishing process. In small-scale operations, preparation may be carried out in the same machines as are used for dyeing. Printing requires color applied in distinct patterns and is thus suited more to *continuous* processes.

Batch processes involve a single vessel in which the textile, water, and chemicals are mixed, stirred, and heated. It thus resembles a typical cooking process at home. Batch sizes usually range from one hundred to one thousand yards but may be more. Operations take place one after the other in the same vat in a total process that may last many hours. Many different machine types are used, depending on the process and the material. The machines used are described in detail in chapter 22. Most dyeing machines are made of stainless steel and heated by steam piped through heating coils. The means of agitation vary.

Continuous wet processing separates the individual steps of a batch process (dye application, fixation of dye, and rinsing for example) into separate components of a continuous dyeing *range*. This is represented schematically in Figure 21.1. Raw material and chemicals are fed in, and treated (dyed, prepared, or finished) material emerges, *continuously*. Speeds of ten to one hundred yards per minute are common. In a continuous process, the fabric may be bunched up in *rope form* or treated flat in *open width*. The fabric may be under tension or may be hanging or sliding loosely. Depending on the complexity of the process, twenty or more individual units make up a range. At the end of one run, all the different pieces of machinery must be cleaned before starting a new process. Bringing all the components into adjustment at the start of a run can take time during which some material is wasted. This makes the use of continuous processes inefficient for short yardages.

The first step in continuous processing is the application of dye/chemical/ finish to the fabric. In preparation, a *saturator* will apply chemicals and leave the fabric dripping wet before the next step. In dyeing and finishing, the amount of liquid

Figure 21.1

Continuous preparation process. Diagram from Grayson, Encyclopedia of Textiles, Fibers, and Nonwoven Fabrics, p. 468. Reproduced courtesy of John Wiley and Sons, Inc.

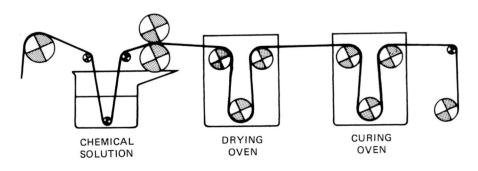

must be controlled and a dipping to apply the dye or finish is followed by a squeezing between rollers to squeeze out the excess; together these make up *padding*.

If more than one chemical must be applied, it may occur "wet on wet," but apart from preparation, an intermediate drying step is usual.

The chemical processes that occur between the chemical and fabric require time and energy to take place. Fabric passes through some component of the continuous range to allow this to happen. A continuous oven or *tenter frame* may apply dry heat. A tenter frame holds the fabric flat using clips or pins; the latter give rise to the oftenseen rows of holes along a fabric selvage. A steam chamber may be used to apply heat and keep fabric moist and/or exclude oxygen, and a *J-box* may keep fabric wet as it continues along the range. *Dwell times*, the amount of time the fabric spends in the steam chamber, may be less than a minute or more than an hour.

If dirt, extra chemicals, or unfixed dye must be removed from the fabric after the heating, a series of washing chambers can be used. A counter-current principle is usually used, which means the cleanest water is used on the cleanest fabric.

Some of the advantages of both batch and continuous dyeing can be achieved in a *semicontinuous* operation, or *pad-batch process*. Chemicals are applied in a pad, after which the material is split into batches for the next steps of reaction and washing. Often the fixation/reaction takes place at low temperature as a roll of fabric turns slowly on an *A-frame* over several hours, saving energy costs.

DRYING

Drying is required after any wet process, and a fabric may be dried several times as it is dyed and finished. Drying is energy-intensive and to be efficient as much water as possible is removed by mechanical means such as squeezing, vacuum extraction, or centrifuging before using heat energy to evaporate water.

Thermal drying requires the application of heat. Passing the cloth over heated cylinders, called "dry cans," is one such drying technique. This would be comparable, in principle, to ironing a wet garment to dry it. The fabric width is not easily controlled on dry cans, and surface features such as a pile may be crushed.

Drying can also be accomplished in the tenter frame discussed earlier as a means of fixing dyes and finishes, although a greater airflow is used to carry off the evaporated water. (See Figure 21.2.) For efficiency, dry cans or an infrared predryer may be used as a first step in a drying process, but the tenter is a good final step because width is controlled and filling yarns can be straightened to minimize bow or skew. (See chapter 16.)

Radio frequency waves and microwaves have been used to dry textiles and work like a domestic microwave oven; only the material being processed and not the equipment itself is heated. These methods are most useful for drying bulky yarn packages, when thermal drying would take several hours and still leave an uneven distribution of moisture.

Of all processes carried out to create textile items, it is these wet-processing steps that have the greatest environmental impact, mostly in terms of energy and water use and possible air and water contamination. Note that in the life of a typical garment, however, far greater amounts of water and energy are used in its routine care than in its processing.

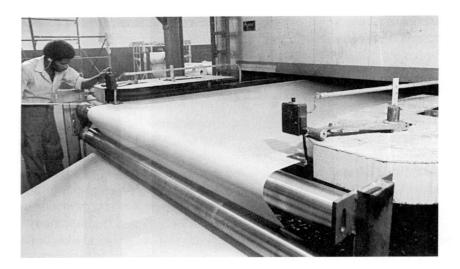

Figure 21.2
Fabric entering tentering frame. Courtesy of West Point Pepperell.

As the processes are described in this and the next chapters, the ways in which they are made more efficient and less polluting are mentioned. Using less energy and water makes good economic sense for a textile mill that must pay for these. Mills are also charged on the quantity and quality of the waste water they discharge, so using less and contaminating less also makes economic sense. It may have been true that "dilution is the solution to pollution" when a contaminant must be present in only small concentrations, but this is an expensive solution! Since the concepts of "reduce, reuse, and recycle" were introduced as the central philosophy of pollution prevention by the Environmental Protection Agency in 1990, almost every technical advance has been examined in terms of its beneficial environmental effects.

PREPARATION OF FABRICS

Fabrics come to wet processing with varying amounts of impurities that have to be removed for successful dyeing and finishing. The preparation steps depend largely on the fiber content. Natural fibers tend to have more impurities and typically require more extensive pretreatment. This is especially true for cotton, which has not usually undergone any prior wet treatment. Fabric of any fiber may also contain lubricants and sizes added to make spinning and weaving more efficient. Fabrics become soiled during weaving, and the dirt must be removed before further treatment is given to the fabrics. In all steps of preparation, even treatment is essential to ensure even uptake of dye later on.

COTTON FABRICS

Singeing

Cotton fabrics are passed over a gas flame to produce a smooth surface finish. (See Figure 21.3.) Surface "fuzz" burns off. The fabric is moved rapidly, and only the fiber ends are burned. Immediately after passing the flame, the fabric enters the saturator bath for the next stage, and that puts out any sparks.

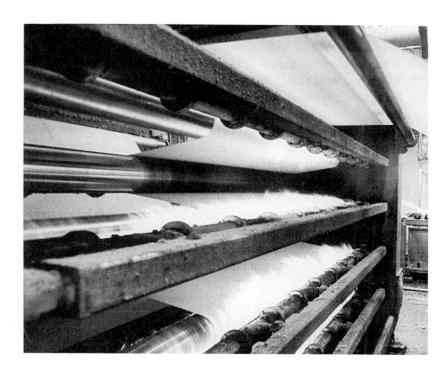

Figure 21.3

Fabric passes over gas flame that singes or burns off excess surface fiber. Courtesy of West Point Pepperell.

Desizing

Sizing materials (described in chapter 16) are removed either by a hot alkaline wash for PVA or by enzymes for starch-sized fabrics. The enzymes break up the starch polymers into smaller molecules that can be washed away.

Scouring

Scouring removes waxes and pectin, and destroys seed residues in cotton and cottonblend fabrics. Sodium hydroxide (caustic soda) is applied to the fabric, swells seed fragments, and converts waxes on the cotton fibers to a soap. This "soap" then serves to wash away any dirt or other impurities. Waxes and pectin can also be removed enzymatically, and considerable research has been carried out into this environmentally friendlier scouring process (Li and Hardin 1997). While it produces absorbent cotton fabrics, it does not remove seed fragments. (See Figure 21.4.)

Knitted goods are often processed in a beck or jet-dyeing machine in which the process is integrated with the subsequent dyeing of the fabric. (See Figures 22.6 and 22.7.)

Bleaching

Cotton fabrics are naturally off-white to tan in color, depending on the amount of pigmentation in the fiber. Bleaching is carried out to produce an evenly white fabric that is essential for bright or pastel shades in dyeing. While bleaching is not required for dark, dull shades, it is usually simpler to bleach fabrics routinely as part of a preparation sequence.

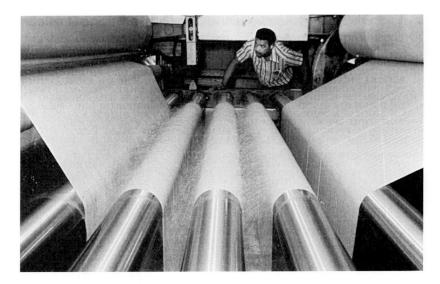

Figure 21.4
Fabric is scoured in a continuous process as it passes through the cleansing solution.
Courtesy of West Point Pepperell.

Bleaches oxidize colored compounds, removing the color. While chlorine bleaches are commonly used in the home, peroxygen bleaches, particularly hydrogen peroxide, are more often used industrially. Hydrogen peroxide is applied along with sodium hydroxide, and the fabric is steamed.

Knitted Fabrics

Knit cotton fabrics are less commonly processed in large enough volumes to make continuous processes economical. The principles of the operations remain the same except that desizing is replaced by the removal of knitting oils. This usually requires the use of specialized detergent materials.

Practical Processes

In a large-scale operation, the desizing, scouring, and bleaching processes are usually carried out in sequence without intermediate drying. The chemical for one stage (enzyme, alkali, or peroxide) is applied in a saturator, and the fabric is passed into a heated, *J*-shaped chamber, where it piles up and moves slowly while the chemical reactions take place. (See Figure 21.5.) A fabric may spend an hour in a J-box. If a preparation range is running at one hundred yards a minute, a J-box may contain three miles of fabric! When it emerges, the fabric is washed then passes into the next saturator/J-box sequence. The fabric can be held at its full width or can be treated in the form of a loose rope.

Continuous preparation can be condensed into two steps using alkali and peroxide to save water and energy. In the first step, desizing and some scouring take place, while in the second step, scouring is completed while bleaching occurs.

For smaller operations where continuous processing is not feasible, fabric preparation may be carried out semicontinuously. Chemicals are padded onto the fabric, and lengths of fabric are rolled up and held on an A-frame over an extended time (typically over night) while the reactions occur. With appropriate choice of chemicals, all three steps (desize, scour, and bleach) can be accomplished together.

Smaller operations can also conduct batch preparation in dyeing machinery.

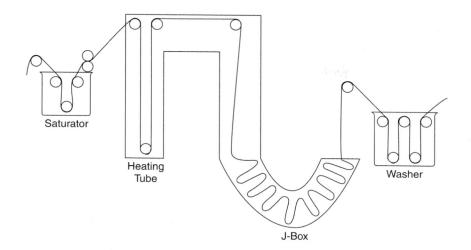

FIGURE 21.5
Schematic of continuous processing in a J-box,

Mercerization

Singeing, desizing, scouring, and bleaching are routine preparation processes, whereas *mercerization* is an optional step for cotton fabrics. Mercerization uses a strong solution of sodium hydroxide to swell the cotton fibers and produce permanent changes. The cotton fabric is briefly immersed under tension in a strong solution of sodium hydroxide (much stronger than that used in scouring), the alkali is washed off, and any excess alkali is neutralized. The alkali is recovered, reconcentrated, and reused. The treated fibers are stronger and have fewer convolutions and a rounder cross section, making them more lustrous. They also have a higher moisture regain and increased dye uptake. Some decorative effects can be achieved by combining mercerized yarns and unmercerized yarns in one fabric because mercerized fibers dye to darker shades than do untreated fibers. The deeper colors obtainable mean that mercerization is important for fabrics that are to be wet-printed.

Mercerization can be applied to either yarns or fabrics. Most good-quality cotton sewing threads are mercerized to improve their strength. *Slack mercerization*, or mercerization of fabrics that are not held under tension, can be used to produce stretch fabrics. During slack mercerization yarns shrink and develop a higher degree of elasticity. The finished fabric can be stretched, and when the tension is removed, the goods will return to their original length. Mercerization is both inexpensive and permanent, and for these reasons it is widely used on cotton goods.

SILK

Silk fibers are covered with the gummy protein sericin. (See chapter 5.) Although for raw silk fabrics the gum is retained purposely to provide body or produce a different texture, most silk fabrics are *degummed* in preparation for dyeing and finishing. The resultant fabric has a much softer hand and a whiter appearance. Silk is usually bleached with dilute solutions of hydrogen peroxide.

Wool

Unlike cotton, wool is scoured to remove much of the dirt and lanolin before yarn spinning can take place. Nonetheless, several steps, including carbonizing, scouring, crabbing, and bleaching are routinely applied to wool fabrics before dyeing.

Scouring

The scouring of wool fabrics removes size and dirt using mild alkali (sodium carbonate) and detergent and is carried out at lower temperatures than the scouring of other fibers to avoid damage. It is often done in batches. Agitating wool in warm detergent can cause felting to take place, so care is required, but this does allow scouring to be combined with milling to produce certain styles of fabric. (See chapter 24.)

Carbonizing

Wool fabrics are *carbonized* to remove vegetable matter. A dilute solution of sulfuric acid is applied, and the fabric is baked. The acid becomes concentrated and chars the cellulose of the vegetable matter while leaving the protein fibers unaffected. The fabric is beaten, and the black, carbonized remains of the burrs, sticks, leaves, and the like fall out as dust. The acid that remains may be rinsed out but can also be retained as an auxiliary in a dyeing or milling process.

Crabbing

Crabbing is a preparation step that sets wool fabric in a flat form to inhibit the setting of permanent creases when fabric is dyed in rope form. It involves running the fabric through boiling water then exposing the hot fabric to cold water. The "thermal shock" of the cold water sets the flat fabric (Schneider, Michie, and Tester 1998). Crabbed fabrics can then be treated later in rope form. Originally this was accomplished in a batch process with the fabric wound on rollers; newer machines work continuously.

Bleaching

Bleaching is required for wool that is to be dyed in pastel shades. Both oxidative and reductive processes may be used. Current processes use hydrogen peroxide under mild alkaline conditions, but for a whiter and more permanent result, a two-step combination of peroxide and a reducing bleach can be used.

FLAX AND OTHER BAST FIBERS

Cellulosic bast fibers must generally be prepared in the same manner as cotton. However, because these fibers contain more impurities and also exist as bundles, the processes must be modified. The scouring and bleaching operations are milder than for cotton because strong alkaline solutions can separate the fiber bundles, leaving extremely short fibers. For this reason, it may not be desirable to bleach the fabrics to a very white color. As with cotton, considerable research has been conducted to investigate the use of enzyme-based processes for bast fibers.

MANUFACTURED FIBERS

Manufactured fibers contain fewer impurities than do natural fibers and, thus, typically require less preparation. The fabrics should be scoured to remove any dirt and either size or knitting oils. Scouring is generally mild and may even be combined with dyeing if the fabric is relatively clean.

Rayon fabrics may be "causticized" to improve dye uptake, especially prior to printing. Fabrics of thermoplastic fibers are routinely heat-set in a tenter frame before dyeing to ensure dimensional stability and avoid creasing. Manufactured fiber fabrics may occasionally require bleaching.

When lyocell was introduced in the 1990s, its dyeing and finishing presented some problems as the fiber tends to fibrillate when subjected to wet abrasion. (See chapter 6.) To produce an even surface, a careful sequence of operations was developed. The fabric is scoured and prefibrillated, deliberately creating fibrils on the surface. These are removed in an enzyme treatment with cellulase. After dyeing, the fabrics are refibrillated (White 2001).

INSPECTION AND REPAIR

Before a fabric is ready to leave the factory, a visual or electronic inspection of the goods is made. This may be done after preparation if the fabric will be transported to another company or destination for dyeing and finishing. In vertically integrated operations, the final inspection is often done after the fabric is dyed and finished.

If the inspection is done visually by a worker, the fabric is run over a flat screen at around 45 degrees. The process is called *perching*, and the machine used is known as a perch. A light is often placed behind the fabric for better visual inspection. (See Figure 21.6.)

FIGURE 21.6
Hand inspection and repair of woolen fabric.

FIGURE 21.7

Computer monitor reports results of inspection of sheets made on an automated machine that cuts, sews, and folds the finished product. Photograph courtesy of CMI Industries, Inc.

The more sophisticated electronic scanning of today is done by a laser that generates selvage markings of defective areas and a computer map showing where all the defects in a roll are located. This map can be used by apparel manufacturers with the aid of computer-controlled cutting systems that automatically cut around defects in the cloth. The data generated by electronic inspection can help to pinpoint sources of defects so they can be corrected. (See Figure 21.7.)

For woolens and worsteds, the greater value of the fabric makes additional repair economically viable. Both specking and burling may have to be done. *Specking*, usually done with tweezers or a burling iron, is the removal from woolens and worsteds of burrs, specks, or other small objects that might detract from the final appearance of the fabric.

Burling is the removal of loose threads and knots from woolens and worsteds by means of a burling iron, a type of tweezer. Many knots must be pulled or worked to the back of the fabric because pulling them out might leave a small hole in the fabric. Broken warp or filling yarns can be removed and replaced. These inspection and repair steps are often done before milling because the yarns are not tightly compacted and defects are easier to see.

SUMMARY POINTS

- Fabrics undergo standard preparation treatments before dyeing and finishing
 - These are done to remove dirt and impurities and to bleach the fabric to a white color
 - Preparation and further dyeing and finishing are called wet processing

- Wet processes can be batch or continuous
 - Batch processing separates the various steps and is more economical for smaller runs
 - · Continuous processing is preferred for large volumes of fabric
 - Fabric can be held flat or processed as a loose rope
- Fiber-specific preparation
 - Cotton
 - Routinely singed, desized, scoured, and bleached
 - Mercerization is optional
 - Silk is degummed and usually bleached
 - · Wool is scoured, carbonized, crabbed, and bleached
 - Manufactured fibers require little preparation
 - Lyocell may go through controlled fibrillation
- · Use of water and energy is an environmental concern

Ouestions

- 1. Why do fabrics go through routine preparation steps before dyeing and finishing?
- 2. Explain the differences in batch and continuous fabric preparation processes. What are the advantages of each?
- 3. List and give the purpose of each of the preparation steps for the following: cotton silk

wool linen

manufactured fibers

References

- Li, Y., and I. R. Hardin. "Enzymatic Scouring of Cotton: Effects on Structure and Properties." *Textile Chemist & Colorist*, 29, no. 8 (August 1997): 71.
- Schneider, A. M., N. A. Michie, and D. H. Tester. "An Investigation of Fabric Conditions During Continuous Crabbing." *Journal of the Textile Institute* 89 Part I, no. 4 (1998): 669.
- White, P. "Lyocell: The Production Process and Market Development." In *Regenerated Cellulose Fibres*, edited by C. Woodings. Cambridge, UK: Woodhead Publishing, 2001.

Recommended Readings

- Abrahams, D. H. "Improving on Mercerizing Processing." *American Dyestuff Reporter* 83 (September 1994): 78.
- Christie, R. M., ed. *Environmental Aspects of Textile Dyeing*. Cambridge, UK: Woodhead Publishing, 2007.
- Hann, M. A. "Innovation in Linen Manufacture." Textile Progress 37, no. 3 (2005): 1.
- Peters, R. H. *Textile Chemistry*. Vol. 2, *Impurities in Fibres*, *Purification of Fibres*. Amsterdam: Elsevier, 1967.

CP5AMunsell Color Wheel showing attributes of hue, value and chroma.

CP5BNaturally colored cotton yarns.

CP5C Hand painted silk yarn.

CP5DHarris Tweed fabric; yarns are made from dyed wool fibers.

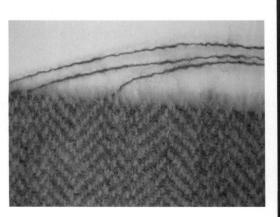

COLOR PLATE 6

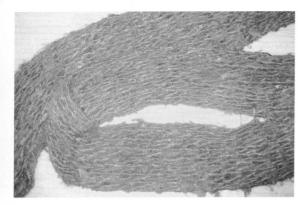

CP6ADyed alpaca yarn.

CP6B
Pigmented
spunbonded
nonwoven fabrics

CP6CTartan plaid fabric made with woven dyed yarns.

CP6DBatik print showing cracked wax remaining on fabric.

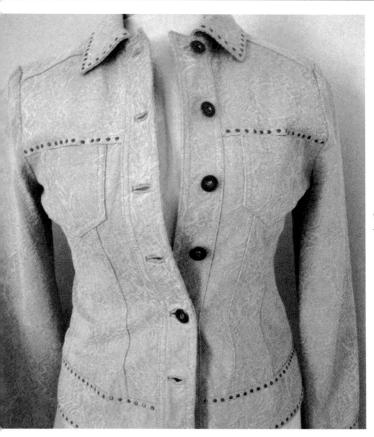

CP7A Jacket of embossed suede.

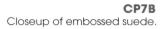

CP7C Flocked print.

CP7D Chintz fabric showing polished finish.

COLOR PLATE 8

DYEINGS ON WOOL	SULPHONOL E and L DYES	C.I. ACID		FASTNESS PROPERTIES									FASTNESS P		SS PR	PROPERTIES						FASTNESS PI			ROPERTIE	
			YEING	Light (Daylight)	Pe	ers - ation		ishing SO 2	DYEINGS ON WOOL	SULPHONOL L and F DYES	C.I. ACID	DYEING	Light Jaylight)	pin	Pers- piration		shing SO 2	DYEINGS ON WOOL	SULPHONOL F and SERIMET	C.I. ACID	THOD	Light (Daylight)	Pers - piration			
			ON	0)	СС	SW	cc	SW					10)		SW	СС	SW		DYES		M	10)	cc	sw	сс	-
	0-15% Sulphonol Yellow E–2GL 0-5%	Yellow 17	A	5–6 6–7	3-4	2-3	2-3	5		0-2% Sulphonol Yellow L-PN 1-2%	Yellow 61	8 (C)	5	4	3	3-4	4		0-15% Sulphonol Brown F–5R 0-9%	Orange 51	C (B)	4	4	4	4	
	0-25% Sulphonol Orange E-PO 1-5%	Orange 28	A	4 4-5	3-4	3	2-3	4-5		0-2% Sulphonol Yellow L-RP 1-2%	Yellow 25	B (A)	4-5		2-3	2-3	4		0·2% Sulphonol Red F–R 1·2%	Red 114	C (B)	3-4	4	4-5	4	
	0-1% Sulphonol Scarlet E-M 0-6%	Red 73	A (8)	5	4	3	3	4-5		0-15% Sulphonol Yellow L-R 0-9%	Yellow 19		4	4	3	3	4		0-1% Sulphonol Red Brown F–BV 0-6%	Red 119	C (8)	3-4	4-5	3	3-4	CONTRACTOR OF STREET,
	0-1% Sulphonol Red E-2G 200% 0-6%	Red 1	A	4 4-5	3	2	2	4-5		0-15% Sulphonol Red L-3GP 200% 0-9%	Red 57	B (A)	5	4	2-3	3	3		1-5% Sulphonol Navy Blue F-3R 3-0%	Blue 319	С	5	5	4	4-5	THE REST CO. PRINCE SERVICE AND ADDRESS OF THE PARTY AND ADDRESS OF THE
	0-2% Sulphonol Blue E-PFN 1-2%	-	A	4-5 5-6	3-4	3	2	4-5	The state of the s	0-1% Sulphonol Blue L-B 0-6%	Blue 25	B (A)	4-5 5-6	3-4	3	2	2		0-2% Serimet Fast Yellow G liquid 1-2%	Yellow 118	С	6	5	4-5	5	THE REAL PROPERTY AND ADDRESS OF THE PARTY AND
	0-1% Sulphonol Blue E-B 0-6%	Blue 45	A	4-5 5-6	2-3	2-3	2	4-5		0·2% Sulphonol Blue L-FG 1·2%	Blue 72		4–5 5–6	3-4	3	2	4		0-3% Serimet Fast Red RBL liquid 1-8%	Red 226	С	4-5	5	5	5	
	0-2% Sulphonal Yellow L-2GP 1-2%	Yellow 29	8 (A)	5	3-4	2-3	3-4	4		0-15% Sulphonal Yellow F-GRX 0-9%	Orange 67	C (B)	4-5	4	4-5	3	3		6-0% Serimet Fast Black R liquid 12-0%	Black 63	С	6-7	5	5	5	

CP8A

Dye companies show their products in the form of pattern cards; a pattern card is usually for a single dye type (e.g. acid dyes) and provides fastness data and application details along with dyed fabric samples.

CP8BAcetate garment showing color change from perspiration stains.

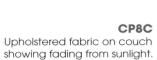

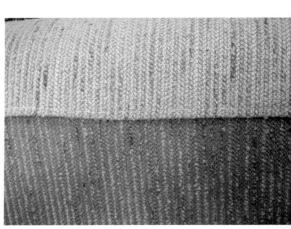

ADDING COLOR TO TEXTILES

Learning Objectives

- 1. Distinguish natural and synthetic pigments and dyes.
- 2. Describe how color is specified in the supply chain and the role of a dyer in producing colored textiles.
- Explain how dyes and fibers interact and the range of dyes and dyeing machines used.

ost objects made by human beings are decorated in some way. Textiles are no exception. The decoration of textiles may be achieved through varying the construction of the fabric, by adding color through dyeing, or by applying color in patterns by printing. Even the earliest fabrics excavated by archaeologists show evidence of ornamentation, using natural fibers of contrasting colors or embroidery or dyes. The first addition of color to fabrics may have been done by painting designs on the cloth, a technique still used by designers today.

DYES AND PIGMENTS

Coloration is achieved by adding natural or synthetic *colorants:* powerfully colored materials. Colorants are divided into dyes and pigments. Dyes are organic chemicals; pigments may be organic or inorganic. Dyes are colorants that are applied to, or formed in, a textile substrate in a molecularly dispersed (i.e., soluble) form (AATCC 2008, 417). The definition stresses that dyes must be soluble or capable of being made soluble in their application so they can penetrate into the fiber, and a cross section of a dyed fiber typically shows color throughout. This property distinguishes dyes from pigments.

Pigments are colorants "in a particulate form which is insoluble in a textile substrate, but which can be dispersed within the substrate to modify its color" (AATCC 2008, 420). They are not molecularly dispersed, as are dyes, but are small, insoluble aggregate particles, similar to the pigments in paints. Pigments may be added to the liquid stage of manufactured fiber spinning (see chapter 2) or are applied to the surface of textile materials and held there with a binder.

Natural Dyes

The coloring of fibers results from the interaction of the functional groups within the fibers and those within the dyestuff and/or a "fitting" of the dye and fiber molecules together. Different fibers require different dye chemistry and properties. With natural dyes, this could be overcome by a treatment of the fabrics with appropriate natural acids or oxides that did, however, improve their colorfastness. These substances, called *mordants*, react with the dyestuff to form a *colored lake*, an insoluble compound, thereby "fixing" the color within and on the fiber. The effect of mordants probably was discovered accidentally when it was realized that washing undyed fabrics in the water of some streams (those high in certain metallic compounds) resulted in their taking and holding colors better.

Some mordants were more effective on animal fibers such as silk and wool; others were preferable for cotton and linen. Workers in the dyer's trades developed skill in using mordants to make fabrics of fairly good colorfastness, although it was not possible to obtain consistently excellent colorfastness until after the invention of synthetic dyes in the nineteenth century.

Natural dyes are mostly organic and derived from plant or animal sources. Plant dyes can be made from flowers, leaves, berries, barks, roots, and lichens. Indigo obtained from the woad plant was produced in Europe from Roman times to the end of the Middle Ages, when it was supplanted by a more productive source of the same blue dye imported from India. Madder, a source of reds, also has the useful quality of producing several different colors or color intensities in combination with different mordants. Aluminum produces pinks and bright reds, while iron produces purple and black colors.

Dyes from animal sources include cochineal, a red color, from scale insects native to South America, and Tyrian purple, a color made from the juice secreted by a small shellfish. The technique for extracting and applying the dye was known as early as 1000 BC and required a lengthy and complex series of steps. First, the dye was "milked" from the shellfish. This white liquid, as it oxidized, turned from milky white to green, to red, to deep purple. Careful control of the process produced a range of red-purple colors, the most desirable being a deep, rich red-purple. The process was time consuming and difficult, and the supply of the dye was limited. Fabrics dyed with Tyrian purple were extremely costly and, therefore, available to only the rich and, in particular, to royalty, so it came to be known as "royal purple." Even today the mounds of discarded shells are evident in locations around the Mediterranean.

The limitations of natural organic dyes made inorganic ("mineral") colors attractive as chemistry developed in the eighteenth and nineteenth centuries, especially in textile printing. Applying two soluble salts that form a colored

precipitate within the fabric was the principle in "iron buff," manganese bronze, chrome yellow, and Prussian blue.

Synthetic Dyes

In 1856 William Perkin, an eighteen-year-old student of chemistry, was experimenting to make the antimalarial medicine, quinine, from coal tar–derived chemicals. His naive attempt failed, but he did produce a purple-colored substance that dyed silk. He was foresighted enough to contact a dyer to ask if it might be interesting, and given a favorable response, he quit school and set up a business to make this first synthetic dye, the reddish purple "Mauveine" (Garfield 2002).

Perkin's discovery stimulated intensive research with other coal tar derivatives, and over the next decades, an enormous range of synthetic dyes made from many chemical substances was developed. By the end of the nineteenth century, they had almost completely replaced natural dyes. Even the good natural dyes, such as indigo and alizarin from madder, had been replaced by the identical materials made synthetically. Synthetic dyes were particularly attractive because the same application process could be used to dye a whole range of colors, whereas different natural dyes required different application techniques. The use of mordants continued with specialized synthetic mordant dyes for wool.

Today natural dyes are used by craft dyers, hobbyists, and a few small-scale commercial operations. Occasionally interest in "natural" things becomes popular, and a return to the use of natural dyes is suggested. The world population and its use of textiles have grown enormously in the past century. It has been calculated that to dye all textiles with natural dyes would require the use of more than 30 percent of the world's agricultural land. Genetic modification has been suggested as a way to increase the dye yield from plants. But how natural is that?

DYES, DYEING, AND THE SUPPLY CHAIN

The color of a textile and its performance require attention throughout the supply chain, not just in the dyehouse. The control of textile color requires the attention of designers, stylists, buyers, and merchandisers, as well as the textile chemist and dyer. Poor color decisions or poor color quality can spell financial disaster. Color is something we are all aware of, but it can occasionally behave in a way that can trap the unwary. Color education for anyone in textiles is important.

Design and Color Selection

Color arises through the interaction of an object, a light source, and an observer. *It is not a fixed property of an object,* something that the human vision system has evolved to deny and yet is clear when two parts of the same object are viewed simultaneously in different lights or when the same scene is photographed at different times of day. This happens to all objects, but for some (those with "poor color constancy") the change is especially dramatic. For a designer to pick a colored thread or paint chip and say "*this* is the color I want" is asking for trouble. That same paint chip will look different in the design studio, in daylight, in the

FIGURE 22.1

Color matching booth for evaluation of color change.

dyer's office, or on the retail store floor. This is true for any object, including samples from a standard set of colors. (See figure CP5A on Color Plate 5.)

So how can a color be communicated clearly through the supply chain? A first step is to specify the light source under which it is seen. The International Committee on Illumination (CIE) has specified standard theoretical light sources, and several manufacturers offer light booths equipped with standard lights. (See Figure 22.1.) An additional step is to specify the way the object interacts with any light, as opposed to its color under one light. This is done by measuring its reflectance curve on a spectrophotometer. With this information, the way the color changes as the light changes can be predicted. Additionally, color specified this way will not fade or get dirty as a real color sample might. As the textile supply chain has become global, the move to such numerically based standards has accelerated. Most recently, the two methods have been combined in "engineered color standards": fabric swatches with an associated reflectance curve. Accurate color specification at the design stage and clear color communication throughout the production process are vital.

The Dyer

The color of the design then must be translated to the textile. A dyer has to "match" the "standard" color, using a combination of dyes—typically red, yellow, and blue. Often the match will be made using different colorants than are present on the standard, and the resulting match will be *metameric* to some degree. This means that while it may match under one light source, it will not match perfectly under another. Changing the particular dyes used can minimize metamerism, but it is again important for the dyer to know under which light the match is to be seen. Dyeing is never perfect; there are a large number of factors that lead to variation.

The dyer will typically carry out small-scale dyeing trials, called "lab dips." These should be communicated to the designer or color specifier for approval. If the dyer is in China and the designer in New York, the approval is much quicker if it is done electronically. Electronic approval may be based on a numerical color difference (see below) or on colors reproduced on an accurately calibrated monitor. Once approval is obtained, the dye recipe can be scaled up for full production. Dyers routinely add less dye than is required by the recipe, and make an "add" to correct the shade. In well-controlled dyehouses, "no-add" dyeings are possible, while "blind dyeing," where the goods are removed without being checked for shade, is a goal for maximum efficiency. Once the dyeing is completed, the question then becomes this: How close to the standard is close enough?

In the past few years, the answer to this question has been obtained less from a subjective human observer and more from an objective measurement of the standard and the match on a spectrophotometer, where the difference in color between two samples is measured. This difference is expressed in terms of ΔE (or DE) using an established color difference equation (AATCC 2008, 307). The color tolerance can be defined in the product specification, and thus, a dyer can know immediately (without waiting for approval from far away) if the match is close enough or not.

A dyeing must also be *level*; that is, the color should be even throughout the textile. In practice, fibers in the middle of a yarn are often dyed lighter than those on the outside, and yarns within a fabric may have pale areas where they cross each other, but as long as the overall appearance is level, such micro-unlevelness is acceptable. Unlevelness on a larger scale, unless it is a deliberate decorative effect, is not acceptable. Levelness relies on the use of a careful dyeing process and dye mixtures that behave well together. High-fastness dyes can often be difficult to dye level. Unlevel dyeings may have streaks, spots, or crease marks, as well as more gradual and subtle variations from side to side, side to middle, back to front, or end to end of a fabric. Unlevelness may render a material unsalable or require reworking. It can often be traced to poor fabric preparation, and in manufactured fiber fabrics, unsuspected dyeability variations, due to combining fibers from different production runs, may be present.

The "dyeing" (the color produced on the textile) must also be *colorfast*. A fabric that retains its color during care and use is said to be colorfast. Fabrics may be more or less colorfast to a variety of different substances or conditions, with the importance of each dependent on the use of the fabric. Colorfastness is discussed in greater detail in chapter 28.

THE DYEING PROCESS

The science of dyeing is highly complex, and the mechanisms of dyeing are not completely understood. This discussion is necessarily superficial and does not provide an in-depth exploration of the subject. For additional background, readers may consult the sources listed at the end of the chapter.

The medium most often used to dissolve or disperse dyes for application to textiles is water. Successful application may require the addition of acids, bases, salts, or other *auxiliaries* to assist in levelness or to increase the uptake of dye.

Dyeing can be conducted in batch or continuous processes (see chapter 21), although among the textile wet processes of preparation—dyeing, printing, and finishing—dyeing is most often done in batches. In batch dyeing the water containing the dye and auxiliaries is called the *dye liquor*. For level dyeing, some form of agitation is required.

For dyeing to take place, attraction between dye and fiber is required. The attraction, or *affinity*, of a dye for a particular fiber is influenced by the chemical and physical nature of each. Ultimately it may be based on ionic forces, together with a range of secondary bonding (such as hydrogen bonds). A dye is also said to have *substantivity* for a fiber. These attractive forces not only allow dyeing to take place, but also operate when the textile is used and laundered, so they can be largely responsible for the fastness of the dyeing. Pigment colors are not soluble and are attached to the surface of the fabric by a binder. (So "pigment dyeing" is an oxymoron.) A polymeric resin serves as the binder. When the resin is cured, or permanently fixed to the fabric, the pigment is also fixed on the fabric surface. The retention of pigment colors is dependent on the durability of the binder, not the pigment. As discussed earlier in chapter 2, and again later, pigments can also be used to color manufactured fibers before spinning.

The dye must have access to the interior of the fiber. Hydrophilic fibers, especially cellulosics, undergo swelling in aqueous dyeing processes, and theorists imagine water-filled pores through which dye can diffuse into the amorphous regions of the fiber. Compared to cotton, the more open structure of mercerized cotton and the less-crystalline rayon both take up dye more readily. The surface barrier represented by the scales in wool requires boiling conditions for dye to penetrate successfully. Hydrophobic fibers such as polyester and acrylic undergo a structural transition at a temperature above which dye can diffuse into the fiber. For acrylic fibers, this is around 80°C. For polyester, it is above 100°C, and polyester does not dye well in traditional processes. Formerly, swelling agents called "carriers" were used, but the large volume of polyester in the market has led to the widespread use of pressurized dyeing machines and dyeing temperatures of around 130°C. Because polyester and acrylic are used at temperatures below these transitions, the dye is essentially "frozen" into the fiber, and fastness is usually good. Nylon has a more hydrophilic nature, has a low transition temperature, and takes up dye readily. It also loses dye more easily; nylon can be a color scavenger in laundering, and achieving high fastness on nylon can be challenging.

Based on the above, the textile and dye liquor are mixed in the dyeing machine. Agitation takes place, and the temperature is raised. Dye migrates to the fiber surface and is absorbed into the fiber structure. The dye concentration in the liquor decreases as dyeing takes place; the dyebath becomes *exhausted* (See Figure 22.2.) Eventually, the process reaches a point where as much dye as possible (in a reasonable time) is absorbed. Dyes are expensive, so as little as possible is wasted. Depending on the dye type and the amount of dye applied, exhaustions of 70 to 99 percent of the dye applied are typical. Once inside the fiber, dyes may undergo changes that make subsequent removal more difficult, that is, that provide better fastness. Reactive dyes, as their name suggests, undergo a chemical reaction that links dye and fiber via a strong chemical bond. Other dyes may become insoluble once inside the fiber.

The bath is cooled, and the textile rinsed to remove unfixed dye and auxiliaries.

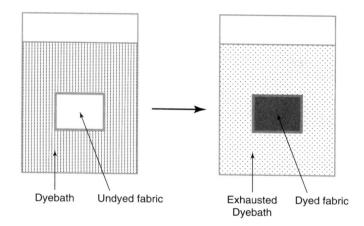

Figure 22.2

Diagram showing exhaustion of dye from dyebath to fabric.

Dyeing at Different Processing Stages

Coloration can be carried out at many different steps in the processing of textile materials. The stage at which dyeing takes place often means the use of a particular type of machinery, so if a material is referred to as "package dyed," it necessarily refers to dyeing at the yarn stage, while "jet dyed" refers to one form of fabric dyeing. But care is necessary; a similar phrasing may be used when referring to the type of dye used, such as "acid dyed" or "vat dyed."

Solution Dyeing

Solution dyeing is the addition of color to manufactured fibers before they are extruded. This process has been variously known as *mass coloration, spun dyeing*, or *dope dyeing*. Even though this is not a true dyeing process involving the attraction between a soluble colorant and a fiber, *solution dyeing* is the currently favored nomenclature. The term *producer-colored* expands the definition to include the application of dye to the fiber in gel form immediately after spinning and before it is drawn, and it also refers to the dyeing of filament tows immediately after drawing. In solution dyeing, colorant, most often pigment, is dispersed throughout the fiber melt or solution. When the fiber is extruded, it carries the coloring material as an integral part of the fiber. (See figure CP6B on Color Plate 6.)

This "locked-in" color is extremely fast to removal by laundering, and the use of pigments makes light fastness also good. The range of colors produced by solution dyeing is rather limited for economic reasons. Substantial volumes of each color must be produced between cleanup steps, and at each subsequent step (yarn spinning, weaving, knitting), multiple colors are held in stock. Furthermore, fiber production takes place well in advance of the time when fabrics reach the market. Fashion color trends may change, so by the time a solution-dyed fabric reaches the market, the color may be out of fashion and not salable. For this reason, solution-dyed fabrics are generally produced in basic colors.

Mass coloration is used most often on olefin fibers, which are generally undyeable by normal methods unless the fibers have been modified. Large volumes of olefin carpet fiber are colored this way. Similarly, solution-dyed nylon is used in carpets, where the superior fastness is an advantage.

Dyeing Fibers

When color is added at the fiber stage, this process is known as *fiber dyeing* or *stock dyeing*. It is usually a batch process. Loose staple fibers are loaded in a perforated carrier, which is in turn loaded into a dye kettle. The dye liquor circulates through the stationary mass of fibers. At the end of the process the carrier is removed and unloaded/reloaded; meanwhile, another carrier can be placed into the kettle and dyed. Levelness may be a problem, but its effect is minimized when fibers are blended later during yarn processing.

Stock-dyed fibers are most often used in tweed- or heather-effect materials in which delicate shadings of color are produced by combining fibers of varying colors. (See Figure 22.3.) The yarns in Harris Tweed fabrics are a distinctive example of fiber dyeing. (See figure CP5D on Color Plate 5.) Fiber-dyed fabrics can be identified by untwisting the yarns to see whether the yarn is made up of a variety of different-colored fibers. In solid-colored yarns, untwisted stock-dyed fibers will be uniform in color with no darker or lighter areas.

Combed fibers for worsted wool fabrics are coiled into "tops" (a form of sliver), and these can be dyed. This variation of fiber dyeing is known as *top dyeing*. Top dyeing can be batch or continuous. By dyeing the fibers after they have been combed, the manufacturer avoids the wasteful step of coloring the short fibers that would be removed in the combing process. The dyed tops can be drawn or gilled together to produce heather effects in the yarns. This method is used to produce a more interesting gray fabric (by combining black and white tops) than is obtained by simply dyeing fabric to a gray color.

Yarn Dyeing

Color can be applied to yarns before they are made into fabrics. Yarns may be dyed in skeins, in packages, or on beams. Special dyeing equipment is

FIGURE 22.3

Tweed effect created by using filling yarns made from stock dyed fibers.

Figure 22.4
Package dyeing of yarns.

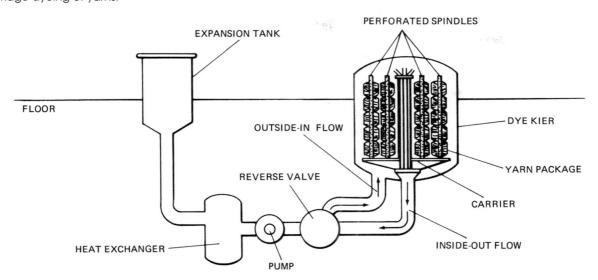

required for each of these batch processes. Little yarn is dyed continuously; the exception is the continuous application of indigo to cotton warps for weaving into denim.

In skein dyeing, large skeins of yarn are hung on sticks and placed in a vat for dyeing. The yarn is free to bulk up, and skein dyeing is useful for carpet and hand-knitting yarns. (See figures CP5C, and CP6A on Color Plate 5 and 6 respectively.) In package dyeing, the yarn is wound onto perforated tubes or springs, which are then stacked onto perforated steel spindles. The dye is circulated through the spindles and, thus, through the yarn to ensure that the yarns have maximum contact with the dye. (See Figure 22.4.) Beam dyeing is essentially the dyeing of one large package, using a larger cylinder onto which a set of warp yarns is wound.

Many types of fabrics utilize yarn of differing colors to achieve a particular design. Stripes in which contrasting sections of color alternate in the length or crosswise direction, chambrays in which one color is used in one direction and another color is used in the other direction, complex dobby or jacquard weaves, and plaids may all require yarns to which color has already been added. (See Figure 22.5 and figure CP6C on Color Plate 6.). Dyed yarns may also be used to weave heavyweight, solid-colored fabrics, where dye penetration into the fabric would be difficult.

Yarn-dyed fabrics may be identified by unraveling several warp and several filling yarns from the pattern area to see whether they differ in color. Not only will each yarn be a different color, but the yarns will have no darker or lighter areas where they have crossed other yarns.

Usually yarns are dyed to one solid color, but in a variant of the technique called *space dyeing*, yarns may be dyed in such a way that color-and-white or multicolored effects are formed along the length of the yarn.

Figure 22.5

Examples of fabrics in which designs are created by using yarns dyed of different colors.

(b)

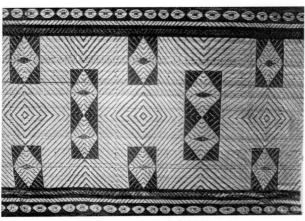

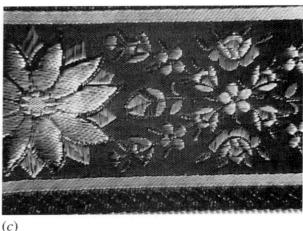

Fabric Dyeing

Color is applied to fabrics to achieve a solid color. This can be done in batches or continuously. Batch fabric dyeing is often called "piece dyeing." A number of different machine types are used for piece dyeing, each of which differs slightly in the way in which the fabric is handled or how the agitation is provided.

Some fabrics are dyed flat, or open width. Knitted fabrics and those woven materials that are not subject to creasing are handled in rope form. (See chapter 21.) They are usually attached at the ends to form a continuous loop. Some dyeing methods are especially suitable for certain types of fabrics and unsuitable for others. Many different kinds of machines can be used for piece dyeing. The processes used are summarized in Table 22.1.

Batch Processes

Beck and *jet* dyeing are batch processes for fabric in rope form. Beck dyeing, also called *box* or *winch* dyeing, is frequently used for dyeing wool fabrics and knits as it places relatively little tension on the fabric during dyeing. The loop of fabric is

Table 22.1
Fabric Batch Dyeing Machines

Bat	ch
Rope Form	Flat Width
Beck	Jig
Jet	Beam

moved through the dyebath by a large reel, or winch, and large sections are allowed to accumulate in the bottom of the beck to increase the residence time in the bath. The bath is agitated only by the movement of fabric through it. (See Figure 22.6.) Up to twelve ropes of fabric can be dyed at the same time. Devices in the machine keep the ropes separate.

Jet dyeing is a newer method that uses a jet of dye liquor, rather than a wheel, to propel the continuous rope of fabric through a narrow orifice and on through an enclosed tube. Both the fabric and dye liquor move, improving agitation and, thus, levelness. Increased agitation also allows for the use of lower liquor ratios, reducing water, energy, and chemical use. The machines are generally enclosed and can be pressurized. (See Figure 22.7.) The agitation in a jet machine can be quite extensive, and variations for delicate fabrics include a mechanical wheel to reduce any effects on the fabric surface or the use of totally immersed ("fully flooded") systems.

Jig and beam dyeing are batch processes that dye fabric in open width. In jig dyeing fabric is wound on one roller and threaded through a stationary dyebath onto a second roller. The fabric is wound from one roller to the other repeatedly until the desired exhaustion or depth of shade is achieved. Jig dyeing places greater tension on the fabric than do the beck and jet machines. The jig also can operate at very low liquor ratios. Because cotton fabrics can withstand tension and cotton dyes exhaust significantly better at low liquor ratios, the jig is the traditional cotton-dyeing machine. Because fabric spends considerable time out of the dyebath, the jig works best for dyeing processes that do not require

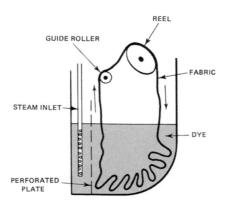

Figure 22.6

Diagram of dye beck showing movement of fabric though the dyebath.

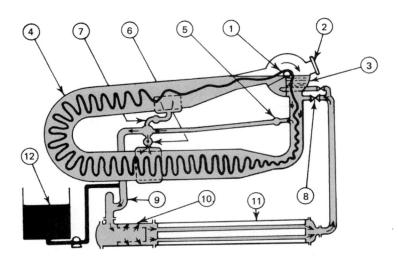

FIGURE 22.7

Hiska jet-dyeing machine. Reprinted by permission of National Knitwear and Sportswear Association.

- 1. Fabric guide roll
- 2. Loading and unloading port
- 3. Header tank
- 4. "U" tube
- 5. Suction control
- 6. Suction control

- 7. Suction control
- 8. Delivery control
- 9. Main pump
- 10. Filter
- 11. Heat exchanger12. Service tank

constant high temperatures. Consequently acetate and nylon are dyed well on jigs. (See Figure 22.8.)

Beam dyeing, which is used for lightweight, fairly open-weave fabrics and stretch knits, utilizes the same principle as beam dyeing of yarns. The fabric is wrapped around a perforated beam and immersed in the dyebath. Dye liquor is then pumped through the beam and the layers of fabric. (See Figure 22.9.) Tightly woven fabrics would not allow sufficient dye penetration; hence, this method must be applied to loosely woven cloth. It has the added advantage of not putting tension or pressure on the goods as they are processed.

Continuous Processes

Continuous dyeing can be used for dyeing all forms of textile material but is most often used in producing large quantities of dyed woven fabric that does not require some kind of conveyor and that can withstand tension. Fabrics pass through a

FIGURE 22.8
Diagram of jig dyeing method. Rollers reverse and fabric is passed through the dyebath multiple times.

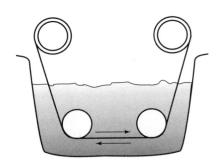

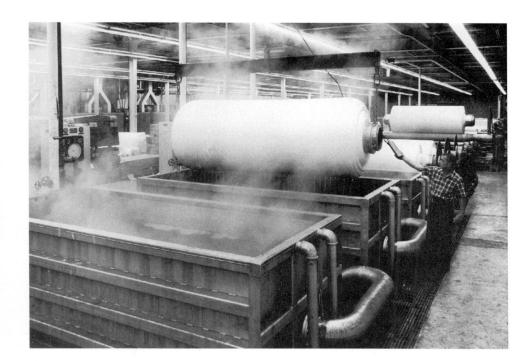

FIGURE 22.9

Beam dyeing of fabric.

Courtesy of Allied

Corporation and

Steinfeld Mills, NC.

trough of dye then through rollers that squeeze out the excess dye (together referred to as "padding"). For thick and heavyweight fabrics, especially pile fabrics, the excess dye can be removed by a vacuum to give more thorough penetration. Additional chemicals (for example, the reducing agents required in vat dyeing) may be applied in a second pad after an intermediate drying. The fabric passes into a steam or heated chamber in which dyeing (penetration of fiber by dye) takes place, through wash boxes to remove unfixed dye, and finally through a dryer. (See Figure 21.1.)

The process is efficient when large volumes of the same shade are required, but it is not without its disadvantages. Leveling can be a problem because the dye absorption may not be uniform, and dye migration to the surface may occur during drying.

Garment Dyeing

Except for dyeing socks and narrow fabrics, *garment dyeing*, or the process of dyeing completed garments, remained relatively unimportant until the 1980s. Interest in coloring garments arose as fashion demanded small lots of garments with stonewashed, ice-washed, tie-dyed, overdyed, and distressed effects. These effects were more readily achieved through garment dyeing than traditional dyeing methods. An increased use of the kind of garments suitable for dyeing (casual sweatshirts, for example) and global sourcing in a quick response mode also contributed. Stocks of undyed garments can be produced and dyed in short order in colors that are selling well, keeping store shelves stocked and avoiding over-production of less popular colors.

The lead time required for delivery of orders in the traditional dyeing system is about eight weeks. For garment-dyed products, lead time is about two weeks. Although the process of garment dyeing is more costly than traditional piece dyeing, savings are achieved because manufacturers and retailers need not maintain large inventories and can readily replenish their stock of colors that are selling well. If undyed merchandise is left from one season, it can be dyed for sale the following season.

Garment dyeing is primarily applied to cotton fabrics; however, high-pressure equipment can be used to process polyester and cotton blends. To achieve consistently good results with garment dyeing, manufacturers must exercise care in a number of areas.

- 1. *Fabric*. All fabric used in one garment must come from the same bolt of fabric. If, for example, one trouser leg of a pair of pants is cut from one bolt of fabric and the other from another bolt, each leg may dye to a different shade. The result would be pants in which the legs do not match.
- 2. *Shrinkage*. Fabric must also be tested for shrinkage before cutting of garments, and garments must be cut large enough to allow for shrinkage so sizes will be accurate.
- 3. Thread. Thread must be chosen carefully and tested to be sure it will accept the dye in the same way as the fabric. One hundred percent cotton thread is preferred, but even with all-cotton thread, there may be problems. For example, mercerized thread will dye to a darker shade than unmercerized garment fabric. This will make the stitching stand out from the background fabric.
- 4. *Labels, buttons, zippers*. All of these supplies must be compatible with the garment fabric in terms of reaction to the dye and shrinkage.

Older machines for garment dyeing and processing include the *paddle machine*, in which paddles in the machine rotate to agitate the garments and dye liquor. *Drum machines* have a perforated steel drum that revolves within the dyebath. The renewed interest in garment dyeing of the 1980s promoted the development of new garment dyeing machines based on (front-loading) commercial washers/dry-cleaning machines. These machines can be automated and typically include washing and hydroextraction steps after dyeing.

Special Washing Techniques

The fashions that provided the impetus for the growth in garment dyeing often had a distressed look in which garments had uneven colors. To achieve this effect, denim or other fabric was treated to destroy color randomly on the garment. Although the most widely used term for this process was *stonewashing*, other names to describe the random removal of color included ice washing, white washing, acid washing, frosting, super washing, and snow washing.

Both indigo and sulfur-dyed denims lose color when exposed to oxidative bleaches. Stonewashing was most commonly done by soaking porous pumice stone in bleach, adding these stones to a load of garments in a type of washing machine without any water, and running the machine for a specified time. The contact of the cloth with the bleach removes color at random on the garment. This treatment

is followed by another wash (in a different machine, as a rule) to remove any excess bleach. Cellulase enzymes are now more often used to produce a stonewashed appearance on fabrics. The process is quicker, cleaner, and does not involve the depletion of a natural resource (pumice).

Dyeing Blends

Textile materials are often made of fiber blends. Each fiber will take up dye differently or require different dyes. The dyes may be applied successively in a single dyebath (a one-bath, two-stage process) or in separate dyebaths (a two-bath, two stage process). Ultimate efficiency is a one-bath, one-stage process, but avoiding the staining of a fiber by the "other" dye and getting good fastness may make this impossible. Blend dyeing is both a challenge and an opportunity for decorative effects. A number of different effects are recognized.

Union dyeing produces solid-colored blended textiles. Dyes of the same color for each fiber in the blend are carefully selected and mixed. The fabric is then placed in the dyebath, and ideally a uniform color is produced. The use of pigments, which are not fiber specific, offers a cheap and easy way to produce solid-colored fabrics, although it is limited to pastel colors because large amounts of binder mar fabric hand.

Cross-dyeing produces a multicolored fabric in one operation by mixing dyes, each of which is specific to one fiber, in one dyebath. Each fiber picks up only its specific dye(s). Plaids or stripes can be created in a fabric by alternating yarns of different fibers, so for instance, nylon yarns are dyed red and polyester yarns are dyed blue to make a blue and red stripe.

A subtle method of creating pattern with color is seen in tone-on-tone, or differential, dyeing. This is easy to imagine where two different types of the same generic fiber are used. Both respond to the same type of dye but differently, so for example, a lighter and darker shade of the same color result. Shaded carpets are often dyed this way, where two or three nylon fibers with differing degrees of affinity for the same dye are blended in the carpet yarns.

Reserve dyeing refers to the case when only one fiber of the blend is dyed, and the other is left white, or "reserved." Sounds easy, but avoiding a stain can be challenging.

DYE CLASSES

With the development of synthetic dyes, there arose several different classes of dye: the classifications are formalized in the Colour Index, originally a set of volumes and now a Web publication, published jointly by the Society of Dyers and Colourists in the United Kingdom and AATCC in the United States. Dyes within a certain class will be suitable for the same fiber(s), have a generally similar method of application, and have broadly similar fastness and level-dyeing character. A certain class of dye may have limitations on the shade range and brightness obtainable and tend to be more or less expensive. In the following discussion of dye classes, the classes are grouped according to the fiber types for which they are most widely (though not exclusively) used.

Dyes for Cellulosic Fibers

Reactive Dyes

These dyes have become the most widely used dyes for cellulose fibers since their introduction in the 1950s. As their name suggests, after diffusing into the fiber in the presence of salt, reactive dyes react chemically with the fiber to form covalent bonds. The reaction is promoted by the use of alkali. Reactive dyes are applied most commonly to the cellulosic fibers, cotton, rayon, and linen. They are easy to apply and can produce a wide range of bright colors. The reaction is not 100 percent efficient, however, and dye that reacts instead with water ("hydrolyzed dye") must be removed from the textile after dyeing in a thorough washing process. If this is done well, reactive dyes have good wash fastness because the chemical bonds between dye and fiber are strong; if not, remaining hydrolyzed dye may bleed and cause poor fastness ratings.

Reactive dyes are a good choice for washable wools and silks because of their colorfastness to laundering. They are also of interest for dyeing wool in black shades of good fastness for formal wear, where people are looking to avoid the use of chrome mordant dyes that may be polluting.

Direct Dyes

Direct dyes (so named because the first members of the class were notable for dyeing cellulose "directly," that is, without a mordant) were also called substantive dyes. They are the simplest dyes to apply to cellulose, involving heating in a bath with the addition of salt to promote exhaustion, and they tend to be economical. They also exhibit bright shades. Because they are water soluble and not chemically bound to the fibers, they tend to show poor fastness to laundering, so their use today is largely focused on items that will not be laundered frequently. An after-treatment with cationic (positively charged) compounds can improve wet fastness slightly.

Vat Dyes

Vat dyes are insoluble in water. In order to apply them to textiles, they are chemically reduced in alkaline solution to a soluble form, dyed onto the fiber, and reoxidized to the insoluble form. This creates a color that is extremely fast to both light and washing. The strength of this class is in the blue/brown/green shades, with few reds and yellows. These dyes are expensive, however, and their manufacture can be polluting.

Indigo is the original vat dye and is widely used for dyeing the warp yarns in denim. However, indigo is not now typical of the class and has its own specialized application procedure involving successive dips and reoxidations to build up the color to the appropriate depth.

Sulfur Dyes

Sulfur dyes produce inexpensive dark and dull colors, such as brown, bottle green, or navy. They provide the cheapest and darkest black shades on cellulose. Like vat dyes, sulfur dyes are applied to textile materials in a soluble form in an alkaline

solution then oxidized to an insoluble form within the fiber. Colorfastness of sulfur dyes is good to washing and fair to light, but chlorine bleach will usually decolor them completely. They would typically be used for men's casual pants, and work wear. If the goods are not carefully rinsed, fabrics dyed with sulfur dyes can become weakened ("tendered") on storage. Black and yellow sulfur dyes may accelerate light degradation of cellulosic fibers.

Azoic Dyes

Azoic dyes (also called naphthol dyes) involve the creation of a dye molecule within the fiber. The dye is produced when two components, a diazonium salt and a naphthol compound, react to form a highly colored, insoluble compound on the fabric. These dyes were also known as *ice colors* because the reaction takes place at lowered temperatures. They have good colorfastness to laundering, bleaching, alkalis, and light, but they do tend to crock somewhat. The colors they provide are mainly in the red range, and they are useful for giving good penetration of heavy fabrics such as toweling and corduroy. Stabilized mixtures of naphthol and diazonium salt (known by their old commercial name of "rapidogens") are useful in textile printing. The color is produced on steaming in an (acetic) acid atmosphere. A variation of the azoic dyeing process is used to get fast "developed black" on acetate. These are now the least commonly used dyes for cellulose fibers.

Dyes Used for Wool, Silk, and Nylon

Acid Dyes

Acid dyes have sulfonic acid functional groups that make them water soluble and anionic (negatively charged). They interact with cationic (usually amine) groups in nylon, wool, and silk in acid solutions. The amount of acid (i.e., the pH) is used to control the dyeing process. These dyes are also applicable to spandex and some modified polyesters and polypropylene. The group covers a wide range of dyes, and the fastness similarly varies widely. Shades can be bright.

Metal complex, or premetallized, dyes also belong to the acid dye class. In their manufacture, dyes are reacted with a metal salt, such as chromium or cobalt, to form a dye-metal complex. Since their introduction, 2:1 dye-metal complexes have become widely used, while older 1:1 types have remained of minor importance. The dyes are very stable, with excellent light and wash fastness, but the resulting colors are not as bright as those of unmetallized acid dyes. These dyes provide the best fastness properties on nylon, especially in dark shades.

Chrome, or Mordant, Dyes

The Colour Index refers to mordant dyes, but because chrome is the most widely used mordant, they are more often called chrome dyes. These dyes are chiefly confined to the dyeing of wool, where they provide economical, deep, fast black and other dark/dull colors. The dye is applied and after-treated with a chromium salt that reacts with the dye molecule to form a relatively insoluble dyestuff with good

wet- and lightfastness. Despite modified processes that minimize the amount of chrome in effluent, their use is declining with increased environmental concerns about pollution from the chrome.

Dyes Used Primarily for Manufactured Fibers

Basic Dyes

Basic dyes contain positively charged (cationic) groups that interact with negative groups in fibers; they are also known as cationic dyes. Many early synthetic dyes were of this class, including Perkin's mauve, and they were known for brilliant colors but poor fastness on wool, silk, and (mordanted) cotton. The introduction in the 1950s of acrylic fibers, which contained anionic groups, renewed interest in these dyes, and new ("modified") basic dyes were produced. Polyester and nylon fibers that have been modified by including cationic groups can also be dyed with basic dyes.

Disperse Dyes

Developed for coloring acetates, disperse dyes are now used to color many other manufactured fibers. The dye is sparingly soluble in water. Particles of dye disperse in the water and slowly dissolve into the fibers. Disperse dyes can be applied to a wide variety of fibers, including acetate, acrylic, aramid, modacrylic, nylon, olefin, polyester, and triacetate, and are really the only practical means of coloring acetate and polyester fibers.

Disperse dyes are unusual among the dye classes in that they are volatile and will sublime (go from a solid to a gas) when heated. This can be a problem if fabrics dyed with them are subjected to high heat but also enables them to be fixed using dry heat; the dye sublimes and dyes the fiber from a gaseous state. This is used in continuous dyeing, in a pad-dry-heat sequence, originally developed by DuPont as the ThermosolTM process. It is also used in heat-transfer printing (see chapter 23), where paper is printed with disperse dyes and the design transferred onto a polyester, nylon, or acetate fabric using dry heat.

Colors produced with disperse dyes cover a wide range and generally have good fastness. Blues, however, tend to be discolored by nitrous oxide gases in the atmosphere and may gradually fade to a pinkish color. Greens may fade to brown. This "fume fading" is apparent primarily in disperse-dyed acetate. (See chapter 6.) The main source of fumes in homes is gas-fired stoves and heaters.

Fugitive Tints

Colors that are not permanent are sometimes called *fugitive tints*. In most dyeing processes, the manufacturer wishes to produce a color that is permanent and one that will not disappear in use or in processing. Fugitive dyes, on the other hand, are used to identify fibers or yarns during the manufacture of fabrics. By coloring fibers or yarns of a particular generic type to a specific tint, the manufacturer has a readily identifiable color code. When the processing of the materials is complete, the manufacturer can remove the color by a simple wash, often in cold water.

SUMMARY POINTS

- Dyes are absorbed by the fibers in a yarn or fabric; they may be synthetic or derived from natural sources
- · Pigments are adhered to the fabric surface with a binder
- · Designers communicate the color required in a textile in several ways
- Dyers have to match the required color in a dyeing that is level and colorfast
- Dyeing can be done at the fiber, yarn, fabric, or garment stage, with different types of equipment
- Dyes are classified by their mode of application and how they interact with fibers
 - Dyes for cellulosic fibers: reactive, direct, vat, sulfur, and azoic
 - Dyes for wool, silk, and nylon: acid and chrome
 - Dyes for manufactured fibers: basic and disperse

Questions

- 1. What is the difference between dyes and pigments?
- 2. Before the discovery of synthetic dyes, what kinds of substances were used to dye fabrics? When were the first synthetic dyes made, and what were they made of?
- Describe the different ways in which a designer can communicate color information to a dyer.
- 4. What are the ways in which someone in New York can decide if a dyed textile is the correct color or not? Are they objective or subjective? Does it necessarily involve a dyed sample being sent?
- 5. How can the satisfactory retention of color by a garment in use by the consumer be predicted?
- 6. What holds dyes and fibers together?
- 7. Identify the stages of fiber and fabric manufacture at which color can be added to a textile.
- 8. Compare batch and continuous dyeing processes.
- 9. What is the basis of the names given to the various dye classes? Explain why all dye classes are not equally useful for fabrics made from all textile fibers. What dye classes might be used in dyeing a polyester/cotton blend?
- 10. What are the advantages and disadvantages of garment dyeing?

References

AATCC. Technical Manual. Research Triangle Park, NC: AATCC, 2005.

Recommended Readings

Aspland, J. R., "Textile Dyeing and Coloration." Research Triangle Park, NC: AATCC, 1997.

Bide, M. "Wool Dyeing: What's New?" *Textile Chemist and Colorist* 24 (April 1992): 17–22.

- Fox, M., and J. Pierce. "Indigo: Past and Present." *Textile Chemist and Colorist* 22 (April 1990): 13.
- Garfield, S. "Mauve: How One Man Invented a Color That Changed the World." New York: W. W. Norton & Co., 2002.
- Perkins, W. S. A Review of Textile Dyeing Processes. Textile Chemist and Colorist 23 (August 1991): 23.
- Rivlin, J. *The Dyeing of Textile Fibers: Theory and Practice.* Philadelphia: Philadelphia College of Textiles and Science, 1992.

TEXTILE PRINTING AND DESIGN

Learning Objectives

- 1. Distinguish among the colorants used to produce different designs.
- 2. Describe the techniques for producing a colored design directly or indirectly.
- Discuss traditional printing processes, and identify the opportunities that ink-jet printing offers.

Although many thousands of yards of fabric are processed in solid colors, thousands more yards have designs applied through printing. As with dyeing, important decisions in the creation of a textile product must be made as it is being designed.

Colored patterns may be applied to fabric by a variety of hand or machine processes. The earliest of these was probably freehand painting of designs on fabrics, but this is a time-consuming procedure that does not always result in a uniform repeat of a motif that is to be used more than once. If a design is transferred to a flat surface that can be coated with a color and stamped onto the fabric, the same design can be reliably repeated many times. This process is known as *printing*. Over many centuries a variety of techniques for printing designs have evolved. Printing can be applied to warp yarns, to fabrics, or to apparel pieces—for example, slogans or pictures on T-shirts.

In general, printing is a cheaper way of creating designs on fabric than weaving or knitting with different-colored yarns. As with dyeing, several different printing "methods" are used and described. This use of the word *method* can be confusing; it can refer to the colorant used, the machinery used, or the means of achieving a certain design.

COLORANTS USED IN PRINTING: BASIC PRINCIPLES

In achieving solid colors on textile materials, dyes are most commonly used. The binders required to hold pigments in place on the fiber surface tend to have a negative effect on fabric hand, so the use of pigments is confined to pale shades (requiring less binder), especially on polyester/cotton blends where the complication of requiring two dye types is avoided. However, in printing, the use of pigments allows for much simpler processing and is much more common; pigments probably account for 50 percent or more of the print market.

Whether dye or pigment is used, the color is usually applied as a thickened paste. Several natural and synthetic materials are used as thickeners, but they tend to have flow properties (or *rheology*) more like mayonnaise than honey. This allows the paste to be spread easily onto the fabric but limits the wicking of the color once printed to maintain a sharp outline.

Most nontextile printing can be done by mixing primary "process colors" (yellow, magenta, cyan, and black) as small dots directly on the substrate. This is readily apparent when a printed magazine, for example, is viewed under a magnifying glass. Large areas of a particular color may be premixed and applied as "spot color." With the recent exception of ink-jet printing, colors do not mix reliably on textiles, and dyes and pigments must be applied to textiles as premixed spot colors. Unless the original design deliberately takes this into account, part of the process is thus reducing an original image to a fixed number of colors for printing.

Printing with Dyes: Wet Printing

To print a design on textile fabrics with dyes requires the application of a paste that contains not only dye and thickening agent, but also auxiliaries to ensure fixation and dye solubility. After printing, the fabric is dried, and a steaming process fixes the dye (and it penetrates the fibers). Subsequently, unfixed dye, thickener, and auxiliaries are washed off the fabric. Printing involves multicolors, so in the washing process, it is important that removed dye not "backstain" unprinted or palecolored areas of the fabric. The steaming and washing steps have led to printing with dyes being referred to as "wet printing."

Cotton and rayon are the most common printed substrates. Reactive dyes, given their bright colors and limited backstaining, are the most widely used dyes. Vat dyes are used for printing where the best fastness is required, especially fastness to light, as in draperies and upholstery. Little printing is done with direct or sulfur dyes. Azoic dyes are printed for the most brilliant reds, such as for Christmas patterns. Polyester dress goods are commonly printed using disperse dyes; nylon (e.g., for swimsuits) and silk (e.g., for shirts and ties) are often printed with acid dyes. Cellulose/polyester blends can be wet-printed, usually with a combination of reactive and disperse dyes, where the need for a soft fabric hand can justify a complex operation.

Printing with Pigments

Pigment printing uses a paste of pigment, binder, and thickener. The print is dried and cured with dry heat to fix the binder. The use of a thickener that is effective at low amounts avoids any need to wash it out of the print. Pigment printing is thus

quicker and cleaner (and drier!) than wet printing, especially for polyester/cotton blends. The simplicity has earned the technique a large part of the overall printing market. Advances in binder technology have minimized limitations of hand and crock-fastness; indeed, binders are often referred to as "low-crocks." Bright colors of good lightfastness are readily achieved. In use, pigment prints tend to develop a frosty appearance as color is removed from fiber surfaces by washing and wear. Unlike dyes, which are transparent, pigments hide what is beneath. Light-colored pigments can be printed on a dark background, and white pigments exist, while white dyes do not. Specialist pigments are also available to give metallic, glow-in-the-dark, thermochromic, and iridescent effects.

MEANS OF ACHIEVING A DESIGN

No matter what colorant or what machinery is being used, a design can be produced on the fabric by printing directly, by printing onto predyed fabric, or by dyeing fabric treated with a resist or mordant.

Direct (Blotch) Printing

The principle of direct printing is creation of a colored design by applying a dye or pigment directly onto a textile substrate (yarn or fabric). Many designs consist of large backgrounds with small details, known traditionally as "blotches" and "pegs." Such direct printing is thus also termed *blotch printing*. Each color in the design is applied separately. A skillful print designer understands how colors spread so a one-millimeter line in the design might end up wider when printed, but a one-millimeter gap might end up smaller as surrounding printed areas wick slightly. Less than perfect alignment of colors in the print can leave white spaces, called "grins." Deliberate overlap of colors, called "trapping," leaves some room for error. When the colors are correctly placed on the fabric, the print is said to be in *registration*.

Each of the colors of blotch-printed fabrics usually has a lighter color on the wrong side than on the right side of the fabric. (See Figure 23.1.) Occasionally, as in a flag, for example, the printer will adjust the paste rheology to give fuller penetration and a more even color on both sides.

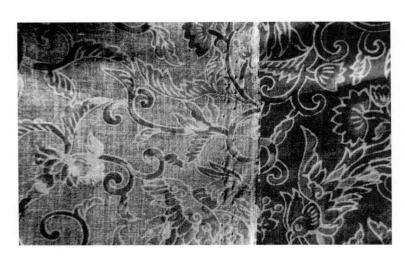

FIGURE 23.1

Blotch print: (a) back; (b) face. Background color is lighter on the fabric back.

Overprinting

Overprinting is application of a design on a fabric that has already been piece dyed. An overprinted fabric can be distinguished from a blotch print because the background color will have the same depth of shade on both the face and the back, but printed areas will be lighter on the back. Overprinting with dyes is successful only when printing dark on light because they are transparent. Because pigments are opaque, a pigment overprint can involve light and dark colors printed on any background.

Discharge Printing

Piece-dyed fabrics may be printed with a *discharge paste* that destroys color in the printed areas of the fabric, producing a white detail. If a discharge-resistant dye is included in the discharge paste, an *illuminated discharge* is produced. The sharpness of the white detail is much better than can be obtained by printing a dark background and leaving the unprinted white area. In the illuminated discharge, destruction and coloring occur in one operation and the *fit* of the colored detail in the background is perfect, unlike the two-step process in direct printing. Discharge prints are recognizable because the color of the background is the same on both the front and back sides (as in an overprint) but in the print areas, traces of this original color remain on the back. (See Figure 23.2.) Many discharge techniques have been explored and used, but the main one in use today involves a reactive-dyed ground discharged with a reducing agent that can simultaneously fix a vat dye used as the illuminant.

Resist Printing

In *resist printing* a substance is applied to the fabric that will prevent the absorption or fixation of dye in the treated areas. Traditional resists are based on mechanical barriers to dye absorption (such as starch, clay, and wax), followed by immersion in a dyebath. The technique has been used to produce textile designs in many different cultures, including those of Persia, India, South America, Egypt, and the Far East.

FIGURE 23.2

Discharge print: (a) face;
(b) back. Background color is the same on both sides.

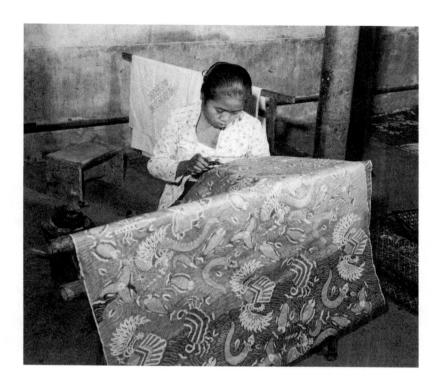

FIGURE 23.3
Indonesian woman uses tjanting for applying wax to a batik fabric.
Courtesy of Exxon
Corporation.

The most common example is batik cloth made by a wax-resist process that originated in the Indonesian Archipelago. Wax is applied from a small, spouted cup with a handle called a *tjanting*. (See Figure 23.3.) A faster, cheaper, and lower-quality process involves printing the wax from a design carved on a *tjap* block. In both cases, when the wax hardens, it coats the fabric so the dye cannot reach the fibers. (See figure CP6D on Color Plate 6.) Each separate color in the design represents an application of wax, dyeing, and boiling to remove the wax, so a multicolor design is a complex operation.

Resist designs can be produced by the tie-dyeing, or tie-and-dye, method in which parts of the fabric are tightly wound with yarns or tied into knots in selected areas. When the fabric is placed in a dyebath, the covered or knotted areas are protected from the dye. Careful attention to the shape of the wrapping and the placement of the tied areas can produce intricate and attractive patterns. In Indian textiles the tie-dyeing method is known as *bandanna*. Often used for T-shirts, dresses, skirts, and other garments, tie-dyeing is carried out on a commercial scale in operations that typically are also engaged in garment washing to achieve distressed and other looks.

Large-scale modern versions of resist printing on fabric involve chemical prevention of the conditions required for fixing the dye, and the resisted dye is often applied by an all-over print, rather than in a dyebath. Thus, for example, reactive dyes that require alkali for their fixation can be resisted by acid. When the resist is chemical, it is possible to illuminate, or color, the resist by simultaneously printing a dye that is not affected by the resisting chemical. Like discharge printing, resist printing can provide well-fitted, small design elements in a dark background.

428

PRINTING MACHINERY

As discussed earlier, a "printing method" can refer to the kind of machine or equipment used to apply the pattern. This use of *method* can usually be combined with those based on the sections above dealing with the colorant used or how the design is achieved. Thus, one might have a screen-printed, pigment-illuminated discharge print, or a vat-dye blotch print applied by copper roller.

Block Printing

Block printing appears to be the oldest direct printing technique. Textile printing blocks have been recovered from Egyptian graves of the fourth century AD (Haller 1939). A block of material (usually wood) has a design drawn on one flat side. The design is carved by cutting away the spaces between the areas that form the pattern, thus placing the design in a raised position. Color is applied to the surface of the block, and the block is pressed onto the cloth and tapped with a mallet to ensure complete contact of the block with the fabric. The principle is familiar to anyone who has ever made a potato or linoleum print. Registration of multiple colors was provided by the use of pins at one or more corners of the block. Variations include blocks in which designs are reinforced by metal. A few commercial block printers still survive, but the technique was largely replaced in the early nineteenth century by more productive processes.

Roller Printing

Continuous roller printing was developed in the late eighteenth century and made possible the large-scale production of printed fabrics. A series of rollers each apply one color to the fabric; a typical machine might have six to ten rollers. The circumference of the roller, typically sixteen inches (four hundred millimeters) or less, determines the length of the repeated print pattern, and machines that print fabric widths greater than forty-five inches are unusual.

The rollers are made of copper, and the design of each color is etched into the surface by a photoengraving process and an acid etching. The rollers are then plated with chromium for durability.

The rollers are installed in sequence (outline first, then light to dark) on the printing machine around a large, central drum. The rollers rotate against a brush that applies print paste then past a *doctor blade* that scrapes off color from the roller surface (leaving paste within the sunken engraving), and the roller then rotates against the cloth moving around the central drum. The fabric thus passes beneath each roller, accepting color from each one in a continuous printing operation. (See Figure 23.4.) The printed cloth is dried then passes to a steamer or oven for dye or pigment fixation.

Rollers must be aligned perfectly to keep the print in registration, and this requires skill and experience on the part of the printer. While the printing itself is fast, changing colors or changing rollers is a slow and difficult task, and storing heavy copper rollers for possible reorders is expensive. The excellent reproduction of fine lines and half tones is offset somewhat by the limited repeat sizes.

FIGURE 23.4

Diagram of a roller printing system. Courtesy of Allied Chemical Corporation, Fibers Division.

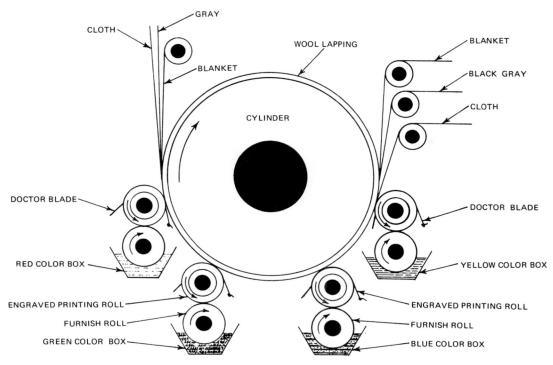

After the introduction of rotary screen printing in the 1960s, roller and screen printing existed side by side for some time while screens were still relatively coarse. As screen printing has improved (see below), the use of roller printing has become obsolete.

Screen Printing

Screen printing involves passing a color paste across a partly blocked mesh screen; color passes through the screen in the print areas, while no color is applied in the blocked (nonprint) areas. The technique has evolved from a slow, manual process using flat silk screens to continuous rotary screen printing via a metal mesh, the most rapid method of applying printed designs to textiles.

In the most common process, screens are first coated with a photosensitive lacquer. The design for a single color is applied to each screen as a black-on-clear film, and the whole is exposed to light, which hardens the lacquer in the clear (nonprint) areas. The lacquer in the unexposed (black) areas remains soluble and is washed out. The screen is baked to harden the remaining lacquer and is ready to use. Rotary screens are also produced in some different ways. In so-called *laser engraving*, a hardened lacquer is burned out from a screen, avoiding the need to produce the design on film. Another alternative combines the creation of the mesh screen with the application of the design; the nonprint areas of such a *galvano screen* are thus solid nickel, rather than blocked mesh.

Flatbed Screen Printing

Printing through flat screens can be done automatically or by hand. In hand screen printing, the fabric to be printed is fixed to a long table. A screen is prepared for each color of the design. The screen for one color, mounted on a frame, is placed in the correct position on the fabric. The print paste is poured into the top of the screen, and the printer (or printers, one on each side of the table) drags a squeegee across the screen to press the paste through the open area of the screen, onto the fabric. The screen is moved farther along the fabric, and the process is repeated. To be efficient, the fabric might be on two tables, so the printers work "up and back" for one color. After one color has been applied, the process is repeated with the next colors. By the time this happens, the color from the first screen is dry, and smudging is avoided.

Hand screen printing is a slow process but is still used for short runs (fifty to five hundred yards) of fabric for, say, a historical reproduction, a custom drapery, or a designer's collection. Printing through flat screens has been automated by making the frames stationary and moving the fabric along on a belt from screen to screen, although the movement is intermittent because the fabric must be still while squeegeeing (also done automatically) takes place. (See Figure 23.5.) T-shirts and decorative dish towels, for example, are also printed by automated flatbed screens, but generally the screens are arranged around a circle, with a

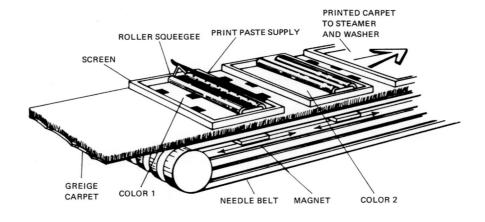

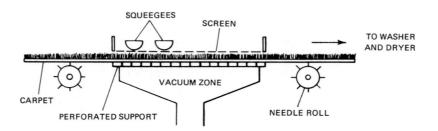

Figure 23.5

Silk screen printing of carpets. Courtesy of Modern Textiles magazine.

station to mount the T-shirt or towel and one to remove the printed item as the first and last.

Flatbed screen printing machines have limited production speeds when compared with rotary screen printing and roller printing, but they do allow very large design repeats and economical and efficient production of small yardages.

Rotary Screen Printing

Rapid continuous roller printing existed side by side with slower flat screen printing for many decades. It was easy to imagine the development of a rotary screen that would print continuously at high speeds. This advance had to wait for a screen in which there is no seam. In the 1960s Stork developed an electrodeposited, seamless, nickel mesh screen, and rotary screen printing rapidly became the dominant textile printing technique.

As in the hand process, a screen is prepared for each color. The dye is fed into the hollow center of the screen, and the screen revolves over the continuously moving fabric while a stationary squeegee (or magnetic rod) forces paste onto the fabric. Machines of up to twenty-four colors have been developed, including those that can change designs while the machine is still running. The screens are light weight, and the repeat size can be varied up to a meter (thirty-nine inches) or more, and fabrics three meters (120 inches) wide can be printed. (See Figure 23.6.) The design is easier to keep in register, and the production of screens for rotary screen

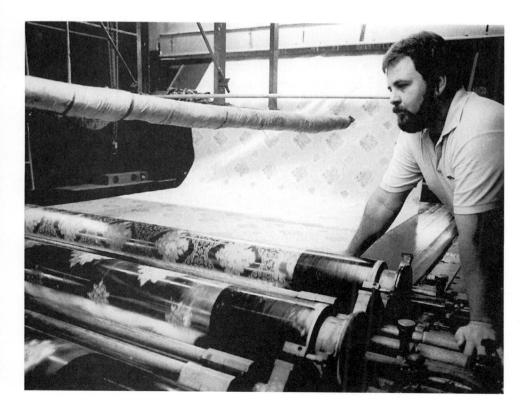

FIGURE 23.6

Rotary screen printing machine. Each cylinder adds a different color and a different part of the total pattern. Courtesy of the American Textile Manufacturers Institute. printing is less costly than the engraving of the heavy copper rollers used for roller printing. Early screens had a relatively coarse mesh, which limited the design possibilities; fine details were hard to print, but developments have made the quality of print close to that obtainable from roller printing. Speeds of fifty to one hundred meters per minute are usual.

Ink-jet Printing

Some of the latest advances in textile printing have been in the area of *ink-jet printing*. The process is similar to the computer-controlled paper printers used for office applications. They eject small droplets of dye liquid onto a textile fabric in a predetermined pattern. The Milliken Company's Millitron[®] system for printing carpets was an early type of continuous ink-jet (CIJ) printer, but newer developments can print fine designs on flat fabrics and typically use drop-on-demand (DOD) technology, with a piezo-electric or thermal pulse to eject droplets of dye from the print head in response to a signal from a computer (Tincher, Hu, and Li 1998).

The major advantages of ink-jet printing derive from the directness of printing from computer to substrate with no intermediate roller or screen to prepare. This allows designers to rapidly proof designs with ink-jet printers in their studios. Even more effectively, printers can produce short yardages of a range of designs and avoid the need to produce rotary screens to print "strike-offs." The designs can be demonstrated to potential customers, and the screens only produced for designs that attract orders (Stefanini 1996). This represents substantial savings given the low proportion of successful designs in a season and that each unsuccessful design might involve twelve screens. Ink-jet printing can print fine detail, and printers must ensure that the ink-jet strike-off is representative of what can be produced with rotary screens. For this reason, the ink-jet machine should be in the print plant and run by printers.

Ink-jet printing is not without its limitations. Producing inks that can be jetted is complex and has different challenges depending on the colorant (dye type or pigment) involved. Not all these challenges have been met. Inks for ink-jets are considerably more expensive than the color required for conventional printing. Some of the auxiliaries that would normally be in a print paste cannot be included in ink for jetting; for example, to make the ink fluid enough for jetting, thickeners cannot be included. To avoid wicking of the design, thickeners are applied to the substrate before printing, along with dye-fixation chemicals, so fabrics for ink-jet printing have to be specially prepared, adding further cost. The main limitation has, however, been speed. While "speed" from design to fabric is high, ink-jet prints are produced at rates measured in yards per hour, rather than yards per minute, and increases tend to have been based on increasing the number of print heads in use; major leaps in speed seem unlikely. They are thus limited to shorter runs of fabric, and they are more effective at printing designs with a lot of white space, rather than those that have all-over dark colors. Further, machines with more than the four basic colors of black, cyan, magenta, and yellow will probably be needed to provide designers with the color variations with which they are used to working.

OTHER PRINTING TECHNIQUES

Heat-transfer Printing

In heat-transfer printing, or sublimation printing, dyes are printed onto a paper base then transferred from the paper to a fabric. The color vaporizes or "sublimes" from paper to fabric as they are pressed together under pressure and at high temperatures (around 425°F, or 200°C). The system is confined to sublimable dyes, which in practice means disperse dyes, and thus, to textiles made of disperse-dyeable fibers (i.e., polyester, nylon, acetate, and acrylic). The method was intensively developed in the polyester boom of the 1970s and remains today as an occasionally useful means of printing thermoplastic fibers. Methods for extending the transfer techniques to wool, cotton, and silk were developed but did not prove commercially successful.

Paper and dyes must be carefully chosen, but the application of dye to paper is not restricted to the textile printing methods. Traditional paper-printing techniques can also be used. Similarly, the colors can mix on the paper, and prints are not limited to twelve or fifteen spot colors as they are from rollers and screens. The sharpness and clarity of print are also good. A major advantage is that the paper is cheap, and once printed, many yards can be held in stock with minimal investment. Designers can choose small amounts of several designs on paper, and they can quickly be transferred to stock fabric. This is much quicker and cheaper than preparing the screens for a range of designs and printing many short yardages. The waste paper still has the design present and may find use, for example, as florists' wrapping paper.

Transfer printing can also be used to apply designs to garments such as T-shirts and jackets. Often the design is composed of pigment colors on plastic film. When this is placed on the textile item and a hot press is applied, the pigments and film are transferred to the fabric. The binding plastic makes the design area somewhat stiffer than the rest of the fabric. (See Figure 23.7.)

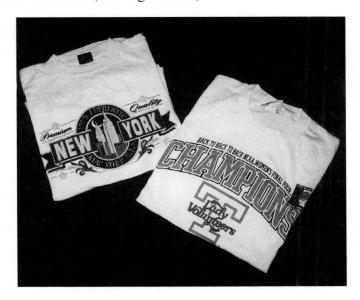

FIGURE 23.7
Transfer printed designs on T-shirts.

^{1.} Sublistatic printing, a term often used in conjunction with heat-transfer printing, is the trademark of the Sublistatic Corporation, a major producer of hear-transfer printing paper.

FIGURE 23.8

Cotton fabric with a photographic print of citrus fruits.

Photographic Printing

Photographic printing is done in a manner similar to the photochemical preparation of screens for screen printing. A photosensitive dye is coated on the fabric, a negative is placed over the fabric, light is applied, and a photographic type of printing takes place. (See Figure 23.8.)

Burnout (Devore) Printing

Burnout printing produces designs on blend fabrics when a pattern is printed with an agent that will dissolve or destroy one of the fibers in the blend. The second fiber is left as a semitransparent design area in an opaque fabric. The technique is an old one but works well today in fabrics of polyester/cotton and polyester/wool; printing an acid (sulfuric acid or aluminum sulfate) or an alkali (sodium hydroxide), respectively, will destroy the natural fiber and leave a polyester skeleton. Burnout prints have also been applied to velvets, destroying the pile of one fiber and leaving the base fabric untouched. (See Figure 23.9.)

FIGURE 23.9
Burn-out design with one fiber dissolved away.

FIGURE 23.10

Cotton plissé puckered design created by printing with sodium hydroxide on the background to shrink the fabric, leaving puffed, untreated areas between.

Plissé Designs

A puckered effect called *plissé* is achieved in fabrics by imprinting them with chemicals that cause the fabric to shrink. When these chemicals are printed in a design, some areas of the fabric shrink, while others do not. This causes untreated areas to pucker or puff up between the treated areas. (See Figure 23.10.) Cottons and rayons react in this way when treated with sodium hydroxide, an alkali, as do nylons printed with phenol, an acid. Although plissé is a fairly durable finish, such fabrics should not be ironed because the pressing of the plissé flattens the surface. Thermoplastic fibers can also be embossed to simulate plissé.

Flock Printing

By imprinting an adhesive material on the surface of a fabric in the desired pattern then sprinkling short fibers over the adhesive, a *flocked print* may be created. Flocking as a type of finish is discussed at length in chapter 20. (See Figure 20.13 and figure CP7C on Color Plate 7.)

Warp Yarn Printing

A complex and unusual variation of resist printing has been applied to yarns in the (originally Malaysian) *ikat* process. *Menigikat* means *tie* or *knot*, and the weaver tied or covered sections of the warp yarns with a resist material—wax, clay, or other yarns as in tie-dyeing. The warps were dyed, leaving the covered areas white, and the resist material was removed. If a more complicated pattern were required, the warp yarns might be treated several times, as in the batik procedure. When dyeing was completed, the filling was woven into place. The resulting fabric had a pattern with indistinct edges due to the slight variations in the positions of the warp yarns as the fillings were inserted and beaten into the fabric structure. (See Figure 23.11a.) In more complex variations, both warp and weft yarns can be resist dyed by the ikat process.

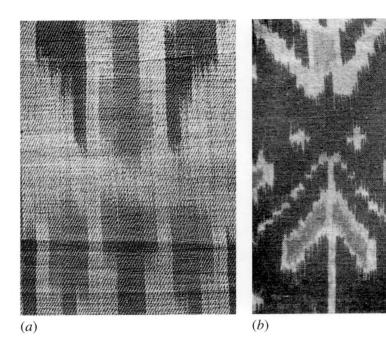

FIGURE 23.11

(a) Ikat fabric; (b) printed fabric made to imitate a woven ikat fabric.

The direct printing of warp yarns before they are woven into the fabric grew out of the ikat process. Like ikat, the resulting fabrics have indistinct print outlines producing a delicate, shimmery quality. (See Figure 23.12a.) Warp printing is applied to higher-priced fabrics. The blurred effect of both ikat and direct-printed warp yarns can be simulated in a cheaper process by directly printing a design with indistinct edges. (See Figures 23.11b and 23.12b.)

Mordant Printing

Historically, many natural dyes came to the dyer as ground-up bark or root that was boiled in a dyebath to extract the dye. They were not available in pure enough form to be applied directly to fabrics. Inventive printers found another means of applying them in color patterns to fabrics. Because they were applied to cotton with mordants, the mordant rather than the dye could be printed onto the fabric and fixed by "aging." The entire cloth was then passed into the dyebath. The mordanted areas absorbed the dye permanently; the rest of the cloth picked up dye only on the surface. Washing removed this unfixed dye from the unprinted areas and left a design on the mordant-printed areas. Different mordants and/or different concentrations of mordant gave different colors from the same dyebath. The technique was especially important for printing madder, with aluminum (pink-red) and iron (purple-black) mordants. Adding a yellow dye to the bath, such as quercitron, extended the colors to include oranges and browns. Thus, a typical palette of nineteenth-century printed fabrics in the "madder style" emerged. The basic technique also had resist and discharge variations. A pattern could be printed with an agent that would prevent the mordant from fixing in the aging process, or an all-over mordant application could be discharged in selected (print)

FIGURE 23.12

(a) Warp printed silk fabric; (b) roller printed fabric made to simulate indistinct pattern of warp printed fabric.

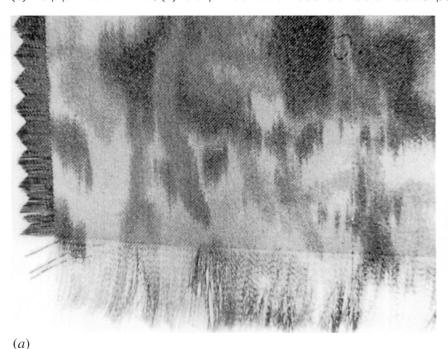

areas. Once alizarin (the coloring matter of madder) became available in pure synthetic form, the madder style was replaced by the direct printing of the colors in the "steam style"; now there was no limiting of the colors to those available from a single dye(bath).

SUMMARY POINTS

- Textiles are printed with designs using dyes and pigments
- · Means of achieving designs
 - Most designs are achieved by printing directly
 - $\circ\,$ Indirect printing methods are overprinting, discharge, and resist
- Different types of machinery are used in printing
 - Large-volume printing is done using rotary screen printing
 - Roller printing is now rarely used
 - Flatbed screens allow very large design repeats
- · Ink-jet printing has found a niche market
 - · Avoids the need to make a screen
 - Uses "process colors" that mix on the fabric
- Other methods include heat-transfer, burnout, warp yarn, and mordant printing

Questions

- 1. What is printing with dyes usually called?
- 2. Why are pigments used more in printing than they are in producing plain-colored fabrics?
- 3. What is the advantage of discharge printing versus direct (blotch) printing?
- 4. Give one example each of a mechanical resist process and a chemical resist process.
- 5. What limitations of roller printing led to its replacement by rotary screen printing for continuous printing?
- 6. How would the purchase of an ink-jet printer save money for a screen printer?
- 7. Ink-jet printers are described both as "fast" and "slow." How can this be?
- 8. Why is heat-transfer printing confined largely to polyester, nylon, and acetate?

References

- Haller, R. "The Technique of Early Cloth Printing." *CIBA Review* 26 (October 1939): 933.
- Stefanini, J. P. "Jet Printing for the Textile Industry." *Textile Chemist and Colorist* 28, no. 9 (1996): 19.
- Tincher, W. C., Q. Hu, and X. Li. "Ink Jet Systems for Printing Fabric." *Textile Chemist and Colorist* 30, no. 5 (1998): 24

Recommended Readings

- Carr, W. W. "Printing Textile Fabrics with Xerography." *Textile Chemist and Colorist* 23 (May 1991): 33.
- Doujak, R. "Automation in the Textile Printing Industry." *American Dyestuff Reporter* 83 (September 1994): 76.
- Graham, L. "Ink Jet Systems for Dyeing and Printing of Textiles." *Textile Chemist and Colorist* 21 (June 1989): 27.
- "Liquid Crystals, Red, Hot, and Blue." The Economist 319, May 18 (1991): 92.
- Shore, J. "Textile Coloration. Part 2: Application by Printing." *Textiles* 19, no. 1 (1990): 19.
- Zimmer, R. "Automating the Textile Printing Industry." *Canadian Textile Journal* 111 (June 1994): 12.

Physical/Mechanical Finishes

Learning Objectives

- 1. Define the purpose of finishing, and distinguish between mechanical and chemical finishing.
- Distinguish among the various mechanical methods of changing the surface texture of textile materials.
- 3. Explain why fabrics shrink, and describe the mechanical shrinkage control methods for various fibers.

After preparation, dyeing, and printing, fabrics undergo finishing processes. These may enhance their aesthetics; change appearance, hand, and/or texture of the material; or improve performance in resisting a challenge such as flames, dirt, moths, or water. Both aesthetics and performance can be changed by finishes that consist of mechanical manipulation or the application of a chemical. While chemical treatments are often used for improved performance, there is no clear division.

The treatments applied may be durable, semidurable, or nondurable to washing or perhaps dry-cleaning treatments. The term *permanent* was formerly used but is less often used today. What qualifies as "durable" may depend on how critical the finish is. A fire-retardant treatment for children's sleepwear must be durable to at least fifty launderings, while a durable softener may last for only ten. Nondurable finishes are useful for items that are not washed, for temporary changes such as making a fabric easier to handle in garment manufacture, or simply to provide an aesthetic benefit at the point of sale. Some finishes are renewable and can be (re)applied by the consumer during the life of the garment.

440

SURFACE FINISHES

Many finishes are used because of the effect they have on the appearance of the fabric. Sometimes these finishes also produce a related change in texture or hand.

Calendering

Calendering is a general term that refers to a mechanical finish achieved by pressing fabrics between a series of two or more rollers. The object of calendering is to smooth the fabric and/or create interesting surface effects. Calendering and related treatments are of limited durability when applied to cellulosic materials, but durability can be increased when calendering is carried out in conjunction with a chemical resin treatment. The use of heated rollers makes calendering durable on fabrics of thermoplastic fibers. Calendering treatments are not usually applied to woolen or worsted fabrics.

Simple Calendering

The simplest form of calendering is comparable to ironing a fabric. The calender rolls are heated, and the dampened cloth is passed between the cylinders to smooth and flatten the fabric and give it a slightly glossy surface.

Schreinering

The Schreiner calender produces fabrics with a soft luster and a soft hand. One of the calender rolls is embossed with about 250 fine, diagonal lines per inch. This roller passes over the fabric, flattening the yarns and producing a more opaque fabric with soft luster and hand. Damask table linens and cotton sateens are among the fabrics given this finish routinely. Thermoplastic tricots are treated with the finish to enhance surface luster.

Glazing

A special calender called a *friction calender* produces fabrics that have a highly glazed or polished surface, such as chintz or polished cotton. (See figure CP7D on Color Plate 7.) Before the fabric is passed through the calender, the cloth is saturated with either starch or resin. The fabric is dried slightly then fed into the machine in which a rapidly moving, heated roller polishes the surface of the more slowly moving fabric. If starch is used to produce the glaze, the finish is temporary. If resins are used, the glaze is durable.

Ciréing

Ciré fabrics are characterized by a high surface polish. A fashion term, the wet look, has sometimes been used to describe ciré fabrics. Made by much the same process as friction calendering, ciré effects on natural fibers or rayon are produced with waxes and thermoplastic resins. Heat-sensitive synthetics are given a permanent wet look when the thermoplastic fibers fuse slightly under the heat of the rollers. When hydrophobic fibers are given a ciré finish, some degree of water repellency results. This occurs as a result of the slight glazing or fusing that the fabrics undergo.

FIGURE 24.1
Embossed cotton fabric.

Embossing

If a calender roller has a raised or lowered design engraved on it, *embossed* effects are produced. The opposite roller is made of paper and has a smooth surface. The embossed roller first presses the design onto the surface of the paper roller; then when the fabric is passed between the rollers, both the engraved roller and the shaped paper roll work together to mold the shape of the pattern into the cloth. (See Figure 24.1 and figures CP7A, and CP7B on Color Plate 7.) Like other calendered finishes, the designs are durable when applied to thermoplastic fibers or fabrics that have been resin treated and are temporary on other fabrics.

Embossed designs provide surface texture at a lower cost than do woven designs. Embossed fabrics should not be ironed or pressed as the design may be diminished by the pressure.

Moiré

The fashion side of *moiré* fabrics has a watered or clouded surface appearance that is sometimes called a "wood grain" pattern. (See Figure 24.2.) The technique is most often applied to ribbed fabrics such as taffeta, faille, or bengaline. The simplest method uses a roller with a moiré pattern etched into its surface and produces a moiré effect with a regular pattern repeat. As with other calender-type finishes, the moiré pattern is durable on thermoplastic fibers or cellulose treated with a resin.

Figure 24.2
Faille fabric with a moiré finish.

The traditional method, applied to many luxurious silks of the eighteenth and nineteenth centuries, uses two lengths of a fabric from the same bolt. They are placed face-to-face, with one layer slightly off-grain in relation to the other. The two fabrics are calendered together under pressure, and the ribs of one fabric press down on those of the other, so the ribs of each fabric flatten those of the other fabric, causing light to be reflected differently across the surface of the fabric. The moiré produced in this manner has a random pattern with no discernible repeats, and as traditionally applied to nonthermoplastic fibers before resins were developed, the pattern would be destroyed by laundering.

Beetling

Linens and cottons that are intended to look like linens are beetled, a process in which the fabric is pounded in a machine equipped with hammers, or *fallers*, that strike over the surface of the fabric, flattening the yarns and making them smoother and more lustrous. (See Figure 24.3.)

Breaking

Fabrics dried on a tenter frame can sometimes be unacceptably stiff. They may be mechanically softened in a process of "breaking." The fabric may be run over and

FIGURE 24.3
Lustrous linen damask fabric reflects light as a result of beetling.

under a series of wooden rails, for example, or over a rapidly spinning wooden roller studded with round protrusions.

Napping and Sueding

Napped and sueded fabrics are fabrics in which fiber ends are brushed up onto the surface of the fabric. Napping and sueding are applied to woven or knitted goods, and although the term *pile* is often used to refer to the fiber ends that appear on the surface of the cloth, these fabrics should not be confused with pile fabrics in which a separate set of yarns is used to create the pile through weaving. (See chapter 17.)

Sueding, also known as *sanding* or *emerizing*, develops a low pile on the surface of the fabric, which can be finished to look and feel like suede leather. The fabric is passed over a series of rollers covered with a sandpaperlike abrasive material. The results are determined by the type of fiber used, the size of the yarn, the coarseness of the abradant, and the intensity of the contact between the fabric and the abrasive material. This is one of the ways that so-called sandwashed silk is produced.

In periods when suedelike fabrics have been fashionable, woven and knitted fabrics finished on sueders were widely available. Attempts to simulate suede leather have ranged from the development of nonwoven fabrics such as Ultrasuede[®], which approximates the hand and appearance of suede leather closely, to those in which finishing with a sueder provides the appearance of suede surface while maintaining the hand and drapability of woven or knitted cloth. Sueding became more widely used with the introduction of microfiber fabrics on which it is used to produce a "peach skin" finish.

Napped fabrics have a deeper pile or nap on the surface of the fabric than sueded fabrics. They are produced by running the fabric over a series of driven rollers with fine wires. These small, hooklike projections catch fibers and pull them up to the surface of the fabric, creating a fuzzy, soft layer of fibers on the surface that are also held in the yarn. Fabrics are produced deliberately to be napped and may be knitted with loose loops on the surface for producing fleece-type materials such as Polartec[®], or be woven of yarns with a fairly loose twist (so-called napping twist). Flannel fabrics are made with such yarns that allow the surface fibers to be easily brushed up. Long ago, napping was done with teasels (plant heads with many fine, hooklike, sharp projections), and some fine napped wools are still made using natural teasels. The terms *gigging* and *raising* are also used to describe the napping process.

Napped fabrics are used for clothing and household textiles in which warmth is desired. The loose fiber ends trap air that serves as insulation. Blankets, sleep-wear, coating fabrics, sweaters, warm activewear, and the like are often made from napped fabrics. Fabrics intended for apparel are generally napped on one side, whereas those for blankets are napped on both sides. (See Figure 24.4.)

Shearing

Shearing cuts fibers projecting onto the surface of fabrics. Napped or pile fabrics may be sheared to make the nap or the pile an even height in all parts of the fabric. Worsted wool fabrics are often sheared to give a clean, clear surface.

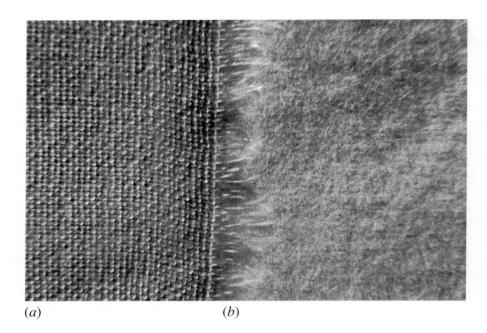

FIGURE 24.4

(a) Cotton fabric before napping; (b) cotton fabric after it has been napped on one side.

The shearing is done in a machine in which sharp, rotating blades cut off fibers or cut the pile or nap to the desired length. The machine has been compared by Potter and Corbman (1967) to the old roller lawn mowers. If some sections of the pile or nap are flattened, and other areas sheared, the uncut sections can be brushed up to achieve a sculpted effect.

Brushing

Fabrics made from staple fibers may be brushed to remove loose fiber from the surface of the fabric that may remain after shearing, for example, or to make the pile on a pile or napped fabric run in one direction. Some fabrics with names such as *brushed denim* or *brushed tricot* are created by napping or sueding or brushing fibers up onto the surface of the fabric to create a soft surface texture. The surface fibers are less dense than in napped or sueded fabrics.

Many napped and pile fabrics are brushed in such a way that the nap or pile runs in one direction. When this has been done, the surface of the fabric will feel smooth in one direction and rougher in the other. Items cut from such fabrics must be handled so the direction of all pieces is the same. If this is not done, the two napped directions will reflect light differently and cause pieces placed side by side to appear to be different in color.

Enzyme Treatment

Cellulase enzymes are used in finishing cotton, rayon, and lyocell to produce smoother surfaces, a softer hand, and lower pilling. The enzymes degrade cellulosic fibers on the surface of the fabric, and mechanical action removes the weakened fibers from the surface. As a result, the fabric becomes softer and smoother. The Danish firm Novo Nordisk calls its enzyme finishing process *BioPolishing*.

If enzyme finishing is applied after fabrics or garments have been dyed with vat, sulfur, or pigment dyes, the effect is similar to that of stonewashing (see chapter 22). The treatment does result in some loss of strength and reduction in weight, so it must be carefully controlled. It is most frequently applied to denim but can be used on any number of cellulosic fabrics.

Milling/Fulling

Wool fabrics are *fulled*, or *milled*, to give them a more compact structure. Fabrics are subjected to mechanical action in the presence of moisture and with moderate heat. Alkaline (soap) or acid conditions can be used. Older milling machines used hammers to pound the wet fabric. Newer machines circulate a rope of fabric between boards. As mentioned in chapter 21, soap milling may be combined with scouring.

The same shrinkage that occurs in milling can happen accidentally if a wool garment is washed too severely. This phenomenon of felting was described in chapter 5. Milling is a controlled felting operation. Wool cloth may be milled to a greater or lesser degree, depending on the desired characteristics of the resultant fabrics. Melton cloth, for example, is one of the most heavily fulled wool fabrics and has a dense, feltlike texture. The milling action tends to begin slowly then increases in effect; finishers must carefully control the extent of the process.

Wool fabrics can be treated chemically to produce machine-washable garments that can safely be laundered; these finishes are discussed in chapter 25.

SHRINKAGE CONTROL

Dimensional Stability

A reduction in the length or width of a fiber, yarn, or fabric is known as *shrinkage*. If fabrics shrink after they have been made into garments or household items, they may decrease in size to such an extent that the item is no longer serviceable. For example, a garment with a twenty-five-inch waist size will decrease by 1.25 inches if it shrinks 5 percent. *Growth* occurs when a fabric increases in dimension.

Some fibers such as wool, cotton, and rayon swell more in water than do others. Fabrics made from these fibers are less dimensionally stable than fabrics made from fibers with lower moisture absorbency.

If a fabric is stretched while it is being dried during finishing, it will tend to maintain those dimensions until it is rewetted. That may not happen until after the fabric has been cut and sewn into a garment and is being washed by the consumer. Wetting a fabric causes the tension that has been applied during its manufacture to be relaxed, so fabrics often shrink in the first few launderings. Tests for fabric shrinkage generally include three to five laundering and drying cycles because this relaxation shrinkage (as discussed in chapter 3) is usually complete by then. It occurs because the moisture within the fibers allows them to return to the dimensions they occupied before they were stretched during processing. The amount of relaxation shrinkage depends on the amount of stretching the fibers underwent during manufacturing. Wool and rayon, which are more extensible, will stretch more and, therefore, have greater potential for relaxation. Woven fabrics generally

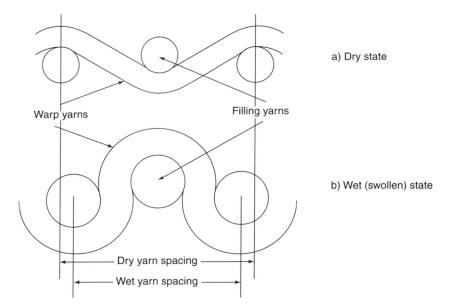

FIGURE 24.5 Diagram showing how develop crimp upon

warp yarns relax and wetting; the spacing between filling yarns shortens, shrinking the fabric in the lengthwise direction.

> shrink more in the warp than in the filling direction because the warp yarns are under greater tension during drying.

> Hydrophilic fibers absorb a significant amount of water and swell. Accordingly, the yarn diameter increases, and the yarns in each direction must move closer together to accommodate the yarns in the opposite direction. This is a less strained position for the yarns and results in a permanent increase in crimp, especially in warp yarns. This relaxation is illustrated in Figure 24.5. Thus, every time a garment is washed, it shrinks slightly due to this yarn swelling and stays that way when it is dried without tension. A newly washed pair of jeans is always a little tighter, for example, but the mechanical stresses of wearing the garment restore it to near the original dimensions.

> Knit goods tend to stretch more during manufacture than do woven goods, and the loops are more easily distorted than are the relatively straight yarns in a woven fabric. Therefore, knitted fabrics are likely to shrink and change shape even more than woven fabrics. This is recognized in fabric specifications, and shrinkage allowances for knits are generally higher than for wovens (say 5 percent versus 3 percent).

> Procedures and solvents used in commercial dry cleaning, as a rule, do not permit fabrics to relax, as washing does, so items that are dry-cleaned may not shrink as readily. Shrinkage in dry cleaning generally results from the high moisture content in the solvent or from steaming the fabric during pressing. The wet cleaning offered by some professional cleaners uses small amounts of water and gentle agitation to minimize shrinkage.

> In manufacture there are mechanical and chemical means of minimizing the shrinkage of fabrics in laundering.

Mechanical Shrinkage Control

For fabrics subject to relaxation shrinkage, such as cotton, linen, and rayon, it would seem logical to "wash" or wet the fabrics and dry them without tension to

allow them to return to their true dimensions. This is the basis of the sponging or "London shrinking" process for high-value/low-volume wool fabrics and is discussed later. For large volumes of fabric, this slow process is not practical for the manufacturer.

One simple way to reduce but not eliminate shrinkage is to minimize the tensions exerted on the fabric when it is being dried on a tenter frame during finishing, although some tension is required to leave the fabric flat and smooth after the drying process. Fabrics can thus be *overfed* as they enter the tenter frame for drying.

More complete shrinkage control can be obtained by a method called *compressive shrinkage*, in which the fabric is mechanically reduced to its correct warp dimensions. This, of course, relies on knowing what the correct dimensions are. Thus, a sample of fabric is measured, laundered, then remeasured, and the percentage of warp shrinkage calculated. This tells the processor how much to compress the fabric.

The fabric is then dampened and placed on a machine equipped with a continuous thick woolen or rubber blanket. The blanket travels around a small roller, and its outer surface is stretched as it does so. The fabric is fed onto the surface of the blanket at this point and is held against the blanket surface. As the blanket leaves the roller, its surface contracts, and the fabric on its surface is forced to contract with it. Heat to dry and maintain the new dimensions is applied at this point. (See Figure 24.6.) The amount of compression applied can be adjusted by the thickness of the blanket or the diameter of the roller. The various patented processes of this type of compressive shrinkage guarantee residual (or remaining) shrinkage of less than 1 percent unless the fabric is tumble dried.

The Sanforized Company has developed a number of different compressive shrinkage control processes for different types of fabrics. All provide for shrinkage of less than 1 percent. The trademark Sanforized[®] is used on woven cotton and cotton blends. Many types of compressive shrinkage machines are available. The process is

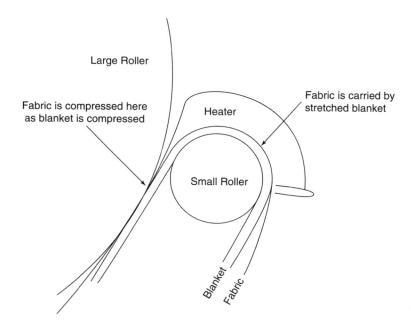

Figure 24.6
Schematic of machine for compressive shrinkage.

often applied in conjunction with a durable-press finish (see chapter 25) that provides wrinkle-free performance and enhances the dimensional stability of the fabric.

Shrinkage Control for Knits

During knitting and finishing, knit fabrics are subject to tension and stretching, especially in the lengthwise direction. The construction of most knits allows for greater stretch, so they have greater potential shrinkage. The shrinkage may be particularly pronounced in the lengthwise direction, often accompanied by growth in the crosswise direction.

Techniques used to control shrinkage in knitted fabrics include subjecting fabrics to treatment with resin-containing solutions, wetting then drying fabrics to relax tensions applied during processing, and compressive shrinkage processes similar to those described for woven fabrics. Excellent results can be obtained by wetting fabrics to at least 40 percent humidity then drying them in a rotary tumbler. This is more practical than for woven fabrics because knits tend to wrinkle less as a result of such processes. However, while dimensional stability of fabrics is excellent, the process is costly because lots must be small and fabrics tend to become knotted or tangled during tumbling.

Synthetic knits are stabilized by heat setting. Without this treatment, fabrics may shrink. Lower-priced knits, for example, may shrink as a result of inadequate heat setting.

Shrinkage Control for Wool

As discussed above, wool and animal hair fibers show progressive shrinkage that can be controlled through milling to produce a felted cloth. In addition to felting shrinkage, wool fabrics display the same type of residual shrinkage from relaxation that other fibers show. Unlike cotton fabrics, however, wool may continue to shrink if the relaxation of the fibers is not complete after one or two washings. Shrinkage treatments for wool are of two types: simple mechanical treatments that alleviate the problems of relaxation shrinkage and chemical treatments that eliminate or ameliorate felting shrinkage, discussed in chapter 25.

Relaxation Shrinkage

Wool fabrics can be set by a number of processes that use moisture to relax the fabric. Because many wool fabrics will be dry-cleaned rather than laundered, these processes do not need to guard against that kind of treatment. However, because wool is used in very expensive tailored garments, where small dimensional changes can lead to unsightly seam puckering, a stable fabric is important. Wool is set by hot, wet treatments, so as the conditions become more intense, the effect becomes more durable. The finishes also lead to changes in hand and are carried out deliberately to produce those changes.

1. Damp relaxing or steam relaxing. High-quality worsted fabrics are subjected to a step that permits them to relax before they are cut into garments. The fabric is dampened or steamed then permitted to dry in a relaxed state. The tensions applied to the fabric during processing are thereby removed.

- The process is also referred to as *London shrinking* or *sponging*, although the former term is not often used by American textile manufacturers.
- 2. Decating or decatizing. In this process wool fabric is wound on a perforated cylinder with a blanket of another fabric between the layers. Jets of steam are released through the holes in the cylinders, causing the fabric to be dampened and relaxed. Cold air is then blown through to set the fabric. Not only does this process set the wool fabric, but it also increases its luster. The process is "full decating" if carried out under pressure and "semidecating" otherwise.
- 3. *Potting or boiling*. For napped, sueded, and fine wools, the fabric may be wound on a roller, wrapped in cotton, and immersed in high-temperature—but not boiling—water. Melton, a full, soft outerwear fabric is traditionally boiled, as are the fabrics used for gaming tables and pool tables.

Shrinkage Control for Thermoplastic Fibers

Fabrics made from thermoplastic fibers may be stabilized through heat setting. Synthetics can be permanently set into shape by subjecting them to heat near their glass transition temperature. The heat allows the molecules to relax so the fiber will not exhibit further shrinkage. This process is used to establish permanent dimensions for these fabrics. Synthetic knits, for example, are relatively free from shrinkage problems during laundering if they are properly heat-set. They may, however, undergo thermal shrinkage when subjected to high heat.

SUMMARY POINTS

- Fabrics undergo finishing to change aesthetics and performance
- Finishing can be mechanical or chemical and can range in durability
- Mechanical finishes that change the surface characteristics of fabrics
 - · Calendering
 - Embossing
 - Napping
- Mechanical shrinkage control
 - Fabrics may shrink when wet, depending on fiber and construction
 - Mechanical processes can be used to control relaxation shrinkage
 - Special processes have been developed to relax or set wool fabrics
 - $\circ\,$ Thermoplastic fiber fabrics can be stabilized by heat setting

Questions

- 1. What is the value of a nondurable finish? How durable does a durable finish need to be?
- 2. Describe the calendering process. How is the process varied to produce different effects? How is calendering made more durable on cellulose fabrics?
- 3. What is the difference between sueding and napping? Name a fabric produced by napping.

- 4. Why do woven fabrics of cotton shrink? How can the shrinkage be reduced by mechanical means?
- 5. What type of shrinkage is unique to animal hair fibers?
- 6. What do sponging, decating, and potting have in common? How do they differ?
- 7. How is the shrinkage of synthetic fiber fabrics reduced by the finisher?

References

Potter, M. D., and B. P. Corbman. *Textiles, Fiber to Fabric*. New York: McGraw-Hill, 1967.

Recommended Readings

Cowhig, W. T. "What Is Moiré?" Textiles 4 (June 1974): 46.

"Finishing Fabrics in the Nineties." *Canadian Textile Journal* 111 (November 1994): 28.

Goldstein, H. E. "Mechanical and Chemical Finishing of Microfabrics." *Textile Chemist and Colorist* 25, no. 2 (1993): 16.

Tyndall, R. M. "Improving the Softness and Surface Appearance of Cotton Fabrics and Garments by Treatment with Cellulase Enzymes." *Textile Chemist and Colorist* 24, no. 6 (1992): 23.

CHEMICAL FINISHES

Learning Objectives

- 1. Identify the major effects achieved through chemical finishing.
- 2. Explain how chemical finishes are applied to fabrics.
- 3. Describe the mechanism of wrinkle-free finishes on cotton.
- 4. Describe the finishes that produce softness, repellency, flame retardancy, antimicrobial activity, and washable wools.

his chapter deals with finishes that are produced through the application of chemicals. In some cases, the same effect may be achieved through either mechanical or chemical means. Finishes for shrinkage control, for example, include mechanical techniques, chemical finishes, or a combination of both.

For most kinds of finish (that is, those that achieve a specific effect), the technology and market typically develop in the same way. When the technology is new, many different chemical types are developed as suppliers compete. As the chemistry and technology mature, the market tends to adopt a few successful ones. Thus, while many different chemical wrinkle-free finishes have been invented and sold, today the market is dominated by just one. Similarly, a review of water-repellent finishes reveals many different chemical approaches to the problem, but fluorochemicals are now ubiquitous.

Chemical finishes add cost to a textile but provide performance that can often mean greater profit. Finishes often provide "added value" to an item and are reflected in the advertising that distinguishes a brand from its competitors. In recent years, wrinkle-free, stain-resistant, moisture-management, and antimicrobial finishes have all been presented to the consumer in this way.

APPLICATION OF CHEMICAL FINISHES

Finishing chemicals rarely have affinity or substantivity for the substrate in the same way that dyes do. Thus, they cannot efficiently be applied in a dyebath or exhausted onto the fabric. Instead, the finishing chemical is mixed with water and padded onto the fabric, which is then heated to cure or fix the finish. Padding was described in chapter 21 under general remarks about the application of chemicals to fabrics. Chemical finishes (such as softeners and repellents) may be confined to the fiber surface, in which case they are called *topical finishes*. Others, such as flame-retardant or wrinkle-free finishes, penetrate within the fibers. The durability of a finish is greater when the finish reacts within the fiber or perhaps forms a crosslinked structure on the fiber surface.

The water used in the application of finishes is only a vehicle and must be evaporated before the fixation is achieved. Reducing the amount of water means using less energy, so the use of *low-wet-pickup* methods that minimize the amount of water used have been investigated and receive particular attention when energy prices are high (Jones 1984). Some examples of low-wet-pickup processes are as follows:

- 1. Vacuum extraction. A vacuum slot is placed after the pad bath to extract some of the water before drying.
- 2. *Transfer padding*. A loop belt that picks up the finish solution is then squeezed against the fabric.
- 3. *Kiss roll*. A roller, instead of a loop belt, picks up the finish solution and transfers it to the fabric.
- 4. Spray. Finishing solution is sprayed onto the surface of the fabric.
- 5. *Foam finishing*. The finish solution is applied as a foam, rather than as a liquid.

Fabrics composed of resilient fibers, such as wool and many synthetics, will usually recover naturally from wrinkling. Thus, a crumpled wool suit will look much smoother after a night on a hanger. Certain fabric types recover from or disguise wrinkling because of their construction. These would include terry cloth, knits, seersucker, plissé, and some "busy" prints with small, close designs covering the fabric. However, plain-colored woven fabrics of cotton, of which there are many, wrinkle easily and require chemical treatment to improve their care properties and minimize the need for ironing either after laundering or after wear.

Wrinkle-resistant Finishes

Wrinkle-resistant finishes date back to 1929 when Tootal Broadhurst Lee, Ltd., patented a urea-formaldehyde resin finish that could be used on cotton and rayon. Such finishes were successful but had a number of drawbacks that prompted continued research into modifications and alternatives. These finishes all have at least two functional groups that react with adjacent cellulose molecules. The newer ones are called reactant finishes because they react solely with the cellulose rather than with themselves. Improvements continue to this day, although since the

1980s most wrinkle-free finishes have been based on dimethyloldihydroxyethyleneurea (DMDHEU).

Cellulose wrinkles because the hydrogen bonds that hold the polymer chains together can easily break and re-form. Once wrinkled, there is no restoring force. Wrinkle-free finishes work by forming covalent bonds—crosslinks—between cellulose chains that replace the weaker hydrogen bonds and provide greater stability in the position of the molecules. After wrinkling, these bonds impart the force or memory to restore the fibers to an unwrinkled state.

The effects do not vary much with the chemical identity of the crosslinking chemical used, although the amount applied and, hence, the number of crosslinks will change the smoothness and permanence obtained. These finishes have thus been described in a number of ways. In the 1950s the terms wrinkle resistant and crease resistant gave way to wash-and-wear or easy care. This emphasized that the finish would eliminate the need for ironing after items were laundered. However, many of these wash-and-wear finishes did require some touch-up pressing before use. When more chemical is applied, they have also been called durable-press finishes or permanent-press finishes. Recent years have seen the return to the terms wrinkle resistant and wrinkle free.

Wrinkle-free finishes have a second major beneficial effect. Treated fabrics shrink much less than do untreated ones. Compressive shrinkage (such as Sanforizing) is used to mechanically preshrink cellulose fiber fabrics. (See chapter 24.) Compressive shrinkage, which results in a loss of yardage as the fabric shrinks, can be replaced or augmented by the application of a crosslinking wrinkle-free finish, which stabilizes the fabric's existing dimensions.

The Finishes: Formaldehyde or Not?

As mentioned above, the most common of these finishes is DMDHEU. DMDHEU has two —OH (hydroxyl) groups and two —CH2OH (methylol) groups that can react with cellulose. The methylol groups are derived from formaldehyde. In use, free formaldehyde can be formed. Formaldehyde is a suspected carcinogen and has an unpleasant odor. Debate continues on what level of formaldehyde in the environment is safe. As with many textile chemicals, the exposure in a mill is many times higher than will be encountered in consumer use, and Occupational Safety and Health Act standards mandate low levels in the workplace. In response, manufacturers have modified the finishes to release less formaldehyde and are developing newer finishes without formaldehyde. Thus, most commercial versions of DMDHEU now have modified methylol groups and are sold, for example, as "ultra-low formaldehyde" brands. Especially in Germany and Japan, there is interest in wrinkle-free finishes that are not derived from formaldehyde, and true zeroformaldehyde wrinkle-free finishes have been the subject of much research. This has mainly focused on polycarboxylic acids such as butane tetracarboxylic acid (BTCA) and citric acid, with multiple acid groups that can form ester crosslinks. These finishes have yet to be widely adopted because they require expensive catalysts and tend to yellow the fabric.

Formerly, finished textiles often developed a fishy odor when stored in plastic bags as formaldehyde was released. Reducing or eliminating the release of formaldehyde has also solved the odor problem.

Manufacturing Wrinkle-free Products

Wrinkle-free finishes are most efficiently applied to flat fabrics in a finishing process. The manufacturer applies the chemical treatment, dries the fabric, then follows with a "cure" period at higher temperature. It is during the curing step that the chemical reaction takes place.

Fabrics given a *precure* (also called *flat-cure*) treatment are finished before delivery to the manufacturer. Precured fabrics have been made into plain dresses or blouses, curtains, table and bed linens, and draperies, all of which require relatively little shaping. Blended fiber items can be shaped successfully through the heat setting of the thermoplastic fibers in the blend. However, it is difficult to put creases into 100 percent cellulose precured fabrics because they have been set as "flat." A further reason for the success of DMDHEU is that it can be successfully *postcured* without releasing formaldehyde. The fabric is impregnated with the finish and dried but not cured. In this state the fabric is shipped to the manufacturer. Garments or other items are manufactured from the cloth, and the finished items are cured in a special curing oven. Creases, pleats, hems, and the like are "permanently" set in this way. Care must be taken to be sure that the fabrics are free from wrinkles or puckers, or these, too, will be permanently set. The wrinkle-free finish can also be applied to the garment after cutting and sewing then cured. (See Figure 25.1 for a comparison of precure and postcure processes.)

The product manufacturer must make changes in sewing techniques to deal with wrinkle-free fabrics. Stitching of long seams may cause puckering unless special thread is used and unless changes in sewing machine tension, type of needle, and length of stitching are made. It is also important for the manufacturer to select findings such as interfacings, linings, hem tape, and the like that will be compatible with wrinkle-free items. They must not wrinkle or shrink differently from the fashion fabric.

Wrinkle-free Fabrics in Use

Crosslinked cellulose fibers are more brittle than untreated ones, and cellulose fabrics treated with crosslinking finishes become stiffer, lose strength, and particularly suffer a decrease in abrasion resistance. One hundred percent cotton fabrics may lose as much as 50 percent of their strength when given durable-press finishes. Collars and cuffs may abrade and fray more easily, and areas subject to wear (the point of a crease or the knee) often show the results of abrasion by *frosting*, a change in color that results from the soft, fuzzy ends of the fibers giving abraded areas a lighter color. (See Figure 25.2.)

Blending cellulosic fibers with synthetics, especially with polyester, can reduce the abrasion problem, but the problem of different rates of abrasion for each fiber remains. Pretreatment with ammonia (akin to a mercerizing treatment) was examined closely as a way to minimize the loss of strength but seems to have fallen out of use. The addition of a softening chemical to the finish application can slightly reduce the loss of abrasion resistance.

Older wrinkle-free finishes tended to retain chlorine from bleach in laundering. When later ironed, the chlorine would be released as hydrochloric acid and weaken the fabric. DMDHEU does not retain chlorine.

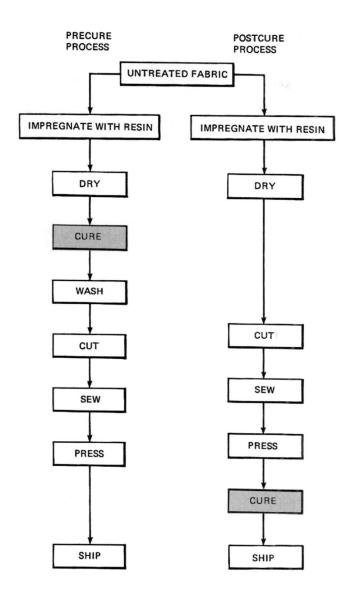

FIGURE 25.1

Comparison of precure and postcure wrinkle free processes.

Earlier durable-press finishes based on relatively high levels of finish tended to be difficult to wash successfully. The treatment made cotton more hydrophobic, which increased attraction of oils and reduced water penetration. As a result, oily soils were absorbed by durable-press fabrics, and laundering (even with detergents that would normally remove oil-based soils) did not clean them effectively. Soil-releasing finishes (discussed later in this chapter) were developed to overcome these difficulties. The durable-press-finished fabrics were also rather stiff. They did not drape as well and were less comfortable to wear in warm weather than untreated fabrics. The amount of finish required to produce wrinkle-free performance is somewhat less, and such fabrics do not tend to suffer these problems.

See Take a Closer Look on page 471 for more information on performance and care aspects that should be taken into consideration when developing or selecting products made from 100 percent cotton wrinkle-free fabrics.

Figure 25.2

Closeup view of fabric in which frosting has taken place. Darker cotton fibers have worn away, leaving a line of lighter polyester fibers.

CHEMICAL SHRINKAGE CONTROL

In chapter 24 the use of mechanical treatments such as sponging, decating, and boiling for wool and heat setting for thermoplastic fibers were described as means of stabilizing those fabrics dimensionally. Compressive shrinkage (such as Sanforizing) is used to mechanically preshrink cellulose fiber fabrics. Wrinkle-free chemical finishes discussed above also serve to stabilize the dimensions of cellulose fiber fabrics.

Washable Wools

Chemical treatment is used to produce wool fabrics that can be laundered in a typical washing machine without the progressive felting shrinkage that is typical of animal fibers. Like most other chemical finishes, there is a long history of research and development, and the market today has settled on a few successful types. Because felting shrinkage is caused by the scale structure of the wool fibers, the finishes work to modify the scales.

Degradative Processes

Many older shrinkproofing treatments for wool were based on chemicals that degrade the scales on the fiber surface. Used alone, these processes may not meet "machine washable" standards, but they are adequate for products designated as "hand washable."

The most common degradative processes use compounds that release chlorine to partially dissolve the wool fiber scales. The chlorine treatment produces chlorinated organic materials as a by-product. These fall under the category of "adsorbable organic halogens," abbreviated AOX, that are considered pollutants in many countries, so alternatives to chlorine have also been used. In line with other textile processes, enzyme treatments, in this case with proteases, have been examined to produce shrink-proof wool, as have plasma treatments.

The treatments are destructive, and the process requires careful control if it is not to weaken or damage the fiber. The hand of the fabric is also spoiled.

Polymer-based Processes

Two other methods for making washable wools involve the use of polymer finishes. One of these is the application of a thin polymeric layer to the surface of the fibers. The polymer coats the scales, inhibiting the interlocking action. To ensure the polymer coats the fibers evenly, a light pretreatment with chlorine is used to make the fiber surface evenly wettable. The two-step process is applied to wool sliver, which is then spun into yarns. Hercosett[®] is the most widely known treatment of this type.

A second polymer treatment for washable wools is applied to finished garments, especially knitted sweaters. A polymer resin is applied to the garments, and unlike the Hercosett finish, the polymer tends to bead up on the fibers and concentrate at the points where the fibers cross each other. When the resin is cured, the fibers are "spot welded" in place and cannot migrate.

Problems encountered in the use of resins or polymers include a tendency for the fabrics to become stiff or harsh to the touch when enough resin or polymer is used to make the fabrics completely shrink proof. The resins also tend to absorb dyes quickly and can make level dyeing difficult. This problem is compounded because the washability means that more wash-fast dyes (that do not level well) must be used. The development of washable wool in the 1980s was accompanied by the development of good reactive dyes for application on wool. (See chapter 22.)

CHEMICAL FINISHES THAT AFFECT FABRIC HAND

Hand Builders and Softeners

Hand Builders

Occasionally, a fuller body is required in a fabric. Traditionally, a fabric would be starched at home. A finisher would similarly add body to fabrics by applying some type of sizing such as starch, gelatin, or resin or a combination of these with softening substances such as oils or waxes. These, however, have limited durability, and inexpensive cotton or rayon fabrics that are heavily starched may become limp after laundering.

Stiffening in this way has declined in popularity and use. The modern equivalent is referred to as "hand building," and acrylic emulsion finishes known as *hand builders* can give fabrics a more substantial hand. These compounds are similar, not to acrylic fibers, but to the binders used for pigment printing.

Softeners

The heat setting of manufactured fabrics or the application of wrinkle-free finishes may leave fabrics with an unpleasant hand. Mechanical *breaking* treatments described in chapter 24 can occasionally reduce this, but usually a chemical fabric softener is applied during finishing to overcome these negative qualities. The chemical compounds used allow a certain amount of slippage between yarns and

fibers and between hand and fabric, thereby creating a more supple, smooth, and pleasant-feeling fabric. Softness is a major attribute of a textile at the point of sale. Consumers routinely add softeners to the rinse or drying stages of home laundry to achieve a good-feeling fabric. Some of these products used in home laundering are discussed in chapter 26. Softening chemicals can be applied in the rinse stages of dyeing in the same way as they are in home laundering. Cationic softeners will exhaust onto the fabric and, if they include a long hydrocarbon chain, will impart a smooth or soft feel to the fabric. These finishes are not very durable.

Other softeners are applied in a more typical pad-cure sequence at the same time as durable-press, flame-retardant, or other functional finishes. Polyethylene emulsions are used primarily as sewing assistants to allow easier needle penetration, but they also provide fabrics with a softer hand. Durable softening is mostly achieved with *silicones*. These are long polymers based on a backbone of —Si—O—Si—, from which a wide range of functional groups can be attached to provide crosslinking (and, thus, greater durability), elasticity, and hydrophilicity. Most silicones are hydrophobic and, thus, make the fabric more water repellent, as discussed later.

Enzyme Treatment

Cellulase enzymes are used in finishing cotton, rayon, and lyocell to produce smoother surfaces, a softer hand, and a decrease in pilling. The enzymes degrade cellulosic fibers on the surface of the fabric, and mechanical action removes the weakened fibers from the surface. As a result, the fabric becomes softer and smoother. The Danish firm Novo Nordisk calls its enzyme finishing process *BioPolishing*.

If enzyme finishing is applied after fabrics or garments have been dyed with vat, sulfur, or pigment dyes, the effect is similar to that of stonewashing (see chapter 22). The treatment does result in some loss of strength and reduction in weight, so it must be carefully controlled. It is most frequently applied to denim but can be used on any number of cellulosic fabrics.

Parchmentizing

A special acid treatment known as *parchmentizing* is used to give some cottons a permanently stiff character. The application of a carefully controlled acid solution causes the surface of the yarn to become softened and gelatinlike. An after-wash in cold water causes the gelatinous outer surface to harden, forming a permanently stiffened exterior. Permanently finished organdy, for example, is made by this process.

Water Repellency

Waterproof Fabrics

A completely waterproof fabric allows no water to penetrate from the surface to the underside. Coatings made from rubber or synthetic plastic materials can create waterproof fabrics, but they tend to be warm and uncomfortable because they create a barrier that traps air and perspiration close to the body.

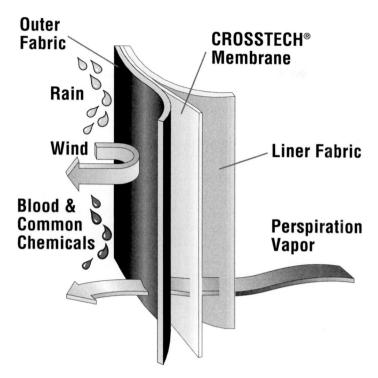

FIGURE 25.3

Manufacturer's diagram shows fabric structure with CROSSTECH® membrane repels water and other liquids but allows moisture vapor to pass through pores that are too small to permit the passage of these liquids. This illustration is reproduced with the pennission of W. L. Gore and Associates, Inc. Copyright © 2007 W. L. Gore & Associates, Inc.

The dilemma of providing protection and comfort was resolved by the development of fabrics that are *waterproof and breathable (WP/B)* and are promoted for use in outdoor clothing and for active sports. One of the first of these products was Gore-Tex[®] (see chapter 20), a laminate of a porous membrane of fluoropolymer between layers of inner and outer fabric. The pores are smaller than a drop of water, which contains many water molecules, but they are larger than a molecule of water vapor. This structure keeps out rain but allows moisture from perspiration to escape. (See Figure 25.3.)

The success of Gore-Tex® has led to the production of other products using similar principles. Many of these use polyurethane coatings with microscopic pores. Sympatex®, a polyester membrane for lamination, is nonporous but breathable. A charged outer surface attracts polar water molecules, which are drawn through the membrane. Also helping to "push" moisture vapor through is the high vapor pressure on the body side (Sympatex 1988).

Performance of waterproof garments is closely related to their construction. Seams must be sealed, so water does not pass through the fabric by way of the holes left by the sewing needle. Tears, rips, or worn spots are also areas in which leaks can occur. The manufacturer recommends that Gore-Tex® garments not be laundered in liquid detergents as these tend to leave surfactants on the surface that may allow the wetting of the fabric. Instead cold-water temperatures and powdered detergent should be used.

Water-repellent Fabrics

The term *water repellent* should not be confused with the term *waterproof*. Water-repellent fabrics resist penetration by water but are not completely waterproof.

460

Such fabrics represent a practical alternative to fabrics that keep out water and air because they resist wetting but also allow the passage of air. The passage of air is imperative if one is to have a garment that is comfortable to wear.

Water repellency is conferred through a combination of appropriate selection of fiber content and fabric construction and the application of finishes that are classified as either renewable or durable. Fibers that are nonabsorbent and fabrics with high thread counts or other compact structures such as microfiber fabrics help to repel water. For higher levels of protection, finishes are required. Of course, in conditions in which the fabric is subjected to long periods of exposure and sufficient force, water will eventually penetrate any water-repellent fabric.

As with other finishing types, many chemical approaches to providing water repellency to fabrics have been developed. Wax emulsions or metallic (often aluminum or zirconium) soaps have been used to secure renewable water repellency. As discussed above under softening, most silicones are hydrophobic and, if applied in larger amounts, will produce good water repellency.

Hydrophobic finishes that repel water typically do not repel oily substances, and many soils are oil based. Indeed, a hydrophobic finish may even attract dirt. More recently, fluorochemical finishes have become more economical, and because they provide both water and oil repellency, these have tended to become more widely used as "all-purpose" repellents, leading to reduced use of other water-only repellent types. Fluorochemicals are discussed in more detail below.

Soils: Repellency and Release

Soiling results when a textile comes into contact with soiled surfaces or with air- or waterborne soils. Soil is retained either by mechanical entrapment of soil particles within the yarn or fabric structure or by electrostatic forces that bond the soil to the fabric.

The problems of soiling can be addressed either by preventing its deposition on the fabric or by making it easier to remove. Finishes have been developed that have taken both of these approaches. Effective soil-releasing finishes should result in fabrics from which common soil is removed during home laundering with normal detergents.

Soil-repellent Finishes

Fluorochemical finishes that repel water and oil may be classified as soil-repellent or stain-resistant finishes. These finishes decrease the surface energy of the fabric so water or oil beads up rather than penetrating the fiber. Figure 25.4 illustrates this principle with two different stain-repellent finishes: fluorochemical and silicone. The fluorochemical finish, like DuPont's Teflon[®] finish on cookware, prevents both oil and water from penetrating the fabric surface. The silicone finish, which also coats the fabric, repels water but not oil.

Stain-resistant finishes are applied to fabrics used in products such as upholstery and tablecloths to prevent soiling by staining. The soils that do not penetrate are readily lifted away when the fabric is laundered or cleaned. They may be applied to an upholstery fabric at the time of manufacture in a liquid form or sprayed onto the fabric after the fabric has been applied to a piece of furniture. Aerosol spray

FIGURE 25.4

(a) The drop of liquid on the left is oil, on the right is water. The fluorochemical stain-resistant finish enables this nylon upholstery fabric to resist both oil- and water-based stains and soil. (b) The silicone finish applied to the upholstery fabric enables it to resist only water-based stains. Oil-based stains are absorbed by the silicone-treated fabric. (Note however that application of silicone finishes over flurochemical finishes will cancel out oil repellency.) Courtesy of 3M Company.

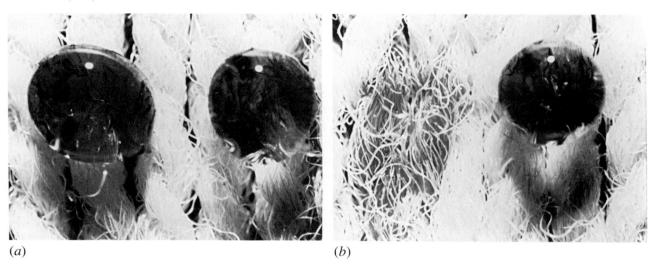

containers of some of these finishes can be purchased for home application. The finish tends to diminish with laundering but can be renewed by using the sprays again. Early versions of stain-repellent finishes had a disadvantage: if a stain did penetrate into the material, it could prove difficult to remove in laundering. These finishes did not *release* soils readily.

Soil-release Finishes

Soil-release finishes were developed as polyester and durable-press cotton fabrics became popular, largely as a result of the tendency of these fabrics to absorb and hold oilborne stains. These finishes typically make the fiber surface more hydrophilic. This reduces the attraction between the fiber and an oily soil and improves the action of water and detergent in removing the soil. Agents such as polyethylene glycol derivatives may be added to the polymer solution before extrusion to make the nonabsorbent fibers more hydrophilic. Most soil-releasing finishes are applied during the finishing of the fabric. Several different chemical types have been developed.

Dual-acting fluorochemical finishes have been developed that have both soil-repellent and soil-release properties, combining the best of both worlds. They are block copolymers of fluorocarbons and polar segments such as esters. In air the fluorocarbon sections come to the surface to repel oily substances. When the finished fabric is immersed in water, however, the polar hydrophilic sections predominate on the surface, attracting water to help release soils. The cost associated with these chemicals has been reflected in a higher price that consumers are willing to pay once they are made aware of the advantages of Stain DefenderTM products and the like.

At the same time that soil-releasing finishes increase the receptivity of fibers to water, a second benefit is gained. Static electricity buildup is decreased as absorbency is increased. Increased absorbency also increases the comfort of the garment in warm weather.

Stain-resistant Finishes for Carpets

Staining is a particular problem in nylon carpets, and stain-resistant finishes were developed to increase resistance to food and other common stains. As discussed earlier, olefin fibers do not readily take up dye, and carpets of olefin fibers are inherently stain resistant.

The finishes often called "stain blockers" are generally sulfonated aromatic condensation (SAC) compounds that function essentially as colorless dyes. The stain blockers, which have negative charges, are attracted to the positive sites in the nylon fibers, tie up the dye sites, and set up a barrier layer to staining materials. Many food stains, for example, which are negatively charged like the stain-resistant molecules, are not absorbed as easily. Today stain-resistant finishes are used on most nylon carpets for residential use. One trademark is DuPont's Stainmaster. Similar technology is used in "syntans" that are applied to nylon after dyeing to form a barrier to dye removal and, thus, improve the wet-fastness properties of the dyeing.

FLAME RESISTANCE

Flame resistance is an important property. That importance is reflected in the legal requirements that textile materials must adhere to. It might be thought that, if the technology exists to make fabrics less prone to burning, it would be widely applied, and we would all be much safer in our clothes and in our homes. However, this is not the case. You can imagine if a regular garment were treated and sold as "flame resistant" and the wearer were somehow injured in a fire, he or she might well consult a lawyer and sue the manufacturer. Few manufacturers wish to put themselves in this position. The vast majority of textiles are not made flame resistant, and only when a particular use requires flame resistance is it considered in the design and choice of fiber and finish. Even then, the aim is usually to make sure that the textile passes the tests required of it, no more, no less.

Terminology

The terminology employed in a discussion of flame resistance can be confusing. The following definitions and descriptions are currently accepted, although usage may vary, particularly from country to country.

1. Flame resistance is defined by the American Society for Testing and Materials as "the property of a material whereby flaming combustion is prevented, terminated, or inhibited following application of a flaming or non-flaming source of ignition, with or without the subsequent removal of the ignition source" (ASTM 1998, 23). The material that is flame resistant may be a polymer, fiber, or fabric.

- 2. Use of the terms *flame retardant* and *self-extinguishing* is discouraged (ASTM 1998, 23, 40). *Flame-retardant treated* and *flame-retardant treatment* are, however, acceptable terms, and *flame retardant* is used in other countries. The ASTM does not approve the use of the term *self-extinguishing* to describe a textile product because it is meaningful only when applied to specific circumstances.
- 3. A *thermally stable* material (fiber or polymer) is one that has a high decomposition temperature and is, thus, inherently flame resistant because of chemical structure (rather than through the presence of added flame-retardant treatments) (Clark and Tesoro 1974).

Flammable Fabrics Act

Flammability of textiles is an important contributor to serious injuries and loss of life and property in fires. This was recognized with the passage of the Flammable Fabrics Act in 1953. The legislation banned the use and sale of *highly* flammable materials for clothing. The law was amended in 1967 to extend coverage (excluding some types of accessories) to carpets, draperies, bedding, and upholstery.

Since 1967 the regulations have been modified still further. Originally only those materials that are *highly* flammable were prohibited, but now the manufacture of *all* flammable carpets, mattresses, and children's sleepwear (sizes 0 to 14) is banned.

In 1972 responsibility for administering and enforcing the law was given to the federal Consumer Product Safety Commission (CPSC). Products found to be in violation of the law are subject to confiscation, and those making or selling them may be fined or imprisoned. Federal flammability standards that products must meet are established in a two-step procedure. The CPSC sets forth a proposed standard. Individuals are invited to offer their opinions about the proposals. Finally, the standard and test method(s) are announced.

Flammability Standards and Tests

Current flammability standards for textile products sold in the United States are prescribed in Title 16 of the Code of Federal Regulations (CFR) (Code of Federal Regulations 1989). Different sections, or parts, of the code address different products and specify criteria that materials have to meet in order to pass the flammability test.

Clothing Textiles

The standard for clothing requires that "a piece of fabric placed in holder at a 45 degree angle and exposed to a flame for 1.0 second must not spread flame up the length of the sample in less than 3.5 seconds for smooth fabrics or 4.0 seconds for napped fabrics" (CPSC 1974, 1). Five specimens measuring two inches by six inches are required for each test. The time of flame spread is taken as an average of five specimens.

On the basis of long experience, plain-surface fabrics of more than 2.6 ounces per square yard and any fabric made of acrylic, nylon, olefin, polyester, or wool routinely pass this test and are exempt from testing.

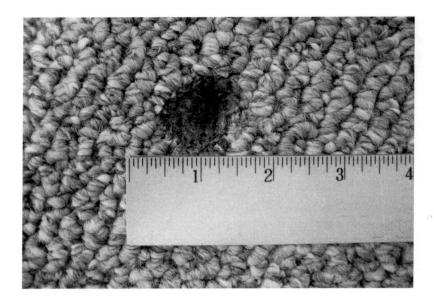

Figure 25.5

Carpet that has passed the pill test. Flame did not spread beyond three inches of point of ignition.

Carpets

Carpet standards are based on the "methenamine pill" test. This pill, which simulates a source of flame such as a match, is placed in the center of a bone-dry sample of carpet and ignited. If the resulting flame does not extinguish itself before it spreads three inches in more than one of the eight samples, the carpet will not pass the test and must not be sold in the United States. (See Figure 25.5.)

The pill test determines only surface ignition. It does not assess the contribution of carpets to the spreading of fires, the behavior of carpets in an environment created by a general fire, or the toxicity of the fumes produced.

There are several exceptions to carpets covered under flammable fabrics legislation. One-of-a-kind carpets need not meet the standards. Handcraft items, oriental carpets, and the like are not covered. Carpets that are six feet by six feet or smaller than twenty-four square feet that do not pass the pill test may be sold, provided that they are clearly labeled as being flammable.

Children's Sleepwear

Since 1972 children's sleepwear in sizes 0 to 6X has been regulated under the Flammable Fabrics Act. After July 1973 flammable children's sleepwear was banned, and the law was extended in May 1975 to sleepwear sizes 7 to 14. The general requirements of the standard use a test in which a specimen of the fabric is clamped in a vertically suspended holder and ignited at the bottom. The length of charred fabric is then measured, with lower char lengths indicating better flame resistance.

These standards must be met not only by new fabrics, but also by those that have been laundered fifty times. All sleepwear must be labeled permanently with instructions as to the care required to maintain the flame-resistant properties. Both manufactured sleepwear items and fabrics intended for use in sleepwear must meet the standard. This includes fabrics and wearing apparel such as pajamas, nightgowns, robes, sleepers, and underwear that is sold in children's sleepwear departments.

In 1996 the CPSC exempted tight-fitting children's sleepwear and infants' sleepwear under size nine months from the mandatory standard. The rationale for this change is that infants six months or younger do not have sufficient mobility to come close to sources of ignition. The commission took the same action on exempting tight-fitting children's sleepwear because "tight-fitting garments can reduce the amount of trapped air needed for combustion, reduce the possibility of contact with a flame, and shorten the reaction time of the wearer" (CPSC 1994).

Mattresses and Mattress Pads

After December 1973 it became illegal for manufacturers to make mattresses and mattress pads that are combustible. The flammability of mattresses is tested using lit cigarettes, which were selected as a source of ignition because statistics showed that the greatest number of mattress fires was caused by smoking in bed.

This testing procedure requires that cigarettes be placed at various points on the mattress and between two sheets on the mattress. To pass the standard, the char length on the mattress surface may not be more than two inches in any direction from any cigarette. The legislation applies to mattress ticking filled with "any resilient material intended or promoted for sleeping upon" and includes mattress pads. Pillows, box springs, and upholstered furniture are excluded.

Upholstered Furniture

In November 1978 the CPSC considered a draft of a mandatory standard for flammability of upholstered furniture. In response to this move by the CPSC, the Upholstered Furniture Action Council (UFAC), a trade organization for the furniture industry, proposed that a voluntary plan devised by the industry be utilized. The industry plan, as it evolved, included a fabric rating system, criteria for construction of furnishings, a labeling plan, and compliance procedures.

The CPSC gave the industry an opportunity to try the voluntary plan. The rating system grouped all upholstery fabrics into one of two classes, based on fiber content. Compliance was monitored through the UFAC by periodic inspections. The commission considered that the voluntary standard provided adequate protection and did not impose a mandatory standard for furniture. However, following a 1993 petition by the National Association of State Fire Marshals, the CPSC began preparing a mandatory standard. In May 2005 a working Draft of Performance Test Requirements for an Upholstered Furniture Flammability was issued for discussion, but as of 2008, no standard is yet in place.

The state of California has established stringent mandatory standards for flammability of upholstery fabrics and other interior textiles that include testing of furniture components as well as mock-ups of the furniture model.

Other Flammability Test Methods

The tests described above and related federal regulations usually have a single pass/fail criterion. A wide variety of additional tests for flammability can be conducted to provide information on burning behavior and effectiveness of finishes. (See Figure 25.6.)

FIGURE 25.6

Flammability tester used to test vertically oriented textile products, in this case a stuffed toy. The specimen is mounted on the regular frame at the center of the upright section of the tester. Ignition is from the small nozzle just below the foot of the toy. Photograph courtesy of James H. Heal & Company, Ltd.

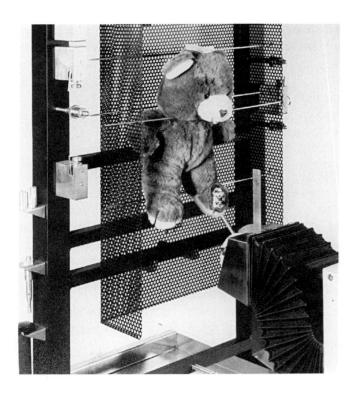

There are tests for carpets other than the pill test required by the federal standard. The Flooring Radiant Panel Test is said to simulate conditions of interior fires more effectively than do other carpet tests. As a result, it is likely to be used by governmental and other regulatory agencies that require the more extensive product evaluation that carpeting installed in hospitals and facilities participating in Medicare and Medicaid programs must meet.

An area of considerable interest in flammability testing of interiors is computer simulation or virtual tests to determine the hazards of real-life situations. For example, data on the furnishings in a prototype room can be used to predict the results of a fire (Gorman 1994). More realistic measures of fire hazards can be obtained and used in such predictive models. These measures, including total heat release, rate of heat release, and toxic gases evolved, are the real dangers from fires involving textiles.

Flame-resistant Textiles

Textile products can be made flame resistant by using fibers that are inherently flame resistant, by using manufactured fibers that have flame-retardant chemicals included in the solution or melt before they are spun through the spinneret, or by application of a flame-resistant finish.

The more thermally stable materials such as asbestos, glass fiber, the aramids, PBI, and PBO could be called fireproof substances that will not burn. Glass fiber has many industrial uses and may be used to a limited extent in household textile products such as window shades or lamp shades. Thermally stable synthetic fibers

have not been developed for general use, but rather are intended for specialized protective clothing for industrial and military uses. Not only are they expensive, but they also lack the aesthetic features that would make them useful in consumer products. Modacrylic fibers offered adequate flame resistance at a moderate cost and were used in carpets, curtains, children's sleepwear, and airline blankets. However, modacrylic has been largely replaced by polyester that has flame-retardant chemicals added. Many other synthetic fibers shrink from ignition flames, providing some protection. Untreated polyester and nylon, for example, will pass the test for children's sleepwear based on this characteristic.

For fibers that are not flame resistant, a flame-retardant treatment can be applied. Several chemical elements will reduce flammability, and the effect is not dependent on the compounds in which they are present. Synergistic effects can occur when they are used in combination. Phosphorus, nitrogen, halogens, boron, and zirconium are commonly used. Durable flame-resistant finishes for cotton and cotton-blend fabrics contain phosphorus and nitrogen. They react chemically with the fibers and inhibit the production of compounds that fuel the flame. Commercial flame-retardant finishes are Pyrovatex[®], Proban[®], and PyronO[®]. A series of brominated diphenyl oxides are widely used as flame-retardant additives for plastics and are used in some textile applications. Some of these chemicals have prompted concern as they are environmentally persistent, and there are moves to ban the use of some of them. The decabromo compound (DBDPO) is of less concern and is still used.

A particular problem in textile flammability is the burning of cotton/polyester blends. Because polyester is less flammable than cotton, one would expect blended fabrics to be less hazardous than all-cotton fabrics. This is, unfortunately, not the case because the char left as the cotton burns serves to hold the melting and dripping polyester in the flame. This is referred to as a "scaffolding" effect that prevents the polyester from dripping away, as it would do in a 100 percent polyester fabric. The polyester remains in the flame and contributes to the burning.

Wool is inherently moderately resistant to burning and provides some protection in apparel and interior furnishings. For more stringent uses such as airplane seats, however, wool is given a flame-retardant treatment. A common finish for wool is Zirpro[®].

Flame resistance conferred through finishing, as opposed to that achieved by use of thermally stable and inherently flame-resistant materials, may be lost or diminished through normal use and care of products. Ammonium phosphate, which is a nondurable flame-retardant treatment, is lost in laundering and must be reapplied. Chlorine bleach, soaps, low-phosphate detergents, and some fabric softeners can harm durable flame-resistant finishes. Laundering in hard water will also decrease the effectiveness of the finish.

ANTIMICROBIAL FINISHES

Microorganisms can cause several problems in textile items. Bacteria and fungi are microbes that can thrive on textiles or on substances present on the textile such as food stains, an applied finish, or weaving sizes. They can weaken the textile or cause staining or odor. Mold spores and dust mite feces (commonly present in bedding) promote allergic reactions.

468

Antimicrobial finishes help to protect fabrics against these attacks. In addition to the finishes described here, manufactured fibers can be produced with antimicrobial agents incorporated into the fiber structure. These modified acetates, acrylics, and olefins can provide durable protection against growth of microbes.

Natural fibers are more prone to attack by microorganisms that have evolved to use cellulose and protein as food sources. Synthetic fibers are much less likely to be attacked, although they can support microbial growth via impurities present. The development of antimicrobial finishes reflects this distinction between natural and synthetic fibers. Many early finishes were applied to natural fibers when they were to be used in conditions that might rot them, such as for sandbags. Nowadays, that need can be met simply by using polyester, for example. However, it may be difficult to clean hydrophobic manufactured fibers completely, and odor-causing impurities may build up. Many early finishes involved chemicals that we now know to be unsafe or unwise to use (mercury or arsenic, for example) and environmental regulations have made many older finishes unusable today.

Antimicrobial finishes are regulated by the EPA under the Federal Insecticide, Fungicide, and Rodenticide Act (FIFRA). FIFRA mandates that only registered chemical compounds can be used, and registration depends on their being determined safe and effective. As new dangers are identified, the number of usable compounds is reduced, and in the past ten years, some well-known types have been withdrawn.

Additionally, the EPA controls the statements that can be made about articles treated with antimicrobial finishes. Thus, in the United States, manufacturers can make claims that refer to the protection of only the treated item itself, such as a towel that will not smell if you leave it damp or a shower curtain that will resist mildewing or socks that will resist odor if worn for an extended period. No claims may be made about health benefits of using the treated article.

The number of different antimicrobial finishes is, thus, rather limited, and research continues to find new ones. Antimicrobial finishes may be bactericidal (killing) or bacteriostatic (growth preventing). Generally, to be bactericidal, the finish must slowly leach off the textile, and the effect is, thus, of less durability than a bacteriostatic finish that does not leach off. At present, the market for antimicrobial finishes is dominated by a few main types. Triclosan, the effective ingredient in most antibacterial soaps, is specially formulated for application to textiles. Cationic compounds have antimicrobial properties, and in this category are quaternary silicones and polyhexamethyl biguanide (PMHB). More recently, the antimicrobial properties of silver have led to considerable research into ways to apply it effectively to textiles.

A recent development in renewable finishes is an inactivated biocide that is chemically bonded to the fiber. The finish is activated during laundering with chlorine bleach. The chlorine serves as the antibacterial agent, and the activated agent can be regenerated when the fabric is bleached again (Sun and Xu 1999).

ANTISTATIC FINISHES

Synthetic fibers, being poor conductors of electricity, tend to build up static electric charges. Electricity causes garments to cling or to build up charges that are dissipated through unpleasant, though mild, electric shocks when the wearer touches a conductor such as a metal doorknob or another person's hand.

Finishes have been developed that attempt to decrease static buildup. However, these finishes tend to have limited effectiveness, largely because they are gradually lost during laundering. Antistatic finishes work on either of two principles: coating the surface of the fiber with a more conductive substance or attracting small amounts of moisture to the fiber that increase its conductivity.

More successful decrease in static buildup of synthetics is achieved through the modification of the polymer before extrusion. This method permanently incorporates compounds in the fiber structure that increase moisture absorbency, which, in turn, increases conductivity.

Another approach is to use special, high-performance antistatic fibers. Metal, metallized, and bicomponent fibers containing metal or carbon are among those used. A small proportion of these fibers is blended with conventional synthetic fibers. Being more conductive, they serve to dissipate the static charges.

Antistatic sprays can be purchased for home use. Fabric softeners applied in the final rinse during laundering will also provide some reduction in static buildup.

SPECIAL-PURPOSE FINISHES

Finishes have been developed to overcome problems of individual fibers or to meet a particular need. Such finishes are applied on a fairly limited basis to particular fibers, yarns, or fabrics, many intended for rather specialized uses.

Mothproofing Finishes

Wool and other animal hair fibers are attacked by the larvae of the clothes moth. Wool is also attacked by carpet beetles. Silk is not attacked by moths as it lacks cystine, a sulfur-containing amino acid moths seem to require.

Finishes that prevent moth damage can act as insecticides to poison the moth larvae or can alter the fiber in some way that makes the wool unpalatable to moth larvae, thereby starving the grubs. These insecticide finishes are applied in manufacturing in a dyeing-like process. Older finishes have been mostly replaced by the use of permethrin (commonly used in insecticidal plant sprays), which is effective at very low concentrations.

Temperature-regulating Finishes

Temperature-regulating fabrics are sensitive to the surrounding temperature or to body heat. Finishes that provide this adaptation include substances called phase change materials (PCMs) (Lennox-Kerr 1998). These substances change from solid to liquid or liquid to solid depending on the temperature. The example we are probably most familiar with is ice changing to water when the temperature rises then changing back to ice again when cooled. Ice absorbs heat to melt, and water gives off heat when it becomes solid. PCMs work the same way but are selected to undergo this phase change around normal skin temperature.

PCMs have been applied to fabrics as microcapsules in coatings, used in nonwoven bonding materials, or included in spinning solutions of manufactured fibers. Outlast Technologies, Inc., produces the microcapsules. The fabrics made

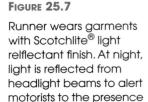

of the wearer. Courtesy of 3M Company.

with these fibers are targeted for outdoor apparel, particularly for cold climates. PCM-containing textile fabrics are expensive because the encapsulation process is technology intensive.

Light-reflectant Finishes

Light-reflectant finishes are created by the application of microscopic reflective beads to the surface of a fabric. The increased number of persons who jog or ride bicycles after dark is probably responsible for the application of this finish to a variety of garments for sports and to other items such as backpacks. A reflective finish called Scotchlite[®] is produced by the 3M Company. The manufacturer notes that the finish does not alter the color or appearance of the garment by day, but after dark the fabric "lights up" when directly in the path of the lights of an oncoming vehicle. (See Figure 25.7.)

Ultraviolet-absorbing Finishes

Many textile fabrics are deteriorated by exposure to sunlight. Light also causes colors to fade, and ultraviolet light is known to cause skin cancer. Finishes that absorb ultraviolet light can combat each of these. As with flame retardants, some materials have inherent resistance (acrylic fibers, for example), and in many cases a light stabilizer is included in the melt before spinning, particularly important for olefin fibers.

Synthetics that have been delustered with titanium dioxide are especially subject to damage from sunlight. This chemical apparently accelerates damage to the fiber and fading of dyes. In apparent contradiction to this, titanium dioxide is used in some sunscreens and, as a finish, has been used in UV-protective fabrics.

In the early 1990s, interest in UV-absorption finishes was centered on increasing the lightfastness of dyed fabrics or the prevention of yellowing in wool. Interest has now shifted to the UV-protective value of fabrics in skin cancer prevention, but similar technology can be used in both cases. The Ultraviolet Protection Factor (UPF) of a fabric can be measured in a standard test (AATCC Test Method 183) that measures the amount of UV light transmitted and factors in the relative damaging effects of different wavelengths. However, the combined effects of fiber type, fabric

TAKE A CLOSER LOOK

Wrinkle-resistant Fabrics of 100 Percent Cotton

Cotton fabrics, as we all know, become wrinkled during use and after laundering. The cause of this wrinkling is described in chapter 4. Wrinkle-resistant finishes were developed to provide cotton fabrics that did not require ironing after washing. These finishes react chemically with the cellulose chains in cotton fibers to prevent deformation of the fibers, which results in wrinkling of the fabric.

Consumers like the comfort of all-cotton fabrics for apparel as well as for home furnishing items such as sheets. Application of durable-press finishes to cotton fabrics increases their consumer acceptance in many end uses. Products made from the finished fabric may be designated as wrinkle resistant, wrinkle free, or easy care.

Current commercial finishes can be applied to both cotton and cotton-blend fabrics. Blending synthetic fibers, such as polyester, with cotton enhances the fabric's smooth-drying properties, and such blends require less of the chemical finishing material. All-cotton fabrics with these finishes exhibit significantly higher wrinkle resistance after washing and drying than do unfinished fabrics. Wrinkle-resistant cotton garments continue to enjoy market preferences, especially in men's casual clothing. The cost is slightly higher for wrinkle-resistant products, but consumers seem willing to pay for the convenience of easy care. Labels on such products should identify the products as wrinkle resistant or wrinkle free.

Both precure and postcure processes are used for wrinkle-resistant cotton products. The precure process is best for fabric that will be made into items without creases or pleats. These include sheets, shirts, and knits.

Postcuring is used for cotton products that have permanent creases or pleats. Creases in pant legs of men's trousers, for example, or in other garment details such as the jeans in Figure 25.8 can be cured and set during or after the garment construction. Once creases and pleats are permanently set, however, making alterations to garments is difficult. It is easier to shorten skirts or trousers than it is to lengthen them, even though it may be difficult to get as crisp a press as the fabric had when it came from the manufacturer. The crease mark of the original hem will always show in a lengthened garment. For these reasons, wrinkle-resistant garments should be bought to fit and should not be given extensive alterations.

Even though the wrinkling properties of cotton are enhanced by these finishes, the fabrics may still need

FIGURE 25.8

Jeans with permanent creases on the back leg.

touch-up ironing, especially at seams and other stitched areas, to achieve the appearance desired by some consumers. The finishes will, therefore, be more effective on cotton garments or home furnishings with less stitching and fewer details.

Wrinkle-resistant finishes also inhibit shrinkage, a property that has led to increased use of these finishes in knit goods. Cotton knits do not wrinkle as much as do woven cotton fabrics, but they usually shrink more, and the wrinkle-resistant finishes stabilize the fabric dimensions. Several companies market 100 percent cotton knit shirts with shrinkage control.

TAKE A CLOSER LOOK

continued

Special care in home laundering is required to produce optimum wrinkle-free performance. Washing should be done at warm rather than hot temperatures. Best results are seen when a warm wash cycle is followed by a cool rinse. Wrinkle-resistant finishes are designed for use in automatic laundering equipment, especially tumble dryers. If items must be line dried, they should be washed in a permanent press cycle or removed from the washer before the spin cycle, in which fabrics may become creased.

Dry fabrics should be removed from the dryer immediately after the cycle ends to keep creases from forming while the item lies wrinkled at the bottom of the dryer. Permanent press cycles, a feature of most modern dryers, have an initial warm-drying phase followed by a cool-air phase that prevents this problem. If items do become wrinkled, they can be placed in a warm dryer for a few minutes with a damp item then immediately removed.

Although wrinkle-resistant finishes increase the smooth-drying property of cotton fabrics, they also decrease their strength and abrasion resistance. Some of the earlier wash-and-wear finishes caused losses in fiber strength and toughness. Consumers should recognize that although this problem is no longer so severe, the wear life of cotton durable-press fabrics is shorter than that of unfinished fabrics. The problem is greater with top-weight fabrics because they are weaker to begin with than the heavier-weight fabrics used for pants and trousers.

Cotton fabrics with a wrinkle-resistant finish may have decreased absorbency. The difference, however, is not large and should not noticeably affect the comfort of the fabrics. Finished cotton fabrics also have an increased attraction for grease and oil. To improve performance in this area, most manufacturers couple the wrinkle-resistant finish with a soil-release finish.

structure, and dye are not easy to predict. In real life, fabrics may also be stretched and be wet, and these are further complicating factors. Knitted fabrics, which usually have a more open structure, generally allow more ultraviolet light through than do woven fabrics; lightweight summer fabrics allow more ultraviolet light to reach the skin than do heavier fabrics with more opaque yarns.

Other Specialty Finishes

Several additional finishes produce special effects. Antislip finishes are resins applied to fabric to hold yarns together at the points where they interlace and keep them from slipping against each other. Resin antislip finishes are durable, while silica compounds that increase yarn-to-yarn friction are temporary.

Another specialty finish contains microencapsulated fragrances that gradually release perfumed oils as the fabric is abraded during wear. The scented finishes have been used in fabrics for men's suits. New, too, are finishes for odor control. These compounds entrap the volatile molecules that cause unpleasant odors. There is growing interest in the inclusion of therapeutic (or pseudotherapeutic) agents such as vitamins in fabric finishes.

SUMMARY POINTS

- · Chemical finishes are used widely to add value to textile products
 - They are mostly applied by padding and curing
 - · Low-wet-pickup methods save energy

- Wrinkle-resistant finishes are applied to cellulosic fabrics
 - Most common commercial finish is DMDHEU
 - Finish can be cured before or after final products are constructed
- Chemical finishes can render wool fabrics washable
- · Hand builders, softeners, and enzyme treatments affect fabric hand
- · Chemical finishes can alter wetting of fabrics
 - Thin membranes make fabrics waterproof
 - · Hydrophobic finishes repel water
- Fluorochemical finishes repel oil and water and release soil in laundering
- Flammability of textiles is regulated by law in many countries
 - Standards are established for specific products
 - Textiles can be made flame resistant by fiber selection or application of a flame-retardant finish
- · Antimicrobial and other finishes are applied for specialty products

Questions

- How do dyes and finishes differ in terms of the ways in which they are applied?
- What are the ways in which energy can be saved in the application of finishes? 2.
- What is the most common chemical used today for wrinkle-free finishing? 3. How does it achieve its effect? What are its benefits compared to other such finishes? What problems can occur in fabrics that have been treated with wrinkle-free chemicals?
- What is the principle involved in creating machine-washable wool? 4.
- What is the most common finish used today for softening?
- 6. Compare objective and subjective methods for describing how a fabric feels.
- 7. What name is often given to enzyme treatments that remove surface hairiness?
- What is the difference between soil repellency and soil release? How can one finish do both?
- If you want to produce a flame-retardant fabric, what options do you have besides finishing?
- Which textile items have specific flammability standards?
- Describe a situation in which a textile treated with an antimicrobial finish would perform better than one that is not treated.
- 12. What are the reasons for applying a UV-absorbing finish?

References

- ASTM. Annual Book of ASTM Standards. Vol. 7.01. West Conshohocken, PA: American Society for Testing and Materials, 1998.
- Clark, J. E., and G. Tesoro. "Textile Flammability." Paper presented at the American Chemical Society's State of the Art Symposium on Man-made Fibers, Washington, D.C., June 1974.
- Code of Federal Regulations. 16 CFR, chapter 11 (January 1, 1989).
- CPSC. Fact Sheet. Washington, D.C.: Consumer Product Safety Commission (June 1974).

- CPSC. "CPSC Votes to Continue Rulemaking on Children's Sleepwear." *News from CPSC*, August 3, 1994.
- Gorman, M. "Update: E-5: The Fire Standards Committee Reaches into the 1990s." *Standardization News* 22, no. 11 (1994): 30.
- Jones B. W., J. D. Turner, and L. G. Snyder. "Comparison of Low Wet Pickup Finish Applicators for Cotton Fabrics." *Textile Industries* 148, no. 10 (1984): 25.
- Lennox-Kerr, P. "Comfort in Clothing through Thermal Control." *Textile Month* November (1998): 28.
- Sun, G., and X. Xu. "Durable and Regenerable Antibacterial Finishing of Fabrics: Chemical Structures." *Textile Chemist and Colorist* 31, no. 5 (1999): 31.
- "Sympatex: Breathable Fabrics without Pores." *America's Textiles International* 17 (November 1988): 72.

Recommended Readings

- Andrews, B. A. K. "Safe, Comfortable, Durable Press Cottons: A Natural Progression for a Natural Fiber." *Textile Chemist and Colorist* 24 (November 1992): 17.
- Brown, R. O. "Enhancing the Performance of Wrinkle Resistant Cotton Garments." American Dyestuff Reporter 83 (September 1994): 106.
- Czech, A. M., J. Pavlenyi, and A. J. Sabia. "Modified Silicone Softeners for Fluorocarbon Soil Release Treatments." *Textile Chemist and Colorist* 29, no. 9 (1997): 26.
- Gurian, M. "The Finishing Needs of the Evolving Commercial Interior Fabrics Industry." *Textile Chemist and Colorist* 29, no. 10 (1997): 21.
- Huang, X. X., Y. K. Kamath, and H.-D. Weigmann. "Photodegradation and the Loss of Stain Resistance of Stain Blocker Treated Nylon." *Textile Chemist and Colorist* 25 (November 1993): 293.
- LeBlanc, R. B. "The Durability of Flame Retardant–Treated Fabrics." *Textile Chemist and Colorist* 29, no. 2 (1997): 19.
- North, B. F. "Reactants for Durable Press Textiles: The Formaldehyde Dilemma." *Textile Chemist and Colorist* 23 (October 1991): 21–22.
- Sabia, A. J. "Use of Silicones to Enhance the Aesthetic and Functional Properties of Microfibers." *Textile Chemist and Colorist* 144 (August 1994): 13–16.

THE CARE OF TEXTILE PRODUCTS

Learning Objectives

- 1. Explain the mechanisms of soil and stain removal from textiles.
- 2. Describe the various laundering aids and their purposes.
- 3. Detail appropriate laundering and dry-cleaning procedures.
- 4. Develop permanent care labels for particular textile products.

Attention to the correct procedures for cleaning and maintaining textile products will extend the useful life of the product. Improper cleaning and storage can result in either severe damage to the fabric or an increased rate of wear over a period of time.

Soil deposited on fabrics is made up of different materials. Some components of soil are simply soluble in water (sugars and salts, for example); other components are oily or greasy in nature and require the use of a detergent in water or a solvent. Others (such as starches and dried blood) are easily removed after they have been chemically degraded, perhaps by an enzyme present in a detergent formulation, or by the use of a bleach. There are also insoluble materials (particles of grit or sand) that are not soluble but that may be held on the fabric by other components of dirt or by simple physical entrapment within the fibers.

Attention to the correct procedures for cleaning and maintaining textile products will extend the useful life of the product. Improper cleaning and storage can result in either severe damage to the fabric or an increased rate of wear over a period of time.

REFURBISHING OF TEXTILES

Soil can be removed from fabrics by laundering or dry cleaning. A general term for both, which also includes subsequent steps such as ironing, is *refurbishing*. These processes can be carried out in the home or by professional cleaners. The principles used are the same in both instances, but the equipment and laundry or drycleaning products will vary.

Laundering

The process of laundering soiled fabrics consists of wetting the fabric and its soil, removing the soil from the fabric, and holding the soil in suspension so it does not redeposit on the fabric during washing. Soaps and detergents increase the cleaning ability of water. The addition of detergent to water decreases the surface tension of water, that is, the molecular forces in the outer layer of the water. The lower surface tension increases the wetting power of water, allowing it to penetrate textiles more completely. Essentially detergents make water "wetter."

A simple experiment will demonstrate this principle. Take a small piece of nylon fabric and float it on the surface of a small bowl of water. The surface tension of the water enables the nylon to float for a time until it becomes wet throughout. Drop a few drops of liquid detergent into the water. The fabric will become wet immediately and sink.

In laundering the fabric is wetted and some type of mechanical action provided to loosen and break up the soil. The mechanical action can be the motion of a washing machine or hand scrubbing. The soil is broken into smaller particles, surrounded (emulsified) by the detergent, and lifted off the fabric by the action of the detergent molecules. The detergent surrounding the soil particles prevents them from being redeposited on the fabric as the washing progresses. When fabrics are rinsed, the soil and detergent are rinsed away.

Soaps

Soap is made from fatty acids and alkali that react together to form the soap. Some degree of alkalinity is necessary for cleaning, and as the soap dissolves, the washing water becomes somewhat alkaline in reaction. Much soil is acid in chemical reaction and will tend to neutralize some of the alkalinity of the soap and decrease its effectiveness. Therefore, more heavily soiled items require more soap.

To ensure that adequate alkalinity is present for thorough washing, extra alkali is added to increase the effectiveness of the soap. Soaps with added alkali are known as *built* or *heavy-duty* soaps and are designed for general laundering. Less alkaline soaps are also available for laundering more delicate fabrics. Because protein fibers are damaged by excessive alkali, mild detergents should be used for washing wool, silk, and other delicate fabrics.

Soap is a good cleaning agent, but it does not perform well in hard water. Hard water is generally found in areas of limestone rock and contains higher concentrations of minerals such as calcium and magnesium. The minerals in the water combine with soap to form an insoluble gray curd, or scum. Once the soap has combined with these minerals, less soap is available for cleaning and larger quantities of soap must be used. Also, the hard-water scum may be deposited on clothing, leaving it gray or dull looking.

Nonsoap Detergents

The term *detergent* can create some confusion. Cleaning agents are commonly known as detergents. Both soaps and synthetic detergents are, technically speaking, detergents, even though the term *detergent* is often used by the general public to refer only to synthetic detergents. For purposes of this discussion, *detergent* will be used to refer to synthetic detergents and to both soaps and detergents where those terms are interchangeable.

Synthetic detergent products are made from petroleum and natural fats and oils. Unlike soaps, synthetic detergents do not form hard-water scum, but dissolve readily not only in hard water, but also in soft water that contains few minerals. The specific formulation of each synthetic detergent varies, of course, from one product to another. Laundry detergents are produced in both liquid and powder form. The use of heavy-duty liquid detergents has grown in recent years. One reason for the increased use of these products is that they can be formulated more readily without phosphates than can powdered detergents.

1. Surfactants. Surfactants, the active ingredient in synthetic detergents, are organic chemicals that alter the properties of water and soil so dirt can be removed. The surfactant molecule has a hydrophobic body that is attracted to oily substances and a hydrophilic head that attracts water and other polar and charged compounds. The action of the surfactant breaks up water droplets that surround soil particles by lowering the surface tension and allowing water to penetrate. Groups of surfactant molecules (called *micelles*) surround the soil, with the hydrophobic body of the molecule attached to the soil and the hydrophilic head of the molecule oriented toward the water in which the particles become suspended. (See Figure 26.1.)

The most commonly used surfactants are linear alkyl benzene sulfonate (LAS), alcohol sulfates (AS), and nonionic surfactants. Both LAS and AS surfactants, as well as soap, are anionic, that is, they generate negative charges in water. Similar electric charges repel each other. Most fabrics also carry negative charges, so the negative charge of the surfactant molecules surrounding the soil particles is effective in preventing the redeposition of soil on the fabrics being washed. Nonionic surfactants do not carry electric charges as they dissolve. They are more effective in removing oily soil than are anionic surfactants. Some common nonionic detergents are based on alkyl phenol ethyoxylates. There is debate about whether these types mimic hormones and, thus, disrupt normal growth patterns in aquatic life when they enter the waste stream from sewage treatment works.

478

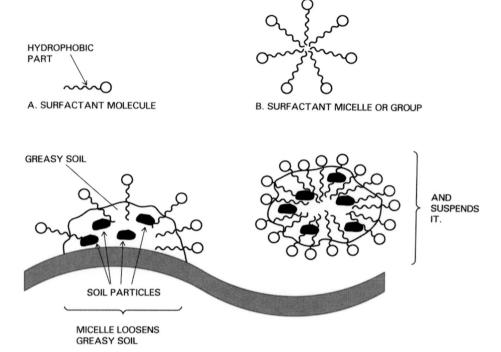

FIGURE 26.1
Diagram showing the action of a surfactant removing and suspending soil.

2. Builders. Builders are substances that soften water and maintain alkalinity. Originally the majority of builders used in detergent formulations were phosphates, which are especially effective in counteracting water hardness. They also disperse and suspend dirt and maintain alkalinity, which is necessary to neutralize many soils that tend to be acid in chemical reaction.

Fears that phosphates contribute to water pollution led some states and communities to restrict the use of phosphate-containing detergents. As a result, detergent manufacturers have developed a variety of nonphosphate or low-phosphate detergents that contain other builders. These nonphosphate builders include sodium silicate, sodium carbonate, sodium sulfate, and sodium citrate.

Some detergents do not contain builders, relying instead primarily on surfactants to keep soil suspended and to combat water hardness. Nonionic surfactants are especially good for the latter purpose because they do not react with minerals that cause water hardness.

- 3. Suds control agents. Some detergents today are made to maintain low suds levels. All suds levels clean equally well, but low-suds formulations are necessary for optimum cleaning in the newer, high-efficiency washing machines. (See page 483.)
- 4. *Processing aids*. Materials added to maintain good powder properties in powdered detergents include sodium silicate (also cited previously as a builder) and sodium sulfate. Liquid detergents may contain alcohol as a solvent to help maintain the detergent in liquid form under colder conditions.

- 5. Agents to protect washing machine parts. Silicates in detergents help to prevent corrosion of the parts of the washer that are exposed to water and detergents.
- 6. Antiredeposition agents. Although anionic surfactants help to prevent the redeposition of soil, other agents are also added to the detergent to prevent redeposition. The most common chemical used for this purpose is sodium carboxymethyl cellulose.
- 7. Fragrances. Many detergents contain fragrances. These products give the laundered items a more pleasant odor.
- 8. Other additives. Enzymes, oxygen bleaches, fluorescent whiteners, bluing, and/or fabric softeners may be added to some detergents to create what the industry calls *multifunctional products*. Each of these additives can also be purchased by the consumer and used separately from the detergent.

Water Softeners or Conditioners

Synthetic detergents do not produce hard-water scum as soaps do, but it is necessary to use larger quantities of detergent in hard water than in soft water. (Soft water is free from dissolved minerals.) Many households, therefore, find it helpful to decrease the hardness of water by some form of water conditioning. Hard water can be softened either by commercial softening systems installed in the home to soften all water used in the household or by the addition of powdered water softeners to the laundry. Powdered softeners are of two types: precipitating and nonprecipitating.

Precipitating water softeners combine with the minerals that cause water to become hard to form a compound that precipitates, or settles out of solution, into visible granules. More common are the nonprecipitating water softeners that keep hard-water minerals tied up in chemical combination and in solution so neither soap scum nor a precipitate is formed. Nonprecipitating softeners can dissolve soap scum formed before the softener was added to the water and can strip scum left in clothes from previous washings in hard water.

Minerals, such as iron or manganese, in water may stain fabrics. The addition of bleach to such water may cause the formation of colored salts that, when deposited on fabrics, cause discoloration. Nonprecipitating water softeners will prevent such staining by tying up the minerals. Calgon[®] is a nonprecipitating water softener.

Bleaches

Bleaches are often used along with soaps and synthetic detergents in laundering. It is important to remember that bleaches do not *clean* clothing. Detergents do the cleaning; bleaches are used to whiten fabrics and remove stains.

Bleaches oxidize the coloring matter in fabric, and some stains are removed by the oxidation of the coloring matter in them. Two basic types of bleaches are used in the home: chlorine bleaches and perborate bleaches.

Chlorine bleaches are the stronger of the two types. They contain active chlorine to oxidize colored matter. But after the chlorine has oxidized all stains, color, and so on, it begins to oxidize susceptible fibers. For this reason, chlorine bleaches

480

need to be used in correct concentrations, must be dissolved thoroughly before application, and must be rinsed out thoroughly, or they may damage the fibers. Some dyes are damaged by chlorine bleach; therefore, it is rarely recommended that colored fabrics be bleached with chlorine bleach.

The following are the most frequent mistakes made in handling chlorine bleach.

- 1. *Using too much bleach*. Follow directions on the package. Do not assume that if a little bleach is good, twice as much is better.
- 2. Pouring bleach directly onto clothing. Bleach should be added to a full tub of water and agitated thoroughly before any laundry is added. Adding concentrated bleach to a washer full of clothing will result in concentrated bleach being poured over some garments, which may damage them. Most washing machines today have bleach dispensers to measure the bleach and add it at the appropriate time.
- 3. Bleaching items that should not be bleached. Read care labels carefully. Some resins or fibers such as spandex will yellow on contact with chlorine bleach. Chlorine bleach damages fibers such as silk, wool, and spandex.
- 4. Soaking heavily stained items in concentrated bleach solutions. Exposure to concentrated bleach solutions may damage certain fibers and should be avoided. Items should not be soaked in even low concentrations of chlorine bleach for longer than fifteen minutes.

Chlorine bleaches are sold in both dry and liquid forms under a variety of trade names, such as Clorox[®] and Purex[®]. It is important to rinse bleached fabrics carefully, or deterioration of the fibers can continue for as long as any bleach remains in the material.

Oxygen bleaches do not use chlorine for oxidation but use other chemicals such as sodium perborate, hydrogen peroxide, and potassium monopersulfate. They also do not whiten as efficiently in a short period of time. These bleaches will work best if used in hot water; new formulations, however, have been developed to function at the lower, "energy saving" washing temperatures of today. Like chlorine bleaches, oxygen bleaches should be diluted before addition to the wash as some colors may be sensitive to the bleaching action of these products. Trade names of oxygen bleaches are Clorox-2[®] and Purex All Fabric Bleach[®]. Hydrogen peroxide is sold in drugstores as an antiseptic.

Pretreatment Products

Certain types of stains are especially hard to remove. Among these are protein-based stains such as body soils, blood, eggs, baby formula, grass stains, and chocolate. Special enzyme presoak products contain selected types of enzymes that break down these soils to simpler forms that are then more readily and completely removed by the laundry soap or detergent. Fabrics are soaked from thirty minutes to overnight, depending on the instructions and the age and amount of the stain. Enzymes are commonly incorporated into the formulations of multifunctional detergents.

Aerosol and spray prewash soil and stain removers that contain perchlorethylene or other petroleum-based solvents are sold for use on synthetics and wrinkle-resistant fabrics. They help to remove greasy stains such as those made by lipstick, bacon fat, coffee with cream, and ballpoint pen. Instructions on the label generally recommend that they be applied to fabrics five minutes or longer before washing.

Fluorescent Whiteners, or Optical Brighteners

Many detergent formulations contain fluorescent whiteners. It is also possible to purchase fluorescent whiteners—referred to as optical brighteners—for use in the home. Fluorescent whiteners absorb light in the visible wavelength range and reemit it in the ultraviolet range. As a result, fabrics treated with brighteners look bluer. These agents do not attach themselves to different fibers to the same degree, so their effectiveness may vary from fiber to fiber. Because cotton is the most widely used apparel fiber, the whitener is usually best suited to cotton. Also, chlorine bleach may destroy the active ingredients in fluorescent whiteners, so the two products should never be added to the laundry at the same time.

Before optical brighteners for household use were developed, white laundry could be treated only with *bluing*. Bluing is a—now rarely used—laundry product that is added to the rinse cycle. It contains small quantities of blue dye that mask yellow color by absorbing it. The fabric becomes very slightly darker, but a very pale neutral gray looks much better than a very pale yellow.

Disinfectants

One of the purposes of laundering clothing and household items is to destroy bacteria. Ordinary laundering procedures using detergent and hot water will destroy many bacteria. Recent trends toward using cooler washing temperatures may have the effect of allowing more bacteria to survive, however, so when there is illness or infection in a home, special care may be required to sanitize items being washed.

To be suitable for sanitizing laundry, a disinfectant should kill bacteria without injuring or discoloring fabrics. Furthermore, disinfectants should not leave a residue that is harmful to the user, and they must be compatible with detergents. Four types of products meet these criteria:

- 1. *Liquid chlorine bleaches*. These are normally a solution of 5 percent of sodium hypochlorite in water.
- Quarternary disinfectants. These are colorless and odorless compounds
 that are effective in hot, warm, or cold water. Such substances are available
 in drugstores; mass merchandisers; grocery stores; and janitorial, hospital,
 or dairy supply houses.
- 3. *Pine-oil disinfectants*. These products are effective in hot or warm water. They have a characteristic odor that does not remain after laundering. The label should state that the product contains at least 70 percent steam-distilled pine oil. Pine-oil disinfectants are sold in supermarkets or grocery stores.
- 4. *Phenolic disinfectants*. Effective in warm or hot water, these products should be used according to directions on the package. Lysol[®] is the brand name of one of the better-known phenolic disinfectants.

Fabric Softeners

Fabric softeners deposit a waxy, lubricative substance on fibers that causes fabrics to feel softer. Fabric softeners used by consumers as laundry aids are based on quaternary ammonium compounds. Although different chemical compounds are used, all have a long fatty chain that imparts the soft feel to the fabric. The softening effect is especially desirable for fabric with a napped or pile surface that may become harsher after laundering, particularly if the fabrics are line dried rather than tumble dried. Towels, washable blankets, corduroy or other pile fabrics, and sweaters are often washed with fabric softeners.

In addition to making fabrics feel softer, fabric softeners cut down static electricity, make ironing easier, and improve the performance of durable-press finishes, often making touch-up ironing unnecessary. At the same time, the continual use of fabric softeners causes a buildup of the softener on the fibers, thereby decreasing absorbency. On items where absorbency is an important function, such as towels, it is recommended that fabric softeners not be used in every wash but in alternate washings or periodically.

Fabric softeners are designed for addition to the wash, the rinse, or the drying cycle. Some detergents today include softeners in their formulations. Wash-added liquid fabric softeners should be added to the wash water before the detergent and the clothes are placed in the water to prevent fabric staining. These products can generally be used in the final rinse cycle as well.

Rinse-added fabric softeners cannot be used in the wash cycle, nor should they be used along with other laundry additives such as water softeners. These products and detergents may interfere or react adversely with the softener. Softeners should not be poured directly onto fabrics as they may cause staining.

Fabric softener sheets, added to a load of laundry in the dryer, are commonly used because of their convenience. These products have softeners impregnated into a nonwoven fabric sheet. The heat of the dryer and the tumbling action of the clothes cause the softener to be transferred to the clothes and spread evenly on the fabric surfaces.

Starches

Starches are sizings that are added during home laundering. They help to restore body or stiffness to limp fabrics. Starches help to keep fabrics cleaner because dirt tends to slide off the smooth finish produced by starching. Also, soil may become attached to the starching material rather than to the fiber, making the soil easier to remove.

Because vegetable starches were used originally for this purpose, the term starch was given to these products. Today, however, "starches" may be either vegetable or resinous compounds. Liquid or dry sizings are added in the rinse cycle of laundering. Aerosol sprays are added at the time of ironing. Vegetable starches must be renewed after each washing. Resins penetrate the fiber more thoroughly and will last through several washings.

Laundry Equipment

Washing Machines. Most laundry in the home is done in washing machines. Types of automatic washing machines used today are listed here:

FIGURE 26.2

Types of washing machines. (a) Top-loading agitator machine; (b) high-efficiency front-loading machine; (c) high-efficiency top-loading machine. Diagrams courtesy of the Soap and Detergent Association.

- 1. *Top-loading agitator machines*. These have a central oscillating shaft with curved blades at the bottom. (See Figure 26.2a.) The items being laundered are covered with water, and the oscillation of the agitator provides the mechanical action needed for soil removal. Eighty-five percent of the washers purchased in 2005 were of this type.¹
- 2. High-efficiency (HE) machines. Driven by interest in water and energy conservation, these machines were developed to use low water levels for laundering. Instead of agitating laundry in a tub of water, a tumbling action moves the water through the laundry. In front-loading HE machines, the washing drum rotates, tumbling the items in and out of the water and up against the flanges of the drum. (See Figure 26.2b.) Top-loading HE washers have rotating wheels at the bottom of the tub, which move the items through the low level of water. (See Figure 26.2c.)

Newer automatic washers of whatever type have programmed cycles that require only the selection of a suitable term, such as *permanent press*, to select water temperature, time duration for washing, and vigor of mechanical action. For older machines, the setting for each condition must be selected manually. Most washers offer a low, moderate, or high water temperature; washing time durations of from two to fourteen minutes; and either gentle or normal agitation. Washing machine instruction manuals give specific directions for selecting settings for varying types and loads of laundry. Table 26.1 offers typical time, speed of agitation, and water temperature for various fiber groups.

The expansion of the use of wrinkle-free finishes has led to the manufacture of washers and dryers that have permanent-press cycles. These cycles are designed to produce optimum performance from wrinkle-resistant finishes by using

^{1.} Data from Soap and Detergent Association.

Table 26.1
Washing Machine Settings for Various Fibers

Fiber	Cycle Time	Water Temperature	Agitation and Spin Speed
Wool	1-3 min	110°-120°F	Slow
Cotton and linen	10-12 min	120°-140°F	Normal
Manufactured and durable press	5–7 min	110°-120°F	Slow

varying water temperatures in washing and rinsing, by offering decreased spin speeds in extracting water, and by ending the drying cycle with a cool temperature to avoid heat-setting wrinkles into dried clothing. During the extraction of the water in the spin cycle, clothes are compressed against the tub or drum walls. If the fabric is warm, the cooling that takes place will cause the fabrics to wrinkle, whereas the cool water cycles of the special wrinkle-resistant cycle provide better wrinkle resistance. If the laundry items are to be dried in an automatic dryer, these wrinkles will be tumbled out of the fabric. If they are to be line dried, however, wrinkle-free items should be removed from the washer before the final spin cycle.

Laundry Procedures

Although the washer and dryer do the physical work of laundering, the selection of appropriate laundry procedures is essential for efficient cleaning. Sorting, selecting washing time and water temperature, pretreating spots and stains, and carefully selecting laundry products for use all require that decisions be made by the person doing the washing.

Laundry should be sorted carefully according to color, fiber type, degree of soil, and delicacy of construction. Items requiring the same laundry products, water temperature, length of washing, and speed of agitation should be grouped together.

White items should be washed together. White wrinkle-free and nylon fabrics are most prone to discoloration if washed with items of color and should be washed with only other whites. Colorfast items may be laundered together, even if the colors are not the same, but it is advisable to separate light and dark colors at least until it has been ascertained that the dark colors will not bleed. Items that are not colorfast should be washed separately; in some cases they may have to be washed by hand. The care labels on products often provide information that is helpful in sorting items.

Fabrics that produce lint, such as bath towels, chenille fabrics, terry cloth items, and the like, should be washed separately from those that attract lint, such as corduroy, synthetic fabrics, and durable press. It is especially important to separate light-colored lint-producing fabrics from dark-colored lint attractors, such as dark nylon underclothing or socks.

Heavily soiled items should be washed not with lightly soiled items, but alone. The lightly soiled items may pick up soil or discoloration from the wash water, and the heavily soiled fabrics may need a more rigorous wash cycle.

Loads should, as much as possible, be balanced with some small and some larger items. This will provide better washing action. However, lightweight manufactured fiber items should be dried separately from heavy cellulosic fabrics, such as towels, because the manufactured fiber items will dry first then become overheated during the time required for the heavier, cotton fabrics to dry.

Heavy items such as blankets or bedspreads may have to be washed alone because of their size. When a heavy load is put into a washer, it should be arranged carefully so the washer balance is maintained during spin cycles. Most washing machines automatically shut off if the load becomes too unbalanced.

Before laundering, clothing should be checked carefully. Pockets should be emptied because coins or other items left in pockets can damage washers or dryers, and tissues left in pockets will produce lint that will be picked up by garments. Lint and dirt should be brushed out of pant cuffs. Zippers and hooks should be closed so they do not catch onto other items and tear them. Pins, heavy ornaments, and buckles may also cause damage to fabrics and should be removed. Tears should be mended before laundering as the agitation of washing and drying may cause them to be enlarged.

Some items may require pretreatment for optimum cleaning. Soil lines that are formed around collars and cuffs may be difficult to remove from synthetic and wrinkle-resistant finished fabrics. The area may be pretreated by dampening the area then rubbing liquid detergent or a paste made of powdered detergent and water over the soiled area.

Stain Removal

Stains, which are specific substances spilled on a fabric as opposed to general soiling through use, should be treated as soon as possible. The longer a stain remains on an item, the harder it will be to remove. Small stain-removal sticks, carried in a pocket or purse, can be applied quickly after an item is stained. (See Figure 26.3.)

FIGURE 26.3

(a) Coffee stain on white cotton fabric; (b) same fabric area after treatment with stain removal stick; (c) same fabric area after washing and drying.

In treating fabrics to remove stains, the first consideration must be the composition of the material that has been stained. Knowledge of fiber content may help to determine appropriate solvents. For example, attempting to remove a nail polish stain on an acetate fabric with nail polish remover that contains acetone would destroy the fabric. Once fiber content has been taken into consideration, then fabric structure must be evaluated. Rubbing hard on a stain on a pile fabric will flatten the pile. Rubbing may abrade the surface of a satin or rib weave fabric.

Before any stain remover is used, the fabric should be tested to determine whether it is colorfast to the stain remover or whether it may have a finish that the stain remover will harm. Fabrics can be tested by sponging a small amount of stain remover onto a seam, hem, or other hidden part of the item. If a suitable stain remover cannot be found, the item should be taken to a professional dry cleaner for treatment.

Table 26.2 lists a wide variety of materials that may produce stains on fabrics and suggests appropriate treatments for fabrics that (1) are washable and (2) have fiber content and fabric structures that are compatible with the recommended treatment. Some stains cannot be removed. Extensive staining by hard-to-remove substances or stains on delicate and/or nonwashable fabrics are probably best removed by a professional dry cleaner who has a variety of spot- and stain-removing chemicals and an expert knowledge of stain removal. It is always helpful to the cleaner, however, if the customer points out the stain and identifies the staining substance.

Drying

Automatic dryers generally provide heat to evaporate the water from laundered items and mechanical action to move the items around, ensuring exposure to the heat. Temperatures for drying may range from no heat to high temperatures. The drying time is determined by the size of the load and the weight of the fabrics being dried. Temperature and time of drying can be set manually, or an automatic setting can be selected so a moisture sensor turns off the dryer when the laundry is dry.

Fabrics that have been laundered may be either line dried or dried in an automatic dryer. Some fabrics should not be dried in dryers because the heat and action of the dryer may cause some shrinkage in heat-sensitive fabrics. Elastics made with natural rubber may lose their elasticity over a period of time if dried in an extremely hot dryer. Care labels should be consulted to ascertain whether fabrics should be placed in a dryer.

Heat-sensitive fabrics, such as those made with olefin or acetate fibers, should be dried at low-heat or no-heat settings. Wrinkle-resistant and synthetic fabrics should be removed from the dryer immediately after completion of the drying cycle to prevent the setting of wrinkles. These fabrics should not be line dried because the wrinkles are not removed as they are in tumble drying.

Dryers in coin-operated laundries often operate at much higher temperatures than do home units. Synthetics that dry quickly and are thermoplastic sometimes melt when they come in contact with the sides of the hot dryer drum when these machines are used.

TABLE 26.2 Stain Removal Chart

Stain	Treatment	
Adhesive tape, chewing gum, rubber cement	Apply ice or cold water to harden surface; scrape with a dull knife. Saturate with cleaning fluid. Rinse; then launder.	
Beverages (coffee, tea, soft drinks, alcoholic beverages)	Sponge or soak stain in cool water; pretreat with stain remover, liquid laundry detergent, or paste of granular laundry product and water. Launder using chlorine bleach or oxygen bleach.	
Blood	If stain is fresh, soak in cold water. For dried stains, soak in warm water with a product containing enzymes. Launder. If stain remains, rewash using a bleach safe for fabric.	
Brown or yellow discoloration from iron, rust, manganese	Use a rust remover recommended for fabrics; launder. Do not use a chlorine bleach. For a rusty water problem, use a nonprecipitating water softener in both wash and rinse water. For severe problems, install an iron filter in the system.	
Candle wax	Scrape off surface wax with a dull knife. Place stain between clean paper towels and press with a warm iron. Sponge remaining stain with cleaning fluid; blot with paper towels. Let dry. Launder. If any color remains, rewash using chlorine or oxygen bleach.	
Chocolate	Prewash with a product containing enzymes in warm water or treat with a prewash stain remover. Launder. If stain remains, rewash using a bleach safe for fabric.	
Collar, cuff soil	Pretreat with stain remover, liquid laundry detergent, or paste of granular detergent and water. Launder.	
Cosmetics	Pretreat with prewash stain remover, liquid laundry detergent, paste of granular detergent, or laundry additive and water or rub with bar soap. Launder.	
Crayon	For a few spots, treat same as candle wax. For a whole load of clothes, wash with hot water using a laundry soap and one cup baking soda. If color remains, launder using chlorine bleach if safe for fabric.	
Dairy products (milk, cream, ice cream, yogurt, sour cream, baby formula, egg, cream soups)	Soak in a product containing enzymes for at least thirty minutes (several hours for aged stains). Launder,	
Deodorants, antiperspirants	Pretreat with stain remover or liquid laundry detergent. Launder and allow to stand five to ten minutes. Launder using an oxygen bleach.	
Dye transfer	Use a packaged color remover, following label directions. Launder. If dye remains launder again using chlorine or oxygen bleach. Launder. This type of stain can be prevented if proper sorting and laundering procedures are followed.	
Fabric softener	Dampen the stain and rub with bar soap. Rinse; then launder.	
Fruit juices	Wash with bleach safe for fabric.	
Grass	Soak in a product containing enzymes. If stain persists, launder using chlorine or oxygen bleach.	
Grease, oil (car grease, butter, animal fats, salad dressings, cooking oils, motor oils)	Pretreat with stain remover, liquid laundry detergent, or liquid detergent booster For heavy stains, place stain facedown on clean paper towels and apply cleaning fluid to back of stain. Let dry; rinse. Launder using hottest water safe for fabric.	
Ink	Some inks may be impossible to remove, and laundering may set some types of ink. Try a pretreatment with stain remover, denatured alcohol, or cleaning fluid. For alcohol or cleaning fluid, first sponge the area around the stain with (continued)	

Table 26.2 (continued)

Stain	Treatment	
	the stain remover before applying it directly on the stain. Place stain facedown on clean paper towels. Apply alcohol or cleaning fluid to back of stain. Another method is to place the stain over the mouth of a jar or glass and hold the fabric in a taut position. Drip the stain remover through the spot so the ink will drop into the container as it is being removed. After either treatment, rinse thoroughly. Launder.	
Mildew	Badly mildewed fabrics may be damaged beyond repair. Launder stained items using chlorine or oxygen bleach.	
Mud	When dry, brush off as much as possible. Pretreat with liquid laundry detergent or a paste of granular detergent and water. Launder. For heavy stains, pretreat or presoak with a laundry detergent or a product containing enzymes. Launder.	
Mustard	Pretreat with prewash stain remover. Launder using chlorine bleach if safe for fabric.	
Nail polish	May be impossible to remove. Try nail polish remover but do not use on acetate or triacetate fabrics. Place stain facedown on clean paper towels. Apply nail polish remover to back of stain. Rinse and launder.	
Paint	Water-based: Rinse fabric in warm water while stains are still wet; then launder. Once paint is dry, it cannot be removed.	
	Oil-based and varnish: Use the same solvent the label on the can advises for a thinner. If label is not available, use turpentine. Rinse. Pretreat with stain remover, bar soap, or laundry detergent. Rinse and launder.	
Perfume	Pretreat with stain remover or liquid laundry detergent. Launder.	
Perspiration	Use a stain remover or rub with bar soap. If perspiration has changed the colo of the fabric, apply ammonia to fresh stains or white vinegar to old stains and rinse. Launder using hottest water safe for fabric. Stubborn stains may respond to washing in a product containing enzymes or oxygen bleach in hottest water safe for fabric.	
Scorch	Treat as for mildew, Launder using chlorine bleach if safe for fabric. Or soak in oxygen bleach and hot water; then launder.	
Shoe polish	Liquid: Pretreat with a paste of granular detergent and water; launder.	
	Paste: Scrape residue from fabric with a dull knife. Pretreat with a prewash stain remover or cleaning fluid. Rinse. Rub detergent into dampened area. Launder using chlorine bleach or oxygen bleach.	
Tobacco	Dampen stain and rub with bar soap. Rinse. Soak in a product containing enzymes; then launder. If stain remains, launder again using chlorine bleach if safe for fabric.	
Typewriter correction fluid	Let stain dry thoroughly. Gently brush excess off with a clothes brush. Professionally dry-clean.	
Urine, vomit, mucus, feces, or stool	Soak in a product containing enzymes. Launder using chlorine bleach if safe for fabric, or use oxygen bleach.	

Source: Adapted from the Soap and Detergent Association.

As in washing, fabrics of similar colors should be dried together. It is possible for colors to run from one fabric to another if damp, noncolorfast fabrics are placed on top of other fabrics during drying.

Pressing

Although many synthetic and durable-press fabrics do not require pressing, other items will need touch-up pressing before use. Linens and cottons require the highest temperature settings; synthetics, the lowest. Even though irons have temperature settings for different fabric types, the iron temperature should be tested in an inconspicuous part of the item as thermostats of irons vary in accuracy.

Fabrics of absorbent fibers are best pressed when they are slightly damp or with steam because wrinkles are removed more easily. Dark-colored fabrics of all fibers, silks, acetates, and rayons should be ironed from the wrong side to prevent shine. When these fabrics require pressing on the right side, press over a press cloth, not directly on the fabric.

Wool fabrics should be pressed with steam or a dampened press cloth. Silk should be pressed with a dry press cloth. Fabrics with textured surfaces should be tested carefully to see if ironing will flatten the surface. Sometimes these fabrics can be pressed lightly on the wrong side over a folded terry cloth towel or other soft surface. Corduroy can be pressed in this way, although it is better to use a special pressing board called a needle board. Velvets, velveteens, and plushes also require the use of a needle board. These fabrics may respond better to steaming (holding a steam iron or a "wrinkle remover" steamer several inches away) then hanging to dry to allow the wrinkles to hang out. The same effect may be achieved by hanging items in a bathroom that is warm and moist from a hot shower.

Commercial Laundering

Commercial laundering procedures are used by local dry-cleaning establishments to clean washable items such as men's shirts, household linens, uniforms, and the like. Commercial laundering procedures are similar to those used in the home, except that the conditions under which laundry is done commercially are more controlled and wash loads are considerably larger than in the home laundry. These large wash loads are made up of items from a number of different customers, so identification numbers or tags must be affixed to each item for identification purposes.

The first step in the commercial laundering process is to sort the fabrics. Items are separated according to color, fiber content, and degree of soil. As many as twelve different classifications can be used.

Different laundries utilize different detergent formulations and procedures, but in general, bleachable items are subjected to several sudsings with soap or detergent and added alkali at temperatures of 125°F to 160°F; a chlorine bleaching at 160°F for three to five minutes; three or four rinses at different temperatures, each one lower than the last; an acid sour; and in the rinse, starch is added for those items for which customers have requested it.

The purpose of the acid sour is to neutralize the alkalinity of the water, to remove iron stains, to kill bacteria, and to destroy excess or unused bleach. Some typical sours are acetic acid, sodium bisulfite, sodium acid fluoride, and oxalic acid.

Light-colored fabrics are washed at lower temperatures than are white fabrics, generally, 100°F to 120°F, and no chlorine bleach is used. Dark-colored fabrics are laundered at still lower temperatures, 90°F to 100°F, as they are more likely to lose color or bleed at higher temperatures. They, too, are not bleached.

After the final rinse, fabrics are spun in an extractor to remove excess water. The extraction may be done by the same machine that washes the items, or it may be done by a separate piece of equipment. This step is comparable to the spin-dry cycle on home washers. After extraction the fabrics are dried in a dryer and, if the customer wishes, pressed. Different types of pressing equipment are used for various items. Flat pieces are ironed on a machine called a *flatwork* ironer. A smooth, heated iron plate provides the heat and pressure, while the fabrics travel across a rotating, padded roll. Special equipment is made for ironing shirts, small pieces, and oversized items such as curtains.

Institutional laundering operations, where large volumes of similar items are regularly washed, may use "tunnel washers." These large washers are composed of a long, metal tube through which the laundry items are moved from one stage to another. The water and laundry aids flow through the tube in the opposite direction, so the cleanest laundry is always subjected to the cleanest water. Many tunnel washers have the capability of dividing the tube into separate pockets for the stages of washing that use different additives at successive stages: detergent, bleach, softener, disinfectant, neutral rinse. Each compartment can be individually controlled.

Dry Cleaning

The term *dry cleaning* derives from the use of special cleaning solvents that dry quickly. Washing of cloth has been the chief method of cleaning washable fabrics since before the beginning of recorded history. Dry cleaning is a relatively recent development, supposedly discovered in 1825 by a Frenchman, Jean Bapiste Jolly, who observed that a tablecloth over which the contents of a paraffin lamp were spilled lost its staining in the area of the spill. He recognized that he might be able to clean clothing using this solvent and established the first dry-cleaning business. Benzene replaced paraffin as the solvent fairly early, but the technique was still a far cry from present-day dry-cleaning processes. Originally, the entire garment was taken apart, and each piece was cleaned separately by dipping it into pans of benzene. The pieces were brushed on a scouring board, dipped again, dried in a warm oven, and ultimately reassembled.

Benzene was replaced by other solvents considered to be less hazardous. Perchloroethylene (known as perc) became the industry standard, but recently concern over the environmental effects of chlorocarbons has prompted a search for alternatives. Candidate solvents being explored are petroleum spirits, which were used by dry cleaners before perc, and liquid carbon dioxide. Most dry-cleaning processes use a "charged" solvent that has a small amount of water and detergent to remove water-soluble soils.

For both economic and environmental reasons, used dry-cleaning solvents are not discarded; instead, they are recycled and reused. Solvents are purified, and accumulated soil is removed by either filtration or distillation. The continual use of dirty solvent will interfere with cleaning.

After cleaning, the garments are checked for spots or stains that have not been removed in the dry cleaning. Spotters are trained to handle different fabrics and stains as effectively as possible.

If dry cleaning and spotting have not been adequate to remove all soil, the garments may have to be wet cleaned. Wet cleaning is not laundering, but rather involves treating fabrics with small amounts of water and mild detergent, with gentle agitation to remove soil. It is a service offered by some professional dry cleaners.

Final touches are given to the clean garment in the finishing department. Buttons or trimmings that have been removed are replaced; garments are steamed or, if necessary, pressed; and minor repairs are made.

STORAGE OF TEXTILE PRODUCTS

Between uses, textile items may be put away for either short or long periods of time. Some attention to the way in which clothing is stored may help to prolong the life of textile products.

Textile products will wear longer if given a chance to "rest" between uses. Rotating items in use, either clothing or household textiles, will provide this rest period. Storage practices may encourage this rotation. For example, towels or bed linens that have been laundered may be placed at the bottom of the stack of items, and the next item to be used taken from the top of the stack.

When table linens, bed linens, or other items are pressed, care should be taken to fold these items at different places. Continuous folding of fabrics, especially where sharp creases are pressed into the material, in the same place will cause the yarns to break or wear first in those spots. This is particularly the case for items made of linen and cotton that have low recovery from creasing and low resistance to edge abrasion.

Fabrics that are to be put away for long-term storage should always be put away clean. Moths or other insects and fungi will more readily attack soiled fabrics. Furthermore, some spots or stains that are only slightly evident may be oxidized or cause fiber degradation. Oxidized stains darken and are exceedingly difficult to remove. Fabrics should not be put away with pins left in them as the pins may rust and cause stains to appear around the pinned area.

Fabrics that are subject to attack by insects and mildew should be stored carefully. The resistance of specific fibers to microorganisms was discussed in the chapters dealing with each fiber. Wool and animal hair fabrics can be mothproofed before storage or stored in tightly closed containers with moth repellents. (See Figure 26.4.)

Fabrics that are susceptible to mildew should be stored clean and dry, in a dry place. The fairly widespread use of central or room air conditioning has decreased humidity in many buildings. Closed closets can hold humidity, so leaving doors slightly ajar or using ventilated doors will help to prevent humidity buildup in closed areas.

If fabrics that are normally starched are to be stored for a long period of time, it is best to store them without starching as silverfish find the starch especially appetizing. If starch is required later, garments can be spray starched before use. If starched garments are stored, they should be put away in a closed container that insects cannot penetrate.

Figure 26.4

Areas that show up as light spots on this photograph are holes created by moth larvae.

PERMANENT-CARE LABELING

In 1972 the FTC published a Permanent-Care Labeling Ruling, which specifies that wearing apparel and fabrics sold by the yard must carry a permanently affixed label giving instructions for the care of the item. Those developing textile products should be familiar with the regulations and include preparation of appropriate labels in their product plans. The provisions of the ruling are detailed in the following section.

Labeling Requirements

All textile wearing apparel and piece goods sold for making apparel are subject to the legislation except shoes, gloves, hats, and items not "used to cover and protect the body," such as belts, neckties, handkerchiefs, and suspenders. Nonwoven, one-time use garments are also excluded, as are manufacturers' fabric remnants up to ten yards in length when the fiber content is not known and cannot easily be determined, and trim up to five inches wide. These provisions apply whether the items were manufactured in the United States or abroad.

Manufacturers are required to provide full care instructions about regular care or to provide warnings if a garment cannot be cleaned without harm. Care labels are attached to finished garments before they are sold. These labels must remain legible throughout the useful life of the garment. Piece goods information is to be provided on the end of each roll or bolt. Consumers, therefore, need to make note of care procedures themselves when purchasing piece goods as copies of instructions are not provided.

Labels must be placed so they can be seen or easily found by consumers at the point of sale. If packaging obscures the label, additional information should appear on the outside of the package or on a hang tag fastened to the product.

Some types of products, however, need not include any care instructions. These are products sold to institutional buyers for commercial use, such as employee uniforms that are purchased by and cared for by a hospital, garments custom made from fabric provided by the customer, and completely washable items sold at retail for \$3.00 or less.

Some other products need not have permanently affixed labels but have to be provided with temporary labels. Totally reversible clothing without pockets and those products granted exemptions because a label would harm their appearance or usefulness are cited in the rule, although special permission for items in the latter category must be obtained through petition. Products that may be washed, bleached, dried, ironed, or dry-cleaned by the harshest procedures available are also exempt, provided that the instruction "Wash or Dry Clean, Any Normal Method" appears on a temporary label that is conspicuous at the point of sale.

The directions to manufacturers as to the contents of the care label make the following stipulations. The label must have either a washing or dry-cleaning instruction. If a product can be both washed and dry-cleaned, it need carry only one of these instructions. If it can be neither washed nor dry-cleaned, the label must read "Do Not Wash—Do Not Dry Clean." The rule included a glossary of terms to be used when applicable.

If a garment is labeled as washable, the label must instruct whether the product should be washed by hand or machine, and if regular use of hot water will harm the product, a water temperature must be stated. For example, a label that reads "Machine Wash, Cold" means that the consumer can machine wash the garment but only in cold water. A label that reads "Machine Wash" means that any temperature ranging from cold to hot could be used. The default is always the most extreme condition when no specific directions are given. The word *wash* cannot be used alone, but must stipulate whether the item should be machine or hand washed.

If all commercially available bleaches can be used on a regular basis, the label need not mention bleach. If chlorine bleach would harm the garment, but nonchlorine bleach would not, the label should read "Only Nonchlorine Bleach When Needed." If all commercially available bleaches would harm the product, the label should read "No Bleach" or "Do Not Bleach."

The appropriate drying method must be stipulated, and if regular use of high temperature would be harmful, the appropriate temperature setting must be given. "Machine Wash, Tumble Dry" would indicate that there are no restrictions of washing or drying temperatures.

Ironing information is to be given if ironing will be needed on a regular basis. As in washing and drying instructions, ironing temperature should be stipulated unless a hot iron can be used without harm.

The rule also requires that consumers be warned against processes that they might be expected to use that would harm the product. For example, if ironing would be harmful to a garment that consumers might touch up occasionally, the label should read "Do Not Iron." If an item is not colorfast, it must be labeled

"Wash Separately" or "Wash with Like Colors." It is not necessary to warn users about alternate procedures that may be harmful to the item. For example, if instructions read "Dry Flat," it is not required that labels also read "Do Not Tumble Dry."

For items labeled as dry cleanable, other provisions apply. If all commercially available types of solvents can be used, the label need not mention any type of solvent. If one or more solvents would harm the product, a solvent that is safe to use must be mentioned. If any part of the dry-cleaning process will harm the garment, the label must warn "Do Not..." or "No..." or provide other wording that would clarify appropriate procedures. For example, "Professionally Dry Clean, No Steam" would indicate that no steam should be used in pressing or finishing the garment. If the words "Dry Clean" are used without the word "Professionally" in front of it, the item should be dry cleanable by any machine process with no restrictions on solvents, moisture content, heat, and steam. "Professionally Dry Clean" is used when the normal dry-cleaning process must be modified in some way. This term is not used alone, but must be followed by a description of the modifications that are needed. For example "Professionally Dry Clean, Short

FIGURE 26.5

(a) Fabric care language; (b) symbols to be used on care labels. Courtesy of the Soap and Detergent Association.

(b)

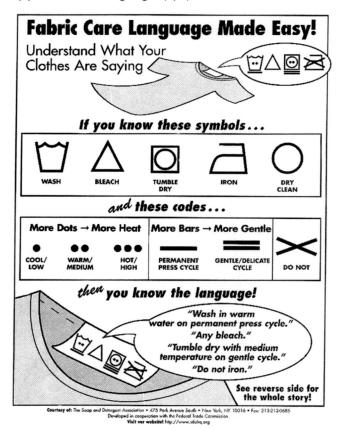

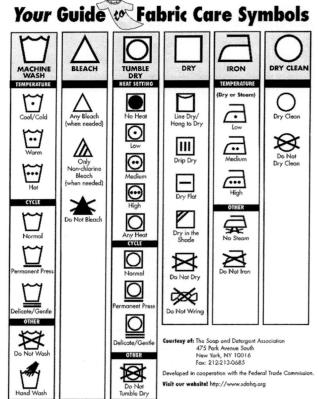

(a)

Cycle, No Steam" would mean that any commercially available solvent could be used, the cleaning time should be reduced, and steam should not be used during pressing or finishing (FTC 1984).

International Care Symbols

As production and sourcing of textile products has moved around the world, the need for globally consistent care labels has become necessary. The International Organization for Standardization, working with national organizations in various countries, developed a set of textile care symbols that are accepted worldwide.

There are five basic symbols: a washtub, a triangle to represent bleaching, a square for drying methods, an iron, and a circle for dry-cleaning recommendations. Temperatures and other conditions are printed below the symbols or can be indicated by dots and/or lines. As shown in Figure 26.5a, more dots indicate a higher temperature is acceptable for a particular refurbishing step. Lines are used to specify how gently the items should be handled. An X through a symbol designates a prohibition against that method. (See Figure 26.5b.) Examples of some labels are shown in Figure 26.6.

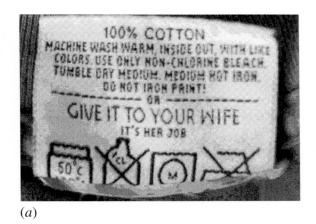

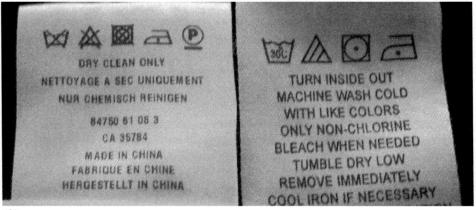

Examples of care labels:
(a) label with incorrect symbol for bleach and inappropriate comment;
(b) labels with symbols used correctly.

TAKE A CLOSER LOOK

Preserving Historic Textiles

Many people wish to preserve textile items such as wedding dresses, vintage clothing, or antique quilts and samplers. In addition, historic costumes and/or textiles may be collected by museums, historical societies, and individuals. Once acquired, these materials are generally stored and may be displayed periodically. The general storage principles outlined on page 491 apply to historic materials, but given their age and fragility, additional cautions should be observed in handling and storing them.

Historic fabrics are generally made from the natural fibers cotton, linen, silk, or wool; or from earliergeneration rayons. The most important considerations in preserving these materials are that they be stored clean, away from light, and in acid-free containers.

When handling historic textiles, be sure you are working in a clean area, that your hands are clean, and that you are not wearing jewelry that will catch on delicate fabrics. Support fragile items so no one place in the fabric must sustain the full weight of the fabric. It is generally a good idea to wear cotton gloves when working with historic textiles because the oil from your fingers can be transferred to the fabric.

As with other materials, it is best if historic fabrics are clean when stored; however, ordinary laundering and dry-cleaning processes may be too harsh for these materials. Some items made from cotton or linen can be laundered by hand if special precautions are taken. Spills or stains that have remained on the fabric for some time may be of such a nature to degrade the fibers (for example, acidic substances on cellulosic fibers), and holes that were not apparent before can emerge when the item is washed, however gently. (See Figure 26.7.)

Wool and silk garments cannot be laundered. Nor should they be dry-cleaned except by an expert in historic conservation who has been trained to handle these materials. To remove loose dust and soil, silk and wool garments can be vacuumed using a small hand vacuum cleaner. Such items should be placed on a flat table for support. Synthetic netting should be placed between the item to be cleaned and the vacuum cleaner. Trimmings should be handled carefully to avoid damaging them.

Ordinary paper contains acid residues that may cause deterioration of fabrics. Special acid-free boxes and tissue paper are manufactured. The names of several firms that sell these supplies are listed below. Items

FIGURE 26.7

1950s dressing robe of rayon and acetate, showing holes from spills on garment.

should not be stored in plastic bags because these bags will deteriorate and release substances that may harm the fabrics, a phenomenon referred to as off-gassing. Ideally, temperature and humidity should be maintained at 70°F, 60 percent relative humidity.

Do not allow newsprint, gummed tape, wood, or iron to remain in contact with objects during storage or display. If textile materials are to be displayed, use only acid-free backing materials, use no glue or adhesives, minimize exposure to light, rotate pieces, and display behind glass that filters out ultraviolet light.

The following are some common problems encountered in long-term preservation of both old and new textiles and the recommended means of preventing or solving those problems.

(continued)

TAKE A CLOSER LOOK

(continued)

Problem	Solution
Loss of strength	Store away from the light, preferably in acid-free materials or wrapped in clean, undyed cotton fabrics. Weighted silks dating from the late nineteenth century up to the 1920s are likely to break apart. Nothing can be done to prevent this nor can damaged fabrics be repaired.
Color changes	White silk and wool will usually yellow over time; this cannot be prevented. Acetate may be subject to fume fading. Store so items are not exposed to atmospheric gases.
Development of stains	Put items away clean so spills that may not show at the time of last usage do not oxidize and appear later. To avoid rust spots, be sure no pins are left in items, and wrap metal zippers, hooks, snaps, and buttons so they will not touch the fabric.
Damage from moths or carpet beetles	Put away clean. Store in closed container with moth repellent, or if odor from moth repellent is a problem, store for a week in an airtight containe with moth insecticide, remove, put away, and monitor material for signs of insect activity.
Damage from mildew	Store only in dry, well-ventilated area. Do not wrap in plastic.
Development of cracks or breaks at folds	If possible, roll large items around a cardboard tube or dowel covered with acid-free paper. Multicomponent or pile fabrics should not be rolled, however, because the inner layer will wrinkle.
	Cover items with clean, undyed cotton fabric. If items must be folded, pad folds with acid-free tissue, and change the position of the folds periodically.
Yellowing of starched cottons and linens	Put items away unstarched. Starch also makes cotton and linen materials appetizing to silverfish.
Mysterious holes in vintage garments of the 1940s and 1950s	Nitrocellulose plastics used in buttons can decompose and, if garments are stored where there is no air circulation, release of nitric acid fumes that damage or discolor the fabric. If items are believed to have buttons of this type, remove before the item is stored.

Sources of Storage Supplies for Historic Textiles

Conservation Materials Ltd., 1395 Greg Street, Suite #110, Sparks, NV 89431 Conservation Resources International, 8000-H Forbes Place, Springfield, VA 22151 Talas, 20 West 20th Street, 5th Floor, New York, NY 10011

SUMMARY POINTS

- Care of textile products includes cleaning for soil and stain removal followed by appropriate finishing and storage
- · Laundering is the most common method of soil and stain removal
 - Includes use of a soap or detergent and some mechanical action
 - Other laundering aids are bleaches, stain removers, brighteners, disinfectants, softeners, and starches

498

- · Washing machines provide mechanical action by agitation or by tumbling
- Laundered items can be tumble dried in a machine or hung or laid flat to air dry
- · Some items may need to be ironed after drying
- Textiles that may shrink or fade in laundering can be professionally dry-cleaned
 - Organic solvents are used to remove soil and stains
 - There are environmental concerns with some solvents
- Storage
 - · Textiles should be stored clean in dry and, preferably, dark environments
 - · Items of historic value require special handling and storage
- Most textile items sold in the United States require permanent-care labels
 - Labels must specify:
 - Laundering or dry cleaning
 - Acceptable laundering temperature and laundering aids
 - Drying method and temperature
 - Ironing instructions
 - International symbols have been developed as an alternative to written instructions

Questions

1. What is the purpose of each of the following substances during laundering of soiled textiles, and how does each substance work?

detergents

bleaches

fluorescent whiteners

builders

water softeners

enzymes

fabric softeners

- 2. How do the new high-efficiency washing machines differ from the more common agitator types? Which would you recommend?
- 3. Why is it desirable to have a cool rinse as the final cycle in laundering durable-press garments?
- 4. Make a list of dos and don'ts that you would give to consumers if you were assigned to advise them about laundering procedures.
- 5. Make a list of dos and don'ts that you would give to consumers if you were assigned to advise them about having clothing dry-cleaned.
- 6. Develop five generalizations about stain-removal procedures that you can derive from Table 26.2.
- 7. How would you clean and store a silk wedding gown from the 1940s?
- Develop care labels with symbols that meet permanent-care labeling requirements for each of the following examples of textile products. Explain why you chose these care procedures.
 - a. Plain weave 100 percent cotton shirt dyed dark navy blue with no functional finishes
 - b. White 100 percent silk chiffon blouse with white silk embroidered decoration
 - c. Jersey knit sweater of 100 percent acrylic fiber

References

FTC. "Writing a Care Label." Pamphlet. Washington, D.C.: Bureau of Consumer Protection, Federal Trade Commission, 1984.

Recommended Readings

- Bevan, G. "Mechanism of Soiling of Textiles." Textiles 8 (October 1979): 69.
- Lusk, C. B. "The Invisible Danger of Visible Light." *Museum News* April (1975): 22.
- McCall, R. E., F. M. A. Patel, G. Mock, and P. L. Grady. "Solvent and Ultrasonic Alternatives to Perchloroethylene Drycleaning of Textiles." *Textile Chemist and Colorist* 30, no. 11 (1998): 11.
- Pullen, J. A. "Decoding the ASTM Care Symbol System." *Textile Chemist and Colorist* 29, no. 12 (1997): 28.

Further Sources of Information

Information to the consumer about the care of textile products is widely available, if sometimes conflicting. Detergent and washing machine manufacturers and consumer magazines frequently publish materials on appropriate care techniques for textiles of all kinds, as do federal, state, and local government agencies (Department of Agriculture or Cooperative Extension Offices, for example). The International Fabricare Institute does research and supplies current information to dry-cleaning establishments and publishes newsletters and fact sheets about dry-cleaning practices and problems.

Althorates and the second sub-section

ne reconsiplicati i e e con mor e e edigida fi

TEXTILES AND THE ENVIRONMENT, HEALTH, AND SAFETY

Learning Objectives

- Identify the steps in textile production that affect worker safety, consumer safety, and the environment.
- 2. Discuss the options for disposal of textile products.
- 3. Describe ecolabeling of textile products.
- 4. Compare cost and environmental benefits in design and production of textiles.

he fundamental purpose of clothing is to *protect:* from cold, from rain, from sun (and from embarrassment!). This protective function has existed since prehistoric humans donned animal skins. As society has changed and developed, the scope for protection has increased, and the role of textiles in providing specialized protection has increased with it. As described in earlier chapters, advanced textile materials are developed for protective applications in medicine, agriculture, industry, the military, and so on. In that way, textiles play a part in increasing safety.

At the same time, the agricultural and industrial processes that produce the billions of pounds of textile items used each year have potentially negative safety implications. The farming of fibers or their raw materials, or the chemical processes that produce synthetic fibers, and the spinning, weaving, knitting, dyeing, and finishing steps that turn them into fabrics will affect the workers engaged in those activities and impact the local and global environments. The textile materials reach the consumer, who can be affected by the materials or the dyes and chemicals present on them. Caring for textiles consumes water, energy, and chemicals that have

environmental costs. Ultimately, the textiles are discarded, representing a further impact on the environment as they are recycled, decompose, or sit in landfills.

As society and its governments catch up with these issues, voluntary codes of conduct and government legislation affect how textiles are produced, sold, used, and disposed of. This chapter examines these environmental, health, and (potentially negative) safety impacts of textiles.

SAFETY AND ENVIRONMENTAL IMPACT

Textile Production

In production of textile items, materials and processes selected have environmental and safety implications that should be considered at the design stages and evaluated as product development proceeds. Fiber choice, fabric construction, and dyeing and finishing methods can all have an impact on the environment and the safety of workers and consumers alike.

Fiber Choice

The early twenty-first century sees a fiber world that is dominated equally by cotton and polyester, based largely on the low cost of those two fibers. Many concerned consumers believe that a return to the use of larger quantities of natural fibers will have a positive effect on the environment. The issue, however, is more complex than it appears. There are not enough natural fibers to supply the demands of consumers from all over the world. Furthermore, natural fibers also require energy for their production and processing, so these fibers are not "energy free." Many fertilizers are made from petrochemicals, and tractors and other farm machinery are run on petroleum fuels. Cellulosic fibers, especially cotton, tend to use large amounts of pesticides, herbicides, and defoliants, with impacts on the environment and potential safety implications for agricultural workers applying them. Intensive agriculture may lead to soil depletion. Sheep require pesticide dips and may overgraze land.

Organically grown or colored cotton may seem an obvious choice in designing an environmentally improved cotton fabric. Organic cottons are, however, more expensive because crops are more susceptible to insect damage than are those treated with pesticides. The yield per acre is lower, and harvesting is less standard. Naturally colored cotton offers an appealing alternative to expensive dyeing processes with synthetic dyes. Most colored cottons are, however, weaker and more difficult to spin into yarns.

Manufactured fibers are often cheaper than natural fibers, but synthetic materials involve chemical processing with its accompanying waste streams and the need to keep workers safe. The environmental effect of rayon production has meant that this fiber cannot economically be produced in the United States. Fibers that are wet or dry spun involve the use of solvents that must be recycled. The antimony catalyst used in the polymerization of polyester raises questions. While synthetic fibers are not as easily biodegraded, they may be more easily recycled in processes that recover the chemical starting material. Manufactured fibers are produced in filaments that can be easily formed into yarns, eliminating the costly steps in spinning staple yarns.

Fiber manufacturers have responded to the environmental challenges with new fibers. Lyocell was developed as a fiber cleaner to produce than rayon. PLA fibers use an annually renewable resource (corn) as a starting material. Some PTT is made from biologically derived propylene glycol, one of its monomers.

As far as textile worker safety is concerned, prudent practice will minimize exposure to obvious sources of danger: chemicals and solvents used in manufactured fiber production and pesticides used in cotton farming and wool production.

Yarn and Fabric Processing

Yarn spinning, weaving, and knitting involve machinery but comparatively few chemicals, and their environmental impact is low. The impact on textile workers derives mainly from dust. The deleterious effect of inhaling minute, invisible particles of grit or hard, inorganic matter has been recognized for many years. This type of exposure has long been acknowledged as a hazard in the production of asbestos. More recently, questions have been raised about whether the inhalation of fibers of glass may cause lung disease, and research into this question is continuing. It has been known for many years that cotton industry workers may develop byssinosis, or "brown lung," after a period of exposure to cotton dust. Research suggests that the cause is probably toxins from bacteria or fungi that are present in the leaf dust that is part of the raw cotton. OSHA has established maximum allowable levels of cotton dust that may be present in the air of factories where cotton is being processed. In the United States, worker exposure to cotton dust has been brought under control by improved equipment and manufacturing operations such as closed systems for processing raw cotton, improved air ventilation, and personal safety devices rather like gas masks.

Production of nonwoven fabrics bypasses the yarn spinning stage and some of the expense and hazards noted above. Dry-laying methods for web formation may pose problems for workers, but use of personal protective equipment (PPE) and also the predominance of manufactured fibers have relieved the situation somewhat. Spunbonded and melt-blown fabrics, with their high fabric processing speeds, offer advantages in safety and energy use. Further, they are used extensively in face masks and filters to protect against pollutants and toxic agents.

Dyeing and Finishing

Processing. The greatest environmental problems in textile processing occur at the dyeing and finishing stages because these steps require chemicals and large quantities of water. Paradoxically, much of the broader environmental impact of wet processing derives from the sizes (perhaps including chemical preservatives) and knitting oils that are applied at earlier steps but are removed in fabric preparation and enter the waste stream from the dyehouse. The component materials selected for a textile product and specifications for the final product determine the dyeing and finishing processes downstream. There may also be trade-offs in performance level and pollution reduction. In striving for good environmental management, processors continue to modify their operations to effect point source reduction of pollutants. In fabric preparation the use of enzymes to lower the use of highly alkaline baths and reduce energy consumption is attracting attention.

No dyeing process is 100 percent efficient, and dyes that are not exhausted onto fibers can be discharged into waterways. Much research has been expended into ways to decolorize effluent, but these often involve additional chemicals. Most dyeing processes use auxiliaries: salt, acids and bases to adjust pH, surfactant materials to assist in level dyeing, and oxidizing and reducing agents, and these are usually discharged into the waste stream at the end of dyeing. In finishing, the organic compounds used in formulating such finishes as durable press or coating of fabrics are evaporated in the curing step, and these must be controlled to reduce air pollution.

Making environmental improvements is complex if a change is not to affect quality or some other part of the overall process. Is it better to use a dye that contains heavy metal and produces a color that lasts a long time or to use a non-metallized dye and produce an item that fades more rapidly and needs to be replaced earlier? Dyers and finishers must obey local regulations to stay in business, but that may still mean inefficient use of water and energy. It is a challenge to go beyond simply meeting local environmental regulations (or "being as bad as the law allows").

An example that illustrates these challenges is dyeing of cellulosic fabrics with reactive dyes. Reactive dyes are a good choice for cellulosic fabrics because of their excellent colorfastness and wide range of colors. Achieving good exhaustion of reactive dyes, however, requires large amounts of a salt, usually sodium sulfate, which ends up in the plant waste stream (Schlaeppi 1998). Hydrolyzed dye (which at the end of the dyeing process has reacted with water rather than with the textile) must be washed off at the end of the dye cycle, using large amounts of water and energy. The complexity of the environmental challenge is illustrated by the different ways that have been proposed and implemented to overcome these disadvantages. Among newer reactive dyes for cellulose are those that dye fabric well with significantly less salt added to the dyebath. A decolorizing process for the spent dyebath will allow the salt to be recycled. Dyes with two or more reactive groups react more efficiently, leaving less dye to be washed off. Using a pad-batch application requires less salt and results in a higher proportion of dye reacting with the fiber, again needing less washing-off. (See chapter 22.)

The possibilities become even more complex when a blend of cotton and polyester is involved, each with its own dyeing requirements, and there are many possible "improvements" that can be made to reduce pollution!

As with much of the chemical industry, computer process control of operations not only saves labor costs, but also ensures precise measurement of ingredients to prevent waste of costly chemicals. Recovery and reuse of chemicals is a good approach, and the reuse of dyebaths (with their dye and chemicals) has been explored at commercial levels.

Energy use is another area of concern. Conservation efforts in the textile industry were spurred by disruption of oil supplies in the 1970s. Not only are petroleum and petroleum by-products the single most important raw material used in the manufacture of synthetic fibers, but fuel for energy is also a major cost in the production of fibers, yarns, fabrics, and finishing materials. Dyeing and finishing are aspects of the manufacture of textiles that are especially energy intensive.

Low-wet-pickup finishing processes, microwave and infrared drying, and use of dyes that are effective at lower temperatures are all energy-saving innovations that have been adopted. The development of combined desizing, scouring, and bleaching processes for cotton-containing fabrics has also contributed to more efficient processing of textiles.

Worker Safety. Some of the chemical substances workers in dyeing and finishing come into contact with are highly toxic. For the most part, companies have been able to identify these substances and to protect workers from contact with them.

From time to time, research findings attribute harm to materials that were not previously identified as presenting any serious health problems. Vinyl chloride is such a chemical. An important ingredient in the production of polyvinyl chloride (PVC) plastics, vinyl chloride is used in the production of plastic backings and coatings for fabrics. Evidence indicates that continued exposure to vinyl chloride monomers will produce cancer of the liver in some of the persons exposed. PVC plants are carefully monitored to detect escape of the monomer during polymerization processes.

Some dyes have been proven to be harmful to workers. When evidence is found linking dyes to health hazards, their use may be discontinued. For example, some dyes with excellent colorfastness characteristics have been removed from use because of health hazards. This is discussed further below.

Formaldehyde is another chemical widely used in the textile industry. Research has indicated that high levels of formaldehyde are associated with nasal cancer in rats. Whether it is a carcinogen in humans has not been proven. Long-term studies of workers exposed to formaldehyde have been inconclusive. The American Cancer Institute is conducting additional studies that may yield more reliable data.

Present allowable levels of formaldehyde in the workplace are one part per million (ppm). Further reductions may be mandated. Although a final resolution has yet to be made about the formaldehyde issue, formaldehyde levels in textile mills and apparel factories have been reduced considerably. Several finishing techniques that reduce the quantity of formaldehyde used or the amounts released into the atmosphere have been developed. (See chapter 25.)

Textile Use

Personal Safety

The headline *Are your clothes killing you?* appeared in a German newspaper a few years ago. Chemicals are present on textiles that may represent a level of danger to human health. While some of these are regulated, most are not, and conscious consumers (especially in Europe) have done much to eliminate what is obviously harmful. Residual chemicals from textile processing may remain. Formaldehyde may be present from a wrinkle-free finish. Since synthetic dyes were developed, a number of them have been recognized as harmful. Those effects have been seen most clearly in workers where the dyes were manufactured. Exposure in dyehouses where the dyes were applied was lower, and so were the effects. Considering the small amounts present on textiles and their fastness, which prevent all

but a small amount from being removed, consumer exposure to dyes and resulting health impacts are minimal. Very few dyes recognized as harmful are still manufactured. The dangers of other dyes are less well proven, but European standards ban the use of any that may lead to possibly carcinogenic breakdown products. This move originated in Germany, and because most of the twenty or so dyes involved are (chemically) azo dyes, the "German azo dye ban" has been wrongly interpreted to mean that all such azo dyes are harmful or have been banned. More than 70 percent of all synthetic dyes and pigments are azo colorants, and such a blanket ban is inconceivable.

Other potentially harmful chemicals may be present on a textile. Residual finishes and solvents, "preservatives" may linger, especially if the textile is stored in plastic bags.

Environmental Impact

Few consumers think deeply about the impact of their clothing choices. However, beyond the environmental considerations implicit in how those textiles were produced, the impact of their care and disposal is as great if not greater.

Laundering. Energy demands and potential pollution problems are inherent in laundering and dry cleaning. Generally, washable fabrics are preferable because of the cost of dry cleaning and the hazards of the solvents used. Washing, drying, and ironing, however, all require the expenditure of energy. One study reported that fiber production accounted for less than 15 percent of the total energy required for production and manufacture of a garment, whereas care of the garment after purchase accounted for 55 to 80 percent (Van Winkle 1978). The selection of fabrics (from low-moisture-regain fibers) that require shorter drying time or can be line dried, as well as those that can be washed in cooler water or do not require ironing, result in lower energy use. Home laundry equipment manufacturers continue to respond to federal mandates to design more energy-efficient products, such as the high-efficiency washing machines described in chapter 26.

Concern over the use of phosphates in laundry detergents to enhance detergent performance led to their replacement by other compounds. Although phosphates posed no problem to human health, they promoted growth of algae and depletion of oxygen (eutrophication), thereby changing the ecosystems in rivers, lakes, and bays.

Detergent manufacturers have produced detergents that are more biodegradable, that is, substances that decompose more rapidly during sewage treatment. Like manufacturers of other products, they are packaging detergents and other laundry aids in recycled cardboard boxes and refillable bottles.

Dry Cleaning. Dry cleaning can also be a source of pollution. There are health and environmental concerns over the chlorinated hydrocarbons used in dry cleaning. Dry cleaners routinely recycle cleaning fluid so its disposal will not be a problem. Alternative solvents are being examined, including "supercritical" carbon dioxide, and gentle wet cleaning akin to the methods used in historic textile conservation. Cleaners deliver clean clothing to customers on hangers inside plastic bags. Some cleaners encourage customers to return hangers and collect the plastic bags for recycling. Others may provide regular customers with reusable cloth bags for delivery and return of laundry.

Disposal of Textile Products

However the item is cared for, it will ultimately reach the end of its useful life. Some items are staples designed for long life and may eventually "wear out." Others are "fashion items" that are not bought with durability in mind, and will probably go out of style before being worn out. At that point, issues of reuse, recycling, and disposal must be considered.

Reuse

Textile items that are discarded can be fed back into the product life cycle by reusing them without destroying the original form. Consumers frequently donate apparel and other textiles to nonprofit organizations or sell them to secondhand stores. Secondhand, or consignment, stores are popular as a source for fashion apparel and accessories that may still be serviceable but can be obtained at low cost. Clothing that remains unsold from these stores and even unsold "new" merchandise is bought by textile recycling businesses and sold to dealers in developing countries. The sale of these textile items for reuse is a thriving business in many of these countries, particularly sub-Saharan Africa, where used clothing is one of America's leading exports (Rivoli 2005).

Another reuse approach is conversion of discarded textile items into other useful products. Some apparel designers have shown that innovative clothing can be made from used jeans, neckties, socks, sports pennants, or woven fabrics with strips of used fabric as filling. (See Figure 27.1 and figure CP4D on Color Plate 4.)

Recycling

If discarded textile items are altered or destroyed then made into different products, they are said to be recycled. Many countries actively encourage recycling of

FIGURE 27.1

Evening dress made from neckties. Design called "Re-Tied" by Shu-Hwa Lin. Photo by Shu-Hwa Lin.

textiles through regulation, tax incentives, or by assigning recycled products preference for purchase by governmental agencies. "Waste exchanges," allow products that would otherwise end up in landfills to find a use. Recycling can occur in several ways.

Preconsumer Waste. Both small and larger textile scraps are produced during the spinning of yarns, fabrication of cloth, and manufacture of garments. Such items that have not yet been used by consumers are known as preconsumer waste. Textile firms may use their waste materials or purchase them from other manufacturers and reprocess them. It is important that the waste not be contaminated with chemicals and nontextile materials such as packaging. Textile waste from manufacturers of garments or other textile products is relatively easy to process because the manufacturer can identify the textile fiber.

Fibers that are long enough may survive *garneting* (a process that shreds fabrics back to the form of fibers) and can then be respun and woven. Despite the modern connotations of recycling, "shoddy mills" of the nineteenth and early twentieth centuries existed solely on the manufacture of fabrics from recycled wool (both pre- and postconsumer) and the Wool Products Labeling Act and its requirement that recycled wool be labeled as such shows clearly that this is a long-established practice. Today wool is still recycled into very high-quality fabrics.

Reprocessing shorter fiber fabrics generally produces lower-value items because the shredded fibers are too short for the production of good yarns. However, they can still be used for recycling into nonwoven materials, for example, for insulation, stuffing, pads, bags, disposables, and reinforcement for composites. (See Figure 27.2.) Cotton and linen fibers can be recycled into fine papers used in banknotes (Collier et al. 2007).

Postconsumer Waste. In the textile recycling industry, items discarded after use are referred to as postconsumer waste. While reclamation of preconsumer waste has been fairly widespread, reclamation of colored fibers and waste from previously

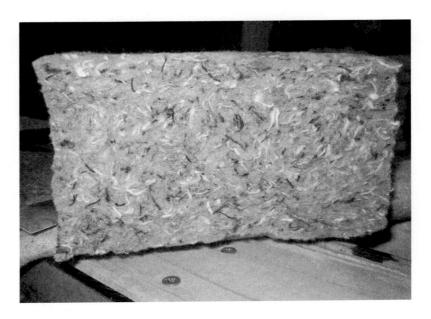

FIGURE 27.2
Shredded cotton waste made into insulating material.

woven or knitted goods made from a variety of different natural and manufactured fibers has been limited. During reclamation, fibers must be sorted into different generic categories, and the identification of unknown manufactured fibers or blends is difficult. Not only is fiber content unidentified, but the quality of fibers may also be uneven as a result of wear. The issue is even more complicated when fiber blends are considered, and finishes applied to fabrics may create additional problems for recycling.

Thus, the recycling of postconsumer waste directly as fiber is difficult and of limited applicability when preconsumer waste can fill the current demand more easily. However, a significant opportunity exists when the recycling process takes material back one step further and uses the recycled item not as a fiber, but as a chemical input/feedstock. As the raw materials from which many textiles are made become scarcer, it is likely that recycling textile products will become increasingly important. Figure 27.3 summarizes the flow of products in textile waste use. For synthetic fiber materials, this represents a loop that could be repeated indefinitely and is seen as a technical version of nature's own continuous recycling.

Such raw material recycling can then involve nontextile items, and the process can go both ways: nontextiles can be recycled into textiles and vice versa. The greatest success story so far has been the recycling of soda bottles into polyester fiber where the large volume of minimally contaminated material is an easy-to-use source of raw material. These bottles are blow-molded polyethylene terephthalate, the same polymer as the fibers. They are collected and initial processing involves separation of the polyester bottles from other foreign materials such as aluminum caps, paper labels, and the rigid base cups used in some bottles. Clear and green bottles are separated to give clean streams of each.

The clear bottles are processed into polyester fibers for use in sleeping bags, carpeting, pillows, quilted jackets, and other products. Polyester waste from film and fiber producers is often added to the waste stream for fiber production. Producers may also add virgin polyester polymer to the melt before extrusion. At least one producer is molding packaging materials from a melt of recycled and virgin PET.

The green bottles can be reprocessed into green polyester fiber that is made into needlepunched nonwoven geotextiles for erosion control and other engineering applications. The black base cups that are used in two-liter bottles for stabilization are composed of polyethylene and must be separated from the PET before reprocessing. Although the base cups can also be reprocessed into packaging materials, separating them from the bottles increases the cost of reprocessing. Increasingly, soft drink bottles are made without the base cup, with a ridged bottom providing the necessary stability for the filled bottles.

Work on refining recycling processing continues with an emphasis on increasing the quality of the recycled fibers. The recycled fibers of today are appearing in apparel and other higher-end products. Wellman, the pioneer in recycled polyester fibers, produces their fiber Fortrel Ecospun for many different end uses. (See Figure 27.4.) Trevira $\Pi^{\text{@}}$, made by Hoechst Celanese from a blend of 50 percent recycled polyester and 50 percent nonrecycled polymer, has been made into T-shirts, baseball caps, tote bags, and cold-weather performance fabrics.

Flow of textile fibers in process and the resulting generation of textile waste at each step of production and

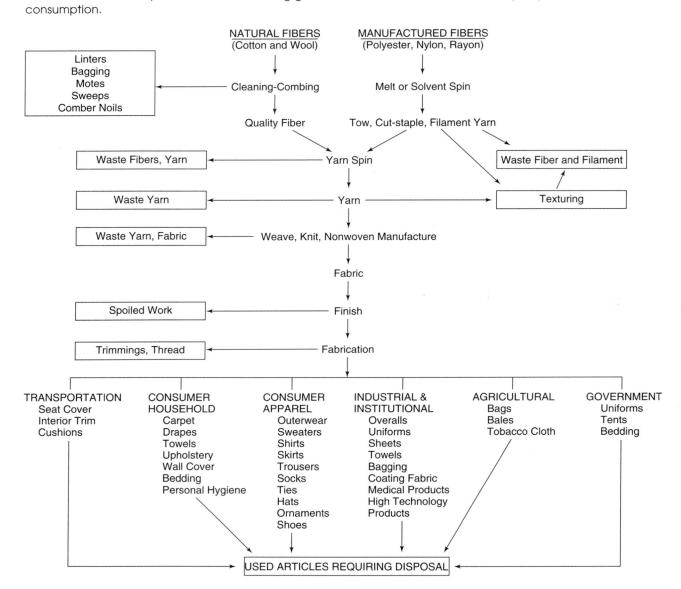

The recycling of carpets has received considerable industry attention over the past few years for several reasons. First, the large volume of carpet waste (about four billion pounds in the United States alone) represents a significant potential environmental impact as successful recycling measures are developed. Second, most carpets have a fairly standard (and known) composition: nylon, polyester, or polypropylene pile; polypropylene backing; and latex synthetic rubber adhesive. This makes identification of components easier and application of separation techniques more feasible.

Evening dress made from polyester fiber recycled from soft drink bottles. Designer Amsale Abera, model Ivanka Trump, photograph by Eric Weiss. Photograph

courtesy of Wellman.

Early recycling processes shredded the carpet fibers and ground them into a polymer mixture. Compatibilizers can bond to two different polymeric materials, facilitating mixing of the polymers. The mixture is melted and re-formed into automobile parts or plastic structures. Later technologies have aimed at taking the pile fibers, more than 50 percent of the carpet weight, back to the original monomeric materials. Several processes have been developed to recover caprolactam monomer from nylon 6 in a pure enough form to be used as the starting material for polymerization of new nylon. The fibers are chemically treated with ammonia at high pressure and temperature.

Disposal

If a textile item is not reused or recycled, it is discarded or disposed of in some way. Some textiles, especially nonwovens, (diapers, wipes, and medical gowns, for example) are designed to be disposable. The vast majority of textiles are not reused or recycled for reasons that are clear from the foregoing discussion. As the amount of fiber consumed annually has increased (with increases in both the world population and the amount of fiber consumed per person) the volume of discarded textiles has increased greatly. Thus, the manner of disposal of these products should also be a factor in design and product development.

The options available are landfilling, composting, and incineration.

Landfilling. Much of the textile waste produced by manufacturers and consumers has been buried in landfills to biodegrade. In landfills natural fibers are biodegradable and will eventually break down, but synthetics are more resistant and are not so easily disposed of. However, they are essentially inert, so they do not represent

a source of pollution but simply occupy space. Olefin fibers are degraded by sunlight but will not have great exposure to the sun when buried in a landfill. Fibers and films for some newer products are being constructed of easily biodegraded materials such as starch and polylactic acid (PLA). Disposal of nontextile solid wastes from textile firms and from chemical companies associated with the textile industry is another difficulty. Burial may lead to the contamination of groundwater, fires, or the generation of noxious gases from the indiscriminate mixing of chemical substances. The design of products and processes can go a long way toward minimizing the volume and toxicity of this waste.

Disposable diapers provide an interesting overview of many of the difficulties that arise from the use of disposable items. Sales of disposable diapers have grown rapidly since their introduction. It is estimated that up to five billion pounds of diapers a year are disposed of. Environmentalists claimed that these products are clogging landfills and that associated viruses and bacteria are leaching into groundwater. About two dozen states either enacted or proposed legislation to discourage or tax use of disposables. The industry responded that diapers make up less than 2 percent of total solid waste in municipal landfills and that there is no evidence of any cases of disease caused by diaper disposal. Industry spokespersons also note that care of cloth diapers, the alternative preferred by some environmentally minded consumers, consumes up to six times as much water as is used in the manufacture of disposables and that laundering cloth diapers creates nearly ten times as much water pollution as manufacturing disposables (Joseph 1990). Work continues on producing disposable diapers that are more easily biodegraded. Similar arguments are made about disposable versus reusable surgical gowns.

Composting. An alternative to burial is composting, which is above-land biodegradation. Materials in a compost have greater exposure to light and water, and the compost is stirred periodically to provide more air for microorganisms. This can be a deliberate strategy for natural fibers, with a philosophy that this is part of a natural biological cycle and that it is simply closing the loop; the composted materials indirectly provide nutrients that contribute to the growth of new fibers. More directly, waste wool has been turned into degradable mulch to suppress weed growth and provide nutrients as it decomposes.

Incineration. Incineration is occasionally used for disposing of garbage, but the threat of hazardous gas emissions has made it unacceptable to many communities. If the waste stream content is known and controlled to eliminate the production of pollutants, it can be useful, as the alternative name "energy recovery" would suggest. Some consider that energy is better produced by burning waste than by burning coal or oil that could be used as sources of new materials. Incineration was carried out, for example, as part of carpet recycling: backing and latex components that could not otherwise be recycled were compressed and burned as fuel.

LEGISLATION AND REGULATION

The generation of air, water, and soil pollution and health hazards for textile workers and consumers has led governmental bodies to enact laws and regulations that are intended to protect individuals and the environment. A number of those laws

have a significant impact on textile product manufacturing and use. As the textile industry has become global, different environmental standards in different countries has led to processes becoming unusable in one country but still widely practiced in another, leading to arguments about "exporting pollution." The United States and Europe have the most stringent environmental regulations. In the United States, the Occupational Safety and Health Act regulates the safety of the workplace, the Toxic Substances Control Act (TSCA) regulates the management of toxic substances within the workplace, and licensing requirements and pollution limits are imposed by the Environmental Protection Agency (EPA) under the Clean Water Act and the Clean Air Act.

The Clean Water Act regulates the discharge of pollutants into waterways and authorizes the EPA to set water quality standards. Discharge of materials into waterways is also controlled under the Safe Drinking Water Act. The Clean Air Act was passed to control air emissions through National Ambient Air Quality Standards. The 1990 amendments to this act addressed specific problems such as acid rain and ozone depletion. The Resource Conservation and Recovery Act regulates the production, transportation, storage, and disposal of hazardous wastes.

The Pollution Prevention Act of 1990 signaled a trend toward source prevention rather than regulation diminishing the downstream problems of remediation and disposal. It requires that businesses submit source reduction and recycling reports each year. The various federal laws relevant to the environment are listed in Table 27.1.

Many states have also enacted environmental legislation that affects textile industries. While these laws have improved the safety of textile production and have helped to protect the environment, they have also had an impact on industry productivity, profitability, and competitiveness with imported products from countries

Table 27.1
Environmental and Safety Legislation

Date	Purpose
1970	Ensure workplace safety
1972	Regulate discharge of pollutants into waterways
1970	Establish air quality standards
1976	Control hazardous waste from generation to disposal
1976	Control hazardous substances before they are produced and sold
1977	Control discharge of toxic pollutants into waterways ^a
1990	Reduce generation of pollution at source
	1970 1972 1970 1976 1976

^aAmendment to Federal Water Pollution Control Act

that do not have comparable environmental legislation. It should also be noted that although the textile industry contributes to environmental pollution, it is not on the list of major polluters targeted by the federal government.

Hazardous Chemicals. As of May 1986, OSHA employee health protection rules required that information about hazardous chemical substances be communicated to employees by the employer. In summary, the requirements are as follows:

- 1. Hazard information must be conveyed to employees through appropriate labels on the products that they use.
 - Material Safety Data Sheets provided to employees must identify hazard information.
 - Affected industries must have written hazards information communications programs.
- 4. Industries must establish and conduct employee chemical hazard training programs.

The specific means by which these requirements are met are not mandated, but both the producers of chemicals deemed hazardous and the industries using the chemicals must comply. The textile industry sectors that manufacture or process a wide variety of textile products are, therefore, affected.

Noise. Noise levels in textile manufacturing plants can be extremely high. Because of the relationship between high noise levels and hearing loss, OSHA standards regulate noise levels in the workplace. The standards limit noise based on the employees' length of exposure and also require periodic hearing tests for machine operators.

Textile manufacturers meet these standards in a number of ways. The problem is most acute in factories using older equipment, which operates at much higher sound levels than does newer equipment, which is engineered to satisfy noise-level regulations. Shuttleless looms have made a significant contribution to reducing sound levels. Those working in areas with high sound levels are required to wear ear protection.

ECOLABELING: GREEN TEXTILE PRODUCTS AND PROCESSES

In the same way that some consumers are "fashion forward" and seek the newest ideas in style, others are "environmentally forward" and actively seek out products that have low impacts on health and the environment. They look for products manufactured in ways that do not harm the environment or human health and products that will save natural resources during or after use. Because few regulations control environmental claims that can be made (as opposed, for example, to the regulations in the United States that control claims such as *lite*, *low salt*, and *low fat* for food products) it can be difficult to separate the real from the spurious green claims. Is a product genuinely green, or is it simply marketing hype?

The issue is further complicated by the length and reach of the textile supply chain and the long sequence of sources and processes that a textile item must go through. How does one compare a claim about how the cotton was grown with one that indicates that a product is biodegradable? The opportunities are endless: recycled polyester, organically grown cotton, formaldehyde-free finishes, corn-based PLA, dyed with natural dyes, no chlorine bleach used. These issues are covered in earlier chapters that deal with fibers and finishing. The issues extend to cover the conditions under which workers were employed to produce the textiles.

In a confusing sea of environmental claims, it is not surprising that standard ecolabeling schemes have emerged to apply voluntary standards to assure the consumer that products are environmentally sound. Once again, these have mostly emerged from Europe, but given the global textile industry, their impacts spread across national and regional borders.

Ecolabels are broadly divided into two groups. First are those that give assurances about the global environment and the effect of the production of the textile. These can also include the broader implications of textile care and ultimate disposal in a life cycle analysis. The second type of ecolabel deals with personal health and the immediate effects on the wearer of the textile and any chemicals present on it. Not surprisingly, ecolabels that cover both sets of concerns have been developed.

Individual companies may develop their own ecolabels, and nongovernmental institutions may develop criteria and certify products as meeting them. Probably the most famous of these is the Oeko-tex scheme developed originally by the Austrian Textile Research Institute and now controlled by an association of European Textile Institutes. Ecolabeling may also be nationally or regionally based. Scandinavian countries have the "Nordic Swan" label; India and Japan each have an "Eco-mark" scheme. The European Union has a flower symbol for its ecolabeling scheme. (See Figure 27.5.)

While the United States has tended to lag behind other countries and does not have a widely recognized ecolabeling scheme, the Federal Trade Commission, working with the EPA, did develop some guidelines for marketers to avoid claims that are erroneous or can be misleading to consumers (FTC 1999). Labeling should include specific information rather than general claims such as "environmentally safe." If organically produced fibers or natural dyes were used, this could be emphasized. The terms *recyclable* and *biodegradable* should be used cautiously in consumer labeling. A technically biodegradable material may nevertheless remain intact in a landfill for many years.

The development of a broadly recognized labeling scheme involves several steps: (1) product selection, (2) criteria development, (3) review process, (4) adoption of final criteria, (5) application for ecolabel, (6) testing and verification, and (7) award of ecolabel.

FIGURE 27.5
European Union ecolabel.

Hazards to Consumers: Product Ecolabeling

The simplest ecolabel is for the product; it is based on the materials present in the textile and represents an assurance that the textile will not harm the user. Hazards to consumers from textiles include dangers posed by flammable fabrics, fibers or finishing materials that may pose health risks, and individual sensitivity or allergy to certain types of textile products. As discussed in chapter 25, some textile products can ignite and burn, and individuals may suffer injuries if garments, mattresses, bedding, or upholstery catch fire.

Textile materials might also contain hazardous substances. Probably the bestknown instance of public concern with textile chemicals is the TRIS case. TRIS was a chemical finish used to make some polyester, acetate, and triacetate children's sleepwear fabrics flame resistant. When it was found to be an animal carcinogen, TRIS-treated garments were withdrawn from the market and its use was prohibited. The issue of safety has also been raised in regard to formaldehyde-finished products. The Consumer Product Safety Commission has concluded that consumers are not at risk because garments do not give off enough formaldehyde to affect wearers. Evolution of formaldehyde from building materials such as plywood and particleboard still remains a problem. The chemical 4-PCH (4-phenylcyclohexene) is used in carpet finishing and associated with "new carpet" odor. Reports of ill effects and death of laboratory mice exposed to carpeting subjected to heating resulted in speculation that 4-PCH might have been the cause. Further laboratory tests on mice indicated no adverse effects even at levels more than a thousand times higher than those that can be expected in new carpet installation ("Tests Show No III Effects ..." 1993).

Dermatological problems associated with textile use are sometimes reported by consumers. In some instances skin irritation may result from continued contact with coarse wool fabrics or fabrics containing glass fiber. Some dyes, especially those used on nylon and polyester, and some chemical finishes have also been associated with consumer complaints. Individual consumers may be allergic to specific fibers, dyes, or finishing materials that do not cause problems for the general population. Consumers may also report irritation or allergic reactions to laundry products. Laundry products most likely to be identified as the source of perceived dermatological problems are soaps and detergents, fabric softeners, and bleaches (Dallas et al. 1992).

Thus, there is clearly scope for a labeling scheme that will assure the consumer that an item of clothing will not constitute a danger. The Oeko-Tex 100 scheme is one of these. Because exposure will vary with the type of textile and the effects of harmful chemicals differ with children and adults, different criteria are used for baby clothes, adult clothes with or without direct skin contact, and nonclothing textile items. The criteria involve testing to ensure that certain materials are absent (heavy metals, pesticides, solvents, "banned" dyes, and so on) and that others such as formaldehyde are present in low amounts and/or are not removed in use, such as when a child might chew on them. (See Figure 27.6.)

Such product ecolabeling is applicable mostly to retailers, who can require that any individual product be tested; apply a label to it; and, thereby, assure customers.

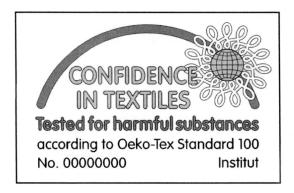

Figure 27.6

Oeko-Tex 100 label.

Hazards in Production: *Process* Ecolabeling and Life Cycle Analysis

Ecolabeling to cover the wider environmental impact of a textile may be based simply on how the textile is produced or based on the total life cycle from production, through use, to disposal. These might apply to retailers but also have relevance to businesses at the corporate level. Companies would make wiser decisions about how to produce textiles and the materials to use. Obviously, such analyses are more complex but probably more relevant. The Oeko-Tex organization that promulgates the "100" product ecolabel also has the 1000 production/life-cycle label. ISO 14000, developed by the International Organization for Standardization (ISO) requires industrial firms analyze and control all the steps in their manufacturing processes. This standard applies not just for textiles, but for all types of manufacturing. Analogous to the ISO 9000 standards for quality control, these environmental standards, if adhered to, can allow producers who are compliant to become certified by the ISO for adherence to ISO 14000 standards.

To be certified (Shaver 1999) companies must do the following:

- 1. Articulate an environmental policy
- Develop a plan that includes objectives and targets for reducing environmental hazards
- 3. Implement the plan and provide documentation that objectives are met
- 4. Monitor operations and institute corrective actions when appropriate
- 5. Review operations and modify the plan when needed

The plan and implementation are reviewed and monitored by a third party before certification is granted.

The American Textile Manufacturers Institute (ATMI) launched its Encouraging Environmental Excellence (E3) campaign in 1992 to promote environmental awareness and good practice in the industry. Member companies pledged to adhere to a ten-point plan of action that included performing environmental audits, developing spill prevention and control plans, conducting employee training in environmental practices, distributing recycling bins, and providing environmental expertise to cities and towns. Because the ATMI has ceased to exist, the E3 scheme has likewise become defunct, and so far no successor has emerged.

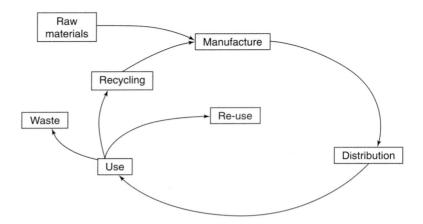

FIGURE 27.7

The product life cycle concept. Courtesy of Textiles Magazine.

Given that a textile item might pass through several plants in the course of its manufacture, ensuring that each one is environmentally sound is not an easy task.

Much of the environmental impact of a textile (or any other) product is determined at the design stage by the materials and processes selected (Heeley and Press 1997). Whether the area of concern is manufacturing processes that contribute to pollution or problems in waste disposal, the journey and fate of textile products are affected by initial decisions made by those involved in the design and development of products. Judgments should be based on accurate information and sound knowledge of the principles and costs of textile materials and processing. Environmental impact should be weighed against cost and other environmental effects. (See Figure 27.7.)

Designers who wish to design an environmentally responsible product have to weigh a vast array of choices, and there is no one solution to any such design problem. In the mainstream apparel sector, especially in the United States, environmental claims are often one dimensional and based on a single criterion (for example, dyed with natural dyes or made with organic cotton). The architectural and interior design communities have developed a more encompassing environmental philosophy and provide good examples of environmental thinking that are making impacts on textile companies. Architect William McDonough together with textile chemist Michael Braungart (http://www.mbdc.com/index.htm) have worked with many large U.S. textile companies and have developed the cradle-to-cradle (as opposed to the cradle-to-grave) concept.

SUMMARY POINTS

Both industry and the public have obligations for the protection of the environment. Whereas at first glance industry would seem to be more responsible for pollution, a deeper examination of the issues leads to the conclusion that this is a shared responsibility. In the long run, the public must be willing to pay for the improvements in pollution control that industries make. Manufacturing of environmentally responsible textiles is, at present, expensive when polluters can produce goods with minimal penalty. Although recent advances are lowering costs, cleaner factories

and mills will be paid for by increasing prices of the items that are marketed. More successes such as carpet recycling and conversion of plastic bottles into polyester fibers should help both consumers and producers of textile products. As more producers become certified by ISO 14000, better industry practices will be put into effect.

At the same time, consumers must recognize that imported fabrics and apparel are often produced in countries that have little or no regulation of the workplace environment. Such goods compete with domestically produced fabrics into which the costs of more environmentally sound processing must be calculated. No one relishes increases in the cost of textiles, but the trade-off for lower prices would be to continue the deterioration of the environment that future generations will inherit.

Questions

- Identify five specific actions consumers can take in relation to textile products that would have a beneficial effect on the environment. Explain the impact of each action you have identified.
- Discuss the environmental impact that design and development decisions can have at each stage of the textile product life cycle. For each stage do the following:
 - a. Identify the impact.
 - b. Describe the considerations in selecting materials and processes using a specific example for each.
- What organization is charged with the responsibility of monitoring the workplace to ascertain whether conditions for workers are safe? What are some of the potential threats to the health and safety of textile employees?
- Imagine that your employer required you to defend the idea that a shirt made from 100 percent cotton fabric would be more environmentally safe than one made of 100 percent polyester. Develop a list of reasons to support this position. Now imagine that you were required to argue against this position. Develop a list of arguments supporting polyester.

References

- Collier, B. J., J. R. Collier, S. Petrovan, and I. I. Negulescu. "Recycling of Cotton." In Cotton: Science and Technology, edited by S. Gordon and Y-L. Hsieh, 484. Boca Raton, FL: CRC Press, 2007.
- Dallas, M. J., P. A. Wilson, L. D. Burns, J. Miller, N. Markee, and B. Harger. "Dermatological and Other Health Problems Attributed by Consumers to Contact with Laundry Products." Home Economics Research Journal 21 (September 1992): 34.
- Federal Trade Commission's Guides for the Use of Environmental Marketing Claims, 16 C.F.R. Part 260 (1996).
- Heeley, J., and M. Press. "Design and the Environment." Textiles Magazine no. 4 (1997): 13.
- Joseph, L. "The Bottom Line on Disposables." New York Times Sunday Magazine, September 23, 1990.

- Rivoli, P. *The Travels of a T-shirt in the Global Economy*. Hoboken, NJ: John Wiley & Sons, 2005.
- Schlaeppi, F. Textile Chemist and Colorist 30, no. 4 (1998): 19.
- Shaver, J. A. "Applying ISO-14001 to Environmental Regulation." *Textile Chemist and Colorist* 31, no. 5 (1999): 27.
- "Tests Show No III Effects from Use of 4-PCH on Carpets." *Textile Chemist and Colorist* 25 (March 1993): 6.
- Van Winkle, T. L., J. Edeleanu, E. A. Prosser, and C. A. Walker. "Cotton versus Polyester." *American Scientist* 66 (May–June 1978): 280.

Recommended Readings

- Blackburn, R. S., ed., *Biodegradable and Sustainable Fibres*. Boca Raton, FL: CRC Press, 2002.
- Bockner, B. "Pollution Prevention: Key to Survival for the Dyestuff Industry." *American Dyestuff Reporter* 83 (August 1994): 29.
- Glover, B., and L. Hill. "Waste Minimization in the Dyehouse." *Textile Chemist and Colorist* 25 (June 1993): 15.
- Gross, P., and D. C. Braun. *Toxic and Biomedical Effects of Fibers*. Park Ridge, NJ: Noyes, 1984.
- Grove, N. "Recycling." National Geographic 185 (July 1994): 93.
- Gund, N. "Environmental Considerations for Textile Printing Products." *Journal of the Society of Dyers and Colorists* 111, no. 1/2 (1995): 7.
- Kumar, S. "Carpet Recycling Technologies." *AATCC Book of Papers*, 220. Research Triangle Park, NC: AATCC, 1997.
- OECD (Organisation for Economic Cooperation and Development). "Eco-Labelling: Actual Effects of Selected Programmes," Document OECD/GD (97)105, May 1997. Paris.
- Thiry, M. C. "Global Scale, Personal Impact." AATCC Review 5, no. 3 (2005): 33.

Textile Product Development and Performance

Learning Objectives

- 1. Define types of specifications and how they are used in product development.
- 2. Define the role of a technical designer.
- 3. Describe standard test methods commonly used for textile products.

hroughout this text readers have looked at the contributions of fiber, yarn, fabric, coloring, and finishing to the performance of textiles in the areas of durability, appearance, and comfort. Whether one is a consumer or a developer of textile products, an understanding of how the textile is made and is likely to perform in use, care, and disposal is valuable. The Putting It All Together case studies in this and other chapters illustrate how the most important properties for a targeted end use product can be matched to performance characteristics of the textile components.

Sometimes there are trade-offs among the various components, and cost and environmental impact must be factors in selecting materials and processes. Fabric components may also complement each other, making the product more than the sum of its parts.

In all cases it is important to focus on the intended end use of the textile. In product development this end use is specified, and manufacturers select fabrics that meet the requirements. Where it is important to predict the performance of fabrics, the effects of all the structural characteristics should be taken into account. Prediction involves testing, and quality assurance requires that fabrics meet the specification of levels of performance required by buyers.

PRODUCT DEVELOPMENT

Retailers and manufacturers of textile products are often heavily engaged in the design and development of those products. Indeed, product development has become an increasingly important activity for many firms. Both the electronic communication now available through the textile supply chain and the liberalization of international trade have facilitated the work of product development.

Specifications

From conception and design to selection of the most appropriate materials for a specific product, knowledge of the textile materials to be used is essential. Those developing textile products communicate the desired properties to their sources through *specifications*. Such specifications can be *material/construction* based or *performance* based. A material specification would be a designation such as, "The product will be a four ounce per square yard, filament nylon, plain weave." An example of a performance specification is the level of colorfastness a fabric should have under certain conditions. (See discussion of colorfastness in chapter 22.) Designers and others engaged in product development will generally concentrate on material specifications, but they should also consider performance of the product during use and care. Retailers wishing to avoid customer complaints will want to know about performance.

Another way to look at specifications is from either the seller's perspective or the buyer's perspective. Sellers provide information that consumers want, for example, the specifications for a computer. In the global textile industry, we work with buyers' specifications. At each stage of putting a textile product together, the buyer, whether he or she is buying fibers, yarns, or fabrics, will specify the properties that particular textile must have. So a buyer's specification might be defined as "a list of requirements that a product must meet to be acceptable."

Large producers of textile merchandise are likely to have their own in-house specifications, which are usually confidential. The most accessible specifications are those that a governmental entity, such as the U.S. military, would issue. The American Society for Testing and Materials (ASTM) in the United States publishes voluntary performance standards for a wide range of textile products. These standards can be used in product development to assure an industry-accepted level of quality. The type of information provided in ASTM specifications is shown in Table 28.1. The table illustrates that there are minimum levels of strength, wrinkle-free appearance, and colorfastness and a maximum shrinkage that ASTM recommends for this product category (men's and boys' woven dress shirts). The specification includes performance levels for other properties as well. Use of standard specifications such as these is one way to provide *quality assurance* or *quality control* as textiles are bought and sold.

Because materials in product development are frequently sourced from different countries, harmonization of test methods and specifications internationally has occurred. Much of this is due to the International Organization for Standardization (ISO), which has developed international standards to facilitate the exchange of goods and production information in the current global environment. In this vein most countries have adopted the *Systéme international d'unités* (SI), or the International

Table 28.1
Selected ASTM Specifications for Men's and Boys' Woven Dress Shirt Fabrics

Performance Property	Minimum Requirement
Breaking strength	111 newtons (25 pounds force)
Tear strength	67 newtons (15 pounds force)
Dimensional change Pressing and laundering Dry cleaning	2% maximum in each direction 2% maximum in each direction
Colorfastness to Laundering Perspiration Light	Class 3 (for alteration in shade) Class 4 (for alteration in shade) Class 4 (for alteration in shade)
Fabric appearance	3.5 durable press rating

Source: Annual Book of ASTM Standards 7.01, 2001.

Note: This specification was withdrawn in 2005 and replaced by one covering the product categories of woven blouse, dress, dress shirt, and sport shirt fabrics.

System of Units, for reporting measurements of textile properties. The SI uses metric units instead of the foot and pound measurements prevalent in the United States.

The ISO has also established a program of quality management standards for industry (called ISO 9000) to ensure product quality across many types of goods. Under the program a company can receive ISO 9000 registration by developing and having approved quality control programs for the design, production, inspection, and installation of its products.

The Development Process

While the product development process is beyond the scope of this text, a brief mention of the work involved and how knowledge of textiles relate is in order. Operating within the global climate and using buyers' specifications, *technical designers* work with designers and merchandisers to map out a plan for putting a textile product together. Here is how one industry professional describes the job of a technical designer:

Even in the recent past, apparel product development involved designers and merchants providing direction to a large domestic support organization which completed the process. This group included fabric buyers, trim sourcers, pattern-makers, specification writers, sample makers, and quality fit technicians. The opportunities of the present and future are to combine this group into one position of Technical Designer. It is her (his) responsibility to prepare a detailed and complete package of all garment construction details, measurements, fabric requirements, colors, and trim details in a manner that can be easily followed by the overseas vendor. The Technical Designer is then responsible for following up through the sampling and production process. Technical Designers who have mastered the complete process are in very high demand.¹

^{1.} William E. Donelan, former director of manufacturing, Harvé, Benard.

Such technical designers need to know what is feasible in translating a design on paper to a textile product. As buyers, they will develop specifications for the various components of the product and communicate those to vendors. Whether developing everyday apparel or branded bedding products, they will also need to know timelines for obtaining the components in order to plan the manufacturing process (Thiry 2007). Hence, knowledge of textile properties, as well as textile processing, is critical. The technical designer and others involved in the development process should be familiar with the following three items: (1) textile trade terminology because they will be writing specifications; (2) regulations in different countries, whether for safety or the environment; and (3) care labeling requirements for the largest markets.

MAINTAINING QUALITY IN THE TEXTILE SUPPLY CHAIN

In the global environment in which textile products and components are bought and sold today, quality is a critical consideration. Textile testing is used to determine whether products meet the specifications that buyers require in developing products. Test methods that are valid and reliable have been developed by experts in the field and are used to determine the physical and performance properties of textiles. *Standard* test methods are published by the American Association of Textile Chemists and Colorists (AATCC) and the ASTM so they can be obtained by those interested in performing such tests. Standardizing the procedures and materials for the test methods ensures that everyone can understand the results. Each of the properties listed in Table 28.1 for dress shirts is related to a specific test method. In contrast, the specifications used by private industry may be individual to a particular company and, therefore, would not be considered standardized.

To ensure accuracy and reliability, textile testing must be carried out under carefully controlled conditions. Atmospheric conditions (particularly the amount of moisture present that might be picked up by fibers) affect the performance of textiles. In the United States, standard conditions for testing are a temperature of 70°F (21°C) and a relative humidity of 65 percent. Standard conditions are different in Europe. Testing equipment must conform to specifications established in the test methods, and fabric specimens must be of uniform size. Test measurements are repeated a number of times because of variability in results from one specimen to another. Results are averaged. Those overall measurements more accurately characterize the materials being tested than does the measurement of a single sample that might possess some atypical quality.

Laboratory testing has limitations in that these tests do not simulate exactly the conditions under which textiles will be used. Consumers will differ from each other in the stresses to which they subject textiles. A farmer will place different demands on a pair of jeans than will an urban high school student. The research literature that deals with the evaluation of textile products contains numerous studies of actual wear tests or of correlations between consumer evaluations of products and standard testing procedures. Studies such as these add another dimension to the testing of textiles. Technical and research publications in the field regularly report new developments in testing as well as the results of tests performed in studies of various aspects of textile performance. In addition, standard test methods

undergo periodic reexamination by professionals to ensure their continued validity and to include new instrumentation that is developed.

Basic Physical Properties

The basic physical properties of fibers, yarns, and fabrics, along with methods for measuring them, were described in earlier chapters. Physical properties, such as fabric weight or yarn size, are usually included in buyers' specifications.

TESTING FACTORS RELATED TO DURABILITY

Mechanical Properties

Fabric strength evaluations are made in terms of breaking strength, tearing strength, or bursting strength. Some tests are not suitable for some fabrics; for example, knits do not tear. A variety of machines is used to measure strength, and fabric samples are prepared for testing according to ASTM test method procedures.

Breaking strength, the force required to break a woven fabric when it is pulled under tension, is measured on a tensile testing machine. (See Figure 28.1.) The strength is reported in pounds or newtons of force required to break the fabric. At the same time that breaking strength is being tested on a tensile testing machine,

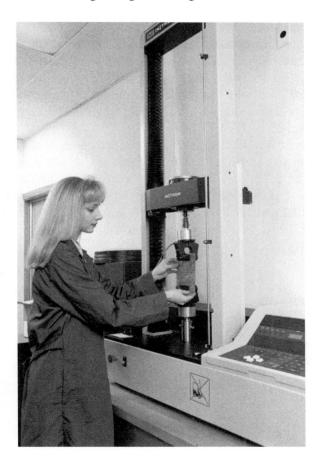

Figure 28.1
Tensile testing machine with fabric specimen mounted in clamps.

the degree of elongation that the fabric undergoes before breaking may be determined and reported as a percentage of the original length. This can be an important consideration for some uses; you would not want a stretchable fabric for seat belts, for example.

Tearing strength of a fabric, expressed in pounds or grams, is the pressure required to continue a tear or rip already begun in a woven fabric. Strength can be measured on a tensile tester by cutting a slit in a fabric specimen and mounting the two parts, or "tongues," in the clamps of the machine. Other instruments provide alternate methods for holding the two split ends of the sample before tearing.

Bursting strength is the force required to rupture a fabric. In this case the force is applied in many directions at once by either pushing a ball through the tautly held fabric or applying air pressure. Bursting strength tests are commonly used to evaluate the strength of knitted and nonwoven fabrics, where the elongation or resistance to stretch in all directions is important. The ASTM specification standard for men's and boys' knitted dress shirt fabrics, in contrast to the specification for woven fabrics, lists a recommended fabric strength of fifty pounds of force, as determined by a bursting strength test rather than a breaking strength test (ASTM 2007b).

Abrasion Resistance and Pilling

Abrasion resistance can be determined on several different types of abrasion-testing machines. The results of tests run on different machines cannot be compared as each machine tests with a different motion and each holds the fabrics in different positions. Some instruments determine only flat abrasion, while others can measure resistance to edge and flex abrasion. Abrasion results depend not only on the type of machine action, but also on the type of abrading surface and the tension on the fabric during abrasion. Results can be reported as the number of rubbing cycles to produce a hole or as the loss in strength, weight, or thickness after a specified number of cycles.

Pilling is a result of abrasion but can also affect the appearance of a fabric. It is often important to determine a fabric's tendency to pill when evaluating its serviceability. There are several types of instruments to determine relative pilling resistance. The Martindale tester shown in Figure 28.2 can measure both abrasion and pilling resistance in different operations. After the fabric is rubbed to induce pilling, it can be subjectively rated against photographs representing different pilling levels.

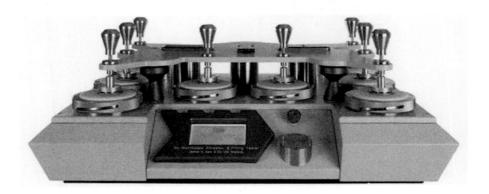

Figure 28.2

Martindale Abrasion and Pilling Tester.

TESTING PROPERTIES RELATED TO APPEARANCE

Fabric appearance is affected by several factors, and testing usually involves measuring the components separately.

Dimensional Stability

Shrinkage or growth of fabric during wear and care can render an apparel or household textile item both unappealing and unusable. Consequently a required level of dimensional stability is often included in buyer specifications as well as in ASTM specifications for particular product categories. It is traditionally determined by placing marks on the fabric; subjecting it to laundering, dry cleaning, or other conditions; then remeasuring the marked area. The shrinkage or growth is reported as a percentage of the original dimensions.

Not only may fabrics shrink, but they may also twist or skew during laundering. Knits and twill weaves are especially susceptible because there are twist stresses built up during the processing of these fabrics. How often have we seen the seams or wales of a T-shirt twist from their vertical position after washing? A test method was developed by the AATCC for determining skewness change in fabrics. The diagonal lines of a marked square are measured and the percent change in their lengths calculated. (See Figure 28.3.)

Wrinkle Resistance

Wrinkle recovery of fabrics is measured by creasing small fabric samples for a specified time, allowing them to recover, and calculating the angle that the two creased ends form. Fabrics with good recovery will result in measured angles that are high, around 150 degrees. Untreated cotton fabrics usually have recovery angles of less than 100 degrees.

Retention of a smooth fabric appearance after laundering can be determined by comparison with standard plastic replicas representing different levels of wrinkling. Fabrics are laundered and visually compared to the replicas. Ratings for smoothness appearance (SA) range from one (poor) to five (very good). Standard test methods also exist for determining the appearance of creases in wrinkle-free items after laundering, an important feature in men's twill-weave casual pants.

Colorfastness

Fabrics may be more or less colorfast to a variety of different substances or conditions, with the importance of each dependent on the use of the fabric. Colorfastness to

FIGURE 28.3

Diagram shows how markings are made on fabrics being tested for skewness or twisting. Skewness is calculated by subtracting the length of BD from the length of AC and dividing by the sum of the two lengths. It can be seen that if there is no skewness, BD will equal AC and the skewness change will be zero. Vol. 82, AATCC Test Method 179-2004, Skewness change in fabric and Garment Twist Resulting from Automatic home Laundering. Pgs 323-236, 2007 AATCC Technical Manual.

laundering is important in garments and textiles that undergo frequent laundering. Perspiration may cause some color change and/or color transfer, and some colors may be lost or diminished by heat. (See figure CP8B on Color Plate 8.) Some dyes tend to *crock*, or rub off on fabrics or other materials with which they come in contact. Others will *bleed* into water during laundering and may be picked up by lighter-colored fabrics. Chlorine bleaches will remove color from many dyed fabrics, but some dyes are more sensitive to the action of chlorine bleaches than are others. Sunlight causes many dyes to fade over time. (See figure CP8C on Color Plate 8.)

Dye performance labeling is not required by any legislation or regulation, but some manufacturers include colorfastness information on labels. Such labels will generally describe the conditions under which the fabric is colorfast, such as "colorfast to laundering but not to chlorine bleaching" or "colorfast to sunlight." A few terms may be found on labels that carry an assurance of colorfastness, such as trademarks that have been applied to solution-dyed synthetic fibers. The colorfastness of one class of dyes, the vat dyes, is so consistently good for laundering that the term *vat dyed* on labels has come to be accepted as an assurance of good colorfastness.

Fastness is assessed via standard tests developed by an independent organization, the AATCC or the ISO, for example. Tests are available to assess fastness to all the agents mentioned above and many others. The test may measure the extent of color change or the degree to which a nearby white material is stained. In each case the result is reported on a one-to-five "Gray Scale" where five is perfect (no color change or no staining). While a dyer may know that the material is to be used for work apparel, bed linens, or curtains and guess the resulting needs, the fastness requirements are better communicated in a specification that lists the fastness tests and the level of performance required on each one. A realistic specification developed at the design stage will allow the dyer to understand what is required and should ensure satisfactory performance of the item when it is ultimately in the hands of the consumer. Dyers achieve the required fastness by choosing the appropriate dyes and applying them correctly to ensure, for example, that any unfixed dye is removed at the end of the dyeing process.

Color change is ascertained by keeping a *control*, an untreated sample of the fabric being tested. Tested samples are then checked against the original. The AATCC Gray Scale makes it possible to determine the degree of color change that has taken place. Samples of both treated and control samples are compared under standard lighting conditions, and the standard scales and numerical ratings are applied. (See figure CP8A on Color Plate 8.) Although visual evaluation can yield reasonably consistent results, computerized color evaluation instruments are more accurate, and visual evaluations are being superseded by electronic measurement.

Fading from exposure to sunlight is measured in a machine that simulates, at an accelerated rate, the fading action of the sun. Samples can be exposed for varying periods of time and tested samples compared to control samples. Among the machines most often used for such tests are the Fade-Ometer and the Weather-Ometer.

Colorfastness to laundering and dry cleaning is done in machines such as the Launder-Ometer. Fabric samples and detergent solution are placed in small sealed cylinders and rotated in a temperature-controlled water bath for a specified time.

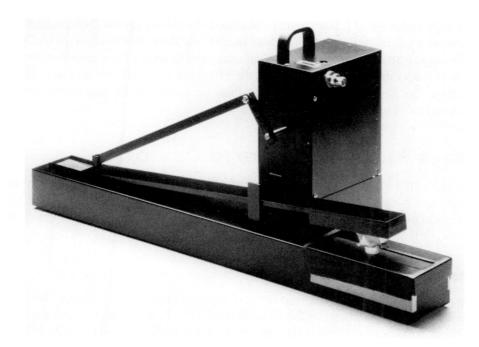

FIGURE 28.4

AATCC Crockmeter that provides standard motion and pressure for determining color-fastness to crocking.

Courtesy of Atlas Electric Devices Co.

The standard test has variations to correspond to hand washing, home laundering, and commercial laundering. One cycle in a laundering machine is said to produce the same color change as five home or commercial launderings (AATCC 1997, 87).

After the test, specimens are examined for color loss. If samples of a "multifiber" cloth containing yarns made of a number of different fibers are added to the cylinders along with test specimens, it is possible to determine whether other fabrics are likely to pick up color from the tested fabric during laundering or dry cleaning.

Both wet and dry crocking can be tested on a device called a Crockmeter that rubs the test sample across a white fabric sample. Color transfer from the test sample to the white sample indicates that the test sample is subject to crocking. (See Figure 28.4.)

A device called the AATCC Perspiration Tester evaluates colorfastness not only to perspiration but also to chlorinated water (as in swimming pools), seawater, water spotting, and the like. The fabric sample is soaked in one of these liquids and subjected to heat and pressure.

Hand and Drape

In contrast to fabric color, where objective judgment is effective and use of color-measuring instrumentation for objective decision making is becoming the norm, the determination of what is or is not a satisfactory fabric hand is extremely difficult. Samples of fabric can be used as reference standards but readily become changed as they are handled. The AATCC has a standard evaluation procedure for fabric hand. Customers and suppliers have a fascinating vocabulary for aspects of hand; beyond simple terms such as *soft* or *stiff*, words such as *buttery*, *sleazy*, *boardy*, *slick*, and *papery* are used.

Drape and hand of fabrics can be measured objectively by the Drapemeter, the Kawabata Evaluation System for fabrics (KES), and the Fabric Assurance by Simple Testing (FAST) system. Literature abounds on the use of these instruments for research purposes such as determining the effects of new finishes on fabric hand and drape, but objective measurement of these properties is not routine for development of most textile products.

TESTING PROPERTIES RELATED TO COMFORT

As with many other fabric properties, comfort is affected by different fabric components and is difficult to measure in a composite sense. What is comfortable for one person may be related to the feel of a textile fabric, to the thermal properties of a fabric, or to the way a garment fits.

Sensorial Comfort

Sensorial comfort is related to surface and softness properties of fabrics. Surface properties can be measured on the Kawabata Surface Tester. Allergies and adverse reactions to abrasion and roughness are really in the realm of medical testing.

Stiffness of fabrics affects not only hand, but also comfort and softness. In addition to the Kawabata and FAST systems, there is an ASTM method to determine bending resistance. A strip of fabric is moved off the edge of a platform until it touches the angled side of the platform. The longer the length of fabric it takes to touch the side, the stiffer is the fabric.

Thermal Comfort

Thermophysiological comfort depends largely on heat transfer and moisture vapor transport, as well as the permeability of the fabric. While these properties can be measured physically, such measurements should be related to subjective evaluations of comfort, which can often be specific to individuals. Textile technologists have defined a unit for measurement of thermophysiological comfort. This unit, the *clo*, represents the insulation or resistance necessary to keep a resting human being (producing heat at a standard rate) comfortable at 70°F (21°C) and air movement of 0.1 meter/second. The clo value is analogous to the R-value used in evaluating home insulation and window coverings.

Putting it all together for . . .

Swimwear

Bathing suits are a fairly specialized end use for fabrics; the fabrics chosen must satisfy both fashion and function. For most women's and girls' swimwear worn today, important functional characteristics are stretch and recovery, colorfastness, absorbency, and environmental resistance. ASTM Standard D 3996 provides minimum performance levels for several of these properties (ASTM 2007a).

Elongation and Recovery

The majority of bathing suits for women and girls are tight fitting with stretch required for getting the garments on and off. Because knits have much higher elongation than woven or nonwoven fabrics, they are the preferred fabric construction for bathing suits that fit tightly to the body.

Fibers, too, play an important role in achieving tightness of fit. Those with lower modulus and high resilience will enhance the stretch and recovery properties of knits. Not only elastomeric fibers, but also nylon have low modulus and good recovery. Nylon and spandex are often chosen for swimwear because of these properties. Polyester is not usually used because it has a higher modulus and, therefore, does not stretch as easily nor recover as well. Knitted fabrics of nylon blended with elastomeric fibers, such as spandex or rubber, will provide the highest amount of stretch. The elastic fibers also have high recovery from stretch.

Colorfastness

Bathing suits are exposed to sunshine, chlorine and other chemicals in swimming pools, and salt water in oceans. Fibers and yarns are both important in maintaining the colorfastness of swimwear that is often made of brightly colored fabrics. (See Figure 28.5.)

Lightfastness of dyed spandex is fair to good, while that of nylon dyed with acid dyes is good. Spandex normally makes up only a small percentage of the fiber content of swimwear fabrics and is often used in core-spun yarns wrapped with nylon. This helps to protect it from sunlight. Colorfastness of nylon and spandex exposed to pool and salt water is fairly good, but these fabrics will show some loss over time.

Absorbency

Because bathing suits are worn while swimming in water, the absorbency of the fabric is a consideration. If a material absorbs and retains a significant amount of water, the weight of the suit will increase, affecting its comfort and function.

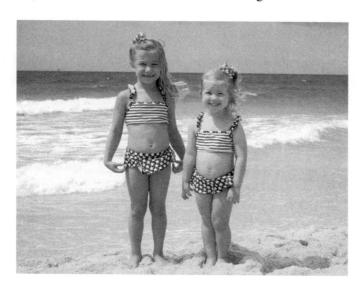

FIGURE 28.5

Colorful printed bathing suits of nylon/spandex.

Synthetic fibers have low water regain and are more appropriate for bathing suits than the natural fibers such as wool that were used many years ago.

Environmental Resistance

Light, chlorine, and salt water can also degrade textile fibers. When this occurs, swimwear fabrics may lose some of their recovery from stretch. Nylon and polyester are more resistant to ultraviolet light and chlorine than is spandex. That is another reason spandex is usually used in small percentages blended with nylon. The use of rubber as an elastomeric fiber in swimwear has decreased because of its susceptibility to degradation by light and other environmental conditions. Because resistance of nylon to degradation by light is higher for fibers that have not been delustered, brighter nylons are usually used in swimwear.

Putting it all together for ...

Automotive Textiles

The average car uses about fifty square yards of textile fabrics. About twenty-five square yards are used for interior trim, and the remainder goes into sound dampening, insulation, and hidden applications such as tires, filters, belts, hoses, and airbags (Smith 1994).

Although the ideal situation for purposes of eventual recycling would be to make all automotive textile materials from the same kind of fiber, various automobile parts use different fibers because of specific performance requirements. Major fibers used in interiors are nylon, polyester, and nylon/polyester blends. Seat belts are most often polyester; airbags are most often nylon; and carpeting is usually nylon. For tire reinforcement, steel predominates, but substantial quantities of high-tenacity polyesters and nylons are also used, as well as smaller quantities of high-tenacity rayon.

Interior Fabrics

While aesthetic considerations are important in visible textile materials such as seat covers, carpets, and wall coverings, good performance is essential. Car interiors are subject to conditions that can degrade fibers, such as light exposure, high temperatures, and atmospheric gases.

Fiber Choices. Both nylon and polyester perform well as upholstery fabrics and wall coverings. Both have excellent abrasion resistance (important in withstanding the sliding of people and objects on and off seats), good strength, and good crease resistance. Nylon has better stretch and recovery, which allows fabrics to conform to the shape of seats for a smooth surface. It is somewhat less resistant to degradation from sunlight than is polyester, but this problem can be overcome by using fibers with ultraviolet light stabilizers, applying ultraviolet light screening films, and dyeing with metal complex acid dyes.

Nylon is the fiber most often used for carpeting. It is preferred because of its abrasion resistance, resilience, and strength.

Colorfastness. Manufacturers can choose among solution-dyed fibers, yarn-dyed, and piece-dyed fabrics. Relatively little solution-dyed fabric is used, even though its colorfastness is superior. It is more expensive and requires a commitment to particular colors farther in advance than yarn or piece-dyed fabrics; however, industry sources predict increased use of solution-dyed fabrics in the future (Fulmer 1993).

Piece-dyed fabrics, though the least costly, have the poorest colorfastness to light. Yarn-dyed fabrics perform well and are widely used. Colorfastness is increased if fabrics have been treated with ultraviolet stabilizers. Laboratory tests have shown no difference in performance between bright and delustered fibers but indicate that as denier per filament decreases, lightfastness decreases.

Airbags

All automobiles and light trucks manufactured in the United States since 1999 were required to have both driver- and passenger-side airbags. Fabrics used in airbags must be capable of holding air when inflated and must be strong enough to withstand impact without rupturing. Nylon is used because of its strength, toughness, and dimensional stability during storage. Although manufacturers are experimenting with the use of polyester, nylon is likely to continue as the predominant fiber due to its greater strength, especially for driver-side airbags where performance standards are higher. Nylon airbags can also be produced at relatively low cost.

To hold the air inside the bag, fabrics are coated with either neoprene or silicone. The European automobile industry has moved to using more expensive, uncoated fabrics constructed so as to be airtight, and the U.S. automobile industry may also move in that direction in the future (Smith 1994).

Molded Parts

Shaped composite materials are used as side and overhead panels, dashboards, and other interior parts. Increasingly these plastic parts are reinforced with fibers for increased impact resistance, and the fibers selected are cellulosic fibers that are biodegradable. Using the methods described in chapter 20, manufacturers produced automobile panels with flax, kenaf, or other bast fibers, which have a high modulus. The fibers are embedded in a matrix of polyester, preferably a biodegradable polyester.

Other Applications

The following areas of automobiles also use textile materials.

Seat cushions, formerly made of urethane rubber foam, are now made from polyester fiber, which is lighter, more comfortable, and recyclable.

Seat belts must resist abrasion and must have high modulus and strength. They are most often made of polyester.

Automotive hoses must be strong and resistant to gasoline, oil, and other chemical substances. The most widely used fibers include polyester, rayon, and high-performance fibers such as aramids.

Insulation requires high-temperature resistance. Fibers in use include glass fiber, ceramic and silica fibers, aramid, molded temperature-resistant composites, and metalized fabrics.

Men's Dress Shirts

Men's dress shirts are a fairly standard commodity textile product in that construction and style do not change much with fashion and time. Aside from variations in construction details such as collars, cuffs, and front closures, the shirts are basic in design. Fabrics used to make them, however, can show some differences within a limited range of suitability. The properties listed in Table 28.1 are important in selecting fabrics for men's dress shirts. These and others are discussed below.

Appearance

Dress shirts should maintain a smooth, attractive appearance to set off the suit or sport coats under which they are worn. Wrinkle resistance is important in this context and can be achieved by selection of fibers that are wrinkle resistant or through wrinkle-free finishes. For the crisp appearance that is often desired in dress shirts, however, starch is applied and cotton fibers that can absorb the starch are preferred. The wrinkle-resistant alternative, polyester, while obviating the need for starching and ironing, will display a limper appearance. Polyester/cotton blends will not achieve the crisp appearance of all-cotton fabrics but will be easier to care for. An additional concern here, though, is pilling of the blended spun yarns.

Also important is dimensional stability. Shirts are purchased with designated neck sizes and sleeve lengths. Shrinkage can alter the fit of these features and, therefore, the appearance on the wearer.

Shirts may become soiled or stained during wear, and the resistance of the shirting fabric to soils and stains, or its ability to release them during laundering, will affect consumer acceptability. Soil-release finishes will help and stain removers and bleach, as discussed in chapter 26, routinely used.

Comfort

A crisper or softer hand is a matter of personal preference but also affects comfort. The basket weave oxford cloth is often used for dress shirts for this reason. It is more flexible, shearing more easily than regular plain weaves, and thus, may feel softer to the touch. Cotton is a soft, smooth, fine fiber, and the finer pima or Egyptian cotton fibers can command a premium price in dress shirts. Polyester, too, however, can be manufactured in fine deniers for use in dress shirts, usually blended with cotton.

Another factor affecting comfort is absorbency. Dress shirts are usually long sleeved, so absorbent fibers, which can absorb moisture and perspiration, are preferred. Cotton wins out here not only because it is absorbent, but also because it feels cool to the touch.

Durability

Strength and abrasion resistance are significant considerations for men's dress shirts. With frequent laundering and wear, dress shirts should be made of durable fabrics, the more so because the fabrics are top-weight fabrics. Tear strength is a factor as well. Plain weaves will have lower tear resistance than will basket weaves, so the latter may be more appropriate in some cases.

Dress shirts have a number of construction details that require a fairly sturdy, although lightweight, fabric. Buttons must be tightly anchored, and a suitably strong base for buttonholes and topstitching is needed. High-count fabrics, backed with nonwoven interfacings in these areas, are used.

Abrasion resistance is another durability point. The shirting fabric will be subjected to abrasion from donning and removing coats and jackets, and the collars and cuffs of the shirt will rub against the neck and wrists of the wearer, and indeed, this is where most of the noticeable abrasion occurs. Wearing away at the collars and cuffs will often be the reason a dress shirt is no longer deemed serviceable. The fibers will abrade at these edges and frosting, which is change in color from rubbing or abrasion, may be seen as well.

Colorfastness

This leads to the necessity for colorfastness in shirting fabrics; colorfastness to laundering, crocking, and perspiration are desirable properties. Oftentimes dress shirts are white or light colored but can be dyed darker or brighter colors and should not fade appreciably during use. The shirts will normally be laundered frequently, whether at home or commercially, and so should be colorfast to water, including hot water, and for the lighter colors, to bleach as well. Crocking may occur with dyed fabrics, and perspiration may also discolor, or stain, the fabric.

SUMMARY POINTS

- Specifications are used to convey textile properties and performance levels
 - Sellers' specifications provide information to consumers
 - Buyers' specifications are the requirements a textile product or component must meet
- Technical designers work with designers and merchants to put a product together using specifications
- · Specifications are based on testing of textiles
- · Routine tests that most textile fabrics undergo
 - Physical properties
 - Behavior during refurbishing: dimensional stability, color change and staining, wrinkle resistance
 - Behavior during use: colorfastness to light, crocking, and perspiration

- · Other tests for research or specialty purposes
 - · Strength
 - Abrasion and pilling resistance
 - Drape and hand

Questions

- 1. What are the challenges in developing and manufacturing textile products in the global environment today?
- 2. How are specifications used in product development?
- 3. What is the role of a technical designer?
- 4. What textile tests would you recommend as the most important for the following products?

draperies

school uniforms

evening gowns

carpets

cycling shorts

- 5. Develop a case study similar to those at the end of this chapter for one of the following products. Focus on fiber, yarn, fabric structure, coloration, and finishes, and include recommended specifications. Do not be concerned about construction details of garments or household textiles.
 - a. Bedsheets
 - b. Women's knit tops and pants
 - c. Men's casual pants
 - d. Children's play shorts

References

- AATCC. AATCC Technical Manual. Research Triangle Park, NC: AATCC, 1997. ASTM. "Standard Performance Specification for Knit Swimwear Fabrics." ASTM
 - Annual Book of Standards 7.01. West Conshohocken, PA: American Society for Testing and Materials, 2007a.
- ASTM. "Standard Performance Specification for Men's and Boys' Knitted Dress Shirt Fabrics." *ASTM Annual Book of Standards* 7.01. West Conshohocken, PA: American Society for Testing and Materials, 2007b.
- Fulmer, T. D. "Dyeing Textiles for Automotive Interiors." *America's Textiles International* 23 (December 1993): 88.
- Smith, W. C. "Automotives: A Major Textile Market." *Textile World* 144 (September 1994): 68.
- Thiry, M. C. "A Bed for the Night." AATCC Review 7, no. 4 (2007): 23

Recommended Readings

- Bresee, R. R., P. A. Annis, and M. M. Warnock. "Comparing Actual Fabric Wear with Laboratory Abrasion and Laundering." *Textile Chemist and Colorist* 25 (January 1994): 17.
- Collier, B. J., and H. H. Epps. *Textile Testing and Analysis*. Upper Saddle River, NJ: Prentice Hall, 1999.

- Hatch, K. L., N. L. Markee, and H. L. Maibach. "Skin Response to Fabric: A Review of Studies and Assessment Methods." *Clothing and Textiles Research Journal* 10 (Summer 1992): 54.
- Johnson, M. J., and E. C. Moore. *Apparel Product Development*. Upper Saddle River, NJ: Prentice Hall 2001.
- Kawabata, S. *The Standardization and Analysis of Hand Evaluation*. Osaka, Japan: The Textile Machinery Society of Japan, 1980.
- Merkel, R. S. Textile Product Serviceability. New York: Macmillan, 1991.
- Saville, B. P. *Physical Testing of Textiles*. Cambridge, UK: Woodhead Publishing, 1999.
- Vatsala, R., and V. Subramiam. "The Integral Evaluation of Fabric Performance." *Journal of the Textile Institute* 84, no. 3 (1993): 495.

in the special contraction is the store of the state of the first characters and the state of th

SUMMARY OF REGULATORY LEGISLATION APPLIED TO TEXTILES

he following summarizes briefly the major pieces of legislation and/or regulations that apply to textile products. Fuller details are provided about each of these acts or rulings in the body of the text. Only those items of legislation that affect consumer products are included. Those that regulate the industry, such as the Occupational Safety and Health Act, are not included.

TEXTILE FIBER PRODUCTS DENTIFICATION ACT

Passed 1960, Amended Subsequently

The TFPIA requires that each textile product carry a label listing the generic names of fibers from which it is made. These generic fiber categories are established by the Federal Trade Commission (FTC), which can add new generic categories as needed. At present there are twenty-five generic fiber categories for manufactured fibers, as well as the names for the natural fibers. Several generic fiber categories have subclasses that are recognized fiber names.

The listing of fibers is made in order of percentage by weight of fiber present in the product, with the largest amount listed first, the next largest second, and so on. Fiber quantities of less than 5 percent must be labeled as "other fiber" unless they serve a specific purpose in the product. Fibers that cannot be identified must be listed as "X percent of undetermined fiber content."

The law prohibits the use of misleading names that imply the presence of fiber not in the product. Labels must carry either the name, trademark, or registered identification number of the manufacturer. All items covered under the law must be clearly and visibly labeled as to whether they are imported or produced in the United States. (For details, see chapter 2, pages 17–20.)

WOOL PRODUCTS LABELING ACT

Passed 1939

This legislation regulates the labeling of sheep's wool and other animal hair fibers. The Wool Products Labeling Act requires that all wool products be labeled and the fibers, except for ornamentation, be identified as either new or recycled wool. The rules and regulations of the FTC established in relation to the act require that the terms wool, new wool, or virgin wool be applied only to wool that has never been used before. Recycled wool is either (1) wool that has never been used in any way by the ultimate consumer but has been spun into yarns or woven or knitted into cloth (these formed but unused pieces of yarns or fabrics are pulled apart and the fibers are reprocessed into fabrics) or (2) wool that has been used by consumers and is reclaimed by pulling the fabrics apart into fibers and spinning and weaving these fibers into other yarns and fabrics.

The law requires that the percentage of wool used in pile fabrics be identified as to the percentage of wool in the face and percentage of wool in the backing. The proportion of fiber used in face and backing must also be noted. Contents of padding, linings, or stuffings are designated separately from the face fabric of products but must be listed with the same items noted. Items of wool must be clearly

and visibly labeled as to whether they are imported or produced in the United States. (See chapter 5, pages 94–96.)

FUR PRODUCTS LABELING ACT Passed 1951

This law requires that a fur product carries the true English name of the fur-bearing animal from which it comes and the name of the country of origin of the fur. (See chapter 5, page 110.)

FLAMMABLE FABRICS ACT

Original Provisions Enacted in 1953

The original provisions of the act stated that wearing apparel (excluding hats, gloves, and footwear) and fabrics that are highly flammable may not be sold. Standards were established for testing to determine whether items were highly flammable. (See chapter 25, pages 463–466, for discussion of the standard.)

Amendments to the Act, 1967

The scope of the act was broadened in 1967 to cover a wider range of clothing and interior furnishings. The act called for the establishment of standards for flammability for items covered by the act, and it banned from sale carpets; mattresses; and items of children's sleepwear, sizes infant to 14, that do not meet the established standards. Some aspects of the standards have been revised periodically. Labels giving care instructions for children's sleepwear that is flame retardant must be placed so they can be

read at the point of purchase. These instructions must be permanently affixed to the garment. Some small carpets and one-of-a-kind carpets are exempt from the provisions of the act but must be labeled indicating that they do not meet the standard. The responsibility for administering and implementing the act was given to the Consumer Product Safety Commission. (See chapter 25 for a full discussion of the legislation.)

PERMANENT-CARE LABELING RULING OF THE FTC

Established 1972

This ruling requires all wearing apparel and bolts of fabric sold by the yard to carry permanently affixed labels giving instructions for care. Exempt from the ruling are household textiles, retail items costing the consumer less than \$3.00, footwear, head gear, hand coverings, and all items that would be marred by affixing a label. The kind of information that must be provided is clearly specified. (See chapter 26 for a complete description of provisions.)

FTC RULING ON THE WEIGHTING OF SILK

Established 1938

No silk products containing more than 10 percent weighting except those colored black may carry a label saying that they are "silk" or "pure-dye silk." Black silks can contain 15 percent of weighting. Fabrics not meeting these standards must be labeled as "weighted silk." (See chapter 5, pages 114–115.)

GLOSSARY

- **Abrasion*** The wearing away of any part of a material by rubbing against another surface.
- **Absorption*** A process in which one material (the absorbent) takes in or absorbs another (the absorbate) as the absorption of moisture by fibers.
- **Adsorption*** A process in which the surface of a solid takes on or absorbs an extremely thin layer of molecules of gases, of dissolved substances, or of liquids with which it is in contact.
- **Amorphous areas (in the fiber structure)** Areas within fibers in which long-chain molecules are arranged in a random, or unorganized, manner.
- **Appliqué** Attaching, usually by sewing, small pieces of cloth or other materials to the surface of a larger textile.
- Bast fibers Fibers found in the woody stem of plants.

 Batik Indonesian technique of resist printing in which areas of fabric that are to resist the dye are covered
- **Batt** A mass of fibers slightly matted together, often formed into a sheet or roll.
- **Bicomponent bigeneric fiber** Bicomponent fiber consisting of two generically different fibers.
- **Bicomponent fiber*** A fiber consisting of two polymers that are chemically different, physically different, or both.
- **Bigeneric fiber** See Bicomponent bigeneric fiber.
- **Bleaching** The process of improving the whiteness of a textile material by oxidation of the coloring matter.
- **Blended yarn** A yarn made by mixing different fibers together.
- **Block printing** The application of printed designs by pressing dye-covered blocks onto a fabric.
- **Bobbin lace** Lace made with a number of threads, each fastened to a spool. The pattern to be followed is anchored to a pillow, so this lace is also called *pillow lace*.
- **Byssinosis** A lung disease to which cotton mill workers are subject; thought to be caused by toxins in the cotton dust.
- **Calendering** The process of passing fabric between rollers with the application of heat and pressure.

- **Carbonizing** The process of removing cellulosic impurities from wool by treatment with mineral acid.
- **Carding** The process step in making spun yarns in which fibers are passed through intermeshing wires that separate and pull them into somewhat parallel form.
- **Ciré** A shiny, lustrous surface effect achieved by applying a wax finish or by heat treatment of thermoplastic fibers.
- Clo A unit of thermal resistance, it is the insulation or resistance necessary to keep a resting human being (producing heat at a standard rate) comfortable at 70°F (21°C) and air movement of 0.1 meter/second.
- **Colorfastness** The ability of a textile material to retain its color during use and care.
- **Combing** A process step following carding in making spun yarns in which the fibers are pulled through a comblike device into a more parallel alignment.
- **Compressive shrinkage** The process of setting the dimensions of a fabric to control relaxation shrinkage.
- Course* In knitted fabrics, the series of successive loops lying crosswise of a knitted fabric, that is, lying at right angles to a line passing through the open throat to the closed end of the loops.
- **Cover factor** The ratio of fabric surface occupied by the yarns to the total fabric surface.
- **Covering power (optical)** The ability of a fabric to hide that which is placed under it.
- **Crabbing** Exposure of wool fabrics to hot then cold water to set it in a flat state.
- **Crimp, fiber** The wavy physical structure of a fiber.
- **Crimp, yarn** The wavy configuration that develops in yarn interlaced in woven fabrics.
- **Crochet** A technique of creating fabric by pulling one loop of yarn through another with a hook.
- **Crocking*** A transfer of color from the surface of a colored fabric to an adjacent area of the same fabric or to another surface, principally by rubbing action.
- **Cross-dye effect*** Variation in dye pickup between yarns or fibers resulting from their inherent dye affinities.
- **Crosslinking** The attachment of one long-chain molecule to another by chemical linkages.

- **Crystallinity** (in fiber structure) Orderly, parallel arrangements of molecules within a fiber.
- **Curing** The application of heat to effect a chemical reaction, such as the reaction of a finish with the fibers in a fabric.
- **Cut** The number of needles per inch in the bed of a circular filling knit machine.
- Cystine linkages Chemical crosslinks in the wool fiber.
- **Decating** Exposure of wool fabric to steam then to cold air to set in a relaxed structure and control shrinkage.
- **Delustered fiber** A manufactured fiber that has had its natural luster decreased by chemical or physical means.
- **Denier** The weight in grams of nine thousand meters of fiber or yarn.
- **Density** The mass per unit volume of a fiber or other material.
- **Desizing** The removal of the sizing material from warp varns after a fabric is constructed.
- **Detergent*** A cleaning agent containing one or more surfactants as the active ingredient(s).
- **Dimensional stability** The ability of a fiber or yarn to withstand shrinking or stretching.
- **Discharge printing** The creation of design by applying a discharge material that removes color from treated areas of a dyed fabric.
- **Doupion silk** A double strand of silk produced by two silkworms spinning a cocoon together. Also called *doupioni silk*.
- **Drawing** (1) In manufacturing fibers, stretching to attenuate the fibers and orient the polymers; (2) in production of staple yarns, blending and drawing out slivers to obtain a single, more uniform strand.
- **Dry-jet wet spinning** The formation of manufactured textile fibers in which the polymer is dissolved in a solvent and extruded through an air gap into a chemical bath where the fibers are hardened.
- **Dry spinning** The formation of manufactured textile fibers in which the polymer is dissolved in a solvent that is evaporated, leaving the filament to harden by drying in air.
- **Durable press*** Having the ability to retain substantially the initial shape, flat seams, pressed-in creases, and unwrinkled appearance during use and after laundering or dry cleaning.
- **Dyes** Natural or synthetic substances that add color to materials by being absorbed therein.
- **Elasticity*** That property of a material by virtue of which it tends to recover its original size and shape immediately after removal of the force causing deformation.
- **Elongation*** The ratio of the extension of a material to the length of the material before stretching.

- **Embroidery** The use of yarns applied to fabrics with a needle in a variety of decorative stitches.
- Ends Warp yarns.
- **Fasciated yarns** Yarns made from a bundle of parallel fibers wrapped with a surface wrapping of other fibers.
- **Felt*** A textile (fabric) characterized by the densely matted condition of most or all of the fibers of which it is composed.
- Fiber dyeing See Stock dyeing.
- **Fiber morphology** The internal structural arrangement of polymer chains in a fiber.
- **Fiber-reinforced composites** Molded materials containing embedded textile fibers or other structures to increase strength.
- **Fibrillation** The creation of fibers or yarns by drawing a polymer sheet in the lengthwise direction so as to cause the sheet to split into a network of fibers (which may be formed into yarns).
- **Filament*** A continuous fiber of extremely long length. **Filature** A factory in which silk fibers are processed.
- Filling* Yarn running from selvage to selvage at right angles to the warp in a woven fabric.
- Fineness* A relative measure of size, diameter, linear density, or mass per unit length expressed in a variety of units.
- **Flexibility*** That property of a material by virtue of which it may be flexed or bowed repeatedly without undergoing rupture.
- **Flock*** A material obtained by reducing textile fibers to fragments, as by cutting, tearing, or grinding, to give various degrees of comminution (powdering).
- **Fulling** In the processing of wool or animal hair fabrics, treatment with moisture, heat, soap, and pressure that causes yarns to shrink, lie closer together, and give the fabric a more dense structure.
- **Garnetting** A process for recovering fibers from yarn or fabric by use of a garnett, a machine similar to a carding machine, which pulls the structure apart.
- **Gel-spinning** The formation of manufactured textile fibers in which the polymer is dissolved in a solvent to form a gel, which is stretched to harden the fibers.
- Generic name Names assigned by the Federal Trade Commission to the various types of manufactured fibers according to the chemical composition of the fiber-forming substance.
- **Gigging** Brushing up of loose fibers onto the surface of a fabric made from staple yarns; a synonym for *napping*.
- **Glass transition temperature*** The temperature at which a polymer changes from a glassy to a rubbery state.
- **Greige goods*** Textile fabrics that have received no bleaching, dyeing, or finishing treatment after being produced by any textile process.

- **Hackling** A step in the processing of flax fibers that is comparable to combing.
- **Heat setting** The treatment of thermoplastic manufactured fibers or fabrics with heat to set the fibers or fabrics into a specific shape or form.
- **Heat-transfer printing** A system of textile printing in which dyes are applied to a paper base and are then transferred from the paper to a fabric under heat and pressure.
- **Heddle** A cord or wire eyelet through which warp yarns are passed on a loom.
- **High wet modulus** The quality in a fiber that gives it good stability when wet.
- **Hydrophilic** Term used to describe materials that have an affinity for water (literally, "water loving").
- **Hydrophobic** Term used to describe materials that have no affinity for water (literally, "water hating").
- **Ikat** A form of resist printing in which sections of warp yarns are made to resist dyes.
- **Ink-jet printing** Printing method that ejects small drops of dye onto a fabric to form a printed design.
- **Kemp hairs** Coarse, straight hairs in a wool fleece that do not absorb dye readily.
- **Latch needle** A needle used in knitting machines that has a latch that opens and closes to hold the yarn on the needle.
- **Leather** An animal skin or hide that has been treated to avoid decomposition.
- **Limiting oxygen index** The percentage of oxygen that just allows burning to take place; it is a measure of the flammability of a textile material.
- **Linters*** The short, fibrous material adhering to the cotton seed after the spinnable lint has been removed by ginning and that is subsequently recovered from the seed by a process called "delinting."
- **Loft** The ability of fibers to return to their original thickness after being flattened or compressed.
- **Luster** The amount of light reflected by a textile material.
- **Macramé** A technique for creating fabric by using a variety of ornamental knots.
- **Man-made fibers** See *Manufactured fibers*.
- **Manufactured fibers** Fibers created by melting or dissolving polymeric materials and re-forming them as fibers.
- Mass coloration See Solution dyeing.
- **Matrix fiber** A bicomponent fiber in which one polymer is dispersed throughout another polymer. See also *Bicomponent fiber*.
- **Melt blowing** A technique in which extruded fiber filaments are hit with high-velocity hot air and entangled to form a nonwoven fabric.

- **Melt spinning** The formation of manufactured textile fibers in which the polymer is melted for extrusion and hardened by cooling.
- **Mercerization** The treatment of cellulosic fibers with a strong basic solution to swell the fibers and produce permanent changes.
- **Microfibers** Very fine fibers, less than one denier.
- **Micron** A measurement that is 1/1000 of a millimeter, or 0.000039 of an inch.
- **Micronaire** A measure of the fineness of cotton fibers; fine fibers have lower micronaire values.
- **Mildew** A fungus that grows on some fibers under conditions of heat and dampness.
- Modulus The resistance to stretching of a textile material.
 Moiré A ribbed cloth that has a wavy, watermarked pattern on the surface.
- **Moisture regain*** The amount of moisture in a material determined under prescribed conditions and expressed as a percentage of the weight of the moisture-free specimen.
- Monofilament yarn* A single filament; also a single filament that can function as a yarn in commercial textile operations; that is, it must be strong and flexible enough to be knitted, woven, or braided.
- **Monomer** The basic repeating unit in a polymer.
- **Mordant** A substance used in dyeing that reacts with both the dyestuff and the fiber to form an insoluble compound, thereby fixing the color within and on the fiber.
- **Morphology, fiber** The arrangement of polymer chains within a fiber.
- **Multifilament yarn** Yarn made from two or more, usually more, filament fibers.
- **Nap** The "fuzzy," raised fibers that have been brushed up on the surface of a fabric.
- **Needlepoint lace** Lace made by embroidering over other threads held in a pattern across a sheet of parchment.
- **Needlepunching** A technique in which fabric is formed by entangling fibers with a series of needles that are punched through a batt of fiber.
- **Netting** A technique of creating fabric by looping and knotting yarns into an open mesh.
- **Novelty yarns** Yarns made to create interesting decorative effects.
- **Oleophilic** A term used to describe materials that have an affinity for oil (literally, "oil loving").
- Open-end spinning machine* A textile machine for converting staple fiber into spun yarn by a continuous process in which the individual fibers or groups of fibers are caused to assemble at the open end of the forming yarn.
- **Optical brightener** Compound that absorbs ultraviolent light and reemits it as visible blue light.

OSHA Occupational Safety and Health Act.

Padding The process of applying a dye or finish to a fabric by passing the fabric first through a solution of the dye or finish then through rollers to squeeze out the excess liquid.

Partially oriented yarns Manufactured fiber yarns that have not been fully drawn.

Phase change material (PCM) A substance, incorporated into a fiber or finish, that stores and releases heat by changing from the liquid to the solid phase (and back again).

Picks Filling yarns.

Piece dyeing Dyeing of woven or knitted fabrics as opposed to dyeing of fibers or yarns.

Pigment** A colorant in a particulate form that is insoluble in a textile substrate, but which can be dispersed within the substrate to modify its color.

Pile (in pile fabric)* The raised loops or tufts (cut loops) that form all or part of the surface.

Pillow lace See Bobbin lace.

Pills* Bunches or balls of tangled fibers that are held to the surface of a fabric by one or more fibers.

Pirns Small metal pins around which yarns are wrapped. These pins are then inserted in a shuttle that carries the yarns across the fabric during weaving. Also called *quills*.

Ply yarns A yarn formed by twisting together two or more single yarns.

Polymer A long-chain molecule formed by chemically bonding repeating units (monomers) of the same or different composition.

Polymerization The formation of polymers.

Progressive shrinkage Shrinkage that continues after the first laundering and/or dry cleaning through successive cleanings.

Pure-dye silk Silk with less than 10 percent of weighting (or less than 15 percent if it is black in color).

Quills See Pirns.

Regenerated fibers Fibers produced from natural materials that cannot be used for textiles in their original form but that can, through chemical treatment and processing, be made into textile fibers.

Relaxation shrinkage Shrinkage that takes place during initial laundering and/or dry cleaning as a result of the relaxation of tensions applied to yarns or fabrics during manufacture.

Residual shrinkage Shrinkage remaining in a fabric after it has been preshrunk. Residual shrinkage is generally expressed as a percentage.

Resilience The ability of a textile material to recover its original position after a distorting force such as stretching, bending, or compression.

Resist printing The achieving of designs by causing sections of fabric to resist dye.

Retting The process of decomposing the woody stem and gums surrounding bast fibers to remove the fiber.

Ring spinning Method of spinning yarns from staple fibers in which the twist is imparted to the fibers by the concurrent movement of a spindle and a metal ring that moves around the spindle.

Roller printing The application of printed designs to fabrics by the use of engraved rollers over which the fabrics pass.

Roving* A loose assemblage of fibers drawn or rubbed into a single strand with little twist. In spun yarn systems, the product of the stage, or stages, just before spinning.

Schreiner finish A finish that improves luster of fabrics that is produced by passing steel rollers engraved with fine lines over the cloth to flatten and smooth the surface.

Scouring A wet process for removing dirt or impurities from textiles by application of chemicals or surfactants.

Screen printing The application of printed designs to fabrics by the use of a screen coated with resist materials that permit dye to penetrate through the screen only in selected areas.

Scrim An open-weave fabric that is often used as a backing material.

Seed hair fibers Those fibers that grow around the seeds of certain plants, such as cotton or kapok.

Sericin The gum that holds silk filaments together in a cocoon.

Sericulture The cultivation of the silkworm for the production of silk fiber.

Shed The passageway between the warp yarns through which the shuttle is thrown in weaving.

Shuttle The device that carries the yarn across the loom, through the shed, in weaving.

Shuttleless machine Weaving machine in which the yarn is carried across the fabric by some means other than a shuttle. These machines may utilize jets of water, air, metal rapiers, metal grippers, or mechanical action.

SI The International System of Units based on specified metric measurements.

Simple yarn Yarn with uniform size and regular surface. **Singeing** Treatment of woven fabrics with heat or flame to remove surface fibers from fabric to produce a smooth finish.

- **Sizing** A chemical compound applied to warp yarns before weaving to make them stronger and more resistant to abrasion; it is typically removed after the fabric is woven.
- **Sliver*** A continuous strand of loosely assembled fibers that is approximately uniform in cross-sectional area and without twist.
- **Solution dyeing** Addition of color pigment to the polymer melt or solution before spinning; also call *mass coloration* or *mass pigmentation*.
- **Specification** A list of required physical or performance properties of a textile material.
- **Specific gravity** The density of the fiber in relation to the density of an equal volume of water at a temperature of 4° C.
- **Spunbonding** A technique in which extruded fiber filaments are randomly arranged and bonded together by heat to produce a nonwoven fabric.
- **Spunlacing** A fabric formation technique in which a fiber web is bonded by air entanglement.
- Staple fibers Fibers of short, noncontinuous lengths.
 Stitch-through A fabric formation technique in which fibers or yarns are held together by stitching through the materials.
- **Stock dyeing** Dyeing of fibers before they are made into yarns or fabrics.
- **Striations** Lengthwise markings on the surface of manufactured fibers visible through a microscope.
- **Sublimation printing** See *Heat-transfer printing*.
- **Surfactant** The active ingredient in synthetic detergents that alters the properties of water and soil so dirt can be removed.
- **Tapa** Cloth made from bark.
- **Tapestry** Woven designs, created on a tapestry loom. **Tenacity** The tensile force a fiber will sustain before rupturing, expressed as force relative to fiber linear
- density. **Tensile strength** The resistance of fibers, yarns, or fabrics to a pulling force.
- **Tentering** Drying of wet fabrics after finishing or dyeing on a frame on which fabrics are stretched taut and flat.
- **Tex** The weight in grams of one thousand meters of fiber or yarn.
- **Textured yarn** A filament yarn in which the smooth, straight form of the fibers has been altered.
- **TFPIA** Textile Fiber Products Identification Act.
- **Thermoplastic** A material that softens and flows under the influence of heat.
- **Thread** Yarn made for the purpose of sewing together sections of garments or other items.

- **Toughness** The ability of a textile material to absorb energy.
- **Tow*** (1) In bast fibers, the short fibers removed by hackling; (2) in manufactured fibers, a twistless multifilament strand suitable for conversion into staple fibers or sliver or for direct spinning into yarn.
- Trademark name A distinctive name registered with the U.S. Patent and Trademark Office by a manufacturer to identify goods as made or sold by that firm. Registration of a trademark is necessary in defending the legal right to exclusive use of the term.
- **Triaxial weave** A type of weaving in which three sets of yarns are utilized, with two sets of yarns moving in a diagonal direction to the third, rather than at right angles.
- Tussah silk Silk fiber from wild silkworms.
- **Union dyeing** The dyeing to the same color of two different fibers with different affinities for dye.
- Wale* (1) In knitted fabrics, a column of loops in successive courses that is parallel with the loop axes; (2) in woven fabrics, one of a series of raised portions or ribs lying warpwise in the fabric.
- Warp* The yarn running lengthwise in a woven fabric.Warp knit A knitted fabric in which the loops interlace vertically.
- **Warp print** A print in which the design is printed on the warp yarns before the filling yarns are interlaced. See also *Ikat*.
- **Weft** The crosswise direction of a woven fabric; the filling.
- **Weft knit** A knitted fabric in which the loops interlace horizontally.
- Wet spinning The formation of manufactured textile fibers in which the fibers are hardened by extruding the fibers into a chemical bath.
- **Wicking** The transmission of a liquid through a textile by capillary action.
- Woolen yarns* Yarn spun from wool fibers that have been carded but not combed or gilled.
- Worsted yarns* Yarn spun from wool fibers that have been carded and gilled, combed, or both.
- Yarn dyeing The dyeing of yarns before they are woven or knitted into fabrics.

^{*}Reprinted, with permission, from ASTM D123-03 Standard Terminology Relating to Textiles, copyright ASTM International, 100 Barr Harbor Drive, West Conshohocken, PA 19428. A copy of the complete standard may be obtained from ASTM (http://www.astm.org).

^{**}A Glossary of AATCC Standard Terminology, 2007 AATCC Technical Manual: 418.

ente e la ser los estados de la como de la la como de la la la como de la la la como de la la como de la como dela como de la como dela como de la como de

. Signingeria, viration for training according to the first himself and the second sec

to a person seminar palar salah bergar 19 darih malimba omentika seminantan personal and bergalah diasa salah di salah malimba salah bergalah salah malimban a kang mili basa salah bergalah salah salah salah salah per

en medintaki lomi mir bertigan en Ersell**aria Afrika.** Pelakuan kampataka alimaka didikan kendaran disibilan di kendaran di kendaran di kendaran di kendaran di kendar Pelakuan

The second secon

The second provided a result for the second part of the second provided at the second provi

taged even often die de week begin in die werde week werd. Die de week begin die de werde werde

el l'un partir e primire no capatet de en l'Esta perè d<mark>ebèlés.</mark> L'accepte de la capatet de la capat

There is not the second of the

bisen to the second of the stress of bisen to the second of the second o

Magazin or harmon some and be suffered to be sufficiently

interior supplies a consequence of the consequence

The second secon

binjakejasow in traditional proforminy († 1965 sy. Bonjan Lagon an fisika sy stalificatoria di dinaga si Bonjan kanana an fisika

elazani internativale antico de la compania de la galleria per establica de la propera de la galleria de la propera de la galleria de la propera de la galleria del galleria de la galleria de la galleria del galleria de la galleria del galleria de la galleria de la galleria della della galleria della galle

ingen ted gescht in die pront menschass in den geschaften die 1905 – Der Germanner von der der der Schriften der S

The control cannot be be proved the control of the

INDEX

Abrasion resistance, 54–55	care procedures, 182
acetate and triacetate and, 143	chemical properties, 178–179
acrylic and, 179	compared with modacrylic, 185
cotton and, 71	compared with wool, 180
flax and, 78	defined, 175
glass fibers and, 212	environmental properties, 179
nylon and, 153	manufacture of, 176
polyester and, 168	mechanical properties, 178
polypropylene and, 191	molecular structure, 177
rayon and, 133	physical properties, 177–178
silk and, 118	properties of, 56, 177–179, 180, 185
testing, 526	trademarks, 182
wool and, 101	uses, 180–182
Absorbency, 48–50	A-frame, 393
of acetate and triacetate, 142	Agreement on Textiles and Clothing (ATC), 10, 11
of acrylic, 178–179	Air-jet looms, 284–285
of cotton, 69	Air-jet spinning, 257
of flax, 77	Air-jet texturing, 240, 241
of glass fibers, 212	Albany International, 219
of nylon, 152	Alpaca, 106–107
of polyester, 167	American Association of Textile Chemists and Colorists
of polypropylene, 190	(AATCC), 39, 417, 524, 527, 528, 529
of rayon, 132	American Cyanamid, 176
of silk, 116	American Fibers and Yarns, 193
of spandex, 200	American Society for Testing and
of wool, 99	Materials (ASTM), 4, 31, 39, 265, 375, 379, 462, 463
Acetate	specifications, 522, 523
care procedures, 145	testing, 524, 525, 526, 527
chemical properties, 142–143	American Textile Manufacturers Institute (ATMI), 517
development of, 138-139	Amoco Fabrics and Fibers Co., 215
environmental properties, 143	Angora, 111
manufacturing of, 139, 140–141	Animal hair fibers, 15
mechanical properties, 142	camel hair, 104–106
physical properties, 141	cashmere, 103–104
properties of, 56, 130, 141–143	cow hair and horsehair, 111
uses, 143–144	fur fibers, 110–111
Acetylation, 139	other members of the camel family, 106–108
Acid dyes, 419	physical dimensions of, 108
Acids, effect of, 52	rabbit, 111
Acrilan®, 176	wool, 91–103
Acrylic	Anso [®] , 154
See also Modacrylic	Antimicrobials, 25
bicomponent, 179–180	finishes, 467–468

Antistatic finishes, 468–469	Bedford cord, 295
Antron [®] , 154	Beetling, 76, 442
Apparel designers, 12	Bemberg Rayon, 134
Appearance factors, 232–233	Bengaline, 294
knitted fabric and, 344	Bias direction, 273, 315
multicomponent fabrics and, 387	Bicomponent bigeneric fibers, 32
nonwoven fabric and, 360	Bicomponent fibers, 31–33, 179–180
testing, 527–530	Bicomponent process, 30
woven fabric and, 315-316	BioPolishing, 444, 458
Appliqué, 372	Bird's eye, 302
Aramid	Bleaches, 479–480
care procedures, 159	Bleaching, 53
development of, 147	cotton, 395–396
manufacture of, 155	wool, 398
properties of, 56, 155–157, 214	Blend level, 261
trademarks, 155	Blends, 260–262
uses, 157–158	dyeing, 417
Asahi Kasei Group, 202, 217	Block printing, 428
Asbestos, 15, 214	Blotch (direct) printing, 425
Aspect ratio, 43	Bluing, 481
Association of the Nonwovens Fabrics Industry, 347	Bobbin lace, 384–385
Austrian Textile Research Institute, 515	Bonded fabrics, 375–377
Automotive textiles, 532–534	Boron fibers, 214
Axminster carpets, 367–368	Box dyeing, 412–413
Azlon, 121	Braided fabrics, construction technique, 266, 385–386
Azoic dyes, 419	Braungart, Michael, 518
,,	Breaking, 442–443, 457, 526–527
Back, fabric, 270	Broadcloth, 294
Backstaining, 424	Brocade, 303
Balanced weave, 274	Brocatelle, 303
Balance plain weave, 292–293	Brushing, 444
Bamboo, 138	Buckram, 292
Bandanna, 427	Burling, 400
Bark cloth, 359	Burnout (devore) printing, 434
Barred effect, 295	Bursting strength, 526
Bases, effect of, 52	Butcher linen, 293
BASF Corp., 215	Butcher Intell, 293
Basis weight, 361	Calendering, 440–442
Basket weave, 295–296	Calender rolls, 355
Basofil [®] , 215	Calico, 293
Bast fibers, 60	Calico Printers Association, 161
dyeing and finishing, preparation for, 398	Camel hair, 104–106
flax, 72–80	Cam looms, 286
hemp, 84–85	Canvas, 296
jute, 81–83	Caprolactam, 148–149, 150
kenaf, 83–84	Carbon fibers, 4
ramie (China grass), 80–81	
Batch dyeing, 413–415	manufacture of, 208–209
Batch versus continuous processing, 392–393	properties of, 208, 209
	uses, 209–210
Batten 277	Carbonization, 94
Batten, 277 Payer 202	wool and, 398
Bayer, 202	Carded, 94
Bayeux Tapestry, 372	Carding, 246, 250
Beam dyeing, 414–415	Care of fabrics
Beating up, 279	dry cleaning, 490–491
Beck dyeing, 412–413	dryers, 486, 489

laundering, 476-485 of flax, 77 laundering, commercial, 489-490 of glass fibers, 212 permanent-care labeling, 492-495 of modacrylic, 184 preserving fabrics, 496-497 of polyester, 167 pressing, 489 of polypropylene, 190-191 stain removal, 485-486, 487-488 of rayon, 132 storage, 491 of silk, 116-117 Carolan®, 144 of spandex, 200 Carothers, Wallace, 147, 161 of wool, 99-100 Carpets Chemical retting, 75 Axminster, 367-368 Chemicals, hazardous, 514 chenille, 368 Chenille, 310 flame resistant, 464 carpets, 368 handmade, 368, 370 Chiffon, 293 stain-resistant finishes for, 462 Children's sleepwear, 464–465 tufting, 364-365 Chintz, 293 velvet-weave, 366-367 Chlorofibers, saran and vinyon, 217, 220 wall-to-wall, 369-370 Chrome dyes, 419-420 Wilton, 367 Chromspun®, 144 Cashmere, 103-104 Ciréing, 440 Catalyst system, 188 Citrus configuration, 30 Caterpillars, 368 Classification and labeling of fibers, 16-20 Cationic dyes, 420 Clean Air Act (1970), 513 Celanese Corp., 144, 215 Clean Water Act (1977), 513 Cellulosic fibers, manufactured Clipped or unclipped spot weave, 310 acetate and triacetate, 60, 138-145 Cloth beam, 276 bamboo, 138 Coated fabrics, 379-380 derivative, 139 Cohesiveness, 43 development of, 125 Coir, 85 dyeing, 418-419 Color, 6, 40 lyocell, 60, 134-138 of acetate and triacetate, 141 rayon, 60 adding, 25, 403-420 rayon, cuprammonium, 134 of cotton, 67 rayon, viscose, 126-134 of flax, 75 regenerated, 126, 139 of glass fibers, 212 wrinkle-resistant finishes, 452-455 of rayon, viscose, 131 Cellulosic fibers, natural selection, 405-406 bast, 60, 72-85 of silk, 115 characteristics of, 60-61 of wool, 96-97 dyeing, 417-418 Colorants leaf, 60, 84-85 See also Dyeing; Dyes miscellaneous, 60, 85 defined, 403 seed hair, 60, 61-72 used in printing, 424-425 wrinkle-resistant finishes, 452-455 Colored lake, 404 Central American Free Trade Agreement (CAFTA), 10-11 Colorfastness, 319, 404, 407 Ceramic fibers, 213-214 testing, 527-528 Chambray, 293 Colour Index, 417, 419 Cheesecloth, 292 Combination fabrics, 261 Cheeses, 277 Combing, 246, 250 Chemical bonding, nonwoven fabrics and, 356 Comfort factors, 233 Chemical finishes. See Finishes, knitted fabric and, 345 chemical multicomponent fabrics and, 387 Chemical properties, 48-53 nonwoven fabric and, 360-361 of acetate and triacetate, 142-143 testing, 530-531 of acrylic, 178-179 woven fabric and, 316-317 of cotton, 69-70 Comonomers, 21

Composites Creslan®, 176, 182 construction technique, 266, 267 Cresloft®, 182 textile-reinforced, 370-371 Crewel embroidery, 372 Composting, 512 Crimp, 42-43 Compressional resiliency, 48 Crinoline, 292 Compressive shrinkage, 447-448, 453 Crochet, 385 Computer-aided design (CAD), 11 Crochet knits, 341 Computer-aided manufacturing (CAM), 11 Cross-dyeing, 417 Condenser, 249 Crosslinked structures, 22 Conductrol®, 182 Cross-stitch embroidery, 372 Consumer Product Safety Commission (CPSC), 463, 465, 516 Crystallinity, 33, 34 Continuous dyeing, 414-415 Cuprammonium rayon, 134 Continuous processing, versus batch processing, 392–393 Copolymers, 21 Dacron®, 161, 169 Corded fabrics, 294 Damask, 303 Corduroy, 309 Damp relaxing, 448-449 Core spinning, 258 Darlexx®, 380 Cortex, 97 Decating or decatizing, 449 Costs, 57 Decitex, 230, 231 Cotton, 15, 22 Degree of polymerization (DP), 22 bleaching, 395-396 Degummed, 397 care procedures, 71-72 Delustering agents, 25 chemical properties, 69-70 Demand-pull system, 7 classification, 64 Denier, 29, 45, 46, 230, 231 count, 230, 231 Denim, 298-299 cultivation, 64-65 Density, 43-44 desizing, 395 Design. See Printing and design; Product development dyeing and finishing, preparation for, 394-397 Desizing, 395 environmental properties, 70-71 Detergents, 477-479 fiber preparation, 246-248 Development. See Product development global market, 61-62 Dew (ground) retting, 75 how it grows, 62-63 Diameter or fineness, 44-46 logo, 62 Diaper cloth, 302 mechanical properties, 68 Differential dyeing, 417 mercerization, 70, 397 Dimensional stability, 54 molecular structure, 66-67 Dimity, 295 organic, 65 Direct dyes, 418 physical properties, 67-68 Direct (blotch) printing, 425 polished, 293 Discharge paste, 426 production of fiber, 65-66 Discharge printing, 426 properties of, 56, 67-71, 78 Disinfectants, 481 scouring, 395 Disperse dyes, 143, 420 singeing, 394 Disposal of textiles, 511-512 types of, 63-64 Distribution centers, 8 uses, 71 DMDHEU (dimethyloldihydroxy-ethyleneurea), 453, 454 Cotton Incorp., 62 Dobby fabrics, 302 Count, fabric, 274-275 Dobby looms, 286-287 Country-of-origin labeling, 19-20 Doctor blade, 428 Covering power/factor, 42, 233 Doffing, 253 Cow hair, 111 Dope dyeing, 25, 409 Crabbing, 398 Dotted swiss fabric, 310 Crash, 293 Double-cloth fabrics, 311–312 Creel, 277 Double-knit fabrics, 331-333 Creep recovery, 48 Doupion silk, 114 Crepe-backed satin, 301 Dow Chemical Co., 217 Crepe fabrics, 301 Dow XLATM, 204

Dragline silk, 120 cationic, 419 Drape, 232, 315 chrome or mordant, 419-420 testing, 529-530 defined, 403 Drawing or stretching, 33-35, 239, 246, 248, 278 direct, 418 Drill, 299 disperse, 420 Drop wire, 278 environmental and safety issues, 503-506 Drum machine, 416 liquor, 408 Dry cleaning, 490-491, 506 metal complex or premetallized, 419 Dryers, 486, 489 natural, 404-405 Dry forming, 348-349 printing with, 424 Drying, 393-394 reactive, 418 Dry spinning, 27-28 substantivity, 408 DSM, 194 sulfur, 418-419 Duck cloth, 296 synthetic, 405 DuPont Co., 16, 147, 148, 155, 161, 176, 193, 198, 202, 219, vat, 418 257, 420, 460, 462 Dyneema®, 194 Durability factors, 230-232 knitted fabric and, 344 Eastman Chemical Co., 144 multicomponent fabrics and, 387 Ecolabeling, 514-518 nonwoven fabric and, 359-360 Ecospun[®], 509 woven fabric and, 313-314 Edge-crimping texturing, 240, 241 Durable-press finishes, 453, 455 Elasterell-P, 203-204 Dwell times, 393 Elastic recovery. See Elongation and elastic recovery Dyeing, 6 Elastoester, 203 See also Wet processing Elastomeric fibers batch, 412-413 See also type of beam, 411-414 defined, 197 beck, 412-413 types of, 197 blends, 417 Electrical conductivity, 50 cellulosic fibers, 418 of acetate and triacetate, 142 continuous, 414-415 of acrylic, 179 cross, 417 of cotton, 69 differential, 417 of flax, 77 environmental and safety issues, 503-506 of nylon, 152 fabric, 412-415 of polypropylene, 190 fiber or stock, 409-410 of rayon, 132 garment, 415-416 of silk, 116 jet, 413 of wool, 99-100 jig, 413 Electronic data interchange (EDI), 7, 8 levelness, 407 Electrospinning, 31 manufactured fibers, 419 Elongation and elastic recovery, 47–48 process, 407-408 of acetate and triacetate, 142 reserve, 417 of acrylic, 178 solution, 25, 409 of cotton, 68 space, 411 of flax, 76 tone-on-tone, 417 of nylon, 151-152 top, 410 of polyester, 166 union, 417 of polypropylene, 190 wool, silk, and nylon, 419 of rayon, 132 yarn, 410-411 of silk, 116 Dyers, role of, 406-407 of spandex, 200 Dyes of wool, 99 See also Color Embossing, 441 acid, 419 Embroidery, 371-373 adding, 25, 403-420 Emerizing, 443 azoic, 419 Emulsion spinning, 29

Encouraging Environmental Excellence (E3), 517	False-twist texturing, 240, 241,
Ends, 273	242–243
Environmental and safety issues	Fasciated yarns, 257
disposal of textiles, 511–512	Fashion marks, 336–337
dry cleaning and, 506	Federal Insecticide, Fungicide, and
dyeing and finishing methods and, 503-506	Rodenticide Act (FIFRA), 468
ecolabeling, 514–518	Federal Trade Commission (FTC), 16, 492, 515
fabric construction and, 503	Felt, 358–359
fiber choice and, 502–503	Felting, 98, 102, 103, 445
laundering and, 506	Fibers
legislation and regulations, 512–514	See also Manufactured fibers; type of
recycling and reusing, 507–511	bicomponent, 31–33
Environmental exposure, response to, 53–54	chemical make-up and physical
Environmental properties	structure of, 20–24
of acetate and triacetate, 143	classification and labeling of,
of acrylic, 179	16–20
antimicrobial finishes, 467–468	defined, 4, 15
of cotton, 70–71	drawing or stretching, 33–35
of flax, 77	dyeing, 410
of glass fibers, 212	hollow, 31
of modacrylic, 184	manufacture of, 24–29
of nylon, 152–153	morphology, 23, 33–35
of polyester, 167	natural, 15, 16, 59–87
of polypropylene, 191	properties, 40–58
of rayon, 132–133	spinning, 26–29
of silk, 117	suitable versus unsuitable, 4
of spandex, 200	variations, noting, 35–36
of wool, 100–101	FiberVisions [®] , 193
Environmental Protection Agency (EPA), 468, 513, 515	Fiber webs. See Nonwoven fabrics
Enzyme retting, 75	Fibrillated films, 380–381
Enzyme treatment, 444–445, 458	Fibrillation, 136, 259
Estron [®] , 144	Filaments, 43
European Disposables and Nonwovens Association	Filament tow, 26
(EDANA), 347	Filament winding, 371
European Textile Institutes, 515	Filament yarns, 224, 239
Exporters, statistics, 10	texturing, 240–244
•	Filature, 114
Fabric	Filling pile fabrics, 308–309
construction methods, 265–267	Filling yarns, 273
count, 274–275	preparing for weaving, 278
dyeing, 412–415	Films
grain, 273–274	construction technique, 266-267, 270-271
hand, 232, 457–458	making yarn from, 258–260
softeners, 482	Fineness, 44–46
structures, 5–6, 266	Finishes, 6
symmetry, 270	beetling, 442
thickness, 269	breaking, 442–443
weight, 268–269	calendering, 440–442
width, 269	ciréing, 440
Fabric Assurance by Simple Testing (FAST), 530	embossing, 441
Fabric-to-fabric bonding, 375–376	environmental and safety issues, 503–505
Fabric-to-foam lamination, 376–377	enzyme treatment, 444–445
	glazing, 440
Face, fabric, 270	milling or fulling, 445
Faller, 442	moiré, 441–442
Fallers, 442 False-twist spinning, 257	napping and sueding, 443–444
raise-twist summing, 437	napping and sucurity, TTJ TTT

shrinkage control, 445-449 Flexibility, 47 surface, 440-445 of cotton, 68 Finishes, chemical of flax, 77 antimicrobial, 467-468 of nylon, 152 antistatic, 468-469 Float, 296 application of, 452 Flocked fabrics, 377-378 enzyme treatment, 444-445, 458 Flock printing, 435 fabric hand and, 457-458 Flooring Radiant Panel Test, 466 flame resistance, 462-467 Fluorochemicals, 460 foam, 452 dual-acting, 461 hand builders, 457 Fluoropolymer, 218-219 light-reflectant, 470 Foam finishing, 452 mothproofing, 469 Folded yarns, 256 parchmentizing, 458 Formaldehyde, 453, 505 softeners, 457-458 Fortrel®, 509 specialty, 472 Friction calender, 440 stain-resistant and soil-resistant, 460-462 Frieze, 306 temperature-regulating, 469-470 Frisons, 114 topical, 452 Frosting, 55, 454 ultraviolet-absorbing, 470, 472 Fugitive tints, 420 water repellency, 458-460 Full-fashioning, 336 wrinkle-resistant, 452-455, 471-472 Fulling, 445 Finishing. See Wet processing Fully oriented varn (FOY), 35 Flame-foam method, 376 Fume fading, 143, 420 Flame resistance Fur fibers, 110-111 carpets, 464 Fur Products Labeling Act (1951), 110, 546 children's sleepwear, 464-465 clothing, 463 Gabardine, 299 defined, 462 Galvano screen, 429 mattresses and mattress pads, 465 Garment dyeing, 415-416 textiles, 466-467 Garnetting, 95, 508 upholstered furniture, 465 Gauze, 292 Flame retardants Gear-crimping texturing, 241, 244 adding, 25 Gel spinning, 29 defined, 463 General Agreement on Tariffs and Trade (GATT), 10, 11 finishes, types of, 467 Geotextiles, 357 Flammability, 51 Gigging, 443 standards and tests, 463-466 Gilling, 249 Flammable Fabrics Act (1953), 463, 464, 546 Gingham, 293 Flannel, 298 Glass fiber Flatbed screen printing, 430-431 composites, 212 Flat-cure treatment, 454 development of, 210 Flax, 15 manufacture of, 210-211 care procedures, 80 properties of, 208, 212 chemical properties, 77 uses, 212-213 cultivation, 74 Glazing, 440 dyeing and finishing, preparation for, 398 Global Acetate Manufacturers Association (GAMA), 144 environmental properties, 77 Global industry fiber preparation, 249-250 exporters, changes in, 9-10 how it grows, 73 trade agreements, 10-11 mechanical properties, 76-77 Glospan®, 198, 202 physical properties, 75-76 Godet rolls, 34 preparation of fiber, 74-75 Gore-Tex[®], 219, 377, 459 properties of, 56, 75-78 Grain, 270, 273-274 uses, 73, 78-79 Graphite fibers, 208 Fleece, 329 Greige fabrics, 275

Hot-fluid jet texturing, 241, 243-244 Grenadine, 205 Huarizo, 107 Gripper or projectile looms, 281-283 Grosgrain, 295 Hybrid fabrics using polymer films, 379–380 Hydrogen bonding, 23 Guanaco, 108 Hydrophobic finishes, 458, 460, 468 Gun-ei Chemical Industry, 216 Ice colors, 419 Hackled fibers, 250 Ikat process, 435-436 Hand Illuminated discharge, 426 builders, 457 Imperial Chemical Industries finishes that affect fabric, 457-458 (ICI), 161 testing, 529-530 Impressa®, 193 Hand (feel), 43 Incineration, 512 Handmade carpets, 368, 370 INDA (Association of the Nonwovens Fabrics Industry), 347 Harness, 276 Ink-jet printing, 432 Heat, effect of, 50-51 Innova[®], 193 acetate and triacetate and, 142 Inspection and repair, 399-400 acrylic and, 179 Interior designers, 12 cotton and, 69 Interlock knits, 333-334 flax and, 77 Intermolecular forces, 23 nylon and, 152 International Committee on Illumination (CIE), 406 polyester and, 167 International Fabricare Institute polypropylene and, 190 (IFI), 159 rayon and, 132 International Organization for Standardization (ISO), 517, silk and, 117 522-523 spandex and, 200 International System of Units (SI), 40, 522-523 wool and, 100 Interwoven fabrics, 311–312 Heat of sorption, 50 Invista, 148, 154 Heat-resistant fibers Islands-in-the-sea configuration, 30 aramid, 155-159, 214 asbestos, 214 Jacquard fabrics, 302-304 melamine, 215 Jacquard looms, 287-288 novoloid, 215, 216 Jacquard weave, 287 polybenzimidazole, 214-215 J-box, 393, 396, 397 sulfar, 215 Jean, 299 Heat setting, 54 Jersey knits, 326-327 Heat transfer, 233 Jet dyeing, 412-413 Heat-transfer (sublimation) printing, 433 Jig dyeing, 413-414 Heddle eye, 278 Jolly, Jean Bapiste, 490 Heddles, 276 Jute, 81-83 Hemp, 84-85 Hercosett®, 457 Kanecaron® and Kanekalon®, 185 Herringbone twill, 298 Kaneka Corp., 185 Hides, 270 Kapok, 72 High-performance fibers Kawabata Evaluation System (KES) for fabrics, 530 See also type of Kawabata Surface Tester, 530 properties of, 208 Kemp hairs, 98 High-pile fabrics, 327 Kenaf, 83-84 High-wet-modulus (HWM) rayon, 126, 129, 130, 133 Keratin, 96 Hoechst Celanese, 509 Kevlar®, 155 Hollow fibers, 31 Kiss roll, 452 Hollow-spindle spinning, 257-258 Knitted fabrics Homespun, 293 basic concepts, 321-326 Homopolymers, 21 care procedures, 342-344 Honeywell, 148, 154, 194 gauge and quality, 324-326 Hopsacking, 296 loop formation, 322-324 Horsehair, 111

patterns and designs, creating, 341	Light-reflectant finishes, 470
performance and, 344–345	Limiting Oxygen Index (LOI), 51
shrinkage and, 342–343, 448	Linear density, 45, 46, 47
three-dimensional, 337	Line fibers, 250
two-bed, 330-334	Linen, 22, 72, 84
warp, 322, 337–341	See also Flax
warp and weft insertion, 342	butcher, 293
weft, 322, 326-330	count or lea, 230, 231
Knotted fabrics	Linen tester, 275
construction technique, 266	Link-chain system, 341
crochet, 385	Link-links machine, 334
lace, 384–385	Lint, 63
macramé, 383	Linters, 63
nets, 382–383	Llama, 106
Kodel [®] , 162	Loft, 48
Kunit fabrics, 353–355	London shrinking, 447, 449
Kynol [®] , 216	Looms. See Weaving machines (looms)
	Looped fabrics, construction
Labeling	technique, 266
bicomponent fibers, 33	Low-wet-pickup, 452
contents, 18-19, 20	Lurex [®] , 260
country-of-origin, 19–20	Luster, 41–42
Lace, 384–385	of acetate and triacetate, 141
Lamb's wool, 93	of acrylic, 178
Laminated fabrics, 375–377	of cotton, 68
Landfills, 511–512	of flax, 76
Lanolin, 94	of rayon, 131
Lap, 246	of silk, 115
Lappet weave, 311	of wool, 99
Laser engraving, 429	Lycra [®] spandex, 198, 202, 380
Lastol, 204	Lynda [®] , 144
Lastrile, 204	Lyocell, 18
Laundering	care procedures, 137
bleaches, 479–480	development of, 134, 138
commercial, 489–490	dyeing and finishing, preparation
detergents, 477–479	for, 399
disinfectants, 481	manufacturing of, 135
dryers, 486, 489	mechanical properties, 136
environmental issues, 506	physical properties, 135–136
fabric softeners, 482	properties of, 130
pretreatment products, 480–481	uses, 136–137
procedures, 484–485	uses, 130–137
soaps, 476–477	Macramé, 383
starches, 482	Mali, 381
washing machines, 482–484	Malimo fabrics, 381
water softeners or conditioners, 479	Malipol, 382
whiteners or brighteners, 481	Man-made fibers. See Manufactured fibers
Leaf fibers, 60, 84–85	Manufactured fibers, 9
Leather, 270	
Leavers, John, 385	See also Cellulosic fibers, manufactured; under type of
Legislation, environmental and safety, 512–514, 545–546	defined, 17–18
Length, 43	dyeing, 420 dyeing and finishing, preparation for, 399
Leno selvage, 275	
Leno weave, 305	regenerated, 15, 16
Lenzing Group of Austria, 129, 134	synthetic, 15, 16 Marquesa [®] , 193
Letting off, 279	
Letting Oil, 219	Marquisette, 305

Martindale tester, 526 mechanical properties, 183 Mass coloration, 25, 409 physical properties, 183 Matelassé, 312 properties of, 56, 183-184, 185 Mattresses and mattress pads, flame resistant, 465 trademarks, 185 Mauersberger, Heinrich, 381 uses, 184 Mayer Textile Machine Corp., 381 Modal®, 129, 133 McDonough, William, 518 Modulus, 47 Mechanical properties, 46-48 of acetate and triacetate, 142 of acetate and triacetate, 142 of acrylic, 178 of acrylic, 178 of cotton, 68 of cotton, 68 of flax, 76 of flax, 76-77 of glass fibers, 212 of glass fibers, 212 of nylon, 151 of lyocell, 136 of polyester, 166 of modacrylic, 183 of polypropylene, 190 of nylon, 151-152 of rayon, 132 of polyester, 165-166 of silk, 116 of polypropylene, 190 of spandex, 200 of rayon, 131-132 of wool, 99 of silk, 116 Mohair, 108-109 of spandex, 200 Moiré, 441-442 testing, 525-526 Monk's cloth, 295 of wool, 99 Monofilament yarns, 224 Mechanical texturing, 240, 241 Monomers, 21 Medulla, 97 Monsanto, 176 Melamine, 18, 215 Mordant printing, 436-437 Melt blowing, 349-352 Mordants, 404, 419 Melt spinning, 27 Morphology, 23, 33–35 Mercerization, 52 Mothproofing finishes, 469 cotton and, 70, 397 Multicomponent fabrics Merge number, 35 braided fabrics, 385-386 Meryl®, 154 carpets, 364-370 Metal complex or premetallized dyes, 419 embroidery, 371-373 Metallic fibers, 216-217 fibrillated films, 380-381 Metallocene system, 188 flocked fabrics, 377-378 Metameric, 406 hybrid fabrics using polymer films, 379-380 Metric, 230, 231 knotted fabrics, 382-385 Microfibers, 29-31, 44 laminated or bonded fabrics, 375–377 Micronaire reading, 45, 46, 66 performance and, 386-387 Microns, 45 quilted fabrics, 374-375 Milkweed, 72 stitch-bonded fabrics, 381-382 Milliken Co., 432 textile-reinforced composites, 370-371 Milling or fulling, 445 wall coverings, fiber and textile, 378-379 Millitron[®], 432 Multifibre Arrangement (MFA), 10, 11, 20, 81 Mills, 8 Multifilament yarns, 224 Misti, 107 Multiknit, 355 Mitsubishi, 144, 182 Multiphase looms, 285 Mixed merges, 35–36 Musk ox, 109-110 Modacrylic Muslin, 293 care procedures, 185 Mylar®, 271 chemical properties, 184 compared with acrylic, 185 Naphthol dyes, 419 defined, 175, 183 Napping, 443-444 environmental properties, 184 Natta, Giulio, 188 manufacture of, 183 Natural dyes, 404-405

Natural fibers	Open-end spinning, 254–256
See also Cellulosic fibers, natural	Open width, 392
defined, 17	Optical covering power/factor, 233
examples of, 15, 16	Organdy, 293
Needlepoint embroidery, 372	Organic, 21
Needlepoint lace, 384–385	Organza, 293
Needlepunching, 352	Oriental carpets, 368
Neps, 246	Orientation, 33, 34
Nets, 382–383	Orlon®, 176
Nitrile rubber, 204	Osnaburg, 293
Noils, 249	Ottoman, 294
Noise levels, 514	Outlast Technologies, Inc., 469
Nomex [®] , 155, 156	Overprinting, 426
Nonwoven fabrics	Owens-Corning Glass Co., 210
bonding, chemical, 356	Oxford cloth, 296
bonding, mechanical, 352–355	Oxidation, 52–53
bonding, thermal, 355–356	Oxidation, 32 33
construction technique, 266	Pad-batch process, 393
defined, 347–348	Padding, 393, 452
	the state of the s
direct extrusion processes, 349–352	Paddle machine, 416
fiber web formation, 348–349	PAN (polyacrylonitrile), 175, 209
global growth of, 348	Parchmentizing, 458
manufacture of, 348–356	Partially oriented yarn (POY), 35
performance and, 359–361	PBT (polybutylene terephthalate), 164
uses, 356–357	PEN (polyethylene naphthalate), 164, 165
North American Free Trade Agreement (NAFTA), 10, 11	Percale, 293
Novoloid, 215–216	Perching, 399
Novo Nordisk, 444, 458	Performance
Nylon, 4, 16	quality control, 524–525
care procedures, 154–155	testing, 525–531
chemical properties, 152	Perkin, William, 405
defined, 147	Permanent-care labeling, 492–495, 546
development of, 147, 148	Permanent-press finishes, 453, 455
dyeing, 419–420	PET (polyethylene terephthalate), 162, 165
environmental properties, 152–153	Phase change materials (PCMs), 469
manufacture of, 148–150	4-phenylcyclohexene (4-PCH), 516
mechanical properties, 151–152	Photographic printing, 434
molecular structure, 150	Physical properties, 40–46
physical properties, 150–151	of acetate and triacetate, 141
polymerization of nylon 6, 150	of acrylic, 177–178
polymerization of nylon 66, 149	of cotton, 67–68
properties of, 56, 150–153, 156	of flax, 75–76
trademarks, 154	of glass fibers, 212
uses, 153	of lyocell, 135–136
Nylstar, 154	of modacrylic, 183
Tylstal, 154	of nylon, 150–151
Occupational Safety and Health Act (OSHA)	of polyester, 165
(1970), 513	of polypropylene, 189–190
Oeko-Tex scheme, 515, 516, 517	of rayon, 131
	of silk, 115
Off-gassing, 496	
Oil prices, impact of, 9	of spandex, 198, 200
Olefin, 25	of wool, 96–99
See also Polyethylene; Polypropylene	Pick glass/counter, 275
defined, 187	Picking, 279
properties of, 56	Pick looms, 281

Picks, 273	molecular structure, 189		
Pigments, 404	physical properties, 189–190		
printing with, 424–425	trademarks, 193		
Pile fabrics, woven, 306–309	uses, 191–193		
Pilling, 55, 526	Polyvinyl chloride (PVC), 379		
Pillow lace, 384	Poplin, 294		
Piqué, 302	Poromerics, 380		
Pirn, 278	Postcured treatment, 454		
Pitch, 208	Potting or boiling, 449		
Plaids, 298	Precure treatment, 454		
Plain knits, 326–327	Precursor fibers, 208		
Plain weave, 291–295	Preparation of fabrics for dyeing and finishing. See Wet processin		
Planar, 265	Pre-pregs, 371		
Plated fabrics, 330	Preserving fabrics, 496–497		
Plissé, 435	Printing and design		
Ply yarns, 225, 256	block, 428		
Polartec [®] , 443	blotch (direct), 425		
Pollution Prevention Act (1990), 513	burnout (devore), 434		
Polyacrylonitrile (PAN), 175, 209	colorants used in, 424–425		
Polybenzimidazole (PBI), 214–215	defined, 423		
Polyester	discharge, 426		
care procedures, 170, 173	flock, 435		
chemical properties, 167	heat-transfer (sublimation), 433		
defined, 161	ink-jet, 432		
development of, 161	mordant, 436–437		
environmental properties, 167	over, 426		
manufacture of, 162–163	photographic, 434		
mechanical properties, 165–166	plissé, 435		
molecular structure, 164	resist, 426–427		
PBT (polybutylene terephthalate), 164	roller, 428–429		
PEN (polyethylene naphthalate), 164, 165	screen, 429–432		
PET (polyethylene terephthalate), 162, 165	warp yarn, 435–436		
physical properties, 165	wet, 424		
properties of, 56, 165–168	with dyes, 424		
PTT (polytrimethylene terephthalate), 163–164, 165	with pigments, 424–425		
trademarks, 168, 169	Proban [®] , 467		
uses, 168, 170, 171	Producers, 9		
Polyethylene, 187	Product development		
compared with polypropylene, 191	process, 523–524		
manufacture of, 194	specifications, 522–523		
Polylactic acid (PLA) fibers, 164, 165	Product life cycle, 518		
Polymer films, hybrid fabrics using, 379–380	Product manufacturers, 8		
Polymers	Properties		
basics of, 21–23	See also under type of		
processing of, 23–24	abrasion resistance, 54–55		
Polynosic rayon, 129	chemical, 48–53		
Polyphenylene benzobisoxazole (PBO) fibers, 213	dimensional stability, 54		
Polypropylene, 187	environmental exposure, response to, 53–54		
care procedures, 193	mechanical, 46–48		
chemical properties, 190–191	physical, 40–46		
color of, 190	of selected fibers, 56–57		
compared with polyethylene, 191	Propylene, 188		
environmental properties, 191	Protein fibers		
manufacture of, 188–189	See also Animal hair fibers; Silk		
mechanical properties 190	description of, 89–91		

list of, 90 Repeating units, 21 regenerated, 121 Reserve dyeing, 417 PTT (polytrimethylene terephthalate), 163–164, 165 Resiliency, 48 Purl knits, 334 of acetate and triacetate, 142 PyronO®, 467 of acrylic, 178 Pyrovatex[®], 467 of cotton, 68 of flax, 76 Qiviut, 109-110 of glass fibers, 212 Quality control, 524-525 of nylon, 152 Quality control specialists, 12 of polyester, 166 Quill, 278 of polypropylene, 190 Quilted fabrics, 374-375 of rayon, 132 of silk, 116 Rabbits, angora, 111 of wool, 99 RadiciSpandex, 198, 202 Resin, 188, 348 Raising, 443 Resist printing, 426-427 Ramie (China grass), 80-81 Resource Conservation and Recovery Act (1976), 513 Rapier looms, 283 Retailers, 7, 12 Raschel knits, 340-341, 382 Retting, 74-75 Rayon, 15, 22, 60 Reversible fabric, 270 development of, 126 Rheology, 424 dyeing and finishing, preparation for, 399 Rhovyl®, 218 high-wet-modulus (HWM), 126, 129, 130, 133 Ribbed fabrics, 293-295 properties of, 56 Rib knits, 331 Rayon, cuprammonium, 134 Ring spinning, 252-254 Rayon, viscose Roica®, 202 care procedures, 133-134 Roller printing, 428-429 chemical properties, 132 Roll goods, 348 environmental properties, 132-133 Rope form, 392 manufacturing of, 127-129 Rotary screen printing, 431–432 mechanical properties, 131–132 Roving, 211, 248 molecular structure, 129 Rubber physical properties, 131 advantages and disadvantages, 204 properties of, 129-133 nitrile, 204 raw materials, 126-127 synthetic, 204 uses, 133 Rya rugs, 368 Reaction injection molding (RIM), 371 Ryton®, 215 Reactive dyes, 418 Recycling and reusing, 507-511 Sacaton, 85 Reed, 277 Safety issues. See Environmental and safety issues Reed dent, 278 Sanding, 443 Refurbishing Sandwashing, 118 dry cleaning, 490-491 Sanforized[®], 447 dryers, 486, 489 Sanforized Co., 447 laundering, 476-485 Saran, 218 laundering, commercial, 489-490 Sateen, 300 permanent-care labeling, 492-495 Satins, 300 preserving fabrics, 496-497 Satin weave, 299-301 pressing, 489 Saturator, 392 stain removal, 485-486, 487-488 Schiffli embroidery, 372-373 storage, 491 Schreiner calender, 440 use of term, 476 Scotchlite®, 470 Regenerated fibers, 15, 16 Scouring, 94 Registration, 425 cotton, 395 Relaxation shrinkage, 445-446, 448-449 wool, 398

wool and, 101, 448-449, 456-457 Screen printing, 429 woven fabric and, 316 flatbed, 430-431 Shuttle, 277 rotary, 431-432 Shuttleless looms, 281–285 Seed hair fibers, 60 Side-by-side bicomponent fibers, 32 cotton, 61-72 Silicones, 458 kapok, 72 Silk, 15 milkweed, 72 care procedures, 119–120 Seersucker, 302 chemical properties, 116-117 Self-extinguishing, 463 compared with wool, 119 Self-twist spinning, 257 doupion, 114 Selvages, 275-276 dragline, 120 Semiworsted system, fiber preparation by the, 249 dyeing, 419-420 Sensorial comfort, 530 dyeing and finishing, preparation Serge, 297 for, 397 Sericin, 114, 397 environmental properties, 117 Sericulture, 112 finishes applied to, 118 Shantung, 295 gum removal, 114 Shape and contour, 40-41 history of, 111-112 of acetate and triacetate, 141 mechanical properties, 116 of acrylic, 177 of cotton, 67-68 molecular structure, 115 physical properties, 115 of flax, 76 production, 112-115 of glass fibers, 212 properties of, 57, 115-119 of nylon, 150-151 raw, 114 of polyester, 165 reeling, 114 of polypropylene, 189-190 spider, 120-121 of rayon, viscose, 131 spun, 114 of silk, 115 tussah, 112 of wool, 97-98 uses, 118 Shaw Industries, 148, 154 weighting, 114-115, 117, 546 Shearing, 315, 443-444 yarns, 114 Sheath-core bicomponent fibers, 32 Silpalon[®], 182 Shedding, 279 Simplex knits, 340 Sheep's wool. See Wool, sheep's Singeing, 394 Shell Chemical Co., 163 Shirts, men's dress, 523, 534-535 Single knits, 326–327 Sirospun yarn, 256 Shoddy, 95 Sizing, 278, 395 Shrinkage, 54 SK Chemicals, 144 acetate and triacetate and, 143 acrylic and, 179 Skins, 270 Slack mercerization, 397 chemical control, 456-457 Slack tension weaving, 307-308 compressive, 447-448, 453 Slashing, 278 controlling, 445-449 cotton and, 71 Slit films, 260 Slubs, 246 flax and, 77 Smart fibers, 219 glass fibers and, 212 Soalon®, 144 knitted fabric and, 342-343, 448 London or sponging, 447, 449 Soaps, 476-477 Society of Dyers and Colourists, 417 nylon and, 153 Softeners, 457-458 polyester and, 168 fabric, 482 polypropylene and, 191 water, 479 rayon and, 133 Soil-resistant finishes and fabrics, 460-462 relaxation, 445-446, 448-449 Solutia Inc., 154 silk and, 118 testing, 527 Solution dyeing, 25, 409

Solution spinning, 29 Stain removal, 485-486 chart, 487-488 Solvents, 23-24, 53 Sonic sewing, 375 Stain-resistant finishes and fabrics, 460-462 Sourcing, 8 Staple fibers, 43 Soysilk, 121 Staple/spun yarns, 224 blending fibers, 244-245 Space dyeing, 411 breaking and opening bundles, 245 Spandex, 22 cleaning fibers, 245-246 care procedures, 202-203 chemical properties, 200 cotton, fiber preparation, 246-248 defined, 197-198 flax, fiber preparation, 249-250 environment properties, 200 transforming filaments into tow, 250-252 manufacture of, 198 wool, fiber preparation, 249 worsted wool, fiber preparation, 249 mechanical properties, 200 physical properties, 198-200 Starches, 482 properties of, 57 Static cling, 6, 50 trademarks, 202 Steam relaxing, 448-449 uses, 200-202 Sterling Fibers, 182 Stiffness, 233 Spanish moss, 85 Specifications, 522-523 Stitch bonding, 353 Specific gravity, 43-44 fabrics, 381-382 of acetate and triacetate, 141 Stitch knitting, 381 of acrylic, 178 Stitch-through fabrics, construction technique, 266, 381 of cotton, 68 Stock dyeing, 410 of flax, 76 Stonewashing, 416 Storage, 491 of glass fibers, 212 Stoving, 97 of nylon, 151 Strength, 46-47 of polypropylene, 190 of rayon, 131 of acetate and triacetate, 142 of silk, 15 of acrylic, 178 of wool, 99 breaking, 525-526 bursting, 526 Specking, 400 Spider silk, 120-121 of cotton, 68 of flax, 76 Spinnerets, 26 of glass fibers, 210 Spinning, 26 air-jet, 257 of nylon, 151 cell, 27 of polyester, 165-166 of polypropylene, 190 core, 258 of rayon, 131-132 dry, 27-28 of silk, 116 false-twist or self-twist, 257 of spandex, 200 hollow-spindle, 257-258 testing, 525-526 melt, 27 open-end, 254-256 of wool, 99 Striations, 41 other methods, 29 Stuffer-box texturing, 240, 241, 244 ring, 252-254 use of term, 239 S twist, 229 wet, 28-29 Sublimation printing, 433 Suede, 270 Split films, 259-260 Sponging, 447, 449 Sueded silk, 118 Spraying finishes, 452 Sueding, 443-444 Spunbonding, 349-352 Sulfar, 215 Sulfur dyes, 419 Spun dyeing, 409 Surah, 298 Spunlacing, 352 Surfactants, 477-478 Spun yarns, 224 Stabilizers, adding, 25 Swimwear, 530-532 Stainmaster®, 462 Swivel weave, 310-311

Symmetry, fabric, 270 Thermosol(TM), 420 Sympatex[®], 459 Thickness, fabric, 269 Synthetic dyes, 405 Thinsulate[®], 193 Synthetic fibers, 15, 16 Thread, 227 Systéme international d'unités (SI) (International System of Thread count, 274-275 Units), 40, 522-523 3M, 193, 470 Throwing, 114 Tactel®, 154 Tie-dyeing, 427 Tafel Parclean®, 182 Tire cords, 233 Taffeta, 295 adhesion, 236 Taking up, 279 linear density, 235 Tanning, 270 tensile properties, 234-235 Tapa, 359 Titanium dioxide, 25, 41 Tapestries, hand-woven, 304-305 Tjanting, 427 Tapestrylike fabrics, 303, 304 Tjap block, 427 Technical designers, 523-524 Tone-on-tone dyeing, 417 Teflon®, 219, 460 Tootal Broadhurst Lee, Ltd., 452 Teijin, 155 Top dyeing, 410 Teijinconex[®], 155 Topical finishes, 452 Temperature-regulating finishes, 469–470 Tops, 249 Tenacity, 46 Toray, 182, 380 Tencel®, 134 Toraylon®, 182 Tensile strength, 46 Toughness, 55 Tenter frame, 393 Tow fibers, 250 Terry cloth, 307-308, 328-329 Toxic Substances Control Act (TSCA) (1976), 513 Terylene[®], 161 Toyobo Co., 213 Testers, 12 Trade agreements, 10-11 Testing, 525-531 Trademarks, 17, 18 Tex. 230, 231 Transfer padding, 452 Textile Fiber Products Identification Act (TFPIA) Transshipment, 20 (1960), 16, 261 Trevira II®, 509 provisions of, 17-18, 20, 545 Triacetate Textile Organon, 57 care procedures, 145 **Textiles** chemical properties, 142-143 applications, 1-2, 12 development of, 139 supply chain, 7-9 environmental properties, 143 Textiles Monitoring Body (TMB), 10, 11 manufacturing of, 139-140 Textile-reinforced composites, 370-371 mechanical properties, 142 Texturing, 35, 43, 224 physical properties, 141-143 air-jet, 240, 241 properties of, 130 edge-crimping, 240, 241 uses, 144 false-twist, 240, 241, 242-243 Triaxial weaving, 313 filament yarns, 240-244 Tricot, 338-340 gear-crimping, 241, 244 TRIS, 516 hot-fluid jet, 241, 243-244 T-shirts, 328 mechanical, 240, 241 Tufting, 364-365 stuffer-box, 240, 241, 244 Tulle, 383 thermomechanical, 240, 241-242 Tussah silk, 112 Thermal bonding of nonwoven fabrics, 355–356 Twaron[®], 155 Thermal comfort, 530-531 Twill weave, 296-299 Thermally stable material, 463 Twining, 305 Thermomechanical texturing, 240, 241–242 Twist, 227-229 Thermoplastic, 23 Tying-in, 278 Thermoplastic fibers, shrinkage control for, 449 Type number, 35 Thermosetting, 215 Tyvek®, 193

Ultrafine fibers, 44 novelty fabrics from basic, 301-302 Ultrasuede®, 380, 443 plain, 291-295 Ultraviolet-absorbing, finishes, 470, 472 rib, 293-295 Ultraviolet Protection Factor (UPF), 470 satin, 299-301 Ultron®, 154 swivel, 310-311 triaxial, 313 Union Carbide Co., 183 twill, 296-299 Union dyeing, 417 Upholstered Furniture Action Council (UFAC), 465 variation of basic, 302-310 Upholstery fabrics, 317-319 Weaving flame resistant, 465 concepts and terminology, 273-276 processes, 277-280 weaving machines (looms) Vacuum extraction, 452 air-jet, 284-285 Vat dyes, 418 Vee bed machines, 330 cam, 286 Vegetable fibers, 15 comparison of speeds, 282 Velour, 308, 329 components of, 276-277 Velvet, 307 dobby, 286-287 Velveteen, 309 gripper or projectile, 281-283 jacquard, 287-288 Velvet-weave carpets, 366–367 Vicuña, 107-108 multiphase, 285 Vinal, 219-220 pick, 281 Vinyl chloride, 505 rapier, 283 Vinyon, 218 shuttle, 280 Viscose rayon. See Rayon, viscose shuttleless, 281-285 Voile, 293 types of, 277 Vonnel[®], 182 water-jet, 283-284 Vulcanization, 204 Weft knit and knitted fabrics, 322, 326-330 warp and weft insertion, 342 Wales, 296, 322 Weft yarns, 273 Wall coverings, fiber and textile, 378-379 Weight, fabric, 268-269 Wall-to-wall carpeting, 369-370 basis, 361 Well-hackled fibers, 250 Warp beam, 276 Warp knit and knitted fabrics, 322, 337-341 Wellman, 509 Wet-adhesive method, 376 warp and weft insertion, 342 Wet forming, 348-349 Warp pile fabrics, 306–308 Wet look, 440 Warp yarns, 273 Wet printing, 424 preparing for weaving, 277-278 Wet processing printing, 435-436 Wash-and-wear finishes, 453 batch versus continuous, 392-393 Washing machines, 482-484 bleaching, 395-396, 398 carbonizing, 398 Waste cotton fabrics, preparation of, 394-397 postconsumer, 508-509 preconsumer, 508 crabbing, 398 recycling and reusing to eliminate, 507-511 desizing, 395 Water-jet looms, 283-284 drying, 393-394 flax and other bast fibers, preparation of, 398 Waterproof, use of term, 459-460 Water repellency, 458-460 inspection and repair, 399-400 Water retting, 75 manufactured fibers, preparation of, 399 mercerization, 397 Water softeners or conditioners, 479 scouring, 395, 398 Weaves basket, 295-296 silk fabrics, preparation of, 397 singeing, 394 clipped or unclipped spot, 310 wool fabrics, preparation of, 398 interwoven or double-cloth, 311-312 Wet spinning, 28-29 lappet, 311 leno, 305 Whiteners, 25

finishes and fabrics, 452-455, 471-472

testing, 527 Wrinkling, 232–233

White-on-white, 302	Yarn
Wholesalers, 8	blends, 260-262
Wicking, 49–50	defined, 4, 227
Width, fabric, 269	dyeing, 410–412
Wilton carpets, 367	filament, 224, 239–244
Winch dyeing, 412–413	filling, 273, 278
Winding, 253	making, from films, 258–260
Women's Wear Daily, 57	preparation, 267
Wool, sheep's, 15	properties of, 232
bleaching, 398	staple/spun, 224, 244–256
carbonizing, 398	twist, 227–229
care procedures, 102–103	warp, 273, 277–278
chemical properties, 99–100	weft, 273
compared with acrylic, 180	wrapping, 257–258
compared with silk, 119	Yarns, classification of
crabbing, 398	bouclé or loop, 226
defined, 91, 95	chenille, 226
dyeing, 418–419	complex, 225
dyeing and finishing, preparation for, 398	cord, 225
environmental properties, 100–101	
fiber preparation by the woolen system, 249	core-spun, 226
fiber preparation by the worsted system, 249	crepe, 227–228
global market, 92–93	fancy, 225
grading, 94	flake/flock, 226
mechanical properties, 99	novelty, 225–226
molecular structure, 96, 97	nub (knot or spot), 226
new or virgin, 95	ply, 225, 256
physical properties, 96–99	ratiné, 226
properties of, 57, 96–101, 119, 180	simple, 225
pulled, 94	single, 224–225
recycled, 95	slub, 226
scouring, 398	spiral/corkscrew, 226
shearing, 93–94	thick-and-thin, 226
shrinkage and, 101, 448–449, 456–457	Yarn size
spinning, preparation for, 94	indirect numbering systems, 230, 231
types of, 91–92	direct numbering systems, 229–230, 231
uses, 101–102	Yarn structure, fabric performance and
	appearance factors, 232–233
washable, 456–457	comfort factors, 233
Woolen count, 230, 231	durability factors, 230-232
Wool Products Labeling Act (1939), 17, 91, 94–96, 545–546	
Woven fabrics	Zeftron [®] , 154
See also Weaves; Weaving; Weaving machines (looms)	Ziegler, Karl, 188
construction technique, 265–266	Zirpro [®] , 467
performance and, 313–317	Z twist, 229
World Trade Organization (WTO), Textiles Monitoring Body	Zylon [®] , 213
(TMB), 10, 11	
Worsted count, 230, 231	
Worsted system, fiber preparation by the, 249	
Wrinkle resistance	

2.048

1846